PHOTOGRAPHY

• Barbara London John Upton •

PEARSON
Prentice
Hall

Pearson Education International

President: *Yolanda de Rooy*
Editor-in-Chief: *Sarah Touborg*
Senior Editor: *Amber Mackey*
Director of Marketing: *Brandy Dawson*
Associate Marketing Manager: *Sasha Anderson-Smith*
Executive Marketing Manager: *Marissa Feliberty*
Manufacturing Manager: *Nick Sklitsis*
Manufacturing Buyer: *Sherry Lewis*
Director, Image Resource Center: *Melinda Patelli*
Manager, Visual Research: *Beth Brenzel*
Manager, Cover Visual Research and Permissions: *Karen Sanatar*
Image Permissions Coordinator: *Debbie Latronica*
Director of Operations/Associate Director of Production:
Barbara Kittle

Senior Managing Editor: *Lisa Iarkowski*
Production Editor: *Pine Tree Composition/Jessica Balch*
Production Liaison: *Joe Scordato*
Production Assistant: *Marlene Gassler*
Creative Design Director: *Leslie Osher*
Cover and Interior Design: *Amy Rosen*
Composition: *Pine Tree Composition*
Printer/Binder: *The Courier Companies*
Cover Printer: *Phoenix Color Corp.*
Cover Photo Credits: (from left to right): *View Camera:*
Ken Kay; "Too Much Sugar" © *Chip Simons; Landscape*
Bavaria: Grant Faint/Getty Images; Women Swimming:
Lou Jones Photography

Photo credits appear on page 408 and constitute a continuation of the copyright page.

© 2009 by Pearson Education, Inc.
Upper Saddle River, New Jersey 07458

Printed in the United States of America
10 9 8 7 6 5 4 3 2 1

ISBN 13: 978-0-13-206117-9
ISBN 10: 0-13-206117-1

Pearson Education LTD. , London
Pearson Education Australia PTY, Limited
Pearson Education Singapore, Pte. Ltd
Pearson Education North Asia Ltd
Pearson Education Canada, Inc.
Pearson Educación de Mexico, S.A. de C.V.
Pearson Education -- Japan
Pearson Education Malaysia, Pte. Ltd
Pearson Education, Upper Saddle River, New Jersey

brief contents

contents

preface

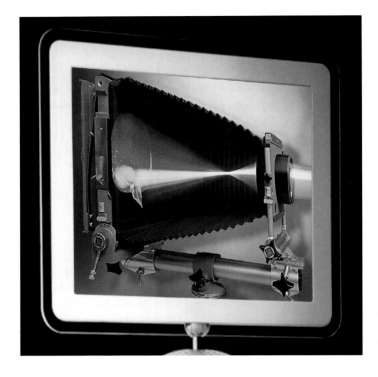

Photography is continually changing, and this version of Photography *reflects that change.* Digital imaging dominates photography. In the image here, a computer screen displays a cutaway view of a view camera, a type of camera that has been in use since the invention of photography. This edition updates the traditional practice of photography as well as updating current technologies.

Throughout this new edition, you will find information about both conventional film photography and digital capture. Techniques such as lighting and composition, central to both digital and film photography, are presented. This book shows how to make photographs, how to control photographic processes, and how different photographers employ them for their own creative purposes.

More than a million copies of *Photography* are now in print. Many people who have used this book have become professional photographers or photography instructors, or are continuing to pursue their personal interest in photography. Whatever your interest in photography, this book is designed to teach the skills that you will need to use the medium confidently and effectively.

This edition continues that tradition, laying out what you need to know to make photographs with film, using a darkroom, but it also moves boldly into the digital age with you. This book presents all facets of photography. The emphasis, however, continues to be in two major areas—technique and visual awareness. The technical material helps you learn how to control the photographic process, or as Ansel Adams put it, to understand the way that the lens "sees" and the light-sensitive material "sees." Equally important, this book can help you see by showing you the choices that other photographers have made and that you can make when you raise a camera to your eye.

Clarity and convenience have always been a focus of this book. In this edition even more effort has been made to organize and format information into an easy guide for beginning photographers and a quick reference for those with experience.
- The easy-to-use format has been maintained, with every two facing pages completing a single idea, skill, or technique.
- Boldfaced topic sentences outline the text on every page.
- Workflow routines are easy to understand and to follow, presented in a step-by-step manner.

The general presentation of technical information has been maintained, with some reorganization for this new edition.
- General photographic techniques are covered completely in Chapters 1–7: digital and film cameras, lenses, sensors and film, exposure, developing and printing black-and-white film, and color photography.
- Chapters 8–11 present information on the digital darkroom, focusing on the information that a beginning student needs to know about bringing images into the computer, adjusting and printing them, and then creating a system so they can be safely stored and easily found.
- Chapters 12–18 cover print finishing, lighting, special techniques (such as making cyanotypes and gum bichromate prints), view camera use, and introduce great historic and contemporary photographs.
- A fully illustrated Troubleshooting Appendix, beginning on page 388, groups together technical problems, their causes, and ways to prevent them.

Improving visual awareness is a major emphasis of the book. Many demonstration photographs make topics easy to understand. Throughout the book you will find hundreds of illustrations by the best photographers showing how they have put to use various technical concepts. See for example:
- The photographs illustrating lens focal length on pages 42–47, or how two photographers use electronic flash plus available light on page 249.

- *Photographer at Work* pages throughout the book feature interviews with photographers who have developed successful careers in everything from sports photography (pages 160–161) to an integration of digital imaging with documentary photography (pages 176–177).
- Chapter 17, Seeing Photographs (pages 318–343), deals with composition, tonality, sharpness, and other visual elements that will help you make better pictures yourself, and see other people's photographs with a more sophisticated eye.
- Chapter 18 (pages 344–387) surveys the history of photography so that you can place today's photography—and your own—in a historical context.

Reasons to use the new Ninth Edition:
In addition to complete coverage of traditional photographic technique, the ninth edition embraces the new photography that is captured, shaped, transmitted, printed, and saved electronically.

- Digital technique is now integrated throughout. Throughout the book, changes have been made to meet the needs of students using an all-digital workflow.
- All new chapters dedicated to digital technique. Four chapters, 8–11, now explore digital photography. Chapter 9 introduces new software applications to manage a digital workflow. It also surveys the range of options you have when adjusting a single image. Chapter 11 covers the organizing of an archive for storing photographs that may have no physical form and can't be saved in a shoebox. It also suggests methods and products to help you to quickly find one image among thousands.
- Over 80 exciting new fine art photographs illustrate technical concepts and help you develop visual awareness. This edition adds a wealth of images from contemporary photographers including Bernd and Hilla Becher, Edward Burtynsky, Nan Goldin, Annie Leibovitz, Loretta Lux, Ed Ruscha, Cindy Sherman, Sandy Skoglund, Alec Soth, and JoAnn Verburg.

Every edition of *Photography* has been a collaborative effort. Instructors, students, photographers, manufacturers, editors, gallery people, and many others participated in it. They fielded queries, made suggestions, responded to material, and were unfailingly generous with their time, energy, and creative thinking.

Special thanks go to instructors who reviewed the previous edition of *Photography*, as well as parts of this edition, and who volunteered many good ideas. They brought a particularly useful point of view, contributing many ideas on not only what to teach, but how to teach it:

Sarah Detweiler, University of Wisconsin, Green Bay

Reed Estabrook, San José State University

Patrick Navin, Green River Community College

Ardine Nelson, The Ohio State University

Joseph Tamargo, Miami Dade College, Wolfson Campus

Without editorial and production assistance, a book of this size and complexity would be impossible to complete. Many thanks to Mary Goodwin for her able detective work finding elusive photographers—and navigating representatives, collections, and estates in several countries and languages. Also, she deserves thanks for her passion for photo books that led to a thorough and comprehensive bibliography. Professor David Jacobs of the University of Houston gave our history chapter a close reading and helped tune it up and extend it by two decades. Special thanks to Amber Mackey, Sarah Touborg, and Joe Scordato at Prentice Hall, and Jessica Balch and the team at Pine Tree Composition for somehow keeping track of it all.

New demonstration photographs were made for this edition by Andrew Crooks and Danny Kaufmann. Kristen Fecker, Dean Arriens, and Chad Person were willing models. Masumi Shibata translated the words and customs of Japan.

Many equipment manufacturers loaned products and answered questions. In no particular order, thanks to Chuck Westfall at Canon USA, Polaroid's Barbara Hitchcock, Linda DiSalvo and Patricia Montesion from Apple Computers, Darren Vena of Lasersoft Imaging, and Adobe Software's Julieanne Kost, Tom Hogarty, and John Nack. Thanks are also due to Hewlett-Packard, Sony, Delkin, Seagate, and SanDisk—all of them forward-thinking corporations that have made their product photographs readily available on the web, simplifying the process of illustrating up-to-date equipment.

Jim Stone owes special thanks for support and tolerance to his parents, Sylvia and Charles, and especially to his wife Linda. Their son Skye, now six, and two-year-old daughters Amber and Jade are already making great photographs because of this book.

This is a book that students keep. They refer to it long after they have finished the basic photo course for which it was purchased. Some of the people who contributed to this edition used the book themselves when they were studying photography, and still have their original, now dog-eared, edition. As you work with the book, you may have suggestions on how to improve it. Please send them to us. They will be sincerely welcomed.

Dedicated to everyone who is part of this new edition.

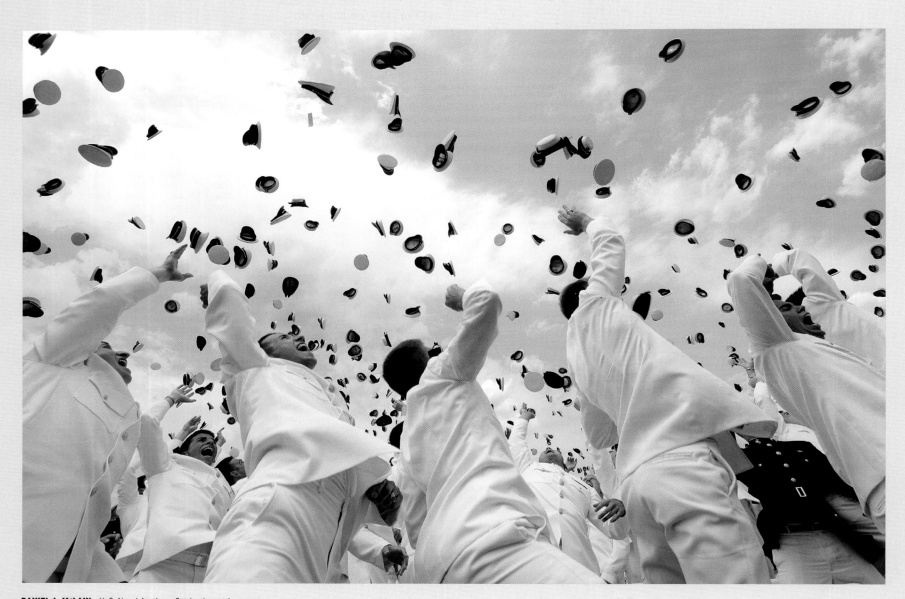

DANIEL J. McLAIN U. S. Naval Academy Graduation and
Commissioning Ceremony, Annapolis, Maryland, 2005

getting started

If you are just getting started in photography, this chapter will walk you through the first steps of getting your camera ready, focusing an image sharply, adjusting the camera settings so your photographs won't be too light or too dark, and making your first exposures. You can go directly to Chapter 2 if you prefer more detailed coverage right away.

Once you know something about the technical basics, the interesting question is—what will you photograph? Here you will find some help in selecting a subject and composing your photograph so that it effectively conveys what you saw.

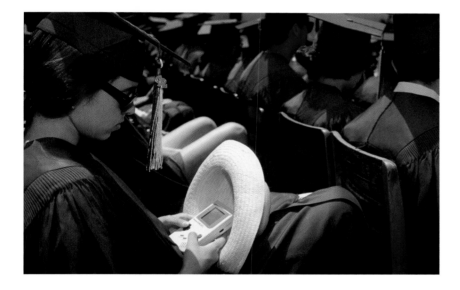

LAUREN GREENFIELD Commencement Ceremony, Crossroads School, Santa Monica, California, 1992

How do you photograph a graduation—or a building or a tree or anything else? *Black and white or color, horizontal or vertical, straight-on or looking up? There are as many ways as there are photographers. In the photograph opposite, from graduation at the U. S. Naval Academy, Photographer's Mate 2nd Class Daniel McLain used a very low point of view to include both the newly commissioned officers and the symbolically thrown hats. Left, Lauren Greenfield captures a moment of ennui as a graduating senior at a private high school plays a video game.*

The steps in this chapter are a basic checklist. Modern cameras vary greatly in design, so read your model's instruction manual or talk to someone who is familiar with your camera. We introduce two kinds of cameras: those that use film and those that record a digital image. To print pictures from a digital camera, you will use a digital printer. If you record your images on film, you can print them in a darkroom, or convert them to digital images by scanning them.

Modern cameras adjust themselves automatically, including the choices of exposure and focus. Nevertheless, many photographers prefer to use manual operation to make their own exposure and focusing decisions. If you are in a photography class, your instructor may ask you to operate the camera manually for your first exposures to help you learn basic camera controls. The following pages cover both manual and automatic operation.

Once you have gotten the basics down, how do you get better? Many of the photographers whose work appears in this book were asked that question. Their advice was surprisingly consistent. "Take more pictures." "Shoot, shoot, shoot." "Persevere." "Just keep after it; you can't help but improve if you do." If this sounds obvious—no secrets or inside information—it seems to be advice that works. These photographers volunteered such comments often and with feeling. They knew how they had improved their skills, and they knew what you should do to get better, too. Don't forget to have fun.

Camera and Film

A camera's main functions when you take a picture (or more precisely, make an exposure) are to help you view the scene so you can select what you want to photograph, focus to get the scene sharp where you want it to be, and adjust the exposure (the aperture setting and shutter speed) so the picture is not too light or too dark.

Read your camera's owner's manual. The basic adjustments of all cameras are the same but the way you set them varies considerably.

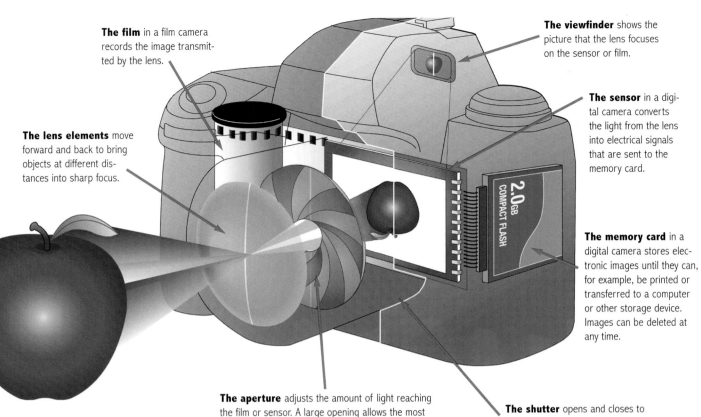

The film in a film camera records the image transmitted by the lens.

The lens elements move forward and back to bring objects at different distances into sharp focus.

The viewfinder shows the picture that the lens focuses on the sensor or film.

The sensor in a digital camera converts the light from the lens into electrical signals that are sent to the memory card.

The memory card in a digital camera stores electronic images until they can, for example, be printed or transferred to a computer or other storage device. Images can be deleted at any time.

The aperture adjusts the amount of light reaching the film or sensor. A large opening allows the most light to pass through the lens. The smallest opening lets in the least amount of light.

The shutter opens and closes to control the length of time that light strikes the light-sensitive surface.

CHOOSE A MEMORY CARD

Digital cameras store pictures on memory cards that vary in capacity and speed. Since there are several types that are not interchangeable, make sure you have one that fits your camera.

CF (Compact Flash)

SD (Secure Digital)

Memory Stick

xD-Picture

ISO Speed (50, 100, 200, and so on) describes a sensor's or film's sensitivity to light. The higher the number, the more sensitive (or "faster") it is, and the less light it needs for the picture to be neither too light nor too dark. Film is made in several speeds; digital cameras allow the user to select one speed out of several choices. For your first exposures, choose a speed of 100 to 200 for shooting outdoors in sunny conditions. In dimmer light, use a speed of 400 or higher.

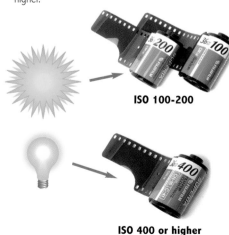

ISO 100-200

ISO 400 or higher

CHOOSE A FILM

Choose negative film for prints or reversal film for slides if you use a film camera. Negative film, either color or black and white, is developed to a negative image, then printed onto paper to make a positive one. Reversal films produce a positive image directly on the film that is in the camera.

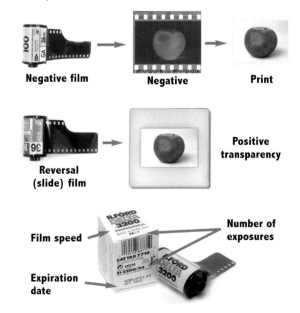

Negative film

Negative

Print

Reversal (slide) film

Positive transparency

Film speed

Expiration date

Number of exposures

DIGITAL CAMERA

Check the Batteries

Make sure the batteries are fresh or the power cell is charged. Your camera won't work at all without power, so keep a spare fully charged power cell or extra batteries handy.

Insert the Memory Card

The camera must be turned off when the memory card is installed or removed. Avoid touching any exposed electrical contacts on the camera or card. Make sure the card is seated properly and close the cover.

Turn the power on and check the display. The number of remaining exposures will be visible. This number varies with the capacity of the card and your camera settings.

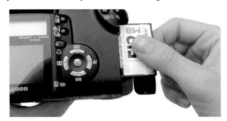

Set the Menu Options

Turn the power on and press the menu button. The first time you turn your camera on, correctly set the date and time. Most of the camera's default settings will be fine for your first photographs, but you should read the owner's manual to become familiar with your choices.

AUTOMATIC FILM CAMERA

Open and Load the Camera

A camera that loads film automatically probably will have a release lever to open the camera. First check the film-frame counter to make sure there is no film in the camera. If there is film in the camera, rewind it, then open the camera by sliding the release lever to its open position. Make sure the camera has fresh batteries.

Insert and Thread the Film

Check for dust in the camera. Clean with a small brush or compressed air. Don't touch the fragile shutter at the camera's center.

Automatic loading. Insert the film cassette. Pull out the tapered end of the film until it reaches the other side of the camera. Usually a red mark or other indicator shows where the end of the film should be. The film won't advance correctly if the end of the film is in the wrong position. Make sure the sprocket holes are engaged.

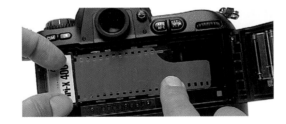

Advance Film to the First Frame

Automatic film advance. Depending on your camera, you may simply need to close the camera back and turn on the power switch to advance the film to the first frame. Some cameras also require you to depress the shutter button.

If the film has correctly advanced, the film-frame counter will display the number 1. If it does not, open the camera back and check the loading.

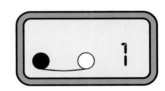

MANUAL FILM CAMERA

Open and Load the Camera

A camera that loads film manually will have a rewind knob on the top. This type of camera usually opens by pulling up on the rewind knob. If not, you will find a release lever on the side.

Insert and Thread the Film

Manual loading. Push down the rewind knob. Pull out the tapered end of the film until you can insert it into the slot of the take-up spool on the other side of the camera. Alternately press the shutter-release button and rotate the film-advance lever until the teeth that advance the film securely engage the sprocket holes at the top and bottom of the film, and any slack in the film is reeled up by the take-up spool.

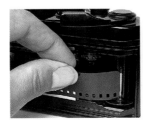

Advance Film to the First Frame

Manual film advance. With the camera back closed, alternately press the shutter-release button and rotate the film-advance lever. Repeat two times.

If the film is advancing correctly, the film-rewind knob will rotate counterclockwise as you move the film-advance lever. If it does not, open the camera and check the loading. Don't rely on the film-frame counter; it may advance even though the film does not move.

Film-rewind knob Advance lever

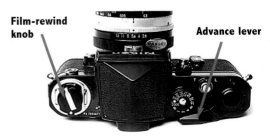

Focusing and Setting the Exposure

SET THE ISO SPEED

Set your camera to an ISO speed, a measure of how sensitive the sensor or film is to light. Film is made in different speeds; the ISO number is marked on the box and on the cassette. Digital cameras can be set to one of several speeds that may be changed for each picture. See page 82.

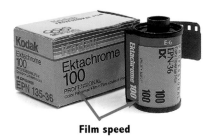

Film speed

Digital Cameras

A digital camera lets you choose an ISO within a specific range. Some cameras allow settings from 50 to 400, others 100 to 3200. Consult the owner's manual to find the range of ISO settings for your camera and how to adjust it.

Film Cameras

DX codes can set the film speed automatically. Some cameras detect the film speed from the code of polished squares on the film cassette and show it on a display. On other cameras you must set the film speed manually. Turn the film-speed dial (marked ISO or sometimes ASA) to the speed of your film.

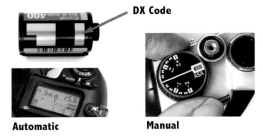

DX Code

Automatic **Manual**

FOCUS

Focus on the most important part of your scene to make sure it will be sharp in the photograph. When photographing a person, this is usually the eye. Practice focusing on objects at different distances as you look through the viewfinder so that you become familiar with the way the camera focuses.

Automatic Focus

Automatic focusing. Usually this is done by centering the focusing brackets (visible in the middle of the viewfinder) on your subject as you depress the shutter release part way. The camera moves the lens for you, bringing the bracketed object into focus. Don't push the shutter release all the way down until you are ready to make an exposure.

Shutter release

**Part way down:
autofocus activated**

**All the way down:
shutter released**

Manual Focus

While looking through the viewfinder, rotate the focusing ring on the lens until the scene appears sharp. The viewfinder of a single-lens reflex camera has a ground-glass screen that displays a scene sharply when it is in focus. Some viewfinders also have a microprism, a small ring in which an object appears coarsely dotted until focused. Others have split-image focusing in which part of an object is offset when it is out of focus.

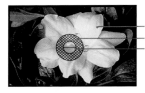

**Ground glass
Microprism
Split image**

FACTORS THAT CONTROL EXPOSURE

To get a correctly exposed picture, one that is not too light (overexposed) or too dark (underexposed), you—or the camera—set the lens opening (aperture) and shutter speed depending on the ISO speed you have selected for your digital camera or the film you have loaded, and on how light or dark your subject is. The aperture size determines how much light passes through the lens; the shutter speed determines the length of time that the light strikes the light-sensitive surface inside your camera.

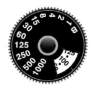 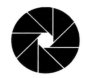

Aperture size **Shutter speed** **ISO setting or
film speed** **Brightness of subject**

EXPOSURE READOUT

Exposure readout about the shutter speed and aperture appears in the viewfinder of most cameras, often along with other information. Here, the viewfinder of a digital camera displays 1/125 sec shutter speed, f/5.6 aperture.

Some older film cameras use a needle-centering display (below right) instead of showing aperture and shutter speed (below left). You change the shutter speed and/or the aperture until the needle centers between + (overexposure) and − (underexposure).

An LCD data panel appears on many cameras, displaying shutter speed and aperture settings (here, 1/500 sec shutter speed, f/5.6 aperture), plus other information. On digital cameras, there is usually also a larger color display for menus and pictures. Make sure you know where the essential exposure information is shown on your camera.

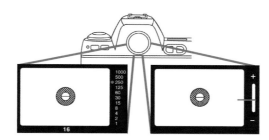

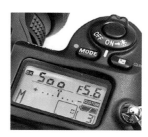

SET THE EXPOSURE—Automatic

With automatic exposure or programmed automatic exposure, each time you press the shutter-release button, the camera automatically meters the light, then sets what it determines is the best shutter speed and aperture combination.

With aperture-priority automatic exposure, you set the aperture (the f-stop) and the camera sets the shutter speed. To keep the picture sharp if you are hand holding the camera (it is not on a tripod) the shutter speed should be 1/60 sec or faster with a 50mm lens. If the shutter speed is slower than 1/60 sec, set the aperture to a larger opening. (The larger the opening, the smaller its f-number. For example, f/8 is larger than f/11.)

With shutter-priority automatic exposure, you set the shutter speed and the camera sets the aperture. To keep the picture sharp if you are hand holding the camera (it is not on a tripod), select a shutter speed of 1/60 sec or faster with a 50mm lens.

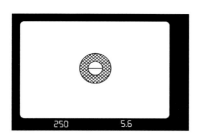

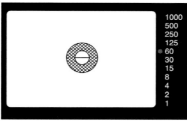

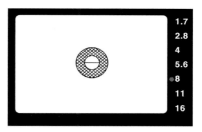

SET THE EXPOSURE—Manual

With manual exposure, you set both the shutter speed and aperture yourself. How do you know which settings to use? At the simplest level you can use a chart sometimes packaged with film, like the one at right. Decide what kind of light is on the scene, and set the shutter speed and aperture accordingly. The chart is based on what is sometimes called the "Sunny 16" rule. On a sunny day, set the aperture to f/16 and use the shutter speed closest to the ISO number. For example if the ISO speed is 100, set the shutter to 1/125 of a second (or 1/100 if your camera allows it) and the aperture to f/16. The chart at right shows an equivalent exposure—a faster shutter speed at a wider aperture, 1/250 sec at f/11.

ISO 100 film Outdoor exposures for average subjects				
Shutter Speed 1/250		Shutter Speed 1/125		
Bright or Hazy Sun on Sand or Snow	Bright or Hazy Sun (Distinct Shadows)	Weak, Hazy Sun (Soft Shadows)	Cloudy Bright (No Shadows)	Open Shade † or Heavy Overcast
f/16	f/11*	f/8	f/5.6	f/4

* f/5.6 for backlighted close-up subjects
† Subject shaded from sun but lighted by a large area of sky

You can use a camera's built-in meter for manual exposure. (Below is yet another way you may see information displayed in a viewfinder. Depending on your exposure, one of the three indicators would light up.) Point the camera at the most important part of the scene and activate the meter. The viewfinder will show whether the exposure is correct. If it isn't, change the shutter speed and/or aperture until it is.

To prevent blur caused by the camera moving during the exposure (if the camera is not on a tripod), use a shutter speed of at least 1/60 sec with a 50 mm lens. A shutter speed of 1/125 sec is safer.

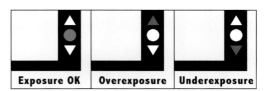

| Exposure OK | Overexposure | Underexposure |

Taking Your Picture

HOLD THE CAMERA STEADY

For horizontal photographs, keep your arms against your body to steady the camera. Use your left hand to support and focus the camera, and your right forefinger to press the shutter release.

For vertical photographs, support the camera in either your right or left hand. Keep that elbow against your body to steady the camera.

A tripod steadies the camera for you and lets you use slow shutter speeds, such as for night scenes or other situations where the light is dim.

TAKE A PICTURE

Make an exposure. Recheck the focus and composition just before exposure. When you are ready to take a picture, stabilize your camera and yourself and gently press the shutter release all the way down.

Make some more exposures. You might want to try several different exposures of the same scene, perhaps from different angles. See opposite page for some ideas.

Keep a record of your exposures. With film cameras, write down the frame number, subject, f-stop and shutter-speed settings, and any other relevant information. Then you won't forget what you did by the time you develop and print the film. Digital cameras record much of the technical data automatically but you may still want to note details about the subject or a reminder of your intent.

NOTE: What to do when your camera won't let you take a picture

- Make sure the camera is switched on and you have some indication—a signal light or menu display—of electrical power.
- Check that the battery is installed properly. If not, reinstall.
- If the battery is properly placed, rub the top and bottom of the battery with a pencil eraser to clean the contacts. If this doesn't work, replace the battery.
- Make sure you have film or an appropriate memory card in the camera. If you do, reload the film or re-seat the card in case it's not engaged properly.
- Try changing from autofocus to manual.
- With a manual camera, advance the film or move the advance lever.
- Try a new roll of film or a new memory card; the one you are using may be damaged.

DOWNLOAD THE PICTURES: Digital Camera

When your memory card is full, or you are finished with a shooting session, download (transfer) the picture files to a computer or portable storage device and—for safety—back them up by duplication as soon as possible. You can download files from the camera through a cable, or remove the card to a card reader. Erase (or reformat) the card from the camera's menu or the computer when you are certain the files are safely stored.

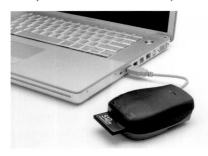

REWIND THE FILM: Automatic Camera

Some cameras rewind automatically at the end of a roll. Others send a signal when no more frames are available, then rewind when you press a rewind button. Rewind the film back into its cassette before opening the camera. Store film away from light and heat until developed.

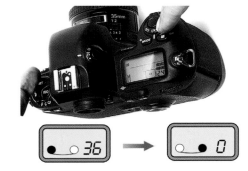

REWIND THE FILM: Manual Camera

You'll know that the roll of film is at its end when the film advance lever will not turn. The film-frame counter will also show the number of exposures you have taken. Activate the rewind button at the bottom of the camera. Lift the handle of the rewind crank and turn it clockwise until its tension releases.

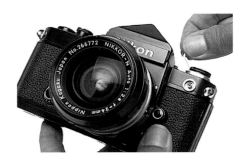

WHERE DO YOU START?

One place to start is by looking around through the viewfinder. A subject often looks different isolated in a viewfinder than it does when you see it surrounded by other objects. What interests you about the scene? Why do you want to photograph it?

Get closer (usually)

Often people photograph from too far away. What part of the scene attracted you? Do you want a picture of your friend from head to toe, or are you interested in the expression on her face?

Look at the edges

How do the edges of the photograph intersect the subject? Does the top edge cut into the subject's head? Is the subject down at the bottom of the frame with a lot of empty space above it? See what you've got and see if you might want something a little different.

Look at the background (and foreground)

How does your subject fit within its surroundings? Will details in the background detract from your main subject? Is there a pole or a tree that appears to grow out of someone's head?

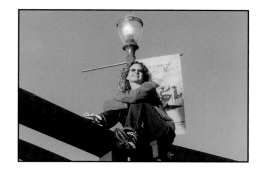

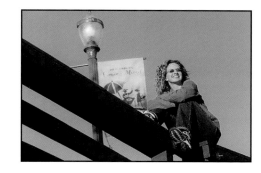

Check the lighting

Is the light more or less even overall? If this is your first roll, you are most likely to get a good exposure if you photograph an evenly lit scene, not one where the subject is against a very light background, like a bright sky.

But why not experiment, too?

See what happens. Include a bright light in the picture (but don't stare directly at the sun through the viewfinder). Try a different angle. Instead of always shooting from eye level, try getting up high and looking down, or try kneeling and looking up.

A good portrait shows more than merely what someone looks like. It captures an expression, reveals a mood, or tells something about a person and about the photographer too. Props or an environmental setting are not essential, but they can help show what a person does or what kind of person they are.

Put your subject at ease. To do this, you have to be relaxed yourself, or at least look that way. You'll feel better if you are familiar with your equipment and how it works so you don't have to worry about how to set the exposure or make other adjustments.

Don't skimp when shooting portraits. Taking three, four, or a dozen shots to warm up can get your subject past the nervousness that many people have at first when being photographed.

Try to use a fast enough shutter speed, 1/60 second or faster with a 50mm lens, so you can shoot when your subject looks good. If you have to ask them to "hold it," they are likely to produce a wooden expression. **NOTE:** Be sure to use a faster shutter speed with a long-focal-length lens.

Photographing close to home can be an easy place to start—or a difficult one. Conventional portraits or snapshots are pleasant and fun, but someday you may want to move beyond them to a more personal image, one that reveals more about the person you are photographing or your relationship with them.

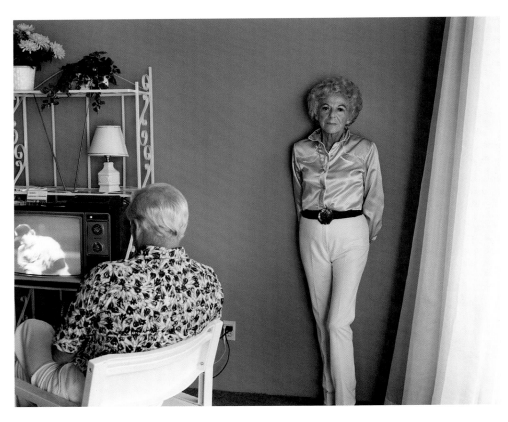

LARRY SULTAN My Mother Posing for Me, 1984

To see our parents is to see ourselves. It can reveal how we feel about them and about ourselves, as well as something about who we might or might not become. Larry Sultan's book Pictures from Home *is a complex view of his family that contains old family snapshots, stills from home movies, text by Sultan, and commentary from his parents, in addition to the pictures he made of them.*

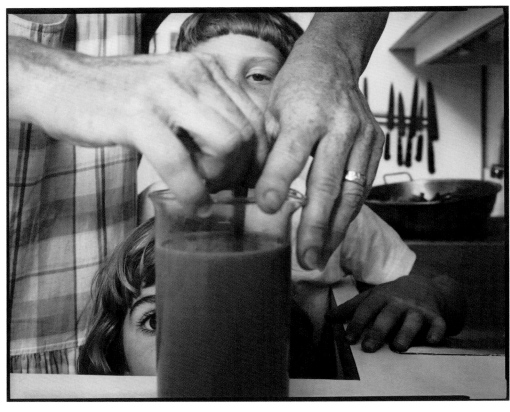

NICHOLAS NIXON
Bebe, Sam, and Clementine, Cambridge, 1990

What makes a portrait? A tight cropping that shows only part of a scene can tell as much about people and their relationships as a more conventional portrait. For a series of family portraits, the photographer used a view camera loaded with individual sheets of film. He included the characteristic edges of the film as part of the photograph.

Some pictures of people look unplanned, made either without the subjects knowing they are being photographed or without seeming posed or directed by the photographer. It isn't always easy to tell if a photograph was posed or not.

Set your camera's controls beforehand if you want to be relatively inconspicuous at a scene. Prefocus if you can, although that may not be possible. Longer-focal-length lenses require more critical focusing than do shorter lenses. A camera with automatic focus can help you work unobtrusively.

A fast shutter speed is even more important for unposed photographs of people than for planned portraits. Your subject is likely to be moving and you are likely to be hand holding the camera rather than using a tripod. A fast film or high ISO setting will be useful; 400 works well in most situations.

DR. PETER MAGUBANE Zulu Women

Portraits showing very different cultures—from the photographer's or from the viewer's—are better when the photograph conveys more than just that difference. Magubane, who lives in South Africa, preserves tribal costumes and rituals in his series Vanishing Cultures of South Africa. But his photograph presents more than just the exotic; the bold colors form the kind of strongly graphic composition that would make a compelling image of any subject.

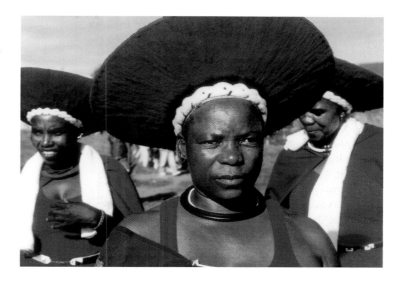

MASSIMO VITALI Marina di Pietrasanta, August, 1994

The beach reveals clearly the way people interact—or choose not to. Vitali erected a platform fifteen feet above the water to achieve an unusal perspective on vacationers. His large, highly detailed prints can be seen as an array of individual portraits in one picture.

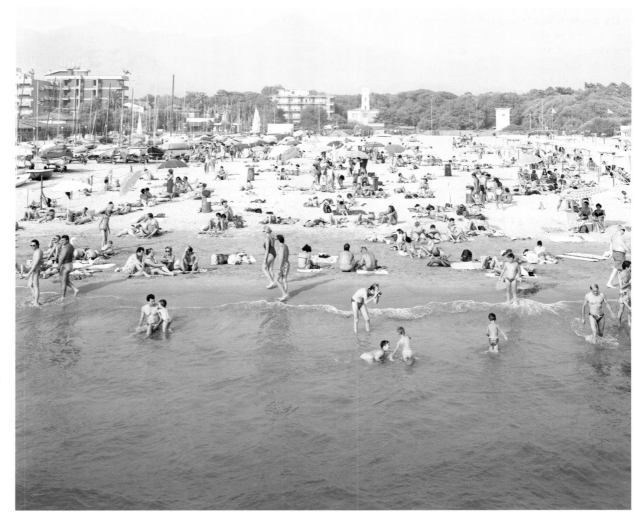

How do you photograph a place? Most important is: What do you want to remember or communicate? What is the best—or worst—part of the place for you? Do you want a large vista or a close-up of a small part of a scene? Look at a scene from different angles, walking around it to view it from different positions. Get closer or step back to see a scene from farther away. When you are close to an object, even a slight change of position will alter its relation to the background. Change your point of view and a subject may reveal something you didn't see at first.

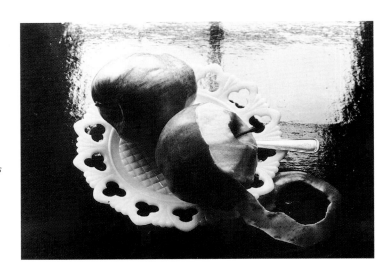

LOUISE DAHL-WOLFE
Apples on a Plate, 1915

Light from a window reflects off an oilcloth as a background for the apples. *Better known for her fashion photographs, Louise Dahl-Wolfe made this still life early in her career.*

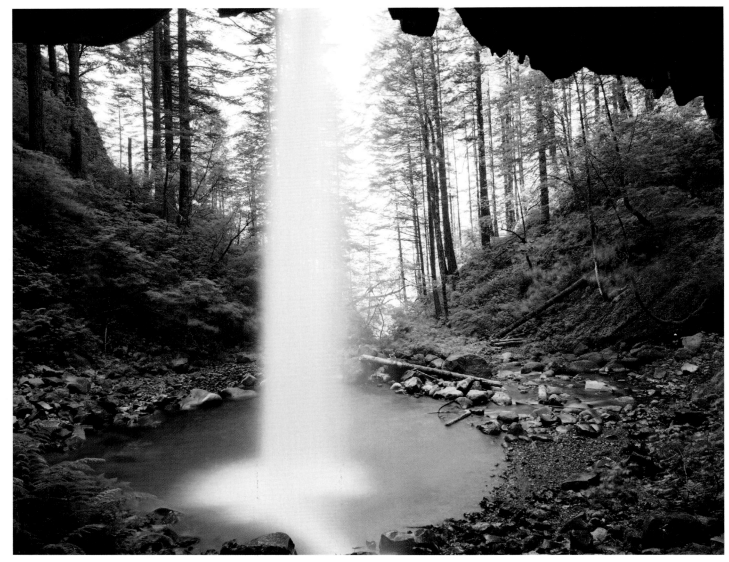

STUART ROME
Horsetail Falls, 1996

Your favorite place can seem more remarkable from a well-chosen vantage point. *Shooting these falls from underneath an overhang framed the water with a curtain of ledge. The delicate softness of the blurred waterfall makes a contrast with the hard darkness of the surrounding rock.*

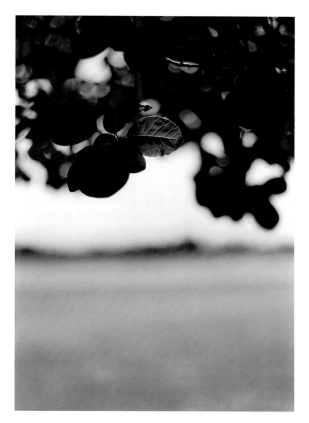

TERRI WEIFENBACH
1. August 1998

A scene doesn't have to be fully described to communicate effectively. *Weifenbach concentrates on the play of light on a single leaf to suggest the entire environment.*

JEM SOUTHAM Bolenowe Moor, Cornwall, England. From *The Red River* 1982–1987

Time of day is important in setting a mood. *Warm interior light contrasts with the coolness of failing daylight, suggesting a human presence and giving life to the scene.*

ANDREAS FEININGER
Photojournalist, 1955

A merging of photographer and camera. *Notice how the dark shadows isolate and emphasize the important part of the picture. "Making a good photograph requires genuine interest in the subject," Feininger said. "Without it, making a photograph sinks to the level of boring routine."*

camera

Why do you need to know how a camera works? Much of modern camera design is based on one of the earliest camera slogans, "You press the button, we do the rest." Automatic-exposure cameras set the shutter speed, aperture, or both for you. Automatic-focus cameras adjust the lens focus. But, no matter what technological improvements claim to make a camera "foolproof" or "easy to use," there are still choices to make before you take a picture. Either you make them or the camera does, based on what the manufacturer calculates will produce the best results for an average scene.

But average results may not be what you want. You have the freedom to interpret what you see. Do you want to freeze the motion of a speeding car or let it race by in a blur? Do you want to bring the whole forest into sharp focus or isolate a single flower? Only you can make these decisions.

If you are learning photography, most instructors recommend using manual operation at first because it will speed your understanding of basic camera controls. If you do have a camera with automatic features, this book tells not just what those features do, but even more important, when and how to override an automatic mechanism and make the basic choices yourself.

Basic Camera Controls

The basic controls on all cameras are similar, helping you to perform the same actions every time you take a picture. You'll need to see the scene you are photographing, decide how much of it you want to include, focus it sharply—where you want it to be sharp, and use the shutter speed (the length of time the shutter remains open) and aperture (the size of the lens opening) to expose the film or sensor to the correct amount of light.

One of the most popular camera types is shown here—the single-lens reflex. Other basic camera designs are described later in this chapter.

As the camera's settings change, the picture changes also. What will a scene look like at a faster shutter speed or a slower one? How do you make sure the background will be sharp—or out of focus—if you want it that way? Once you understand how the basic camera controls operate and what your choices are, you will be better able to get the results you want, rather than simply pressing the button and hoping for the best.

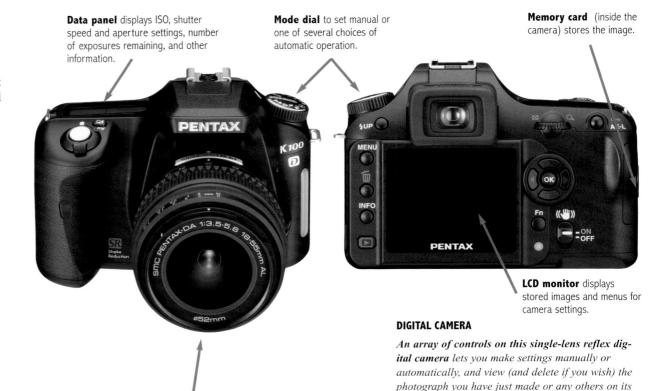

Data panel displays ISO, shutter speed and aperture settings, number of exposures remaining, and other information.

Mode dial to set manual or one of several choices of automatic operation.

Memory card (inside the camera) stores the image.

LCD monitor displays stored images and menus for camera settings.

DIGITAL CAMERA

An array of controls on this single-lens reflex digital camera lets you make settings manually or automatically, and view (and delete if you wish) the photograph you have just made or any others on its memory card.

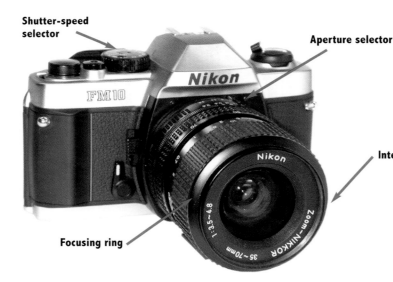

Shutter-speed selector

Aperture selector

Focusing ring

Interchangeable lens

Control dial for manually selecting shutter speed and/or aperture.

Mode dial

Focusing ring for manually focusing the lens.

Switch for selecting manual or autofocus.

MANUAL FILM CAMERA

Manually adjusted controls on this 35mm single-lens reflex camera let you set the shutter speed (the length of time the shutter remains open), select the lens aperture (the size of the lens opening), focus on a particular part of the scene, and change from one lens to another.

AUTOMATIC FILM CAMERA

On automatic cameras, control keys often replace adjustable knobs or rings. This model automatically adjusts the focus, shutter speed, aperture, and lens focal length and fires a built-in flash when necessary. You can override the automatic features if you want to adjust the camera's settings yourself.

Viewfinder image

The viewfinder shows you the entire scene that will be recorded and indicates which part of the scene is focused most sharply. The viewfinder usually displays exposure information—here the shutter speed (1/250) and aperture (f/16).

Slow shutter speed

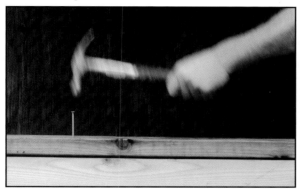

Fast shutter speed

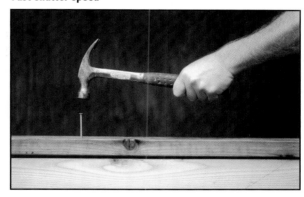

The shutter-speed selector controls the length of time that the shutter remains open. A shorter time decreases the likelihood that a moving object will appear blurred.

Large aperture opening

Small aperture opening

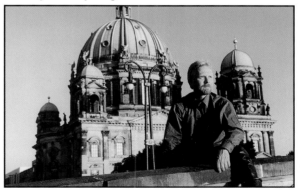

The aperture selector adjusts the size of the lens opening—created by the blades of the diaphragm. The smaller the aperture opening, the greater the depth of field (the part of the scene from near to far that will be sharp).

Short-focal-length lens

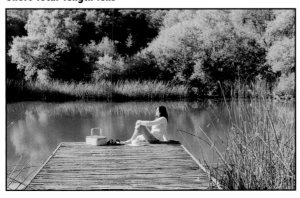

Long-focal-length lens

Interchangeable lenses let you select the lens focal length, which controls the size of objects in the picture and the extent of the scene that will be recorded on the film or captured digitally.

Two controls adjust the amount of light that reaches the sensor or film: the shutter, described here, and the aperture (pages 24–25). The combination of an aperture and a shutter speed is an exposure, which must be a correct one so your picture is neither too light nor too dark.

Adjusting the length of time the shutter remains open controls the amount of light that reaches the light-sensitive surface. Doubling the amount of time it is open gives one stop more exposure—twice the amount of light. Halving the amount of time gives one stop less exposure—half the amount of light. Each full stop shutter setting is half (or double) the time of the next one and is marked as the denominator (bottom part) of the fraction of a second that the shutter remains open: 1 (1/1 or one second), 2 (1/2 second), 4 (1/4 second), and so on through 8, 15, 30, 60, 125, 250, 500, 1000 or higher. Some cameras have shutters that reach 1/8,000 of a second. B (bulb setting) keeps the shutter open as long as the release button is held down. T (time setting) opens

the shutter with one press of the release, and closes it with another.

Electronically controlled shutters can operate at any speed, for example, 1/38 second. These "stepless" speeds are set by the camera in automatic exposure operation; some cameras allow you to dial them in yourself—others don't.

Some digital cameras use a shutter for exposure. Others use them only to block light when the sensor needs darkness; they control exposure by turning the sensor on and off for a precisely-timed duration.

NOTE: The term "stop" in photography refers to a change in illumination, whether the shutter speed or the aperture is changed to achieve it. To give one stop more exposure means to double the amount of light reaching the film either by doubling the exposure time or by doubling the size of the aperture (see page 25). To give one stop less exposure means to cut the light reaching the film in half by halving the exposure time or by halving the size of the aperture.

WHERE SHUTTER SPEED SETTINGS ARE DISPLAYED ON VARIOUS CAMERAS

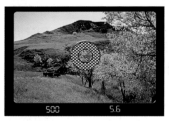
In the camera's viewfinder

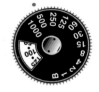
On the shutter-speed dial

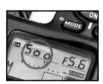
In the data-panel readout

For the above examples, each camera is set to 1/500 sec. Notice that the camera displays only the bottom number of the fraction.

SHUTTER SPEEDS—WHAT YOU SEE AND WHAT YOU GET

Cameras used to provide shutter speeds only in full stops. Older mechanical shutters could only provide a modest number of settings so they were made only to let in light for double the amount of time of the shutter speed before it or half that of the one after it. Cameras today with electronically controlled shutters will also set shutter speeds in between. Most cameras display increments of one-half or one-third stops and allow you to choose which of those you see. This chart shows how long each full stop remains open, plus how your camera may display fractional stops.

Many of these numbers are rounded off. Don't be surprised by inconsistency in shutter speeds among camera manufacturers. For example, an exact half-stop setting between 1 and 2 should be the square root of two, approximately 1.4142. One camera displays this as 1.4, another as 1.5.

NOTE: Don't confuse 2, meaning 2 seconds, with 2, meaning 1/2 second; 4, meaning 4 seconds, with 4, meaning 1/4 second, and so on.

If your camera allows you to choose among different ways to set shutter speeds, use full stops while learning photography. Do the same with aperture settings (see page 24).

Actual time in seconds	Shutter speeds your camera may display		
	FULL STOP	1/3 STOP	1/2 STOP
1 sec	1	1 1.3 1.6	1 1.5
1/2 sec	2	2 2.5 3	2 3
1/4 sec	4	4 5 6	4 6
1/8 sec	8	8 10 13	8 11
1/15 sec	15	15 20 25	15 20
1/30 sec	30	30 40 50	30 45
1/60 sec	60	60 80 100	60 90
1/125 sec	125	125 160 200	125 180
1/250 sec	250	250 320 400	250 350
1/500 sec	500	500	500

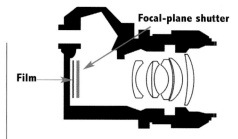

HOW SHUTTERS WORK

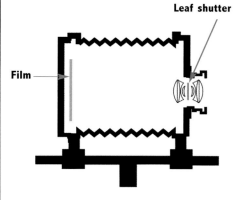

Film

Leaf shutter

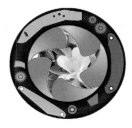

A leaf or between-the-lens shutter is generally located inside the lens itself. All view cameras, many medium-format cameras, and most point-and-shoots use leaf shutters. The leaf shutter consists of a number of small overlapping metal blades. As shown at right, when the shutter is released, the blades open up for an amount of time determined by the selected shutter speed, then shut again. The total amount of light admitted during this cycle produces the fully exposed photograph (see top of the page).

Many compact digital cameras use a particular kind of CCD sensor (called interline transfer) that controls the length of exposure electronically. Most of these have a leaf shutter that is normally open, but closes momentarily before exposure to allow the sensor to initialize.

Advantages/Disadvantages. A leaf shutter is quieter than a focal-plane shutter and can be used with flash at any shutter speed. But since the leaf shutter has to open, stop, and then reverse direction to close again, most have top speeds no higher than 1/500 second. If your interchangeable-lens camera uses leaf shutters, the shutter is probably built into the lens. The cost of a shutter then adds to the price of each lens. Also, actual shutter speeds might be a little slower or faster than each other. Generally, the difference is small, but it could be enough to make a noticeable difference in exposure when changing from one lens to another.

Because a leaf shutter only has to open until it reaches the outer edge of the aperture, many cameras can set a higher shutter speed for small apertures than for large ones. Leaf shutters are so quiet that many compact digital cameras are programmed to emit an electronic shutter-like sound when the button is pressed so the user can tell when an exposure has been made.

Focal-plane shutter

Film

A focal-plane shutter is built into the camera body and is located directly in front of the sensor or film; it consists of two overlapping curtains. When the shutter is released at slow shutter speeds, the first (opening) curtain moves across the frame, revealing a window through which the sensor or film is exposed. The shutter waits for the correct amount of time, then it closes the second (following) curtain to stop the exposure. At higher shutter speeds, the following curtain begins to close before the opening curtain has completed its travel. The film or sensor is exposed through what appears to be a moving slit. As the shutter speed increases, this slit narrows.

The series to the right shows the shutter travel at fast shutter speeds. The narrow slit exposes only part of the frame at any one time, but every part of the film or sensor receives light for the same amount of time. Above, see the effect of the entire exposure, with all sections of the film or sensor having received the proper amount of light.

The shutter shown here moves from side to side. Some cameras have another type of focal-plane shutter (called a guillotine) that moves from top to bottom. Some digital single-lens reflex cameras use an interline transfer CCD sensor (see text at left). They also have a focal-plane shutter but do not use it to control the length of exposure.

Advantages/Disadvantages. Interchangeable lenses for a camera with a focal-plane shutter can be less expensive than those for cameras requiring leaf shutters, since a shutter does not have to be built into each lens. And focal-plane shutters can reach higher speeds than leaf shutters—as high as 1/8000 sec.

Generally, however, you can't use electronic flash when both shutter curtains are moving at the same time. The highest shutter speed at which the opening curtain has completed its travel before the following curtain begins to move—called sync speed—may be as slow as 1/60 second. At any faster shutter speed than a camera's sync speed, a flash will illuminate only the slice of the frame revealed by the slit at the moment the flash is triggered.

Because you must use a relatively slow shutter speed with flash, existing (or ambient) light may register on the film or sensor as well as light from the flash. This can leave a "ghost" or second image in the picture.

The faster the shutter speed, the sharper a moving subject will be. A blurred image can occur when an object moves during an exposure, because its image projected onto the sensor or film by the lens will move during the time the shutter is open. If the object moves swiftly, or if the shutter is open for a relatively long time, this moving image will blur and be indistinct. But if you increase the shutter speed, you can reduce or eliminate the blur. You can control this effect and use it to your advantage. A fast shutter speed can freeze a moving object, showing its position at the instant of exposure (see opposite page). You can use a slower shutter speed to increase blurring and accentuate the feeling of motion (see pages 22 and 23). Generally, the amount of motion blur will double if you increase the shutter speed by one stop (toward a longer time).

Shown below are the effects of varying shutter speed and camera movement. In the picture at far left, the bicycle moved enough during a relatively long exposure of 1/30 second to leave a broad blur on the film. In the next photograph, at a shutter speed of 1/500 second, the bicycle is much sharper. A moving subject may vary in speed and thus affect the shutter speed needed to stop motion. For example, motion slows and sometimes stops at the peak of a movement that reverses, such as the peak of a jump just before descent (opposite page), and even a relatively slow shutter speed will record the action sharply.

Other factors besides shutter and subject speed also affect the amount of blurring in a photograph. What matters is how far an image actually travels across the film or sensor during the exposure. In the photograph below of the rider moving directly toward the camera, the bicycle's image remains in virtually the same position in the frame. Thus there is far less blurring even at 1/30 second. A subject close to the camera that is moving slowly, such as a cyclist 10 feet away, will cross more of the film or sensor and appear to blur more than the same subject moving at the same speed but farther away.

A long-focal-length lens magnifies objects and makes them appear closer to the camera. A moving subject will appear more blurry when photographed with a long lens than it would if photographed with a normal lens used at the same distance.

Panning keeps a moving subject sharp while blurring the background. In the picture below, right, the camera was moved (panned) in the same direction the bicycle was moving. Since the camera moved along with the bicycle, the rider appears sharp while the motionless background appears blurred. Successful panning takes both practice and luck. Variables such as the exact speed and direction of the moving object make it difficult to predict exactly how fast to pan. Decide where you want the object to be at the moment of exposure, start moving the camera a few moments before the object reaches that point, and continue the motion after the exposure (follow-through) as you would with a golf or tennis stroke. The longer the focal length of the lens, the less actual camera movement will be necessary.

DIRECTION OF A MOVING OBJECT AFFECTS THE AMOUNT OF BLUR

1/30 second

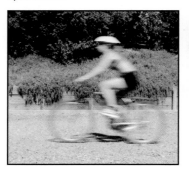

1/500 second

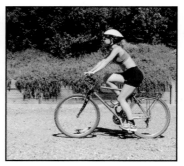

1/30 second

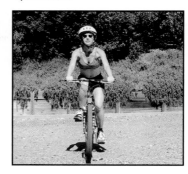

1/30 second, camera panned

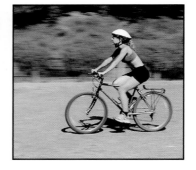

When a subject is traveling parallel to the plane of the film or sensor, considerable movement is likely to be recorded on the film. The subject will be blurred, unless the shutter speed is fast.

If the subject is moving directly toward or away from the camera, no sideways movement is recorded so a minimum of blur is produced, even at a relatively slow shutter speed.

During panning, the camera is moved in the same direction as the subject. The result is a sharp subject and a blurred background.

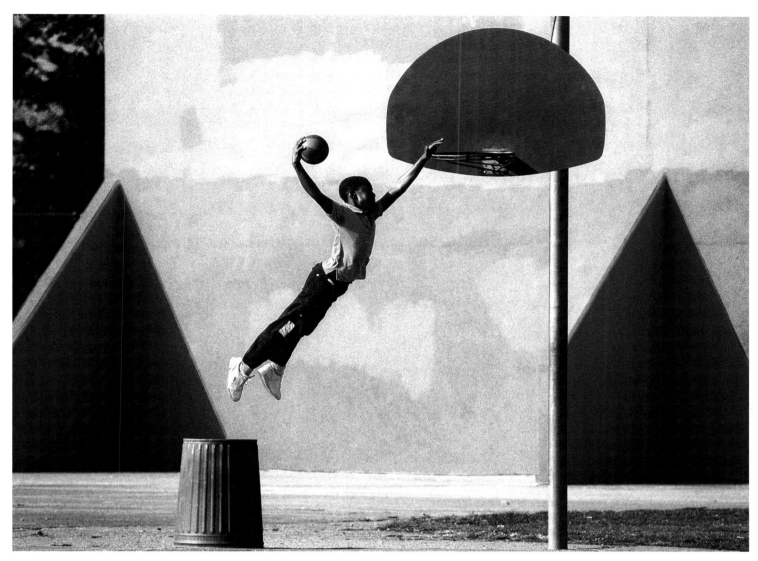

CLIFFORD OTO Slam Dunk, 1990

Motion slows at the peak of an action that reverses, such as this leap into the air. At that moment of slower movement, the shutter speed doesn't have to be as fast to show the motion sharply. Here the boy jumps from an overturned garbage can for a slam dunk.

The key word in photographing action is anticipation. What direction is the subject moving? Where should you be focused? When might an interesting moment occur? Think about what is going to happen, rather than trying to catch up to what has already happened.

SHUTTER SPEEDS TO STOP ACTION PARALLEL TO THE IMAGE PLANE

Type of Motion	Speed	Camera-to-Subject Distance		
		25 feet	**50 feet**	**100 feet**
Very fast walker	(5 mph)	1/125	1/60	1/30
Child running	(10 mph)	1/250	1/125	1/60
Good sprinter	(20 mph)	1/500	1/250	1/125
Speeding car	(50 mph)	1/1000	1/500	1/250
Airplane		_____	_____	1/1000

Conveying Motion in a Still Photograph

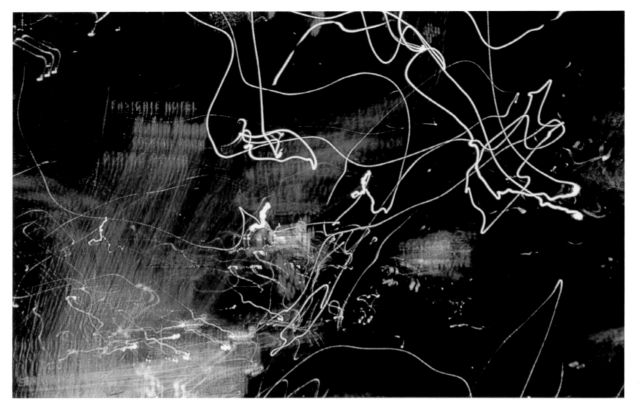

Here are three ways to represent movement. Each provides a different opportunity for a creative response to motion, as an alternate to simply attempting to freeze it. The camera moves against a stationary subject (top), camera and subject are both in motion (bottom), and the camera is held still while the subject moves (opposite).

LÁSZLÓ MOHOLY-NAGY
Untitled, c. 1941

An inveterate experimentalist, Moholy-Nagy used camera movement and a long exposure at night to explore an entirely abstract world of color and shape. The New Bauhaus school he started in Chicago encouraged experimentation in all media, and was especially important for paving the way for today's wide acceptance of photography in higher education.

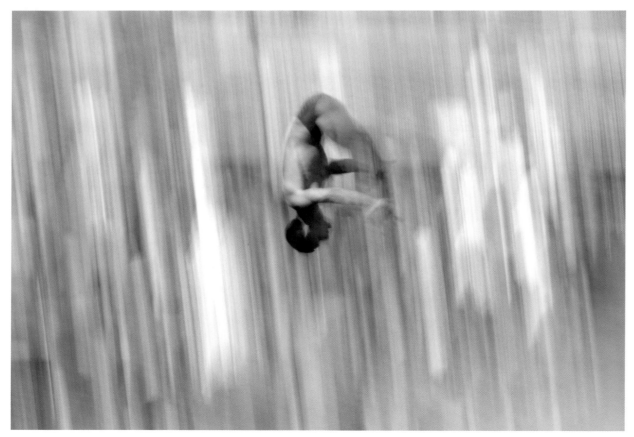

SIMON BRUTY
Men's 10M Platform Diving Semifinals, World Swimming Championships, Barcelona, Spain, 2003

Panning (moving the camera to follow the subject) is an effective way to separate the subject from the background. Bruty's lens followed the diver toward the water. His 1/15-second exposure turned the background of stands and spectators into a blurred field that isolates the athlete.

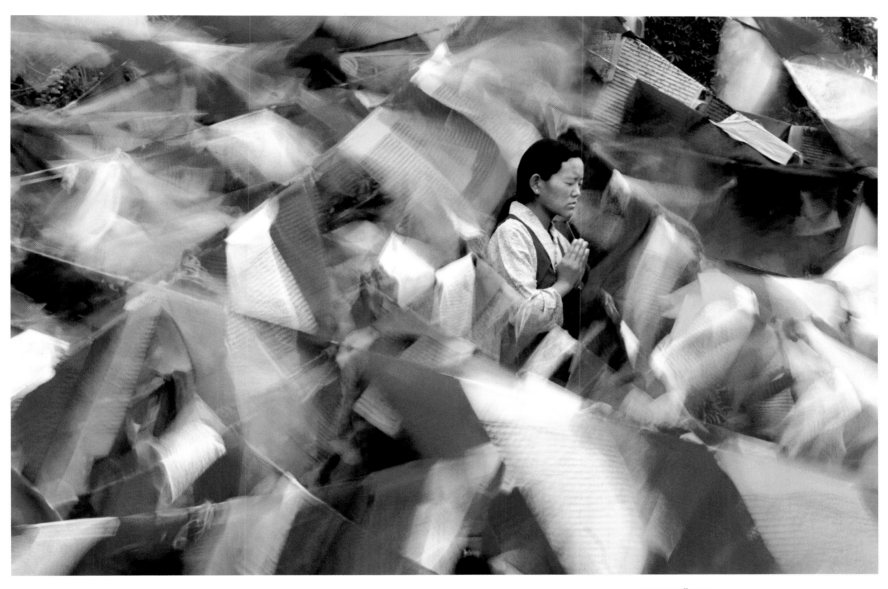

OLIVIER FÖLLMI Pilgrimage to Bodghaya, India, 2002

A long exposure blurred the moving flags, while rendering sharply the praying figure. Föllmi used the chaos of blurred color to contrast with the serenity of the subject's contemplative moment.

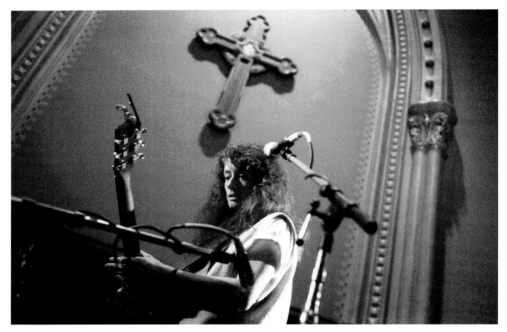

NUBAR ALEXANIAN
Patty Larkin,
Philadelphia, 1994

A fast lens, one that opens to a wide aperture, is useful in dim light, such as indoors. A wide aperture lets you set a shutter speed fast enough so that you don't have to use a tripod to keep the camera steady. It is also useful when photographing action by letting you shoot at a fast enough shutter speed to show moving subjects sharply.

F-STOPS: CONTROLLING THE SIZE OF THE LENS APERTURE

Lenses come with a limited range of apertures (f-stops) usually marked in full stop increments. Each full stop lets in half the amount of light as the one before it and double that of the one after it. (Note that the smaller the f-number, the larger the lens opening.) Apertures are continuously variable; on many cameras they can be set anywhere in between full stops. But your lens or display may only indicate one-half or one-third stop increments.

This chart shows a range of full and fractional aperture openings. Not all cameras number the fractional apertures exactly as shown. If your camera allows you to choose among different ways to set apertures, using full stops will be less confusing while you learn photography.

Apertures in full stops	1/2 stop	1/3 stop
f/1.4	**f/1.4**	**f/1.4**
	f/1.7	f/1.6
		f/1.8
f/2	**f/2**	**f/2**
	f/2.3	f/2.2
		f/2.5
f/2.8	**f/2.8**	**f/2.8**
	f/3.4	f/3.2
		f/3.5
f/4	**f/4**	**f/4**
	f/4.7	f/4.5
		f/5
f/5.6	**f/5.6**	**f/5.6**
	f/6.7	f/6.3
		f/7.1
f/8	**f/8**	**f/8**
	f/9.5	f/9
		f/10
f/11	**f/11**	**f/11**
	f/13	f/13
		f/14
f/16	**f/16**	**f/16**
	f/19	f/18
		f/20
f/22	**f/22**	**f/22**
	f/27	f/25
		f/28

The aperture (the size of the lens opening) controls the brightness of the light that reaches the sensor or film. The aperture works like the pupil of an eye, enlarging or contracting to admit more light or less. In a camera lens, the diaphragm—a ring of thin, overlapping metal leaves located inside the lens—is the mechanism that controls the size of the aperture. Its movable leaves can be opened wide to let in more light or closed down to let in less (see opposite).

The size of an aperture is indicated by its f-number or f-stop. On early cameras the aperture was adjusted by individual metal "stop" plates that had holes of different diameters. The term stop is still used to refer to the aperture size, and a lens is said to be "stopped down" when the size of the aperture is decreased.

Part of the standardized, full-stop series of numbers on the f-stop scale is shown in the box, right. The smaller numbers correspond to the larger apertures, and admit the most light. Each larger-numbered full f-stop (shown in boldface) admits half the light of the previous one. A lens that is set at f/4 admits half as much light as one set at f/2.8 and only a quarter as much light as one set at f/2. (Notice that f-stops have the same half or double relationship that full-stop shutter-speed settings do.)

The full-stop numbers continue in both directions. Wider apertures, for example f/1 or f/0.7, are possible but such lenses are too expensive for general use. Smaller ones—f/32, f/45, f/64, f/90—are seen only on specialized lenses. The change in light over the full range of f-stops is large; a lens whose aperture is stopped down to f/64 admits less than 1/4000 of the light that comes through a lens set at f/1.

Few lenses provide a range of apertures greater than eight stops. A general-purpose lens for a single-lens reflex camera, for example, might run from f/1.4 to f/16. A camera lens designed for a large view camera might stop down to f/64 but open up only to f/5.6. **NOTE:** The widest possible aperture on your lens may not be a standard full stop. A lens's f-stops may begin with a setting such as f/1.2, f/3.5, or f/7.7, then proceed from the next full stop in the standard sequence.

Lenses are often described as fast or slow. These terms refer to the width of the maximum aperture for the lens. A lens that opens to f/1.4 opens wider and is said to be faster than one that opens only to f/2. Faster lenses allow you to shoot more easily in low light or at higher shutter speeds. They also are more expensive than slower lenses.

The size of the lens opening—the aperture or f-stop—controls the amount of light that passes through the lens. The lens shown here has apertures from f/2.8 to f/22. Each setting is one stop from the next; that is, each lets in twice as much light as the next smaller opening, half as much light as the next larger opening.

The higher the f-stop number, the smaller the lens opening and the less light that is let in. On this lens, f/2.8 is the largest opening and lets in the most light. As the numbers get bigger (4, 5.6, 8), the aperture size gets smaller and the amount of light admitted decreases.

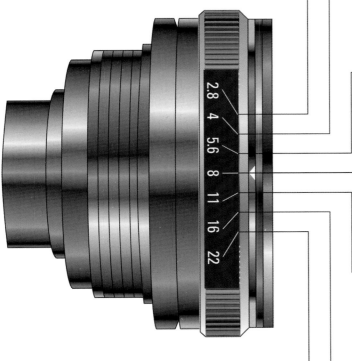

NOTE: *Some lens barrels no longer display the apertures as shown above. Rather than twisting a ring on the lens to set the aperture, you dial in the setting on the camera body. Regardless of how you change the aperture, though, you are still changing the size of the lens opening and thus the intensity of light that strikes your film or sensor.*

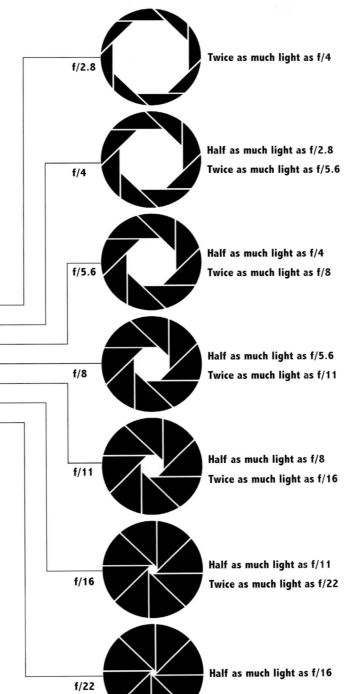

f/2.8 — Twice as much light as f/4

f/4 — Half as much light as f/2.8
Twice as much light as f/5.6

f/5.6 — Half as much light as f/4
Twice as much light as f/8

f/8 — Half as much light as f/5.6
Twice as much light as f/11

f/11 — Half as much light as f/8
Twice as much light as f/16

f/16 — Half as much light as f/11
Twice as much light as f/22

f/22 — Half as much light as f/16

WHERE APERTURE SETTINGS ARE DISPLAYED ON VARIOUS CAMERAS

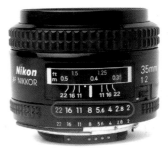

In the camera's viewfinder

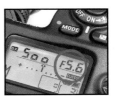

In the data-panel readout

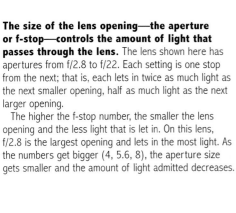

On the lens barrel

LARGE APERTURE, LESS DEPTH OF FIELD

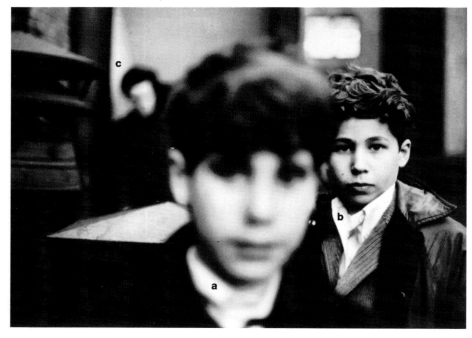

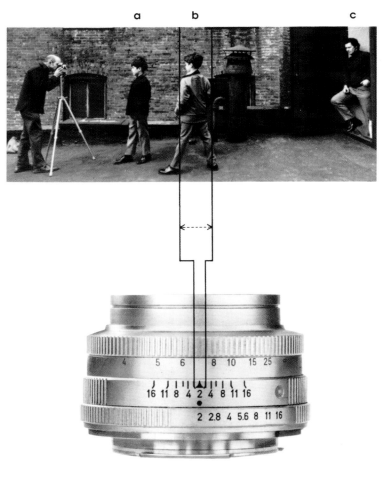

The smaller the aperture size, the more that a scene will be sharp from near to far. As the aperture is stopped down and gets smaller, more of the background and foreground in a given scene becomes sharp. The area of acceptable sharpness in a picture is known as the depth of field.

The two larger photographs shown on these pages were taken under identical conditions but with different aperture settings. In the photograph above, the diaphragm was opened to its widest aperture, f/2, and the lens was focused on the boy (b) about seven feet away (see side view of photographer Duane Michals and his subjects, above right). The resulting photograph shows a shallow depth of field; only the middle boy (b) is sharp, while both the boy in front (a) and the man behind (c) appear out of focus. Using a small aperture, f/16, gives a different picture (opposite page). The lens is still focused on the middle boy, but the depth of field has increased enough to yield sharp images of the other figures as well.

Some types of cameras let you see the extent of the depth of field. With a view camera, you look directly through the lens. As the lens is stopped down, the increasing sharpness is visible on the ground-glass viewing screen. A single-lens reflex camera also allows you to look directly through the lens. But most models, regardless of which aperture is selected, will automatically show the scene through the widest aperture. They are designed this way because looking through the lens at its widest aperture gives you the brightest possible view for framing and focusing.

Depth of field is the area from near to far in a scene that is acceptably sharp in a photograph. *As the aperture changes, the depth of field changes too. If your lens has a depth-of-field scale (many do not), you can use it to estimate the extent of the depth of field. On this lens, the bottom row shows the aperture (f-stop) to which the lens is set. The top ring shows the distance on which the lens is focused. The paired numbers on the middle ring correspond to f-stops and show the nearest and farthest distances the depth of field covers when the lens is set at various f-stops.*

Here, the lens is set to its widest aperture, f/2, and focused on the middle boy (see side view of scene above), who is at a distance of 7 ft. The depth of field extends from more than 6 ft to less than 8 ft; only objects within that distance will be acceptably sharp. If depth of field is shallow, as it is here, a lens can be sharply focused on one point and still not produce a picture that is sharp enough overall.

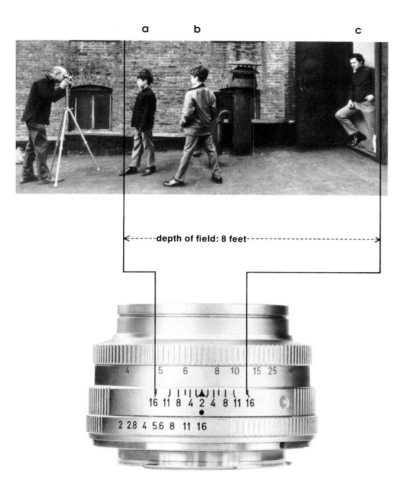

depth of field: 8 feet

When the lens is stopped down to its smallest aperture, here f/16, the depth of field increases. *Almost the entire scene—everything between about 5 ft and 13 ft—is now sharp at the same focusing distance of 7 ft.* **NOTE:** *The bigger the f-stop number, the smaller the lens opening (you can see this illustrated on page 25); f/16 is a smaller aperture than f/2.*

SMALL APERTURE, MORE DEPTH OF FIELD

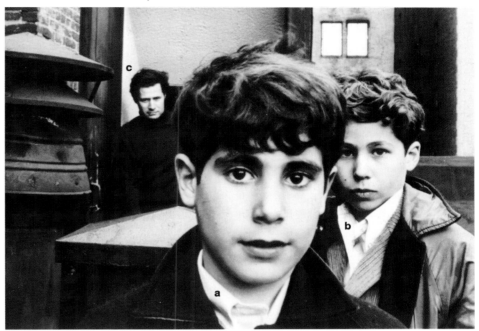

Looking through the widest aperture also means you see the scene with the least possible depth of field. Some cameras provide a depth-of-field preview button that stops down the lens so that the viewfinder image shows the depth of field at the aperture you have selected. However, stopping down the lens reduces the brightness of the viewfinder image. In dim light or at a very small aperture, that image may become too dark to be seen clearly. but single-lens reflex film cameras and view cameras do give you a way to check depth of field visually at all apertures.With a digital camera you can make (and later delete) a test shot to evaluate depth of field from the monitor display.

Other camera designs show the scene differently. Rangefinder and some point-and-shoot designs have a window in which you frame your shot. Through this viewfinder, objects at all distances appear equally sharp.

Some lenses have a depth-of-field scale from which you can estimate the depth of field. This scale is printed on the lens as paired numbers that bracket the distances of the nearest and far-thest points of the depth of field. As the lens is focused and the f-stop set, the scale shows approximately what part of the picture will be in focus. (See the lenses at left.) The farthest distance marked on the lens appears as the symbol ∞. When this infinity mark appears within the depth of field shown on the scale, all objects beyond the closest distance in focus will be sharp.

Both shutter speed and aperture affect the amount of light entering the camera. To get a correctly exposed picture (one that is neither too light nor too dark), you need a combination of shutter speed and aperture that lets in the right amount of light for a particular scene and particular ISO speed.

Equivalent exposures. Once you know a combination of shutter speed and aperture that will let in the right amount of light, you can change one setting as long as you change the other in the opposite way. When using full stops, each aperture setting lets in twice as much light as the next smaller opening (larger-numbered setting). Each shutter speed lets in twice as much light as the next faster speed. (See photographs at right.) You can use a larger aperture if you need a faster shutter speed, or you can use a smaller aperture if you want a slower shutter speed. The same amount of light is let in by the combination of f/16 aperture at a 1/8-second shutter speed, as by f/11 at 1/15 second, and so on. This back-and-forth balance is called a reciprocal relationship.

Shutter speed and aperture also affect sharpness, but act differently. Shutter speed affects the sharpness of moving objects; aperture affects depth of field, sharpness from near to far. Their different effects are shown in the three photographs at right. In each, the lens was focused on the same point, and shutter speed and aperture settings were balanced to admit the same total amount of light into the camera. But the equivalent exposures resulted in very different photographs.

In the first picture, a small aperture produced considerable depth of field that rendered background details sharply. However, the shutter speed needed to compensate for this tiny aperture had to be so slow that the rapidly moving flock of pigeons appears only as indistinct ghosts. As the aperture was set wider and the shutter speed faster in the middle photo, the background is less sharp, but the pigeons are visible, though still blurred. At far right, a still larger aperture and faster shutter speed sacrificed almost all background detail, but the birds are now very clear, with only a few wing tips still blurred.

A BUCKET OF LIGHT

The quantity of light that reaches the film or sensor inside a camera depends on both aperture size (f-stop) and exposure time (shutter speed).

How long does it take to fill a bucket with water flowing from a faucet? That depends on how wide the faucet is open and how long the water flows. If the wide-open faucet fills the bucket in 2 seconds, then the same bucket will be filled in 4 seconds from a half-open faucet. But regardless of how long it takes to fill the bucket, the bucket always holds the same amount of water.

Film and digital sensors are like these buckets. To be properly filled with light (exposed), each always requires the same amount—the same number of "gallons"—of light.

If the correct exposure for a scene is 2 sec at f/4, you get the same total amount of exposure with twice the length of time (next slower shutter speed) and half the amount of light (next smaller aperture)—4 sec at f/5.6.

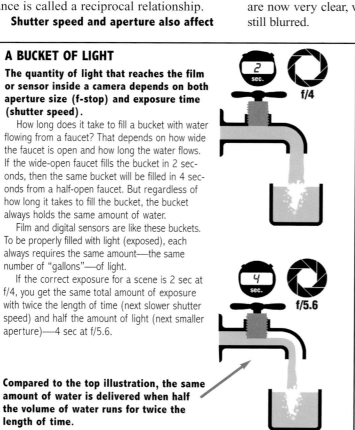

Compared to the top illustration, the same amount of water is delivered when half the volume of water runs for twice the length of time.

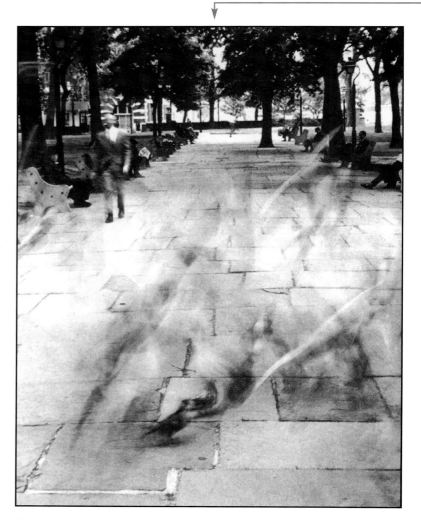

Small aperture (deep depth of field), slow shutter speed (motion blurred). *In this scene, a small aperture (f/16) produced great depth of field; the nearest paving stones as well as the farthest trees are sharp. But to admit enough light, a slow shutter speed (1/8 sec) was needed; it was too slow to show moving pigeons sharply. It also meant that a tripod had to be used to hold the camera steady.*

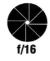

f/16 **f/11** **f/8** **f/5.6** **f/4** **f/2.8** **f/2**

1/8 sec. 1/15 sec. 1/30 sec. 1/60 sec. 1/125 sec. 1/250 sec. 1/500 sec.

Equivalent exposures. Each combination here of f-stop and shutter speed produces the equivalent exposure (lets in the same amount of light) but produces differences in depth of field and motion.

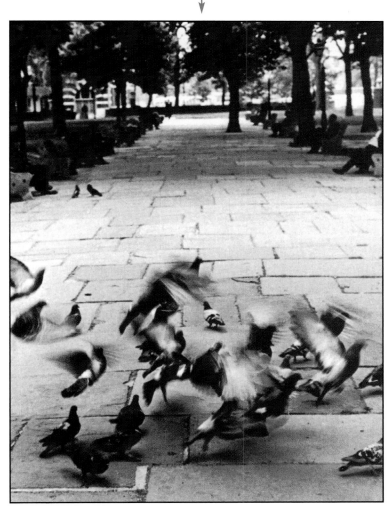

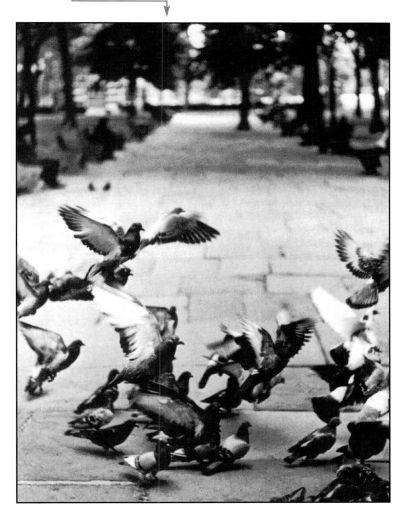

Medium aperture (moderate depth of field), medium shutter speed (some motion sharp). *A medium aperture (f/4) and shutter speed (1/125 sec) sacrifice some background detail to produce recognizable images of the birds. But the exposure is still too long to show the motion of the birds' wings sharply.*

Large aperture (shallow depth of field), fast shutter speed (motion sharp). *A fast shutter speed (1/500 sec) stops the motion of the pigeons so completely that the flapping wings are frozen. But the wide aperture (f/2) needed gives so little depth of field that the background is now out of focus.*

Choosing a camera will be easier if you first decide what kind of pictures you want to take, then think about which basic camera design best fits your needs. If your picture taking consists of occasional snapshots of family, friends, or sightseeing views, then an inexpensive, nonadjustable, point-and-shoot camera may be satisfactory.

If you are a photography student, a serious amateur, or just someone who would like to learn more about photography, you will want an adjustable camera. For most people this is a digital or 35mm (thirty-five millimeter describes the film size) single-lens reflex camera. A camera may have automatic features, but at a minimum it should also give you the option of manually selecting the focusing distance and either the shutter speed or aperture, preferably both. You also want a camera that accepts interchangeable lenses. Be sure to read about lenses in Chapter 3; lens selection is important in your choice of a camera.

Shop around to compare prices, accessories, and service. Make sure you like the way the camera fits in your hands, and that buttons and knobs are conveniently placed and easy to manipulate. With the more automatic models, see if it is convenient to override the automatic features. If you wear glasses, make sure you can see the entire image.

You may be able to find a good used camera at a considerable saving, but look over used equipment carefully. Avoid cameras with dents, scratched lenses, rattles, or gouged screw heads that could indicate a home repair job. A reputable dealer will exchange a camera, new or used, if your first photographs are unsatisfactory. Examine your first frames or that first roll carefully for soft focus, scratches, or other signs of trouble.

The size of the film or the resolution of the sensor determine the quality of the image the camera produces. High-quality images can be produced by 35mm film, which is less than 1 1/2-inches wide. But a 35mm negative, for example, has to be enlarged much more than a 4 x 5-inch negative to make the same size print. The larger the negative, the sharper, smoother, and more detailed any image will be rendered. Film size also determines the size of the camera itself. Obviously, the smaller the film format, the smaller the camera can be.

One measure of a digital camera's sensor is the number of pixels it captures. All other things being equal, a ten megapixel (MP) camera can make higher-quality pictures than a six megapixel camera.

SINGLE-LENS REFLEX CAMERAS

A single-lens reflex (SLR) camera shows you the scene directly through the lens. The camera has a mirror and pentaprism that let you see through the taking lens to focus the scene and compose it exactly. Wth some cameras you can preview how much of the scene will be sharp, from foreground objects to a distant background. Most SLRs use 35mm film or have a digital sensor (these are abbreviated D-SLR or DSLR).

Advantages: Since the viewing system uses the camera lens itself, it works well with all lenses from wide angle to supertelephoto; whatever the lens sees, you see—and that is what will be recorded. This is especially useful for close-ups. An exposure meter built into the camera measures the light passing through the lens, with the area being metered defined in the viewfinder.

Disadvantages: A single-lens reflex is heavier and larger than a rangefinder camera that uses the same size film, or a compact digital camera (opposite, right). An SLR is relatively complex, with more components that may need repair. Its moving mirror makes a clack during exposure, very loud in the medium-format models; this is a drawback if you are stalking wild animals or self-conscious people. When the mirror moves up for exposure, it momentarily blacks out the viewing image, a distraction in some situations. And the motion of the mirror and shutter may cause vibrations that make the camera difficult to hold steady at slow shutter speeds.

Choosing a camera: Single-lens reflex cameras are the most popular when a buyer moves beyond snapshot level. SLRs offer a great variety of interchangeable lenses and accessories, plus features such as built-in flash.

Automatic features abound: automatic exposure, focus, flash, and film winding are often standard; some can be fired in rapid bursts. Some cameras follow your eye movements in the viewfinder to focus automatically in whatever direction you are looking. Stop for a moment to think about what features will be really useful to you before you pay extra for some special feature you might need only once in a while.

Make sure the camera allows you to manually override automatic features when you want to make exposure and focus choices yourself. For example, some film cameras automatically set the ISO speed for you by reading the DX coding on the film cassette. That's convenient, but it's best to have a camera where you can override this feature when you want to select a film speed different from the nominal one.

Also consider how convenient it is to select or override automatic features. Does the camera have easy-to-adjust, conveniently located knobs and dials or tiny, difficult-to-access buttons, and hard-to-read menus?

A single-lens reflex camera has a viewing system that is built around a mirror. While viewing, light coming through the camera lens is reflected by this mirror up to a viewing screen, then usually travels to a five-sided pentaprism that turns the inverted image around so it appears the correct way to the eye (diagram, below left). When the shutter is released, the mirror first swings up, permitting light to reach the shutter and film or sensor at the back of the camera (diagram, below right). The image produced is the same as the image viewed through the lens.

While viewing

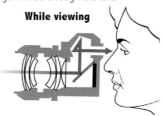

During exposure

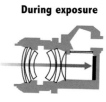

Choosing a camera: Medium-format rangefinder cameras combine relatively large film with a compact rangefinder design. They are light weight, have a quiet shutter and a bright, easy-to-focus viewfinder Some models have interchangeable lenses. They are popular with professionals and others who want a camera that is easy to carry in the field, but that delivers a high-quality negative larger than 35mm. The film frame above is 6 x 9cm in size.

RANGEFINDER/VIEWFINDER CAMERAS

A viewfinder camera shows you the scene through a small window (the viewfinder). The viewfinder is equipped with a simple lens system that shows an almost —but not quite—exact view of what the picture will be. Many inexpensive point-and-shoot cameras have a viewfinder plus automatic focus.

A rangefinder camera has a viewfinder, plus a coupled rangefinder that lets you focus the camera manually as you view the scene. Most rangefinder and viewfinder cameras use 35mm film; a few, like the one left, use other film sizes.

Advantages: The camera is compact, lightweight, and fast handling. Compared to a single-lens reflex camera, it has few parts that move during an exposure, so it is quieter and less subject to vibration during operation. A high-quality rangefinder camera has a bright viewfinder image, which makes it easy to focus quickly, particularly at low light levels where other viewing systems may be dim. Wide-angle lenses are likely to be sharper than those made for reflex cameras because reflex cameras need a more complex design to provide clearance for the reflex mirror.

Disadvantages: Because the viewfinder is in a different position than the lens that exposes the negative, the camera suffers from an inherent defect called parallax that

prevents you from seeing exactly what the lens sees. The closer the subject to the camera, the more evident the parallax. Better cameras correct to some extent for parallax but a viewfinder camera is a poor choice for close-up work. Even when the edges of the picture are corrected for parallax, the alignment of objects will be different because they are seen from slightly different angles by the viewfinder and the lens that exposes the film.

Choosing a camera: A 35mm rangefinder camera with adjustable controls gives you more flexibility than a simple point-and-shoot model. You focus and set the exposure yourself, or with some models have the option to do so automatically. A high-quality 35mm rangefinder camera has long been a favorite of experienced photographers who want to work inconspicuously and quickly. They value the camera's dependability and its fast and precise focusing.

Medium-format single-lens reflex cameras are popular with photographers who want a negative larger than 35mm with the versatility of a single-lens reflex. Not only are lenses interchangeable, but sometimes the camera's back is too; you can expose part of a roll of black-and-white film, remove the back, and replace it with one loaded with color film or designed for digital capture. These cameras are bigger, heavier, and noisier than 35mm single-lens reflex cameras—and the price is often higher, too. Some make a 6 x 6cm (2 1/4-inch square) negative; others are rectangular, such as 6 x 7 cm (2 1/4 x 2 3/4 in.) or 6 x 4.5cm (2 1/4 x 1 5/8 in.)

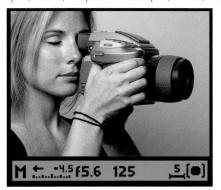

Medium-format digital cameras—or medium-format film cameras with a digital adapter back—have a large sensor (that may be square or rectangular) to capture a very highly detailed image. Because they are not consumer items produced in high volume they are very expensive. Older digital adapter backs for medium-format SLRs needed to be tethered (connected by a wire) to a computer during use.

COMPACT DIGITAL CAMERAS

Compact digital cameras, like digital SLRs, generate photographs by focusing the light rays of a scene through a lens onto a sensor—an array of light-sensitive diodes. The sensor converts the image to data that is transferred to a memory card in the camera. Some compact cameras—the more expensive ones—rival digital SLRs (D-SLRs) in picture quality and features, but most are designed for the pockets of tourists and casual snapshooters. Many cell phones are also compact digital cameras.

Advantages: Cameras are available in a wide range of styles, features, and price that can accommodate any individual preferences. Some record short segments of video. Ultra-compact cameras fit in a shirt pocket.

Disadvantages: Some are difficult or impossible to adjust manually and most have a non-interchangeable lens. Many cameras have no viewfinder, so the image must be viewed through a monitor that drains batteries rapidly. There is often a noticeable delay—called shutter lag—between pressing the shutter button and the actual exposure that can cause you to miss peak action. Digital noise (that reduces picture quality) is greater and the ISO range is lower than in D-SLR cameras that have a larger sensor.

Choosing a camera: A serious photographer will probably want to have a single-lens reflex. But a serious photograher will also probably have more than one camera. The best camera is always the one you have with you.

TWIN-LENS REFLEX CAMERAS

Twin-lens reflex (TLR) cameras use only film, usually 6 x 6cm (2 1/4 inches square), the size pictured above. With most models, lenses are not interchangeable, and few models are currently manufactured. TLRs are quiet, reliable, and generally less expensive than other types of medium-format cameras. Finding an inexpensive used TLR is a good way to experiment with larger-format film.

POINT-AND-SHOOT CAMERAS

Point-and-shoot film cameras, also called compact cameras, share the low-priced end of the market with compact digital cameras. Most use 35mm film (or a smaller format called APS) and are usually mercilessly nonadjustable: they read the speed of the film you put in the camera, advance it to the first frame, focus, calculate exposure, trigger a built-in flash if you need it, advance the film after each exposure, and rewind at the end of the roll. Better-quality ones have a zoom lens and offer some control of focus, exposure, or flash functions. Point-and-shoot cameras are small, inexpensive, and easy to use. They often take excellent pictures, but they are easy to outgrow as soon as you become more seriously interested in photography.

VIEW CAMERAS

A view camera has direct, through-the-lens viewing and a large image on a viewing screen. It is the simplest and oldest basic design for a camera. A view camera has a lens at the front, a ground-glass viewing screen at the back, and a flexible bellows in between. You focus by moving the lens or the back forward or back until you see a sharp image on the ground glass.

The view camera is often the camera of choice for architectural photography, fine art, or any use where the photographer's first goal is carefully controlled, technically superior pictures.

Advantages: The image on the ground glass is projected by the picture-taking lens, so what you see is exactly what will be on the negative or digital capture back; there can be no parallax error (as in a rangefinder camera, previous page) and you can preview the depth of field at the selected aperture. The ground glass is large, and you can examine it with a magnifying glass to check sharpness in all parts of the picture. With film, the available sizes are also large (4 x 5, 5 x 7, 8 x 10 inches or larger) and 4 x 5 digital backs capture a larger area than any other digital camera—all for sharp detail. The camera parts are independently adjustable; you can change the position of lens and back relative to each other so that you can more precisely control focus or perspective. When using film, each picture is exposed on a separate sheet, so you can give negatives individual development.

Disadvantages: The cameras are bulky and heavy, and almost all require using a tripod. They are slow to use. You must set up and focus first, then insert the film to make the exposure. The image projected on the ground glass is not very bright. To see it clearly you must put a focusing cloth over both your head and the back of the camera. The image you see on the viewing screen comes directly from the lens, so it is upside down, with left-side objects on the right, right-side objects on the left. You get used to this, but it is disconcerting at first.

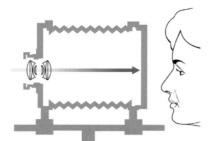

In a view camera, the light comes directly from the subject, through the lens to a ground-glass viewing screen. The image you see comes directly from the lens, so it is upside down. As an aid in composing and aligning your subject, the ground glass may be etched with a square grid.

GLEN FISHBACK Edward Weston Using His 8 x 10 View Camera, Point Lobos, 1937

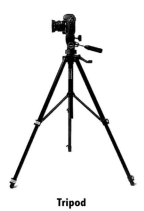

Tripod

Monopod

Tabletop tripod

To hand hold a camera, support the camera from underneath with your left hand. The right hand presses the shutter and operates controls. Press both arms against your body, relax, breathe out, and squeeze the shutter release gently to avoid jerking the camera.

With the camera held vertically, the left or right hand can support the camera. Keep that arm against your body to steady the camera.

With a long lens or at a relatively slow shutter speed without a tripod, try to find some extra support such as a stool, chair, or other object to brace yourself against.

A tripod provides the steadiest support for a camera. It is essential for slow shutter speeds. Some tripods have a center shaft that can be removed and reversed; the tripod head and camera can then hang upside down so the camera can be brought very low to the ground. A cable release lets you trigger the shutter without jarring the camera. Leave a little slack in the cable instead of pulling it taut.

MINIMUM SHUTTER SPEEDS FOR HAND HOLDING A 35MM OR DIGITAL SLR CAMERA

Lens Focal Length	Minimum Shutter Speed
24–28mm	1/30 sec
35–50mm	1/60 sec
85–100mm	1/125 sec
135–200mm	1/250 sec
300mm	1/500 sec
600mm	1/1000 sec

Keep the camera steady during an exposure. Even with the finest camera and lens, you won't be happy with the pictures you take if you don't keep the camera steady enough during the exposure. Too much camera motion during exposure will cause sharpness problems ranging from slight image softness to hopeless blurring.

How much camera movement is too much? That depends on several factors, including how large the image will be. Any blur is more noticeable when viewed closely or in a big print. The camera's design affects how much it moves during an exposure; SLRs are particularly prone to vibration. The slower the shutter speed, the more you have to worry about camera movement. The longer the focal length of the lens, the more movement becomes apparent. Longer lenses magnify objects on the film—and camera movement too.

If you are hand holding a camera, use a shutter speed faster than the focal length of the lens: for example, 1/250 second or faster with a 200mm lens (see chart below left). Press the shutter release gently and smoothly. If you can, brace your body in some way by leaning your back against a wall or your elbows on a table, fence, or other support.

Using a tripod and cable release is the best way to prevent camera movement. The tripod should be sturdy enough for the camera; if you balance a large, heavy camera on a flimsy, lightweight tripod, your camera can end up on the floor. On the other hand, if your tripod isn't very heavy, you are more likely to make a habit of carrying and using it. When making portraits, putting the camera on a tripod lets you take your eye away from the viewfinder and establish more rapport with your subject.

Tabletop tripods are sometimes useful; their very short legs can be steadied on a table or car fender or even against a wall. A monopod, a single-leg support, gives extra stability if you have to keep moving, for example, along a football sideline.

Image stabilization (or "anti-shake") helps a lot. Some digital cameras move their sensor and some lenses move an element to let you hand hold a shutter speed up to three stops slower than without it.

photographer at WORK

Photojournalist James Nachtwey

James Nachtwey's gentle manner and voice belie the violence and heartache he has recorded. A contract photographer for *Time* magazine, Nachtwey is one of the best-known and most widely respected photojournalists. He has covered wars and civil strife in El Salvador, Nicaragua, Lebanon, Sri Lanka, Afghanistan, Chechnya, Northern Ireland, Rwanda, South Africa, the West Bank and Gaza, Bosnia, Kosovo, and Iraq.

Nachtwey taught himself photography, then began his career with four years on a newspaper. Black Star, a photo agency, helped him get assignments and publish pictures when he started freelancing. In 1986 he joined Magnum, the respected photo cooperative, leaving to form the VII Photo Agency in 2001.

When arriving in a war zone, Nachtwey says, he first establishes a logistical base. This includes transport, communication (often involving an interpreter), and a place to stay. Lodging might be a hotel, a room with a local family, the floor of an abandoned bombed-out building, or a sleeping bag or blanket on the ground. If possible, he contacts a local newspaper or one of the international wire services to orient himself to the ongoing situation.

When photographing in tumultuous situations, Nachtwey uses patience and common sense. "Many photographers rush their images," says Robert Stevens, Nachtwey's editor at *Time*. "They arrive, see a subject in front of them, and start shooting. They often think they have recorded what is important in a few moments, but they haven't. It's important to take time and wait. Jim waits and waits until the time is right."

Many photographers forget about the background, Stevens explains, and end up with images where the background distracts from the most important part of the photo. Using a Canon digital single-lens reflex camera and a zoom lens, Nachtwey frames his photos in a deliberate but fast way, by shifting his body up or down, right or left to get elements the way he wants them. He can upload his pictures by telephone directly to *Time*, and rarely edits his pictures before they appear in the magazine.

Nachtwey works on the front lines, but he avoids reckless behavior. "I try to be aware of the changing dynamics of whatever situation I am in," he says. "I make split-second decisions, based on a combination of intuition and experience, calculated to enable me to do an effective job and survive. In the riskiest situations, I usually work alone, but sometimes with another, trusted colleague."

Emotional strength can be as critical as technique or tactics. How does he continue photographing while witnessing horror? "If you go with a camera to places where people are experiencing a great tragedy, you have a responsibility," he told one interviewer. "The value of the work is to make an appeal to the rest of the world, to create an impetus for change through public opinion. Public opinion is created through awareness. My job is to make people aware."

"I used to call myself a war photographer," he says. "Now I consider myself an antiwar photographer."

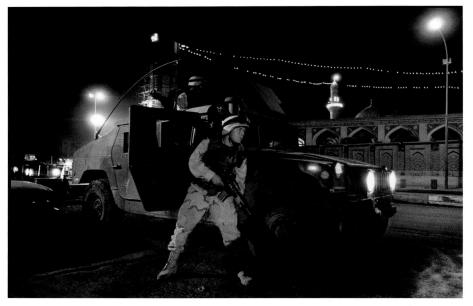

JAMES NACHTWEY Baghdad Platoon, 2003

"Nachtwey's photographs are always clean and striking compositions. . . . because he is honest and clear in his stance," writes historian Luc Sante. *The photographer sees images such as this one of an army sergeant taking a defensive position near Baghdad's principal Sunni mosque "as a visualization of the kind of hell on earth that can be created by human beings for human beings."*

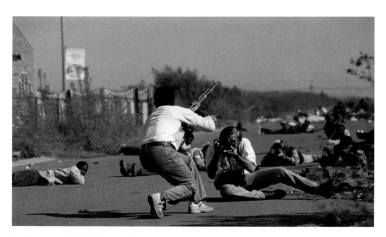

DAVID TURNLEY Nachtwey Under Fire

Photojournalist James Nachtwey takes the front line during a gun battle in South Africa. According to writer David Friend, fellow journalists say Nachtwey borders on being invincible under fire, almost as if shielded by a force field.

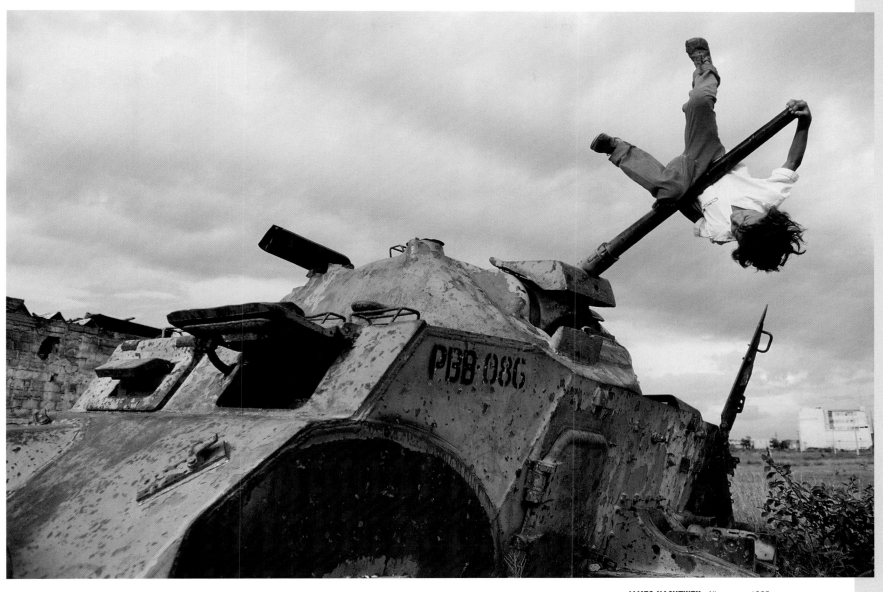

JAMES NACHTWEY Nicaragua, 1982

Nachtwey covers conflicts as they take place but also shows their impact on people's lives. *For a Nicaraguan child, an abandoned tank provides a playground.*

JULIE ANAND
Water Lenses, 2003

The simple lens formed by a water-filled fishbowl inverts an image exactly the way your camera's more complex lens does. Anand uses the device to comment on water use in America's arid southwest.

CHAPTER/THREE lens

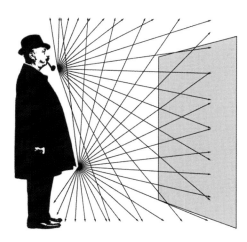

Light must be controlled if our eyes or our cameras are to form images of objects. You can't simply place a rectangle of sensitized film or an array of light-sensitive diodes in front of a subject and wait for an image to appear. Light reflecting from the subject would hit the surface in a random jumble, resulting not in a picture but in a uniform exposure over the entire surface. Light acts both like rays and like waves. For simplicity's sake, this drawing shows it as rays—only a few coming from just two points on the man. But their random distribution over the surface makes it clear that they are not going to produce a useful image. What is needed is some sort of light-control device between the subject and the film or digital array that will select and aim the rays, placing the rays from each part of the image where they belong, resulting in a clear picture.

All photographic lenses do the same basic job: they collect light emanating from a scene in front of the camera and project it as an image onto a light-sensitive surface (a piece of film or a digital sensor) at the back of the camera. This chapter explains how you can use lens focus (which adjusts the sharpest part of an image), lens focal length (which controls the magnification of a scene), lens aperture, and subject distance to make the kinds of pictures you want. Lenses for both film and digital cameras follow the same principles of optics.

From Pinhole to Lens

Light acts in some ways like rays and in some ways like waves. All points in any scene emanate or reflect rays or waves in all directions. All the light reflected from a point or an object isn't necessary to produce an image, a selection of it will do.

When light from an object reaches a barrier with a small pinhole in it, like that in the drawings on the far right, all but a few rays from each emanating point are deflected by the barrier. Those few rays that do get through, traveling in straight lines from the subject, can make an image when they reach a flat surface, like film at the back of a camera. The image is rotated upside down. Everything that was at the top of the subject appears at the bottom of the image and everything at the bottom appears at the top. Similarly, left becomes right and right becomes left.

The trouble with using a pinhole as a lens is its tiny opening. It admits so little light that very long exposures are needed to register an image on film or a sensor. If the hole is enlarged, the exposure becomes shorter, but the image becomes much less sharp, like the center photograph at right.

A pinhole, small as it is, actually admits a cluster of light rays. Coming at slightly different angles, these rays continue through the hole in slightly different directions. They fan out, so that when they hit a surface, like film, the rays from a point on the subject make a tiny, blurry circle instead of forming a point again. As the size of the hole is increased, a larger cluster of light rays gets through to the film or sensor and makes a wider, even blurrier circle. These circles overlap, so the wider each circle becomes, the less clear the picture will be.

A lens creates a sharp image with a relatively short exposure. To get sharp pictures, the image of a small point should also be a small point. But there is no way to achieve that using a pinhole on a camera. Even a tiny opening, which admits little light and requires long exposure times, will not make a very sharp image. To admit more light and to make a sharper picture than even the smallest pinhole, a different method of image formation is needed. That is what a lens provides.

Photograph made with small pinhole

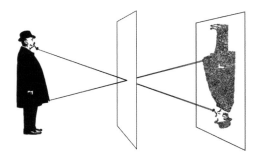

To make this picture, the lens of a camera was replaced with a thin metal disk pierced by a tiny pinhole, equivalent in size to an aperture of f/182. Only a few rays of light from each point on the subject got through the tiny opening, producing a soft but acceptably clear photograph. Because of the small size of the pinhole, the exposure had to be 6 sec long.

Photograph made with larger pinhole

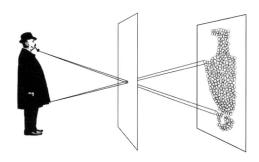

When the size of the pinhole was increased to f/65, the result was an exposure of only 1/5 sec, but an extremely out-of-focus image. The larger hole let through more rays from each point on the subject. These rays spread widely before reaching the light-sensitive surface, making large circles that overlapped one another creating a very unclear image.

Photograph made with lens

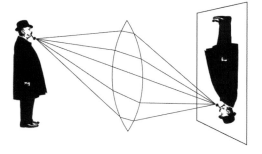

This time, using a simple convex lens with an f/16 aperture, the scene appeared sharper than the one taken with the smaller pinhole, and the exposure time was much shorter, only 1/100 sec. The lens opening was much bigger than the pinhole, letting in far more light, but it focused the rays from each point on the subject precisely so that they were sharp.

Most modern photographic lenses are based on the convex lens. Thicker in the middle than at the edges, a convex lens collects a large number of light rays from any single point on an object in front of the lens and refracts, or bends, them toward each other so that they converge at a corresponding single point (diagram, left) behind the lens. Each point in the scene (object point) corresponds to a point behind the lens (image point). Inside a camera, a strip of film is stretched flat (or a flat digital sensor is positioned) across the image plane, sometimes called the film plane. All the points in a corresponding object plane in the scene will focus as points on that surface, so the picture will be sharp for everything in that plane.

How does a lens refract (bend) light to form an image? When light rays pass from one transparent medium, such as air, into a different transparent medium, such as water or glass, the rays refract, or bend. Look at the shape of a spoon half submerged in a glass of water and you will see a common example of refraction: light rays reflected from the spoon are bent by the water and glass so that part of the spoon appears displaced.

For refraction to take place, light must strike the new medium at an angle. If light rays are perpendicular to the surface when they enter and leave the medium (diagram left, (1), the rays will pass straight through. But if they enter or leave at an oblique angle (2), the rays will be bent to a predictable degree. The farther from the perpendicular they strike, the more they will be bent.

When light strikes a transparent medium with a curved surface, such as a lens, the rays will be bent at a number of angles depending on the angle at which each ray enters and leaves the lens surface. They will be spread apart by concave surfaces (3) and directed toward each other by convex surfaces (4). Rays coming from a single point on an object and passing through a convex lens (the simplest form of camera lens) will cross each other—and be focused—at the image point.

A modern compound lens, as this cutaway view shows, is usually made up of six or eight separate lenses. Each lens is added to correct some of the aberrations or focusing defects in the others. This lens has six elements in four groups. An element is a simple lens with two curved sides or one curved and one flat side. A group may be a single element, like (a) or (d), or it may be two or more elements cemented together, like (b) and (c).

Because lens aberrations are mathematically predictable, some of these focusing defects can be eliminated digitally from the picture after it has been made, but using a well-designed lens is always the best start.

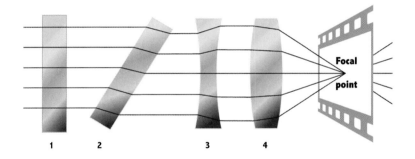

How refraction works is shown in this diagram of light rays passing through four glass blocks. The rays, entering from the left, strike the first block head on (1) and therefore pass straight through. The next block (2) has been placed at an angle; the rays are bent, but as they exit the block they are bent back to resume their former direction. The concave surfaces of the third block (3) spread the rays apart, but the last block (4)—a convex lens like the basic light-gathering lenses used in cameras— draws the rays back together so that they cross each other at the point of focus.

Lens Focal Length

The most important way lenses differ is in their focal length. Since the camera you are most likely to choose can be used with interchangeable lenses, you can also choose which lens to buy or use. A lens is often described in terms of its focal length (a 50mm lens, a 12-inch lens) or its relative focal length (normal, long, or short). Technically, focal length is the distance between the lens's rear nodal point and the focal plane when the lens is focused at infinity. Theoretically, infinity is a distance immeasurably far away, beyond the edge of the universe. In photographic terms, infinity is a distance from which light enters the lens in parallel rays. Lens designers call the image point where those rays come together the focal point.

Focal length controls magnification, the size of the image formed by the lens. The longer the lens, the greater the size of objects in the image (see diagrams, right).

Focal length also controls angle of view, the amount of the scene shown on a given size of sensor or film (see photographs opposite). A long-focal-length lens forms a larger image of an object than a short lens. As a result, on a given size of sensor or film, the long lens includes less of the scene in which the object appears. If you make a circle with your thumb and forefinger and hold it close to your eye, you will see most of the scene in front of you—the equivalent of a short lens. If you move your hand farther from your eye—the equivalent of a longer lens—the circle will be filled by a smaller part of the scene. You will have decreased the angle of view seen through your fingers. In the same way, the longer the focal length, the smaller the angle of view seen by the lens.

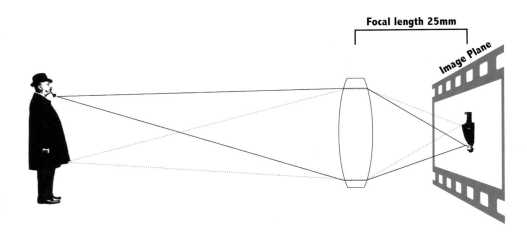

Focal length 25mm

A lens of short focal length bends light sharply. *The rays of light focus close behind the lens and form a small image of the subject.*

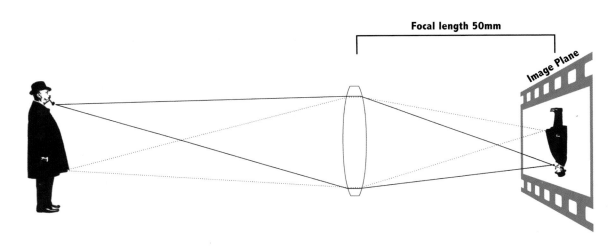

Focal length 50mm

A lens of longer focal length bends light rays less than a short lens does. *The longer the focal length, the less the rays are bent, the farther behind the lens the image is focused, and the more the image is magnified. The size of the image increases in* proportion to the focal length. If the subject remains at the same distance from the lens, the image formed by a 50mm lens will be twice as big as that from a 25mm lens.

17mm

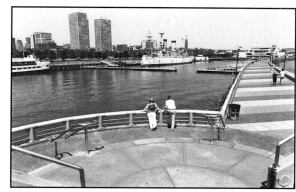

28mm

The effect of increasing focal length while keeping the same lens-to-subject distance is an increase in magnification and a decrease in angle of view. Since the photographer did not change position, the sizes of objects within the scene remained the same in relation to each other. The diagram below shows the angle of view of some of the lens focal lengths that can be used with a 35mm camera. The focal length of a digital camera lens is often stated as a 35mm equivalent.

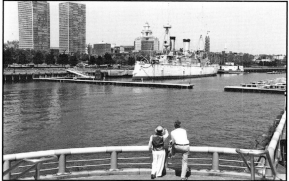

50mm

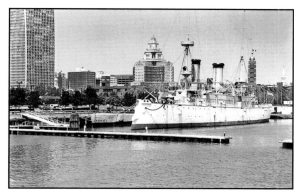

85mm

135mm

300mm

500mm

1000mm

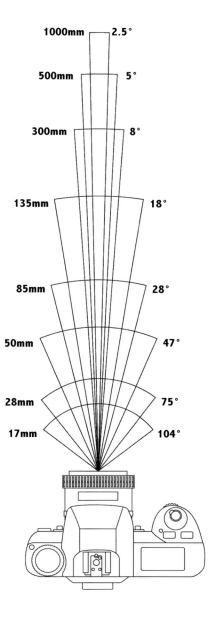

1000mm — 2.5°
500mm — 5°
300mm — 8°
135mm — 18°
85mm — 28°
50mm — 47°
28mm — 75°
17mm — 104°

A normal-focal-length lens, also called a standard-focal-length lens, approximates the impression human vision gives. One of the greatest of modern photographers, Henri Cartier-Bresson, who described the camera as "an extension of my eye," often used a normal lens. His picture opposite includes as much of the scene as you would probably be paying attention to if you were there, the angle of view seems natural, and the relative size of near and far objects seems normal.

A lens that is a normal focal length for one camera can be a long focal length for another camera. Film or sensor size determines what will be a normal focal length. The larger the size, the longer the focal length of a normal lens for that format; it corresponds roughly to the measurement of a diagonal line across the film frame or sensor surface (see below).

A camera using 35mm film takes a 50mm lens as a normal focal length (50mm is about two inches). For a camera taking 6 x 7cm pictures on 120 film, a normal focal length is about 80mm. For a camera using 4 x 5-inch film, a 150mm lens is normal. The sensors in most digital cameras are smaller than a 35mm frame, so their normal lenses are shorter than 50mm. Usage varies somewhat: for example, lenses from about 40mm to 58mm can be referred to as normal focal lengths for a 35mm camera.

A lens of normal focal length has certain advantages over lenses of longer or shorter focal length. Most normal lenses are faster; that is, they open to a wider maximum aperture, so can be used with faster shutter speeds or in dimmer light than lenses that do not open as wide. They often are less expensive, more compact, and lighter in weight.

Choice of focal length is a matter of personal preference. Some photographers habitually use a shorter focal length because they want a wide angle of view most of the time; others prefer a longer focal length that narrows the angle of view to the central objects in a scene. If you aren't sure, start with a normal focal-length lens.

A lens of a given focal length may be considered normal, short, or long, depending on the size of the film you are using or the sensor in your digital camera. If the focal length of a lens is about the same as the diagonal measurement of the light-sensitive surface (broken line), the lens is considered "normal." It collects light rays from an angle of view of about 50°.

The photograph on the right was taken with a 4 x 5 view camera using a 150mm lens. The diagonal measurement of 4 x 5-inch film is about 150mm, so a 150mm lens is a normal focal length for that size film.

But 150mm is much longer than the diagonal of 35mm film. A 150mm lens is a long-focal-length lens for a 35mm camera and—since few digital sensors are as big as a 35mm frame—it is very long for most D-SLRs. (see bottom photos, right).

View of 150mm lens on a 4 x 5-inch view camera

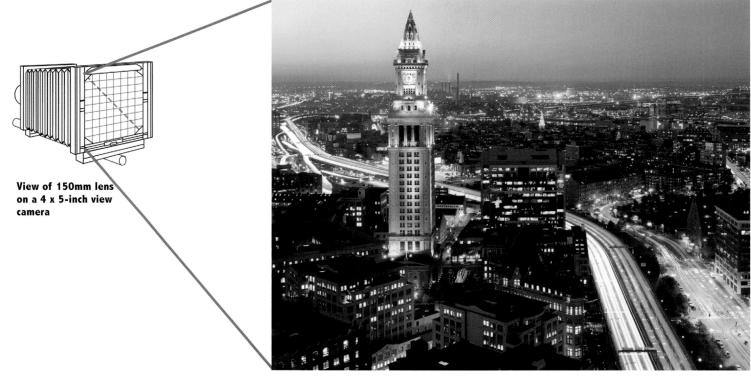

PETER VANDERWARKER Custom House Tower and Central Artery, Boston, 1989

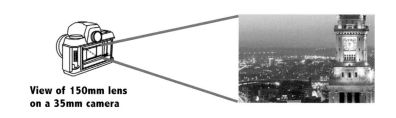

View of 150mm lens on a 35mm camera

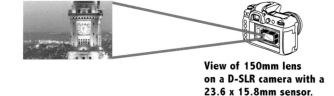

View of 150mm lens on a D-SLR camera with a 23.6 x 15.8mm sensor.

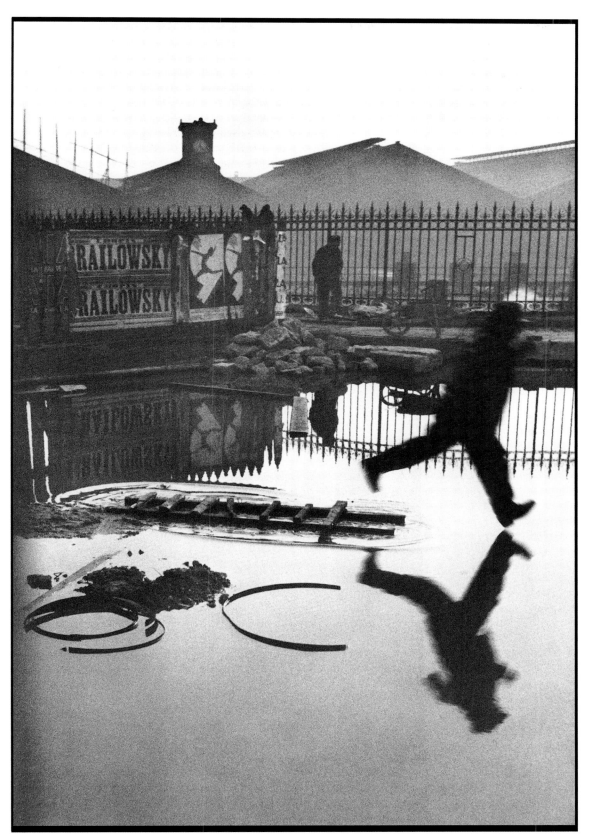

HENRI CARTIER-BRESSON Place de l'Europe, Paris, 1932

Using a normal-focal-length lens is a way for the photographer to let the subject speak. *Wide and long lenses make a stronger statement about the technical decisions a photographer must make, such as about perspective or depth of field.*

Although Cartier-Bresson resisted discussing technique, it is known that he frequently used a normal (50mm) lens on his Leica camera. In this case, the size relationships in the frame—clues that give us our sense of perspective—are not unusual. We are drawn to what the photographer wants us to notice, the poetry of an instant snatched from the fabric of time itself. Cartier-Bresson called this a "decisive moment."

Long Focal Length

A long-focal-length lens provides greater image magnification and a narrower angle of view than a normal lens. For a 35mm camera (or a D-SLR camera that uses a sensor the same size as a 35mm frame) a popular and useful long focal length is 105mm. For a camera using 120 film for 6 x 7cm negatives, a popular comparable focal length is 150m; for a 4 x 5 view camera, it is about 300mm. Most D-SLR cameras have sensors smaller than a 35mm frame; there is a multiplier factor you can use to compare angles of view to lenses for 35mm use. A digital camera with a 22.5 x 15mm sensor has a multiplier of 1.6; any lens on that camera will have the same angle of view as a lens with a 1.6 times longer focal length on a 35mm film camera. For example, a 65mm lens used with a 22.5 x 15mm sensor will be comparable to a 105mm lens used on a 35mm film camera.

Long lenses are excellent when you cannot or do not want to get close to the subject. In the photograph opposite, the photographer seems to be in the middle of the action even though he is not. Long lenses make it possible to photograph birds and animals from enough distance that they are not disturbed. Medium-long lenses are excellent for portraiture; most people become self-conscious when a camera is too close to them so their expressions are often artificial. A long lens used at a moderate distance also avoids the kind of distortion that occurs when shorter lenses used close to a subject exaggerate the size of whatever is nearest the camera—in a portrait, usually the nose (see below).

There are subtle qualities that can be exploited when you use a long lens. Because a long lens has less depth of field, objects in the foreground or background can be photographed out of focus so that the sharply focused subject stands out clearly. (See opposite page.) Also, a long lens can be used to create an unusual perspective in which objects seem to be closer together than they really are (see page 61).

Long lenses have some disadvantages, and the longer the lens the more noticeable the disadvantages become. Compared to lenses of normal focal length, they usually are heavier, bulkier, and more expensive, especially telephotos with wide apertures. Because they have relatively shallow depth of field, they must be focused accurately.

They are difficult to use for hand-held shots since they magnify lens movements as well as subject size. The shutter speed for a medium-long lens, such as a 105mm lens on a 35mm camera, should be at least 1/125 second if the camera is hand held. For a 200mm lens, you will need at least 1/250 sec. Otherwise, camera movement may cause blurring. A tripod or other support is your best protection against blurry photos caused by camera movement.

Photographers commonly call any long lens a telephoto, or tele, although not all long lenses are actually of telephoto design. A true telephoto has an effective focal length that is greater than the actual distance from lens to film plane. This design makes the lens shorter and easier to handle. A tele-extender or teleconverter contains an optical element that increases the effective focal length of any lens. It attaches between the lens and the camera body and magnifies the image from the lens onto the film. With these devices, the effective length of the lens increases, but less light reaches the film. A converter that doubles the lens focal length, for example, loses two f-stops of light.

Long lenses often produce better portraits. A moderately long lens (such as an 85mm or 105mm lens on a 35mm camera) used at least 6 ft from the subject (near right) makes a better portrait than a shorter lens used close to the subject (far right). Compare the size of nose and chin in the two pictures of the same subject. Photographing a person at too close a lens-to-subject distance makes features nearest the camera appear too large and gives an unnatural-looking dimension to the head.

Long lens, moderate distance

Short lens, up close

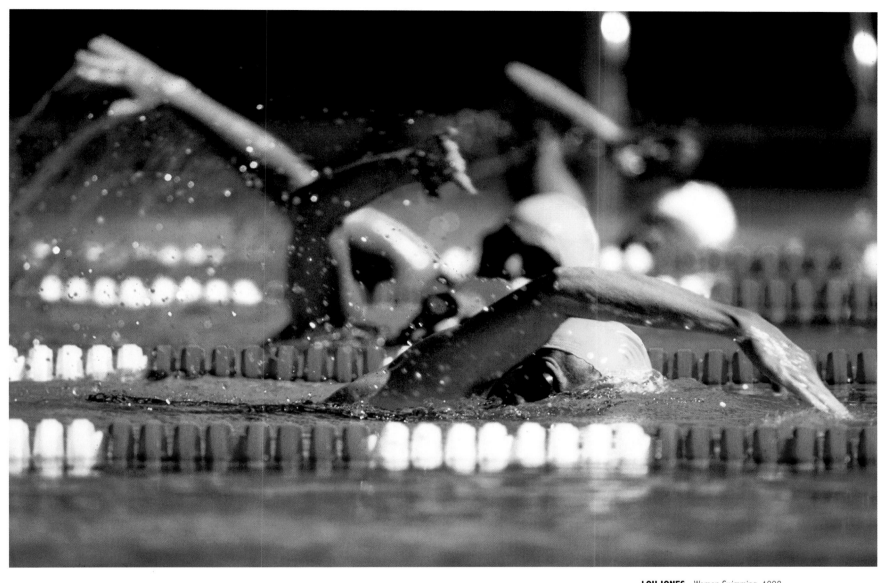

LOU JONES Women Swimming, 1998

Athletes at sporting events, like these swimmers, can be at a considerable distance. Photographers often rely on long lenses—like the 600mm telephoto used here—to come in tight on the action. Jones set his lens to the next-to-widest aperture so he could use a very high shutter speed. The shallow depth of field resulting from that wide aperture blurs out the background and calls attention to the sharply-focused swimmer in the foreground.

Short Focal Length

A short-focal-length lens increases the angle of view and shows more of a scene than a normal lens used from the same position. A short lens (commonly called a wide-angle lens) is useful when you are physically prevented (as by the walls of a room) from moving back as much as would be necessary with a normal lens.

For a 35mm camera, a commonly used short focal length is 28mm. A comparable lens for a 6 x 7cm camera is 55mm. For a 4 x 5 view camera, it is 90mm.

Wide-angle lenses have considerable depth of field. A 24mm lens focused on an object 7 feet away and stopped down to f/8 will show everything from 4 feet to infinity in sharp focus. Photographers who work in fast-moving situations often use a moderately wide lens, such as a 35mm lens on a 35mm camera, as their normal lens. They don't have to pause to refocus for every shot, because with this type of lens so much of a scene is sharp. At the same time it does not display too much distortion.

Pictures taken with a wide-angle lens can show both real and apparent distortions. Genuine aberrations of the lens itself such as curvilinear distortion are inherent in extremely curved or wide elements made of thick pieces of glass, which are often used in wide-angle lenses. While most aberrations can be corrected in a lens of a moderate angle of view and speed, the wider or faster the lens, the more difficult and/or expensive that correction becomes.

SLR cameras need a special kind of wide lens called a retrofocus, to leave room behind the lens for the reflex mirror to move. It is more difficult to correct aberrations in this kind of lens; wide-angle lenses for cameras without mirrors—rangefinders and view cameras—often perform better.

A wide-angle lens can also show an apparent distortion of perspective, but this is actually caused by the position of the photographer, not by the lens. An object that is close to a lens (or your eye) appears larger than an object of the same size that is farther away. Since a wide-angle lens is often used very close to an object, it is easy to exaggerate this size relationship (below and right). The cure is to learn to see what the camera sees and either minimize the distortion, or use it intentionally (pages 49 bottom and 61 right).

KARL BADEN
Amelia, 1995

A wide lens lets you work in close quarters, like this child's bedroom. *The unusual perspective, caused by a very short distance from lens to feet, creates a vision that is both amusing and a bit disorienting.*

DAVID MUENCH
Sand Dunes, Monument Valley,
Arizona, 1985

With a 75mm lens on his
4 x 5 view camera (a wide-
angle lens for that format),
David Muench positioned
his camera relatively close
to the furrows of sand in the
foreground. The result was
to increase the apparent
size of the furrows nearest
the camera and to create an
impression of great distance
from foreground to
background.

Zoom lenses are popular because they combine a range of focal lengths into one lens. Using a 28–105mm zoom, for example, is like having a 28mm, 50mm, 85mm, and 105mm lens instantly available, plus any focal length in between. The lens elements inside a zoom can be moved in relation to one another; this changes the focal length and therefore the size of the image.

It is convenient to be able to frame an image merely by zooming to another focal length, rather than by changing your lens or position. Some photographers carry only two lenses: a 24–80mm zoom and a longer 80–200mm zoom. A zoom lens is particularly useful for making color slides, since cropping the image later is not easy.

A zoom has some disadvantages. Compared to fixed-focal-length (sometimes called "prime") lenses, zooms are often more expensive, bulkier, heavier, and they can be optically inferior. But one zoom lens will replace two or more fixed-focal-length lenses.

The best prices and fewest drawbacks are found with a modest zooming range, from 35mm to 105mm, for example. The greater the range, the more evident the disadvantages become.

Some zoom lenses are best used where light is ample because they have a relatively small maximum aperture. Zooms that keep the same maximum aperture at all focal lengths are complex designs and therefore relatively expensive; most reduce the size of the maximum aperture as their focal length increases. For example, a 28–105mm zoom may open to f/4 when it is set to 28mm, but only to f/5.6 at 105mm focal length. **TIP:** With a zoom, be especially careful to make sure your shutter speed is fast enough to avoid blur caused by camera movement. With the lens at 28mm, you can use a minimum shutter speed of 1/30 second, but when you zoom out to 100mm, you will need at least 1/125 second unless you have the camera on a tripod.

Used outdoors during the day, most zoom lenses work fine. However, to shoot indoors with available light you may want a zoom that stays at a minimum of f/2.8 over its entire range.

A zoom lens gives you a choice of different focal lengths. Here, the photographer used the widest focal length for the picture on the left, then took the center picture, below, at a focal length near normal. The third photograph, bottom, used the longest focal-length of the lens. All three photographs were made while standing in the same position.

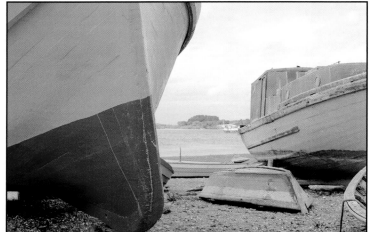

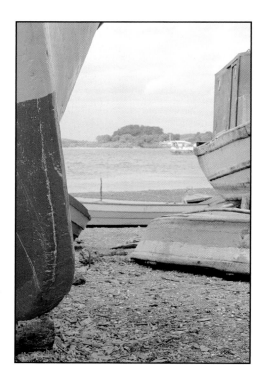

MARTIN PARR
Taunton, England, 1998

A macro lens is useful for photographing very close to a subject without having to use other accessories such as extension tubes. When you photograph close to a subject, depth of field is very shallow—only a narrow distance from near to far will be sharp.

Parr finds he can say more about a subject by coming in close and showing a detail. He says, "How on earth a one-eyed candy can tell us about the modern condition, I will never know, but it seems to work. Such are the riddles of photography."

CHIP SIMONS
Too Much Sugar, 1995

A fisheye lens distorted space to illustrate an article on hyperactive youth. The photograph shows a fisheye lens's typical characteristics: very deep depth of field, pronounced differences in size between objects very close to the camera and those in the background, and barrel distortion curving straight lines in the image. Simons chose the lens for its radical rendering and then enhanced the viewer's vertigo by putting gels over the studio strobe lights for saturated, surreal colors.

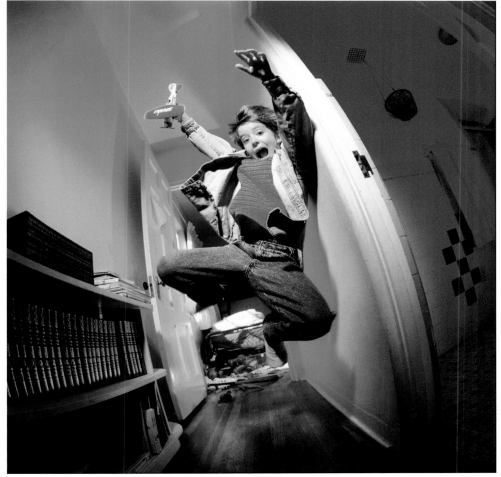

A macro lens is useful for extremely close shots (left, top). The lens lets you focus at a very close range and is corrected for aberrations that occur at close focusing distances. The lens is occasionally called, somewhat inaccurately, a micro lens. Some zoom lenses have a macro feature. They focus closer than a non-macro zoom but not as close as a fixed-focal-length macro lens.

For the widest of wide-angle views, consider the fisheye lens. A fisheye has a very wide angle of view—some even more than 180°—and exaggerates to an extreme degree differences in size between objects that are near to the camera and those that are farther away. Inherent in its design is barrel distortion, an optical aberration that bends straight lines into curves at the edges of an image. Fisheye lenses also produce great depth of field. Objects within inches of the lens and those in the far distance will be sharp. It is not a lens for every—or even many—situations, but it can produce startling and effective views (bottom left).

Aberrations are deliberately introduced in a soft-focus lens, also called a portrait lens. The goal is to produce an image that will diffuse and soften details such as facial wrinkles.

A perspective-control lens brings some view-camera adjustments to other types of cameras. The lens shifts up, down, or sideways to prevent parallel lines, such as the sides of a building, from tilting toward each other if the camera is tilted.

A catadioptric or mirror lens is similar in design to a reflecting telescope. It incorporates curved mirrors as well as glass elements within the lens. The result is a lens with a very long focal length but modest size, one much smaller and lighter than a lens of equivalent focal length that uses only glass elements. A unique effect caused by the front mirror is that out-of-focus highlights take on a donut shape. A "cat" lens has a fixed aperture, usually rather small—f/8 or f/11 is typical.

Image stabilization can be built in to a lens. Micromotors adjust the position of special floating lens elements. Sometimes the same lens is also available in a less-expensive version without stabilization.

With manual focus, you select the part of the scene you want to be the sharpest. What is the most important part of the scene to be sharp? What do you want to emphasize? What do you expect viewers to look at first? If you are photographing a person, focus on the eye. If the person is at an angle and you are up close, both eyes may not be sharp in the photograph. Depending on the scene, it may be more important to have the near eye or the far eye sharp.

The nearer you are, the more important it is to focus critically. If you are 2 feet away, focus is critical, because depth of field will be shallow, with only a narrow area from near to far appearing sharp. If you focus on something 200 feet away, everything at that distance and beyond will be sharp.

Focus manually like you might tune a guitar. Go a little past the point you think is correct, then come back. If you adjust the focus until the image looks sharp, then adjust it a little more until the subject looks unsharp, then go back to sharp, you'll know exactly when your subject is at its sharpest.

Follow focus is a technique that lets you keep a subject that is moving toward you well focused. If a runner is coming toward you, you have to adjust the focus at about the same rate that the runner's distance is changing.

One way to learn how to follow focus is to practice focusing on people moving toward and away from you. Then practice on faster things, such as the license plates of moving cars. You don't need this skill if still lifes are your only subject, but it is vital if you want to photograph football games, auto races, dancers, or anything else that moves fast.

NOTE: Don't forget that shutter speed and aperture also play an important role in making objects appear sharp in the final picture. If your shutter speed isn't fast enough, a moving object will appear blurred in a photograph, no matter how sharply focused it was. This applies to autofocus as well. If your aperture isn't small enough, you may have focused on an important area, but an equally important nearby area may be out of focus. See, for example, the photographs on pages 26–27.

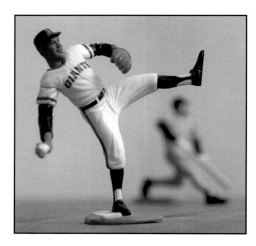

Sharp focus attracts the eye. When you are photographing, it is natural to focus your eyes—and the camera—on the most important area of a scene.

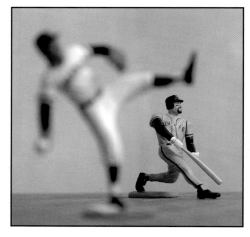

Sharp focus is a signal to pay attention to a particular part of an image, especially if other parts are not sharp.

VIEWFINDER SCREENS FOR MANUAL FOCUS

Single-lens reflex and view cameras use ground-glass viewing screens. Light coming through the lens hits a pane of glass that is etched, or ground, to be translucent. This ground glass creates a surface on which a viewer, looking at it from the other side, can see an image and focus it. As you move your lens in and out to focus—usually by rotating it—the ground-glass screen shows clearly when a scene is sharp and in focus (left, above) and when it is not (left).

Reflex cameras may also include a microprism, a circle that appears dotted until it is focused, and sometimes a split-image focusing aid that appears offset until the image is focused.

Rangefinder cameras have split-image focusing, which operates by superimposing two images of the same subject on the focusing screen (left). One image passes through a viewfinder and one is reflected by a rotating prism connected to the lens. The two images appear exactly superimposed (left, below) only when the lens focuses sharply on the subject. The red circles on the images here call attention to the focusing aid. They would not appear in the viewfinder.

NOTE: If you have vision problems, you might find manual focusing difficult at times. Some cameras come with a viewfinder adjustment that allows you to dial in a correction (called a diopter) like prescription glasses. Other cameras offer an accessory called a diopter lens, available in several strengths, that screws directly onto the eyepiece to do the same. Your optometrist can tell you the appropriate correction to buy.

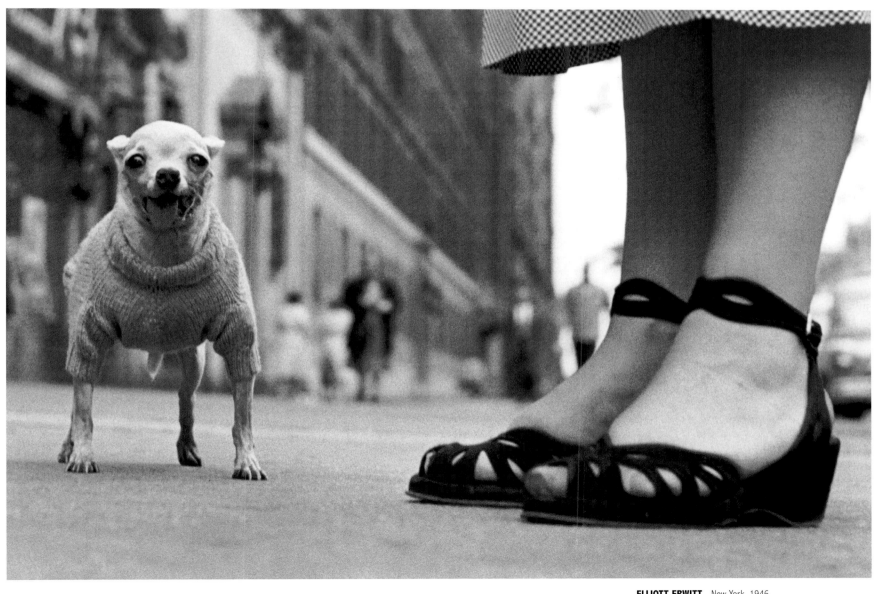

ELLIOTT ERWITT New York, 1946

***With everything in the photo soft except the dog
and feet,*** *which are in the same plane of focus, the
photographer leaves no doubt about where he
wants the viewer's eye to go. The human brain
looks for sharpness in a scene or in a photograph.
By controlling focus, photographers also can
control where people look when an image is
viewed.*

Automatic focus (AF) does the focusing for you. In the simplest designs, you press the shutter-release button and the lens brings the image into focus. The camera adjusts the lens to focus sharply on whatever object is at the center of the viewfinder or within the focusing brackets. This type of autofocus works well in situations where the main subject is—and stays—in the middle of the picture. The camera may beep or display a confirmation light when it has focused, but the presence of a light does not assure that the picture will be sharp overall.

If your subject is not in the center, you can use autofocus lock to make it sharp. Frame the subject within the focusing brackets or simply point the camera straight at it. To temporarily lock in the focus, press the shutter release halfway down. Keeping the shutter button partially pressed, reframe the scene, then press the shutter release all the way down for an exposure (see photos, right).

Wide-area focus systems provide more options. Some viewfinders display several focusing brackets. By rotating a dial or thumbwheel on the camera back, you select a bracket that covers the subject you want to be sharp. When you press the shutter, the camera focuses on the selected area—allowing you to maintain your framing without having to center, lock, and reframe each picture. This allows you to shoot fast-moving subjects that are not in the center of the frame (see photo, opposite page, below right).

Some wide-area autofocus systems use light reflected off your eye to identify your subject by the direction you are looking, and therefore what area of the picture to bring into sharp focus. Other systems automatically select the nearest subject in the picture and focus there.

Once you lock onto a subject, some cameras predict where the subject is likely to be next, keeping the subject in focus even if it moves across the frame. These tracking systems can lock onto a subject,

adjusting the focus as the subject moves closer to, or farther from, the camera. These systems work especially well if the subject, like a race car, is traveling at a constant speed toward or away from the camera.

Some cameras have two autofocus systems. Active autofocus sends out a beam of infrared waves. The camera uses the part of the beam that bounces back to measure the distance to the subject. Passive autofocus looks instead at the image inside the camera, using the principle that contrast on the focal plane is greatest when the subject is sharpest.

Both are used because neither one works in every situation. The infrared beam in active autofocus, for example, will bounce back from the glass in a window instead of from a subject on the other side of the glass. Passive autofocus may miss the focus if a subject has very low contrast, is in very dim light, or consists of a repetitive pattern like window blinds or plaid. Cameras that employ both systems are more likely to find maximum sharpness under most conditions.

An autofocus system can be fooled. If you are photographing a soccer game focusing on the goalie, for example, and the referee moves in front of your camera, autofocus may track the referee and not the player. The camera does not know what you are trying to photograph, so unwanted subjects can cause the lens to focus incorrectly.

Your camera may let you select among its several focus modes. Manual focus is frequently supplemented by two other options—single-shot autofocus, sometimes called focus priority, and continuous focus. With a modern camera, if you want the machine to make quick and accurate decisions for you, you must understand its methods.

Read your camera's instructions so you know how its autofocus mechanism operates and when you would be better off focusing manually.

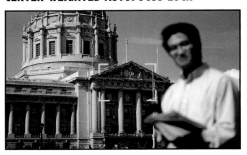

Shutter-release button

Subject off center, out of focus. Autofocus cameras often focus on the center of a scene. This can make an off-center main subject out of focus if it is at a different distance from whatever is at the center. Above, brackets at the center indicate the focused area.

Halfway down, autofocus activated

Focus on the main subject. In autofocus mode, first focus by placing the autofocus brackets on the main subject; with many cameras, you press the shutter button part way. Keep partial pressure on the release to lock focus.

 All the way down, shutter released

Hold focus and reframe. Next, reframe your picture while keeping partial pressure on the shutter release. Push the shutter button all the way down to make the exposure. You can get the same results—a sharply focused main subject—simply by focusing the camera manually if your camera allows that.

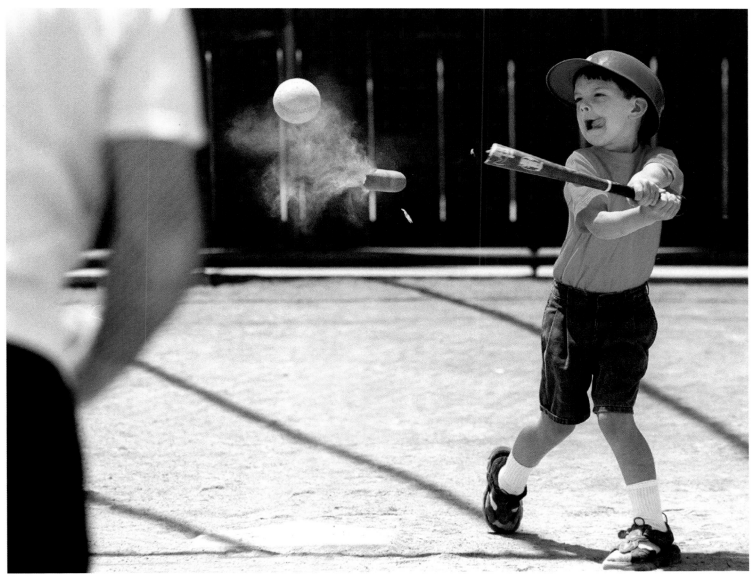

Center-weighted auto-focus can be fooled in a situation like this one, *where it might have focused on the fence in the background instead of the batter. You can use autofocus lock (see opposite page) to lock focus on the batter and then reframe the picture.*

Wide-area autofocus allows you to stay framed on the situation *while using a dial or other camera control to select the part of the image you want to be in focus, in this case, the batter. You could have selected the left-hand segment of the focusing brackets to focus on the person in the left-hand part of the frame. Some systems offer even more precise control.*

Focus and Depth of Field

What exactly is sharpness, and how much can it be controlled? In theory, a lens can only focus on a flat plane at one single distance at a time (the plane of focus) and objects at all other distances will be less sharp. But, in most cases, part of the scene will be acceptably sharp both in front of and behind the most sharply focused plane. Objects will gradually become more and more out of focus the farther they are from the most sharply focused area.

Depth of field is the part of a scene that appears acceptably sharp in a photograph. Depth of field can be shallow, with only a narrow band across the scene appearing to be sharp (photo, opposite), or it can be deep, with everything sharp from near to far (photo, right). To a large extent, you can control how much of it will be sharp. There are no definite endings to the depth of field; objects gradually change from sharp to soft the farther they are from the focused distance.

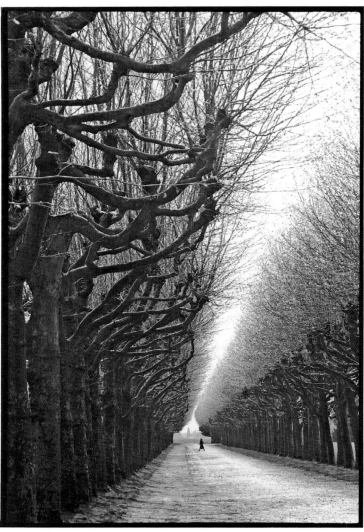

MARTINE FRANCK Meudon Observatory, 1991

Depth of field, the area in a scene in which objects appear sharp, can be deep or shallow. In the photograph above, everything is sharp from the nearest tree to beyond the figure in the background. The smaller the aperture, the greater the depth of field.

The circle of confusion affects the depth of field.
Light from a single point on the subject reaches the lens in the shape of a cone. Behind the lens, that same light converges, again in the shape of a cone, to a corresponding image point. If your film or sensor is located at the tip of that cone of light, that image point will be exactly in focus (see diagram, below).

If the recording surface is not at the tip of the cone and instead slices through the cone in front of or behind the focus point, it wll record a small circle instead of a point (diagram, below).
 A circle can be just small enough that you can't see that it's a circle instead of a point. This size is called a circle of confusion. Any points in the recorded image that make a circle this size or smaller will appear to be in focus. Any points within this range are inside the depth of field.

Reducing the size of the lens aperture makes the base of each cone of light smaller and its angle narrower (diagram, below). The same size circle of confusion can be recorded farther from the focus point. So even though a smaller aperture doesn't change the actual location of the plane of focus, it widens the range of points that appear to be in focus, thus increasing the depth of field.

In general, the more a print is enlarged, the less sharp it seems because the enlargement increases the size of each image point, making more of them larger than the circle of confusion and no longer appearing to be sharp points. But sharpness is also affected by viewing distance, something we unconsiously adjust. A mural-size print viewed at a comfortable distance of 15 feet may appear sharp; the same print viewed up close may not.

MICHA BAR-AM Yad Vashem Holocaust Memorial, Jerusalem, 1981

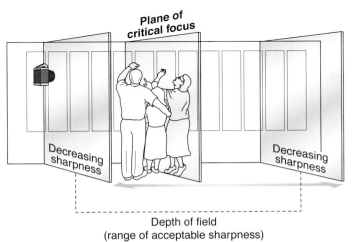

Plane of critical focus

Decreasing sharpness

Decreasing sharpness

Depth of field
(range of acceptable sharpness)

A lens focuses on the plane of critical focus, also called the image plane; in this case, it is a column of names at the memorial in Jerusalem that commemorates the six millions Jews killed in World War II. Imagine the distance on which your lens is focused as a pane of glass—parallel to the camera's light-sensitive surface—stretched across the scene in front of you. Everything at this distance (all points in the plane of critical focus) will be sharp in the photograph. That's why the face on the right is in focus too; it is the same distance from the camera as the text on the left that is in focus. In front of and in back of the plane lies the depth of field, the area that appears acceptably sharp.

The farther that objects are from the plane of critical focus, either toward the camera or away from it, the less sharp they will be. When objects are far enough from the plane of critical focus, they lie outside the depth of field and will appear noticeably out of focus. At normal focusing distances, the depth of field extends about one-third in front of the plane of critical focus, two-thirds behind it. When focusing very close to a subject, the depth of field is more evenly divided, about half in front and half behind the plane of critical focus.

The search for missing relatives continues to this day. Hand and Name is the literal meaning of Yad Vashem; yad also means memorial. Journalist Bar-Am has been photographing Israel since its independence in 1948.

Evaluating and controlling the depth of field is more important in some situations than in others. If you are relatively far from the subject, the depth of field (the distance between the nearest and farthest points in a scene that appear sharp in a photograph) will be greater than if you are up close. If you are using a short-focal-length lens, you will have more depth of field than with a long lens. If the important parts of the scene are more or less on the same plane left to right, they are all likely to appear sharp as long as you have focused on one of them.

But when you photograph a scene up close, with a long lens, or with important parts of the subject both near and far, you may want to increase the depth of field so that parts of the scene in front of and behind the point on which you focused will also be sharp.

Sometimes, though, you will want to blur a distracting background that draws attention from the main subject. You can accomplish this by decreasing the depth of field.

You can use the aperture to control depth of field. To increase the depth of field so that more of a scene in front of and behind your subject is sharp, setting the lens to a smaller aperture is almost always the first choice. Select f/16 or f/22, for example, instead of f/2.8 or f/4. This is the case even though you have to use a correspondingly slower shutter speed to maintain the same exposure. A slow shutter speed can be a problem if you are photographing moving objects or shooting in low light.

To decrease the depth of field and make less of the scene in front of and behind the subject sharp, use a wider aperture, like f/2.8 or f/4.

There are other ways to control depth of field. You can increase the depth of field by changing to a shorter focal length lens or stepping back from the subject, although both of those choices will change the picture in other ways as well (see opposite).

To decrease the depth of field and make less of the scene in front of and behind your subject sharp, you can use a longer lens or move closer to the subject. These alternatives will also change the composition of the picture (see opposite).

Most D-SLRs and all compact digital cameras have sensors smaller than a 35mm frame. For them, a lens with a given angle of view (for example, its normal lens) will have a shorter focal length and give more depth of field at any given aperture than a lens with the same angle of view—in this case, a 50mm lens—on a 35mm camera. This is an advantage if you want everything in your picture to be in focus, but a limitation if you want to set a subject apart from its background (see page 320 and 329.)

Why does a lens of longer focal length produce less depth of field than a shorter lens used at the same f-stop? The answer relates to the diameter of the aperture opening. The relative aperture (the same f-stop setting for lenses of different focal lengths) is a larger opening on a longer lens than it is on a shorter lens (see below).

Different lenses go out of focus differently. The word *bokeh* (Japanese for blurring) refers to the way an out-of-focus subject looks in a photograph, which depends on both the shape of the aperture and the design of the lens.

LENS FOCAL LENGTHS, APERTURES, AND LIGHT

The two lenses below, both set at f/4, let in the same amount of light, even though the actual opening in the 100mm lens (left) is physically smaller than the opening in the longer 200mm lens (right).

The longer the focal length, the less light that reaches the sensor or film, therefore a long lens will form a dimmer image than a short lens unless more light is admitted by the aperture.

The sizes of the aperture openings are determined so that at a given f-stop number the same amount of light reaches the film, no matter what the focal length of the lens. The f-stop number, also called the relative aperture, equals the focal length of the lens divided by the aperture diameter.

$$\text{f-stop} = \frac{\text{lens focal length}}{\text{aperture diameter}}$$

If the focal length of the lens is 100mm, you need a lens opening of 25mm to produce an f/4 aperture.

$$\frac{100\text{mm lens}}{25\text{mm lens opening}} = \frac{100}{25} = \text{f/4}$$

If the focal length of the lens is 200mm, you need a lens opening of 50mm to produce an f/4 aperture.

$$\frac{200\text{mm lens}}{50\text{mm lens opening}} = \frac{200}{50} = \text{f/4}$$

SHARPNESS & DEPTH OF FIELD

The smaller the aperture, the greater the depth of field. Here the photographer focused on the front clock. Near right: with a wide aperture, f/2, the depth of field is relatively shallow; other clocks that are farther away are out of focus.

Far right: using the same focal length and staying at the same distance, only the aperture was changed—to a much smaller one, f/16. Much more of the scene is now sharp. Changing the aperture is the best way to change the depth of field because it does not affect other aspects of the photograph.

LESS DEPTH OF FIELD

Wider aperture f/2

MORE DEPTH OF FIELD

Smaller aperture f/16

The shorter the focal length of the lens, the greater the depth of field. Near right: with a 180mm lens, only the first subject is sharp.

Far right: with a 50mm lens at the same distance, set to the same aperture, and focused on the same point as the previous shot, the person in the background is sharper. Notice that changing the focal length changes the angle of view (the amount of the scene shown) and changes the magnification of everything in the scene. The kind of picture has changed as well as the sharpness of it.

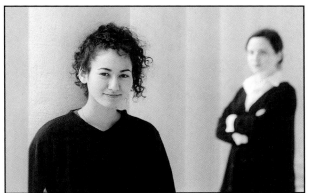

Longer focal length 180mm

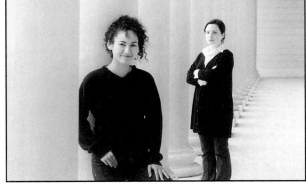

Shorter focal length 50mm

The greater the distance from the subject, the greater the depth of field. Near right: with the lens focused on the subject in front about 3 ft away, only a narrow band from near to far in the scene is sharp.

Far right: using the same focal length and aperture, but stepping back to 10 ft from the front subject and re-focusing on her made much more of the scene sharp. Stepping back has an effect similar to changing to a shorter focal length lens: more of the scene is shown, and more of the scene is sharp.

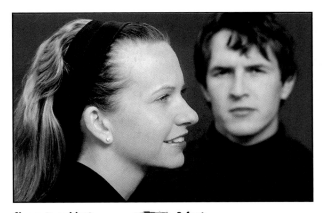

Closer to subject 3 feet

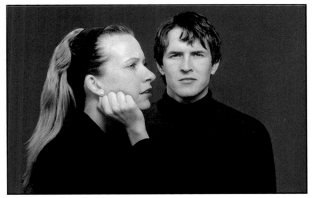

Farther from subject 10 feet

Two more techniques let you control depth of field, zone focusing (this page) and focusing on the hyperfocal distance (opposite). For these you need a lens with a depth-of-field scale. A fixed-focal-length lens is more likely to have such a scale; a zoom lens may not. Ordinarily, you will need a camera that can be focused manually, although a few autofocus cameras let you adjust the camera appropriately.

Zone focusing lets you set the depth of field in advance of shooting. It is useful when you want to shoot rapidly without refocusing, and can predict approximately where, if not exactly when, action will take place (for example when photographing strangers on the street). It lets you be relatively inconspicuous by not having to spend time focusing with your camera to your eye.

To zone focus, use a lens's depth-of-field scale to find the f-stop settings that will give you adequate depth of field (see lens diagram, below). Everything photographed within the near and far limits of that depth of field will be acceptably sharp. The precise distance at which something happens is not important because the whole area will be sharp. Generally, zone focus works best with normal- or short-focal-length lenses. A long-focal-length lens may have too little depth of field to make the technique practical.

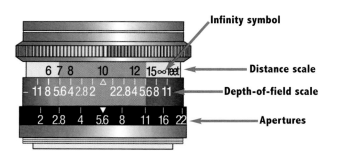

Infinity symbol

Distance scale

Depth-of-field scale

Apertures

Zone focusing uses a lens's depth-of-field scale so you can be ready to shoot without focusing before every shot. Suppose the nearest focus point you want sharp is 7 ft away, and the farthest is 13 ft away. Turn the focusing ring until those distances on the distance scale fall opposite a matched pair of f-stops on the depth-of-field scale. If you set your lens aperture to that f-stop, objects between the two distances will be in focus.

Here, the two distances fall opposite a pair of f/5.6 marks. With this lens set to f/5.6 or a smaller aperture, such as f/8 or f/11, everything between 7 ft and 13 ft will remain sharp. You will not need to refocus as long as the action stays between those distances.

HELEN LEVITT New York, c. 1942

If you think that focusing your camera could distract your subject, you can zone focus. Before you begin to photograph, use your lens's distance scale to prefocus, then adjust the depth-of-field scale to find the area that will be sharp in front of and behind the focus point. It is often faster to zone focus in advance of action than it is to try to focus on a particular subject during a peak moment.

Helen Levitt made many photographs of children playing on New York City streets. Ben Maddow wrote of her work, "She sees, trails, hunts, and seizes hold of those dances that ordinary people do on their own turf."

Focusing on the hyperfocal distance will give you maximum depth of field for the lens you're using, with objects as sharp as possible from the foreground to the far distance. When a scene extends into the distance, you may find that you focus visually on the part of the scene that is quite far away. In photographic terms, you have probably focused on infinity, which is as far as the eye can see and as close as the lens usefully gets to the film. (Infinity is marked ∞ on the lens distance scale.)

But for maximum depth of field in a scene that extends to a far distance, don't focus on infinity. Instead turn the focusing ring so that the infinity mark falls just within the depth of field for the f-stop you are using (see lenses, below). You are now focused on the hyperfocal distance, a distance that is closer to the lens than infinity. Everything far will still be sharp, but more of the foreground will also be in focus. The hyperfocal distance, different for every aperture, gives you the most possible depth of field every time.

JOHN PFAHL Vernal Falls, Yosemite National Park, California, 1992

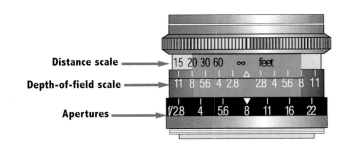

Distance scale
Depth-of-field scale
Apertures

For maximum depth of field in a scene that extends to the far distance (infinity in photographic terms, ∞ on the lens distance scale), do not focus on the infinity symbol. With the lens to the left, if the aperture is f/8 and the lens is focused on infinity, everything from 20 ft to infinity will be sharp.

Instead, as has been done with the lens to the right, set the distance scale so that the infinity mark lines up opposite your chosen f-stop on the depth-of-field scale (f/8 in this example). Now, with the lens still set to f/8, everything from 10 ft to infinity will be sharp.

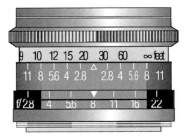

Perspective

The camera image can seem surprisingly different from reality, so it is vital to see things the way the camera sees them. A long lens used far from a subject gives a so-called telephoto effect. In the photo opposite left, for example, the people and traffic seem impossibly compressed. A short lens used close to a subject produces what is known as wide-angle distortion. Opposite right, it enlarges part of the human form to unnatural proportions. These photographs seem to show distortions in perspective.

Perspective is the way the brain judges depth in a two-dimensional representation. Depth is perceived mostly by comparing the sizes of objects, so it seems to increase if foreground objects appear larger than background ones.

Perspective is affected by the lens-to-subject distance, not by lens focal length. Moving your camera closer to a subject will make objects in the foreground larger relative to those in the background.

Below, the pictures in the top row were taken from the same distance with lenses of different focal lengths. The shortest lens produces the widest view; the longest lens gives the narrowest view, but is simply an enlargement of the scene. The relative sizes of the eggs in the foreground and the bird remain constant because all three pictures were taken from the same distance.

The pictures in the bottom row were taken with the same lens from different distances. The closer the lens came, the bigger the foreground objects (the eggs and nest) appear relative to the background one (the cage).

In only one sense does the focal length of a lens affect the perspective. A short lens can focus closer to an object than a long lens, and it doesn't eliminate most of the scene from view when you move in close. Consequently, a short lens can produce wide-angle distortion because it is easy to use it up close. A long lens can produce a telephoto effect because you are more likely to shoot from relatively far away. But the lens isn't creating the effect; the distance from the subject is doing so.

FOCAL LENGTH CHANGES, CAMERA POSITION STAYS THE SAME

Short-focal-length lens, far from subject

Medium-focal-length lens, far from subject

Long-focal-length lens, far from subject

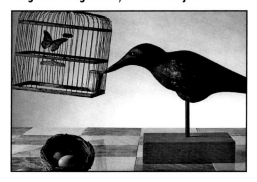

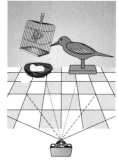

Lenses of different focal lengths change the size of all the objects, not the size of one compared to another. Each photo above was shot from the same position but with a longer focal length lens each time. Eggs, bird, and cage all increased in size the same amount.

FOCAL LENGTH STAYS THE SAME, CAMERA POSITION CHANGES

Short-focal-length lens, far from subject

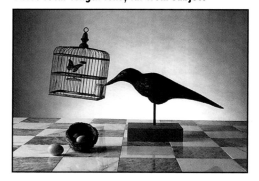

Short-focal-length lens, medium distance

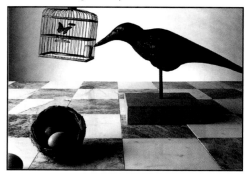

Short-focal-length lens, close to subject

Changes in a lens's distance from a scene change the relative size of near and far objects. As the lens came closer, foreground objects enlarged more than background ones to give three different perspectives. The nest is smaller than the cage in the first picture, bigger than the cage in the last picture.

ANDREAS FEININGER Midtown Fifth Avenue at Lunch Hour, New York, 1950

A short-focal-length lens used up close (above) *increases the apparent size of the part of the subject that is closest to the camera, producing what is sometimes called wide-angle distortion. Like the compressed appearance of the photograph at left, this is caused by the distance from the lens to the subject, not by the lens itself.*

Exaggerated perspective, the impression of compressed or expanded space in a photograph, is one way to add impact to an image or to communicate an idea visually.

A long-focal-length lens used far from a subject produces what is known as the telephoto effect. It seems to compress the objects in a scene into a crowded mass. Andreas Feininger made many photographs of New York that conveyed its beehive crowding and intense activity. The super-long lens he used for these pictures was so long that he had to add a two-legged extension to his tripod to support the lens.

Start with a normal lens or a zoom lens with a moderate-focal-length range if you are getting a camera with interchangeable lenses. Don't buy more lenses until you feel a strong need to take the different kinds of pictures that other focal lengths can provide.

Get your lenses one at a time and think ahead to the assortment you may some-day need. Begin by buying lenses in increments of more or less two times the focal length; for example, a good combination for a 35mm camera is a 50mm normal lens for general use, a 28mm wide-angle lens for close-in work, and a 105mm long lens for portraits and for magnifying more distant subjects. Be wary of ultra-wide-angle (24mm or below) and extra-long (above 200mm) lenses. They may be a lot more expensive than the others and are so specialized that their usefulness is limited.

Also, when buying a zoom lens, beware of the ones that reduce the aperture as you increase their focal length. Many are relatively cheap but don't let in enough light to shoot indoors without flash or without a tripod when they are extended to their longer focal lengths.

Don't spend money on extra-fast lenses unless you have unusual requirements. Buying a lens with a couple of extra f-stops—or one with image stabilization—may cost you an extra couple of hundred dollars. With today's high-speed films and sensors that reach higher ISOs in digital cameras, a lens that can open to f/2.8 is adequate in all but the dimmest light. With this lens, you can take pictures indoors without flash.

NOTE: Lenses made by reputable manufacturers can be assumed to be reasonably good. And yet two lenses of the same focal length, perhaps even made by the same company, may vary widely in price. This price difference usually reflects a difference in the speed of the lens. The faster and more expensive lens will have a wider maximum aperture and admit more light. It can be used over a wider range of lighting conditions than the slower lens, but otherwise may perform no better. It may, in fact, perform less well at its widest aperture because of increased optical aberrations.

Consider a secondhand lens. Many reputable dealers take used lenses in trade, and they may be bargains. But look for signs of hard use, such as surface wear, a dented barrel, scratched lens surface, or a slight rattling that may indicate loose parts, and be sure to check the diaphragm to see that it opens smoothly to each f-stop over the entire range of settings.

Test your lens. The only sure way is to take pictures with it on your own camera at various f-stops, so insist on a trial period or a return guarantee. If you plan to buy several lenses eventually, a good investment is a standardized test chart that can give an accurate reading of a lens's sharpness.

A lens shade is a very desirable accessory to attach to the front of the lens to prevent flare. Buy one that is matched to the focal length of the lens; too wide a shade is inefficient, too narrow a shade will vignette or cut into the image area. This is more likely to be a problem with wide-angle lenses.

Maximum aperture. The lens's widest opening or speed. Appears here as the ratio 1:1.8. The maximum aperture is f/1.8, the last part of the ratio.

Manufacturer

Focal length. The shorter the focal length, the wider the view of a scene. The longer the focal length, the narrower the view and the more the subject is magnified.

On the lens barrel (below) are controls such as a ring that focuses the lens and a switch to turn off autofocus. Cameras and lenses vary in design, so check the features of yours. For example, some cameras have push-button controls on the camera body instead of an aperture control ring on the lens.

Engraved around the front of the lens (above) are its focal length, maximum aperture, and other information. Some lenses also indicate the filter size. A 50mm lens, for example, may require a 49mm filter, expressed on the lens rim as Ø 49mm.

Focusing ring rotates to bring different parts of the scene into focus.

Distance marker indicates the distance at which the lens is focused.

Depth-of-field scale shows how much of the scene will be sharp at a given aperture. Not all modern lenses have this feature.

Aperture-control ring rotates to let you select the f-stop (size of the lens opening).

TYPICAL FOCAL LENGTHS FOR CAMERAS USING VARIOUS FRAME SIZES			23.7 x 15.6mm digital sensor (1.5 lens multiplier factor)		6 x 4.5cm (2 1/4 x 1 5/8 in) or 6 x 6cm (2 1/4 x 2 1/4 in)	6 x 7cm (2 1/4 x 2 3/4 in) or 6 x 9cm (2 1/4 x 3 1/4 in)	
Focal lengths are usually stated in millimeters, sometimes with very old lenses in inches or centimeters. There are approximately 25mm to an inch.	**Frame size**	**D-SLR**	**35mm**	**120 Film**	**120 Film**	**4 x 5 in**	
	Short focal length	24mm or shorter	35mm or shorter	55mm or shorter	65mm or shorter	90mm or shorter	
	Normal focal length	35mm	50mm	75mm, 80mm	80mm, 90mm	150mm (6 in)	
	Long focal length	55mm or longer	85mm or longer	120mm or longer	150mm or longer	210mm (8 1/2 in) or longer	

PROTECTING AND CLEANING YOUR CAMERA AND LENS

Cleaning inside a film camera. If you are cleaning the lens or changing film, also check inside the camera for dust that can settle on the film and cause specks on the final image. Blow or gently dust along the film path, particularly along the winding mechanisms, tilting the camera so the dust falls out and isn't pushed farther into the camera. With a single-lens reflex, be careful not to damage the shutter curtain in the body of the camera or the film pressure plate on its back. The shutter curtain is particularly delicate; don't touch it at all unless absolutely necessary.

Cleaning a digital sensor—actually, cleaning the low-pass filter that covers the sensor—is risky and should be done very carefully. Follow your owner's manual to enter the camera's cleaning mode. Use compressed air to remove loose dust. Special cleaning products can be used to clean streaks and particles that have become attached to the surface, but you may want to leave that to trained repair personnel.

Cleaning the lens. First, blow or brush any visible dust off the lens surface (above). Holding the lens upside down helps the dust fall off the surface instead of just circulating on it. Be especially careful with granular dirt, like sand, which can scratch the lens surface badly. To clean grease or water spots from the lens, wad a clean piece of camera lens tissue or a specially coated cloth into a loose ball and moisten it with a drop or two of lens cleaner solution. Don't put drops of solution directly on the lens; they can seep along the edges of the lens to the inside. Wipe the lens gently with a circular motion (right). Finish with a gentle, circular wipe using a dry lens tissue. **NOTE:** Don't use any products designed for cleaning eyeglasses.

Protect from dust and dirt. The best way to keep equipment clean is not to get it dirty in the first place. Cases and bags protect cameras and lenses from bangs and scratches as well as keep them clean. Sand is a particular menace; clean your equipment well after using it on the beach. **NOTE:** A UV or skylight filter on the lens can help protect it. If you scratch a protective filter, it is much less expensive to replace than a lens. When you take a lens off a camera, protect both front and back lens surfaces either by placing the lens in a separate lens container or by capping both ends.

Protect from moisture. Modern cameras are packed with electronic components that can corrode and malfunction if exposed to excessive humidity or moisture, especially salt water. On a boat or at the beach, keep equipment inside a case when it is not in use. If you use it where salt spray will get on it, wrap it in a plastic bag so just the lens pokes out. Digital cameras are particularly sensitve to high humidity.

Protect from temperature extremes. Excessive heat is the worst enemy. It can cause parts to warp, lubricating oil inside the camera to flow into places it should not be, and memory cards and film to deteriorate. Avoid storage in places where heat builds up: in the sun, inside an auto trunk or glove compartment on a hot summer day, or near a radiator in winter.

Excessive cold is less likely to cause damage but can make batteries sluggish and lubricants stiff. If you photograph outdoors on a very cold day, keep your camera warm inside your coat until you are ready to use it, then return it afterward. Moisture can condense on a camera, just as it does on eyeglasses. Any metal or glass that has gotten cold outdoors will get damp when it comes indoors and meets warm, humid air. Keep a cold camera wrapped up and lenses capped long enough to reach room temperature.

Protect during storage. If you won't be using the camera for a while, release the shutter, make sure the power is off, and store in a clean, dry place. If humidity is high, ventilation should be good to prevent a buildup of moisture on electronic components. Wind and release the shutter once in a while; it can become balky if not used for long periods of time. For longer term storage, remove batteries to prevent possible damage from corrosion.

Check the battery strength regularly (see manufacturer's instructions). Most film cameras and all digital cameras need electric power to operate. Lithium ion (Li-Ion) and nickel metal hydride (NiMH) batteries are rechargable and last longer, but check the manufacturer's directions, since not all models accept them.

Use professional care for all but basic maintenance. Never lubricate any part of a camera yourself or disassemble anything for which the manufacturer's manual does not give instructions. Cameras are easier to take apart than they are to reassemble.

Cameras and lenses are rugged, considering what precision instruments they are. Commonsense care and a little simple maintenance will help keep them running smoothly and performing well.

A clean lens performs better than a dirty one. Dust, grease, and drops of moisture all scatter the light that passes through a lens and soften the sharpness and contrast of the image. **NOTE:** Although a lens should be kept clean, too frequent or too energetic cleaning can produce a maze of fine scratches or rub away part of the lens coating. Manufacturers coat lens surfaces with a very thin layer of a metallic fluoride that helps reduce reflections and subsequent flare. The coatings are extremely thin, as little as 0.0001mm, and relatively delicate. Treat them with care when cleaning the lens.

Stopping down the lens aperture often improves the image by eliminating rays from the edges of the lens where certain aberrations increase. Even a well-designed lens will have some aberrations that were impossible to overcome in design. This is especially so if it is a zoom, extremely wide-angle, or telephoto lens, or if it has a very wide maximum aperture or is used very close to the subject.

There is a limit to the improvement that comes with stopping down. As light rays pass across a sharp, opaque edge, like the edge of the diaphragm opening, the rays scatter slightly. As the lens is stopped down and the aperture becomes smaller, this scattering—called diffraction—increases, reducing sharpness and contrast over the entire image.

Most lenses are sharpest, because lens aberrations are reduced the most, at an aperture closed down one or two f-stops from the widest. Diffraction, at this point, is not a noticeable problem. But closing down the aperture past this point, even though depth of field increases, decreases sharpness (remember that lens sharpness is not the same as depth of field). In general, you should close down the aperture far enough for the depth of field you need, but no farther.

photographer
at WORK

Documentary Photographer Mary Ellen Mark

Mary Ellen Mark has been called a documentary photographer, a social documentarist, a documentary portraitist, and even a psychodocumentist. She has photographed prostitutes and circus performers in India; mental patients in Oregon; runaway teenagers in Seattle; and a homeless family living in a car in North Hollywood, California. "I like feeling that I'm able to be a voice for those people who do not have a voice," she says, "the people that don't have the great opportunities."

Many documentary photographers try to get to know their subjects before taking pictures. Despite her uncannily intimate photographs, Mark does not. "I start shooting right away—always," she says. "If you don't, you're misrepresenting your role in the relationship. You are there to take pictures." In fact, most of Mark's subjects look steadily into the camera's lens. "I don't often like it when people smile for the camera. Sure, sometimes when they laugh it can be beautiful. Often, though, a smile is a defense—people are uncomfortable. If someone has a fake smile I would tell them not to smile."

Mark approaches her subjects with a wide-angle lens and moves in close. They know she is there. She also likes the sense of place that a 28mm lens (on her 35mm film camera) provides. She often shoots for months on end, returning daily to finally overcoming her subjects' initial hesitance at being photographed.

Mark's project on Indian prostitutes demonstrates her persistence. Bombay's Falkland Road is notorious for its brothels. In the book she produced about Falkland Road, Mark writes, "Every day I had to brace myself, as though I were about to jump into freezing water. But once I was there, pacing up and down the street, I was overwhelmed, caught up in the high energy and emotion of the quarter. And as the days passed and people saw my persistence, they began to get curious. Some of the women thought I was crazy, but a few were surprised by my interest in and acceptance of them. And slowly, very slowly, I began to make friends."

Although this project is in color, most of Mark's work is black and white. "The difficulty with color is to go beyond the fact that it's color," she observes. "To have it be not just a colorful picture but really be a picture about something."

Mark is obsessed with her subjects, not with her equipment. Still, she relies on a variety of tools. While photographing the Indian circus she carried four Nikon bodies and seven lenses, four Leicas, five Leitz lenses, four Hasselblads with six lenses, a Polaroid, several flash units, and a half-dozen assorted light meters.

She likes the detail of a large-format camera but cherishes the spontaneity of a hand-held one. "I want to take strong documentary photographs that are as good technically as any of the best technical photographs, and as creative as any of the best fine-art. I take images that I think other people will want to see. I don't take pictures to put in a box and hide them. I want as many people to see them as possible."

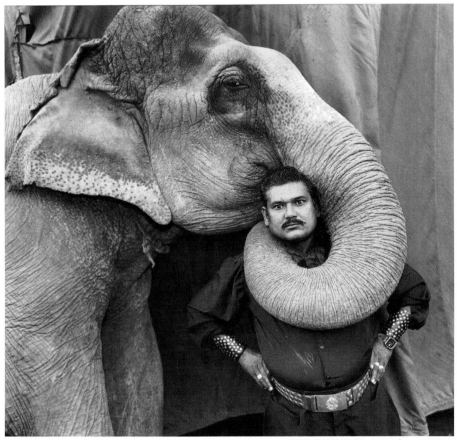

MARY ELLEN MARK Indian Circus, 1990

NANCY STROGOFF Mary Ellen Mark at Work

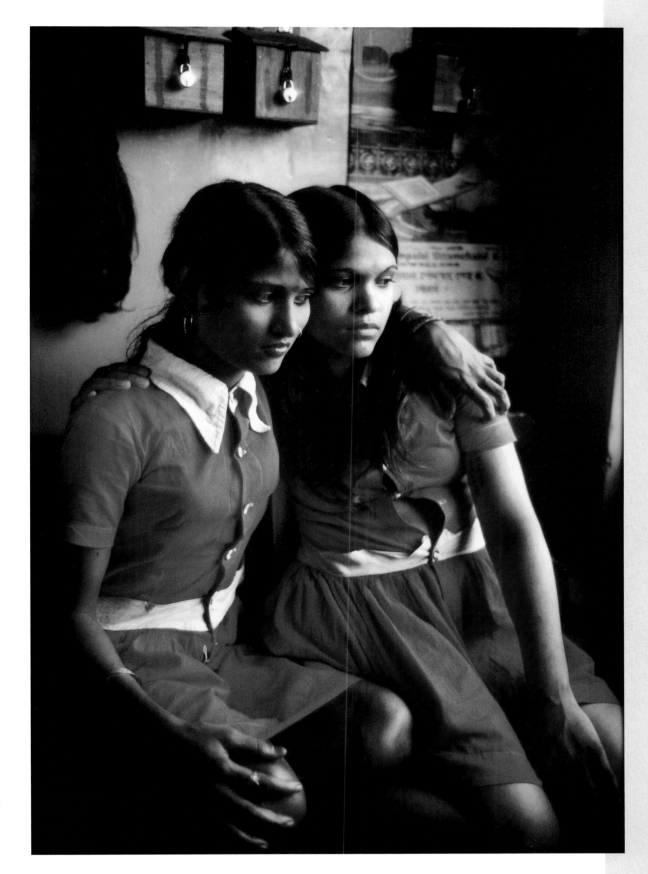

MARY ELLEN MARK Two Women, Bombay, India, 1978

Mary Ellen Mark seeks to show people "immersed in their environments"—here, a sensitive portrait of two prostitutes in Bombay's Falkland Road brothel area. Above the women's heads are the wooden boxes in which each puts her daily earnings. "I look for a sense of irony," she says, "of humor and sadness at the same time," a combination also present in the photo opposite, top.

KENNETH JOSEPHSON Stockholm, Sweden 1967

In photography, exposure refers to the light that reaches a light-sensitive surface and makes an image. Here, exposure to sunlight carved a negative image of the car by melting the snow outside its shadow.

exposure, sensors, and film

CHAPTER/FOUR

Exposing pictures properly, letting the right amount of light into the camera, involves understanding just three things:

1. How the shutter speed and the aperture (the size of the lens opening) work together to control the amount of light that reaches the light-sensitive surface in the camera.

Shutter speed

Aperture size

2. The ISO rating of your film (its speed) or the sensitivity of the sensor in your digital camera.

3. How to meter the amount of light and then set the camera's controls, either automatically or manually.

To get a rich image with realistic tones, dark but detailed shadows, and bright, delicate highlights, you need to start with a correct exposure. That is, you need to set the shutter speed and aperture so they let in the right amount of light to strike your film or digital sensor. And how do you know the right amount of light? Your camera can probably decide everything for you, but educated judgment is better. This chapter tells when you can rely on automatic exposure and when to override it.

You can make great photographs using either a digital camera or film, but there are differences you should understand. Either way, experience will be your best accessory.

Exposure = Intensity (aperture) x Time (shutter speed). Exposure is a combination of the intensity (brightness) of light that reaches the digital sensor or film (brightness is controlled by the size of the aperture) and of the length of time the light strikes that light-sensitive surface (duration is controlled by the shutter speed).

The more light that reaches film, the greater the buildup of silver density in the negative. In the same way, the more light that strikes the sensor in a digital camera, the higher the numerical level recorded at each point on the array. Regardless of whether you're working with a digital camera or with film, you can adjust the exposure of your pictures by changing the shutter speed, aperture, or both.

An exposure calculated by a light meter provides a combination of aperture and shutter speed that should expose your picture correctly. If you are using a manual camera, or your camera has a manual mode, you can set the aperture and shutter speed accordingly. If your camera is automatic, it will set the combination for you.

But you are not limited to this one combination, even though most meters built into cameras show you only one. There are many different combinations—for every photograph you take—that you could choose.

Which combination you choose is one key to creative photography. Your choice determines how you decide to control depth of field (the sharpness of objects from near to far) as well as how much you decide to stop or blur motion.

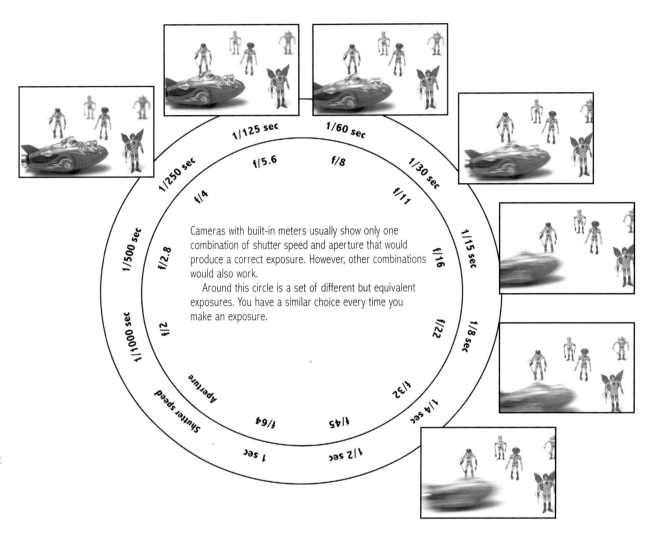

Cameras with built-in meters usually show only one combination of shutter speed and aperture that would produce a correct exposure. However, other combinations would also work.

Around this circle is a set of different but equivalent exposures. You have a similar choice every time you make an exposure.

DIFFERENT COMBINATIONS: SAME EXPOSURE

In the series of pictures of windup toys above, shutter speed and aperture settings are shown one full stop apart. A change from one shutter speed to the next slower speed, such as from 1/250 sec to 1/125 sec, doubles the length of time light reaches the light-sensitive surface. A change from one lens aperture setting to the next smaller aperture, such as from f/4 to f/5.6, lets in half the amount of light. (Remember that the larger the f-number, the smaller the aperture, and so the less light let into the camera.)

Suppose your meter indicated a correct exposure of 1/125 sec shutter speed at an f/5.6 aperture. You can get the same exposure (the same overall lightness and darkness of the image) by selecting different combinations of aperture and shutter speed that let the same amount of light enter the camera.

Compare the photo above next to f/250 sec at f/4 with the one next to 1/4 sec at f/32. The overall exposures (lightness and darkness of the images) stayed the same, but changes did take place in the depth of field (the sharpness of objects from near to far) and in how the motion of the moving toy in the foreground was shown.

Try this for yourself. Use a copier to duplicate the circles above and cut out the inner (aperture) circle. In an evenly-lit situation in which the lighting will not change, take an exposure reading with your in-camera meter. Place the copied aperture circle over the one above and rotate it to line up the f-stop and the shutter speed your camera meter indicates. Once this combination is set, you can easily see the other combinations available to you.

Leave your camera in the identical situation and change the f-stop on your camera. Your camera meter will recommend a new shutter speed. Look at your paper meter again and you will see that the new camera combination coincides with one of the combinations on the paper meter.

If you make several different exposures in other locations using the paper meter along with your in-camera meter, you will be able to understand—and control—these basic relationships.

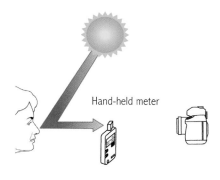

A reflected-light meter can be hand held (right, top) or built into a camera (right, center). Aim the sensor at a subject to make a reading of the light reflected from the subject.

Hand-held meter

Built-in meter

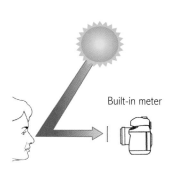

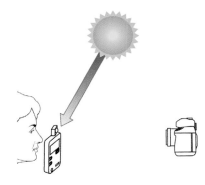

An incident-light meter is faced toward the camera from the position of the subject to make a reading. It measures the light falling on a subject.

A light sensor on a reflected-light meter measures the brightness of light reflected by or emitted by the subject. A light sensor covered by a diffusing dome on an incident-light meter measures the brightness of light striking the subject.

ISO indicator displays the film or sensor speed you have selected.

Shutter-speed readout

f-stop readout

You need an exposure meter in order to make consistently correct exposures, so that your pictures are neither too light nor too dark. Exposure meters (commonly called light meters) vary in design, but they all perform the same basic function. They measure the amount of light; then, for a given ISO (film speed or sensor sensitivity), they calculate f-stop and shutter-speed combinations that will produce a correct exposure for a scene that has an average distribution of light and dark tones.

Exposure meters average the tones in a scene. Meter designers assume that most scenes, which consist of a variety of colors and tones, including very dark, medium, and very light values, average out to a medium gray. Most scenes, in fact, do come quite close to that. The meter calculates an exposure that will reproduce the average level of light as a medium-gray tone in the final photograph.

The medium-gray that has become an industry standard is called middle gray. It is color-neutral and reflects exactly 18 percent of the light that falls on it. You can buy a standard gray card for precise meter readings.

Reflected-light meters measure the light reflected from a subject. All the meters built into cameras and most hand-held meters are reflected-light meters. They measure luminance, the light reflected from (or emitted by) the subject. The meter is pointed at the subject, or—at close range—at the particular part of the subject the photographer wants to measure, and the reading is made. The light-admitting opening of a hand-held reflected-light meter typically reads an angle of view similar to that of a normal lens, about 30°.

Some meters built into cameras are capable of more sophisticated calculations, such as comparing the brightness of one part of a scene to another and calculating an exposure based on preset patterns.

Spot meters read light reflected from a very small area of a subject. The angle of light they admit may be as little as 0.5° so that you can take precise readings of very limited areas. A 1° spot meter can measure light from the side of a building several blocks away, a person's face at 20 feet, or a dime at 18 inches. You can calculate very accurate exposures with a spot meter, but you must carefully select the areas you want to read.

Incident-light meters measure light falling on a subject. Incident meters measure illuminance, the light falling on (incident on) the subject. You point an incident meter not toward the subject but toward the camera from the subject's position, so that the meter receives the same light that the subject does. Incident-light meters are all hand held and integrate the light falling on a subject from a very wide angle, about 180°. The advantage of an incident meter is that it is never fooled by the lightness or darkness of a subject.

Some meters can make either reflected or incident readings. With a dual meter, when the sensing cell is open to direct light, it acts as a reflected-light meter. Sliding a dome-shaped diffuser over the sensing cell transforms it into an incident-light meter.

Flash meters. Most meters measure a continuously burning source of light, such as the sun or a tungsten lamp, but flash meters measure the output from the brief burst of light of an electronic flash. Most flash meters can measure in both reflected and incident mode. Multipurpose light meters can make reflected, incident, spot, and flash readings.

Color temperature meters (like the built-in white-balance measurement of a digital camera) measure the color of a light source. With color film, a color-temperature meter can be used to calculate filters that might be needed for a specific color balance.

Meters built into cameras measure the light reflected or produced by objects in their view and then calculate an exposure setting. To use a built-in meter, you look through the camera's viewfinder while pointing the meter at the scene or at the part of the scene that you want to meter. Shutter speed and/or aperture settings may be displayed in the viewfinder or in a camera's data panel. An automatic camera sets the shutter speed, aperture, or both for you based on the meter reading (see opposite page).

Many built-in meters are averaging meters and are center-weighted. The meter averages all the light in the scene but weights its average to give more emphasis to the area at the center of the viewfinder than to the surrounding area. This system is based on the assumption—usually, but not always, correct—that the most important part of the subject is in the center of the scene. A center-weighted meter can give an inaccurate reading if the subject is at the side of the frame, for instance, and the surroundings are much lighter or darker.

Some cameras have multisegment meters. They make individual readings from different parts of the viewfinder image, instead of averaging together readings from all parts of the image. These cameras are programmed by the manufacturer to adjust for some potential exposure problems, such as a backlit subject.

A camera may offer several different metering modes, such as multisegment metering, center-weighted metering, and spot metering. See the manufacturer's instructions.

Certain scenes can cause a meter to produce the wrong exposure. Most meters are designed to calculate an exposure for scenes that include both light and dark areas in a more or less equal balance that average out to a middle gray tone. If a scene is uniformly light (such as a snow scene), the meter still calculates an exposure as if it were reading middle gray. The result is not enough exposure and a photograph that is too dark. The following pages tell how to identify such scenes and how to set your camera for them.

What you see in your camera's viewfinder

What an averaging meter system "sees"

In a camera's viewfinder, you can see details of the scene, but a built-in light meter does not. Many meters average together light from all parts of a scene and as a result "see" only the overall light level. The meter will give you a correct exposure if the tones in the picture average out to a medium 18 percent gray. Sometimes you will want to override the meter's settings.

TYPES OF BUILT-IN METERS

Meters built into cameras can emphasize different parts of a scene when calculating exposure readings.

An averaging meter reads most of the image area and computes an exposure that is the average of all the tones in the scene.

A center-weighted meter favors the light level at the center of an image, which is often the most important part to meter. An overall average reading would be misled by the bright window in this picture.

A spot meter reads only a small part of an image and is useful for exact measurements of individual areas. An average, or center-weighted, meter would be misled by the dark area surrounding the subject.

A multisegment meter divides the scene into areas that are metered individually and then evaluated against a series of patterns stored in the camera's memory. The resulting exposure is more likely to avoid problems such as underexposure of a subject against a very bright sky.

EXPOSURE MODES

Manual. You set both shutter speed and aperture. The camera's built-in meter can be used to calculate the correct settings.

Aperture-priority automatic. You select the aperture and the camera adjusts the shutter speed.

Shutter-priority automatic. You select the shutter speed and the camera adjusts the aperture.

Programmed (fully) automatic. The camera adjusts both shutter speed and aperture based on a built-in program. Depending on the program, the camera may select the fastest possible shutter speed or set a slower shutter speed to avoid opening the lens to the widest aperture.

WHEN TO USE THEM

Selecting the best combination manually is ideal when you are working in a situation in which the lighting remains constant. In a changeable situation, one of the automatic options below may work better for you.

You can control depth of field using this mode. For example, setting the aperture at its widest will often blur the background and will provide the fastest shutter speed possible in each situation.

Use this mode to set the shutter speed at its fastest to stop action and to avoid undesirable blur caused by camera movement. Or, you might want to select a very slow shutter speed so that you can pan and capture the feeling of movement in your picture.

Some cameras will select the fastest shutter speed possible for each situation, which helps you avoid blur caused by camera movement. They may also sense the length of the lens you are using and adjust the settings accordingly. For example, if you have been using a 105mm lens, a shutter speed of 1/125 sec would usually prevent blur caused by camera movement. If you change to a 200mm lens or zoom to a 200mm focal length, some models will detect this and change the shutter speed to 1/250 sec.

OVERRIDING AUTOMATIC EXPOSURE

Automatic exposure works well much of the time, but for some scenes you will want to alter the exposure set by the automatic circuitry. You may want to increase the exposure to lighten one picture or decrease the exposure to darken another. Most cameras have one or more of the following means of allowing you to do so. Camera design and operation vary. See the manufacturer's instructions for your model.

Manual mode. An option on many cameras. You adjust both shutter speed and aperture settings to lighten or darken the picture as you wish.

Exposure compensation dial. Moving the dial to +1 or +2 increases the exposure one or two stops and lightens the picture (some dials say x2 or x4 for comparable settings). Moving the dial to −1 or −2 (x1/2 or x1/4 on some dials) decreases the exposure one or two stops and darkens the picture.

Backlight button. You may find this on a camera without an exposure compensation dial. Depressing the button adds a fixed amount of exposure (usually one to one-and-a-half stops) to lighten a picture. It cannot be used to decrease exposure. As its name indicates, it is useful for backlit scenes in which the main subject is against a much lighter background.

Exposure lock. This feature temporarily locks in a shutter speed and aperture combination. You move close to meter the most important part of the scene (or take a substitution reading from an area of about the same tone). You lock in the settings, then recompose the picture and photograph the entire scene at that exposure. You activate the lock by pressing the shutter release halfway down or by using a separate lock button.

Film-speed dial. With film cameras (this doesn't work with digital), resetting the film-speed dial causes the camera to give the film less or more exposure than normal. To lighten a picture, decrease the film speed: halving a film speed (for example, from 400 to 200) increases exposure by one stop. To darken a picture, increase the film speed: doubling the film speed (for example, 400 to 800) decreases the exposure one stop. Remember to reset the dial after taking your picture. **NOTE:** If your film camera automatically sets the speed from a DX bar code on the film cassette, you may not be able to manually change a film-speed dial, but you may be able to change the film speed for a whole roll of film. Some camera stores sell foil stickers that let you change the DX coding on the film cassette. Paste on the new sticker, and your camera will think it is working with a higher or lower film speed than it is and change the exposures accordingly.

Most cameras incorporate automatic exposure. If your camera is an automatic one, a meter built into the camera measures the average lightness or darkness of the scene in your viewfinder. Electronic circuitry within the camera automatically calculates an exposure that would be correct for an average scene, and then sets shutter speed, aperture, or both, based on the speed of your camera's film or the speed set for its digital sensor. Some cameras are more sophisticated. Their multisegment meters compare readings from different parts of the scene, then adjust the exposure or warn you of possible problems. The basic modes of automatic exposure are listed in the box at left, top. Your camera may operate in several of these modes or only in one. See the manufacturer's instructions for details.

Sometimes automatic exposure can underexpose or overexpose your subject because it is giving you an "average" exposure rather than one that is best for a specific scene. A typical example is when a subject is against a much lighter background such as a bright sky. An automatic system can underexpose a backlit scene, just as a non-automatic system will if you simply make an overall reading. Unless your camera has a metering system that adjusts for such scenes, you will have to override the automatic exposure mechanism to get the exposure you want. Various means to do this are listed in the box at left, bottom.

Digital cameras immediately show your results so you can correct for exposure errors with another picture—if your subject hasn't changed. Usually, each photograph is displayed on the camera's monitor for a few seconds after the exposure, long enough to see if you got what you wanted. For a longer look, you can call it back with a playback button. Better digital cameras can also display a histogram (see page 172) that gives very precise exposure information about stored images.

How do you get a good exposure—that combination of f-stop and shutter speed that lets just the right amount of light reach the sensor or film, so that your picture is not underexposed and too dark or overexposed and too light? For many scenes, the correct exposure is easy to calculate: Use a reflected-light meter to make an overall reading of the scene (opposite page, left and center). If you have an incident-light meter, make a reading of the overall amount of light falling on the scene (opposite, right).

A digital camera's instant feedback lets you take and evaluate a test exposure, but don't let this feature make you lazy. There will be situations that don't give you enough time; if you understand how to use the camera's metering system, you'll be ready for those moments that can't be repeated.

An overall reading works well for metering average scenes, where light and dark tones are of more or less equal distribution and importance. But a meter is only a measuring device—it cannot interpret what it reads, nor does it know whether a scene is average or if you want the subject to be light or dark. In some cases you have to think for the meter and override the settings it recommends. The following pages will tell when to do so.

A reflected-light meter (built into the camera or hand held) expects the scene it is metering to be middle gray. It averages all the tones in its angle of view and then calculates an f-stop and shutter speed combination that will produce middle gray in a print. The assumption is that the average of all the tones from light to dark in a scene will be a middle gray, so an exposure for middle gray will be correct for the entire scene. This method gives a good exposure in many situations.

Make sure that the meter is reading only the subject area you want it to read. If your meter is built into the camera, you can see in the viewfinder the area that the meter is reading. If your hand-held meter does not have a viewfinder, you can estimate the area the meter is covering. Most reflected-light hand-held meters read an angle of about 30°, about the coverage of a normal focal-length lens.

An overall reading may not work well for contrasty scenes. You may get a deceptively high reading (and a picture that is too dark) if the scene contains very light areas like a bright sky or light sources like the sun or a lamp. Your reading may be too low (and the resulting picture too light) if a very large dark area surrounds the subject.

An incident-light meter reads only the light falling on a subject. Hold it in the same light as that falling on the subject and point it toward your camera (see opposite, right) so that it receives the same amount of light as the subject, as seen from camera position. Its reading is not altered if the subject is against a much lighter or darker background. An incident-light meter can help balance the illumination in studio setups where lights can be arranged at will. However, it cannot measure the tones of individual objects in a scene, and it cannot give an exposure for an object that is itself emitting light, such as a neon sign, a lamp, or a sunset.

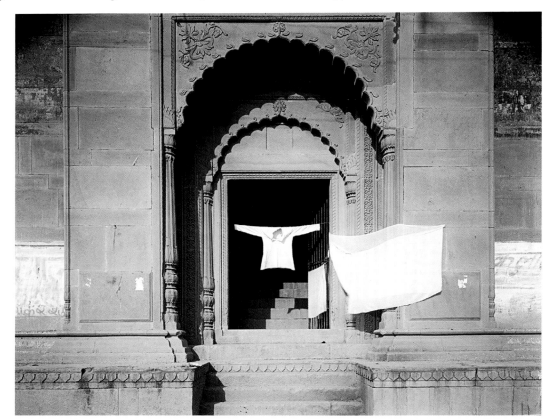

LINDA CONNOR Shirt, Benares, India, 1979

Most meters assume that the scene you are metering contains an average distribution of tones from light to dark. If, in fact, this is so, a meter reading of the overall scene will produce a good exposure. You can make an overall reading with a meter built into a camera or one that is hand held (see opposite page).

USING A REFLECTED-LIGHT METER BUILT INTO A CAMERA

1 Set the meter to the ISO rating (film speed) of the film you are using or select an ISO for your digital camera. More about ISO on page 82.

2 Set the exposure mode of the camera, if you have a choice: aperture-priority automatic, shutter-priority automatic, programmed automatic, or manual.

3 Look at the scene through the camera's viewfinder and activate the meter. You will be able to see the meter readout either in the viewfinder or the camera's data panel.

4a **In aperture-priority automatic operation,** select an aperture small enough to give the desired depth of field. The camera will adjust the shutter speed. If your subject is moving or if you are hand holding the camera, check the metering readout to make sure that the shutter speed is fast enough to prevent blur. The wider the aperture you select, the faster the shutter speed that the camera will set. (Remember that a wide aperture is a small number: f/2 is wider than f/4.)

4b **In shutter-priority automatic operation,** select a shutter speed fast enough to prevent blur. The camera will adjust the aperture. Check that the aperture is small enough to produce the desired depth of field. The slower the shutter speed you select, the smaller the aperture will be.

4c **In programmed automatic operation,** the camera will adjust both shutter speed and aperture.

4d **In manual operation,** you select both shutter speed and aperture. Use information from the camera's built-in meter to calculate the settings.

USING A HAND-HELD, REFLECTED-LIGHT METER

1 Set the meter to the ISO rating of the film you are using or the setting you have selected for your digital camera.

2 Select a shutter speed and set it on the meter.

3 Point the meter's sensor at the subject from the direction of the camera. Activate the meter. Don't let your arm or the meter cast a shadow on the area you are measuring.

4 The meter will indicate an aperture. (With non-digital meters, line up the number registered by the meter's indicator needle with the arrow on the calculator dial.)

5 To select a different aperture, change the shutter speed, and the meter will automatically calculate and display the new aperture. You don't need to take a new reading. All combinations produce the same exposure.

The sensor in a reflected-light meter measures the light reflected by a subject. Swivel-head meters let you read the display with the sensor pointed away from you and toward the subject.

USING AN INCIDENT-LIGHT METER

1 Set the meter to the ISO rating of the film you are using or the setting you have selected for your digital camera.

2 Select a shutter speed and set it on the meter.

3 Point the meter's dome-covered sensor away from the subject, toward the camera lens. Activate the meter. You want to measure the amount of light falling on the subject, so make sure that the meter is in the same light as the subject. For example, don't shade the meter if your subject is sunlit.

4 The meter will indicate an aperture. (With non-digital meters, line up the number registered by the meter's indicator needle with the arrow on the calculator dial.)

5 To select a different aperture, change the shutter speed, and the meter will automatically calculate and display the new aperture. You don't need to take a new reading. All combinations produce the same exposure.

An incident-light meter measures the light falling on a subject. A diffusing dome covers the meter's sensor. The dome must be pointed toward the camera.

The most common situation in which overall metering does not work is one with a subject against a much lighter background, for example, a portrait outdoors with a bright sky in the background. If you use a reflected-light meter to meter the scene overall, the bright sky will increase the entire reading too much. The meter will calculate an exposure that will underexpose the main subject and make it too dark.

Meter up close to prevent problems with contrasty scenes. If a subject is against a much lighter background, such as a bright sky, a very light wall, or a bright window indoors during the day, move in close enough so that you are metering mostly the main subject rather than the lighter background. Set the aperture and shutter speed from the up-close reading before you move back to take the picture (see this page, top and opposite page, top row). Similarly, try not to include light sources, such as the sun or a lighted lamp, in a meter reading.

If you are metering a landscape, cityscape, or other distant scene, tilt the camera or meter down. That will exclude most of a bright sky from the reading; the lower reading will give a more accurate exposure for the land elements in the scene (opposite page, bottom row). If your main subject is the sky itself, such as a cloud formation, take your reading directly from the sky.

Less common, but sometimes a problem, is a subject against a much darker background, especially if the subject occupies only a small part of the image. Metering such a scene overall with a reflected-light meter would produce a reading that is too low and an overexposed and too-light picture. Prevention is the same: Move in close to meter mostly the main subject (opposite page, middle row).

How do you use an automatic camera to expose a picture with a background much lighter or darker than the subject? You can't simply meter the scene up close and then step back to take the picture. The camera will automatically recalculate the exposure from farther away, including the light or dark background that you want to exclude from the metering. You can change from

automatic to manual operation, if that is possible with your camera, so that you can meter up close and then set both shutter speed and aperture yourself. Or use one of the means of overriding automatic exposure described on page 71. Spot meters work well in all these situations.

If you are using an incident-light meter to determine the exposure for a scene that has both brightly lit and shaded areas, decide whether the light or dark areas are more important. If shaded areas are more important, make your reading in the shadows or with the meter shaded by your body or hand. If brightly lit areas are more important, make a reading with the meter held in the light.

What do you do if you can't get close enough to the subject to make a reading and you don't have a spot meter that can make a reading at a distance? The solution is to make a substitution reading (see this page, bottom). You can often find a nearby object with a similar tone and in similar light to meter instead.

One object always with you that can be metered is the palm of your hand. Average light-toned skin is about one stop lighter than the middle-gray tone for which meters are calibrated, so if your skin is light, give one stop more exposure than the meter indicates. If the skin of your palm is dark, use the indicated exposure. Even better, calibrate your palm: meter it, then meter a gray card (described below), and change readings from your palm accordingly.

Another useful substitution reading is from a gray card, a test card with one side a standard neutral-gray tone that reflects 18 percent of the light falling on it and the other a white that reflects 90 percent of the light. Light meters are calibrated for a middle-gray tone of that 18 percent reflectance, so a gray card reading produces an accurate exposure if the card is placed so that it is lit from the same angle as the subject. If the light is very dim, make a reading from the white side of the card; it reflects five times as much light as middle gray, so increase the indicated exposure five times (two-and-one-third stops).

METERING UP CLOSE

Metering up close gives good results when the most important part of the scene is much darker or much lighter than its surroundings.

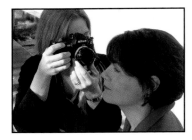

With a meter built into a camera, move in until the main subject fills the viewfinder (be careful not to block the light on the subject). Take the reading, set the shutter speed and aperture, then move back to the original position to take the picture. With an automatic camera, set the camera for manual operation or override the automatic exposure.

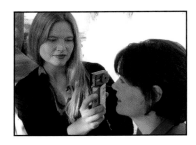

With a hand-held, reflected-light meter, move in close enough to meter mostly the main subject, but not so close that you block the light. A spot meter, which reads a very narrow angle, can be used to meter a small part of a scene from farther away.

MAKING A SUBSTITUTION READING

A substitution reading is useful when you can't meter from up close or when you want a standardized reading.

Metering the palm of your hand makes a quick substitution reading, for example, when photographing fast-moving situations. Hold your palm so that the light on it is about the same as on the people or objects you want to photograph. If the skin of your palm is an average light tone, expose one stop more than the meter indicates. If the skin of your palm is dark, use the indicated exposure.

You can calculate an exposure by metering the light reflected from a standard-gray test card. Face the card to the camera, parallel to the film plane, and meter the card from the direction that the camera will be when you are shooting. When you meter any object at close range, hold the meter or camera so that it (or your hand) does not cast a shadow on the subject.

METERING A SUBJECT AGAINST A BRIGHT BACKGROUND

An overall reading of a subject against a much lighter background often produces a subject that is too dark. Here, a bright waterfall was included in the metered area, and indicated a high light level. But the person in shadow did not receive enough exposure and came out dark.

Move in close to meter a subject against a much lighter background. Come close enough so that the meter reads mostly the subject, but not so close that you cast a shadow on the area you are metering.

A better exposure. After metering up close to the main subject, return to the original position to make the photograph at that exposure. Now the face is more accurately rendered. A camera that automatically sets f-stops or shutter speeds must sometimes be manually overridden, as it was here, to get the exposure you want.

METERING A SUBJECT AGAINST A DARK BACKGROUND

An overall reading of a subject against a much darker background can produce a subject that is too light. Here, the painter occupied a relatively small part of the scene and was in bright sun, while the large background was shaded. The painter received too much exposure and came out too light.

Move in close to meter a subject against a much darker background. Come close enough so that the meter reads mostly the subject, but not so close that you cast a shadow on the area you are metering.

A better exposure. After metering up close to the main subject, return to the original position to make the photograph at that exposure. Now the subject does not appear overly bright.

METERING A LANDSCAPE THAT INCLUDES A BRIGHT SKY

An overall reading of a landscape that includes bright sky can underexpose the scene. So much light comes from the sky that the reading produces too little exposure for the land elements in the scene. Here the sky is properly exposed, but the buildings are too dark and lack detail.

Tilt the meter down to exclude a bright sky when you meter a landscape. For a proper exposure for the buildings, light reflected from them should be dominant when the reading is made. Point the camera or hand-held reflected-light meter slightly down so that the meter "sees" less of the sky and more of the buildings.

A better exposure. After measuring light reflected off the buildings, tilt the camera up to its original position. Now the buildings are lighter and reveal more detail. The sky is lighter also—it is often the lightest part of a scene—but can be darkened when printing.

You can decide in advance the tonal value of an important area in your final photograph. This is possible because a reflected-light meter always recommends an exposure that will render any single metered area as middle gray. If you take three meter readings to make three different photographs—first of a white polar bear, then of a medium-gray elephant, and finally of a black gorilla—the meter will indicate three different exposures that will record each subject as middle gray (photographs, right).

You can choose how light or dark an area will appear by adjusting the exposure indicated by the meter. An area given more exposure than the meter indicates will be lighter than middle gray in the final print. Less exposure will make an area darker than middle gray. For example, if you want the white polar bear to appear realistically as very light but still show substance and texture, expose two stops more than the meter recommends. (Snow scenes are a typical situation in which you might want to increase the exposure a stop or two because an overall reading can make the scene too dark.) If you want the black gorilla to appear rich and dark with full texture, expose two stops less than the meter recommends.

When calculating exposure for a portrait, meter the skin tone. While clothing and background can vary from very light to very dark, most people's skin tones are rendered within about a three-stop spread. Dark skins seem natural when printed as middle gray or slightly darker. Most light-toned skins appear natural if they are one stop lighter than middle gray. Very light skins can appear natural as much as two stops above middle gray. To use a skin tone as the basis for exposure, meter the lighter side of the face (if one side is more brightly lit than the other). For dark skin, use the exposure indicated by the meter; for medium light, give one stop more exposure; for unusually pale, give two stops more.

With color slides and some digital cameras, even slight overexposure can lose significant detail from highlight areas that cannot be added later.

With negative film, it is better to overexpose the film than to underexpose it. If you want objects and details in shadow areas dark but still clearly visible, meter the shadow area (which will give it the exposure for middle gray). Then expose two stops less than the meter indicates.

Changing the exposure affects all the values in the image, not just the tone you meter. One area will always stay relatively lighter or darker than another—for example, a man's face will always be lighter than his black pants—but all will be either darker or lighter as the scene is given less or more exposure.

White polar bear given exposure suggested by meter

White polar bear given 2 stops more exposure

Light meters calculate exposures for middle gray. If you want a specific area to appear darker or lighter than middle gray, you can measure it and then give less or more exposure than the meter indicates.

Gray elephant given exposure suggested by meter

Black gorilla given exposure suggested by meter

Black gorilla given 2 stops less exposure

BRACKETING EXPOSURES

Bracketing produces lighter and darker versions of the same scene and helps if you are not sure about the exposure. To bracket, make several exposures of the same scene, increasing and decreasing the exposure by adjusting the aperture, shutter speed, or both. Among these different exposures, there should be at least one that is correct. Professional photographers bracket—whenever possible—as protection against having to repeat a shooting session.

To bracket by one stop, first make an exposure with the aperture and shutter speed set at the combination you think is the right one. Then make a second shot with one stop more exposure (either set the shutter to the next slower speed or the aperture to the next larger opening) and a third with one stop less exposure. In some situations you might want to bracket even more, giving two stops more exposure and two stops less.

Bracketing can be simple with an automatic exposure camera. Many automatic cameras let you set an automatic bracketing mode. With other automatic cameras, however, if you change to the next larger aperture, the camera will simply shift to the next faster shutter speed, resulting in the same overall exposure. In this case you will have to override the automatic exposure. See your owner's manual for specific instructions.

Suppose an exposure for a scene is 1/60 sec shutter speed at f/5.6 aperture. Using any one of the combinations below will give exactly the same exposure:

Shutter speed 1/8 1/15 1/30 1/60 1/125 1/250 sec

Aperture f/16 f/11 f/8 f/5.6 f/4 f/2.8

Bracketing for one stop less exposure. To darken a picture (lighten a negative) by giving one stop less exposure, use the next smaller aperture:

or the next faster shutter speed.

Bracketing for one stop more exposure. To lighten a picture (darken a negative) by giving one stop more exposure, use the next larger aperture:

or the next slower shutter speed.

1/60	
f/5.6 → f/8	
1/60 → 1/125	
f/5.6	

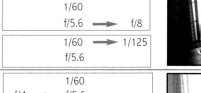

1/60	
f/4 ← f/5.6	
1/30 ← 1/60	
f/5.6	

Some scenes can't be metered in the usual way. If there is light enough to see by, there is probably light enough to make a photograph, but the light level may be so low that you may not be able to get a reading from your exposure meter. Try metering a white surface such as a white paper or handkerchief, then give two stops more exposure than indicated by the meter.

If metering is not practical at all, the chart below gives some starting points for exposures at ISO 400. Since the intensity of light can vary widely, bracket your exposures by making several shots at different exposures. The range of exposures will bring out details in different parts of the scene, giving you a choice. And, unless your subject moves, you can merge dark values from one bracket and light ones from another using the Merge to HDR (high dynamic range) feature in Photoshop (see page 190).

With film, very long exposures can cause underexposure. If the exposure time is one second or longer, the film does not respond the same way that it does in ordinary lighting situations. Photographic reciprocity means light intensity and exposure time are reciprocal; an increase in one will be balanced by an equal decrease in the other. But reciprocity does not hold for very long or very short exposures.

Reciprocity fails differently for different films (though not at all with digital sensors). At exposures longer than about a second or shorter than 1/1000 second, most films decrease in effective speed. To compensate, you must increase the exposure. Manufacturers publish exact data; the chart at right gives a starting point.

Very long exposure times also cause an increase in contrast and with color film a shift in color. Contrast can be reduced with less development (see box, right) and most color shifts can be corrected in post-processing. Digital sensors remain linear (exposure and color values do not change), but they generate more noise during long exposures (see page 83).

COMPENSATING FOR RECIPROCITY FAILURE: GIVE MORE EXPOSURE AND LESS DEVELOPMENT WITH MOST BLACK-AND-WHITE FILMS

Indicated exposure	Open up aperture or to	Increase exposure also time to	Decrease development time by
1 sec	1 stop more	2 sec	10%
10 sec	2 stops more	50 sec	20%
100 sec	3 stops more	1200 sec	30%

EXPOSING HARD-TO-METER SCENES

SITUATION	APPROXIMATE EXPOSURE FOR ISO 400	
Stage scene, sports arena, circus event	1/60 sec	f/2.8
Brightly lighted downtown street at night, lighted store window	1/60 sec	f/4
City skyline at night	1 sec	f/2.8
Skyline just after sunset	1/60 sec	f/5.6
Candlelit scene	1/8 sec	f/2.8
Campfire scene, burning building at night	1/60 sec	f/4
Fireworks against dark sky	1 sec (or keep shutter open for more than one display)	f/16
Fireworks on ground	1/60 sec	f/4
Television or computer monitor image: •Focal-plane shutter speed must be 1/8 sec or slower to prevent dark raster streaks from appearing in photographs of the screen •Leaf shutter speed must be 1/30 sec or slower to prevent streaks	1/8 sec 1/30 sec	f/11 f/5.6

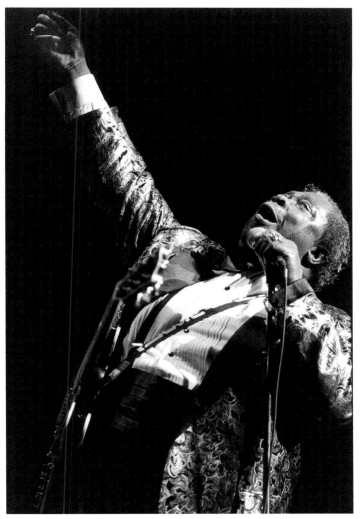

MARC POKEMPNER B. B. King, 1991

A high ISO is useful when you want to work unobtrusively but you still need to make accurate exposures. Previous experience photographing performances let blues fan Marc PoKempner use only the stage lights to capture the action.

Responding to Light
Silver and Pixels

An image on film starts with a reaction between light and silver halide crystals. The crystals are a compound of silver plus a halogen such as bromine, iodine, or chlorine. Together with the gelatin in which they are suspended they are called the emulsion. Electrically charged silver ions, also in the crystal, move about when light strikes them, coming to rest at the site of an impurity such as silver sulfide. When several of these silver ions collect at a sensitivity speck, as the

impurities are called, they combine into a bit of metallic silver. Too small to be visible even under a microscope, this bit of silver is a part of the latent image, a stored but invisible record of the action of light that will eventually become a photograph. Developing chemicals use latent image specks to build up density, the larger quantity of metallic silver required to create a visible image. Crystalline specks of metallic silver are black. The denser the build-up silver, the darker an area will be.

Chromogenic (color) film is somewhat different. A chromogenic emulsion contains dye couplers as well as silver halides. During development, the presence of silver that has been exposed to light leads to a proportional buildup of dyes. The original silver is then bleached out, leaving the dyes that form the visible image. Most wet-process color materials use chromogenic development to produce the final color image in three different-color dyes.

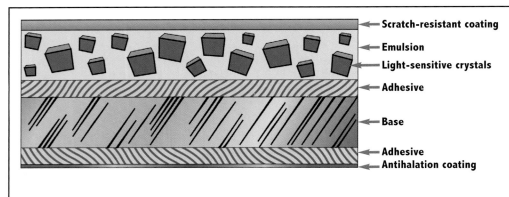

Scratch-resistant coating
Emulsion
Light-sensitive crystals
Adhesive
Base
Adhesive
Antihalation coating

Black-and-white film consists of several layers.

The topcoat is a thin protective coating to prevent scratches on the emulsion layer below.

The emulsion, where the image is formed, consists of about 60 percent gelatin and 40 percent light-sensitive silver-halide crystals. (Chromogenic film also contains dye couplers in the emulsion.)

An adhesive bonds the emulsion to the film base.

The base, a firm but flexible clear plastic, provides support and dimensional stability.

An antihalation coating bonded to the base adhesive prevents light from reflecting back through the emulsion and causing halos around bright parts of the picture.

A digital camera focuses light onto a sensor made out of silicon. It is a grid of tiny photosites, each one a photodiode that absorbs photons and releases electrons. These electrons accumulate during an exposure, then each photosite's electrons are converted, or digitized, into a number that corresponds to its total.

A sensor's array of photosites usually resembles a checkerboard with millions of squares. One might contain 3000 rows with 4000 photosites in each, for a total of 12 million. The number of electrons captured at each photosite (which varies with the brightness of the scene and the length of exposure) is stored, along with the location of that photosite in the grid, in a digital file. The array of brightnesses represented by the string of numbers in that file can be reassembled on a screen or as a print to make a photograph.

In most sensors, each photosite sensor represents a square called a pixel, a contraction of picture element. Ordinarily, the array of photosites is arranged in equally spaced rows and columns that produce square pixels. A camera whose sensor has 2000 x 3000 photosites is called a six megapixel (for six million pixels) camera.

Conventionally designed sensors—using either CCD (charge-coupled device) or CMOS (complementary metal-oxide semiconductor) photodiodes—have a tiny red, blue, or green filter covering each photosite (usually twice as many green as red or blue because of the human eye's heightened green sensitivity). Each pixel's brightness information is only for one primary color; the presence of the other two colors at that exact spot is automatically calculated from neighboring photosites by interpolation.

A sensor like this is the built-in light-sensitive surface inside a digital camera. *They vary in size from about 4x5mm to about 40x50mm, and in the number of megapixels from one to almost forty.*

Working with film leaves you some basic choices. Your decisions will determine some of the visual characteristics of your pictures as well as a way of working. If you want to print digitally, film originals must be scanned first (see page 169), an extra step. But film gives you images in a physical form that has a predictable (and relatively long) lifetime.

Do you want black-and-white? You can produce digitally a black-and-white print from a color original, but there may be other reasons to choose black-and-white film. It can be fun to develop your own film, and you may want to try black-and-white darkroom printing at a later date.

Do you want color? Color negative film (which often has "color" in its name—Ektacolor, Fujicolor) reverses the tones and colors of the scene so it can be printed on photographic (wet-process) color paper that reverses them again. Color negatives have a built-in orange color (called a mask) to make conventional printing easier, but it can be troublesome in scanning.

Color reversal film (which has "chrome" in its name—Ektachrome, Fujichrome) makes a positive color transparency. A 35mm transparency is called a slide when mounted in cardboard or plastic so it can be projected for viewing. Reversal films have a more limited dynamic range than negative films (see page 80), but are easier to scan.

Color balance is a basic choice for color film. Daylight-balanced color films produce the most natural colors in the relatively bluish light of daylight or electronic flash. Tungsten-balanced color films give the best results in the relatively reddish light from incandescent or halogen light bulbs. Some color balance problems can be corrected in post-processing but the best results come from a good match between film and illumination.

What film speed do you need? The faster the film speed, the less light you need for a correct exposure, but the grainier and coarser your pictures will be (pages 82–83).

What film size should you buy? Size and format (the dimensions of the image) depend on the camera you use.

35mm films are packaged in cassettes usually containing 24 or 36 exposures. To reduce cost, some 35mm films can be purchased in 50- or 100-foot rolls, then bulk loaded into separately purchased cassettes.

Roll films are wound around a spool and backed with a protective strip of opaque paper. Roll film can be any film that is rolled, but most often, roll film refers to 6cm-wide 120 and (longer) 220 size. Depending on the camera, roll film makes exposures that are 6 x 6cm square or one of several different rectangular formats—4.5 x 6, 6 x 7, and 6 x 9cm are common.

Sheet films, or cut films, for view cameras are made in 4 x 5-inch and larger sizes. They are packed 10 or more sheets to a box. Film sheets must be loaded in holders (in a darkroom) before use or you can buy them in disposable packets that can be handled in daylight.

STORING AND HANDLING FILM

Store film away from heat. Heat affects any film adversely, so don't leave it where temperatures may be high, such as in the glove compartment of a car on a hot day or near a heater in winter.

For longer storage, refrigerate film. Refrigeration extends the life of film. Room temperature is fine for short-term storage, but for longer storage, especially in warm weather, a refrigerator or freezer is better for most films. (Don't freeze Polaroid instant-picture film.) Make sure that the dealer has refrigerated film if that is recommended by the manufacturer, as it is for color film labeled "professional" and infrared film..

Protect film from moisture. The original film packaging should be moisture proof, but if you refrigerate the film after opening the box, put the film first in a moisture-proof container such as a tightly closed plastic bag. **NOTE:** Let refrigerated or frozen film warm to room temperature before opening the package, so moisture does not condense on the film surface. One roll of film or a 10-sheet box of sheet film needs about an hour to warm up; a 100-ft roll of bulk-load 35mm film or a 100-sheet box of sheet film needs about 4 hours.

Load and unload your camera out of strong light. If you are outdoors, at least block direct sun from hitting the film by shading the camera with your body. Put exposed film where strong light won't reach it.

Light can ruin your pictures by fogging them with unwanted exposure if the light leaks around the edges of the film spool or into the opening out of which the film feeds.

Check the film's expiration date before buying. There is a steady decline in film quality after the expiration date, more rapid if stored at room temperature rather than in a refrigerator. Camera stores will discount film that is about to expire, which can make it a bargain. Freeze film if it is close to its expiration date. The date is listed on the side of the film package.

Consider protecting your film from airport security X-ray machines. These devices are supposed to be safe for film, but can fog undeveloped film if the machine is not adjusted correctly. This is more likely to be a problem with very high-speed film (more than ISO 1000) than with slower-speed films, especially if your travel takes you to several airports and exposes the same film to X-rays several times. You can ask to have film (and camera, if it is loaded) inspected by hand rather than passing it through a machine. By law, U.S. airports should comply but not all foreign airports will do this. Airports x-ray checked baggage with high-powered devices. Do not pack film in checked baggage, even in lead-foil bags. If you travel internationally, consider buying film at your destination and shipping the exposed film back by airfreight, which is not usually x-rayed.

Exposure Latitude and Dynamic Range
How Much Can Exposures Vary?

In very contrasty lighting, no film or digital sensor can record color and details simultaneously in very light highlights and very dark shadows because the range of tones in the scene is greater than the usable exposure range of the film or sensor. The usable exposure range of a specific film is sometimes called its latitude; more precisely, the usable exposure range of film or a digital sensor (or a range of subject brightness) is called dynamic range.

When the dynamic range of a scene exceeds the dynamic range of the capture medium, you are likely to lose some detail. If the lightest areas are correctly exposed, the shadows will be too dark. If shadows look good, highlights will be too light. Try exposing for the most important part of the scene, then bracket additional exposures (see page 76).

Sometimes, if the subject is not too large or too far away, you can use a reflector or a flash unit to add fill light to lower the contrast in a scene. With film, use color negative instead of transparency material (see the page opposite) if you know you'll be shooting in hard, or contrasty, light.

It is easier to get good exposures with color if lighting is soft or flat, with relatively little difference between the lightest and darkest areas (see photograph, right). With such a scene it is less likely that areas will lose detail and be much too light or much too dark.

Image-editing software can merge bracketed exposures, if neither camera nor subject moved between making one exposure and making the next. Using two or more exposures to ensure capture of a contrasty scene is called HDR, for high dynamic range (see page 190).

EVE ARNOLD Traditional Doctor, China, 1979

Shooting in soft, diffused light is simpler than working in contrasty light, because the range of tones from light to dark better fits the capture range of light-sensitive materials. Diffused light is also kind to the human face, creating soft shadows that are often more complimentary than the hard-edged, dark ones of direct light.

Adjusted prints from negatives below

Color negative film has enough exposure latitude for most scenes. The best results are from a correctly exposed negative (center), but you will be able to get a passable image from even a badly overexposed or underexposed frame. Here, exposures on the strip of film varied by one stop between each frame.

Negatives

Transparencies

Transparencies

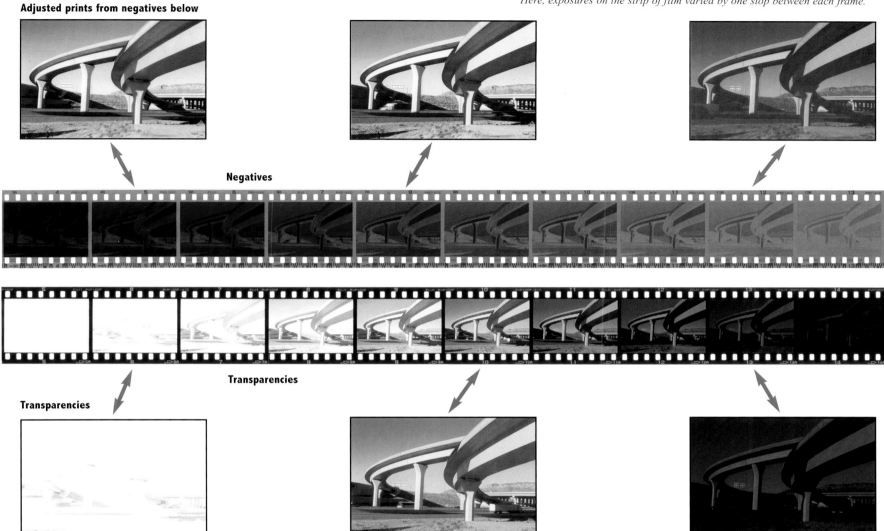

Color transparency film has little exposure latitude. Even a small amount of overexposure or underexposure is readily visible, especially when shadows and highlights measure more than (the optimum) five stops apart. Exposures on the strip of film above varied by one stop between frames.

Below, both pages. Exposures from a digital SLR camera have slightly more latitude than negative film. These exposures varied by one stop between frames. Dynamic range, the span of tones that a digital camera can capture, is greater in some cameras than others.

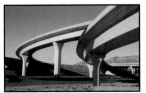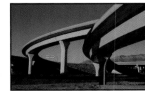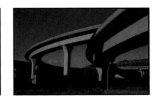

Film and Sensor Speed
Speed and ISO

An ISO (International Organization for Standardization) number tells how sensitive a film or sensor is to light. Other rating systems you may see are older: ASA (American Standards Association), EI (exposure index), or the European DIN.

The higher the ISO number, the less light is required to produce an image, so you can make pictures in dimmer light, or use faster shutter speeds or smaller apertures. An ISO 200 film—or a sensor set for ISO 200—is twice as fast as one at ISO 100 (one stop faster), and half as fast as ISO 400 (one stop slower). A correct exposure at ISO 200 needs half as much light as (one stop less than) one at ISO 100, and twice as much light as (one stop more than) ISO 400.

A fast film or high ISO setting is useful indoors, for example, choose ISO 400-1600 if you use only the room's existing light, and do not supplement it with electronic flash or portable incandescents (called hot lights). A lower ISO, from 50-200, is good for brightly lit scenes, such as outdoors in full daylight, or with static subjects when you can use a tripod for longer exposures.

What speed should you use? Faster films have lower resolution and produce grainier pictures (see opposite page). Digital sensors cannot actually change their sensitivity to light; setting a higher ISO simply amplifies the data it collects. Because sensors produce more random data, called noise, in areas of lower illumination, photographs at higher speeds have a higher proportion of unwanted pixels. Theoretically, regardless of how you are shooting, the best results come from the slowest film or the lowest ISO setting usable in each situation.

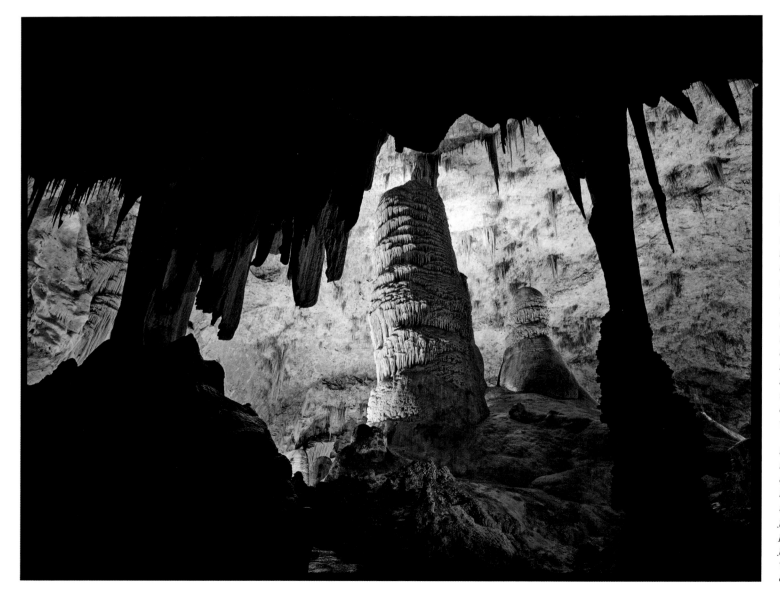

DAVID TAYLOR
Hall of Giants, Carlsbad Caverns, New Mexico, 2006

Caves are a surprisingly difficult working environment, with relative humidity hovering around 95% year-round. Film's gelatin emulsion swells with moisture and can move during a long exposure—Taylor's exposures averaged 8 minutes. After a maker of digital backs for his view camera told him to "stick with film" because of the digital noise generated by long exposures, he adapted his film holders to keep the film motionless and flat with a vacuum pump, a technique familiar to astronomers, whose exposures are even longer.

The faster the film, the more visible its grain. The light-sensitive part of film consists of many tiny particles of silver halide spread throughout the film's emulsion. A fast film is fast because it has larger crystals than a slower film. The larger crystals more easily capture the few rays of light in a dark environment. When the fast film is developed, its larger crystals yield larger bits of silver (the size of these bits is also affected by the degree of development and the kind of developer). The advantage is that fast film needs less light to form an image. The potential disadvantage is that these larger crystals reproduce what should be uniform gray areas not as smooth tones but with distinctly visible specks or grain.

Higher film speeds affect more than grain. Compared to slower-speed films, faster speeds also produce lower resolution and less detail, and—with color film—lower saturation and less accurate colors.

Large grain is not always to be avoided; its distinct visual qualities can be used for special effect. But if maximum sharpness and minimum graininess are your desire, select slower rather than faster films.

ISO 100 film speed

ISO 400 film speed

ISO 3200 film speed

ISO 100 film speed

ISO 1600 film speed

Usually, the slower the film (the lower its ISO number), the finer the grain structure of the film and the smoother and more detailed the image that the film records. Compare the three black-and-white and two color enlargements, taken with films of different speeds.

In a digital photograph, the lower the light, the more the noise. Noise is the presence of pixels whose color and brightness is unrelated to the subject. Most kinds of noise increase (or are more noticeable) when there is very little illumination reachng the sensor, something you can cause in two ways.

Higher ISO settings increase noise. A photosite does not change its sensitivity—the way it responds to photons falling on it by collecting and counting electrons—when you adjust the ISO number to a higher setting. The camera's circuitry simply amplifies the data collected. With a higher ISO, you shoot with a smaller aperture or higher shutter speed, so the sensor receives lower overall illumination. The kinds of noise that are always present at a low level are then amplified more than they would be at a lower ISO, and form a more noticeable part of the image.

Longer exposures increase noise. You use a long exposure when very little illumination reaches the sensor—perhaps because of a very small aperture or a dimly lit subject. One kind of noise, heat-generated electrons called dark noise, accumulates over time, and so forms a more noticeable part of an image made with a long exposure.

Some noise can be removed. Some D-SLR cameras have a setting for Long Exposure Noise Reduction that works because some kinds of noise, notably dark noise, are predictable. A long exposure is followed automatically by an equally long exposure with the shutter closed. Noise generated during the second exposure is then subtracted from the first.

Digital images can be degraded with noise, random light pixels that appear in dark areas. Noise increases with long exposures, although some cameras can remove it automatically.

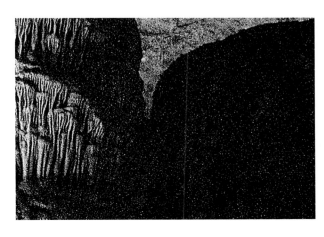

Reflected infrared radiation can produce unusual photographs, particularly in black and white. In a landscape made with black-and-white infrared film, blue sky will appear very dark, with green foliage unexpectedly light (see opposite). In a portrait, skin tones will have a luminous, almost unearthly glow (see below). Infrared color film produces color variations that are often scientifically useful but not always as visually appealing as with black-and-white infrared film. Digital cameras can be made to replicate the qualities of infrared films.

How infrared photography works: infrared film and digital sensors are sensitive to all visible light but also to invisible infrared wavelengths that are slightly longer than the visible waves of red light. This near-red radiation can create unusual photographic effects when it is not reflected in the same amounts as visible light. Objects that appear dark, because they reflect little visible light, may be highly reflective of infrared radiation. This gives some infrared images unexpected, even surreal, tonal relationships. These effects are particularly evident when a filter is used on the lens to block most visible wavelengths so that the photograph is taken mostly with reflected infrared waves.

Leaves, grass, and skin in an infrared photograph will be very light because they reflect infrared very strongly. Water particles in clouds also reflect infrared, making clouds very light. But blue sky becomes very dark, because its blue light is mostly blocked by the filter. Black-and-white infrared film has a grainy look that softens detail and can produce an overall texture. Details may also diffused by halation, a diffuse, halo-like glow that surrounds very light objects, especially with overexposure.

Digital cameras can make infrared photographs, but it's an uphill battle. All digital cameras are made with an infrared-removing filter covering the sensor that blocks almost all wavelengths longer than visible red. Some fearless tinkerers have made successful infrared photographs by removing the IR-cut filter from their cameras. This, of course, makes a camera useless for general work and voids the warranty.

The IR-blocking filter in some cameras is less effective than in others; some allow just enough infrared to pass for satisfactory results. Many photographers have posted the results of their experiments online; with a little searching you can find out whether your particular digital camera can make infrared photographs without disassembly.

Uses for infrared film are many. Infrared photographs are made for pictorial intent but there are also scientific and technical applications. Aerial photographers utilize infrared film for its ability to penetrate haze. It can be used to track water pollution, timber resources, lava flow, and many other phenomena. It can decipher charred documents, detect forgeries, photograph in the dark, and do many other things.

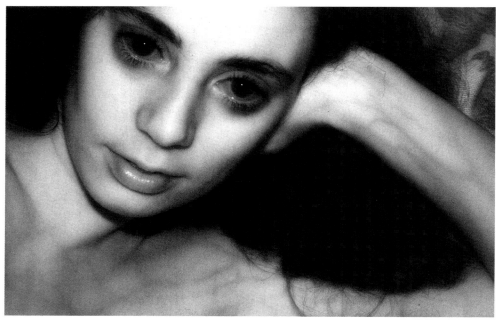

LUTHER SMITH Brenda, 1976

Infrared makes skin tones luminous. Smith used flash, covered with a #87 gelatin filter (see box, right).

USING INFRARED FILM

Storage. Exposure to heat will fog infrared film with unwanted exposure. Buy infrared film only if it has been refrigerated by the dealer, and keep it under refrigeration yourself as much as possible. Let the film come to room temperature before opening the package.

Handling. Even slight exposure to infrared radiation will fog the film, so load and unload the camera in total darkness, either in a darkroom or in a changing bag (a light-tight cloth sack into which you put your hands, the camera, and the film). The slot through which 35mm film leaves its cassette does not block infrared radiation, so only open the film can to take out the cassette in total darkness. Put exposed film back in the can before you bring it into the light.

Focusing. A lens focuses infrared slightly differently than it focuses visible light; so if you focus sharply on the visible image, the infrared image will be slightly out of focus. With black-and-white film, focus as usual, then rotate the lens barrel very slightly forward as if you were focusing on an object just a little closer. A lens may have a red indexing mark on the lens barrel to show the adjustment needed. Make this correction if depth of field is very shallow, for example, if you are using a long-focal-length lens at a wide aperture or if you are focusing on a point very close to the lens. But the difference is so slight that you don't need to adjust for it otherwise; the depth of field will be adequate to keep the image sharp, even if the critical focusing point is slightly off. No adjustment is necessary with color infrared film.

Filtration. See manufacturer's instructions. Kodak recommends a #25 red filter for general use with black-and-white infrared film. This increases the infrared effect by absorbing the blue light to which the film is also sensitive. Kodak recommends a #12 minus-blue filter for general use with color infrared film.

Exposure. Infrared wavelengths are not accurately measured by ordinary light meters, whether built into the camera or hand held. You can try setting a film speed of 50, metering the scene, then bracketing. If your meter is built into the camera, meter without a filter over the lens. Kodak recommends the following manually set trial exposures for average, front-lit subjects in daylight.

Kodak High-Speed Infrared black-and-white film used with #25 filter: distant scenes—1/125 sec at f/11; nearby scenes—1/30 sec at f/11.

Kodak Ektachrome Infrared color film used with #12 filter: 1/125 sec at f/16.

Flash exposures. You can use infrared film with flash by having a red filter on the lens and using your flash in the usual way. Or you can cover the flash with a #87 filter, as in the photograph, left, which passes only infrared radiation. Shoot a test roll with a series of trial exposures to determine the best starting exposure.

MINOR WHITE Road and Poplar Trees, Upstate New York, 1955

Infrared film helped make this landscape look more like a dreamscape. *The perspective of the converging lines of road and trees funnels the eye down the road to the dark mountains beyond. The repeated shadows of the trees reinforce the depth in the scene as the distance between them apparently diminishes. The altered tonalities of the infrared film, which render the foliage as extremely light, make the whole scene slightly unrealistic.*

* Minor White often found the sublime in the ordinary. There is no sure way to make a landscape like this happen out of a road lined with trees, no matter what film you use. The landscape itself has to cooperate. White often put forth his basic rule of composition: Let the subject generate its own composition.*

Instant films give you a print almost at once. As with a digital camera, you don't have to wait to have film developed and printed to see the results. Polaroid films, like the one diagrammed at right, have an emulsion plus processing chemicals in one packet. After the picture is exposed, the chemicals are spread between negative and a receiving sheet as the entire package is pulled between metal rollers. The image is transferred from the negative to the receiver (the process is called diffusion transfer) across the developing chemicals at the center of the sandwich. The result is a positive image.

Polaroid makes instant materials in many formats. In addition to the pack film made for amateur cameras, individual sheets of 4 x 5-inch or 8 x 10-inch film can be used (with a special film holder) in any standard view camera. Several kinds of film are available in each format.

Instant film is popular with professional photographers, who use it to make a quick check of a setup. If lighting, focus, and composition are crucial, one exposure can help you avoid mistakes before taking the final picture with standard film. Some photographers also use Polaroid film as an end product.

JOYCE NEIMANAS, Untitled #3, 1980, SX-70 Collage

Joyce Neimanas assembled this collage from over one hundred small SX-70 prints. She said that she wanted to "reject the eminence of the single, definitive image." Each print is a realistic fragment, but the assemblage fractures the reality of the scene into a complex and richly textured pattern.

INSTANT FILM FOR VIEW CAMERAS

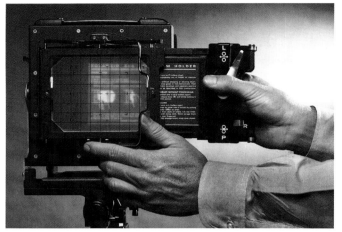

Polaroid makes films for use with view cameras. You load a packet containing a sheet of film into a special film holder that you then insert into the camera like an ordinary sheet film holder.

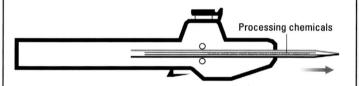

Processing chemicals

To process the film after it is exposed, flip a lever on the holder to engage the rollers and pull the packet firmly and steadily out of the holder. The rollers break a pod of processing chemicals within the packet and spread them evenly within the packet to develop and fix the picture.

CHROMOGENIC FILM

Chromogenic black-and-white films, such as Ilford XP2 and Kodak BW400CN, produce a dye image rather than a silver one. (A chromogenic emulsion is one that contains dye couplers as well as silver halides; color negative and color reversal films are chromogenic.) The film must be developed as if it were a color negative, which can be conveniently done at any one-hour photo lab—and you can have a set of proof prints made at the same time.

Chromogenic films have wide exposure latitude, which means you can expose individual frames at different film speeds. Frames exposed at about ISO 100 will have finer grain, but frames on the same roll of film can be exposed at speeds as high as ISO 800 and still produce printable negatives. (This is unlike conventional films, which require you to expose the whole roll at a single film speed.)

The inventor of Polaroid film, Edwin Land, first developed the sheet polarizer. A filter made from it passes only light waves vibrating in one plane. Light waves ordinarily vibrate in all directions perpendicular to their direction of travel. But light reflected from nonmetallic smooth surfaces or scattered by haze becomes polarized—the waves vibrate mostly in one plane. Rotating a polarizer in front of your eye or lens will adjust its effect. A polarizing filter does not change the color of light.

Without a filter

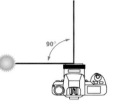

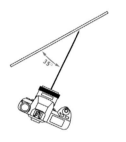

With a filter

A polarizing filter can darken a blue sky by blocking light reflected from particles in the atmosphere. This effect is at its maximum when you are taking pictures at approximately a right angle to the sun.

A polarizer can reduce reflections from a shiny surface like glass or water. It is most efficient at an angle from 35°–60° to the reflecting surface. Directly facing the surface, the filter will have no effect.

MARTIN STUPICH Roosevelt Dam Before Entombment, Arizona, 1987

Polaroid's Type 55 film makes a 4 x 5 negative along with a print. Enlarging the full negative shows the residue of chemical action at the edges. After this photograph was made, this graceful dam succumbed to regional demand for more water and more power. First opened in 1911, it was encased in concrete to raise its level by 77 feet, completely covering what you see here. It reopened in 1995. Using this film, Stupich—who often photographs in remote areas—can see a print and negative on the spot and be assured that he is returning with exactly what he needs.

Attach a filter to the front of a lens, and you change the light that reaches the film. The name—filter—describes what most photographic filters do: they remove some of the wavelengths of light reflected from a scene. By doing so, they change the way that the scene looks in a photograph.

Glass filters screw or clamp onto the front of the lens. They come in sizes to fit various lens diameters. Look on the ring around the front of your lens. Some lenses show the diameter (in mm) following the symbol Ø. Glass filters are convenient to use and sturdy but can be expensive.

Gelatin or plastic filters are taped to the front of the lens or placed in a filter holder. They cost less than glass but can be damaged relatively easily; handle them only by the edges to avoid abrasions or other damage to their surfaces. There are holder systems and adapters that may let you use the same filter with several lenses.

You need to increase the exposure when using a filter. The chart below shows the compensation for common filters used with black-and-white film.

TYPES OF FILTERS

Filters let you control the relative lightness and darkness of tones in a black-and-white photograph. They absorb light of certain colors and thus make objects of those colors appear as darker tones of gray. You can predict the effect of a colored filter if you think of it as subtracting (and darkening) colors, not adding them. For example, if you look through a red filter, it seems to tint the entire scene red. But the filter isn't adding red; it is removing blue and green. As a result, blue and green objects appear darker.

A contrast filter absorbs its complementary color, the color or colors opposite it on a color wheel (see below): a yellow filter absorbs blue, a green filter absorbs red and blue, and so on. Used with black-and-white film, a colored filter appears to lighten objects of its own color, but only because it makes other colors darker. Compare the photographs on the opposite page, left.

Magenta
Blue
Red
Cyan
Yellow
Green

Correction filters are colored filters designed to correct the response of film so that it shows the same relative brightnesses that the human eye perceives. For example, film is more sensitive to blue and ultraviolet wavelengths than the eye is. A blue sky photographed without a filter can look too light in a black-and-white photograph, almost as light as clouds that seemed at the scene to be much lighter. A yellow filter absorbs blue, and darkens the blue of the sky so that clouds stand out (see the examples on the opposite page, far right).

FILTERS ALSO USED WITH COLOR FILM AND DIGITAL CAMERAS

Neutral density filters absorb an equal quantity of all wavelengths of light. They reduce the overall amount of light that reaches the film while leaving the color balance unchanged; they can be used with either black-and-white or color film. Their purpose is to increase the exposure needed for a scene, so that you can use a slower shutter speed (to blur motion) or a larger aperture (to decrease depth of field).

A polarizing filter affects only light vibrating at certain angles. It can be used with either black-and-white or color film to remove reflections, darken skies, and intensify colors.

Some filters or lens attachments are available that produce special effects. A cross-screen attachment causes streamers of light to radiate from bright lights such as light bulbs. A soft-focus attachment softens details and makes them slightly hazy.

FILTERS FOR BLACK-AND-WHITE FILM	Number or designation	Color or name	Physical effect	Practical use	Exposure increase in: Daylight	Tungsten
	8	yellow	Absorbs ultraviolet and blue-violet	Darkens blue sky to bring out clouds. Increases contrast by darkening bluish shadows. Reduces bluish haze. Balances panchromatic film to match normal visual response.	1 stop	2/3 stop
	15	deep yellow	Absorbs ultraviolet, violet, and most blue	Lightens yellow and red subjects such as flowers. Darkens blue water and blue sky to emphasize contrasting objects or clouds. Increases contrast and texture and reduces bluish haze more than #8 filter.	1 1/3 stops	2/3 stop
	25	red	Absorbs ultraviolet, blue-violet, blue, and green	Lightens yellow and red subjects. Darkens blue water and sky considerably. Increases contrast in landscapes. Reduces bluish haze more than #15 filter. Used with infrared film.	3 stops	2 1/3 stops
	11	yellowish green	Absorbs ultraviolet, violet, blue, and some red	Lightens foliage, darkens sky. For outdoor portraits, darkens sky without making light skin tones appear too pale. Balances values in tungsten-lit scenes by removing excess red.	2 stops	2 stops
	47	blue	Absorbs red, yellow, green, and ultraviolet	Lightens blue subjects. Increases bluish haze.	2 2/3 stops	3 2/3 stops
FILTERS ALSO USED WITH COLOR FILMS	1A or UV	skylight or ultraviolet	Absorbs ultraviolet	Little or no effect with black-and-white film. Used by some photographers to protect lens surface from damage.	0	0
	ND	neutral density	Absorbs equal quantities of light from all parts of the spectrum	Increases required exposure so camera can be set to wider aperture or slower shutter speed. Comes in densities from 0.1 (1/3 stop more exposure) to 4 (13 1/3 stops more exposure).	varies with density	
	—	polarizing	Absorbs light waves traveling in certain planes relative to the filter	Reduces reflections from nonmetallic surfaces, such as water or glass. Penetrates haze by reducing reflections from atmospheric particles. Darkens sky at some angles.	1 1/3 stops	1 1/3 stops

The exposure increase for a filter may also be listed as a filter factor, which tells how much the exposure should be increased.

If filter has a factor of . . .	1.2	1.5	2	2.5	3	4	5	6	8	If you use two or more filters together, add the
Then increase the exposure (in stops)	1/3	2/3	1	1 1/3	1 2/3	2	2 1/3	2 2/3	3	number of stops or multiply the filter factors

The actual scene in color. *Colors that appear very different to the eye can be confusingly similar in black and white.*

Without any filter, *the red tomato soup is the same tone as the green dishware.*

A green filter #58 *absorbs much of the nearly opposite color red, making the tomato soup darker than the green dishware.*

CONTROLLING COLOR IN BLACK-AND-WHITE PHOTOGRAPHS

The actual scene in color. *One of the most common uses for a filter in black-and-white photography is to darken a blue sky. Colored filters work for this purpose only when the sky is blue, not gray. They do not darken the sky on an overcast or hazy day.*

Without any filter, *the sky in this photograph appears very light, barely differentiated from the clouds. Black-and-white film is somewhat more sensitive to blue than other colors and is also sensitive to some ultraviolet wavelengths. This sensitivity, plus the fact that skies are often brighter than other parts of the scene, causes skies to appear too light in many black-and-white photographs.*

A yellow filter #8 *absorbs some of the sky's blue light, making the sky in the picture at left appear somewhat darker than it does above. Using a #8 filter should render all colors in natural-looking tones in black and white.*

A red filter #25 *absorbs nearly all blue as well as green light, making the sky much darker than it normally appears. The filter will have other effects. For example, it will darken green foliage. Shadows often appear darker when filtered, because they are illuminated largely by blue light from the sky that the red filter blocks.*

Before making an exposure, stop for a moment to visualize how you want the final image to look. Do this especially if you are using a camera in an automatic exposure mode. Using many automatic exposure cameras is like using a hand-held reflected-light meter to make a reading of the overall scene. If the scene has an average tonal range, an overall reading produces a good exposure. But many scenes (like those on these pages) do not have an average range of tones. For these kinds of situations, make your own metering decisions.

When using negative film, both black-and-white and color, photographers usually meter the important shadow areas and make sure those areas receive enough exposure. With a contrasty scene, giving shadow areas adequate exposure may give the highlights too much. But overexposed highlights still contain details that you can bring out in printing, while underexposed dark areas of a negative provide very little detail and can't be salvaged.

The reverse is true for digital cameras and transparency film. Exposing for shadows can leave completely washed out highlights. Unless that effect would lend drama to an image, photographers usually use a middle-gray reading or, in a very contrasty situation, expose for the highlights and let the shadows go black.

Sometimes you will want an out-of-the-ordinary interpretation, like the silhouette on this page, top, that can be produced by underexposing part of a scene. Terminology like "underexposed" implies that there is a "correct" exposure. There may be a standard exposure but don't be afraid to experiment.

ERNST HAAS Movie Still, "The Big Country," 1958

Exposing for the sky— the brightest area of the scene—silhouetted the backlit cowboys in this picture on a movie set.

WILLIAM ALLAN ALLARD Stan Kendall, Nevada, 1979

Exposing for the darker part of this scene caused the brightest areas to completely wash out in this photograph of a man turned from the brightness of the day toward the dim interior of the bar. Color film (especially transparency film) and digital exposures do not have the latitude to hold detail in both shadows and bright areas of contrasty situations like this one. The photographer sacrificed the highlight detail to keep the viewer's attention on the solitary man.

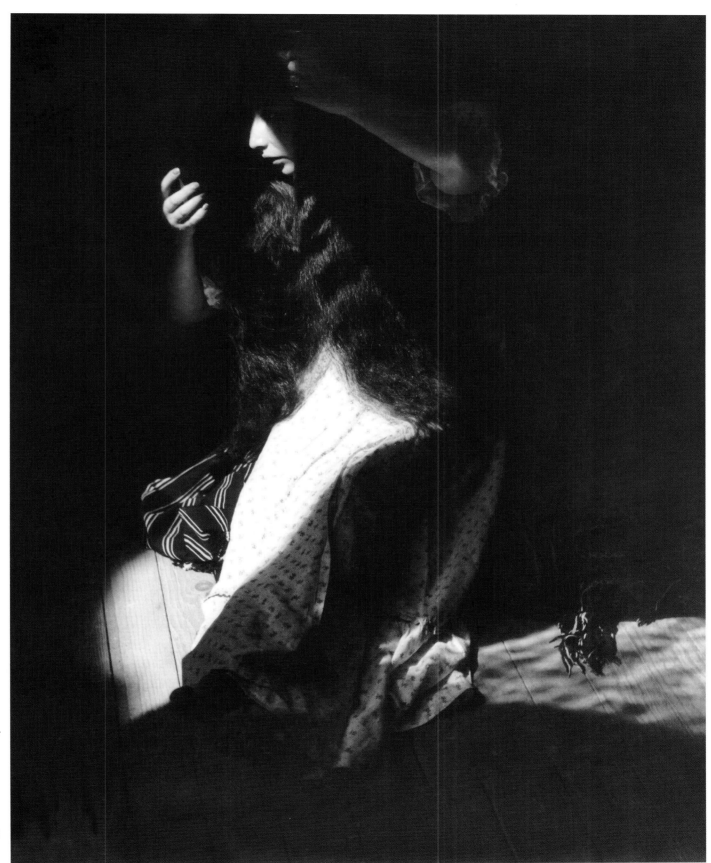

MANUEL ALVAREZ BRAVO
Portrait of the Eternal (Isabel Villaseñor),
1937

Manual Alvarez Bravo added a
surrealist sensibility to his views of
Mexican life. An ordinary domes-
tic scene is transformed by the tip
of the woman's shawl creeping out
of the shadows behind her back.

The picture could have been
radically different depending on
the exposure. More exposure would
have lightened the image, making
the background less mysterious.

photographer
at **WORK**

Advertising Photographer Clint Clemens

What makes a good advertising photograph? For Clint Clemens, the answer is simplicity, and he thinks that many photographers lose sight of that. "They complicate it too much," he says. "Too often there isn't a simple statement or any purity of thought."

Lighting can be dramatic in Clemens's pictures, but it always looks natural. "In nature, there is only one source of light—the sun. Lighting in a photograph should have that single-source feeling, whether it is indoors or outdoors." Clemens likes to give light a direction so that it comes from one area and moves across the picture. A viewer's eye tends to go to the lightest part of a picture first, which means that light, especially when it contrasts with a darker background, can direct attention where the photographer wants it to go.

Clemens always visualizes a photograph before he begins to shoot. He has a clear idea in advance of how the product should be presented, how it should relate to the type in the ad, how the picture will be cropped for the layout, and so on. "You have to be able to see the picture beforehand and be able to describe it to others. You would drive everyone crazy if you didn't have a good idea of what you wanted it to look like." He isn't rigidly tied to his ideas and will take advantage of something that happens spontaneously, but often the final picture is exactly what he visualized before the shoot.

Clemens feels that advertising is a very personalized business. He gets to know his clients and lets them know that their job is the most important one he has. More than that, he makes sure that every job is his most important one. "You never, never blow a job. You always have to give it your best, and that requires preplanning and constant attention to detail, especially when you are shooting. But don't get so bottled up and rattled that you can't think. You have to be willing to take chances, too."

Instead of being studio based, Clemens works mostly on location. He has one assistant who takes care of the equipment, then hires freelance help on individual shoots. He rents a studio, as needed, or hires a production crew to work at a site. When he used to work mostly in his studio, he often took on apprentices, as many advertising photographers do. He recommends apprenticeship as a good way to learn. His apprentices stayed six weeks, got no pay, worked intensely, and got the kind of experience that is impossible to get in a school or from a book.

Clemens says that if you want to be an advertising photographer, you have to be businesslike: "You have to learn how to deal with people, how to go out and get work, how to present and promote yourself, what to put in a portfolio, and many other things." But the most important attribute is a desire to understand every aspect of photography. "You have to want to learn. That is absolute."

CLINT CLEMENS Photograph for Porsche, 1996

Clint Clemens believes that to get an advertising message across effectively you have to understand the psychology of your audience: how people perceive themselves and what intangibles the product might supply to them. For example, imparting a feeling of power for a Porsche ad is as important as showing the car's design.

JASON EVANS

Clint Clemens on location shooting Prada Sport campaign.

CLINT CLEMENS Photograph for Sportswear Manufacturer Sperry Top-Siders, 1996

GRETCHEN SCHOENINGER Negative Print, 1937

Printing a photograph as a negative image instead of as a positive one often makes the literal recording of a scene less important (as with the porch steps at left) and strengthens the graphic elements of line and form. The dark shadow areas in the original scene (or in a positive print) become light so that light seems to come from behind or within the subject. The geometric details in this print—the tonally reversed patterns of sunlight and shade—flatten the space and become an engaging abstraction.

developing the

negative

O nce your image has been exposed, your next step is to make it visible. The moment the camera's shutter closes after an exposure, the picture has been made. Yet, when you are using film, nothing is visible. The image is there, but it is latent—temporarily invisible. Not until it has been developed, and printed is the image there to be enjoyed. How enjoyable it will be depends to a great extent on the care you use when you process the film.

There are many opportunities in developing to control the quality of the final photograph. You may choose to have your film developed for you, especially if it is color film. Color chemicals are more hazardous than those for black and white, and temperatures must be held more exactly—usually a lab that develops film all day every day will be more consistent. But, especially with black and white, you may can have more control over the process that begins with the devel-

opment of the negative. The techniques are simple; primarily you need to exercise care in following standard processing procedures and in avoiding dust spots, stains, and scratches. The skills needed to develop good negatives are quickly learned and the equipment needed is modest, but the reward is great—an increased ability to make the kind of pictures you want.

This chapter shows processing for black-and-white film. If you are using a digital camera, you may enjoy reading this chapter anyway, or you can skip to the next one. The procedures and equipment for color film processing are the same as those shown here, although there are a few more steps, and disposal of exhausted chemicals may be more stringently regulated in your area. Consult the chemical manufacturer's published guidelines.

How to Process Black-and-White Roll Film

Equipment and Supplies You'll Need

EQUIPMENT TO LOAD FILM

Developing reel holds and separates the film so that chemicals can reach all parts of the emulsion. Choose a reel to match the size of your film, for example, 35mm, or the larger 120 roll-film size. Some plastic reels adjust to different sizes.

Stainless-steel reels are a bit more difficult to learn to load than plastic reels. However, many photographers use them because they are durable and easy to clean of residual chemicals.

Developing tanks accept one or more reels loaded with film. Loading must be done in the dark, but once the film is inside and the light-tight top in place, processing can proceed in room light. A light-tight opening in the top of the tank lets you pour chemicals in and out. Ideally, the cover should let you turn the tank upside down to agitate the solution inside during processing.

Miscellaneous: **Bottle-cap opener** pries off the top of a 35mm film cassette. Special cassette openers are available. **Scissors** trim the front end of 35mm film so it is square and cut off the spool on which the film was wound. **Practice roll of film** lets you get used to loading the developing reel in room light before trying to load an actual roll of film in the dark. Light hitting the practice roll will ruin it, so don't use a roll you want to keep.

A completely dark room is essential for loading film on the reel. Even a small amount of light can fog film. The room is not dark enough if you can see objects in it after 5 minutes with lights out. If you can't find a dark enough room, use a **changing bag,** a light-tight bag into which fit your hands, the film, reel, tank, cover, opener, and scissors. After the film is loaded on the reel and in the tank with the cover on, you can take the tank out of the bag into room light.

...TO PROCESS FILM

TRI-X FILM		
	65° F	68°
D-76	9 min	8 min
HC-110 (Dilution B)	8½ min	7½ min
Microdol-X	11 min	10 min
Xtol	7 min	6 min

Manufacturer's instructions, which are included with the film or developer, give recommended combinations of development time and developer temperature.

Containers for working solutions must be large enough to contain the quantity of solution needed during processing. Measuring graduates are convenient to use. Have three for the main solutions—developer, stop bath, and fixer. It is good practice to reserve a container for developers only; even a small residue of stop bath or fixer can keep the developer from working properly.

Optional: **Tray or pan** can be used as a water bath for the containers of working solutions to keep them at the correct temperature.

Timer with a bell or buzzer to signal the end of a given period is preferable to a watch or clock that you must remember to consult. An interval timer can be set from 1 sec to 60 min and counts down to zero, showing you the time remaining.

Film washer is the most efficient way to wash the film. If one isn't available, you can insert a hose from a water tap into the core of the reel in the processing tank.

Film clips attach washed film to a length of string or wire to hang to dry. Spring-loaded clothespins will do the job. A dust-free place to hang the wet film is essential. A school darkroom usually has a special drying cabinet; at home, a bathroom shower is good.

Optional: **Photo sponge** or squeegee to wipe down wet negatives so that they dry rapidly and evenly.

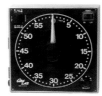

Negative storage pages protect the dry film.

...TO MIX AND STORE CHEMICALS

Source of water for mixing solutions, washing film, and cleaning up. A hose on a faucet splashes less than water straight from the faucet.

Photographic thermometer measures the temperature of solutions. An accurate and easy-to-read thermometer is essential because temperatures must be checked often and adjusted carefully. You will need a temperature range from about 50° to 120° F.

Graduated containers measure liquid solutions. Two useful sizes are 32 oz and 8 oz. Graduates can also be used for mixing and for holding the working solutions you will need during processing.

Mixing containers hold solutions while you mix them. You can use a graduated container for small quantities or a container with a wide mouth for larger ones.

Storage containers hold chemical solutions betwen processing sessions. They should be of dark glass or plastic to keep out light. Caps should close tightly to minimize contact with air, which causes oxidation and deterioration of chemicals. Some plastic bottles can be squeezed and capped when partially full to expel excess air.

Stirring rod mixes chemicals into solution. The rod should be of an inert and nonabsorbent material such as hard plastic that will not react with or retain chemicals.

Funnel simplifies pouring chemicals into storage bottles.

Safety equipment, such as rubber gloves, tongs, and safety goggles, protects you from unwanted exposure to chemicals. See details on page 98.

CHEMICALS TO PROCESS FILM

Three basic chemical solutions are used to process black-and-white film—developer, stop bath, and fixer. In addition, a washing aid is highly recommended; a wetting agent is optional.

Developer converts the latent (still invisible) image in exposed film to a visible image. Choose a developer formulated for film, not for prints.

An all-purpose developer is your best choice for general use and for your first rolls of film, for example, Edwal FG7, Ilford ID-11, or Kodak D-76 (T-Max developer if you use T-Max films).

Fine-grain developers, such as Ilford Ilfotec HC or Kodak Microdol-X, produce finer grain, but with possible loss in contrast and apparent sharpness; some dilutions cause a loss in film speed. See manufacturer's data. The life of a developer depends on the type of developer, storage conditions, and other factors. See How to Mix and Handle Chemicals, right.

Stop bath stops the action of the developer. Some photographers use a plain water rinse for a stop bath. Others prefer a mildly acid bath prepared from about 1 1/2 oz of 28 percent acetic acid per quart of water.

An indicator-type stop bath is available that changes color when it is exhausted, but many photographers simply mix a fresh stop bath each time.

Fixer (also called hypo) makes film no longer sensitive to light, so that when fixing is complete the negative can be viewed in ordinary light. Some fixers come with an optional hardener, which makes film more resistant to surface damage. Use a rapid fixer with T-Max films.

Fresh fixer treats about 25 rolls of film per quart of working solution (fewer rolls with T-Max films). The age of the solution also affects its strength.

Fixer check or hypo check is the best test of fixer strength. A few drops of the test solution placed in fresh fixer will stay clear; the drops turn milky white if the fixer is exhausted.

Highly recommended: **Washing aid** (also called a clearing bath, clearing agent, or fixer remover) such as Heico Perma Wash or Kodak Hypo Clearing Agent. After the film has been fixed and rinsed, immersing it in the washing aid solution, then washing in running water provides more effective washing in much less time than washing in water alone. The shortened wash time, in addition to saving water, reduces swelling and softening of the emulsion and makes the wet film less likely to be damaged.

Different brands vary in capacity and storage; see manufacturer's instructions.

Optional: **Wetting agent**, such as Kodak Photo-Flo, used after washing, reduces the tendency of water to cling to the surface of the film and helps prevent water spots during drying, especially in hard-water areas.

A small amount of wetting agent treats many rolls of film. Discard the diluted solution periodically.

HOW TO MIX AND HANDLE CHEMICALS

Record keeping. After processing film, write down the number of rolls developed on a label attached to the developer bottle—if you are not using a one-shot developer (see below). The instructions that come with developers tell how many rolls can be processed in a given amount of solution and how to alter the procedure if the solution is reused. Each succeeding roll of film requires either extra developing time or, with some developers, addition of a replenisher. Also record the date the developer was first mixed, because even with replenishing most developers deteriorate over time. Check the strength of the fixer regularly with a testing solution made for that purpose.

Replenishing developers. Some developers can be used repeatedly before being discarded if you add additional chemicals to them to keep the solution up to full strength. Carefully follow the manufacturer's instructions for replenishment.

One-shot developers. These developers are designed to be used once and then thrown away. They simplify use (in that no replenishment is needed), and they can give more consistent results than a developer that is used and saved for a long time before being used again.

Mixing dry chemicals. Add dry chemicals to water at the temperature suggested by the manufacturer. Pour powders carefully to avoid getting chemical dust in the air. Stir gently until dissolved. If some of the chemicals remain undissolved, let the solution stand for a few minutes. Then stir again. Make sure all the particles are dissolved before using the solution. Be sure the solution has cooled to the correct temperature before using.

Diluting a stock solution to a working solution. Chemicals are often sold or mixed first as concentrated liquids (stock solutions). When the chemical is to be used, it is diluted into a working solution, usually by the addition of water. The dilution of a liquid concentrate may be given on an instruction sheet as a ratio, such as 1:3. The concentrate is always listed first, followed by the diluting liquid. A developer to be diluted 1:3 requires 1 part developer and 3 parts water. To fill a 16-oz developing tank with such a dilution, use 4 oz developer and 12 oz water.

Adjusting temperatures. To heat up a solution, run hot water over the sides of the container (a metal one will change temperature faster than glass or plastic) or place it in a pan of hot water. Placing a container in a tray of ice water will cool down a solution in just a few minutes; cooling by running tap water over the container can take a long time unless the tap water is very cold. Stir the solution steadily as you watch the thermometer; the temperature of the solution near the outside of the container will change faster than at the center.

Avoid unnecessary oxidation. Oxygen speeds the exhaustion of most chemicals. Don't use the "cocktail shaker" method of mixing chemicals by vigorously shaking the solution; this adds unwanted oxygen. Store all chemicals in tightly closed containers to prevent their exposure to air. Accordion-like containers that allow you to squeeze out extra air help extend the life of solutions. Developers are also affected by light and heat, so store them in dark-colored bottles or in a dark place at temperatures below 70° F, if possible.

NOTE: Contamination—chemicals where they don't belong—can result in many darkroom ills. Fixer on your fingers—even dried—transferred to a roll of film being loaded for development can leave a permanent tracery of your fingerprints on the film. A residue of the wrong chemical in a tank can affect the next solution that comes into contact with it. Splashes of developer on your clothes will slowly oxidize to a brown stain that is all but impossible to remove. These problems and more can be prevented by taking a few precautions:

Rinse your hands well when chemicals get on them and dry them with a clean towel; be particularly careful before handling film or photographic paper. It isn't enough just to dip your hands in the water in a temperature-control pan or print-holding tray; that water may also be contaminated.

Launder your darkroom towels frequently; they can quickly become loaded with chemicals. If you use paper towels for drying, choose ones that are lint free.

Rinse tanks, trays, and other equipment well both before and after use. Using soap is not necessary to remove chemicals from your hands or darkroom surfaces, they are all soluble in plain water. Be particularly careful not to get fixer or stop bath into the developer; they are designed to stop developing action, and that is exactly what they will do. Make sure reels, especially plastic ones, are completely dry before loading film.

Wear old clothes or a lab apron in the darkroom.

Keep work areas clean and dry. Wipe up spilled chemicals and wash the area with water.

CHEMICAL SAFETY

Photographic chemicals should be handled with reasonable care, like all chemicals. The following guidelines—in many cases, simple common sense—will prevent problems and minimize injury if problems occur. If you have allergies, asthma, sensitive skin, or are pregnant, consult your doctor first.

The goal is to avoid getting chemicals onto, and especially into, your body. Preventing problems is much better than fixing them. The more often you expose yourself to a chemical, the more likely you are to eventually have a problem.

Know what you are handling. Read labels before using any new product so you know what hazards might be present and what to do if problems occur.

Material Safety Data Sheets (MSDS) provide valuable additional information, and the law says they must be made available to the user. They are normally available for any photochemical on manufacturer's Web sites or at your camera store. If not, you can request them from the manufacturer.

Additional information is available from manufacturers, professional organizations, and other groups. See this page, right, for some phone numbers. See also the Bibliography for safety publications and where to get them.

Avoid skin contact. Look for label warnings such as "Harmful if absorbed through the skin." Dermatitis (reddening, itching, peeling, or other skin disorders) can be caused by repeated contact with chemicals, especially Metol-based developers. Several Metol-free developers are available, which may reduce the problem: for example, for film—Cachet AB-55, Edwal FG7, Ilford Ilfotec HC, and Kodak Xtol; for paper—Edwal "G," and Ilford Multigrade or Bromophen.

Rubber gloves and printing tongs will keep chemicals off your hands. Thin disposable gloves provide only temporary protection; heavier rubber ones are better. Rinse gloves thoroughly before taking them off so you don't get chemicals on your hands. A waterproof apron will keep chemicals off your clothes.

If you do get chemicals on your skin, wash immediately. Developers, which are alkaline, should be washed off with a pH-balanced soap such as pHisoderm. Replace skin oils with a good hand lotion.

Avoid getting chemicals in your eyes. Protective goggles are the best defense when handling toxic substances.

If you do get chemicals in your eye, immediately rinse the open eye for 15 minutes in cool running water. Keep a hose attached to the cold water tap for just this purpose. A permanent eye-wash station is even better. **Get medical attention immediately.**

Avoid getting chemicals in your mouth. Don't eat or drink in the darkroom. It's too easy to get chemicals on your hands, then into your mouth.

Don't smoke in the darkroom. Not only can you get chemicals onto a cigarette and into your mouth, but inhaling will carry chemical dust and fumes deep into your lungs.

Wash your hands after handling chemicals, especially before eating, so you don't carry chemicals out of the darkroom onto your plate.

Avoid inhaling chemicals. Using liquid chemicals rather than mixing dry powders will prevent accidental inhalation of chemical dust.

Adequate ventilation is vital wherever chemicals are used. Ideally, the ventilation system should completely replace the air once every five minutes.

A particle mask or respirator can prevent inhalation of chemicals. A particle mask can block some chemical dust. A respirator may be necessary in certain situations, such as when handling large quantities of dry chemicals or cleaning up a toxic spill. Proper fitting of the respirator is essential, as is training for its maintenance and use.

Clean up chemical spills promptly, safely, and thoroughly. Rinse well areas that came in contact with chemicals, and rinse well the equipment you used for cleanup. Clean your clothing and shoes, if they came in contact with the spill.

Additional measures: Depending on the extent of the spill and the toxicity of the chemical, you may also need to increase ventilation to the area and make use of protective gear, including a respirator. Discard sponges, mops, or cloths used to clean up toxic chemicals; you don't want to use them again and accidentally spread chemicals over another surface. Don't hesitate to call 911 if the spill is so toxic that you feel you can't clean it up safely, such as a large spill of concentrated acid.

Take extra precautions with certain chemicals. Concentrated acids, strong alkalis, color chemicals, intensifiers, bleaches, reducers, and toners are particularly likely to cause problems if you splash them onto yourself.

Be cautious when using any acid, particularly in a concentrated form. Add acid to water, never water to acid. This will decrease the possibility of concentrated acid splashes or spatter.

For external contact with a concentrated acid, flush with cold water immediately—do not scrub—until the area is completely clean. Do not use ointments or antiseptic preparations. Cover with a dry, sterile cloth until you can get medical help.

For eye contact, immediately flood the eye with running water for at least 15 minutes. Then get medical help.

For internal contact, do not induce vomiting. Instead, dial 911 or get medical help immediately.

Store chemicals safely and out of the reach of children. Mark bottles clearly, close them tightly, and keep them where others, especially children, won't mistake them for beverages or other everyday substances. Don't reuse milk bottles or juice containers that might confuse children. Be aware that children are more sensitive to toxic chemicals than adults are.

If you do have a problem, don't try to self-medicate. A little skin rash is worth a visit to the doctor before it grows into a major problem. Avoid over-the-counter medications, especially those advertised for reducing itching; they can make the problem worse.

Dispose of chemicals properly. Small amounts of most photo chemicals can be safely discarded into a public sewer system if local regulations don't forbid it. Mix the developer (a base) with the fixer (an acid), to neutralize the pH of the two, then flush down the drain with running water. Try to find a nearby school or commercial lab that will take your used fixer. Even if it is legal in your locality to put it down the drain, it is an environmental hazard. Only very small amounts of photo waste should go into a septic tank; it's better to have the solutions hauled away by a commercial waste-collection company.

Larger users, like schools, must comply with federal, state, and local environmental regulations that usually require silver recovery programs or commercial waste collection.

If you have questions, don't guess. Check with local environmental agencies or call Kodak's environmental hotline (see this page, right).

More information about chemical safety is available from:

Agfa (800) 879-2432. Emergencies are handled by Rocky Mountain Poison and Drug Center, 24 hours, (800) 222-1222. www.rmpdc.org

Chemtrec handles chemical emergency inquiries (emergencies only, no product information) for many companies, including Fuji and Edwal, 24 hours, (800) 424-9300. www.chemtrec.com

Ilford (201) 265-6000 Emergencies, 24 hours, (800) 842-9660. www.ilford.com

Kodak emergency health, safety, and environmental hotline, 24 hours, (585) 722-5151.

Kodak general information, including requests for Material Safety Data Sheets, (800) 242-2424. In Canada (800) 465-6325.

Kodak's environmental hotline provides information on the safe disposal of photochemicals, (585) 477-3194. www.kodak.com

Other useful Web sites
www.onecachet.com
www.fujifilm.com
www.falconsafety.com/edwal/

WALKER EVANS Photographer's Window Display, Birmingham, Alabama, 1936

Processing Black-and-White Roll Film Step by Step

STEP	YOU'LL NEED	PROCEDURE
1–2. Preparation (numbered steps begin on opposite page)	Developer, stop bath, fixer, time-and-temperature chart, thermometer, containers for chemicals. Rubber gloves will protect against possible skin irritation.	Select a developing time and developer temperature from the time-and-temperature chart.
		Dilute the chemicals to working strength. Adjust the developer temperature exactly. Adjust the stop bath and fixer to within 3° F of the developer.
3–9. Loading the film	Film, developing reel and tank (with cover), bottle-cap opener, scissors, a completely dark room	Set out the items needed. Make sure your hands and equipment are clean and dry.
		TURN OUT ALL LIGHTS. Load the film onto the reel, put it in the tank, and put on the tank cover. Lights can be turned on when the tank is covered.
10–13. Development	Developer at the selected temperature, timer	Check the solution temperatures and adjust, if needed. Start the timer.
		Pour the developer into the tank through the pouring opening in the tank cover. DO NOT REMOVE THE TANK COVER. Cap the tank opening so it can be agitated without leaking.
		Rap tank bottom against a solid surface to dislodge any air bubbles. Agitate by inverting the tank 5 times during 5 sec, then in the same way for 5 sec out of every 30 sec of development time.
		A few seconds before the development time ends, pour out the developer through the pouring opening in the cover. DO NOT REMOVE ENTIRE COVER.
14–15. Stop bath	Stop bath within 3° F of developer temperature	Immediately fill tank through pouring opening with stop bath. Agitate for 30 sec.
		Pour out through pouring opening. DO NOT REMOVE ENTIRE COVER.
16–18. Fixing	Fixer within 3° F of developer temperature	Fill tank through pouring opening with fixer. Agitate for 30 sec, then for 5 sec out of every 30 sec for the recommended time, about 5–10 min with regular fixer, 2–4 min with rapid fixer. The tank cover can be removed when fixing is complete.
19. Washing aid (highly recommended)	Running water plus washing aid (diluted to working strength) within 3° F of developer temperature	Rinse 30 sec in running water, then immerse in the washing aid solution for about 2 min (check manufacturer's instructions). Agitate for 5 sec at 30-sec intervals.
20. Washing	Running water within 3° F of developer temperature	Wash for 5 min if you used a washing aid, at least 20 min if you did not. Wash water should flow fast enough to fill tank several times in 5 min. Dump water out of the tank several times during the washing period.
21. Wetting agent (optional)	Wetting agent diluted to working strength within 3° F of developer temperature	Immerse the film in the wetting agent, agitating gently for about 5 sec.
22–23. Drying	Clothespins or film clips, a dust-free place to hang the film	Remove film from reel and hang to dry. Handle gently; wet film is easily scratched.
24. Protect the dry negatives. Clean up.	Scissors, negative storage pages	Cut the film into lengths to fit your storage pages. Rinse all processing equipment well.

PREPARING TO WORK

Kodak T-Max 400 Professional Film

KODAK Developer	Small-Tank Developing Time in Minutes				
	65° F (18° C)	68° F (20° C)	70° F (21° C)	72° F (22° C)	75° F (24°C)
T-Max (1:4)	—	7	6 ¹/₂	6 ¹/₂	**6**
D-76	9	**8**	7	6 ¹/₂	5 ¹/₂
D-76 (1:1)	14 ¹/₂	**12 ¹/₂**	11	10	9
HC-110 (Dil B)	6 ¹/₂	**6**	5 ¹/₂	5	4 ¹/₂
Microdol-X	12	**10 ¹/₂**	9	8 ¹/₂	7 ¹/₂

The development times in bold type are the primary recommendations.

1 **Select a time and temperature for your film and developer combination.** See the manufacturers' charts that accompany films and developer. If a chart lists different times for large tanks and small tanks (also called reel-type tanks), use the small-tank times.

The preferred temperature (listed on the chart in bold type) is usually 68° F. Use a higher temperature (and shorter development time) if your tap water is very warm. Ideally, wash water should be within about 3° F of the developer temperature.

Set the timer to the selected time, ready to start at the beginning of the development.

2 **Mix the developer, stop bath, and fixer to their working strengths and adjust their temperatures.** Mix at least enough solution to completely cover the reel (or reels) in the tank or, better, to fill it completely. Using protective gloves to protect against skin irritations, especially while handling developers, is a sensible precaution.

Adjust the temperature of the developer exactly; the other solutions should be within about 3° F of the developer. Excessive temperature changes can cause increased graininess and other problems in the film. Rinse the thermometer between chemicals.

LOADING THE FILM

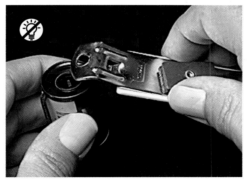

3 **Set out materials for loading the film.** Arrange in a light-tight area the film cassette, bottle-cap opener, scissors, reel, and developing tank. Make sure you have all the parts to the tank. The film is loaded onto the reel in the dark and has to be put into the tank and covered before you turn on the lights.

All the materials, the working surface, and your hands should be clean and dry. If the reel adjusts to different sizes of film, set it to the size you are using.

4 **Lock the door and turn off all the lights, including any darkroom safelights, before you open the film.** Remove gloves, if you used them to prepare chemicals. If it is an unfamiliar darkroom, let your eyes adjust to the darkness for a few minutes first to check for light leaks.

To remove film from a standard 35mm cassette, find the spool end protruding from one end. Hold the cassette by this end while you pry off the other end with the bottle opener. Slide the spool of film out of the cassette.

How to develop film successfully.

Developing film is a relatively straight-forward procedure, and a little attention to detail will go a long way toward producing consistent and satisfactory results.

Orderliness will make development simpler. Developing your first (and all future) rolls of film will be simplified if you arrange your equipment in an orderly and convenient way. The process starts in total darkness and, once begun, moves briskly.

Consistency also pays off. If you want to avoid unpredictable results such as too dense, too thin, or unevenly developed negatives, mix your solutions accurately, adjust their temperatures within a degree or two, agitate film at regular intervals during processing, and watch processing times carefully.

Cleanliness of your hands, containers, surfaces, and anything else your film and chemicals might contact will prevent inconsistent development, mysterious stains, and general aggravation. Darkrooms usually have a dry side where film is loaded and printing paper exposed, and a wet side with sinks where chemicals are mixed and handled. Keep chemicals and moisture away from the dry side and off your hands when you are loading film.

Alternate method: 2 1/4-inch roll film

4a **Opening 2 1/4-inch roll film.** Break the paper seal and unwind the paper until you reach the film. Let the film roll up as you continue unwinding the paper. When you reach the end of the film, gently pull it free of the adhesive strip that holds it to the paper. Do not pull the adhesive too rapidly or you may generate static electricity that produces enough light to streak the film.

5 **Use the scissors to cut off the half-width strip at the beginning of a roll of 35mm film.** Try to cut between the sprocket holes, not through them, or the film may not load properly onto the developing reel. Or you can cut straight across the film, then clip the corners at an angle to cut off the first sprocket holes.

To test the cut, run your finger along the squared-off end of the film. (Remember, you are doing this in the dark.) If you feel a snag, make another cut close to the end of the film. When the end feels smooth, the cut is correct.

6 **Align the film to the reel and insert.** Hold the spool of film in either hand so that the film unwinds off the top. Hold the reel vertically in your other hand with the entry flanges at the top, evenly aligned and pointing toward the film.

Insert the end of the film just under the entry flanges at the outermost part of the reel. Push the film forward about half a turn of the reel.

7 **Wind the film onto the reel.** Hold the reel in both hands and turn the two halves of the reel back and forth in opposite directions to draw the film into the reel.

Alternate method: Stainless steel reel

7a **Align the film to the reel.** Hold the spool of film in either hand so that the film unwinds off the top. Unwind about 3 inches and bow it up slightly between thumb and forefinger. Pinching the film too tightly will make crescent-shaped marks on it. Hold the reel in your other hand with the ends of the reel's spiral coils at the top, pointing toward the film.

Alternate method: Stainless steel reel

7b **Insert the end of the film into the center of the reel.** Some reels have a clip or metal prongs at the center to grip the film end. Rotate the top of the reel away from the film to start the film into the innermost spiral groove of the reel. Continue to bow the film just enough to let it slide into the reel's spirals without catching at the edges. If the film kinks, unwind past the kink, then rewind.

8 **When you reach the end of the roll,** use the scissors to cut the film free from the cassette's spool.

9 **Assemble the tank and reel.** With this type of tank, put the loaded reel on the tank's center column and put both into the tank. Put the funnel/cover over the center column. Twist the cover to lock it in place.

Developing one reel of film in some two-reel tanks (and any stainless-steel tank) requires putting an empty reel on top of the loaded one to keep the loaded reel from bouncing around as you agitate it.

With the funnel/cover in place, the film is protected from light. You can now turn on the lights or take the tank to the developing area.

10 **Check the solution temperatures.** If necessary, adjust them before pouring the developer into the tank. Wear gloves while using chemicals.

A tray filled with water at the developing temperature will help maintain solution temperatures, especially in a cold darkroom. Leave each container of chemicals in the tray until you are ready to use it.

Start the timer and quickly pour the developer into the tank. Keep the tank cover in place as you pour chemicals in or out through its funnel opening. Some tanks fill more quickly if the tank is tilted slightly.

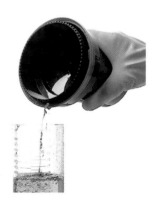

11 **Start agitation immediately. Put the cap on the tank to keep liquids from leaking.** First, rap the bottom of the tank sharply against the sink or counter several times to dislodge any air bubbles that may have attached themselves to the film.

12 **Begin the regular agitation pattern to be followed throughout the development time:** Turn the tank upside down, then right side up again 5 times, with each of the 5 inversions taking about 1 sec. Avoid a repetitive pattern of flow by not inverting the tank in exactly the same way each time. Put the tank down for the remainder of the first 30 sec.

Continue to agitate by inverting the tank as above for 5 sec out of every 30 sec of the remaining development time.

13 **Remove only the tank cap so you can pour out the developer. Leave the funnel/cover in place to protect the film from light.** Begin pouring out the developer ten or fifteen seconds before the timer signals that development is completed. The development time is over as soon as you begin to pour in the stop bath.

STOP BATH

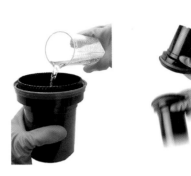 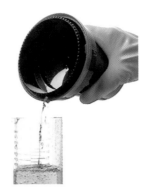

14 **Quickly pour the stop bath into the tank through the funnel opening in the cover. Replace the cap on the tank.** Agitate continuously for about 30 sec.

15 **Remove the tank cap, leaving the funnel/ cover in place, and pour out the stop bath.** Discard plain water if you use it instead of a chemical stop bath. You can save an acetic acid stop bath for reuse, but some photographers throw it out because it is inexpensive and easier to store as a concentrated solution. You can reuse indicator stop bath until it changes color.

FIXING

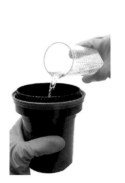

16 **Pour fixer into the tank through the funnel opening in the cover. Replace the cap on the tank.** Agitate the fixer continuously for the first 30 sec of the recommended fixing time, then for 5 sec at 30-sec intervals. Fixing takes 5–10 min with regular fixer, 2–5 min with rapid fixer.

17 **Check that the film is clearing.** About halfway through the fixing period, open the tank to take a quick look at the end of the roll. If the film has a milky appearance, the fixer is weak and should be discarded. Replace the tank cover and refix the film in fresh fixer. The tank can be left uncovered when the milky appearance is gone.

18 **Pour out the fixer, saving it for future use.** Either keep track of the number of rolls processed in the fixer and discard it when the manufacturer's recommended limit is reached, or test the fixer regularly with a fixer check solution, which indicates when the fixer is exhausted and should be discarded.

WASHING AND DRYING

19 **Treat the film with a washing aid before washing.** This optional, but highly recommended, treatment greatly reduces washing time and removes more of the fixer from the film than water alone can remove.

Follow manufacturer's directions for use. Start with a rinse in running water (30 sec to 2 min), followed by immersion in the clearing bath for about 2 min. Agitate for 5 sec at 30-sec intervals.

20 **Wash the film.** Adjust faucets to provide running water within about 3° F of the development temperature. Leave the reel in the open tank in the sink and insert the hose from the tap into the core of the reel. Let the water run fast enough to completely change the water in the container every 5 min. Empty the water and refill several times.

Wash the film at least 20 min if you did not use a washing aid, about 5 min if you did. If one is available you can use a specially designed—and more efficient—film washer.

21 **After washing, treat the film with a wetting agent,** such as Kodak Photo-Flo. This procedure is optional, but is useful to help prevent water spots. In hard-water areas, mix it with distilled water. Follow manufacturer's directions for use, especially for the dilution.

22 **Unwind the film from the reel and hang it up to dry.** Attach a clip or clothespin to the bottom end of the film to keep the film from curling. Let dry in a dust-free place. A film-drying cabinet is the best place. At home, a good dust-free location is inside a tub or shower with shower curtain or door closed.

23 **If water spots are a problem,** even if a wetting agent is used, try removing excess water by very gently running a damp, absolutely clean photo sponge or squeegee down the film.

Handle wet film very gently; the wet emulsion side, in particular, is soft and and easily scratched. Resist the temptation to examine the negatives before they are dry because dust embeds itself in wet film.

24 **Protect the dry negatives and clean up the darkroom.** Discard a one-shot developer or save and replenish developer that can be reused. Store solutions that you want to save in tightly closed containers. Clean your hands, the reel, tank, containers, and any other equipment that came in contact with chemicals.

When the film is completely dry, cut it into appropriate-lengths to fit into protective sleeves. Hold film only by its edges to avoid fingerprints or scratches. Careful treatment of negatives now will pay off later when they are printed.

A general knowledge of developer chemicals is useful background information in case you want to mix a developer from a formula. Packaged developers only need to be dissolved in water; all the chemicals are present in the proper amount, but you may want to experiment with specialized mixes.

The most important ingredient is the reducing agent, or developing agent. Its job is to free metallic silver from the emulsion's exposed crystals so it can form the image. Each crystal contains silver atoms combined with a halogen such as bromine, chlorine, or iodine in light-sensitive compounds, like silver bromide. Manufacturers don't divulge the exact mix of compounds in film or paper, so the light-sensitive part of an emulsion is usually referred to simply as silver halides. The reducer cracks the exposed crystals into their components: metallic silver, which stays to form the dark parts of the image (shown above, right), and the halogen, which unites chemically with the developer. In a chromogenic film, the silver is later replaced by dyes. Often, two reducing agents, Metol and hydroquinone, are used together.

Other common components in a developing formula are an accelerator, restrainer, and a preservative, to control the activity of the developer, prevent fogging, extend its useful life.

After development, fixer makes the image on the film permanent. Silver halides remaining in the emulsion will turn dark if exposed to light. A fixing agent prevents this by dissolving these crystals so they can be washed out of the emulsion.

The active agent in fixer is sodium or ammonium thiosulfate. The latter is called rapid fixer, and is sold as a liquid concentrate—sodium thiosulfate is supplied as a powder. The early name for fixer was sodium hyposulfite, and it is still often called hypo.

If film is left a very long time in the fixer, the image eventually bleaches. If not left in long enough, agitated well, or if the fixer is exhausted, silver halide crystals are left that will later darken the film.

Undeveloped silver bromide crystals | **Developed 1 minute** | **Developed 5 minutes and fixed**

Exposed crystals of silver halides are converted to pure silver during development, as shown above in these electron microscope images (5,000x magnification) of silver bromide. At first (above, left) the crystals show no activity (dark specks on some crystals are caused by the microscope procedure). After a minute (above, center), about half the crystals are developed, forming strands of dark silver. Above, right, all exposed crystals are developed; undeveloped crystals have been removed by fixer, and the strands now form the negative image.

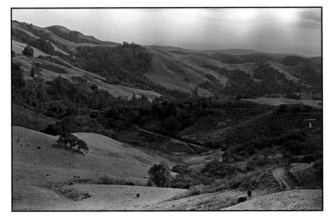

Agitating film too often and too vigorously, as occurred above, forces fresh developer through the 35mm film's sprocket holes. This causes the area around the holes to be overdeveloped—denser in the negative and lighter in the print.

Developed for 2 minutes | **Developed for 5 minutes** | **Developed for 15 minutes**

Grains of silver in the negative emulsion get denser as development time increases. In these cross sections of film emulsion (enlarged about 2,500x), crystals near the surface (the top of the cross section) clump together into grains first and grow in size. As developer soaks down, subsurface grains form.

The longer the development time, the darker and more contrasty the negative becomes. Density in an image does not increase uniformly. Increasing the development time causes the greatest change in those parts of the negative that received the most exposure (the bright areas in the original scene). Some changes occur in those areas that received moderate exposure (the midtones), but only a little change in areas that received little exposure (the shadow areas). For any negative, lengthening or shortening development time has a marked effect on contrast—the difference in density between light and dark tones.

The developer begins to work on the surface crystals immediately but needs extra time to soak into the emulsion and develop crystals below the surface, as shown at left, bottom. Your original exposure determines how many crystals are available to be developed, but the total amount of time you allow the developer to work determines how deeply it penetrates and how fully it develops the exposed crystals.

Three other factors also influence the amount of development, which in turn controls contrast and density. In addition to increasing the time of development, a higher temperature of the developer solution, more concentration of developing agent in the solution, and greater agitation—all will increase development.

Manufacturers expect you to use a standard agitation pattern and follow their recommendations for concentration. They provide a chart (opposite page, bottom) suggesting a development time for temperatures between 65° and 75° F. Below 65°, developers work poorly; at around 80°, the film's gelatin emulsion softens and may separate from the base. The temperatures generally recommended are 68° or 70° F, which are safe, practical, and chemically efficient. Higher temperatures may be used, carefully, when tap water is very warm, as it is in many areas during the summer.

Agitation supplies fresh chemicals to the emulsion by moving the solution inside the developing tank at regular intervals. Inadequate agitation in the developer allows the chemicals to stop working and form a stagnant area where development activity slows down and eventually stops. Too much agitation creates problems even more often than too little agitation. Turbulence patterns can cause uneven development along the edges of the film (opposite page, center).

Agitate (in more than one direction to avoid a repetitive pattern of flow) for 5 out of every 30 seconds. Put the tank down between cycles; holding it continues the agitation. If you are developing one reel of film in a two-reel tank, put in an extra empty reel so that the loaded one does not bounce up and down when you invert the tank.

Always use fresh solutions. Film can be ruined because the chemicals are exhausted from overuse or age. Black-and-white film looks milky if it is grossly underfixed, but even normal-looking film can deteriorate over time if the fixer was not fresh. Prevention is easy: Never use exhausted chemicals. Manufacturers specify exhaustion rates and how long solutions can be stored. Fixer can be checked with an inexpensive testing solution that indicates when it should be discarded.

After complete fixing, film must be thoroughly washed. Any of the soluble silver compounds or unconverted silver halides left in the film will eventually darken and stain the negative. Any fixer left in the emulsion will eventually convert the silver image of the negative to silver sulfide, the same kind of reaction that causes silverware to tarnish.

Proper washing and drying is relatively easy. Water for washing must be clean, near the temperature of the earlier solutions, and constantly moving. It is best to use a clearing bath (also called a washing aid or hypo remover) to reduce washing time. Handle the film as little as possible while it is wet and hang it to dry as soon as the wash steps are completed. Make sure your film dries in a clean place free from drafts but with good ventilation.

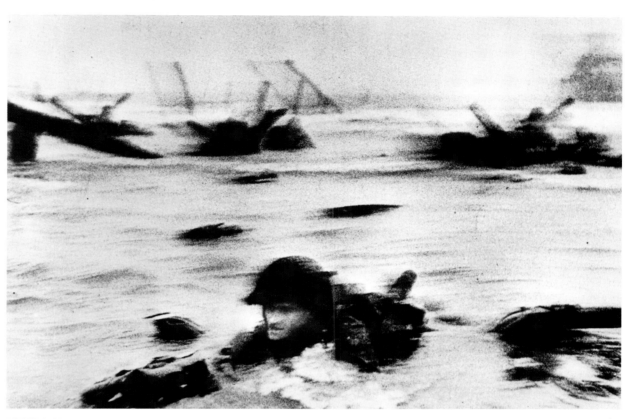

ROBERT CAPA Normandy Invasion, June 6, 1944

This famous image by Robert Capa was nearly ruined by poor handling in the darkroom. Capa photographed the D-Day invasion of Normandy during World War II. His film was rushed to London for processing before it was to be shipped to Life magazine. Under extreme pressure to get the film out quickly, the lab technician let the developed film overheat in the drying cabinet, which caused the emulsion to melt off the film base. Only a few frames out of the take were usable. The graininess of the image, due in part to the improper drying, adds to the feeling of the pounding tumult of battle.

Film and developer manufacturers provide a time-and-temperature chart for development. Times for the recommended temperature are shown in boldface type: It is 68° F for most of the developers listed on this chart. The exceptions are the two T-Max developers and Microdol-X diluted 1:3, for which the recommended temperature is 75° F. A change in temperature of even a few degrees can cause a significant change in the rate of development and therefore requires a change in the development time. Note that the EI (exposure index or effective film speed), shown in the chart's far left column, decreases with some developers.

Kodak T-Max 400 Professional Film
Developing Times (Minutes)—Roll Film
Small Tank
(Agitation at 30-Second Intervals)

EI (Film Speed)	Kodak Developer	65° F (18° C)	68° F (20° C)	70° F (21° C)	72° F (22° C)	75° F (24° C)
400	T-Max (1:4)	NR	7	6 ¹/₂	6 ¹/₂	**6**
400	D-76	9	**8**	7	6 ¹/₂	5 ¹/₂
400	D-76 (1:1)	14 ¹/₂	**12¹/₂**	11	10	9
400	T-Max RS	NR	7	6	6	**5**
320	HC-110 (Dil B)	6 ¹/₂	**6**	5 ¹/₂	5	4 ¹/₂
200	Microdol-X	12	**10¹/₂**	9	8 ¹/₂	7 ¹/₂
320	Microdol-X (1:3)	NR	NR	20	18 ¹/₂	**16**

Note: The primary development times are in boldface.
NR—Not recommended

A correctly exposed and properly developed negative will make your next step—scanning or darkroom printing—much easier. You are likely to produce a good negative if you simply follow the manufacturer's standard recommendations for exposure (film speed) and development (time and temperature). But, after you have a grasp of the basic techniques, you may want to adjust exposure or development. If you are just beginning in photography, come back to this material after you have had some experience making prints.

Expose for the shadows, develop for the highlights. This old photographic rule is based on the fact that the amount of exposure and the amount of development both affect the negative, but in different ways.

Changing the development time has little effect on shadow areas, but it has a strong effect on highlight areas. The longer the development at a given temperature, the denser the highlights become; the greater difference between the density of the highlights and that of the shadows increases the contrast of the negative overall. The reverse happens if you decrease development time: there will be less difference between highlights and shadows, therefore less overall contrast in the negative.

Enlarging paper and scanners don't respond as well to areas of high density. Be careful to avoid overdevelopment, especially if you have shots on the roll from high-contrast scenes (see Exposure Latitude and Dynamic Range, pages 80–81).

Changing the exposure affects both highlight and shadow areas: The greater the exposure, the denser they both will be. But exposure is particularly important to shadow areas because increasing the development time does not significantly increase the density of shadow areas. They must receive adequate exposure if you don't want them to be so thin that they are without detail.

Learn to judge detail from looking at the negatives. The illustrations opposite show a negative with good density and contrast (top) plus negatives that are thin, dense, flat, and contrasty—and tell what to do if too many of your negatives look that way.

RALPH GIBSON Untitled, 1983

A high-contrast scene, such as one outdoors in hard sunlight, can easily have a nine-stop or greater range between shadows and highlights—too much for details to show in both. In such a very contrasty situation, you can give enough exposure to maintain details in the shadows, then decrease the development to about 70 percent of the normal time to keep highlights—like the white towel in full sun above—from being overly dense.

WHAT ABOUT PUSHING FILM?

Pushing film means exposing at a higher ISO than the film's rating and developing for a longer-than-normal time. As explained at left, more development raises contrast—highlight density is increased with very little change in the shadows. By raising the ISO you are underexposing the film; see the example on the opposite page, center left. Shadow detail is lost. Nothing can produce shadow detail if it is not on the film. Longer development is used with pushed film because it produces a negative that can be printed more easily on traditional (wet-darkroom) photo paper. But pushed film will likely have little shadow detail.

The best scans come from fully detailed negatives. With careful image editing, you can make a wide range of adjustments to the the tones of an negative, even replicating the results of over- or under-development. But overdevelopment can compress highlight tones by pushing them into what is called the shoulder region of the tone curve, the parts marked as highlights in the graphs on the opposite page. Compressed highlights reduce the amount of tonal information available to a scanner and can lower quality. Underexposing your film loses shadow detail but if you must, and you plan to scan it, develop normally.

EVALUATING DENSITY AND CONTRAST

Shadows

Midtones

Highlights

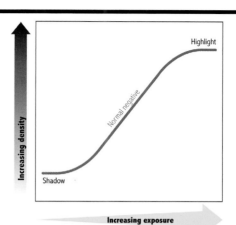

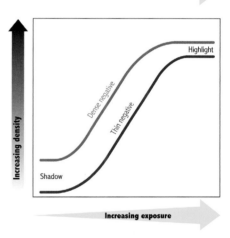

A normal negative has normal density and contrast. It will have good separation of tones in highlights, midtones, and shadows (if it is from a scene of normal contrast).

Density is the amount of silver built up in the negative overall or in a particular part of the negative. A dense negative will have more density (will be darker) overall compared to a thin negative.

If your negatives are consistently very thin or very dense, check your meter.

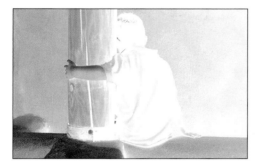

An underexposed negative has little or no detail in shadow areas and is thin or light overall.

If your negatives are often thin, increase exposure by setting a lower film speed (divide ISO by two to increase exposure one stop).

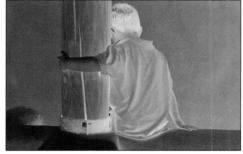

An overexposed negative has dense (very dark) highlights and more than adequate density in shadows.

If your negatives are often dense, decrease exposure by setting a higher film speed (multiply ISO by two to decrease exposure one stop).

Contrast is the difference in density between the thinner (lighter) parts of the negative, such as shadow areas, and the denser ones like bright highlights. A contrasty negative will have a greater difference in density.

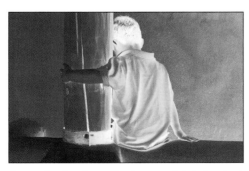

An overdeveloped negative has a great deal of contrast, or difference between highlights and shadows. Highlights are very dense, shadows very thin.

High contrast may result from high contrast in the original scene as well as from overdeveloping the film. If your negatives are often contrasty, decrease film development; start with 80 percent of the normal time.

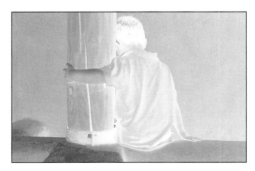

An underdeveloped negative is flat, or low in contrast; highlights are not very much more dense than the shadows.

Low contrast can be the result of low contrast in the original scene or from underdeveloping the negative. If your negatives are often flat, increase film development; try developing 20 percent more than the normal time.

RAY K. METZKER Philadephia, 1983

printing
in a darkroom
CHAPTER/SIX

Printmaking in a darkroom is one of the most pleasurable parts of photography. Unlike film development, which requires rigid control, darkroom printing lends itself to leisurely creation. Mistakes are inevitable at first, but a wrong choice can be easily corrected simply by making another print.

Like film, printing paper is coated with an emulsion containing light-sensitive silver compounds. Light is passed through the negative and onto the paper. After exposure, the paper is placed in a developer where chemical action converts into visible metallic silver those compounds in the paper's emulsion that have been exposed to light. A stop bath halts the action of the developer; a fixer removes undeveloped and unexposed crystals; finally the print is washed and dried.

The negative is a reversal of the tones in the original scene. Where the scene was bright, the negative contains many dense, dark grains of silver that hold back light from the paper, prevent the formation of silver in the paper's emulsion, and so create a bright area in the print. Where the scene was dark, the negative is thin or even clear, and passes much of the light to the paper, creating dense silver in the emulsion and a dark area in the print.

Darkrooms for printing are set up with a dry side and a wet side. On the dry side, photographic paper is exposed to make a print. On the wet side, the exposed paper is processed in chemicals similar to those used for developing negatives.

Dust is a common problem on the dry side. Every dust speck on your negative produces a white spot on your print. Remove dust from negatives each time you print them, and keep working surfaces and equipment clean. Handle negatives by their edges to avoid fingerprints. Dust and fingerprints on enlarger lenses or condensers decrease the contrast and detail in a print; clean them as you would a camera lens.

Contamination can cause a plague of spots, stains, and weakened chemicals. A typical printing session involves many trips from enlarger to developing trays and back again, so it's important to keep chemicals away from places where they don't belong. Put a wet print into a dry, clean tray if you want to carry it away from the sink; don't let it dribble onto dry counters, floors, or your clothes. After handling chemicals, wash and dry your hands before picking up negatives or printing paper. Chemical contamination transferred to a negative or print may show up as a permanent fingerprint or stain that may not appear until months later. Drain a print for a few seconds as you transfer it from the developer to the stop bath or fixer so that you don't transfer an excess of one solution into the next. Even more important, don't get stop bath or fixer into the developer; they are designed to stop developer action—and they will.

Dry side

Wet side

Gerry Russell's well-equipped darkroom features a 121-square-foot work space that includes a filtered, temperature-controlled water supply, two sinks that are 5 feet and 8 feet long, and two enlargers, one for printing 4 x 5-inch negatives, another for printing 8 x 10-inch negatives.

Enlarger projects light through the negative onto the printing paper. See pages 114–115.

Printing paper is coated with a light-sensitive emulsion onto which the image is exposed.

Easel holds printing paper flat on the enlarger's baseboard for enlargements. This easel has adjustable sides for cropping the image and creating white borders.

Printing frame holds negatives and paper tightly together for contact prints. A sheet of plain glass can be a substitute.

Focusing magnifier enlarges the film grain or the projected image when setting up an enlargement so that you can focus sharply.

Means of cleaning the negative. To remove dust, use a soft, clean brush, or, if you use compressed gas, buy a type such as Dust-Off, which does not contain environment-damaging chlorofluorocarbons. Use a liquid film cleaner to remove fingerprints or other sticky dirt; even better—handle negatives by their edges so they don't get dirty in the first place.

Safelight. Printing paper is exposed and developed under safelight, not ordinary room light. A relatively dim amber safelight produces enough light for you to see what you are doing, but not so much that the paper becomes fogged with unwanted exposure. A suitable safelight for most papers is a 15-watt bulb in a fixture covered with a light amber filter (such as Wratten OC) placed at least four feet from working surfaces. Check the manufacturer's instructions if you use any special-purpose papers; safelight filters vary for different types of papers.

Paper cutter or scissors cuts paper for test strips or small prints.

Timer or clock with sweep second hand times the processing.

Trays hold solutions during processing. For 8 x 10-inch prints, you'll need three trays of that size for developer, stop bath, and fixer, plus a larger tray to hold fixed prints until you are ready to wash them.

Tongs lift prints into and out of solutions, keeping your hands clean so that you don't need to wash and dry them so often. You'll need at least two sets, one for the developer only, one for stop bath and fixer.

Print washer circulates fresh water around prints to remove fixer during washing.

Washing siphon is a simple means of washing. It clamps onto a tray, pumps water into the top of the tray, and removes it from the bottom.

Sponge or squeegee wipes down wet prints to remove excess water before drying.

Drying racks or other devices dry prints after processing.

Developer converts into visible metallic silver those crystals in the paper's emulsion that have been exposed to light. Choose a developer made specifically for use with paper. Neutral or cold-tone developers such as Kodak Dektol produce a neutral or blue-black tone when used with neutral or cold-tone papers. Warm-tone developers such as Kodak Selectol increase the brown-black tone of warm-tone papers.

A concentrated stock solution lasts from 6 weeks to 6 months, depending on the developer and how full the storage container is; the more air in the container, the faster the solution deteriorates. Discard the diluted developer working solution if it turns dark, after about 30 8 x 10-inch prints have been developed per quart of working solution, or at the end of a working day.

Stop bath halts the action of the developer. A stop bath can be prepared from about 1 1/2 oz of 28 percent acetic acid to 1 quart of water.

Stop-bath stock solution lasts indefinitely. Discard the diluted working solution after treating 20 8 x 10-inch prints per quart. An indicator stop bath changes color when exhausted.

Fixer removes undeveloped silver halides from the emulsion. A fixer with hardener prevents softening and possible damage to the emulsion during washing, especially when the tap water temperature is high. A rapid fixer is supplied as a liquid and is faster acting than regular fixer.

Fixer stock solution lasts 2 months or more. Working solution lasts about a month in a full container and will process about 25 8 x 10-inch prints per quart before it should be discarded. A testing solution called hypo check (or fixer check) is the best test of fixer exhaustion.

Washing aid (also called fixer remover, hypo clearing bath, or hypo neutralizer), such as Heico Perma Wash or Kodak Hypo Clearing Agent, is optional but highly recommended for fiber-base prints. It is not used with RC (resin-coated) papers. It removes fixer better and faster than washing alone.

Capacity and storage time vary depending on the product; see manufacturer's instructions.

An enlarger can produce a print of any size—larger, smaller, or the same size as a negative, so it is sometimes more accurately called a projection printer. Most often, however, it is used to enlarge an image. An enlarger operates like a slide projector mounted vertically on a column. Light from an enclosed lamp shines through a negative and is then focused by a lens to expose an image of the negative on printing paper placed at the foot of the enlarger column. Image size is set by changing the distance from the enlarger head (the housing containing lamp, negative, and lens) to the paper; the greater the distance, the larger the image. The image is focused by moving the lens closer to or farther from the negative. The exposure time is controlled by a timer. To regulate the intensity of the light, the lens has a diaphragm aperture with f-stops like those on a camera lens.

Image size is limited by column height. For bigger prints, some enlargers tilt 90° or rotate to allow projection on a wall or floor.

An enlarger should spread light rays uniformly over the negative. It can do this in several ways. In a diffusion enlarger, a sheet of opal glass (a cloudy, translucent glass) is placed beneath the light source to scatter the light evenly over the negative, or the light rays are bounced within a mixing chamber before reaching the negative. In a condenser enlarger, lenses gather the rays from the light source and send them straight through the negative. Sometimes a combination of the two systems is used (see diagrams, opposite).

The most noticeable difference between diffusion and condenser enlargers is in contrast. A diffusion enlarger produces less contrast in a print than a condenser enlarger. A diffusion system has the advantage of minimizing faults in the negative, such as minor scratches, dust spots, and grain, by lessening the sharp contrast between, for example, a dust speck and its immediately surrounding area. Some photographers believe that this decreasing and smoothing of contrast can also result in a loss of fine detail and texture in a print, especially when a negative is greatly enlarged; however, many photographers find no evidence to support this.

The focal length of the enlarger lens must be matched to the size of the negative, as shown in the chart, opposite. If the focal length is too short, it will not cover the full area of the negative, and the corners will be out of focus or, in extreme cases, vignetted and too light in the print. If the focal length is too long, the image will be magnified very little unless the enlarger head is raised very high.

Condensers must be matched to the lens for even illumination. Depending on the enlarger, this is done by changing the position of the negative or condensers or by using condensers of different sizes.

The light source in an enlarger is usually a tungsten or quartz-halogen bulb, although in some diffusion enlargers a cold-cathode or cold-light source (fluorescent tubing) is used. Fluorescent light is usually not recommended for use with variable-contrast or color printing papers.

A stable and correctly aligned enlarger is a vital link in the printing process. The best camera in the world will not give good pictures if they are printed by an enlarger that shakes when touched or tends to slip out of focus or alignment. School enlargers, which get heavy use by a multitude of people, are particularly prone to problems. If you are doubtful about your enlarger's alignment, try setting its lens to a relatively small f-stop such as f/11 or f/16. This will increase the depth of field in the projected image, overcoming problems caused by the enlarger's stages not being exactly parallel.

ELAINE O'NEIL
Festival, Lidul Park, Guanxian, China, 1987

To make a black border like this on your prints, try to find a negative carrier with an opening slightly larger than the actual image. Or, you can enlarge an existing opening by filing away the edges—very carefully. If the opening is too large, it won't hold the negative flat, and if the edges are rough, you may scratch your negatives. Paint over the edges with flat black metal paint when you have finished.

When you're ready to print, adjust the easel blades so that the final print will include both the image and its black border.

TYPES OF ENLARGERS

A condenser enlarger uses one or more lenses to concentrate light directly on the negative. Exposures are shorter and black-and-white print contrast higher than with a diffusion enlarger. If color filters are inserted, the enlarger can be used for color printing.

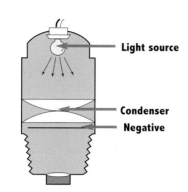

Light source

Condenser

Negative

A diffusion enlarger scatters unfocused light over the negative. Black-and-white image contrast is lower, and the effect of dust and other defects on the film is minimized. In this simple diffusion system, light from an incandescent bulb passes through a sheet of cloudy glass onto the negative. In a cold-light system, which can be used only for black-and-white printing, the light source is a grid of neon-like tubes.

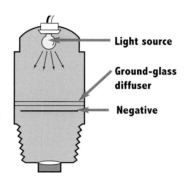

Light source

Ground-glass diffuser

Negative

Another type of diffusion enlarger bounces light from a high-intensity tungsten-halogen bulb into a diffusion chamber. In this dichroic color head, three color filters are built into the head for color printing or variable-contrast black-and-white printing. Dials move the filters into or out of the light beam to provide the desired amount of filtration.

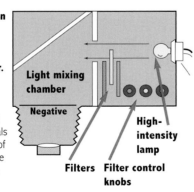

Light mixing chamber

Negative

High-intensity lamp

Filters Filter control knobs

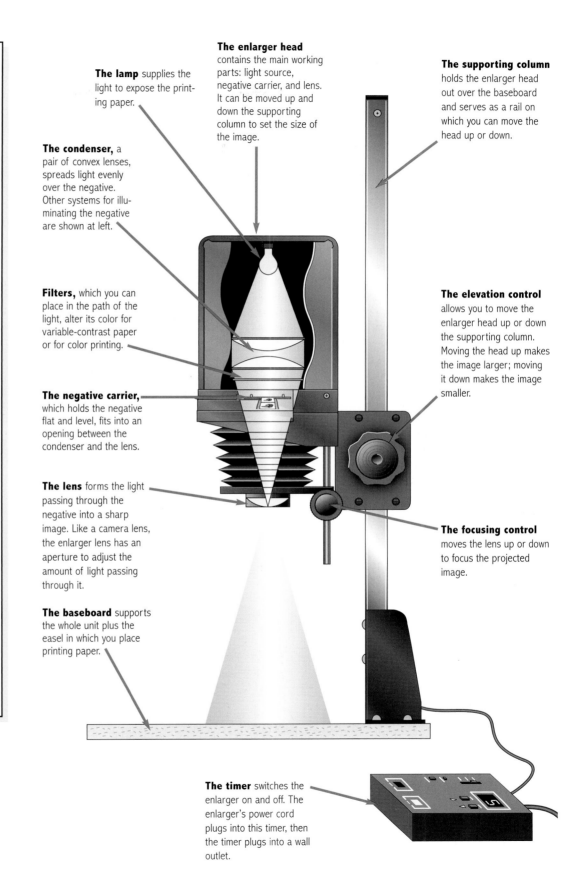

The lamp supplies the light to expose the printing paper.

The enlarger head contains the main working parts: light source, negative carrier, and lens. It can be moved up and down the supporting column to set the size of the image.

The supporting column holds the enlarger head out over the baseboard and serves as a rail on which you can move the head up or down.

The condenser, a pair of convex lenses, spreads light evenly over the negative. Other systems for illuminating the negative are shown at left.

Filters, which you can place in the path of the light, alter its color for variable-contrast paper or for color printing.

The elevation control allows you to move the enlarger head up or down the supporting column. Moving the head up makes the image larger; moving it down makes the image smaller.

The negative carrier, which holds the negative flat and level, fits into an opening between the condenser and the lens.

The lens forms the light passing through the negative into a sharp image. Like a camera lens, the enlarger lens has an aperture to adjust the amount of light passing through it.

The focusing control moves the lens up or down to focus the projected image.

The baseboard supports the whole unit plus the easel in which you place printing paper.

The timer switches the enlarger on and off. The enlarger's power cord plugs into this timer, then the timer plugs into a wall outlet.

ENLARGER LENS FOCAL LENGTH

Negative size	Focal length to use
35 mm	50–63mm
2 1/4 x 2 1/4 inches	75–80mm
2 1/4 x 2 3/4 inches	90–105mm
4 x 5 inches	135–165mm

Black-and-white printing papers vary in texture, color, contrast, and other characteristics (see box, opposite). Choices are extensive, but rather than buying a different type of paper every time, start with one type and explore its capabilities before trying others. A camera store should be able to show you paper samples. For your first prints, a package of variable-contrast, glossy, resin-coated (RC) paper will work well.

Variable-contrast paper is more economical than graded-contrast paper because you have to purchase only one package of paper. With a variable-contrast paper, you change contrast by changing the color of the enlarger light, so you will also need a set of variable-contrast filters or an enlarger with built-in filtration. Eventually you may want to add variety by trying graded papers, which some photographers believe produce a higher quality print.

Many photographers prefer a glossy surface, smooth-textured paper because it has the greatest tonal range and brilliance. Prints are seen by reflected light, and a matte surface or rough texture scatters light and so decreases the tonal range between the darkest blacks and the whitest highlights.

Resin-coated (RC) papers require much less washing time than fiber-base papers. They are often used in school darkrooms and are also popular for contact sheets and general printing. However, many photographers do not use RC papers for their better prints because they prefer the tonality and surface quality of fiber-base papers. The latter are also better for long-term archival preservation, a factor of particular interest if prints are sold to museums and photography collectors. Graded fiber-based papers are usually marketed as a premium product for fine-art printing.

Paper storage is important because stray light fogs unprocessed paper, giving it an overall gray tinge. Time and heat do the same. Store paper in a light-tight box in a cool, dry place. Open a package of paper only under darkroom safelight. Most papers last about two years at room temperature, considerably longer if kept refrigerated. Check the expiration date on the package.

FRANK P. HERRERA
Globe Swift, 1977

Smooth tones demand careful printing.
Herrera chose a warm-tone graded paper for this print.

Reproduced from a cold-tone print

Reproduced from a warm-tone print

Cold-tone papers produce a blue-black image; warm-tone papers produce a brown-black image. The developer you use can emphasize the paper tone.

BLACK-AND-WHITE PRINTING PAPERS

PHYSICAL CHARACTERISTICS

Texture. The surface pattern of the paper. Ranges from smooth to slightly textured to rough. Some finishes resemble canvas, silk, or other materials. Smoother surfaces reveal finer details in the image and any graininess of the negative more than rougher surfaces do.

Gloss. The surface sheen of the paper. Ranges from glossy (greatest shine) to luster or pearl (medium shine) to matte (dull). The dark areas of glossy papers appear blacker than those of matte papers; therefore, the contrast of glossy papers appears greater. Glossiness shows the maximum detail, tonal range, and grain in a print. Very high gloss can cause distracting reflections.

Paper base tint. The color of the paper stock. Ranges from pure white to off-white tints such as cream, ivory, or buff. Many papers contain optical whiteners to add brilliance to highlights.

Image tone. The color of the silver deposit in the finished print. Ranges from warm (brown-black) to neutral to cold (blue-black). Can be emphasized by the print developer used; a developer that helps produce a noticeably warm or cold tone indicates this on the package.

Weight. The thickness of the paper stock. Fiber-base papers are available in single weight and double weight. Single-weight papers are suitable for contact sheets and small prints. Double-weight papers are easier to handle during processing and mounting of large prints. RC papers come in a medium-weight base that is between single and double weight.

Size. 8 x 10 inches is a popular size. You can cut this into four 4 x 5-inch pieces for small prints. Some commonly available precut sizes include 4 x 5, 5 x 7, 11 x 14, 14 x 17, 16 x 20, and 20 x 24 inches.

Resin coating. A water-resistant, plastic-like coating applied to some papers. Resin-coated (RC) papers absorb very little moisture, so processing, washing, and drying times are shorter than for fiber-base papers. They also dry flat and stay that way, unlike fiber-base papers, which tend to curl. Too much heat during drying or mounting RC papers can damage the surface; see manufacturer's directions.

PHOTOGRAPHIC CHARACTERISTICS

Printing grade. The contrast of the emulsion. Graded papers are available in packages of individual contrast grades ranging from grade 0 (very low contrast) through grade 5 (very high contrast). Grade 2 or 3 is used to print a negative of normal contrast. With variable-contrast papers, only one kind of paper is needed; contrast is changed by changing filtration on the enlarger. Without a filter, variable contrast paper has the same contrast as with a #2 filter.

Speed. The sensitivity of the emulsion to light. A paper made for contact printing, like Kodak's AZO, is rather slow and requires a relatively large amount of light for exposure. Papers used for enlargement needs to be faster, since the enlarger can project only a rather dim light through a negative. The speed of different grades of graded papers can vary slightly; the speed of variable-contrast papers changes with the filtration.

Color sensitivity. The portion of the light spectrum to which the emulsion is sensitive. Printing papers are sensitive to the blue end of the spectrum; this makes it possible to work with them under a yellowish safelight. Variable-contrast papers are also somewhat green sensitive, with contrast being controlled by the color of the filter used on the enlarger. Panchromatic papers are sensitive to all parts of the spectrum; they are used to make black-and-white prints from color negatives.

Latitude. The amount that exposure or development of the paper can vary from the ideal and still produce a good print. Most printing papers (especially high-contrast papers) have little exposure latitude; even a slight change in exposure affects print quality. This is why test strips are useful in printing. Development latitude varies with different papers. Good latitude means that print density (darkness) can be increased or decreased somewhat by increasing or decreasing development time. Other papers have little development latitude; changing the development time to any extent causes uneven development, fogging, or staining of the print.

Premium papers. A few papers, which cost more than conventional papers, are capable of producing richer blacks and a greater tonal range. They contain extra silver in the emulsion or otherwise enhance the tonal range. Brands include Cachet Expo, Ilford Galerie, Kentmere Kentona, and Oriental Seagull.

A contact sheet or proof is useful when you want to choose a negative to enlarge. In contact printing, negatives are pressed against a sheet of photographic paper. A print is made by shining light through the negative to expose the paper. The result is a print that is the same size as the negative.

Don't be tempted to skip the contact printing stage and select a negative to be enlarged by looking only at the film itself. Pictures are often difficult to judge as negatives, and small size compounds the difficulty with 35mm negatives. If you made several shots of the same scene, they may differ only slightly from one another. A carefully-made contact will let you compare similar pictures. Use the contact sheet to find the frame you want to print but be careful not to make judgements about exposure or focus. Those are best made by viewing the negative itself through a loupe.

The back of the contact sheet is a good place to keep notes. You may want to record technical information, like exposure and development. It is also a good place to write those things that you may lose track of after several years and a few hundred more rolls of film—like where you were, when you were there, and who or what the subject was.

Contact sheets are easy to make. An entire roll (36 negatives of 35mm film or 12 negatives of 2 1/4 x 2 1/4-inch film) just fits on a single sheet of 8 x 10-inch paper. The contact sheet then becomes a permanent record of negatives on that roll. The procedure for making a contact print shown here uses an enlarger as the light source. Another method uses a contact printer—a box containing a light and having a translucent surface on which the negatives and paper are placed.

Making a test strip will help you determine the correct exposure for your first contact prints. A test strip has several exposures on the same piece of printing paper so you can choose the best one for the complete contact print.

NOTE: Make your test strip and contact print on a medium-contrast paper. Use a variable-contrast paper with a number 2 filter in the enlarger or a number 2 graded-contrast paper.

MAKING A CONTACT SHEET

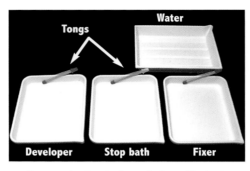

1 Prepare the developing solutions. Mix developer, stop bath, and fixer and set them out in trays along with a tray of water so they will be ready to use as soon as the print is exposed. Set out tongs, if you use them. See steps 1 and 2, page 125.

2 Prepare the enlarger. Insert an empty negative carrier and lower the enlarger head onto the carrier. If you will be using variable-contrast paper, insert a #2 filter into the enlarger's filter drawer. Turn on the enlarger lamp and raise the head until the light that is projected covers slightly more than the entire printing frame or easel. Turn the lamp off. Open the lens aperture to f/4.

3 Identify the emulsion side of the film. The emulsion side of the film must face the emulsion side of the paper or your prints will be reversed left to right. Film tends to curl toward its emulsion side, which is usually duller than the backing side. You are looking at the emulsion if the frame numbers on the edge of the film read backwards.

4 Identify the emulsion side of the paper. Darkroom safelights should be on, with room lights and enlarger lamp off, before opening the package of paper. The emulsion side of paper is shinier and, with glossy papers, smoother than the back. Fiber-base paper curls toward the emulsion. RC paper curls little, but may have a visible manufacturer's imprint on the back.

You'll need only a small piece of paper to test the exposure. Cut an 8 x 10-inch sheet of printing paper into strips, about 2 x 5 inches each. Put all but one strip back in the package and close it.

5 Place negatives and test strip under glass.
You can leave the negatives in clear plastic storage pages, if you wish. The contact print will not be quite as sharp, but leaving the negatives in the page saves time, minimizes handling, and protects against accidental damage.

The paper goes emulsion side up. The negatives go above the paper, emulsion side down. You can use a printing frame to hold the negatives and paper tightly together. If you don't have a printing frame, put the paper on an easel or on the enlarger's baseboard, with a plain, clean sheet of glass over all.

6 Expose the test strip. Set the enlarger timer to 5 sec. Press the timer button to turn the enlarger light on and expose the entire test strip. Cover about 1/5 of the strip with a piece of cardboard. Expose for 5 sec. Give the strip three more 5-sec exposures, covering an additional 1/5 of the strip for each exposure. Your finished test strip will have five exposures of 5, 10, 15, 20, and 25 sec.

7 Process the test strip as shown on pages 124–127.

25 20 15 10 5 sec
63 TX 23 KODAK 5063 TX 24 KODAK 5063 TX 25

8 Evaluate the test strip in room light to select a printing time. Look at the sprocket holes along the film edges. Choose the segment that just barely shows a difference between the sprocket holes and the surrounding film.

Don't be influenced by the images on the test strip. Standardizing the exposure of the contact print will give you a better guide to the negatives. When you are ready to make an enlarged print, it will be useful to see, for example, which images are too dark on the contact sheet (negative was underexposed) or too light (overexposed).

9 Make a complete contact print. Insert a full sheet of printing paper under the glass and expose for the selected time. Process the print.

Personal judgments are important when selecting negatives for enlargement when you have many shots of the same scene. Which had the most pleasing light? Which captured the action most dramatically? Which expressions were the most natural or most revealing? Which is the best picture overall? Use a permanent marker or a grease pencil (also called a china marker) to mark the contact sheet as a rough guide for cropping. Permanent markers don't smear and will also write on the plastic of your negative pages; the advantage of a grease pencil is that you can rub off the marks to try a different cropping.

Consider technical points as well. As an example, is the negative sharp? With a magnifying glass, examine the negative itself, and all similar negatives, to check for blurring caused by poor focusing or by movement of the camera or subject. If the negative is small—particularly if it is 35mm—even slight blurring will be quite noticeable in an 8 x 10-inch enlargement because the defects will be enlarged as well.

Standardized exposure and development of your contact sheets will help you evaluate the individual frames. On the contact sheet, sprocket holes should be black against just barely visible film edges, as shown in step 8, page 119. If a negative was considerably underexposed in the camera (shown on the contact sheet as a picture that is very dark) or considerably overexposed (a picture that is very light), it will be difficult or even impossible to print successfully. However, minor exposure problems (a picture a little too light or dark on the contact sheet) can be remedied during enlargement.

A standardized contact sheet can also help you estimate what filter to use with variable-contrast paper or what contrast grade of graded paper to use. The higher the contrast of the image on the contact sheet, the lower the filter or the lower the contrast grade of paper you'll need.

SETTING UP AN ENLARGEMENT

1 Select a negative for printing. Under bright light, examine the processed contact sheet with a magnifying glass or loupe to determine which negative you want to enlarge.

2 Insert the negative in the enlarger's carrier. Place the negative over the window in the carrier and center it. The emulsion side must face down when you put the carrier in the enlarger.

3 Clean the negative. Use an antistatic brush or compressed air to dust the negative and the carrier. Look for dust by holding the negative at an angle under the enlarger lens with the lamp on; it is often easier to see dust with room lights off. Dusting is important because enlargement can make even a tiny speck of dust on the negative big enough in the final print to be visible.

4 Insert the negative carrier in the enlarger. If you work in a darkroom with others, turn the enlarger lamp off whenever you insert or remove the negative carrier so that stray light doesn't fog other people's undeveloped paper. Room lights should be off so that you can see the image clearly for focusing.

5 **Open the enlarger's aperture.** Set the lens to its widest f-stop so you will have maximum light for focusing. Turn on the enlarger lamp.

6 **Insert a piece of white paper in the easel.** Paper shows the focus better than even a white easel surface.

7 **Adjust the masking blades of the easel.** Set them first to hold the size of the paper being used and later to set borders and crop the image.

8 **Arrange the picture.** Raise or lower the enlarger head to get the desired degree of image enlargement, adjusting the easel as needed to compose the picture.

9 **Focus the image.** Focus by turning the knob that raises and lowers the lens. Shift the enlarger head only if you want to change the size of the enlargement.

10 **A magnifier helps make the final adjustments in focus.** Some types magnify enough for you to see and focus on the grain in the negative.

A test strip will give you some exposure choices for your final print. The test will show strips of your image exposed for increasing times. The test print shown here exposes each strip 5 seconds longer than its neighbor and produces total exposures of 5, 10, 15, 20, and 25 seconds.

Try a number 2 enlarger filter with variable-contrast paper or use a number 2 graded-contrast paper.

Stop down the enlarger lens a few stops from its widest aperture. This gives good lens performance plus enough depth of focus to minimize slight errors in focusing the projected image.

Due to the intermittency effect, five separate exposures of 5 seconds each may not produce exactly the same effect as a single 25-second exposure. However, the procedure described here is satisfactory for all but the most exacting purposes. If you ever need to do critical testing, you can prevent any possible variation by uncovering only a single segment of the test strip at a time and exposing it for the full length of the desired exposure.

MAKING A TEST STRIP

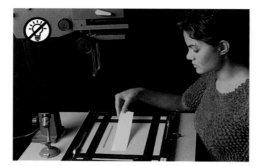

1 Insert paper for a test strip. Before you turn the enlarger lamp off, locate an important highlight in the image, a light tone (dark in the negative) such as light-colored skin, clothing, or some other light area in the scene. Turn the enlarger lamp off. Remove a strip of paper (a 2 x 5-inch strip will be adequate) and place it, emulsion side up, approximately where the light-toned part of the image is.

2 Expose the test strip. Set the enlarger timer to 5 sec. Press the timer button to turn the enlarger light on and expose the entire test strip. Cover about 1/5 of the strip with a piece of cardboard. Expose for 5 sec. Give the strip three more 5-sec exposures, covering an additional 1/5 of the strip each time. Your finished test strip will have five exposures of 5, 10, 15, 20, and 25 sec.

For a test print with a greater range of tones, double the differences in the total exposure for each strip. For example, to get total exposures of 2 1/2, 5, 10, 20, and 40 sec, expose the entire strip for 2 1/2 sec. Cover 1/5 and expose for 2 1/2 sec. Cover 2/5 and expose for 5 sec. Cover 3/5 and expose for 10 sec. Cover 4/5 and expose for 20 sec.

25 sec

20 sec

15 sec

10 sec

5 sec

3 Process the test strip as shown on pages 124–127.

4 Evaluate the test strip in room light to select a printing time. Look for the time that produced good texture and detail in lighter areas. Remember that the greater the exposure, the darker the print will be.

Time, rather than aperture setting, is generally changed when adjusting the exposure during printing. If the negative is badly overexposed or underexposed, however, change the lens aperture to avoid impractically long or short exposure times.

If you bring the wet print away from the darkroom sink, put it in a tray or on a paper towel so it doesn't drip fixer where you don't want fixer to be.

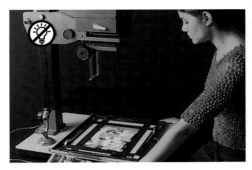

1 Expose a full-size trial print. Recheck the focus. Set the timer to the exposure indicated by the test strip. Insert a full sheet of paper in the easel and expose.

2 Process the print as shown on pages 124–127. After fixing for about half the total fixing time, you can evaluate the print in room light.

Now you are ready to make a full-size print. Don't be discouraged if the print is less than perfect on the first try. Often several trials must be made. For economy, you may want to cut a sheet of paper into quarters to make smaller test prints until you are sure of your exposure and contrast.

Evaluate the print under ordinary room light. Darkroom safelight illumination makes prints seem darker than they actually are. **NOTE:** Some papers will "dry down" and be 5–10 percent darker than a wet print when dry; you can reduce the exposure time accordingly to allow for that. If you change print contrast, the printing time is also likely to change, so make another test strip for the new contrast grade.

Dodging and burning. Most prints need some local control of exposure to lighten or darken specific areas, which you can provide by holding light back (dodging) or adding light (burning).

When you are satisfied with a print, complete the fixing, washing, and drying. To make reprints simpler, make a note of the final aperture, exposure time, and burning and dodging times.

3 Look at the highlights to confirm the exposure time. Are light-toned areas bright, but with good texture and detail? It is not always possible to tell from a test strip how all areas of the print will look.

When highlights are right, look at the shadows to evaluate the contrast. Are shadows inky black with little or no detail? Decrease the contrast by using a lower number filter with variable-contrast paper or a lower grade with graded-contrast paper. Are shadows flat and gray looking? Increase the contrast by using a higher number variable-contrast filter or a lower grade of graded-contrast paper.

If you are not sure whether or not the contrast should be changed, test by exposing a small piece of printing paper with increased (or decreased) contrast. Expose the paper across a dark area of the image, process it, then see if it improves the dark values.

PROCESSING A BLACK-AND-WHITE PRINT—A SUMMARY

STEP	YOU'LL NEED	PROCEDURE	TIPS FOR BETTER PRINTS
1–2. Preparation (numbered steps begin on opposite page)	Developer (suitable for papers), stop bath, and fixer; a washing aid is recommended for fiber-base prints. Manufacturer's recommendations for dilutions and processing times. Trays, two or three pairs of tongs, thermometer.	Mix the chemical stock solutions needed. Dilute to working strength and adjust temperature as recommended by manufacturer.	Temperature control is less critical for black-and-white printing than for negative development. 65°–70° F is ideal; 60°–75° F is acceptable. Below 65° F, chemicals take longer to work. Much above 75° F, the developer can fog or gray the highlights, and the paper emulsion softens and is more easily damaged.
3–5. Development	Developer timer	After exposing the paper, slip it quickly and completely into the developer and begin to agitate. Development times can range from 45 sec to 4 min (see manufacturer's directions). Agitate gently and constantly with tongs or by rocking the tray. If two or more prints at a time are processed, rotate individual prints from bottom to top of the stack in the tray.	Do not cut short the development time to salvage a print that darkens too rapidly; uneven development, mottling, and loss of contrast will result. If the print is too dark, make another with less exposure. Development time for some papers can be extended to slightly darken a too-light print, but this can also cause staining. If the print is too light, make another with more exposure.
Selective development	Developer cotton swab or ball	You can darken part of a print during development by gently rubbing the area while holding the print out of the tray or by pulling the print out of the tray, rinsing it with water, and swabbing the area with cotton dipped in warm or concentrated developer.	Prints kept too long out of the developer will stain. Darkening individual areas by burning during exposure works better.
6–8. Stop bath	Stop bath	Agitate prints in stop bath for 30 sec (5–10 sec for RC paper). Agitation during the first few seconds is important.	Keep stop bath fresh by draining developer from print for a few seconds before putting print into stop bath. Avoid getting stop bath or fixer into the developer; use developer tongs only in developer tray, stop bath-fixer tongs only in those trays.
9–11. Fixing	Fixer	Fix for the time recommended by manufacturer, as little as 30 sec for RC paper to as much as 5–10 min for fiber-base paper. Agitate frequently. If several prints are in the fixer at one time, agitate more often and rotate individual prints from bottom to top of the stack. If fixer becomes exhausted during a printing session, refix all prints in fresh fixer.	The most complete and economical fixing uses two trays of fixer. Fix the print in the first tray for half the fixing time. Then transfer the print to the second tray for half the fixing time. When the fixer in the first tray is exhausted, replace it with the solution from the second tray. Mix fresh fixer for the second tray.
Holding until wash	Tray of water	After fixing, place prints in a large tray filled with water until the end of the printing session. Gently run water in tray or dump and refill frequently. Wash RC paper promptly for best results; ideally, total wet time for RC should not exceed 10 min.	Remove prints promptly from fixer at the end of the fixing time or they will take longer to wash and may bleach or stain.
12. Washing aid (highly recommended for fiber-base prints)	Washing aid	Rinse prints in running water for about 1 min (or as directed). Then agitate prints in the washing-aid solution for the time indicated by the manufacturer—usually just a few minutes. Do not use a washing aid with RC paper.	While using a washing aid with fiber-base paper is optional, it is a very good practice. Prints treated with a washing aid will be washed cleaner of residual chemicals than untreated prints and in much less time.
13. Washing	Source of running water. A washer designed for prints or a tray and siphon.	Wash RC paper 4-5 min; change water several times. If a washing aid is used with fiber-base prints, wash 10–20 min (or as directed). Otherwise, wash for at least 1 hr. Adjust the water flow or dump and refill the tray so that the water changes at least once every 5 min.	If several prints are washed at one time, they must be separated or circulated so that fresh water constantly reaches all surfaces. Some print washers do this automatically. In a tray, it must be done by hand.
14–15. Drying	Sponge or squeegee. A means of drying the prints, such as a blotter roll, a heated dryer, drying racks, or simply a clean surface.	Sponge or squeegee excess water off each print. RC paper dries well on racks, face up. Fiber-base paper can be dried on racks face down, on a heated dryer, or between blotters.	

PREPARATION

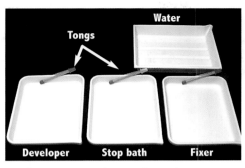

1 **Set out trays and tongs.** Set out four trays—one each for developer, stop bath, fixer, and water. If you use tongs, use at least two pairs: one for the developer and one for stop bath and fixer. Never put the stop-bath or fixer tongs in the developer tray. Until the print is fixed, expose it only to safelight, not ordinary room light.

2 **Prepare the solutions.** Mix the processing solutions and adjust their temperatures. Solution temperatures are not as critical as in film development. Manufacturers often recommend about 68° F for the developer, 65° to 75° F for stop bath and fixer.

DEVELOPMENT

3 **Begin development.** Turn darkroom safelights on, room lights off. Expose the print. Slip the exposed printing paper smoothly into the developer, emulsion side up, immersing the surface of the print quickly.

4 **Agitate the print gently in the developer.** Rock the developer tray gently and continuously to agitate the print. If you must use tongs to agitate the print because the tray is too big to rock, avoid touching the print's image area with the tongs. Tongs can leave scratch marks on the print. Develop for the time recommended for the developer and paper. If the print develops too rapidly or too slowly, process for the standard time anyway. After processing, you can examine the print and change exposure as needed.

5 **Drain developer from the print.** Hold the print above the tray for a few seconds so that the developer solution, which weakens the stop bath, can drain away.

STOP BATH

6 **Transfer the print to the stop bath.** The stop bath chemically neutralizes the developer on the print, halting development. Keep developer tongs out of the stop bath.

7 **Agitate the print in the stop bath.** Keep the print immersed in stop bath for 30 sec (5–10 for RC [resin-coated] paper), agitating gently. Use stop-bath tongs.

8 **Drain stop bath from the print.** Again lift the print so that solution can drain into the stop-bath tray. Don't let stop-bath solution splash into developer.

FIXING

9 **Transfer the print to the fixer.** Slip the print into the fixer and keep it submerged.

10 **Agitate the print.** Continuous agitation is not necessary, but agitate the print frequently so that fresh fixer remains in contact with the print. Fix the print as recommended by the manufacturer, as little as 30 sec for RC paper to as much as 5 to 10 min for fiber-base paper. Room lights can be turned on after about half the fixing time and the print examined. Make sure your package of printing paper is closed before turning on the lights.

11 **Remove the print from the fixer.** After fixing, transfer the print to a water-filled holding tray until you are ready to wash.

WASHING

12 **Treat a fiber-base print in a washing aid.** This step is optional but highly recommended for fiber-base papers because it greatly reduces the washing time required. A washing aid is not needed with RC (resin-coated) papers.

13 **Wash the print.** Wash an RC print for 4 min. Wash a fiber-base print that has been treated with a washing aid for 10 min (single-weight paper) to 20 min (double-weight paper), or as recommended by manufacturer. Wash a fiber-base print that has not been treated with a washing aid for at least 60 min.

14 **Remove surface water from the print.** Place the print on a clean sheet of plastic or glass. An overturned tray will do if you clean it well and the tray bottom is not ridged. Use a clean photo sponge, a squeegee, or your hand to gently wipe down first the back of the print, then the front.

DRYING

15 **Dry the print.** Drying methods range from temperature-controlled automated dryers (above) to simply letting the print air dry.
 Make sure any drying surface that the print comes in contact with is clean. One poorly washed print still loaded with fixer and placed in a dryer will contaminate and stain other prints that are dried in the same position.

Drying racks covered with fiberglass screening let prints air dry at room temperature. Place fiber-base prints face down, RC prints face up. Wash the screening from time to time to keep it clean. You can dry RC papers simply by placing them face up on a clean surface.

A blotter roll or book made for photo use is one way to dry fiber-base papers. Replace any blotter that becomes tinged with yellow, a sign of fixer contamination.

Evaluating Density and Contrast in a Print

Prints are judged—and adjusted—for density and contrast. The goal during printing is usually to make a full-scale print—one that has a full range of tones (rich blacks, many shades of gray, brilliant whites) and a realistic sense of texture and substance (opposite page, bottom). You may deliberately depart from this goal at times, but first learning how to make a full-scale print will give you control over your materials so that later you can produce whatever kind of print you want. When you are evaluating a print and deciding how to improve it, do your judging under ordinary room light because prints look much darker under safelight.

Density refers to the overall darkness or lightness of the print (opposite, top left). It is controlled primarily by the amount of exposure given the paper—the greater the exposure, the greater the density of silver produced and the darker the print. Exposure can be adjusted either by opening or closing the enlarger lens aperture or by changing the exposure time, usually the latter.

Contrast is the difference in brightness between light and dark areas within the print (opposite, top right). A low-contrast or flat print seems gray and weak, with no real blacks or brilliant whites. A high-contrast or hard print seems harsh and too contrasty: large shadow areas seem too dark and may print as solid black; highlights, very light areas, seem too light and may be completely white; texture and detail are missing in shadows, highlights, or both. The contrast of a print is controlled mainly by the contrast grade of the paper used or, with variable contrast paper, by the printing filter used.

How to proceed. First, judge the density to find the correct exposure. Then, judge the contrast to find the correct contrast grade of printing filter or paper. Finally, evaluate the print overall. With some experience, you can judge both density and contrast at the same time, but it is easier at first to adjust them separately.

Judge the density. Make a test strip (shown on page 122). Examine the test strip or trial print for an exposure that produced highlights of about the right density, especially in areas where you want a good sense of texture. If all sections of a test strip seem too light, make another test strip with more exposure by opening the enlarger aperture a stop or two. If all seem too dark, make a test with less exposure by stopping down the aperture.

Judge the contrast. When the highlights seem about right in one section of the test, examine the shadow areas in that section. (Sometimes it helps to compare the shadow areas to a small piece of paper that has been exposed and developed to be pure black.) If they are too dark (if you can see details in the negative image in an area that prints as solid black), your print is too contrasty. Make another test strip on a lower-contrast paper. If your shadow areas are too light and look weak and gray, your print does not have enough contrast. Make another trial using a higher-contrast paper.

Evaluate the print overall. When one of the tests looks about right, expose the full image so you can judge both the density and contrast of the entire print. It can be difficult to predict from a small test strip exactly how an entire print will look, so now take a look at the density and contrast of the print overall. Examine the print for individual areas you may want to darken by burning or lighten by dodging. Prints, especially on matte-finish papers, tend to dry down, or appear slightly darker and less contrasty when dry. Experience will help you take this into account.

If you are printing a portrait that is mostly a close-up of the person's face, the skin tones are most important. Adjust the exposure so that bright skin areas are not completely textureless, but show a little detail. Then, if necessary, adjust the contrast. Beginners tend to print skin tones too light, without a feeling of substance and texture.

DENSITY

40 sec

20 sec

10 sec

5 sec

2 1/2 sec

Increasing printing time

CONTRAST

#5 contrast-grade paper or #5 filter

#4 contrast-grade paper or #4 filter

#3 contrast-grade paper or #3 filter

#2 contrast-grade paper or #2 filter

#1 contrast-grade paper or #1 filter

Increasing print contrast

Test prints help you judge the density (darkness) and contrast of a print. First, choose the exposure that renders good detail in important highlight areas. Then, look at dark areas; if they appear neither too dark and harsh nor gray and flat, the contrast of the print is correct.

DENSITY

Too light. *Increase exposure time.*

Too dark. *Decrease exposure time.*

CONTRAST

Too flat. *Use higher contrast paper grade or higher print filter.*

Too contrasty. *Use lower contrast paper grade or higher print filter.*

BLACK-AND-WHITE TEST PATCHES

Black-and-white test patches are an aid in judging a print. To evaluate the density and contrast of a print, you need standards against which to compare the tones in your print, since the eye can be fooled into accepting a very dark gray as black or a very light gray as white, enough to make the difference between a flat, dull print and a rich, brilliant one. Two small pieces of printing paper will help, one developed to the darkest black and the other to the brightest white that the paper can produce. By placing a black or white patch next to an area, you can accurately judge how light or dark the tone actually is.

As a bonus, the black patch indicates developer exhaustion; the developer should be replaced when you are no longer able to produce a black tone in a print as dark as the black patch no matter how much exposure you give the paper. The white patch will help you check for the overall gray tinge caused by safelight fogging.

Make the patches at the beginning of a printing session when developer and fixer are fresh. Cut two 2-inch-square pieces from your printing paper. Use the enlarger as the light source to make the black patch. Set the enlarger head about a foot and a half above the baseboard. The patch should be borderless, so do not use an easel. Expose one patch for 30 seconds at f/5.6; do not expose the other. Develop both patches with constant agitation for the time recommended by the manufacturer. Process as usual with stop bath and fixer. Remove promptly from fixer after the recommended time, then store in fresh water. To avoid any possible fogging of the white patch, cut and process the paper in a minimum amount of safelight.

950 HATS, DON'S BAR: MEMPHIS, NEBRASKA

JIM STONE Don's Bar, 1983

A full-scale print of normal density and contrast will have texture and detail in both major highlights and important shadow areas. With a little printing experience, you will be able to judge whether a print is too light, too dark, too flat, or too contrasty (see top of page).

This photograph was made on Polaroid Type 55 4 x 5 film, which produces both a positive print and a negative. The negative was later reprinted in a 5 x 7 glass negative carrier so that the entire edge of the negative shows.

Contrast—the relative lightness and darkness of areas in a scene—is important in any photograph. Frequently you will want normal contrast—a full range of tones from black through many shades of gray to pure white. Sometimes, however, you may feel that a particular scene requires low contrast—mostly a smooth range of middle grays (such as a scene in the fog). For another scene (perhaps a fireworks display or a rock band) you may want high contrast—deep blacks and brilliant whites and limited detail in between. By the time you are ready to make a print, the contrast of the negative has been set, by the contrast in the subject itself, the type of film, and the way it was developed.

You can adjust the contrast of the final print. You can use a variable-contrast paper, with which you alter the contrast by changing the color of the enlarger light with filters. Or you can use a graded-contrast paper, each grade of which has a fixed contrast.

Suppose you shot a scene in very contrasty light. Your negative would probably have large differences between its thinnest and densest areas, producing too-dark shadows and overly bright highlights. Printing on a low-contrast paper will decrease this contrast, making shadows not so dark, highlights not so bright.

If you shot in flat, dull light, the reverse would be true. Your negative might have relatively small differences between its thinnest and densest areas, producing weak shadows and grayish highlights. Printing the negative on a high-contrast paper, however, would create greater differences between the darkest and lightest areas and so more contrast overall.

Other factors besides the printing paper affect contrast: the enlarger, the surface finish of the paper, and the type of paper developer. (Kodak Selectol-Soft, for example, lowers contrast.) But the basic ways of changing contrast in a print are to use a different contrast grade of paper or to use a different contrast filter with variable contrast paper (see below).

GRADED-CONTRAST PAPERS

Some photographers prefer to work with graded-contrast papers. Even though you have to purchase each contrast grade separately, graded papers are made in a greater variety of surface finishes than variable-contrast papers are.

Graded-contrast papers are available in grades 0 and 1 (low or soft contrast) through grade 2 (normal or medium contrast), grade 3 (sometimes used as the normal contrast grade for 35mm negatives), and grades 4 and 5 (high or hard contrast). Not all papers are made in all contrast grades and not all manufacturers use the same grading system, so some experimentation may be needed with a new brand of paper.

VARIABLE-CONTRAST PAPERS

With variable-contrast paper, you produce different degrees of contrast by filtering the enlarger light. The paper is coated with two emulsions. One, sensitive to yellow-green light, produces low contrast; the other, sensitive to blue-violet light, produces high contrast.

You change the contrast of your print by inserting appropriately colored filters in the enlarger. A typical filter set has eleven filters numbered 0, 1/2, 1, 1 1/2, 2, and so on, rising by half steps to number 5. The number 2 filter is about equal to a grade 2 in a graded-contrast paper; also, variable-contrast paper will usually be a grade 2 if you use no filter.

The filtration affects the color of the light that reaches the printing paper from the enlarger light source and thus controls print contrast. The lower the number of the filter, the less the contrast. If you have an enlarger with a dichroic head, used for color printing, you can dial in the filtration.

Variable-contrast paper is convenient and economical because you buy only one kind of paper. You can get a range of contrast out of one package of paper and a set of filters instead of having to buy several different packages of graded-contrast paper. Because the filters come in half steps, it is easy to produce intermediate contrast grades. You can also fine tune the contrast by burning or dodging with different filters or by printing with more than one filter (see split-filter printing, opposite page).

Change the exposure if you switch between filters. Filters 0 to 3 1/2 are density matched, which means they all require about the same printing exposure. Filters 4 to 5 need about one additional stop of exposure. With a color enlarger head, you must change the exposure each time you dial in a new filtration. It is always a good idea to make a new test strip any time you change filtration, and even when you use up a box of paper and open a new one—the emulsion speed can change slightly between batches.

Changing the contrast of a print. Depending on the graded-contrast printing paper or the variable-contrast printing filter used, a print will show more, less, or about the same amount of contrast as is in the negative. Compare the range of tones in the prints at right. The higher the number of the paper or of the filter, the greater the contrast of the print.

#0 contrast-grade paper or #0 filter

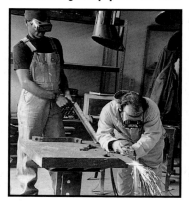

#1 contrast-grade paper or #1 filter

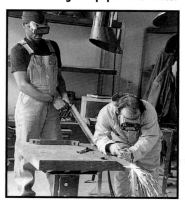

SPLIT-FILTER PRINTING WITH VARIABLE-CONTRAST PAPER

Test strip with number 0 filter

Combined exposure

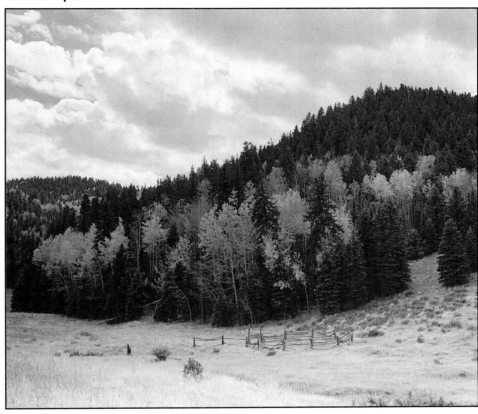

Test strip with number 5 filter

Split-filter printing lets you fine tune print contrast. It uses a low-contrast filter to control bright areas and a high-contrast filter to control dark areas.

1. Make a test strip with a number 0 filter in place. Choose the best exposure for the highlights.

2. Make a second test strip with a number 5 filter. Choose the best exposure for the dark areas.

3. Make a full print first through the number 5 filter, then on the same piece of paper through the number 0 filter. Be sure to use the number 5 filter first or the highlights will be too dark.

In the photo above, the two filters produced rich blacks plus good detail in the sky.

#2 contrast-grade paper or #2 filter

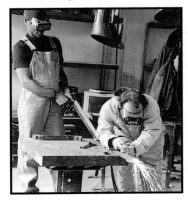

#3 contrast-grade paper or #3 filter

#4 contrast-grade paper or #4 filter

#5 contrast-grade paper or #5 filter

Dodging and Burning

You can give different exposures to different parts of a print by dodging and burning. Often, the overall density of a print is nearly right, but part of the picture appears too light or too dark—an extremely bright sky or a very dark shadow area, for example.

Dodging lightens an area that prints too dark. That part of the print is simply shaded during part of the initial exposure time. A dodging tool is useful; the one shown at right, top, is a piece of cardboard attached to the end of a wire. Your hand, a finger, a piece of cardboard, or any other appropriately shaped object can be used (right, top). Dodging works well when you can see detail in shadow areas in the negative image. Dodging of areas that have no detail or dodging for too long merely produces a murky gray tone in the print.

Burning adds exposure when part of a print is too light. After the entire negative has received an exposure that is correct for most areas, the light is blocked from most of the print while the area that is too light receives extra exposure. A large piece of cardboard with a hole in it works well. You can use your hands, cupped or spread so that light reaches the paper only where you want it to (right, bottom).

If you want to darken an area considerably, try flashing it—exposing it directly to white light from a small penlight flashlight. Unlike burning, which darkens the image, flashing fogs the paper: it adds a solid gray or black tone. Tape a cone of paper around the end of the penlight so it can be directed at a small area. Devise some method to see exactly where you are pointing the light. Either do the flashing during the initial exposure or add the flashing afterward with the enlarger

light on and an orange or red filter held under the lens. The filter prevents the enlarger light from exposing the paper but lets you see the image during the flashing. With variable-contrast paper, the filter may not block all the light that the paper is sensitive to, so keep the enlarger light on for a minimum of time.

TIP: Keep the dodging or burning tool, your hands, or the penlight moving. Move them back and forth so that the tones of the area you are working on blend into the rest of the image. If you simply hold a dodging tool, for example, over the paper, especially if the tool is close to the paper, an outline of the tool is likely to appear on the print.

Many prints are both dodged and burned. Depending on the print, shadow areas or dark objects may need dodging to keep them from darkening so much that important details are obscured. Sometimes shadows or other areas are burned to darken them and make distracting details less noticeable. Light areas may need burning to increase the visible detail. Skies are often burned, as they were on the opposite page, to make clouds more prominent. Even if there are no clouds, skies are sometimes burned because they may seem distractingly bright. They are usually given slightly more exposure at the top of the sky area than near the horizon. Whatever areas you dodge or burn, blend them into the rest of the print so that the changes are a subtle improvement rather than a noticeable distraction.

Digital-imaging software includes dodging and burning capability. Any changes you make to an image can be saved so that the next time you print it, you won't have to repeat the dodging and burning.

Dodging holds back light during the basic printing exposure to lighten an area.

Burning adds light after the basic exposure to darken an area.

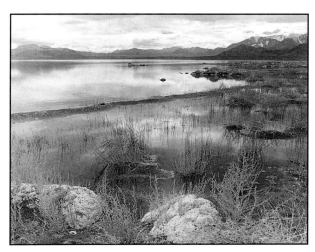

Above, the original, straight print was exposed for 10 seconds without any manipulation. Below, each band of a test strip became darker as the photographer added light. Test strips not only help determine the best overall exposure, but also guide decisions about how much more time to expose certain areas (burn) or how much time to subtract from the basic exposure (dodge) in parts of the print.

5 sec 10 sec 15 sec 20 sec
Additional exposure

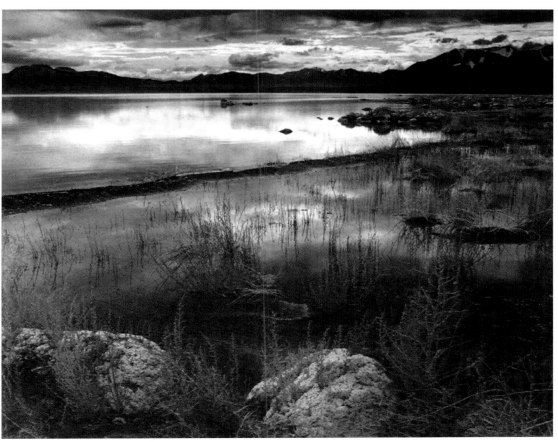

GERRY RUSSELL Mono Lake

Dodging, burning, and the exposure in general give you choices. You can make a relatively realistic rendition of a scene or choose to emphasize and dramatize parts of it, as in sky above.

Reprints will be easier if you make notes of what you did. A very light print (left) or a sketch of the print records how much to burn or dodge each part of the image.

ARNOLD NEWMAN Igor Stravinsky, 1946

Arnold Newman is famous for portraits that use graphic and symbolic elements to suggest what a person does. One of his best-known photographs is of the composer Igor Stravinsky, a portrait that Newman cropped to its essentials. Newman knew what he wanted to do, but, just starting out at the time, he didn't have a longer lens. He moved back until he had what he wanted in the frame, then cropped the photograph later. Newman says that the image "echoed my feelings about Stravinsky's music: strong, harsh, but with a stark beauty of its own." (Page 235 shows Newman at work.)

Eventually you must decide on cropping—what to leave out and what to include along the edges of a photograph. Some photographers prefer to crop only with the camera. They frame their subject in the viewfinder, and do not change the cropping later. However, most photographers crop while printing if doing so improves the image.

Sometimes cropping improves a picture by eliminating distracting elements. Sometimes a negative is cropped to fill a standard paper size; square negatives may be cropped so that when enlarged they fit a rectangular format. Cropping can direct the viewer's attention to the forms and shapes as the photographer saw them.

Cropping by enlarging a very small part of a negative can create problems, because the greater the enlargement, the more grain becomes noticeable and the more the image tends to lose definition and detail. It is best to get exactly what you want on the negative, but within reasonable limits cropping can improve many photographs.

Two L-shaped guides will help you decide how to crop a picture. Place them over the photograph to try various croppings, as shown at right. Think of the photograph as a window and notice how the edges of the frame cut or enclose the objects in the picture. You can experiment with the guides on the contact sheet, although the image there is small, but you will probably want to refine your cropping when you enlarge the image. Making an enlargement of the entire negative before doing any cropping can be useful because there may be potential in the print you would not otherwise see.

Two L-shaped pieces of paper are useful cropping tools. Lay them over a photograph to help you visualize different croppings.

ARCHIVAL PRINT PROCESSING

Following is one standard procedure for archival processing. Ilford has developed another method that shortens processing times considerably. Details can be found with Ilfobrom Galerie printing paper.

Paper. Use a fiber-base paper. RC papers are not recommended for archival processing because of the potential instability of the polyethylene that coats them.

Exposure and development. Expose the print with a wide border—at least 1 inch around the edges. Develop for the full length of time in fresh developer at the temperature recommended by the manufacturer.

Stop bath. Agitate constantly for 30 sec in fresh stop bath.

Fixing. Use 2 baths of fresh fixer. Agitate constantly for 3–5 min in each bath. You can agitate a print in the first bath and store it in gently running water (or in several changes of water) until a number of prints have accumulated. Then all prints can be treated for 4 min in the second bath by constantly shuffling one print at a time from the bottom to the top of the stack.

First Washing. Wash at 75°–80° for five minutes. Separate the prints frequently if the washer does not. Ideally, the water in the washer should completely change at least once every 5 min.

Protective toning. Use the selenium toner formula on page 136, which includes a washing aid. If no change in image tone is desired, mix toner at 1:20 to 1:40 dilution. Use selenium toner in good ventilation and do not get it on your skin.

Final Washing. Wash again as above, at 75°–80° F. Wash until the prints test acceptably free of hypo (see test procedure below), which will take 30 min to 1 hr or longer, depending on the efficiency of the washer.

Testing for hypo. Mix the hypo test solution (below) or use Kodak's Hypo Test Kit. Cut off a strip from the print's margin and blot dry. With a dropper, place a drop of test solution on the strip and allow to remain for 2 min. Blot off the excess and compare the stain that appears with the comparison patches in Kodak's Black-and-White Darkroom Dataguide, their publication R-20. The stain should be no darker than the recommended comparison patch.

Kodak Hypo Test Solution HT-2
 750 ml distilled water
 125 ml 28% acetic acid (3 parts glacial acetic acid diluted with
 8 parts distilled water)
 7.5 gm silver nitrate
 distilled water to make 1000 ml

Store in a tightly stoppered brown bottle away from strong light. The solution causes dark stains; avoid contact with hands, clothing, or prints.

Drying and mounting. Dry on clean fiberglass drying screens. Leave prints unmounted or slip corners into plastic or archival paper photo corners attached to mounting stock, then overmat (see page 224). An archival-quality mounting stock is available in art supply stores; ask for 100% rag, acid-free boards. Separate prints with sheets of 100% rag, acid-free paper. Store in polyethylene or polyester bags or sleeves.

How long does a photograph last? Some very early prints, particularly platinum prints that were produced around the turn of the century, have held up perfectly. Platinum paper has a light-sensitive coating that contains no silver and produces an extremely durable and very beautiful image in platinum metal. Other photographs not nearly so old have faded to a brownish yellow, their scenes lost forever.

Conventional prints, which have a silver-based image, have a long life if they are processed in the ordinary way with even moderate care. But today, many museums and individuals are collecting photographs, and, understandably, they want their acquisitions to last.

Archival processing provides maximum permanence for fiber-base silver prints. Resin-coated (RC) paper is generally not recommended for archival purposes. Archival processing is not very different from the customary method of developing, fixing, and washing for fiber-based paper. It is basically an extension of the ordinary procedures and involves a few extra steps, some additional expense, and careful attention to the fine details of the work.

Archival processing eliminates residual chemicals, those that washing alone cannot remove entirely. Among the substances that are potentially harmful to a print are the very ones that create the normal black-and-white image: salts of silver, such as silver bromide or silver chloride. During development, the grains of silver salts that have been exposed to light are reduced to black metallic silver, which forms the image; but unexposed grains are not reduced and remain in other parts of the print in the form of a silver compound. If not removed, they will darken when struck by light and will darken the image overall. The chemical used to remove these unexposed grains is fixer, or hypo as it is sometimes called, which converts them into soluble compounds that can be washed away.

Fixer itself must also be removed completely. It contains sulfur compounds, which if allowed to remain in a picture will tarnish the metallic silver of the image just as sulfur in the air tarnishes a silver fork. Also, fixer can become attached to silver salts and form complex compounds that are themselves insoluble and difficult to remove. When these silver-fixer complexes decompose, they produce a brown-yellow sulfide compound that may cause discoloration.

Protective toning converts the silver in the image to a more stable compound, such as silver selenide. This protects the image against external contaminants that may be present in air pollution. Selenium toner is used most often. Gold toners used to be recommended for maximum protection but are much more expensive than selenium, and there is now some evidence that they are not as effective as once believed. Experts don't always agree on which is the best method of archival processing. One widely accepted procedure is summarized at left.

Store prints (and negatives) away from ordinary paper. Acids in most paper—in contact or just nearby—will transfer over time to photographic materials and shorten their life. Special acid-free paper or cardboard folders, envelopes, and boxes are available from specialty retailers, along with bags and sleeves in standard print sizes made from long-lasting plastics like polyester and polyethylene. Stability is particularly important for long-term storage; Changes of temperature and humidity can undermine the most careful archival processing. Consistent low temperatures and moderate humidity are best.

See the Bibliography for more detailed sources of information.

Toning for Color and Other Effects

Toning can make a significant change in print color. By immersing a print in a chemical toner solution, you can change a black-and-white print to a color such as sepia (yellowish brown), brown, red, orange, blue, or bluish green (see box, below left). You can selectively color different areas of a print by coating part of the print with rubber cement or artist's frisket, toning the print, then peeling up the coating. You can add more than one color by repeating the process: coating other areas, then toning the remainder with another color.

Toning for intensification changes the print color only a little—just enough to remove the very slight color cast present in most prints and to leave a neutral black image (box left, bottom). This type of toning increases the density of the dark areas of a print, which also increases the richness and brilliance of the print. Negatives can also be toned for intensification to increase their contrast (box, below right).

Most toners help increase the life of a print. The silver in an image can deteriorate in much the same way that a piece of silver jewelry tarnishes. A toner increases the stability of the silver in the print by combining it with a more stable substance, such as selenium.

NOTE: Use gloves or tongs to handle prints in any toner. Use toners only in a well-ventilated area; fumes released during processing may smell bad or even be toxic if ventilation is inadequate. Read and follow manufacturer's directions carefully.

FREDERIC OHRINGER Coco, 1994. Sepia-toned print

TONING BLACK-AND-WHITE PRINTS

Paper and development. Changes during toning depend not only on the toner but on the type of paper, type of developer, development time, and even print exposure time. Sepia toners lighten a print slightly, so start with a slightly dark print. Bluish toners containing ferric ammonium citrate darken a print, so start with a slightly light print. Test the effect of a toner on your particular combination of paper and chemicals.

Fixing and washing. Prints will stain if they have not been properly fixed and washed before toning. Two fixing baths are recommended (see page 135). Different toners require different procedures. Following is a general procedure for toning using Kodak Rapid Selenium Toner, which produces chocolate brown tones on warm-tone papers, purplish brown tones on neutral-tone papers, and little or no change on cold-tone papers. **TIP:** Some toners work better with prints that have been fixed in an unhardened bath. After toning, use a fixer with hardener.

Toning. Follow the manufacturer's instructions for diluting the toner. Set out three clean trays in a well-lighted area. Ideally, light should be similar to that under which the finished print will be viewed. A blue tungsten bulb will show the color under daylight viewing conditions. Place the prints in water in one tray, the diluted toner in the middle tray, and water in the third tray—gently running, if possible.

Place a print in the toning solution. Agitate constantly until the desired change is visible. As a color comparison, particularly if you want only a slight change, place an untoned print in a tray of water nearby. Changes due to residual chemicals can take place after a print has been removed from the toner, so remove prints from toner just before they reach the tone you want.

Final Wash. After toning, treat fiber-base prints with fresh washing aid and give a final wash. Do not reuse the washing aid; it may stain other prints. Resin-coated prints need only a 4-min wash after toning.

TONING NEGATIVES FOR INTENSIFICATION

Toning a black-and-white negative in selenium intensifies and adds contrast to the negative.

Preparation. The negative should be completely washed. Bring all solutions to 68° F.

Dilute Kodak Rapid Selenium Toner with 2 parts working-strength Kodak Hypo Clearing Agent.

Optional. To prevent staining caused by possible improper fixing during the original negative processing, immerse for 3 min in a plain hypo bath of 8 oz sodium thiosulfate per quart of water. Rewash.

Processing. If not already wet, immerse negative in water for 3 min. Then immerse in the toner for up to 10 min. Immerse in Hypo Clearing Agent for 3 min. Wash and dry as usual.

TONING PRINTS FOR INTENSIFICATION

This formula for a selenium toner for prints slightly deepens blacks and produces a rich, neutral black image. The formula incorporates a washing aid, which eliminates its use as a separate step. See also the general toning instructions above.

Dilute 1 part Kodak Rapid Selenium Toner with 10 to 20 parts washing aid (such as Kodak Hypo Clearing Agent) at working strength. Some papers react more rapidly than others to toning, so adjust the dilution if you get too much—or inadequate—change.

Toning. Fix prints in a two-step fixing bath (see page 135). Prints can be toned after being rinsed, after a first wash (if you are processing archivally), or they can be completely washed and dried for later toning. Soak dry prints in water for a few minutes before toning. Keep RC prints wet for as little time as possible.

Place a print in the toning solution. Agitate until a slight change is visible, usually within 3 to 5 min. Very little change is needed—just enough so the print looks neutral or very slightly purplish in the middle-gray areas when compared to an untoned print. Remove the print from the toner just before the desired change is visible, because the toner continues to work for a short time afterwards. For archival processing, adjust the concentration of toner to ensure a full five minutes in the toning/clearing bath. Immediately rinse the print in clean water. Wash for the recommended time.

OLIVIA PARKER Bosc, 1977

Olivia Parker's still life pairs a real pear with its abstracted outline and verbal definition. As in this assemblage, Parker often incorporates aged or weathered objects, illustrations, and type into constructions that she then photographs. Although the effects are subtle when reproduced in a book, split toning expands the apparent depth of the photograph. Shadow areas become very dark brown, while lighter areas are a contrasting and cooler black.

SPLIT TONING

Paper. Silver-chloride contact printing papers, such as Kodak AZO, work best.

Negative. You'll need a negative the same size as the print you want. You can either make a large-format negative using a view camera, or contact print a smaller negative onto film to make an interpositive, then enlarge that onto sheet film for a final-size negative.

Paper developer. Develop the print in Kodak Selectol-Soft, diluted 1:1. The temperature of the print developer is important. Keep the developer temperature between 73° and 77° F by putting the developer tray inside a larger tray filled with water at the recommended temperature. Fix the print after development and put it in a tray of water until you are ready to tone. Frequently change the water and circulate the prints to avoid later staining.

Water. The hardness or softness of the water with which you dilute the developer can affect the toning. Experiment to see if your water produces good results. Unfortunately, water can vary at different times of the year, and distilled water, which would be consistent, does not produce a good split.

Toning. Fix the print in a second fixing bath for 4 min. Transfer into a toner-clearing bath of 70 ml selenium toner, 30 ml Heico Perma Wash, and 20 g Kodak Balanced Alkali or sodium metaborate, plus water to make 1 liter of solution. Agitate in the toner until the desired effect is achieved, usually 4 min or more. After toning, wash for at least 20 min.

If you have problems with staining, try separating the toning ingredients. Immerse the prints for 5 min in 30 ml Perma Wash and 20 g Kodak Balanced Alkali in 1 liter of water. Then transfer to the toning bath of 70 ml selenium toner in 1 liter of water.

JOEL MEYEROWITZ Florida, 1976

*Color photographs can capture hues that are subtle and subdued as well as
those that are bright and crisp.* Here, Joel Meyerowitz combines both in one pho-
tograph. As he compares color on the left to black-and-white (or at least mono-
chrome) on the right, he is also contrasting deep space against flat, and the materi-
al world against a transient projection.

color

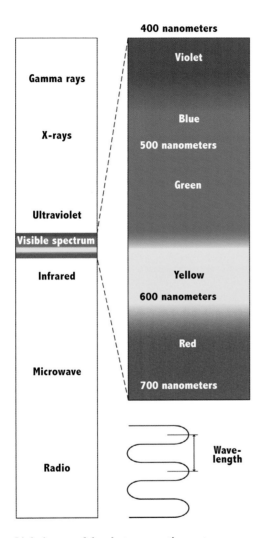

400 nanometers

Violet

Blue

500 nanometers

Green

Ultraviolet

Visible spectrum

Yellow

600 nanometers

Red

700 nanometers

Gamma rays

X-rays

Ultraviolet

Infrared

Microwave

Radio

Wave-length

Light is part of the electromagnetic spectrum, a continuum of wavelike energy from gamma waves through visible light to radio waves. The waves can be measured; the wavelength or distance from crest to crest ranges from 0.000000001 millimeter for some gamma rays to six kilometers for some radio waves. The human eye—and most digital sensors and films—will respond to wavelengths from about 400 nanometers (billionths of a meter) to 700 nanometers.

Without light we would have no photography—nor vision, for that matter. If you understand light and its key component—color, you'll be better able to produce the photographs you want.

Developing and printing color film is similar to developing and printing black-and-white film—with some important differences.

Walter Iooss, Jr. looks for something to make his sports photographs more than simple action pictures.

Color photography was at one time a special and unusual process. Now, we think of black-and-white photographs as regular pictures with the color turned off. Photographing in color can sometimes produce unexpected results. We tend to ignore slight shifts in color balance that result from the color shifts in daylight or from different types of light bulbs. Color photographs record those shifts. This chapter deals in depth with how to control color balance to help you make your colors appear natural—when you want them to.

The human eye is sensitive to a small range of wavelengths near the middle of the spectrum. When radiation in this visible part of the spectrum strikes the eye, the brain senses light and color. Most sensors and films are manufactured to respond to about the same range of wavelengths that the eye sees. But they can also respond to other wavelengths the eye cannot see, such as ultraviolet and infrared radiation.

Color is a quality of your subject, of the light falling on it, and of the image you make from it. To make the best use of color's expressive possibilities, you need to understand some of the science of color and some of its psychology, along with how to measure, name, translate, and control the full spectrum.

All colors can be created by mixing three primary colors—the additive (red, green, and blue) or the subtractive (cyan, magenta, and yellow) primaries. An additive process is used in today's digital sensors, television sets, and computer monitors. One was used briefly in early color photography. A subtractive process is used in modern color films, as well as in all printing—from desktop digital printers to the giant offset presses that print magazines and books.

Additive color (right, center) mixes red, green, and blue light in varying proportions to produce any color. Mixed together at full strength, all three primaries together produce white light.

Additive mixing requires three separate light sources. Your television or CRT computer monitor, for example, reproduces a full range of colors by using three separate electron beams that each illuminates one of the three sets of colored phosphors coated on the inside of the screen. An LCD monitor has a screen, lit with white light from behind, that uses liquid crystals and millions of transistors to regulate how much light is allowed to pass through tiny red, blue, and green filters.

Subtractive color (right, bottom) mixes the subtractive primary colors, cyan (a bluish green), magenta (a purplish pink), and yellow. These colors absorb (in turn) red, green, and blue wavelengths, thus subtracting them from white light. These subtractive primaries are the complementary colors of the three additive primaries, red, green, and blue (see color wheel, right, top). Mixed all together at full strength, the subtractive primaries absorb all colors of light, producing black. But, mixed in varying proportions, they can produce any color in the spectrum.

A color slide, for example, has three layers of dye images superimposed on a transparent support. The colors on the slide—and in the photographic image on that slide—change as the amounts of dyes in each area change.

Many primary art teachers confuse red with magenta and blue with cyan, so most of us grew up thinking—in error—that red, yellow, and blue are the primary colors.

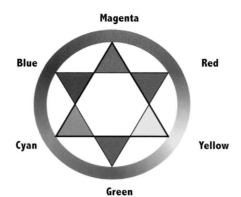

Magenta

Blue Red

Cyan Yellow

Green

The photographic color wheel. The color primaries for the subtractive process are cyan, magenta, and yellow (CMY). The additive primaries are their complementary colors (those opposite on the color wheel), red, green, and blue (RGB). Removing quantities of these colors (in the subtractive process) or adding them (in the additive process) can create all other colors. Cyan is sometimes confused with blue and red with magenta, especially in the way they influence mixed colors; learning to tell them apart will make it easier to identify the color that needs to be changed when you are adjusting colors in an image.

In the additive method, separate colored lights combine to produce other colors. The three additive primary colors are red, green, and blue. Although it is difficult to imagine, green and red light mix to produce yellow. Easier to believe is that red and blue light mix to produce magenta, and green and blue mix to produce cyan. When equal parts of all three primary-colored beams of light overlap, the mixture appears white to the eye. Color television produces its color by the additive system. A picture tube is covered with green, red, and blue phosphors that can be mixed in various combinations to produce any color, including white.

A computer's monitor works the same way; the image you see on it has been created by a mix of illumination in the additive primaries.

In the subtractive process, colors are produced when a dye or pigment absorbs some wavelengths and so passes on or reflects only part of the spectrum. White light is a mixture of all wavelengths. Here, the three subtractive primaries—yellow, cyan, and magenta—have been placed over a source of white light. Where yellow and cyan (which absorb blue and red, respectively) overlap, they pass green; where cyan and magenta (which absorbs green) overlap, they pass blue; where magenta and yellow overlap, they pass red. Where all three overlap, all wavelengths are blocked and we see no color—black. All modern photographic and printing materials utilize the subtractive process.

Color negative film

Color transparency film
or
Digital image

Color film consists of three layers of emulsion, each sensitive to blue, green, or red (as diagrammed here by color dots over a film cross section). During exposure, light from each color of the toy airplanes shown here produces an invisible latent image on the emulsion layer or layers sensitive to it. Because the wheels are black, no emulsion or diodes are exposed. All three layers are exposed equally for the gray propellers and even more—also equally—the white surface on which the planes are resting. This results in three superimposed latent images.

 Inside a digital camera, similarly, light from each primary color exposes one of three sets of light-sensitive diodes on a sensor, diodes that are covered with a filter of the same primary color they record. Data that represents each color is recorded separately in one of three channels; all three combine to make a full color image.

During development of the film, each latent image is converted into a negative image. This produces three separate negative images, each is darkened in proportion to the amount of red, green, or blue to which each was exposed.

When exposed color negative film is developed, a colored dye combines with the silver in each black-and-white negative image. The dyes are cyan, magenta, and yellow—the complements of red, green, and blue. The silver is then bleached out, leaving three superimposed layers of negative dye images (shown separately here). The color negative also has an overall orange color or "mask" to compensate for color distortions that would otherwise occur in printing.

 To make a positive print from a negative, light is passed through a color negative onto paper containing three emulsion layers like those in film. Developing the paper produces three superimposed positive images of dye plus silver. As with film, the silver is then bleached out of the print leaving the final color image.

The positive color image of a transparency (or slide) is created by a reversal process. After a first development, the developed silver is removed by bleaching. Then all the remaining silver halides—the ones that weren't initially exposed and developed—are exposed to light or treated with a chemical that produces the same effect. A second development forms black-and-white positive images in the emulsion. Dyes then combine with the metallic silver positive images to form three superimposed positive color images.

A digital image resembles a transparency; it is usually viewed as a positive image. The three channels store a record of the varying brightness in the scene of each of the three additive primaries. To aid in post-processing, these channels may be displayed one, two, or three at a time on a monitor in black-and-white or in their respective primary colors.

A color photograph always begins as three superimposed black-and-white images. A digital camera's sensor uses a tiny red, blue, or green filter over each of its photosites—the light-sensitive diodes in an array on its surface—to capture an electronic brightness value for one primary color at each square (or pixel) on a grid. That grid of pixels will eventually be assembled into a full-color image but it is stored as three separate channels of data, the equivalent of three different black-and-white images of the scene.

Color film consists of three layers of emulsion, the coating on film that contains light-sensitive silver halides. Each layer is basically the same as in black-and-white film, but responds to different parts of the spectrum. The top layer is only sensitive to blue light. The middle layer records the green, and below it is a layer that is exposed only by red light. When this film is exposed to light and then developed, the result is a multilayered negative or positive, but one that is not yet in color.

In film, colors are created during development. The developer converts light-sensitive silver halide compounds in the layers of emulsion to metallic silver. As it does so, the developer oxidizes and combines with dye coupler chemicals that are either built into the layers of emulsion or added during development. Three dye colors are formed—the subtractive primary colors of yellow, magenta, and cyan—one in each emulsion layer. The blue-sensitive layer of the film forms a yellow image, the green layer forms a magenta image, and the red layer forms a cyan image. A bleach then removes all the silver, and each layer is left with only a color image. This basic process is used in the production of color negatives, positive color transparencies (slides), and photographic color prints.

Photographic color can't duplicate colors in a scene, it can only fool the eye. Light reflected from an object usually contains all the wavelengths of the visible spectrum in varying quantities. The daylight that illuminates a green apple contains all wavelengths in more-or-less equal quantities. The apple relects a high percentage of the green wavelengths and very little (absorbing the remainder) of the red and blue ones, so we see green.

To reproduce that sensation of seeing the green of an apple, photographs are limited to using three very specific primary colors that do not necessarily contain all the wavelengths of the spectrum. Photographic color can look accurate because of the way our eyes identify color. But the colors in a photograph are not actually the same as those of its subject, in the same way that the photograph itself is not actually the same as its subject.

Color systems divide all colors into three measurements—hue, value, and saturation. Hue is the most intuitive of these; it is what we normally name the color of an object—a blue car, a green hat.

Value (sometimes called lightness or luminance) is a measure of the brightness

or darkness of the color, or of the gray that would be left if a color's hue were removed, as in a black-and-white photograph. You can imagine a blue car and a green hat that might have the same luminance.

Saturation (or chroma) is a description of a color's purity. You could have a tomato and a brick that might be the same red hue (neither one more blue or yellow than the other). The difference is that a tomato is a more pure—or saturated—red than a brick. Various factors can affect saturation (see box below).

The way photographs are made gives you control over some important characteristics of their color. Remember that the colors in a photograph only reference, but don't duplicate, those of a subject; it is up to you, the photographer, to control that difference for your own ends.

You may want your viewer to believe strongly in the accuracy of your photographs, or it may be more important that your viewer have a specific emotional response to them. The way you treat color has a strong effect on the interpretation of your pictures; experiment to find out how to make the best use of these important controls.

MARIA ROBLEDO Cheese Still Life

CHARACTERISTICS OF A COLOR PHOTOGRAPH

Color balance. To our eyes, a white shirt looks white both outdoors in daylight and indoors in artificial light. But the two light sources do not have the same mix of colors; our brains compensate for the difference in a way that lets us also see blue pants as the same blue in both places. Light from a lamp switched on near a window during the day will look comparatively yellow; at night it looks white. Unless there are two light sources to compare, we ignore the differences—but photographs record them (see page 147).

Regardless of whether you shoot digitally or with film, color balance has an important influence over the impact and effectiveness of your photographs (see pages 144–145). Even subtle shifts in color balance can create dramatic changes in emotional content.

Saturation. The purity—or vividness, or intensity—of a color is referred to as saturation. The color saturation that exists in front of the camera depends on the physical characteristics of objects in the scene, and on the kind of illumination. Saturation in the way colors are reproduced is also affected by the specific kind of sensor or film used to capture the image, and the manner of post-processing—film development, image editing, and printing.

The look of color films is linked to film speed. Slower films have more saturated colors (and also appear sharper) than faster films. Some films are made in different versions, producing more saturation (advertised as "vivid" color) or less.

Digital post-processing (computer image editing) gives direct control over saturation.

Contrast. Two kinds of contrast are important in a photograph; both are strongly affected by the kind of illumination on the scene, but can also be altered by your technique. Overall (or global) contrast, sometimes called dynamic range, is the difference between the lightest and darkest parts of a scene, print, transparency, or negative. The extent of a scene's dynamic range you can capture is very dependent on what you use to capture it. Different films and digital sensors have distinct limits to the overall contrast, or dynamic range, that they can capture (see page 80).

Local contrast is what makes photographs look crisp or soft, and has to do with the edges and transitions of color and tone. It is affected by the quality of the lens (and how clean that lens is) as well as the kind of film (slower films have more contrast) or sensor used.

JIM SCHERER Artichoke and Eggplant Pizza, 2003

Realistic, or at least pleasing, color is important in food photography, *where the intention is usually to appeal to the appetite by way of the eye. But considerable personal variation is still possible.*

In this setting for a prepared frozen pizza's packaging illustration, above, the colors are saturated—full and vivid. The cheese photograph

(opposite page) is low in saturation, nearly a black-and-white, but because of that we are drawn even more to the colors that are present,

Stylists are often used in food photography to prepare the food, usually in multiple, so the photographer always has a fresh dish to shoot. Lighting, focus, composition, and items that won't

wilt are arranged before the food is ready, using a mock-up of the main dish. An image-perishable dish is the last thing to hit the set. Timing, coordination, and teamwork are critical, because the ideal is to photograph the food as soon as possible after it is done, before it melts, congeals, dries up, bleeds water, or otherwise visually deteriorates.

ROBERT RICHFIELD Brighton/Hove, East Sussex, England, 1993

Midmorning and midafternoon are the best times to let the colors of the subject dominate. Richfield took seven photographs leaving his tripod in the same location while rotating his large-format camera for each exposure.

Colors in your photographs will vary depending on the time of day that you made them. Photographing very early or late in the day can produce strikingly beautiful pictures simply because the light is not its usual "white" color. As you become aware of color changes, you will be better able to predict the effect that the time of day will have on your pictures.

In the earliest hours of the day, before sunrise, the world is essentially black and white. The light has a cool, shadowless quality. Colors are muted. They grow in intensity slowly, gradually differentiating themselves. But right up to the moment of sunrise, they remain pearly and flat.

As soon as the sun rises, the light warms up. Because of the great amount of atmosphere that the low-lying sun must penetrate, the light that gets through is much warmer in color than it will be later in the day—that is, more on the red or orange side because the colder blue hues are filtered out by the atmosphere. Shadows, by contrast, may look blue because the gold sunlight doesn't reach them; they are only illuminated by blue from the sky.

The higher the sun climbs in the sky, the greater the contrast between colors. At noon, particularly in the summer, this contrast is at its peak. Digital cameras set a white balance of 5200K for daylight; film for use in daylight is balanced for 5500K (see page 147). Either is likely to render midday colors reasonably accurately, even though the color temperature of midday sunlight varies somewhat.

As the sun goes down, the light begins to warm up again. This occurs so gradually that you must remember to look for it; otherwise the steady increase of red in the low light will do things to your photographs that you do not expect. Luckily, these things can be beautiful. If the evening is clear and the sun remains visible right down to the horizon, objects will begin to take on a golden glow that is typical of sunset light. Shadows lengthen, so surfaces become strongly textured.

After sunset there is a good deal of light left in the sky, often tinted by sunset colors. This light can be used, with longer exposures, almost to the point of darkness, and may produce pinkish or even greenish-violet effects that are delicate and lovely. Just as before sunrise, there are no shadows and the contrast between colors is low.

Finally, just before night, colors fade. With the tinted glow gone from the sky, colors disappear, and the world once again becomes black and white.

You can suppress or exaggerate these effects. Digital cameras let you adjust white balance warmer or cooler or set the camera to do this for you. The camera will sense the ambient color temperature and—if you let it—compensate for any difference from noon daylight, removing the subtle shifts of color described here.

Color correcting filters placed over the lens of a film camera will also shift the color balance of a photograph. A very light blue filter, for example, can reverse the warming effect of late-afternoon sun.

At dusk, at dawn, sometimes indoors, the light may be so dim that exposure times become very long, even with the lens aperture wide open. Very long exposures with film produce an exposure and color balance problem called reciprocity failure (see page 77). Very long exposures with a digital camera increase noise (see page 83).

GEORG GERSTER Australian Pinnacles Desert

Late in the day, shadows are very long and colors are warm and golden. As the sun gets lower in the sky, the color of light moves to the reddish end of the spectrum, giving a warm tone to everything it illuminates.

PETER TURNER Ibiza Woman, 1961

At twilight, at dawn, or under a cloudy sky, colors are cool and blue.

JOHN UPTON Torii and Swimmer, Lake Biwa, Japan, 2005

Midday sunlight is bright, with objects having the colors you would expect.

Reflected light can also reflect colors. Almost every photographer has, at one time or another, found that in a picture a subject has taken on the colors reflected by a nearby strongly colored surface, like a wall or drapery. The eye tends to see almost every scene as if it were illuminated by white light, whereas color film reacts to the true color balance of the light. Color casts, or shifts of color, are less noticeable on objects that are strongly colored but are easy to see on more neutral shades, such as skin tones or snow.

A color cast may be a desirable addition. In the picture on this page, the bluish light adds an icy coldness to the snow. The gold tones of sunset can make a landscape glow warmly (page 144, center).

But sometimes a color shift can be a problem, as in a portrait shot beneath a tree. People photographed under such seemingly flattering conditions can appear a seasick green because the sunlight that reaches them is filtered and reflected by the green foliage.

Colors can add the impression of heat or weight in a picture. Because they trigger mental associations, golden yellows and reds appear distinctly warm, while blues and yellowish greens seem cool. But the impressions go beyond mere illusions of temperature. Warm colors, especially if they are dark, can make an object seem heavy and dense. Pale, cool colors, on the other hand, give an object a light, less substantial appearance.

Color can affect the illusion of depth. Warm colors can appear to be farther forward, cool colors farther back. You can use this distance effect to increase the illusion of depth within a picture by placing warm-colored objects against a cool-colored background.

DAVID MUENCH
Reflection of El Capitan in Merced River, 1970

Shadowed areas can appear surprisingly blue in a photograph, especially if the subject itself is not strongly colored. In this Yosemite landscape, the rocks and snow are shaded from direct light from the sun and are illuminated only by skylight, light reflected from the blue dome of the sky. Sunlight, direct rays from the sun, is much less blue.

Compare the skylit snow to the sunlit—and less blue—granite outcropping of El Capitan, visible in the reflection in the water. Here, the contrast between the two tones adds interest to the picture, but for less of a bluish cast, on a digital camera the white balance could be set lower or, with film, a 1A (skylight) or 81A (light yellow) filter could be used over the lens.

"White" light sources are not all the same; their color is measured on a temperature scale in degrees Kelvin (K). Accurate color in your photographs comes from a close match between the color temperature of the light on your subject and the color balance of your film or digital sensor. Without that match, all the colors in a photograph will be shifted up or down the spectrum, becoming too cool (blue) or too warm (red).

A digital camera allows this color balance (called white balance) to be manually adjusted or determined automatically by the camera. It can be further adjusted in computer post-processing.

Daylight films produce the most natural-looking results when exposed in the relatively bluish light of daylight (below, far left) or electronic flash. Tungsten-balanced films should be used when photographing in the relatively reddish light of incandescent bulbs. Filters are available to adapt either film to fluorescent light or to change the color balance in other ways.

MIGUEL RIO BRANCO Pelourinho District, Salvador, Brazil, 1985

Mixed light can be a mixed blessing. Warm tungsten light from the interior presents a sharp contrast with the cool (higher color temperature) dusk daylight illuminating this courtyard.

Daylight color film is balanced for the relatively bluish color balance of midday light (5500K color temperature), as in left photo. Open shade (second photo) is more blue, because the light from a blue sky has a higher color temperature than direct sunlight. If you use daylight color film in the warmer light of a tungsten bulb (third photo, about 2800K), your picture may look more reddish than you expect. The fourth photo was taken under fluorescent light, which tends to have proportionately more green than daylight. In each, a piece of white cardboard was held behind the man, and he is wearing the same gray shirt.

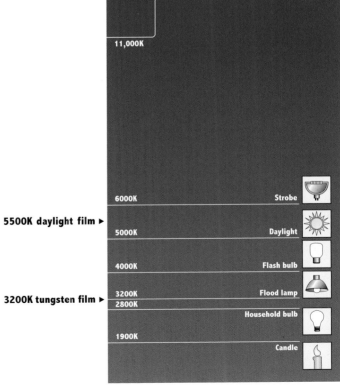

Skylight (without direct sun)

11,000K

6000K — Strobe

5500K daylight film ▶ 5000K — Daylight

4000K — Flash bulb

3200K tungsten film ▶ 3200K — Flood lamp
2800K

Household bulb

1900K

Candle

Filters can correct the color balance a lot—or a little. In addition to the relatively large change needed when tungsten film is shot in daylight, or vice versa, smaller corrections can also be useful. Although electronic flash units are exactly balanced for daylight films, the results may seem somewhat bluish; a light yellow filter helps if flash-lit pictures are often too blue. Tungsten film is balanced for 3200K light bulbs. Ordinary light bulbs are usually lower in color temperature, producing warmer, yellowish tones. If you must shoot one type of film in a different type of light, a filter will correct the imbalance to give you a better match. Color temperature meters are available if it is important to balance the light precisely.

It is important to balance the light the way you want it when making color slides, because the film in the camera is the final product that will be projected for viewing. Exact balance is not as important with color negative film used for color prints because corrections can be made during printing, and image editing on the computer gives you even more control over color balance. But no matter how you work, printing will be easier and your results probably better with a properly balanced negative.

An exposure increase is needed with a filter. A filter removes some wavelengths of light, resulting in an overall loss of light intensity. If your camera meters through the lens, it will compensate for this automatically. If you are using a hand-held meter, increase the exposure as shown in the chart. Remember that increasing the exposure one stop means changing the shutter speed to half the original speed or opening the aperture to twice the size.

If you are mixing fluorescent light with flash, you may want to filter the light from the flash in addition to putting a filter on the lens. A green gel on the flash head will make the bluish light from the flash relatively green. Then the magenta filter on the camera lens will correct the light overall. Without a green gel on the flash, the magenta filter will correct the color of the fluorescent light, but may give the parts of the scene lit by the flash a magenta cast.

FILTERS FOR COLOR FILM

Number or designation	Color or name	Type of film	Physical effect	Practical use	Increase in stops	Filter factor
1A	skylight	daylight	Absorbs ultraviolet rays	Eliminates ultraviolet that eye does not see but that film records as blue. Useful for snow, mountain, marine, and aerial scenes, on rainy or overcast days, in open shade.	—	—
81A	yellow	daylight	Absorbs ultraviolet and blue rays	Stronger than 1A filter. Reduces excessive blue in similar situations. Use with electronic flash if pictures are consistently too blue.	1/3	1.2
		tungsten		Corrects color balance when tungsten film is used with 3400K light sources.	1/3	1.2
82A	light blue	daylight	Absorbs red and yellow rays	Reduces warm color cast of early morning and late afternoon light.	1/3	1.2
80	blue	daylight	Absorbs red and yellow rays	Stronger than 82A. Corrects color balance when daylight film is used with tungsten light. Use 80A with 3200K sources and with ordinary tungsten lights. Use 80B with 3400K sources.	2 (80A) / 1 2/3 (80B)	4 / 3
85B	amber	tungsten	Absorbs blue rays	Corrects color balance when tungsten films are used outdoors or with flash.	2/3	1.5
FL	fluorescent	daylight or tungsten	Absorbs blue and green rays	Approximate correction for excessive blue-green cast of fluorescent lights. FL-D used with daylight film, FL-B with tungsten film. Or try a CC30M filter.	1	2
CC	color compensating			Used for precise color balancing. Filters come in various densities in each of six colors—red, green, blue, yellow, magenta, cyan (coded R, G, B, Y, M, C). Density indicated by numbers—CC10R, CC20R, etc.	Varies	
	polarizing	any	Absorbs polarized light (light waves traveling in certain planes relative to the filter)	Reduces reflections from nonmetallic surfaces, such as water or glass. Penetrates haze by reducing reflections from atmospheric particles. The only filter that darkens a blue sky without affecting color balance overall.	1 1/3	2.5
ND	neutral density	any	Absorbs equal quantities of light from all parts of the spectrum	Increases required exposure so camera can be set to wider aperture or slower shutter speed. Comes in densities requiring from 1/3 stop more exposure to 13 1/3 stops more exposure.	Varies with density	

Some manufacturers list the exposure increase needed with filters as a filter factor.

If the filter has a factor of …	1	1.2	1.5	2	2.5	3	4
Then increase the exposure (in stops)	0	1/3	2/3	1	1 1/3	1 2/3	2

If the filter has a factor of …	5	6	8	10	12	16	
Then increase the exposure (in stops)	2 1/3	2 2/3	3	3 1/3	3 2/3	4	

If you use two or more filters together, add the number of stops of change: (1 stop + 1 stop = 2 stops) or multiply the filter factors (factor of 2 x factor of 2 = factor of 4, equivalent to 2 stops)

Daylight film in daylight

Daylight (color temperature 5500K) illuminated these pictures taken outdoors. Photographed with daylight film (above, left), the colors look normal. When shot with indoor (tungsten) film designed for a 3200K

Tungsten film in daylight

color temperature (center), the scene takes on a bluish cast. If an 85B filter is used on the lens, the colors produced by the indoor film look more realistic (right).

Tungsten film in daylight with 85B filter

Since the filters block part of the light reaching the film, increase the exposure (about 2/3 stop with an 85B filter). This can create inconveniently long exposures, so it is more efficient to use the correct type of film.

Tungsten film in tungsten light

Tungsten light (color temperature 3200K) illuminated these pictures taken in a room lit by typical household bulbs. The scene looks normal when photographed with indoor film (left), but daylight film in the

Daylight film in tungsten light

same light produces a yellowish cast (center). An 80A filter produces a near-normal color rendition with the daylight film (right).

Daylight film in tungsten light with 80A filter

In this situation, too, increase the exposure (2 stops with an 80A filter). This can create inconveniently long exposures, so it is more efficient to use the correct type of film.

Fluorescent light has an excess of blue-green wavelengths compared to other types of lighting. The result is a greenish cast to pictures taken under fluorescent light with daylight-balanced film (center), a bluish cast to pictures made with tungsten film. An FL (fluorescent) or magenta filter improves the color balance for fluorescent-lit scenes by absorbing some of the green wavelengths so that the color image looks closer to normal (right).

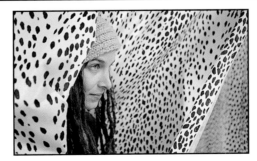

Daylight film in fluorescent light

It is difficult to give exact filter recommendations for fluorescent light because standard fluorescent tubes don't produce a smooth mix of colors. Instead, they produce a limited spectrum, with some wavelengths dominant and others almost entirely missing. In addition, the color balance varies depending on the type of lamp, the manufacturer, how old the lamp is, and even voltage fluctuations. Don't be surprised if the color photographs you make in fluorescent light are not always perfectly satisfactory.

Daylight film in fluorescent light with 30M filter

Under fluorescent lights, use an FL or CC30M filter to absorb the greenish cast emitted by the fluorescent tube. You will need to open your lens about a stop to provide more exposure.

Developing Color Film

Process color materials carefully. Processing color film is similar to processing black-and-white except that any change in the processing has a greater effect on the final product. Color materials are more sensitive to changes in processing times, temperatures, and other variables; color balance and density can shift significantly with even slight variations in processing.

Most photographers use a commercial lab for developing color film. A commercial lab often produces more consistent results than you can in your own darkroom. Custom color labs—those that cater to professionals—usually process both slide and negative film within a few hours of receiving it. Kodak Kodachrome, has a complicated processing procedure designed for automated commercial equipment; the chemicals are not available to consumers.

Some photographers prefer to do their own color film processing. Doing your own film processing may be less expensive than lab work and it may be faster than sending your film out. You may be able to maintain better quality control if your local lab is not geared for high quality. See the film manufacturer's instructions for the processing chemicals and procedures to use.

Color film can be pushed (underexposed and overdeveloped) when you need to shoot at a faster-than-normal film speed. Color balance, contrast, and grain are usually better with normal processing, but some adjustment can be made when you have no other options. Most labs will push or pull (increase or decrease the development for) reversal film slightly to make your transparencies a little darker or lighter. If you shoot a lot of film at once and are unsure, custom labs will do a "clip test" by cutting off and processing the first few inches of a roll so you can judge.

Cross processing produces unconventional and sometimes unexpected results in color, saturation, and contrast (see page 278 for an example). Cross-processed color negative film is developed in chemicals normally used for transparencies. Color transparency film is processed in chemicals normally used for negatives.

PETER MARLOW Max on Mobile Telephone, London, 1999

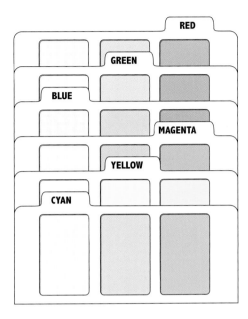

Color print viewing filter kit is an assortment of graded color filters used for viewing a print. It helps you determine any changes needed in filtration when you make the next print.

YOUR PERSONAL STANDARD FILTER PACK

The first step in color printing is to make test prints to establish a standard filter pack. The color balance of color prints is adjusted by inserting colored filters between the enlarger's beam of light and the paper. Paper manufacturers suggest combinations of filters to produce a print of normal color balance from an average negative or transparency. However, these suggestions are only a starting point for your own tests to determine a standard filter pack for your particular combination of enlarger, film, paper, processing chemicals, and technique. Personal testing is useful because so many variables affect the color balance of prints. Once your standard filter pack has been established, only slight changes in filtration will be needed for most normal printing.

You will need a negative (or a transparency, if you are using reversal materials) that is of normal density and color balance. It should be a simple composition and contain a range of familiar colors, flesh tones, and neutral grays. Do not use a sunset or other scene in which almost any color balance would be acceptable.

Make a note of the filtration that makes a good print from the negative. Use that filtration for your first prints from other negatives. If you use more than one brand or kind of film, you will want to find a standard filter pack for each one.

EQUIPMENT FOR PRINTING

Enlarger. Any enlarger that uses a tungsten or quartz-halogen lamp may be used. A fluorescent (cold light) enlarger lamp is not recommended. Having your enlarger connected to a voltage controller may be very important. Some color enlargers have them built in. If your electricity supply is not stable, colors will change from print to print.

If your enlarger was not designed especially for color, you may need to place a piece of heat-absorbing glass above the negative stage in the enlarger head. The light sources of many enlargers give off enough heat to damage color negatives.

Filtration. The color balance of the print is controlled by the color of the light that falls on it, which you adjust by placing filters of the subtractive primaries—yellow (Y), magenta (M), and cyan (C)—between the enlarger lamp and the paper. The strength of the filtration is indicated by a density number: the higher the number, the stronger the filter. For example, 20M means a magenta filter 4 times denser than an 05M filter.

A color-head enlarger has built-in dichroic filters; the strength of each color is adjusted simply by turning knobs or other controls on the enlarger to dial in the desired filtration. Dichroic filters resist fading.

Some black-and-white enlargers have a drawer for holding filters between the lamp and negative. To print color, you can place acetate color printing (CP) filters in the drawer. If your enlarger is an older model that does not have a filter drawer, you can attach a filter holder below the lens. In this position, acetate filters cause optical distortions, so use the more expensive gelatin CC (color compensating) filters.

Filters of the same color can be added to provide a stronger density of a color: 20Y + 20Y gives the same density of yellow as a filter marked 40Y. Any number of filters can be added to create the color balance desired, but do not use more than three CC filters below the lens at any one time. Using the smallest number of filters possible gives you the least optical distortion and the shortest enlarging times. You will probably never need to add cyan filtration; decreasing magenta and yellow has the same effect.

If you use CP or CC filters, Kodak recommends the following as a basic kit: one each 2B, 05Y, 10Y, 20Y, 05M, 10M, 20M; two each 40Y and 40R (a red filter is equivalent to a 40Y + 40M).

EQUIPMENT TO PROCESS THE PRINT

For manual processing, a tube-shaped plastic processing drum is a popular device. Each print is processed in small quantities of fresh chemicals, which are discarded after use. This provides economical use of materials as well as consistent processing. Once the drum is loaded and capped, room lights can be turned on so you don't have to work in the dark.

The next step up is mechanized agitation. A motorized base for the processing drum provides a consistent agitation of the drum, which is important for color processing. The unit shown provides temperature control for the processing solutions and for the processing drum, as well as mechanized agitation of the drum. You add and drain the chemicals yourself.

A completely automated processor does everything for you. You feed in the exposed paper at one end, and a few minutes later a completely processed and dried print comes out at the other end. The unit controls solution temperatures, agitates the print in each solution, and transports the paper from one stage to the next at the correct time. It meters the paper as it goes through, and automatically adds small amounts of chemicals (called replenishers) to keep the processing consistent. Most also wash and dry the prints, too.

All the processing devices shown impose a limit to the size of the largest print you can make.

Check the manufacturer's instructions. Not all processing chemicals can be used with all papers; make sure the paper and chemicals are compatible.

TIP: Refrigerate color paper when not in use. Take it out several hours before printing to let it reach room temperature and prevent moisture from condensing.

The following pages show how to make prints from a color negative, and especially how to evaluate and adjust the color filtration so that you get the color balance you want. Read the manufacturer's current directions carefully, because filtration, safelight recommendations, processing, and so on vary considerably with different materials and change from time to time.

Keep darkroom light to a minimum. Kodak recommends handling color paper in total darkness, and you should eliminate stray light from such sources as the enlarger head, timers, or digital displays. If you must have some light, Kodak recommends a 7 1/2-watt bulb with a number 13 amber safelight used at least 4 feet from the paper.

Consistency is vital every time you make a print—more so than with black-and-white printing. The temperature of the developer is critical and must be maintained within the limits suggested by the manufacturer. The same agitation pattern should be used for all tests and final prints; even the time between exposure and development must be fairly uniform with some processes.

Contamination will cause trouble, so if you are handling chemicals, don't splash one chemical into another or onto the dry side of the darkroom. Be particularly careful not to contaminate the developer with bleach-fix or stop bath. Use a separate container for developer only, and wash mixing and processing equipment carefully after use.

Color chemicals are more toxic than those for black-and-white. Be sure to wear protective gloves, eye protection, and a respirator when mixing the chemicals, and always work in a well-ventilated space. Be particularly careful to read instructions on how to handle and dispose of chemicals safely.

MAKING A COLOR TEST PRINT

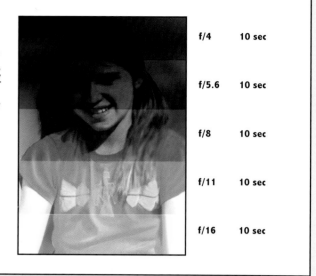

f/4	10 sec
f/5.6	10 sec
f/8	10 sec
f/11	10 sec
f/16	10 sec

Five exposures of the same negative are made in the test print shown at right, producing a range of densities from light to dark. See the manufacturer's suggestions for a starting filter pack. For example, for Professional Supra Endura paper, Kodak recommends 45M + 45Y.

When feasible, it is better to change the aperture while keeping the exposure time the same. This is because extremely long or extremely short exposures could change the color balance and make test results difficult to interpret (the same reciprocity failure that affects film). In this test each successive strip received one additional full stop of exposure, but the best exposure for a particular negative is often between two of the stops. Exposure times between 5 sec and 30 sec generally do not create noticeable reciprocity failure, so after you get an approximate exposure you can fine-tune by changing the time.

Keep notes of time, aperture, and filtration for each print if you want to save time and materials at your next printing session.

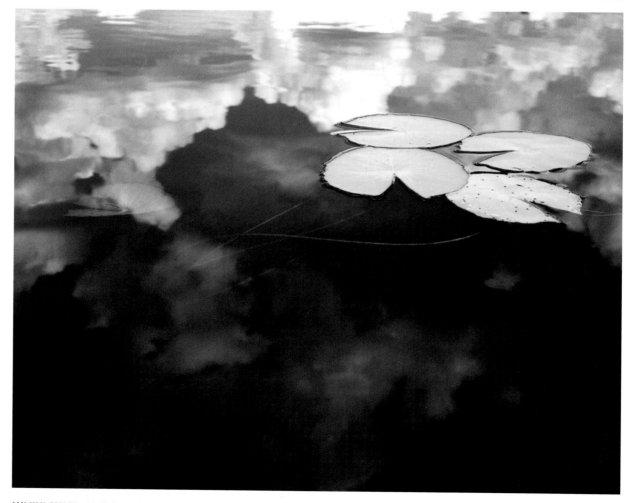

IAN VAN COLLER Lily Pads and Reflection, South Africa, 2005

1 **Prepare the negative.** Clean any dust off the film and off the negative carrier. Place the negative (dull, emulsion side toward paper) in the carrier and insert in the enlarger.

2 **Set up the enlarger.** Insert the heat-absorbing glass, if required. Dial in filtration (or insert CP or CC filters) according to the manufacturer's recommendations.

3 **Compose and focus the image.** If you use a focusing magnifier, focus on the edge of an object since a color negative has no easily visible grain.

4 **Set the lens aperture.** A test strip for a color print is made by changing the lens aperture, not the time (see box, opposite). Set the lens to f/16 as a starting f-stop for an 8 x 10 print made from a 35mm negative. Set the enlarger timer for 10 sec.

5 **Make the first test exposure.** Place a sheet of printing paper in the easel, emulsion side up. Hold a masking card over all but one-fifth of the paper, and expose the first test section. Cover the first section with another card. Move the first card to uncover the next one-fifth of the paper.

6 **Continue making the test exposures.** Open the aperture one stop, and expose the next section for 10 sec. Continue moving the cards, opening the aperture one stop, and exposing until the last one-fifth of the paper is exposed.

7 **Process the paper.** Here the exposed paper is being fed into a processing machine. The machine fully processes the print, which can then be examined in ordinary room light. If you develop the paper by hand using a processing drum, room lights can be turned on once the paper is loaded in the drum with the cap secured so that you can perform the processing steps in the light.

8 **Evaluate the print.** Color prints are judged and corrected first for density, then for color balance. Finally, evaluate the print for areas that might be dodged or burned. See next pages.

Color prints are judged—and adjusted— first for density (the darkness of the print), then for color balance. This is something like black-and-white prints, which are evaluated first for density, then for contrast.

The color balance of a test print will probably be off, so try to disregard it and evaluate just the density. Look for the exposure that produces the best overall density in midtones such as skin or blue sky. Important shadow areas should be dark but with visible detail; textured highlights should be bright but not burned-out white. Try not to judge both density and color at the same time; making a print darker or lighter may shift some colors. Some local control with burning and dodging may be needed.

The illumination for judging a color print is important. It affects not only how dark the print looks but also its color balance. Ideally you should evaluate prints using light of the same intensity and color balance under which the print finally will be viewed. Since this is seldom practical, some standard viewing conditions have been established. Color prints are best viewed and judged under a 5000K light, one whose spectrum in very close to standard daylight. Special 5000K tubes that fit an ordinary fluorescent fixture are readily available at electric supply stores or big home-improvement centers. Some photographers prefer to combine tungsten and fluorescent light for a warmer viewing light, adding one 75-watt frosted tungsten bulb for every two 40-watt 5000K fluorescent tubes.

Examine prints carefully, but when judging density, don't view a print very close to a very bright light. Average viewing conditions are likely to be less bright, and the final print may then appear too dark. At the least, make sure you always use the same viewing light from a constant distance.

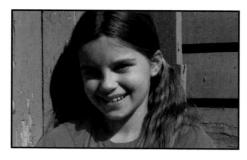

1 stop too dark
Give 1/2 the previous exposure: close enlarger lens 1 stop or multiply exposure time by 0.5

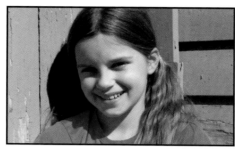

1/2 stop too dark
Give 3/4 the previous exposure: close enlarger lens 1/2 stop or multiply exposure time by 0.75

◄ **CORRECT DENSITY**

1/2 stop too light
Give 1 1/2 times the previous exposure: open enlarger lens 1/2 stop or multiply exposure time by 1.5

1 stop too light
Give twice the previous exposure: open enlarger lens 1 stop or multiply exposure time by 2

USING VIEWING FILTERS TO CORRECT THE COLOR BALANCE

Viewing filter kits help you determine any changes needed in the color balance of a print. With Kodak's Color Print Viewing Filter Kit, hold the white side of the card containing the filters toward you to view prints made from color negatives.

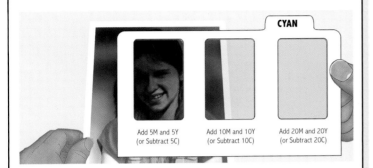

CYAN

Add 5M and 5Y
(or Subtract 5C)

Add 10M and 10Y
(or Subtract 10C)

Add 20M and 20Y
(or Subtract 20C)

Hold the filter a few feet away from the print. Flick the filter in and out of your line of vision as you look at light midtones in the print, such as light grays or flesh tones, rather than dark shadows or bright highlights. When you find the filter that makes the print look best, make the changes to the enlarger filter pack that are printed below each filter.

BALANCING A PRINT MADE FROM A NEGATIVE

To adjust the color balance of a print made from a negative, change the amount of the subtractive primary colors (magenta, yellow, and cyan) in the enlarger printing light. Usually, changes are made only in magenta and yellow (M and Y).

Print is	Do this	Could also do this
Too magenta	Add M	Subtract C + Y
Too red	Add M + Y	Subtract C
Too yellow	Add Y	Subtract C + M
Too green	Subtract M	Add C + Y
Too cyan	Subtract M + Y	Add C
Too blue	Subtract Y	Add C + M

COLOR WHEEL

A color wheel arranges the primary colors of light in a circle. Each color is composed of equal amounts of adjacent colors (red is composed of equal parts of magenta and yellow). Each color is complementary to the color that is opposite (magenta and green are complementary).

Magenta

Blue

Red

Cyan

Yellow

Green

The first print you make from a negative usually needs some change in the color balance. This is done by changing the filtration of the enlarger light. If your enlarger has a dichroic head, just dial in the filter change. If you are using CP or CC filters, you must replace individual filters in the pack. Decide what color is in excess in the print and how much it is in excess, then change the strength of the appropriate filters accordingly. The strength of printing filters is often designated in "points." It is best to evaluate dry prints, since wet prints will appear a few points too blue and slightly darker than they do after drying.

You can check your print against pictures whose colors are shifted in a known direction, such as the "ring-around" test chart on the next page. The chart helps identify basic color shifts, although printing inks used in a book seldom exactly match photographic dyes. Whenever possible, use something to make a direct comparison to each test print; look at your second test next to your first in order to see and evaluate the change.

A good method for evaluating prints is to look at them through colored viewing filters to see which filter improves the color balance. Kodak makes a Color Print Viewing Filter Kit for this purpose. See Using Viewing Filters to Correct the Color Balance, left.

To correct the color balance of a print made from a negative, change the enlarger filtration in the opposite direction from the color change you want in the print. In other words, if you want to remove a color from a print, add that color to the enlarger filtration. It's best to change only the magenta or yellow filters; instead of adding cyan, subtract both magenta and yellow. Correct colors either by subtracting the viewing filter color that corrects the print or adding the complement (the opposite on the color wheel) of the viewing filter color that corrects (see chart and color wheel, left). Kodak's Color Print Viewing Filter Kit also tells you which colors to change.

The cure for a print that has too much magenta is to add—not decrease—the magenta in the filter pack; more magenta in the printing light produces a print with less of a magenta cast. A green viewing filter visibly corrects a print that is too magenta; add magenta (the complement of green) to the filter pack.

You can correct colors using their complements. Excess blue is corrected by adding yellow—lighten the filter that absorbs blue, the yellow filter, and the filter pack will then pass more blue light. The print (reacting in an opposite direction) will show less blue. A yellow viewing filter visibly corrects a too-blue print; subtract yellow (the complement of blue) from the filter pack.

Learn to identify primary colors when they are mixed with others. At first it is difficult to tell what is making a green lawn or blue sky look not quite right. It is difficult to see cyan in green grass or green in a blue sky. Learn to tell the difference between red and magenta, cyan and blue. With practice you will be able to identify very subtle color shifts and to make a pleasing color print quickly. Learning to judge and print color the traditional way also makes it easier to get good color when you use image-editing software for digital prints.

Making a Color Print from a Negative continued

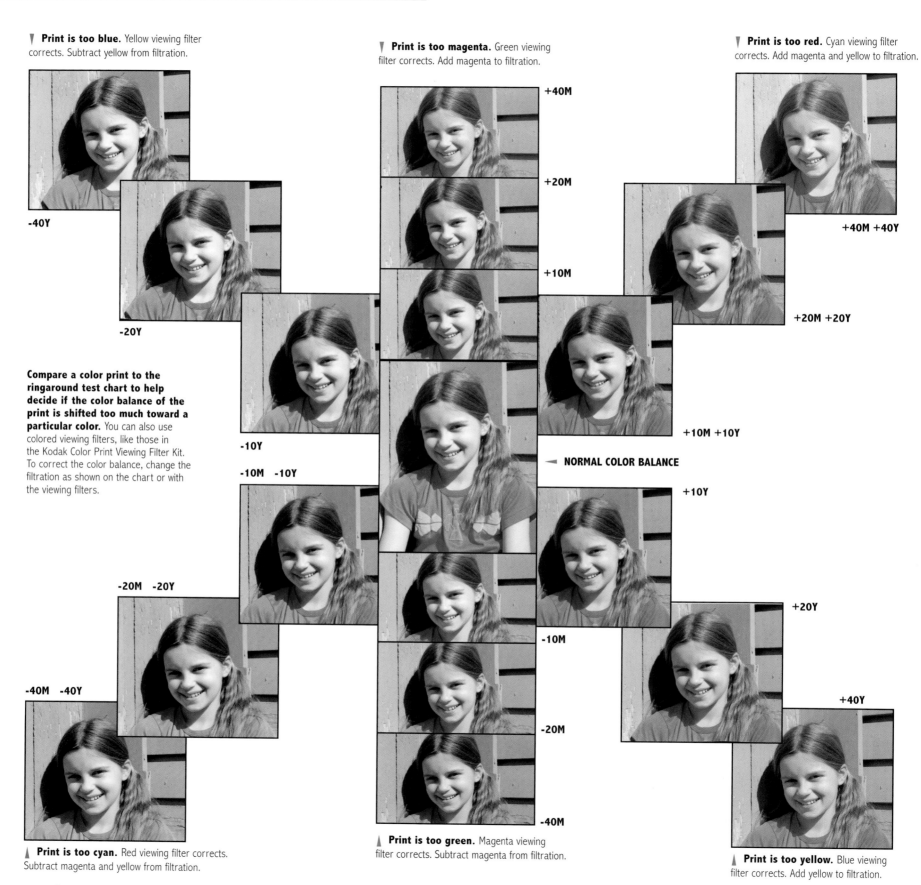

▼ **Print is too blue.** Yellow viewing filter corrects. Subtract yellow from filtration.

▼ **Print is too magenta.** Green viewing filter corrects. Add magenta to filtration.

▼ **Print is too red.** Cyan viewing filter corrects. Add magenta and yellow to filtration.

-40Y

-20Y

+40M

+20M

+10M

+40M +40Y

+20M +20Y

Compare a color print to the ringaround test chart to help decide if the color balance of the print is shifted too much toward a particular color. You can also use colored viewing filters, like those in the Kodak Color Print Viewing Filter Kit. To correct the color balance, change the filtration as shown on the chart or with the viewing filters.

-10Y

-10M -10Y

-20M -20Y

-40M -40Y

◄ **NORMAL COLOR BALANCE**

+10M +10Y

+10Y

+20Y

+40Y

-10M

-20M

-40M

▲ **Print is too cyan.** Red viewing filter corrects. Subtract magenta and yellow from filtration.

▲ **Print is too green.** Magenta viewing filter corrects. Subtract magenta from filtration.

▲ **Print is too yellow.** Blue viewing filter corrects. Add yellow to filtration.

BARBARA LONDON Spaghetti Face, 2005

After you change the filtration of a test print, you may then need to make a final exposure change, because the filtration affects the strength of the exposing light and thus the density of the print. When feasible, adjust aperture rather than time.

Small filtration changes with dichroic filters will need little exposure adjustment. If you make large changes—20 points or more with yellow, 10 or more with magenta—you will want to increase the exposure with more filtration, decrease it with less. CP or CC filters require exposure adjustment for changes in both filter density and the number of filters. See the manufacturer's literature either with the paper or the viewing filter kit. Kodak's Color Darkroom Dataguide contains a computing dial that simplifies calculation of new exposures with Kodak materials. As a rough guide, ignore yellow changes, adjust exposure 20 percent for every 10M change, then adjust 10 percent for changes in the number of filters (including yellow).

Do not end up with all three subtractive primaries (Y, M, C) in your filter pack. This condition produces neutral density—a reduction in the intensity of the light without any accompanying color correction—and may cause an overlong exposure. To remove neutral density without changing color balance, subtract the lowest filter density from all three colors.

70Y	30M	10C	If pack contains three primaries
−10Y	−10M	−10C	Subtract to remove neutral density
60Y	20M		New pack

Dodging and burning a color print is feasible to some extent, as in black-and-white printing, to lighten or darken an area. For example, you may want to darken the sky or lighten a face or shadow area. If you dodge too much, an area will show loss of detail and color (one description of the effect is smoky-looking).

You can also change color balance locally. To improve shadows that are too blue, which is a common problem, keep a blue filter in motion over that area during part of the exposure. Anything more than slight burning or dodging can cause a change in color balance in the part of the print that receives different exposure. If a burned white or very light area picks up a color cast, use a filter of that color over the hole in the burning card to keep the area neutral. Use a filter instead of an opaque object to dodge, too. Try a CC30 or CC50 filter of the appropriate color.

Color prints may need spotting to remove white or light specks caused by dust on the negative. Retouching colors made for photographic prints come in liquid or cake form and as pencils. All three can be used to spot out small specks. The dry cake dyes are useful for tinting large areas. Black spots on a print are more difficult to correct. One way is to apply white opaquing fluid to the spot, then tint to the desired tone with colored pencils.

Mount prints to protect them and to give a finished look. Heat shortens the life of color prints. Overmatting eliminates the need for heat mounting. Dry-mount tissue is usable, but use the lowest temperature setting that is effective. Preheat only the press and mount board. When the print, dry-mount tissue, and board are positioned, insert in the press for the minimum time that will fuse the tissue to both print and mount.

Protect color prints from excess light. Color prints fade over time, particularly on exposure to ultraviolet light. Prints will retain their original colors much longer if protected from strong sources of ultraviolet light such as bright daylight or bright fluorescent light, or by using UV-filtering glass or plastic in frames.

You can make color prints from transparencies (slides) using reversal color print materials. Make your first print a test to determine basic exposure and filtration. See the manufacturer's suggestions for a starting filter pack.

Clean the transparency carefully before you place it in the enlarger. Specks of dust on it will appear on the print as black spots, which are more difficult to deal with than the white spots normally caused by dust.

For best results, print from a fully exposed transparency with saturated colors and low to normal contrast. Starting with a contrasty transparency often leads to considerable print dodging or burning. Ilford makes a low-contrast paper, but reducing excess contrast can also require masking, done by sandwiching the transparency in register with a black-and-white panchromatic contact negative. The photograph below was printed with a contrast-reducing mask.

Be careful if you handle any color processing chemicals. Mix chemicals in a very well-ventilated area. Wear protective gloves to prevent contact of chemicals with your skin. Safety goggles will protect your eyes. Do not pour chemicals directly down the drain; the bleach is corrosive and must be mixed with the other solutions to neutralize it for disposal. This is done by draining the spent processing solutions into the same container in the order that they are used. If you then dispose of them down the drain, follow with a generous amount of water. See the manufacturer's guidelines.

MATERIALS AND EQUIPMENT NEEDED FOR PRINTING FROM A TRANSPARENCY

You can make a positive print directly from a positive color transparency with reversal materials like Ilford's Ilfochrome Classic paper processed in P30 chemicals.

Several types of print materials are available. A resin-coated (RC) paper is available in a glossy and pearl finish. The pearl finish is not as likely as the glossy surface to show fingerprints or surface scratches. Also available is a glossy surface material on a polyester base, which dries to a high gloss. The polyester base provides better color stability and is the preferred choice for archival preservation. Medium- and low-contrast papers are available.

The equipment for printing from a transparency is basically the same as that for printing from a negative. Prints must be handled in total darkness until processing is complete.

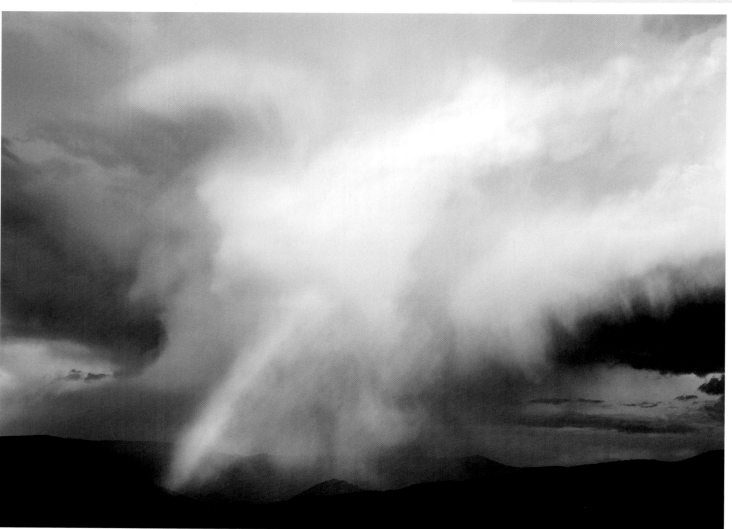

JAMES BAKER Rainbow and Clearing Storm, Roaring Fork Valley, Colorado, 1990

James Baker used a 4 x 5 view camera and transparency film to photograph this rainbow from a vantage point he visits frequently. Baker printed the image on Ilfochrome print material using a black-and-white contrast mask to bring out subtle tonalities in the highlights. His choice of materials "was inspired by the way painters of the Hudson River School in the 19th century were able to render the luminosity of air and capture the color of light."

Print is too magenta. Green viewing filter corrects. Subtract magenta from filtration.

Print is too blue. Yellow viewing filter corrects. Add yellow to filtration.

Print is too red. Cyan viewing filter corrects. Subtract yellow and magenta from filtration.

NORMAL COLOR BALANCE ►

Print is too cyan. Red viewing filter corrects. Add yellow and magenta to filtration.

Print is too yellow. Blue viewing filter corrects. Subtract yellow from filtration.

Print is too green. Magenta viewing filter corrects. Add magenta to filtration.

Unlike printing from a negative, reversal print materials respond the same way that slide film does when you expose it in the camera. If the print is too dark, increase the exposure (don't decrease it). If the print is too light, decrease the exposure.

Adjust the color balance by making the same change in the filter pack that you want in the print. Adding a color to the filter pack will increase that color in the print; decreasing a color in the pack will decrease it in the print. For example, if a print is too yellow, remove Y from the filtration (see chart below and prints, left).

Evaluate and adjust density first, because what looks like a problem in filtration may simply be a print that is too dark or too light.

Then evaluate color balance by examining the print with viewing filters or by comparing the print against a ringaround test chart (left). With Kodak's Color Print Viewing Filter Kit, hold the black side of the cards containing the filters toward you.

When overall density and color balance are good, look for areas that need dodging or burning. If an area is too dark, add exposure and burn the area, instead of dodging it as you would with negative/positive printing. If an area is too light, dodge the area to reduce the exposure.

Whatever you do, keep notes—on the print, with the transparency, or in a notebook.

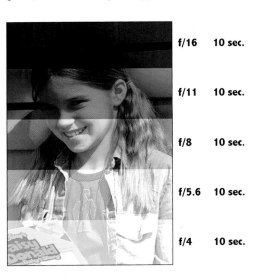

f/16	10 sec.
f/11	10 sec.
f/8	10 sec.
f/5.6	10 sec.
f/4	10 sec.

BALANCING A PRINT MADE FROM A TRANSPARENCY

To adjust the color balance of a print made from a positive transparency, change the amount of the subtractive primary (yellow, magenta, and cyan) filtration. Avoid neutral density when changing the filtration; don't have all three colors in the filter pack.

Print is	Do this	Could also do this
Too dark	Increase exposure	—
Too light	Decrease exposure	—
Too magenta	Subtract M	Add Y + C
Too red	Subtract Y + M	Add C
Too yellow	Subtract Y	Add C + M
Too green	Add M	Subtract Y + C
Too cyan	Add Y + M	Subtract C
Too blue	Add Y	Subtract C + M

photographer
at WORK

Another Angle on Sports—Walter Iooss, Jr.

Walter Iooss has photographed nearly every aspect of every type of athletic contest. Today, editors often hire him for his interpretive photos about athletes and their games—portraits, perhaps, or photos in which he chooses the location and controls the action.

Iooss has always looked for ways to make his sports photographs more than simple action shots: the graphic interest of an unusual point of view; human interest; or an interesting background against which he can position a player. Many sports photographers stay in predictable positions because they know they will get at least something from there. At a basketball game they stay right under the basket or just to one side of it; at a baseball game they keep to the first-base or third-base lines. "I really enjoy going to places that photographers have been to time and again—and finding a picture that no one has taken before."

He would often gamble a whole game, waiting in a particular spot for the action to move to just the place he wanted. He would go to a stadium the day before a game to see where the light was best or what setting might be good.

Iooss says that you don't have to go to professional games to make great sports pictures. "Go to a kids' football game. It's late in the afternoon, the light is terrific, you have kids crying, screaming, sweating—and their parents doing the same. It's better than professional football."

Spring training in baseball is another good time to photograph. It is open to anybody, and you often have opportunities there to be with the players. "Spring training is great because you have more freedom there than at any other sport. Players move between the fields, which means they are moving between the fans. They talk to you, just like players in the old parks where the fans were very close to the players. Baseball years ago was an intimate spectacle, and it still is at spring training."

The action isn't always on the playing field. "I have always been interested in what goes on at a sport's perimeters—the sidelines, a vendor, the fans—not just a guy sliding into third base."

His advice if you are interested in sports photography: "You have to shoot constantly. If you look at top performers—athletes or photographers—they do what they do all the time. I'm always working, shooting, thinking pictures. If you are really interested in doing well at anything, you have to give yourself to it."

"Sometimes you work and work to make a picture," he says. "At other times, it's just seeing and being ready to shoot during those few moments when everything is just perfect, and you feel, 'This is it.' But I may have been shooting for an hour leading up to that moment. Chance favors you—if you are prepared."

WALTER IOOSS, JR. Bernard Hopkins., Philadelphia, 2005

"When boxers leave the locker room and walk to the ring," Iooss says, "it's a very dramatic moment. They walk through the crowd and the crowd is screaming and they're sweating and they have their handlers and there's music blasting. They're gladiators entering the ring. The drama of that moment is as good as the fight." Iooss wanted to recreate that moment. "I created a tunnel of black in his gym, lit it from above, and used a reflector to light up his face. We used a smoke machine in the background. Those are his handlers and some fans."

Iooss had a digital camera, but hadn't used it much. This session was a turnaround for him. "It was a lot faster, the focus was perfect....you could look at every image. It was the first really good picture I'd taken digitally, and I've been using it ever since. Now I'm surprised when anyone wants me to use film.....I'm a traditionalist but I guess I've changed a little."

WALTER IOOSS, JR. Walter Iooss, Jr. at Work, 1998

Professional sports figures are used to photographers, but they still may need to loosen up and relax, especially if you are trying to pose them. "The first roll or two may not be very good until they feel comfortable with you."

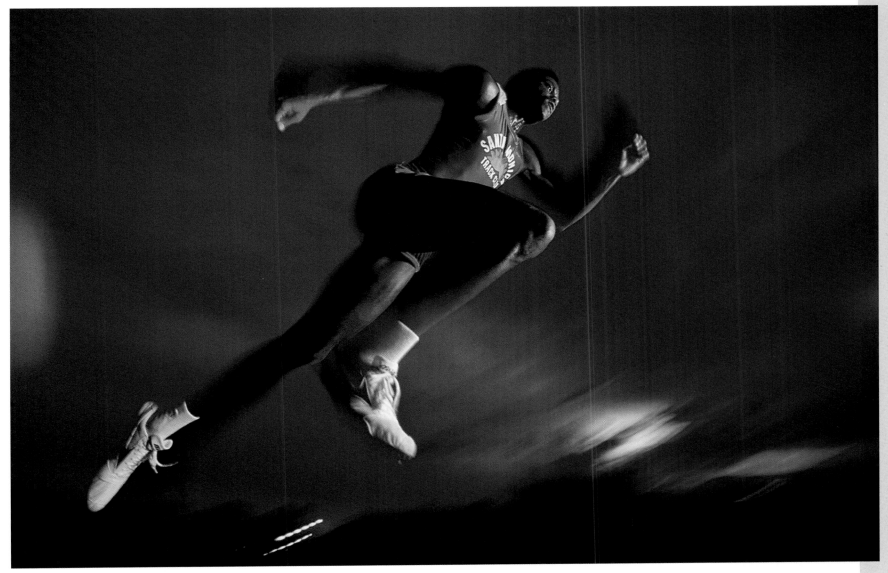

WALTER IOOSS, JR. Carl Lewis, Houston, 1992

COLIN BLAKELY The Perpetual Threat of Violence I, 2006

Colin Blakely used digital tools and combined several different elements. *To this photograph of his daughter made on medium format film, Blakely added frames from horror movies, bits of home videos, and a scanned sky chart. "Through digital collage," he says, "my own personal fears and desires are written into the scene."*

CHAPTER/EIGHT

setting up
a digital darkroom

Digital pictures are made up of a grid of pixels.
Each pixel is a square filled with a uniform shade
of a particular color. If the pixels are small enough
(or seen from far enough away) the individual
squares will not be distinctly visible, and the
photograph will appear to be continuous tone.

Digital imaging—electronically producing, viewing, or reproducing an image—has become standard photographic practice. Photographs destined for print, from news to advertising, are virtually all shot with digital cameras, and those made on film are converted to a digital image when they are prepared for publication. The Internet gives you a way to send digital photographs almost anywhere instantly and also provides a medium for their display. The tools of digital photography let you easily enhance and manipulate your images, combine them in myriad ways, and produce high-quality prints on nearly any material.

This chapter gives you the basics of working with digital images, an explanation of the terms and concepts, and help with setting up an electronic working environment. It introduces scanning, for digitizing existing prints or conventional film. The following chapters show you, once you have an image in your computer, some of the ways that image can be manipulated and printed, and how to minimize the risk of losing it. You don't have to purchase every part of the system yourself. If you are taking a class, equipment may be made available to you. Computer service bureaus, copy shops, and even public libraries in many towns give you access to computers, scanners, printers, and other devices.

Hardware and Software

An Overview

The center of your digital darkroom is a computer. After you capture an image with a digital camera, or digitize an existing image with a scanner, it exists as data, a string of numbers (digits) that is most easily directed or manipulated in a computer. That computer can send those numbers to a monitor so your image can be viewed or to a printer to render it as a hard copy, a print on paper. The computer can store internally the numbers that make up your image, transfer them to other computers, or write them to a removable storage medium.

Digital photography can place serious demands on a computer; you are better off with a recent one that has a relatively fast processor (measured in megahertz or gigahertz) and a lot of RAM (random access memory) and hard drive space (both measured in megabytes or gigabytes).

Commands to your computer are delivered through its operating system. You are most likely to be using an Apple computer that uses the Mac OS (operating system) or a PC that uses the Windows operating system. Illustrations in this book were made with an Apple computer.

Image-editing software that runs within your operating system should be installed on the computer. Software (sometimes called a program or application) is purchased and installed separately to perform a specific task. Adobe Photoshop allows an extremely broad variety of manipulations to be made to a still image; it is available in separate, nearly identical, versions for Windows and Mac. Because Photoshop is so widely used, it has been used for most of the illustrations in this book. Other less expensive programs are available with different features.

Applications can often be expanded with other software made to be run within them, called plug-ins. Plug-ins for Photoshop, for example, simplify or automate actions, operate scanners, mimic specific films, or generate "creative" textures and frame edges. And there are many separate but related applications for other tasks, like downloading, converting, storing, and finding pictures.

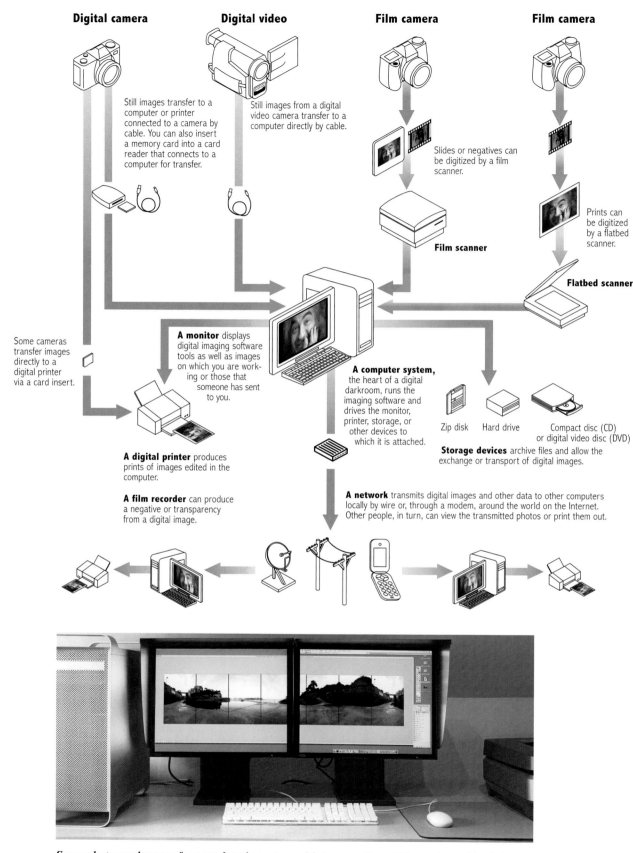

Digital camera

Still images transfer to a computer or printer connected to a camera by cable. You can also insert a memory card into a card reader that connects to a computer for transfer.

Digital video

Still images from a digital video camera transfer to a computer directly by cable.

Film camera

Slides or negatives can be digitized by a film scanner.

Film scanner

Film camera

Prints can be digitized by a flatbed scanner.

Flatbed scanner

Some cameras transfer images directly to a digital printer via a card insert.

A monitor displays digital imaging software tools as well as images on which you are working or those that someone has sent to you.

A computer system, the heart of a digital darkroom, runs the imaging software and drives the monitor, printer, storage, or other devices to which it is attached.

Zip disk Hard drive Compact disc (CD) or digital video disc (DVD)

Storage devices archive files and allow the exchange or transport of digital images.

A digital printer produces prints of images edited in the computer.

A film recorder can produce a negative or transparency from a digital image.

A network transmits digital images and other data to other computers locally by wire or, through a modem, around the world on the Internet. Other people, in turn, can view the transmitted photos or print them out.

Some photographers prefer a workstation set up with two monitors. This one is used by Robert Richfield, whose multipanel photograph appears on page 144. Many people isolate the full image on one monitor, keeping controls, palettes, and menus on the other.

For the same image size, higher resolution looks finer but requires more pixels. You need to know how large you want your image to be (image size) and how much detail you need (resolution) in order to determine how many pixels (file size) will be required.

The finer the resolution, the larger the number of pixels needed. Whether you plan to work on a photograph taken with a digital camera or one scanned into digital form from a traditional print, slide, or negative, you will want to understand the relationship between size and resolution (the fineness of detail) in your final image.

A digital image is like a set of colored tiles that create a realistic scene in a mosaic. The more tiles in the mosaic, the more detail is possible in the scene. Each pixel in an image is equivalent to one tile in a mosaic. The color and location of each pixel is stored as one number. A long string of such numbers that represents all the pixels in one image is called a file. The image file size corresponds to the total number of pixels; as with tiles in a mosaic, the more pixels, the more detail that is possible—and the larger the file.

Image size is the physical size of a photograph, like the surface where the mosaic is being installed—a 1 foot square on a bathroom wall, for example. Image size usually refers to the dimensions of a final print.

Resolution is the number of pixels (or tiles) per unit of length, in pixels per inch (or tiles per foot). If your resolution is 4 tiles per foot, the tiles must be 3 inches square. You will need 16 tiles (4 tiles by 4) to fill a 1-foot-square space.

If you kept the space the same size but used smaller tiles—say 1 inch square—you could make a design with much finer detail. But then you would need quite a few more tiles—144 of them. You can see the relationship: Finer detail demands more pixels, therefore a larger file. Without adding more pixels, increasing the image size decreases the resolution and vice versa.

When you know the final image size and resolution you need, you can correctly choose or adjust a digital camera or set your scanner to get what you desire.

BIT DEPTH

Computers record information in binary form using combinations of the digits one (1) and zero (0). A bit is the smallest unit of information, consisting of either a one or a zero. It can represent only two different possibilities—yes or no, black or white, on or off. A byte is an eight-bit sequence that can represent 2^8 (or 256) possibilities, such as black, white, and 254 different shades of gray in between. The size of an image file is the number of bytes that it contains.

bit

0	0	1	0	1	0	0	0

byte

bit: Smallest unit of digital information
byte: 8 bits
kilobyte (K or KB): 1,000 bytes
megabyte (MB): 1,000,000 bytes
gigabyte (GB): 1,000,000,000 bytes
terabyte (TB): 1,000,000,000,000 bytes

The numbers are rounded off. For example, a binary kilobyte actually contains 1,024 bytes. A megabyte actually contains 1,048,576 bytes (1,024 x 1,024).

The amount of information in a digital image—and therefore its technical quality—is determined by both the number of pixels and the number of possible values each pixel can hold. The greater the number of pixels that represent a given image, the greater the amount of detail that can be recorded. In two pictures of the same size, one with smaller (therefore more) pixels can hold finer pictorial detail.

Similarly, the more finely divided the values or tones in each pixel (the bit depth or number of bits per pixel), the smoother the gradation can be from one pixel to another. With more bits per pixel, each pixel can render a greater selection of possible colors and tones (see photos, right). Many factors affect quality, but, in general, the more data in an image, the better the final photograph will be.

The human eye can differentiate more than 100 different shades of gray between black and white, but fewer than 256. Eight bits per pixel for each primary color is more than enough to reproduce what we can see. But when you adjust the tones of a photograph, you may choose to stretch only a few pixel values in your file over a wide range of tones in a print. This can produce a kind of posterization called banding. Starting with extra data—the 12 or 16 bits per color (36 or 48 per pixel) that many cameras and scanners can capture—will prevent such problems.

1 bit per pixel gives 2 values. The image can have only two tones: usually black and white.

8 bits per pixel gives 256 tones. From 0 (black) to 255 (white), 256 tones provide excellent black-and-white rendition.

24 bits per pixel (eight per color) gives 16,777,216 colors, enough for a color image with smooth gradations and full tonality, comparable to a traditional color film photograph. A color photograph is made up of three images, one in each of the three primary colors. With 8 bits each, those three colors can each have 256 different shades—red from darkest to lightest, for example—making more than 16 million possible colors.

Photographs are stored in a computer as a file, just like a word-processing document, an e-mail message, or a spreadsheet (these are data files), or a software program (an application file). Any file is simply a string of binary numbers (page 165) but files for different purposes can be written and stored in many different formats. Many data files can only be opened or read by the programs that created them; they are written in proprietary file formats.

You have a choice of different formats when you save a digital image (see the box below), but you must also make a choice when you capture one. Although digital cameras will create a JPEG file that is universally readable, it is wise to set your digital camera to save your exposures in a form that preserves all the original data. Better digital cameras can save your images as unprocessed, raw files, and the manufacturers provide software to open them. Unfortunately, current proprietary camera-raw formats may become unsupported (meaning that software to read them will be unavailable) in the future.

The DNG (digital negative) format was developed by Adobe to provide a more universal camera-raw format. It is open-source (not proprietary), Adobe provides a free converter, and the DNG file it makes can contain your original raw file as well as a version that you can adjust, save, and later change in any image-editing program. Some camera manufacturers are now using DNG as their camera-raw format.

If you scan from film or prints you should be able to return, if necessary, to the originals. But saving the raw scan is a good practice. Scanning software usually produces TIFF files, a format that is lossless (explained below), open-source, and universally readable.

One reason to choose one format over another is to reduce file size. Larger image files take longer than smaller files to save, open, and transmit, and they use more file space to save. Fortunately, image files can be compressed.

You squeeze a large picture into less space by eliminating redundant information. Consider a picture with a large blue sky. To represent many blue pixels, the computer may store hundreds of identical numbers, each representing the same color blue. Compression software calculates the number of successive, identical blue pixels and stores the total count rather than repeatedly storing the same numbers for each individual pixel.

For example, if x stands for blue, the original file might be xxxxxxxxxxxxxx xxxxx, but the compressed file would be x20, taking up much less space. To decompress the image, the program sees x20 and lays out 20 blue pixels representing the sky. If the method of compression exactly preserves all the data, it is called "lossless." The reconstituted picture is then exactly the same as the original, and it may be compressed and expanded any number of times without change.

Other file compression methods exist, called "lossy," in which some picture quality is lost. JPEG is the most common lossy format. Depending on the degree of compression, you may see some degradation of the image, or none at all. Generally, the more the file size is reduced, the more the image is visibly degraded. Lossy compression is useful for photographs destined for Web pages, where short download times usually are more important than the quality of reproduction.

FILE FORMATS

You can save a picture file in a variety of formats. Following are the common choices and the reasons for choosing one format rather than another.

JPEG (.jpg) compresses photos by discarding pixels determined to be unnecessary. A 24-bit image saved as a JPEG file can be reduced to as little as one-twentieth its original size. JPEGs, with their smaller file sizes and faster transmission time, are the preferred means of displaying photographs on the Web or sending snapshots over the Internet. Digital cameras

offer this format as a file option.

It's possible to save JPEGs at various quality levels. More compression reduces both file size and image quality.

TIP: Opening a JPEG, changing it, and saving it as a JPEG again degrades the image. Each time an image is compressed, it loses quality. After you have opened a JPEG from a digital camera, save it as a TIFF or PSD file so you can open, change, and save it again without losing quality. Save a picture as a JPEG only if you need to save space or transmit the image on the Internet.

TIFF (.tif) is the universal format for high-quality photographs and can be opened on any computer by nearly every program that works with photographs. It is the most widely used format for publishing and printing. Saving a file as a TIFF makes no changes to it, and its optional compression (LZW) is also lossless.

PSD (.psd) is Adobe's proprietary format for Photoshop documents. PSD files can be opened and edited only in Photoshop. If you are using Photoshop to edit a file, there are few reasons to use any other format

until your editing is complete and you save the file for a specific purpose.

Camera RAW: .CR2 and .CRW (Canon), .NEF (Nikon), .PEF (Pentax), .ORF (Olympus), .3FR (Hasselblad), etc.

Raw files are the most direct representation of an exposure on a camera sensor. No captured data is lost. A camera-raw file saves individual photosite data (remember that each captured pixel represents only one primary color) in its full bit depth. Choices like white balance, for example, are saved with the file but pixel values are not changed by them.

Raw file formats are proprietary; each camera manufacturer has its own. Fortunately, most raw files can be opened (by Photoshop and other applications) and resaved in a different format.

DNG (.dng) is a camera-raw format that is open-source, which means any camera or software company can use it in their product. Any other camera-raw format can be converted and, if desired, kept intact within the DNG shell.

PNG (.png) is a lossless compression format used for Web-based photos. It can interlace images and

be displayed in browser windows with up to 256 colors.

GIF (.gif) produces small Web files and is best for flat-color images with type or line drawings included. It is not good for photos.

EPS (.eps) can save photographs, illustrations, and text together. It is commonly used in publishing but rarely in any other field.

BMP (.bmp) and **PICT (.pct)** are platform-specific graphic formats: BMP for Windows and PICT for Macs.

PAUL BERGER Card Plate # 7, 1999

Paul Berger was a pioneer in the use of digital imaging as a fine art medium. This work begins with the metaphor of a printing-press sheet, on which many pages in the same book are printed at the same time. The printing industry was the first to be radically altered by the introduction of digital imaging.

The elements in these images repeat and change from one section to another, letting viewers create their own set of relationships between the different parts.

Before you can digitally adjust or print your photographs you must get them into a computer. The process of transferring image files from a digital camera into a computer is called downloading. Scanning is a process that reads an existing negative, slide, or print, converts it into a digital image file, and sends it to a computer.

You can download your photographs directly from a digital camera by connecting it to your computer with a wire, or you can remove its memory card and insert it into a card reader (below, right) that is connected to a computer. There are several noninterchangeable memory card formats, so make sure your cards fit your card reader. In the field, away from your main computer, it is safer to download regularly rather than to store your pictures on memory cards (see pages 4 and 212).

The best travel solution is to download them to a laptop, so you can easily organize and back up your files. There are smaller and more portable storage devices (like the one shown below) that will let you see the photographs and verify that the files have not been corrupted (damaged) by the transfer. Portable CD burners are available that incorporate a memory card slot for a direct transfer. With an adapter, you can transfer image files directly to a portable hard drive or a portable digital music player (an MP3 device or iPod). With these options, however, you may not be able to display images or verify the files.

A portable storage and viewing device will allow you to back up your work or clear your memory cards without using a computer.

Scanners are the bridge between film and the digital darkroom. A digital camera captures what you see directly as pixels that can be edited on the computer. But photographs that were made on film need to be digitized first. A scanner reads color and tonal values from film or from a print and converts them into a pixel grid just as though the picture had been taken with a digital camera.

Scanning software controls the process, offering you various choices about how your image will be scanned (see opposite page). Image editing software gives you many more tools for editing, and allows more precise adjustments than scanning software, but it's still a good idea to make as many corrections as possible in the scan. Making good exposure, contrast, and color balance decisions when you scan can improve your results considerably.

Very small card readers are available, some barely bigger than the card itself.

Film scanners are made specifically for transparencies or negatives and cannot scan anything opaque. Some have a batch feeder that holds a stack of mounted slides. Film scanners that accept medium- and large-format film are considerably more expensive than those made only for 35mm.

Flatbed scanners were originally designed for opaque, reflective originals, (such as photographic prints) but many now are equipped with a transparency adapter and rival the quality of a dedicated film scanner for negatives and slides. The scanner s bed is a rectangular sheet of glass. Most scanners are letter (8 1/2 x 11 inches) or legal (8 1/2 x 14 inches) size; professional models may be tabloid (11 x 17 inches) size or larger. A flatbed scanner will digitize anything placed on the glass: a photograph, drawing, magazine page, or even your hand or face.

Drum scanners are very expensive professional tools (they cost as much as a new car), that yield the best possible quality from both film and prints. If you make photographs on film for publication or for extreme enlargement, you may want to have them drum scanned at a prepress shop or service bureau.

SCANNER FEATURES THAT AFFECT QUALITY

Optical resolution is the maximum number of pixels per inch the scanner can capture. If it is described by two numbers, such as 1200 x 2400 ppi (pixels per inch), the first number is the resolution across the width of the scanning area, the second its height. Since the captured pixels are square, the smaller number represents the scanner s real optical resolution.

If you want to make large prints from scanned 35mm film, you will need a scanner with an optical resolution of at least 2700 ppi. Film scanners with 4000 ppi resolution are better, and fairly common.

Interpolated resolution uses software to guess what the pixels might look like in between the ones the scanner can actually measure. No real information is generated; scan no higher than the optical resolution.

Dynamic range (the tonal range or contrast) of a scanner should be at least 3.5. Slides have a wide dynamic range very dense shadows and very light highlights and usually are more challenging than negatives to scan. A dynamic range of 4.2 will gather almost anything on film and will get the most out of difficult originals.

Bit depth. At least 24 bits per pixel (8 bits red, 8 green, 8 blue) are needed; 36 or 48 bits will allow more precise tonal adjustments.

Scanning software may be an independent program that operates the scanner and produces a file to be opened in an image-editing program. Some exist as a plug-in that permits scanning directly into Photoshop for further manipulation. Most scanners come with dedicated software; third-party vendors such as SilverFast and VueScan sell scanning software that may be more sophisticated and provide more control.

Focusing may be automatic or manual and can be used to adjust for warped or buckled film frames, for example.

Sharpening usually is an option in scanning software. Photoshop s sharpening tools usually allow more control, so sharpening can be left for later editing.

Dust removal is provided in some scanners by an extra infrared channel (RGB+IR) that can be used to detect and remove dust, fingerprints, scratches, and other surface damage from the scanned image. **NOTE:** This may not work with conventional black-and-white film or Kodachrome but does with most dye-based slides, color negatives, and chromogenic black-and-white films.

Image-editing features such as histograms (step 9)

Output (step 7)

Resolution (step 8)

Preview (step 5)

Making a Scan. Scanners and scanning software differ between manufacturers. These steps are a basic guide for scanning, but find the appropriate controls on your own equipment. The instructions assume that you have already connected the scanner to your computer and installed the appropriate software.

1. Turn on the scanner, then turn on the computer. Some computer systems need the scanner to be turned on first to recognize it.

2. With a flatbed scanner, make sure the glass plate is clean. In a school lab, the lab may want you to use a particular cloth or cleaner. Dust or clean the print or negative as needed. The scanner will assume that any dust is part of the image. Some film scanners have dust- and scratch-reducing features that can help a damaged original.

3. Place a print facedown on the glass of a flatbed scanner or load fim into the appropriate film holder.

4. Start up the scanner software, such as via Photoshop s pulldown menu. File>Import>SilverFast (or your scanner s software name). A window listing options will appear (see left, top).

5. Click Preview (or Prescan) to make a quick, low-resolution image so you can see the image and make adjustments to the cropping, tonality, or other settings.

6. Crop the image to exclude any areas that you know you won t want in the final scan. Scanning unneeded area takes up storage space and slows down the process.

7. Set the image output size. How big will your final image be? The software needs to know this in order to record enough information for that size.

8. Set the resolution based on how you plan to display the image (see box below).

9. Make preliminary corrections for contrast and color. Depending on your software, you might have access to a histogram (page 172), curve controls, or other features. Additional corrections can be made in Photoshop, but it s a good idea to make those that you can before you scan the image.

10. Make the final scan and save in the appropriate format (see box page 166). Check the image before removing your original from the scanner. If you think it needs more adjustments, such as of color balance, scan it again with the new changes.

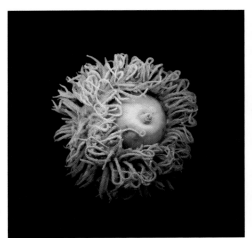

DENNIS DEHART From the series *Burn*, 2002

Dennis DeHart uses his flatbed scanner as a camera. He treasures the qualities of seemingly insignificant objects picked up from the ground on his long walks. A scanner's light source accompanies its line of CCDs as they move across the *subject, so in addition to illumination and focus falling off in the background (just as they do with a camera and flash making a photo from one position) the light and focus across the image change as the scanner's light and CCDs move.*

BEFORE YOU START, DECIDE HOW MUCH RESOLUTION YOU NEED

The quality of an image captured by a scanner is determined by resolution, the amount of information that is recorded. You will want good resolution, but capturing more than you need will create larger files, which can create storage problems and slow down the processing time.

 To determine the resolution needed, decide how the image will be displayed. For example, many computer monitors display about 100 ppi (pixels per inch). If you know you will be using a particular image only on the Internet, you won t need more than 100 ppi at the size you want the image to be displayed. However, if you intend to print the image, 240—360 ppi (at final size) is needed for good quality.

Intended use	Scanning resolution
Internet	100 ppi
Newspaper	150 ppi
Photographic-quality print (inkjet or dye-sublimation printer)	240—360 ppi
Glossy magazine, book	400 ppi

Color Management

How can you make sure the colors you end up with look like the original scene? How can you make a print look the same as the image does on your computer monitor? Understanding how digital imaging deals with color will give you better control of tools that can help you produce the final image you want.

Digital imaging reproduces all the colors in the scene by using only the three primary colors: red, green, and blue (see diagram, right top). Digital photographs are captured, stored, and displayed as pixels, each of which represents specific brightnesses of red, green, and blue light. With 8 bits per pixel producing 256 tones, each color's brightness—from dark to light—is represented by a number from 0 to 255 (see page 165 to review bit depth). So the color of one pixel, might be written as 68, 122, 213, a mix of a dark red, medium green, and light blue.

This notation is used in the RGB color mode. The publishing and printing industries use the CMYK mode, which adds black (abbreviated K to avoid confusion with blue) to the subtractive primary colors, cyan, magenta, and yellow. Colors in the CMYK mode are described by four numbers.

Gamut is the entire range of colors that can be seen, captured, described, or reproduced by a given device. Our eyes perceive a greater gamut (many more colors) than

Calibrate your monitor with a hardware device at least monthly to adjust its display to a predefined standard. Try to arrange your workplace to have consistent light and no reflections or glare. Avoid brightly-colored walls and furniture.

any film, digital camera, or scanner can record or any computer monitor can display. In turn, these can capture and display more colors than any printer or printing press can reproduce.

A problem occurs because each device operates within a different gamut. When they look at the exact same color, digital cameras and scanners will each read a slightly different set of numbers; given the same numbers, different monitors and printers will produce different colors.

Color management is the process of coordinating a digital image's colors from nature to camera to monitor to print, so that you can be sure of the color that finally will be produced. With some attention to color management, you can make reasonably accurate color images and avoid unpleasant surprises.

Color profiles are mathematical descriptions of the color characteristics of each piece of equipment you use to capture, view, or print. They are used as translators to map one gamut onto another so you can keep colors consistent as you work. That process is called color management.

Profiles are most important for printers (see page 202) and monitors. Generating a profile for your monitor is called calibration, which means changing the behavior of a device to meet a standard. The brightness and color of any monitor can drift over time; make sure your monitor is calibrated, using dedicated software and hardware, at least once a month.

You can generate an input profile for a digital camera using software, plus a test chart of standardized colors. A profile can save time if your camera exhibits a distinct bias, if all your photographs are too red, for example. But unless you need absolute accuracy, you can color correct well enough during image editing.

This page introduces you to the basics of color management. More appears in the next chapter and in the bibliography. You don't need to deal with every issue right away, but as you become more exacting in wanting a particular image to look a particular way, you will want to fine-tune your color management.

Digital imaging uses primarily an RGB (red, green, blue) color mode. All scanners, digital cameras, monitors, film recorders, and television sets are called RGB devices because separate amounts of these three primary colors of light—red, green, and blue—combine to create other colors.

Green and red light mix to produce yellow; red and blue light produce magenta; green and blue produce cyan. Black is the absence of any of the colors, white is the simultaneous maximum brightness of all three together, and neutral grays are made up of equal amounts of each.

A gamut is the range of colors that a device such as a monitor or printer can capture or display. Above, the gamut for a monitor shows—in 3-D—all the colors it can display, from dark at the bottom to light at the top. Its outer edges, projected below it, are the limits of saturated color.

Below, the same gamut is shown superimposed with the gamut of a glossy paper on an inkjet printer. Colors the printer can print but the monitor can't show (some saturated middle-value yellow-greens and reds) are projected beyond the outer shell. Profiles help translate the colors so that a color seen in one system will be reproduced similarly in another system.

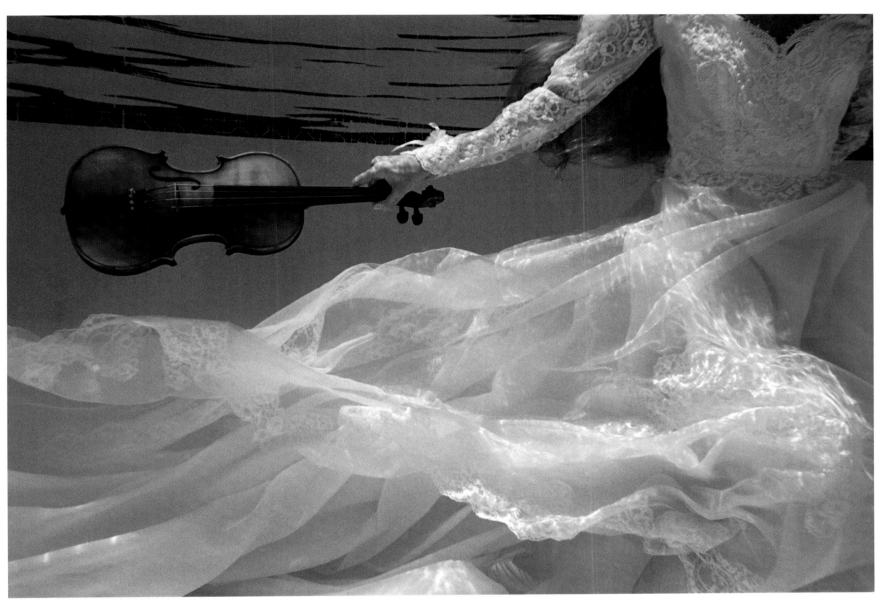

KENDA NORTH Urban Pools #136, 2005

***Digital imaging gives great control of color and
how it is rendered.*** *For Kenda North, "The ability
to modulate the color through Photoshop is very
exciting. Many years ago I worked extensively with
dye transfer materials which offered seemingly
exquisite control of color and contrast. Photoshop
gives me even more opportunities to modify color
to suit my personal palette. For example, a pink*
*highlight can remain vibrant against a blue
shadow, something that is very difficult to do with
conventional color printing."*

*In addition to control of color, digital imaging
lets North print on many different paper surfaces
and sizes. "This print was done on heavyweight art
paper, giving texture and physicality to the print. I
once again have artistic control of the final print."*

Histograms
Anatomy of a Digital Image

A histogram shows the brightness values of all the pixels in an image. The height of each bar in the chart represents the number of pixels of a particular brightness level that occur anywhere in the image. In an 8-bit image, the histogram shows each of the 256 tones available for the picture. Black is 0, middle gray is 128, and white is 255.

For most scenes, a rich print uses most of the 256 tones, from the subtle tones of a white cloud to the deep shadows on the side of an old barn. Empty space on either end of a histogram usually means a digital image has no bright highlights or no dark shadows. It can be a sign of a scene with a very low contrast range or a scan made without correct settings for the white and black points.

Digital cameras display a histogram as a kind of digital light meter. An image in a camera's monitor is often too small or too dim to see clearly. The histogram of an image you have just taken will tell you if your picture was over- or underexposed so you can immediately adjust your shooting strategy.

In scanning software and photo editing programs, a histogram guides your lightness and contrast adjustments. The software displays a histogram (see Using Levels, page 185) and you redistribute the tones in the image according to the information it presents. Scanning software displays a histogram so you can direct the scanner to capture the tonal range you need, and to adjust the tones within that range.

HISTOGRAM: A TEST FOR YOUR EXPOSURE
A histogram displayed after each shot tells you if tones have been clipped, which means some highlights have been recorded as pure white or some shadows as pure black.

CORRECT EXPOSURE
The histogram for this well-exposed image has pixels distributed across the range, with none at the extreme ends.

UNDEREXPOSURE
This underexposed image shows pixels only at the shadow end of the histogram. Detail is absent in the subject's darker areas because those tones have shifted to black, the far left end of the histogram.

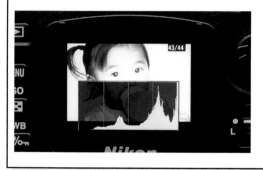

OVEREXPOSURE
Overexposure shifts all pixels toward the highlights. Clipping (a sharp cutoff of tones at either end of the scale) is visible at the right, just as it is at the left, in the underexposure histogram above.

HISTOGRAM: A GRAPH OF A DIGITAL IMAGE
A histogram shows the brightness values of all the pixels in an image. The height of each bar represents the total number of pixels of a given brightness in the whole photo. The spread shows the frequency of each of the 256 tones available for the picture. Pure black is 0; middle gray is 128, and white is 255.

Shadows — Highlights

Pure Black 0 — Middle Gray 128 — Pure White 255

NORMAL CONTRAST

The histogram for this normal-contrast image has pixels well distributed in shadows, highlights, and all the tones in between.

HIGH CONTRAST

The light and dark tones in the histogram for this high-contrast image are clustered at either end, near pure black and white with very little gray in between.

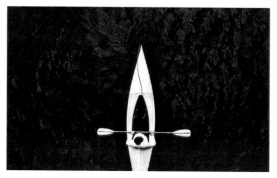

LOW CONTRAST

The tones in this low-contrast image are bunched in the middle of the histogram with fewer pixels in the highlights and shadows.

A color photograph may be displayed as three histograms, each representing one of the three primary colors (the bottom three histograms, below). For example, the red brightness values of each pixel in a full-color image can be displayed as a separate monochromatic image in black and white or in color, as shown here. Each of the components of a color image (four for a CMYK image) is called a channel (more about channels on page 183).

A single histogram that represents the full color image (the top histogram, below) may be enough information in many cases. For example, it can be used to determine exposure with a digital camera (opposite page, right). Separate histogram displays of each channel are particularly useful for scanning; they help you set individual black and white points and balance each color.

KEITH JOHNSON Spring, Boston, Massachusetts, 2006

A color photograph can have histograms that represent each channel separately, or a combined one that merges them (both types are shown at right for the photograph above). In the R, G, and B histograms, you can see a bump in the highlights (at the far right of each channel) from pixels in the very light sky. Each of those pixels has a higher blue and a lower red value (a typical sky-blue pixel might be R200, G215, B230), so the blue bump is shown farther to the right. The broader, higher rise in each color histogram is wider in the red channel, and lighter (farther to the right), because of the large number of pixels representing pink flowers.

Knowing the distribution of colors can help you make better editing decisions about them.

Workflow is a recently popular term for a traditional concern: establishing an efficient series of steps to achieve a finished product. If you are a photographer using digital tools, your workflow might simply be this: capture, download (or scan), organize, edit, output, and archive.

Capture is what most people think photography is all about—searching, shooting, camerawork—whether you use film or a digital camera.

Downloading (sometimes called importing) gets your captured images from a camera into a computer so you can complete the rest of the steps. The computer is the command center for all the operations of your workflow. Downloading the images to your computer's hard drive also frees the camera's memory card to be reused. Scanned images are sent directly from the scanner to the computer.

Organize your images, keeping in mind that you may soon have thousands of them. Pages 213 and 214 discuss ways to make sure you can find the needles in your haystack. Essential information can slip from your memory if there are long delays between shooting and organizing; try to make time to put your image files in order at the end of every shooting day.

Editing has two different meanings in a photographer's workflow. The traditional version of editing, letting the "good" pictures rise to the top, is actually part of organizing. Digital image editing, or post-processing, encompasses a wide range of alterations to a photograph that can go well beyond the choices that could be made when printing an image in a darkroom. Software available for photographers, such as Apple's Aperture and Adobe Lightroom, can perform most of the standard image

adjustments—cropping and rotating, changing size, modifying hue, value, and saturation. Adobe Photoshop, as shown in Chapter 9, can do much more.

Image editing is used to prepare an image for the next step, output. Since you may have several different uses for the same image, you may use image editing to prepare several different versions. Editing has its own workflow, see An Image Editing Workflow, pages 196 and 197.

Output is not limited to printing, although that may now be your primary focus. Later you may want to show a prospective client your work on a laptop or e-mail images to a gallery. Your output may be destined for a billboard and a Web site, as well as a wall. To create the best file for each use will require several different editing strategies.

Archiving means keeping your work in an organized way so it is preserved against change, damage, and loss, and so that individual items may be retrieved, or found, when necessary.

Digital files present unique challenges for long-term storage (see page 215) but have a big advantage over most materials; they can be identically copied. A copy of a file (or of an entire drive) is called a backup. All the media on which files can be kept are vulnerable to well-understood threats like theft, fire, and flood, but each has its own set of weaknesses to things like dust, magnetism, heat, and shock. Your best defense is to make multiple copies of everything you do, as early in the process as possible, and to create two or more identical archives stored in different locations. A digital file can vanish in an instant; once it is gone—if you don't have a copy—it is gone forever.

HULLEAH J. TSINHNAHJINNIE Idelia, 2003

Hulleah Tsinhnahjinnie uses digital imaging to address complex issues of identity. Her works combine Native American symbols, abstract imagery, and personal references from her own life.

GARY HALLMAN Icarus Too, 2003

Icarus was a mythological figure who attempted to fly with wings of wax and feathers, but flew so close to the sun that the wings melted, and he fell to his death in the sea. Here, a suited, formal figure is shrouded, as if his wings are melting over him.

photographer at WORK

Digital Storyteller—Pedro Meyer

Pedro Meyer has found that digital imaging frees him to tell stories. For many years a documentary photographer, he now works in a way that is very different from the traditional documentary. He combines and alters images and openly challenges objections that the results might not be altogether truthful. He was probably the first serious photographer to completely make the transition from the world of the darkroom to the world of the computer and digital photography. Today, Meyer refers to his work as either "B.C." (before computers) or "A.D." (after digital).

"Manipulation exists at the very moment the original picture was made," Meyer says. "Everything else that follows are only ensuing stages of further manipulation. The reason to use manipulation in making images is that we have always done that, only now we can do it with greater ease, and that expands our abilities to express ideas."

Meyer's alterations are somewhat controversial. Are they really "documentation"? Are they "realistic"? He compares his work with that of a documentary film director. The film camera starts and stops many times. The editor then rearranges a vast number of separate takes into a final coherent order, collapsing both time and space into a 90-minute film that tells a story. The computer, Meyer says, gives still photographers the tools of a movie editor to tell stories with their images. Photographers have become accustomed to the notion of "having content and geometry make an appointment, in great part through luck," he says. "I personally dislike the notion that my work be determined mainly by luck."

"It's very important for people to realize that images are just a representation of reality," Meyer observes. "I'm not suggesting that a photograph cannot be trustworthy. But it isn't trustworthy merely because it's a picture. It's trustworthy because somebody we trust made it. We don't trust words because they're words, but we trust pictures because they're pictures. That's crazy. It takes away our responsibility to investigate the truth for ourselves, to approach images with care and with caution."

Meyer maintains a virtual gallery and a lively discussion place on the Internet. "I have heard so many arguments about the intrinsic advantage of the 'real' gallery space over the Internet variant," he writes, ". . . the sensorial nature that is being allegedly lost. I wonder when was the last time that anyone was allowed to 'touch' . . . pictures in a traditional gallery or museum. Why all this nostalgia about touching. . . . Everything we are taught to do with pictures is about 'not touching.' Do not touch the negative, the slides, the prints. Today the image is as much under 'glass' (a monitor) as when the thing hung framed on the wall. However, there is one very important advantage to the digital image when seen on a screen: It is backlit. The actual tonal range that a photograph can offer when viewed on the computer screen is larger than when the same image is printed out on paper."

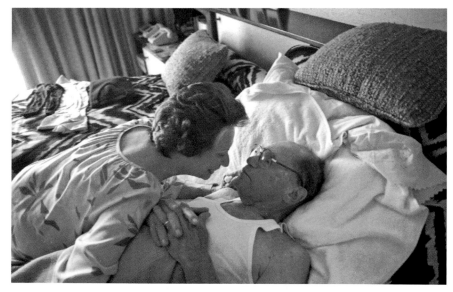

PEDRO MEYER I Photograph to Remember, 1987

Pedro Meyer's career has embraced traditional documentary photography as well as digital storytelling. His moving black-and-white documentary, "I Photograph to Remember," chronicles the decline and deaths of his mother and father. Above, his ailing father is comforted by his wife. For this project, Meyer constructed a CD-ROM that incorporated the images and his own commentary about his parents. You can view the project at zonezero.com.

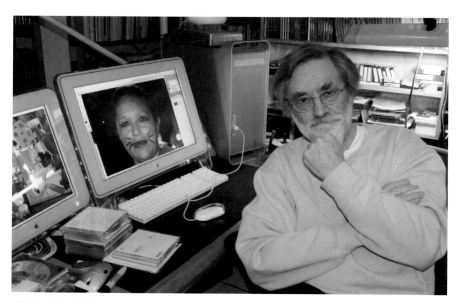

PEDRO MEYER Self-portrait of the artist at work in his "darkroom," 2003

PEDRO MEYER The Storyteller, Magdalena Jaltepec, Oaxaca, 1991—1992

Pedro Meyer likens his role in creating photographs to that of a stage director in a theater. *His photograph of a woman erecting a backdrop for an outdoor stage in a village in Mexico reminded him of the beginning of a children's story. "And who would be in that story?" he asked himself.*

Meyer had taken a series of photographs of an elderly man sitting in a straight-backed wooden chair. "They were lovely portraits," Meyer said, "but they didn't go farther than that." The elderly man provided a storyteller for the stage. Then, performers were inserted from a photograph of a man next to giant papier-mâché figures, all reduced to little figures in the foreground.

For more about Meyer and his work, see his Web site, zonezero.com.

Chris Collins, *Frogs in Server Room*, 2004

Complex composite images like this one require planning. *The client, a software company, wanted to suggest that their product could protect a user's data against catastrophe but—reasonably enough— didn't want a plague of frogs in their own computer room. They were added later in post processing.*

Collins first photographed the room, then built a half-size model of it in his studio and duplicated the original lighting setup. He made dozens of shots of the model with hundreds of frogs piled in different positions around the floor, *then chose several of those images to be composited into the scanned photograph of the full-size room (see page 194).*

Collins set up lights and a soft landing place for the individual airborne frogs and made over 200 exposures of a dozen different ones (he called them the "VIP" frogs) jumping and falling from his hand. For the final product, he added those frogs to the final image one at a time, then tilted the horizon "to give the image a hurried, photojournalistic quality."

Image-editing software lets you change any of a photograph's overall characteristics, such as size, contrast, and color.

You can also select any area within a photograph for the same control.

Other techniques let you create a variety of special effects or composite one part of an image into another.

Setting up a workflow will help you organize what you need to do first—and next.

Any result you can produce in a traditional darkroom—and some that you can't—can be achieved with the help of digital image-editing programs. Digital imaging can simply enhance an image or radically change it.

Saving a digitally edited photo preserves all your decisions exactly and produces results of identical quality from one generation of an image to another. Regardless of how much you have manipulated a digital image, once finished you can print it now or in six months, a year, or more and still get the same results from the original file. In addition to performing typical darkroom procedures such as changing contrast or lightening and darkening an image, you can combine images, add color, posterize, draw on, and otherwise manipulate a photograph. In effect, you can create a new image with qualities that are never fixed because you can always go back and change them.

Digital Post-Processing and Editing: Getting Started

Choosing Software

How do you manage your photographs after you take them? Post-processing operations may be a few steps or many, using one application (software program) or several. For years, Adobe Photoshop has been the leading application for editing digital images. It has the broadest reach and the highest level of precision for adjusting, manipulating, and combining images. Recently developed applications such as Adobe Photoshop Lightroom and Apple's Aperture are image editors with a more limited, practical set of image adjustments, but they incorporate other features aimed at the breadth of a professional photographer's

workflow. These include tools not found in Photoshop for downloading, organizing, comparing, rating, storing, and finding photographs, all discussed in Chapter 11. Photoshop itself is also available in a feature-limited (and less expensive) form called Elements.

Image editing, the anchor of post-processing, encompasses all the adjustments you make to the way one photograph looks. The kinds of adjustments each program allows, and the tools that apply those ajustments, are similar from one program to another. Most software is available in a free trial form; read these

chapters to get an overview of post-processing, then try them to see what fits your needs.

Photoshop CS3 is illustrated in this book, but to use it competently you will also need one of the many widely available user's manuals written for it. Popular software is updated frequently; make sure you have a recent version of your program and a book that matches it.

There are often several ways to achieve the same result. Use whatever works for you, but, especially if you perform an operation frequently, check to make sure there isn't a faster or easier way.

LORETTA LUX The Fish, 2003

The little girl is believable but surreal. Sophisticated image-editing software has given us the tools to explore the edge of the plausible, as well as making it easy to reach well into the realm of completely invented imagery.

Tools and commands are used to manipulate your photograph in image-editing software such as Adobe Photoshop CS3, shown here. Tools are displayed on screen as small symbols called icons, arranged in a toolbox (the series of small boxes shown here at the left side of the screen).

Commands, such as Blur, Sharpen, and Transform, can be reached from pull-down menus across the top of the screen. Such commands will often open a dialog box, for entering further refinements of your command. Photoshop displays palettes, such as the Layers palette or Info palette shown on the right of the screen, to provide information as well as more tools and menus of commands.

One of the most important commands is Undo (not shown here). Choose the Undo command from the Edit menu (menu paths like this are abbreviated in this book as Edit>Undo) to cancel your last action, returning the image to its previous state. This lets you try an effect, then undo it to see how it looked before. Edit>Redo reinstates the command. Photoshop also has a History palette that displays a number of previous states (see box, below right) to which you can return the image.

Save an unaltered copy of your image so you can experiment and still have the original to go back to in case you change your mind. Use File>Save As and give the file a slightly different name so you can tell which version is which. With very complex edits, you may want to save intermediate versions as you work, to avoid having to return to the very beginning.

Programs like Aperture and Lightroom (that offer more of a full workflow) are organized around digitally captured photographs in camera-raw form (file formats are detailed on page 166). They store image adjustments separately from the original file but apply them whenever the file is opened. The display on the monitor or the print you make looks the way you have decided it should look, but none of the originally captured data is altered—even when you save multiple differently edited versions—until you export the file.

Tool Options bar lets you define the characteristics of the tool highlighted in the Toolbox (see below). Here, the options for the Polygonal Lasso tool are shown.

Menu headings open to reveal various commands. Here, the Window menu is open; it lets you display or close palettes on the screen.

Palettes, kept on the screen or hidden, provide information and ways to modify images. Clicking on a palette's menu icon reveals other commands and options.

Image file size

Toolbox holds commonly used editing tools that let you use the mouse to, for example, select, crop, lighten, or measure parts of an image. Select one by clicking on it. Click and hold to show other options for that tool.

Tools with arrows to the right provide access to related tools. A tool's characteristics can be adjusted using the Tool Options bar at the top of the screen.

PREFERENCES AND SETTINGS

Image-editing programs can be customized with your preferences. Most of the default preferences—those that are installed with the program—are fine, but check through them to see what they control and whether there are any you want to change. You can make a number of individualized adjustments that will reappear identically every time the program is opened.

Some preferences can have significant but indirect consequences. For example, in Photoshop you can specify the number of steps back (History states) you can take. The choice affects how the computer's RAM memory is used. Setting too high a number can make the program operate very slowly. All the books on

Photoshop discuss Preferences in detail; make sure your book corresponds to the version number (for example, 7.0 or CS2) of the program you are using.

Some settings govern the behavior of tools and commands. Look for options whenever you use a tool for the first time; some options, like the shape of a drawing brush, can be collected and saved in a set.

Color settings are particularly important to ensure that your final results look exactly the way you expect. Open a photo file, then select Edit>Color Settings to reveal a dialog box.

Every photograph's color numbers should be assigned to a color space so it will look the same, for example, on any

calibrated monitor. In the dialog box under Working Spaces, set your RGB to Adobe RGB (1998) and your Gray to Gray Gamma 2.2.

When you calibrate your monitor (page 128), choose a matching gamma, 2.2, and a white point of 6500K. There are other choices; you can learn more from a book on color management (page 404). If you are working in a group setting, like a school lab, some of these choices may be made for you.

If a file opens in the sRGB working space and you plan to edit it in Photoshop, convert it to Adobe RGB (1998) using Edit>Assign Profile. Most digital cameras use sRGB, but it is not the best choice for editing and printing.

SETTING UP THE IMAGE, STEP BY STEP

1 Open your file. Start by opening your image-editing program, here it is Photoshop. Use the Open command to open a file. A double-click on the file name should open both the editing application and the file.

2 Save a copy. Use the File>Save As command to give your working file a new name and to keep the original file intact in case you decide to return to its original state. Your original file may be in TIFF, JPG, or RAW format (see page 166), but save your working file as a Photoshop document (PSD). With Lightroom and Aperture, even though they don't alter your original data, you should still have at least one backup copy.

3 Fit the image to the screen. View>Fit on Screen will make your image as large as possible without hiding any of it. See the illustration, top right.

4 Rotate the image if it needs it. You may not have held your camera exactly level, or maybe you placed the print a little crooked on the scanner. Now is the time to align the image the way you want. Choose Select>All, then Edit>Transform>Rotate. When the cursor is near a corner, you can click and drag the corner to rotate the image as desired. If there is a line you'd like to be exactly horizontal, like the horizon, you can align the Measure tool with it (the angle will be displayed in the Info palette) and rotate the image an exact number of degrees. The Measure tool is in the Toolbox, an option under the Eyedropper tool.

5 Crop to the shape you want. If you have rotated the image, you'll want to make its edges square again. Select the Crop tool by clicking on it or press the C key. Click and drag the cursor to surround the part you want to keep. You can adjust the borders separately to get exactly what you want, then press the Return key to discard everything outside the borders.

VIEWING THE IMAGE LARGER OR SMALLER

Choose View>Fit on Screen to display your entire picture, edge to edge, on the screen. Depending on the shape of your photograph, it will exactly fill the screen either top to bottom or side to side.

Photoshop and other applications let you use keyboard commands as an alternate to clicking with the mouse for commonly used menu items. Remembering some keyboard shortcuts can often add up to a considerable saving of time and motion over a typical work session. The shortcut for Fit on Screen is ⌘0 (Ctrl 0 on a PC).

View>Actual Pixels displays your image using one monitor pixel for each image pixel. Photoshop calls this 100% magnification, shown in the lower left corner of your screen. Your screen probably displays about 100 pixels per inch. This photograph makes a print that is 10 x 13 inches at 300ppi, but the entire image at 100 percent display (or 100 ppi) would be 30 x 40 inches—so large you can only see part of it at a time.

The actual pixel view is the most accurate version of your image. You can use it to inspect complex edits or retouching and to evaluate sharpening. To see various parts of the picture when it is enlarged, use the navigating methods shown below.

ZOOMING AND NAVIGATING

To zoom in or out

Select the Zoom tool by clicking on it or by pressing the Z key. Click on the image to zoom in. Hold the option key and click to zoom out (hold the Alt key in Windows).

If you have zoomed in enough to see only a part of the image on the screen, you'll need to navigate around the image (see right) to display the part of it you want to see.

To navigate the viewing area to see different parts of the image

Use the scroll arrows at the sides of the window.

Select the Hand tool, or press the H key. Click and drag to move through the image. If you have any other tool selected, hold down the spacebar to select the hand tool.

Use the keyboard. The Home and End keys navigate to the upper left or lower right corner. The Page Up and Page Down keys move up and down one full screen at a time.

Converting a color image to black and white can give the photograph a sculptural quality that is more dramatic than the color version.

The three layers that make up every color photograph are easy to see when the image is displayed in Photoshop. An RGB image shows on the monitor in full color (top left) and its components—three different black-and-white images—are visible in the Channels palette (Window>Channels). Each channel is a version of your picture made up of the pixel values of one of the three primary-color images. (Photoshop gives you the option to display the channels in black and white or in the primary colors.) Just like the three separate dye layers that make up a color negative or transparency, each channel is a monochromatic record of how much red, green, or blue light was recorded from the scene. You can view and/or edit each channel separately.

The CMYK color mode has four channels; it is used mainly by graphic arts professionals because cyan, magenta, yellow, and black are the ink colors used in printing presses. If you are making photographs to be used, for example, in a magazine, it is best to make them look the way you want in RGB, and submit them that way. The conversion to CMYK will be done in a step called prepress by someone who knows the characteristics of the specific printing press and inks to be used.

COLOR TO BLACK AND WHITE: GRAYSCALE OR DESATURATE

The simplest way to convert a color photograph to black and white is to select Image>Mode>Grayscale. This one-step method discards all color information. The three channels are blended together, the color is removed, and the file shrinks to one-third of its former size.

A black-and-white image can still have color. Another one-step conversion, Image>Adjustments>Desaturate, keeps the image in the RGB mode but makes the three color values for each pixel the same, resulting in a black-and-white image. This kind of monochromatic file in RGB can be further altered to add a subtle color to the image; it can look like a sepia-toned antique print, for example, or one printed on a cold-toned silver paper. Use Image>Adjustments>Hue/Saturation and check the Colorize box. Move the Saturation slider to a low number, such as 7, then move the Hue slider to select the tone you want.

The mode for black and white is called Grayscale. A black-and-white image can be an RGB file with each pixel's color values the same for all three colors (93, 93, 93, for example). But its file size is three times larger than it would be in grayscale, which is represented by only one channel.

You may choose to work in black and white even if you are capturing color photographs. Any digital color file can be changed easily to black and white (see left) and the conversion gives you a spectrum of subtle variations. You can see quickly—without committing to a change—whether a color image might be more dramatic in black and white than in color. Many publications continue to print only in black and white, and most photographers whose work appears in them prefer the control of converting their own color images into black-and-white prints rather than having someone else do so.

COLOR TO BLACK AND WHITE: CHANNELS

Each color channel has a different black-and-white image. You can make several very different conversions to black and white from the same color image. To see the channels individually, choose Window>Channels. By looking at the image in each channel—red, green, and blue—you may find a black-and-white version that already looks close to what you want in your final print.

Converting to grayscale while only one channel is selected eliminates the other two of the channels, strips its color but retains its contrast information. To gain even more control over the color-to-black-and-white conversion, combine the channels with Image>Adjustments>Black & White. Position the sliders for the proportion of each channel or color you want to appear in the final image.

Red channel

Green channel

Blue channel

Adjusting Color and Value

There are several ways to adjust color balance with image-editing software. Photoshop's Variations command provides a simple visual method for getting started correcting overall color balance (top right). Go to Image> Adjustments>Variations to bring up a dialog box that looks like a ringaround test chart used by darkroom color printers to check color balance in enlargements.

The advantage of Variations is that it lets you view and make changes in hue, saturation, and brightness while viewing multiple possibilities. With most other color-adjustment methods, you are limited to switching back and forth between your original and the altered version using a preview command, or seeing a before and an after version displayed side by side.

But Variations is less precise than other adjustment tools; use it while you get comfortable with image editing on the computer or while you are learning to identify and differentiate color casts—the difference between cyan and blue, for example.

More exact changes (and more reversible ones) can be made in Photoshop with the Levels (page 185), Curves (pages 186–187), or the Image>Adjustments>Hue/Saturation command. Whatever method you use to make changes, make them using Adjustment Layers (pages 188–189), which lets you perform and view color and tone alterations on an image while protecting its original pixel data. Variations adjustments cannot be kept in a changeable adjustment layer; pixel values change as soon as you click on OK to accept the edit.

Aperture and Lightroom perform color-balance and value adjustments without making permanent changes (see bottom right). Both let you make and save multiple versions of an image within the program itself and to revisit and readjust any changes at a later time. Your edits are saved by the program and incorporated into the file when it is displayed on the monitor or printed. But the original pixel information is altered only when you export a file, for example, into Photoshop for further editing.

Variations, a command in Photoshop, displays various color and value versions of your photograph from which you can then make a selection. It is a good way to learn some basic possibilities in making adjustments, but eventually you'll want to make more exact adjustments with other tools. See next pages.

Apple's Aperture displays its color and value adjustments at the side of the screen or as a translucent box called HUD (heads-up display) over the image itself. Also displayed is a histogram (top) that can be used like Photoshop's Levels adjustment shown on the opposite page.

Adobe Lightroom uses color sliders and a histogram for information and control. Clicking on different parts of the histogram gives you control over several tonal ranges, making it an even more powerful tool than Photoshop's Levels command.

This image's histogram shows too little contrast (shadows are too light, while highlights are too dark). There is too narrow a range of tones, and an obvious color cast. These problems could be caused by a low contrast scene or, as in this case, a poorly made scan. Using histogram sliders in an image-editing program, as shown below, will repair the problems. Even better, the same adjustments should have been applied earlier, when scanning the original.

Levels uses a histogram display to alter an image. The settings displayed in Photoshop's Levels command are similar to the adjustments available in other image editors and in scanning software. You adjust the brightness or value separately for dark, middle-toned, or light pixels (shadows, midtones, or highlights). Sliders let you set the exact points that will become black (0) and white (255). Then you can lighten or darken the middle tones with little change to the extreme highlights or the deep shadows.

Levels are a good introduction to tonal adjustments because the command displays and uses a photograph's histogram (shown at left), a valuable visual key to understanding the distribution of brightnesses in an image. See more about histograms on pages 172–173.

Go to Layer>New Adjustment Layer> Levels to edit in a layer (an Adjustment Layer) that can be altered, saved, or discarded (see page 189).

Set the black-point sliders to the lowest level present for each primary color. The darkest pixels in that color will be given a value of zero. If the slider is to the left of that point, the darkest areas in the image will not be black.

Set the white-point sliders to the level of the lightest pixels. The bump at the right of each histogram represents the clouds in the image. If the sliders are to the right of the brightest pixels, the brightest highlights will not be fully white.

Use the midtone sliders to adjust the color balance. Move the red channel's midtone slider to the right to reduce the red. Move the green channel's midtone slider to the left to increase green. More green is the same as less of its complement, magenta (see page 140).

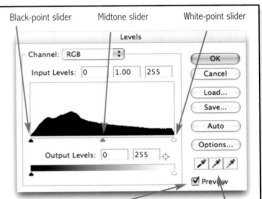

Preview checkbox. Check and uncheck it while working to compare the original with the adjusted image.

Black-point, Neutral, and White-point eyedroppers.

A Levels histogram first shows all three channels combined. Any adjustments here affect the overall image. Each channel can be adjusted separately for more precise control. Setting each black-point slider to the lowest value in the image and each white-point slider to the highest will often neutralize a color cast. Any residual color balance problems can then be adjusted with the individual midtone sliders.

Eyedroppers give you a quick way to balance color. Double click on the black-point eyedropper to set its RGB values to 10, 10, 10. Do the same for the white point, setting 244, 244, 244. If you click on the black dropper, then click on a point that you want to be black, it will be set to a neutral 10, 10, 10. Click the neutral-point dropper on any color to make it neutral.

Curves offers you the most control over the lightness, darkness, or contrast of an image. With Curves you can adjust—independently and with great precision—the tones, contrast, and colors of your image as well as its black and white points. Image>Adjustments>Curves will open a dialog box like the one on the opposite page, top right. Its main feature is a square graph with a corner-to-corner diagonal line.

This graph plots input (existing pixel brightness levels) on the horizontal axis against output (the values of those same pixels after adjustment) on the vertical axis. Shadows are, by default, at the bottom and left, highlights at top and right. You can reverse these positions if you prefer, but that is how they are shown here.

The starting 45° diagonal line represents all the values of the image as they are before any adjustment. You can put an adjustment point anywhere on that line by clicking on the line; click and hold will let you move that point. The line becomes a smooth curve, anchored at the ends and passing through that point.

If you move any parts of the curve above the original diagonal line, those tones will be made lighter. If you click on the center point (128/128) and move it straight up to 140/128, the adjusted level of anything that was middle gray (128) becomes lighter (140), along with all the other tones. See the top photograph on this page. Middle gray has moved the farthest from its original location; other tones will change proportionately less. Grab that midpoint and move the curve down, and all the tones become darker (second photograph, right). To change a more narrow range of tones, click at several points, then adjust sections individually (top photograph, opposite).

The shape of the curve (or any section of it) indicates contrast. A steeper slope produces more contrast, a more horizontal shape means lower contrast. When you increase contrast in one part of the curve, you must lose it somewhere else. You can move the endpoints to reset black point and white point, and set separate curves (and separate white and black points) for each color channel.

Move the curve up to lighten all tones in the image. Middle tones are displaced—and lightened—the most.

Move the curve down to darken all tones in the image. Very light and very dark tones don't change much.

An S-curve shape makes light tones darker and dark tones lighter, lowering the contrast of midtones.

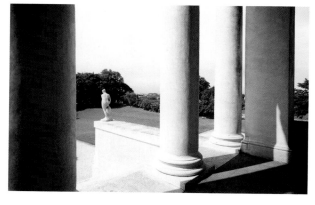

This S-curve makes light tones lighter and dark tones darker, raising the contrast in the midtones.

Several points can be added to the curve to allow very precise adjustments.

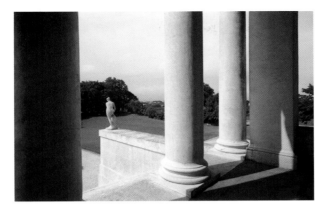

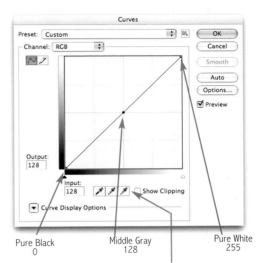

Pure Black
0

Middle Gray
128

Pure White
255

Exact input and output numbers are displayed in boxes for any selected point on the curve. The preview checkbox lets you compare your set of adjustments to the unadjusted image.

Black-point, white-point, and neutral eyedroppers are available to make important settings rapidly that can be refined with precision afterward. The histogram overlay is optional.

Curves for each channel can be adjusted independently. Here, to enhance the impression of early morning light, the blue channel is lightened in the highlights. The light areas become less blue and more yellow—the complement of blue. The shadows appear colder because blue has been increased in the low values.

LAWRENCE MCFARLAND Villa Rotunda, Vicenza, Italy, 2002

The Villa Rotunda, or Villa Almerico-Capra, was built by Andrea Palladio starting in 1550 and completed after his death. McFarland scanned his 120 color-negative film shot in a 1960s panoramic camera called a Veriwide.

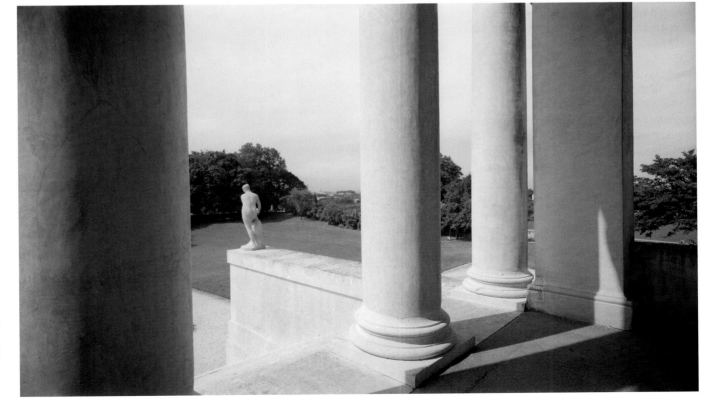

Selecting an area lets you edit or adjust **exactly the part of an image** you want. All the pixels in a subject may be selected or just one. You may choose to select pixels in a geometric shape like a rectangle or circle, or to follow a subject's outline to select all the pixels that form a particular image, for example, of a bird. Your selection may encircle one shape or be formed of several separate pieces. Pixels can be partially selected, which lets subsequent editing commands be partially applied.

A selected area is like a separate picture: it can be made darker or lighter; its color or contrast can be changed; it can be made bigger or smaller; it can be rotated or distorted; it can be moved to another part of the picture or even to another picture entirely. Selecting is the first step toward compositing—assembling an image from separate pieces (see pages 194–195).

A selection (without its contents) may be saved with your image, to be brought back, or loaded, at any later time. You can add to or subtract from a selection's shape, invert it (change the area selected into the area not selected) or feather its edges.

Learn how to use several of the tools that select an area. Different tools let you select an area in a predetermined shape, like a square or oval, or draw your own shape. You can select all the pixels in your image of a specific color or value, or within range of colors or values.

An adjustment layer (opposite page) uses a selection as a mask. Using one, an adjustment reaches your image fully through selected pixels, partially through partially selected pixels, and not at all through pixels that are not selected. A selection like this is called a mask, and can be viewed (it is saved as a channel) as a black-and-white image. White areas of a mask allow you to view or adjust through those areas. Black prevents anything from getting through the mask, and different grays represent partial views or partially accessed adjustments.

Applying an adjustment layer through a selection is an incredibly powerful tool; you can manipulate the color and tone of multiple areas of a photograph separately.

Selecting an object lets you adjust it separately from its background. When the overall colors and values look good in the photograph at the far left, the white butter dish is too dark and has a color cast. Using the Lasso tool (below) to follow its outline lets a Curves adjustment layer make it right.

Any selection can be inverted, selecting the background instead of the object. Any of the background's characteristics can then be changed. Also possible, and frequently useful, is eliminating a background entirely.

Selecting with the Lasso tool is like drawing with a pencil. A computer mouse makes a somewhat clumsy pencil; drawing tablets are available if you do a lot of direct selecting.

Magic Wand selects pixels by color. It is most useful where a background is relatively uniform or where foreground and background colors or values are strongly contrasting.

Quick Mask mode uses drawing tools to make and modify a selection. Switch between a standard view of your selection and seeing it displayed as a mask in a translucent color overlay. Painting the mask white creates more selected areas, black removes them.

The Toolbar in Photoshop displays selection tools and their variations.

A new scan or a saved file will open as the background layer in the Layers palette (below, right). This scanned transparency was a little underexposed, making all the values too dark, with the shadow areas especially obscured.

Think of a layer as a glass plate that sits on top of your photograph. The glass plate can hold a piece of another picture while you assemble different elements. If you use a layer to hold a picture, or part of a picture, all or some of the image below it is blocked from view. Artists use Layers for complex image combinations (see Compositing, pages 194–195). Photoshop shows the layers of an image (you can have as many as your computer can fit in its memory) in the Layers palette, and displays your image on the monitor or prints it, altered by cumulative changes that are applied from the top to the bottom.

Adding layers makes the image file larger, using additional RAM memory to edit (which may make your computer perform more slowly) and requiring more storage space. In exchange, Layers give you great control because each can be separately edited and changed.

Adjustment layers are the ultimate "Oops" command. An adjustment layer (Layer>New Adjustment Layer) can hold one of the image adjustment commands,

like Levels, Curves, or Hue/Saturation. Keeping the alteration in an adjustment layer above the original leaves the photograph's pixels unaffected during editing and compositing. After you make a test print, for example, you can return to the adjustment layers to fine-tune your results.

Flatten the file when you need only one layer. Most desktop printers will print a layered file directly from Photoshop. But if you need to place your file into another application, such as a word processing program, or if you need it for the Web or to e-mail, flatten the layers (Layer>Flatten Image) to compress all your edits into a single layer. All the changes are then applied and cannot be undone.

TIP: Before flattening the file, use File> Save As to create a duplicate of it with a new name. Then you can keep copies of both the flattened and unflattened images.

Not all file formats can save layers. TIFF is a standard format that can hold layers, but generally you should keep complex, layered files in the native Photoshop (PSD) file format.

Make a Curves adjustment layer. First, use it to set the black and white points, then adjust the overall color balance.

Two other adjustment layers, for luminosity and saturation, should make all the overall corrections the image needs. Luminosity adjustments can be made in the Curves layer instead, but it is easier to fine-tune the image if you separate them into two layers.

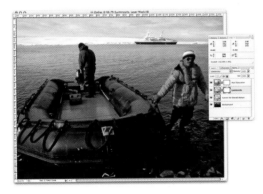

Part of the image is selected and becomes a mask in an adjustment layer. Here, the boat was isolated to lighten it slightly; the mask keeps this adjustment from affecting pixels outside the selection.

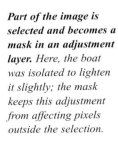
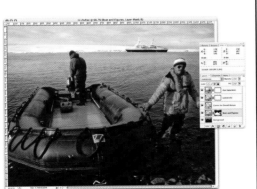

An icon, here a curve, indicates that it is an adjustment layer and identifies the type of adjustment.

An eye icon indicates that the layer is visible on the monitor. Click the eye off to see how the photo looks without the layer. Here, with all the eyes present, the cumulative effects are visible.

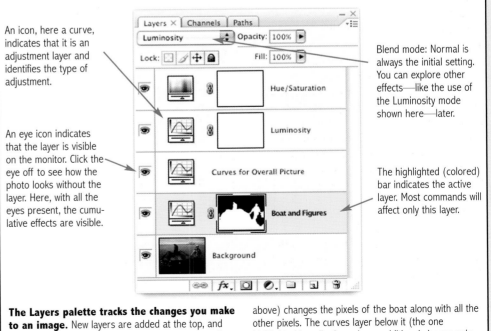

Blend mode: Normal is always the initial setting. You can explore other effects—like the use of the Luminosity mode shown here—later.

The highlighted (colored) bar indicates the active layer. Most commands will affect only this layer.

The Layers palette tracks the changes you make to an image. New layers are added at the top, and their effect is applied from the top down. The overall curves layer (third layer from the top in the palette above) changes the pixels of the boat along with all the other pixels. The curves layer below it (the one highlighted in yellow) produces additional change only to the pixels of the boat and the two figures.

Photographers have always struggled to capture scenes with high dynamic range, scenes with highlights too bright and shadows too dark to be recorded simultaneously. Some 19th century photographers used a separate negative to add clouds to a print because their materials could not capture detail in a landscape and a sky at the same time. In the 20th century, landscape photographers working in black and white could use the Zone System to tame excessive contrast while studio photographers arranged lights so that the brightness range of their scene didn't exceed the range their film could record.

Software gives us a chance to overcome the limitations of film or digital media. Photoshop's Merge to HDR feature lets you seamlessly blend the lighter areas of one frame with the darker areas of one or more other frames. It automatically selects data from the best parts of each frame.

For best results with Merge to HDR, shoot a nonmoving subject with a digital camera that is on a solid tripod. Use at least three frames, each exposure one or two stops from the next. Five to seven frames will give better results. Bracket the exposures by changing shutter speeds rather than apertures to avoid depth-of-field varia-

tion between frames. A scanned series of exposures on film can work also, but not as well.

In Photoshop, go to File>Automate> Merge to HDR. You will be prompted to select the files you wish to merge. After the files are merged, adjust the image for preview on the screen. The dynamic range of the merged image is more than your computer screen can show. The preview adjustment keeps the merged image from looking too dark or too light on screen, but it has no affect on the way the merged image (32 bits per channel) is finally rendered as a normal (8 or 16 bits per channel) file.

1 second at f/22

2 seconds at f/22

4 seconds at f/22

8 seconds at f/22

15 seconds at f/22

30 seconds at f/22

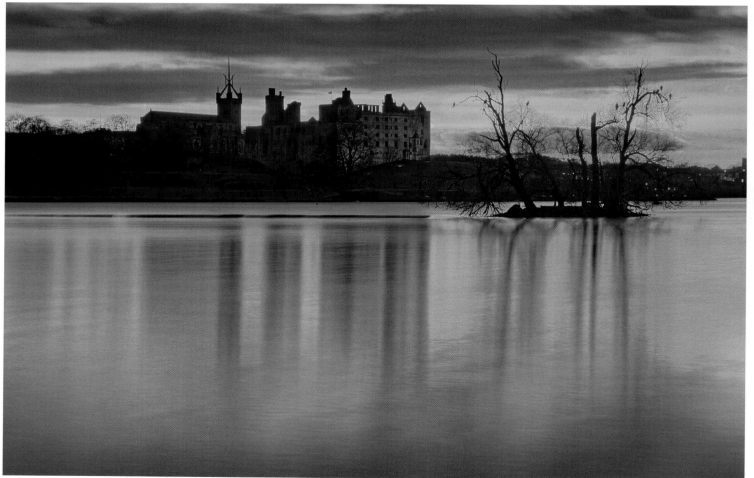

DUNCAN SMITH Linlithgow Palace Sunset, Scotland, 2005

60 seconds at f/22

Best known as the birthplace of Mary, Queen of Scots *in 1542, the palace is now a ruin. Smith is a native of Scotland and appreciates it for, as he says, the "sense of history, permanence, and belonging." He used Photoshop's Merge to HDR command to blend seven exposures (shown at right) taken one stop apart.*

From the dark walls of the castle to the bright sunset sky encompassed a brightness range of 14 stops, well beyond the grasp of a single exposure with any available film or digital camera. Movement of the clouds across the sky while Smith made the exposures produced visible colored artifacts.

Filter>Artistic>Watercolor

Filter>Sketch>Stamp

Filter>Sketch>Chrome

Filter>Distort>Glass

Filters are one approach to creating special effects in digital imaging. Under the Filter command in the menu bar lie numerous filters, everything from Accented Edges to Zig-Zag. Choosing a filter almost always opens a dialog box offering other options. The filter names give some indication of the effect, but the best way to learn about them is to try them all.

Here, the Rectangle Marquee tool was used to select each quarter of the image at left. A different filter was applied to each selection.

Retouching can be tedious with conventional photographs, particularly if you make multiple prints. With digital imaging you make corrections once, save the file, and print as many copies as necessary without ever making another correction. Unless you are working in layers (page 189), always retouch an image after you have made all other adjustments to it.

Sharpening improves most digital images but won't save an out-of-focus shot. It should be the final adjustment you make to any file before printing. You can sharpen just part of an image by selecting an area with a selection tool, feathering the edges, and following the steps below. There are other advanced sharpening and blurring techniques to explore on your own.

REPAIRS AND SPOTTING

To repair damaged photographs or to remove unwanted specks and scratches, various tools are available, such as the clone stamp, healing brush, smudge, focus, toning, and sponge tools, along with the patch tool shown here. Before you begin, adjust the image for contrast, brightness, and, if working in color, color balance.

Go to Source in the Tool Options Bar. Using the patch tool that appears, draw around the area needing repair (a). Drag the selection onto an undamaged area close in value, color, and texture to the damaged part (b). The pixels from the undamaged area will combine with those in the selection (c) to make a natural-looking repair.

For best results, build up the repair slowly. Work in Layers to protect the original scan. Go to Layers>Duplicate Layer, then perform corrections on the new layer rather than the Background layer. This damaged old photograph from a family album was first retouched to remove damage, then colorized and adjusted with Levels.

SHARPEN WITH UNSHARP MASK

Don't be confused by the name. Unsharp Mask sharpens a digital image. By emphasizing contrast at the edges between different tones, the filter corrects softening of detail that occurs during scanning or resampling and improves digital camera photographs. Experiment for the best results.

Open an image file, then choose Filter>Sharpen> Unsharp Mask.

Different photographs need different amounts of sharpening. Try setting the amount to 70 percent, the radius to 1, and the threshold to 4. A threshold of 0 affects all pixels; a higher number affects edges more and minimizes noise. Compare effects using preview.

Different uses need different amounts of sharpening. More sharpening and, especially, a higher radius, are needed for a print than for screen display.

Don't overdo it. With too great an amount of sharpening, the image develops unwanted specks of digital noise, especially visible in shadow areas. Preview any sharpening at 100 percent magnification.

TIP: The higher the resolution of the photo, the higher the percentage of sharpening you will need. Sometimes it is better to select and sharpen parts of an image rather than the overall picture.

FRANCINE ZASLOW Cover from *Great Chefs Cooking for Great Friends*, 2004

Digitally captured photographs like this one can benefit from careful work in post-processing. *That work always includes sharpening and usually, although it was not needed in the photograph at right, retouching.*

This photograph was among those commissioned for a cookbook published to benefit a Boston hospital. The book was a collection of recipes donated by the city's top 50 chefs. Zaslow says she "was given creative freedom to come up with a concept that would represent each of the different chapters in the book. For the cover [this photograph] I decided to combine classic elements that would be used by these great chefs with props that one might find in a professional's kitchen."

Making a composite image is an exciting way to use the digital darkroom. Digital editing simplified one of the most complex areas of photography, but didn't make it automatic. To integrate multiple images seamlessly, choose ones that are very similar in lighting, color balance, and sharpness. Some of these characteristics can be enhanced or controlled in the editing process, but it is always a good idea to have a vision of your final image when you take the pictures.

You may not want your composite image to look as believable as a traditional photograph. Editing software can be used to make images that integrate the traditions of other graphic arts areas, such as print-making, design, or typography, into those of photography. The tools are in your hands; your creative ideas should always guide your decisions.

Follow the making of this composite from its component elements. The original photographs were all made in the same location at the same time, making the color balance and lighting largely (but not completely) consistent.

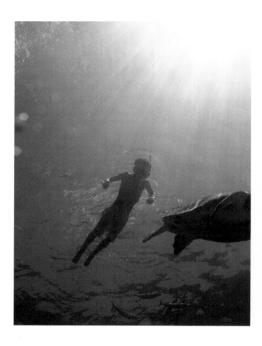

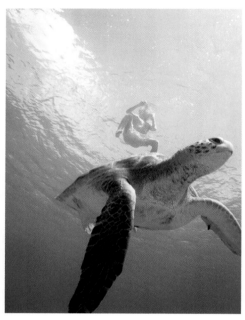

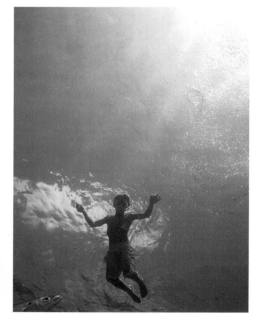

The three photographs at left are the original sources for the composite image opposite. The photograph far left was used for the background. The center photograph of the turtle was separately composited with another to add a different version of the flipper on the turtle's left side. The image of the boy was taken from the image near left.

The background image was adjusted with Levels *using an adjustment layer. Various elements were retouched out wherever they wouldn't be hidden behind another layer.*

The levels adjustment removed highlight detail in the upper right corner, *so an adjusted copy of just the corner was added in the third layer. See the larger version of the Layers palette on the opposite page.*

Two more adjustment layers were added to control the colors of the background. *First, a Color Balance layer produced the desired colors which were then made more vibrant by increasing saturation with a Hue/Saturation layer.*

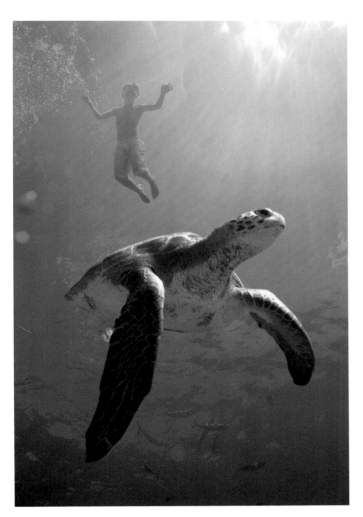

JAMEY STILLINGS Sea Turtle and Boy, 1999

The Layers palette of the file's final version (above right) shows the addition of two layers at the top. The boy and turtle were each copied onto the background layer. Photoshop automatically creates a new layer whenever another image is copied or moved into a file. Each figure was isolated from its original surroundings with the eraser tool, after which its edges were feathered slightly. The upper right corner of the layers palette shows that the highlighted layer's opacity has been set at 87 percent to make the figure of the swimmer look more distant.

JULIEANNE KOST Prison, 2003

Superimposing several different images suggests the layering of memory in this self-portrait.

Image editing seems complicated at first, because you have so many choices, but that is the power and appeal of the medium. The more familiar you become with the process, the easier it will be to get the results you want. Here is a basic image-editing workflow: a series of steps to follow, from opening the image to seeing it look the way you want on the screen. Printing has its own separate workflow starting where this one ends, detailed in the next chapter.

If you work in Photoshop, put as many of your changes as possible into Layers, which let you adjust an edit without starting all over again. Workflow programs like Aperture and Lightroom are, by comparison to Photoshop, limited in their editing capabilities. But they don't apply any changes until you export a file or print it, making it easy to revisit your decisions at any time.

1 Open the image in your image editor. Make sure you have at least one duplicate of the file. In Photoshop use File>Save As and give the working file a different name that indicates that it is edited. Check that your file has been assigned a color space (page 181). If your image's final destination is the Web, use sRGB. Otherwise use Adobe RGB (1998).

2 Rotate and crop if your image needs it (page 182). Use a horizon as a guide, if one appears in the image. In Lightroom and Aperture, you can change these decisions later without losing other adjustments. In Photoshop, you will have to return to your saved file.

3 Set the black and white points. Open a Levels or Curves adjustment layer (pages 185–187). Refer to the histograms for each channel to see if they should be set separately. Use the black and white eyedroppers for a rapid way to set the points; you can refine them later.

4 Adjust the overall color balance. With camera raw files, you may only need to reset the white balance. Use Curves (pages 186–187) to neutralize any color casts.

5 Adjust the tones in your image. Sometimes called brightness, value, or luminance adjustments, changing the tones in your photograph means deciding how dark the dark pixels will look, and how light the light ones will be. This control can be combined with color adjustment—making all the red pixel values higher will make the image lighter as well as more red—or it can be separate. See pages 184–187.

6 Adjust saturation. This is easy to apply globally to make all the colors in your image more vibrant or more subtle. But saturation can also correct for a camera sensor's slight oversensitivity to red or an inkjet printer's tendency to make greens look electrified (pages 184–187).

7 Decide whether any parts of the image need separate adjustment. One of the greatest advantages of digital image editing over traditional darkroom printing is the ability to effect control over separate areas of a photograph with absolute precision and repeatability. You can adjust a clearly defined subject or area, for example, making a sky darker and its blue more intense or increasing the contrast in someone's face. You can also separately adjust a range of values—only the highlights, for example, or only the dark green pixels. See Selection tools, page 188.

8 Retouch the image (page 192). Dust on sensors during capture or on film during scanning wil make marks that should be cleaned up. You may prefer to perform this step earlier in the workflow, but you can judge its effectiveness better with your adjustments in place. Some photographers retouch a copy of the background layer, leaving the original below it.

9 Save your adjustments now. If you made multiple exposures of the same subject in identical lighting, you can work more efficiently by saving all your adjustments from the first image and applying them to all the images.

10 Resize for your intended use (Image>Image Size). Images for a Web site will be relatively small, and sized for screen viewing at about 100ppi. For slideshow presentations, images should have the same or more pixels than the screen; most monitors and projectors display between 800 and 1200 pixels high, 1000–2000 wide. For print, you need 200–400ppi at the final size.

Resizing to make the file smaller (called downsampling) will not adversely affect the image. Upsampling to increase its size or resolution can reduce quality.

11 Sharpen the image (page 192). Some photographers like to make a duplicate background layer to sharpen, preserving the original background in the file. Different sizes, resolutions, and uses of the same image can require different amounts of sharpening. Don't sharpen until you have set the final size and resolution, and know the form of output or display.

In the Layers palette, the area being affected is shown in a mask icon to the right of the image icon.

An all-white mask indicates a global adjustment, one that is applied to all the pixels in the image.

Black in a mask represents those areas unafffected by the adjustment.

This is the Layers palette for the image on the opposite page. Adjustments are applied in sequence from the top to the bottom.

MARK KLETT View from the Tent at Pyramid Lake, 7:45 am, Nevada, 9/16/00

Klett's editing workflow always includes three adjustment layers. *First he sets black and white points and adjusts overall color with a color curve. Next, a curve set to luminosity mode adjusts overall brightness and contrast without affecting colors. Then a hue/saturation layer adjusts overall saturation allowing him easily, for example, to reduce the magenta in a blue sky. In this case,* *saturation is increased in the yellows and blues to deepen the sky and accentuate the early morning sunlight.*

Following the global correction layers, Klett uses masked adjustment layers (shaping the mask with drawing tools) to adjust individual parts of the photograph. The layers palette for this image is shown on the page opposite.

ANSEL ADAMS Moonrise, Hernandez, New Mexico, 1941

Ansel Adams remains the acknowledged master of the grand landscape. *His great vistas are mythic images that reinforce our romantic ideals of nature. Adams was a superb technician who controlled his medium completely to amplify and bring to life the tonalities in an image. No book reproduction can convey the range of tones in the original print, from the glowing brilliance of the clouds and crosses to the subtle detail in the dark shadows. The photograph is everything that we imagine such a scene might look like in reality and, for some of us, seeing his print may be a more profound experience than that of being there to see it ourselves.*

It may seem odd to start a chapter on digital printing with someone who didn't live to see digital photography flourish (Adams died in 1984). But he saw it coming and was ready to embrace it.

In 1981 he wrote "I eagerly await new concepts and processes. I believe that the electronic image will be the next major advance. Such systems will have their own inherent and inescapable structural characteristics, and the artist and functional practioner will again strive to comprehend and control them."

CHAPTER/TEN digital printing

Much pleasure lies in taking pictures and skimming through them onscreen, but a big reward lies in printing and viewing the results. Yet some photographers never seem to finish their images; they shoot a lot but have few pictures that they carry to completion. Printing translates your vision into an object that can be displayed on a wall, in a gallery, or in other locations in addition to email or the Internet. Digital imaging makes copying and altering photographs easier, but also makes it easier to copy and alter them inappropriately. Be aware of the limits.

Aside from pressing the shutter release, holding a newly printed photo is a photographer's most rewarding moment. Although the digital darkroom lets you view your images through every step of editing, seeing the photo on paper remains a high point. Getting to that point involves not only shaping your image, but making a series of choices among printers (this page) and papers and inks (page 203).

PEGGY ANN JONES The Veil Project, 2005

Jones used a wide-format inkjet printer to print directly on cloth for this gallery installation. Each image was sewn to a fabric panel that was hung from the ceiling and tied at the bottom to a rock. The panels cast shadows on walls, floor, and ceiling. Panels and shadows move with the air motion created as viewers walk past, seeming almost alive.

Print your photograph as soon as you have edited it, or proof it in stages, with a desktop inkjet printer like this one.

Inkjet printers spray fine droplets of colored dyes or pigments onto paper. They are commonly used in schools and by individual photographers because of their low purchase price and the high quality of their prints.

Print size is limited by the printer's width. Desktop printers typically print a maximum width of 8.5 or 13 inches. They take standard sheets (for example 8.5 x 11 inches, called letter size) and some can make long panoramic prints using rolls of paper. School labs often have wide-format printers in 17-, 24-, and 44-inch sizes, service bureaus may have 60-inch and wider sizes. Wide-format printers accept large single sheets as well as feeding from rolls.

Many entry-level inkjet printers use combined color cartridges: cyan, yellow, and magenta in one package, black in another. Rarely do all three colors run low at the same time, so there is always some waste, which is expensive. Printers with individual ink cartridges often are a better value despite their higher starting prices.

Dye-based inks produce prints with more vibrant colors, but they fade rapidly compared to pigmented inks. Many combinations of pigmented ink and paper exceed the best traditional color photographic prints for longevity.

Film recorders print digital files onto continuous-tone film that is then processed just like any conventional film. Making slides from digital files may be useful for a portfolio or for projection.

You can also convert your file to a negative after performing corrections that would be difficult or impossible to do in a conventional darkroom. From that negative you can make a silver-based print in a traditional darkroom, or you can print it in an alternative process, such as platinum, that uses a negative the same size as the final print.

Photographic laser printers make digital prints on traditional wet-process photographic paper. Laser light, guided by a computer file, exposes photo paper (usually 50-inch-wide color paper) that is then fed directly into a roller-transport color processor. The result is an extremely high-quality digital print with the wide color gamut and predictable archival qualities of a traditional color photograph.

Large and very expensive, these machines (LightJet and Lambda are the best known) can be found only in professional color labs and service bureaus.

Dye sublimation printers produce beautiful continuous-tone prints. Tiny heating elements vaporize dyes in a multi-colored ribbon. The colored gas that is released condenses on a paper's surface as it passes below.

Dye sublimation printers are more expensive and offer fewer paper and ink choices than are available for professional inkjet printers.

Color laser printers use dots to build images. They are faster and much cheaper to operate than other printers but don't produce prints as good as traditionally made continuous-tone photographs or those printed on inkjet printers.

Inkjet printers come in small and large sizes. This one measures six feet across and prints on media up to 44 inches wide. Small, affordable desktop printers can make modest-sized prints with exactly the same characteristics as those from larger printers. Those prints can be displayed or used as proofs—or both.

USING AN INKJET PRINTER

Install the driver, the software that tells your printer what to do with the information sent from your image file.

Test the printer by following its instructions and using the utility programs that came with it. One utility may test that the printer heads are aligned, which is the key to crisp and accurate images. Some printers do this alignment automatically; others initiate the process when a new cartridge is added. Print a test page monthly to verify that the print heads are working properly.

Clean the print heads. Print heads contain multiple jets for each color. Printers spray ink through these jets to clean them as part of their warm-up cycle when you turn on the power. Some repeat this cleaning routine periodically whenever they are on. Print heads can still clog, however, especially when a printer isn't used often.

Clogged jets in print heads can result in bands, gaps, or inconsistent colors. Another software utility can check for this and lets you run a head-cleaning cycle manually. If the head-cleaning process fails, check the manufacturer's support website for recommendations and search the web for user newsgroups or blogs.

Select the right paper–ink combination. When starting out, stay with the papers and inks recommended by the printer's manufacturer. As you become more comfortable with digital printmaking, you can explore the capabilities of other papers and inks.

Load the paper correctly. The printing side of glossy photo paper usually is shiny; the nonprinting side is dull or has a watermark. Some brands have a cut corner to identify the printing side. Try not to touch the printing side.

Dry prints made on photo-quality and glossy papers at least 10 minutes before handling them, at least 6 hours before framing. Don't leave prints sitting in the output tray when printing multiple copies, or they may stick together. Make sure your hands are dry when handling prints. Store prints away from direct sunlight. All digital prints, when displayed, will last longer under glass or coated with a UV-blocking spray and kept away from direct light.

Your printer doesn't actually print pixels. Inkjet printers, for example, spray very tiny droplets of ink on paper. These dots must be much smaller than a square pixel, small enough for the dots from a small number of ink colors in the printer to combine and produce the large number of color values a pixel might be. This is similar to the way tiny halftone dots in only four colors are used to reproduce a full-color photograph in a magazine or book (look at the photographs in this book under a strong magnifier or loupe).

Translating your image made of pixels (sometimes called a raster image) into dots is done by a printer driver, software that comes with the printer. That job can also be done by a RIP, or raster image processor. RIP software is sometimes used by graphic artists because it can also interpret vector images—drawings saved as an outline—made by illustration and page-layout programs, or in big labs because it can organize and print many smaller images on a large sheet or roll.

A driver uses the host computer to calculate the translation from pixels to dots; with a large file or a slow computer this can take a significant amount of time. RIP software is usually installed on a separate computer, so you can send it your file and go back to work.

Printers use only 8 bits per channel. If you are printing from high-bit files (those with 16 bits per channel) the extra data will increase the RIP's or driver's processing time. Printing from a layered file or one at a higher-than-necessary resolution will also cause delays in processing. It may save time to prepare your file for printing first—flatten any layers, change to 8-bit mode, and downsample to 300ppi. Downsampling (Image>Image Size) reduces the number of pixels in a file; your print probably won't look any better if you have more than 300ppi at the size you print (you can test your printer with the same file at a higher resolution to make sure). If you have more than 300ppi at final size, downsample to that resolution for printing but save the original file in case you want to make a bigger print—that will need more pixels to make it 300ppi—later. If you have less resolution than 300ppi at final size, don't upsample; an upsampled image will rarely look better than one sent to the printer at its original resolution.

Printers all use subtractive primaries for printing and are called CMYK devices (even if there are extra colors added to the basic four). But most work best with RGB files; the driver is designed to make a conversion to CMYK that is customized for that printer. Don't convert your file from RGB before printing. If you do, most drivers will convert the file to RGB first and then back to CMYK again; the image is likely to lose some quality in the process.

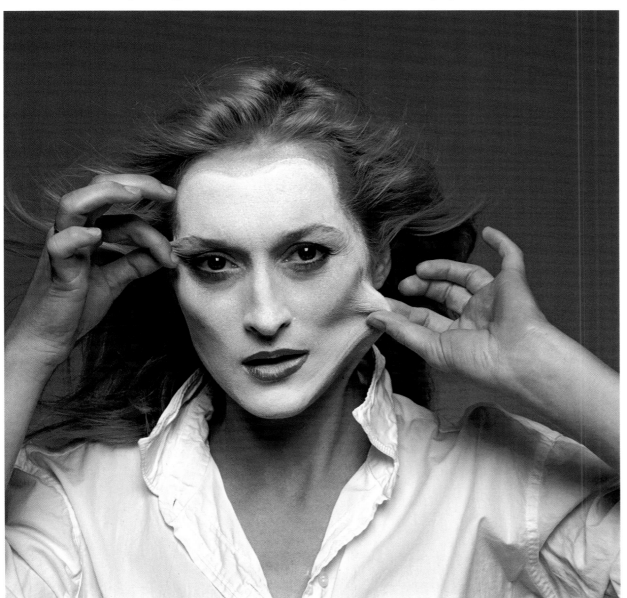

ANNIE LEIBOVITZ Meryl Streep, New York City, 1981

The celebrities in Annie Leibovitz's photographs often stretch their public image, so to speak. They are instantly recognizable, but may be doing things you wouldn't expect. Even though Leibovitz made this photograph—like many of her great images— on film, she now exhibits large prints made digitally from scans of her original film or directly from her more recent, digitally-captured photographs.

Profiles help make your print look the way you want. Remember that a profile is a stored file that lets your computer translate the color numbers of each pixel into a real color that you see. Without accurate profiles for both your monitor and your printer, an RGB value of 128, 128, 128 might produce a bluish gray on the monitor and a brownish gray in a print, even though both should be neutral middle gray.

An accurate monitor profile changes your display to meet a standard; color numbers are displayed the same way on any calibrated screen. But each different combination of printer, paper, and ink requires its own separate printer profile for your output to be predictable. With accurate output profiles you can make colors appear the way you want them to.

Standard profiles are installed with the driver when you first set up a printer, but only for that manufacturer's papers and inks. Manufacturer's profiles are usually very accurate, and having them available is another good reason to start out with products made by the printer manufacturer. Paper manufacturers who market specialty paper for inkjet printing usually provide profiles for using their papers in widely-distributed printers, but usually only with the printer manufacturer's inks.

You can make custom profiles if you are using a nonstandard ink-and-paper combination, or if you are interested in a higher degree of accuracy. You will need special profiling software to generate a set of color patches that you print using your own printer/ink/paper combination. Then you use a spectrophotometer (usually bundled with the profiling software) to read those patches back into the computer. The software then generates a profile and, if needed, lets you adjust it slightly.

Soft proofing uses a monitor to simulate a print. It is useful because, unfortunately, you can't make a print that looks exactly like the image you have been editing on your screen. Monitors glow from inside and have a wider gamut, or range of colors, than printers. Instead of hoping to print the screen image—an impossibility—you can make your monitor resemble the print

you'll get. That's the job of soft proofing.

Not only do printers have a smaller gamut than your monitor, each printer has a different one. A soft proof can show you the image that your desktop inkjet printer—or a giant offset printing press—can actually produce.

Keep in mind that a soft proof is only a simulation. Once the image is printed, you may decide to adjust the image further to get the results you want. A monitor does not look the same as a piece of paper, no matter how close the simulation. With time, your eye and brain will adapt, and you will begin to see the final print when you look at the screen.

Consider also the light under which your print will be viewed. Different light sources have different color balances. Tungsten light is relatively reddish, while daylight is relatively bluish (see page 147). Metamerism is the change in our perception of a color under different light sources. If the color balance of your print is important to you; try to view the print in the light under which it will later be displayed.

It's impossible to control the lighting on your print in every situation, but if you know, for example, that your print will be displayed mostly in daylight (or you're not sure) evaluate the print under full-spectrum 5000K bulbs like those that are standard in the graphic arts and printing industry.

DORNITH DOHERTY Dry Garden, 2003

Doherty makes proofs on an inkjet printer but has a custom lab make her large exhibition prints with a photographic laser printer. The same file, with a different profile for each printer, gives her exactly the print she wants from both. In this image from a series made in Kyoto, Japan, the rice refers to the use of sand in a karesansui, a Japanese rock garden.

Soft proofing opens a dialog box like this when you select View>Proof Setup>Custom. The image displayed is then altered to simulate actual output. Select Window>Arrange>New Window for... to compare the image to its soft proof side-by-side.

When you are ready to print, use File>Print to see a dialog box like the one at right. For Color Handling select Photoshop Manages Colors and select the correct profile for your printer, paper, and ink for Printer Profile. Select Perceptual for Rendering Intent and check the box for Black Point Compensation. For a more detailed explanation of these choices, see one of the recommended books on Photoshop or color management (page 404).

Each printer manufacturer designs its machine to work best with its own brand of papers and ink. Your safest approach when starting out is to stay with these; there is usually a very wide choice. But the ability of inkjet printers to print on a variety of surfaces offers a visual and tactile freedom previously unavailable to photographers, who used to be limited to coated light-sensitive surfaces that could withstand prolonged submersion.

Experiment with the other excellent papers and inks available once you are comfortable with the basics of inkjet printing on your printer manufacturer's products. And remember, inkjet printers can use all kinds of paper, from those with qualities similar to traditional photo papers to textured watercolor papers, tissue, vellum, and even canvas. Depending on the printer model, print sizes can vary from the miniature to the mural.

PAPERS

The greatest tonal range from black to white, a paper's contrast, belongs to glossy papers, with luster or semigloss surfaces, matte, and uncoated papers following in order. The combination of ink and paper (papers for printing are often called media) determines the maximum possible dynamic range, or contrast between white and black, that a print can achieve. The brightness of the paper, sometimes enhanced by fluorescent chemical brighteners, determines the highest reflectance. The lowest reflectance is determined by the black density or D-Max, a measure of the darkest possible black from that specific inkset/paper combination. When you experiment with the different paper surfaces, remember that the paper's color, in addition to its texture, will affect its dynamic range.

If you don't have a profile for a given paper and ink combination, make an adjustment layer (or two—you may need to adjust both curves and saturation). The settings for those adjustment layers can be saved and loaded into the next print you make with the same paper and ink.

Color saturation is richest on glossy papers, as it is with traditional photographic papers. Matte or uncoated papers do not yield blacks as deep, and colors may appear less intense. You may be able to restore some of the missing color saturation with a Hue/Saturation adjustment layer. Some printers can use two different black inks—one for matte papers and one for gloss and semi-gloss.

Image sharpness is more apparent with glossy papers. Uncoated papers absorb more ink, which spreads slightly. Lower-resolution images and printer settings (with fewer pixels per inch) often give better results on uncoated stock.

Paper thickness is your choice too. Paper is ordinarily specified by weight, in grams per square meter (gsm) or in pounds. The metric measure (gsm) is easier to use for comparisons; the weight in pounds is usually for a ream, 500 sheets, but the size of the weighed sheet varies. Most important for your printer, however, is a sheet's thickness, because that determines whether it will feed properly. Printers with a stack-loading tray often have a manual feed slot that can accommodate thicker stock.

Options abound with other materials. Sheets or rolls of translucent material make prints for light-box display. Transparency supports intended for use in overhead projectors are finding popularity with photographers who want to make large negatives for alternative processes such as cyanotype, gum, or platinum (see photographs on pages 272–273). Also available for inkjet printers are specialty items such as papers with adhesive backing, a metallic surface, refrigerator magnets, or iron-on transfers.

INKS

When selecting inks, keep in mind that color dyes fade, even those used in film-based photographs.
Dye-based inks offer brilliant, saturated colors and a wide color gamut. They are compatible with a wide variety of papers, and they dry quickly. Unfortunately, prints made with them fade quickly, too.

Dye-based inks in combination with "photographic" glossy paper for inkjet printers provides fine looking—if not permanent—results. These are good for learning and experimenting, and many photographers use them as proofs or for portfolios.

Printers using dye-based inks are marketed for general use. Those printers promoted for photographic printing generally use pigmented inks.

Pigment-based inks last longer. Some printers can accommodate either dye-based inks or pigment-based inks but not both. Some use dye-based colors and a pigmented black. Pigment-based inks offer greater longevity than most dye-based inks. These inks can be less vibrant than dye-based inks, but many improve on traditional photographic tonal quality. Some pigmented inks don't print well on glossy paper.

With any inkjet print, longevity is tied to a specific combination of ink and paper, and results can vary widely. Recently, testing several of one manufacturer's papers using the same printer and pigmented ink showed that the papers ranged from 61 to 162 years before the onset of noticeable fading.

Manufacturers are constantly conducting research and developing new products. To stay abreast of longevity tests for inkjet inks and papers, check wilhelm-research.com.

Ink colors. Inksets for inkjet printers include at least the three subtractive primary colors, C cyan, M magenta, Y yellow, plus K black. In theory, a 100% mix of C, M, and Y should produce black, but that usually results in a muddy brown color. Black ink is added to ensure that a real black appears.

Most inkjet printers intended for photo printing include more than just the fundamental CMYK. For example, adding a light cyan and light magenta increases the resolution in highlights. Adding gray (or "light black") improves black-and-white printing.

Inkjet printers are deceptively inexpensive. Inks are not. There are ways to cut costs with inks, but be aware that such solutions are not simple.

Replacement cartridges from the original equipment manufacturer (OEM) are an easy choice, but are usually the most expensive. Tests show, however, that OEM inks are likely to produce the most permanent prints.

Refill kits are messy and can result in problems with leaky cartridges and air pockets that can cause clogging. It may take time and patience to master these, but you will save money.

Continuous ink supply products replace the standard cartridges with new ones connected by tubes to large ink bottles stored beside the printer. This is another money-saving approach that can be mastered with patience but also may be subject to air bubbles and clogging. Not all printers can use these, so research it before you proceed.

Digital imaging has fueled passions for panoramic prints. Printers are limited only by the width of paper they can feed, not by the length. It's not uncommon to find a letter-width printer that can make an 8 1/2-inch-wide print that is almost four feet long or a 24-inch wide-format printer that can print the entire length of a 50-foot roll.

Digital image editing takes the labor out of assembling panoramic photographs. Confronted by a grand view that spreads across the horizon, you have choices. You can capture the scene with a wide lens, but that may give you a view that emphasizes the foreground and sky more than you want. You can crop the scene, but that reduces the overall quality. Or you can capture the important, more distant, parts of the scene in segments with a longer lens, and reassemble them.

The traditional presentation of a scene made of segments uses the dividing lines as part of the image, like the one below or the seven-panel photograph at the top of page 144. But image editing software makes it possible to stretch or compress edges to align objects, to match adjacent colors and densities precisely, to merge several images into one, and to retouch merged borders seamlessly. Photoshop can do all that but it is a meticulous, step-by-step process.

Stitching software automates the assembly of sequential photographs into a larger image. Panoramas are their most prominent use, but some can be used to stitch together small segments from a limited-resolution camera to make a large, sharp print. Others assemble 180° or 360° views, popular with realtors, to be displayed on the Internet with "virtual reality" software.

Well-designed stitching software reads the files for lens focal-length information stored automatically by digital cameras (see metadata, page 213) and reshapes each element accordingly.

Digital cameras can encourage panoramas. Some compact digital cameras incorporate a panorama mode to facilitate the making of a set of photographs to be stitched. After the first exposure, the camera's monitor displays a thin slice from the right edge of that photograph on its left edge (or vice versa). The slice appears translucent to make it easy, when framing the next shot, to align objects in the image and to create enough overlap for stitching software to work effectively.

MARK KLETT AND BYRON WOLFE Four Views from Four Times and One Shoreline, Lake Tenaya, Yosemite National Park, California, 2002

Klett and Wolfe located vantage points for well-known photographs of Yosemite and found many that were nearly identical, although the photographs had been made decades apart. They combined three earlier photographs—Eadweard Muybridge 1872, Ansel Adams c. 1942, and Edward Weston 1937—with several of their own views (the background image is called Swatting High-Country Mosquitoes) into a panorama that links both space and time.

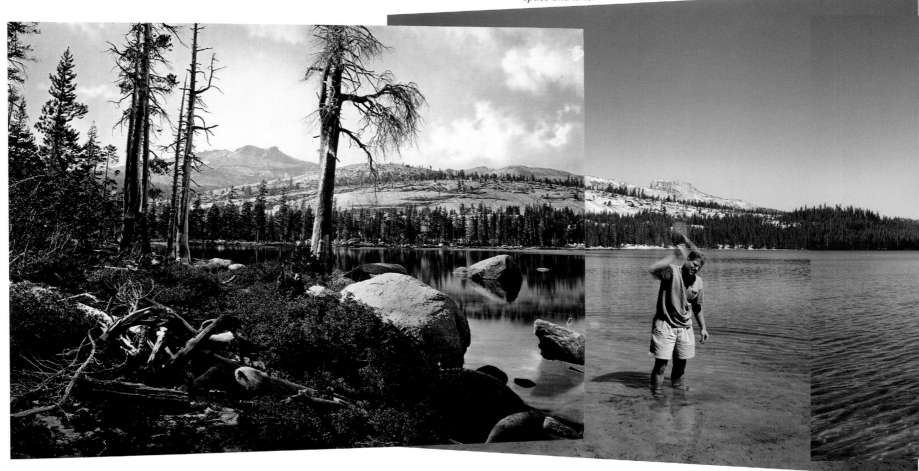

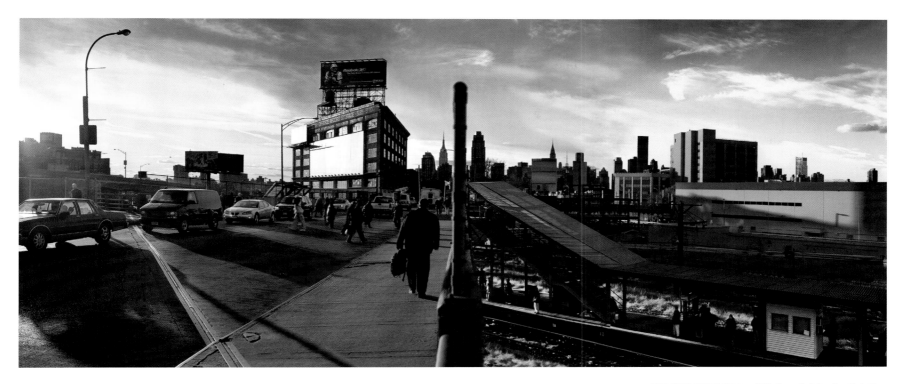

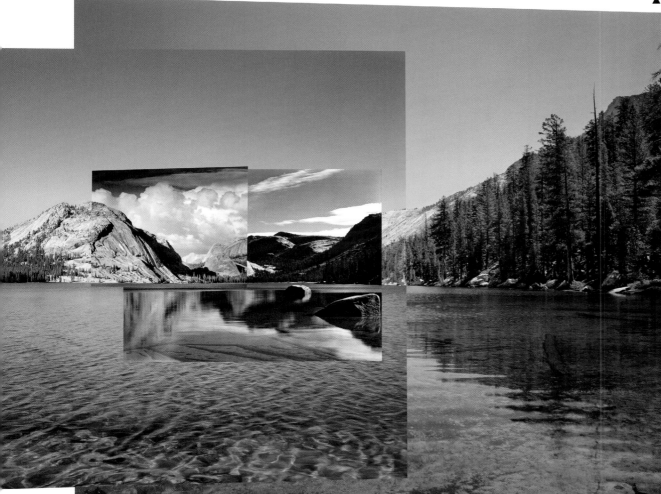

▲ **JEFF CHEN-HSING LIAO** LIRR, Hunter's Point, New York City, 2004

Liao sees this subway line as a "conduit that connects many ethnically diverse neighborhoods," and says, *"I am still constantly awed by the complexity of the communities formed alongside it."* For this series, he shot each scene in as many as 15 separate images on 8 x 10 transparency film, scanned them, and stitched them together in Photoshop. The final prints measure 8 feet wide.

When printing an image in black and white you can decide whether to print your image using color inks or just black. Most printers provide an option for printing with black ink only, but the results often are better if you print your black-and-white image with color inks (see right).

Black-and-white prints made on a color printer are likely to have a longer, richer tonal range than a print made with black ink only. The print color may be close to neutral but most will have some overall color cast. A simple color cast can be neutralized easily by adjusting the file; it is a more complex problem if the highlights turn one color and the shadows another.

Black-only printing, which uses just the black ink in a color set, has proponents who refer to its effects as digital Tri-X. These photographers want the neutral blacks and somewhat grainy effect produced when the other colors are not used.

Printers installed with inks in both black and shades of gray are a popular option for those who make most of their work in black and white. With a little added complexity you can achieve excellent results making black-and-white prints with a wider brightness range than prints made in a conventional darkroom, and which have extremely favorable long-term keeping qualities.

Help is available when print quality is critical. Many photographers share the steps they follow when preparing a black-and-white image for printing. These printing workflows are something like soft proofing color prints so they match what is on the screen. They often include the application of a curve adjustment layer.

Go to groups.yahoo.com and search for digital black-and-white printing. There are many sites and discussion groups devoted to digital printing, including some focusing on specific printers.

PRINTING IN BLACK AND WHITE WITH COLOR INKS

Desaturate an RGB image (Image>Mode>Desaturate), or otherwise convert it to monochrome (page 183) but leave the mode in RGB. Print it as you would a full-color image. If the R, G, and B values are equal for each pixel and you have an accurate printer profile, your print should be a neutral black-and-white rendering. If using color inks to create black causes a color cast, you can neutralize it with a Curves adjustment layer.

If you convert the image to grayscale, you can only control color casts with your printer profile or driver settings. In either case, you can produce monochromatic prints with any degree of color, from black-and-white with a hint of cool or warm tone to graphic images in a wild, saturated color.

RON HARRIS Bristlecone Pine, California, 1997

PRINTING IN BLACK AND WHITE WITH BLACK AND GRAY INKS

Quadtone and hextone printing are exciting alternatives for black-and-white enthusiasts. These systems replace the color cartridges in an inkjet printer with archival inks in different shades of gray. With six-color printers, for example, the black cartridge provides 100% black and the others contain shades of gray at 15%, 25%, 45%, 50%, and 75%. The result is a print with smooth tonality and little color cast. Although complex and difficult to balance, quadtone and hextone printing produces excellent results rivaling those of the traditional continuous-tone print.

Piezography BW is a combination of pigmented grayscale (and toned) inks and software intended to be used with certain four-, six-, and seven-color Epson printers. The software includes profiles for many different papers and so directs the printer to lay on the ideal amount of ink for each paper. Selenium tone and warm neutral inks produce toned results.

MIS Variable Tone inks are archival grayscale sets of carbon-pigment ink that replace the color inks in Epson printers. No additional software is necessary, but special Photoshop Curves (free of cost) are available for these inks when used with specific printers. These will yield different tonal effects with the inks.

The comparison to the right shows four versions of the same image, printed on the same paper with the same inkset, but with a different tone curve applied to each image.

PAUL ROARK The Grand Teton, 2002

PHILIP TRAGER
Kazuo Ohno, 1988

In a series of photographs made for his book, Dancers, *Philip Trager photographed Kazuo Ohno, one of the founders of the Japanese avant garde Butoh dance movement. Here, Ohno is in costume for one of his dances. The image was made on film, then scanned and printed.*

The Internet is the gallery with the world's largest audience. There are good reasons why. There are interesting places to visit on the Web, it is a good source of information about products and techniques, and you can show your own work there. Some groups host online discussions where you can interact with others interested in topics such as the history of photography or photographic techniques and equipment.

Photographers share techniques, help one another solve problems, provide tips on software and equipment, and more in a multitude of discussion groups. Groups, companies, and individuals have created sites that provide material such as online magazines and stores, educational information, and galleries. Newsgroups let you post and receive material about photography.

YOUR OWN VIRTUAL GALLERY

You can create your own Web page. Do you have photographs you'd like to show to a wider audience? A personal Web site (or home page) is one way to do so. If you are using e-mail, your Internet Service Provider (ISP) probably allows you to have your own site. The simplest pages contain text, photographs, and graphics. More advanced designs can include music, video, and animation.

Some ISPs offer ready-to-use templates to get you started. But Photoshop (File>Automate>Web Photo Gallery) will guide you through steps to make a simple gallery you can upload to your ISP. For more sophisticated pages, investigate the different software programs that are available for building Web sites.

TIP: Unlike files prepared for printing, images going to the Web should be in the sRGB working space for best display. Convert them by going to Edit>Convert to Profile. Under Destination Space, choose sRGB.

Saving images for Web display is an exercise in trade-offs between resolution, file size, and quality. Typically, you need to keep file sizes small (no more than 30 kilobytes per picture). The larger the file, the longer it takes to appear on a Web site, and viewers may not be willing to wait several minutes for a page to download.

Photoshop (File>Save for Web & Devices) lets you preview resolution choices and the corresponding quality for each before making a final decision.

EXPLORING THE WEB

How do you find photo sites on the Web? Suppose you are interested in a topic but don't know where to look. Try using a search engine such as Yahoo (yahoo.com) or Google (google.com). Researching with these sites is like doing a subject search in a library catalog. Type in a subject or keywords, and a list of sites related to that topic will be displayed.

No published list of Web sites useful to photographers could possibly include them all, nor would it remain accurate for long. But the Web itself offers numerous sites that can help you. A portal is a site that collects Web addresses (URLs) that relate to a specific subject. Use a search engine to search for "photography portal" to find numerous sites that, in turn, list and link other sites for photographic manucturers and products, education, books, magazines, galleries, museums, organizations, discussion groups, jobs, trade shows and expos, services, and more.

One of these photojournalists is not really there. This photograph of all the members of the photo agency VII was originally commissioned for a magazine. By the time it was selected for the camera company's ad, one of the members had been replaced. The new member, at the far right, was shot in the same New York cafe in the same position as the man he repaced, then added to the picture digitally.

Just because you can alter an image, should you? Digital methods haven't changed much about the laws or ethics of photography, it has simply become much easier to violate them. Now that almost anyone can make extensive changes in a photograph that are sometimes impossible to detect, the limits of acceptability are constantly tested and debated.

Has photography lost its reputation for accurate representation of reality? For a 1982 *National Geographic* cover, digital imaging was used to move one of the Great Pyramids a little for the cover photograph so it would fit the magazine's vertical format better. When some readers objected, the change was defended as being merely "retroactive repositioning," the same as if the photographer had simply changed position before taking the shot. Was it different? The magazine has since eliminated this practice.

Photojournalists usually follow fairly strict rules concerning photographic alterations. Generally, they agree that it's acceptable to lighten or darken parts of an image. However, many newspapers don't allow the use of digital imaging to, say, remove a distracting telephone pole or, worse, to insert something new.

Advertisers often take considerable leeway with illustrations. We even expect some exaggeration from them, as long as they don't misrepresent their products. Few people would object to the altered photograph below, left, even if the advertiser didn't mention a change. But would the same image be acceptable without explanation if it ran with a news story instead of a product advertisement?

Digital imaging raises ethical questions in the fine arts as well. It is easy to scan a photograph from a magazine or download one from the Internet and use all or part of it as your own. Perhaps you intend to criticize or comment on consumerism by incorporating recognizable pieces of advertising in a montage. Artists' appropriation of copyrighted material—incorporating an image as a form of critique—has been a widely-debated topic and the subject of a number of legal battles.

Copyright laws have certain built-in exceptions called fair use; among them is education. What you make for a class project may be protected, but if you try to sell it in a gallery or distribute it on your web site you may be infringing on someone's copyright.

Working photographers are concerned about financial matters. When your efforts result in something you can sell, you will probably think it is stealing if someone uses it without asking. How can you protect your rights when images are easily accessible electronically? How can you collect fees for use of your work when images, after they leave your hands, can be scanned, altered, and then incorporated in a publication? Is it ever acceptable for someone else to appropriate your image and use it without paying for it? There are more questions than answers, and they won't be settled soon.

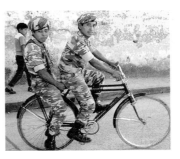 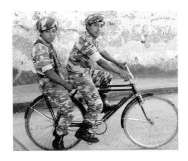

MICHAEL KIENITZ Nicaragua, 1982

How much change is acceptable? During a survey of 1600 magazine and newspaper editors, communications professor Shiela Reaves presented the two photographs above. She asked, "This photo was edited to eliminate the person in the background so that he wouldn't be distracting. Do you agree with the computer-editing change?" About half the magazine editors found the change acceptable, compared with only 10% of the newspaper editors who did.

As it becomes easier to seamlessly alter photographs, will more of them be changed, incorporating everything from a little enhancement to all-out fabrication? Will anyone believe that the camera does not lie? Should anyone ever have believed that?

STAN STREMBICKI Untitled, from the series *Memory Loss, a 9th Ward Photo Album*, 2005

Flood-damaged photo albums, in the wake of a natural disaster, remind us of the fugutive nature of our own saved memories. A non-resident, Strembicki had been photographing New Orleans several times a year for over twenty years before Hurricane Katrina landed, decimating the city. In the aftermath, he began to make monthly trips to record the damage and efforts to rebuild. "As an artist, I felt compelled to do something, anything," he says. Trying to avoid an excess of pathos, he "looked for symbols of loss, and gravitated toward found photo albums."

Photo albums were often among the debris bull-dozed into piles in front of houses that had been under water for weeks. Strembicki was careful not to enter houses, and took nothing away but the images in his digital camera. There is a caution in this work; your own photographs are vulnerable, too. After each day of location shooting, Strembicki takes care not to lose his; he downloads all the files onto a laptop, duplicates them onto a portable hard drive, and then writes them to a DVD.

organizing and storing your work

CHAPTER/ELEVEN

Getting organized is always harder than it seems. Pictures can accumulate quickly and you can have thousands of them before you know it. But the computer is the perfect oganizing tool and it is easy, especially if you are shooting digital pictures, to let it help. One of the best things about a digital picture is that each one has a hidden compartment to hold all the information you might want to save about the image. And this saved information can help you find that particular picture quickly—even if it is stored with tens of thousands of others.

Traditional photographic materials must be stored carefully in order to last. Prints, too, no matter how they were made, can be damaged by time and careless storage. You may not be selling work to museums now, but it is good to know that—when your time comes and the curators are lining up with checkbooks in hand—your prints will be as perfect as the day you made them.

As soon as you create a digital image, you have to think about storing it. The amount of storage space that image files occupy is a consideration whenever you are using a digital camera, scanning prints or negatives, editing files, or archiving them.

Save your files in their original form. The file as it is captured by your camera or scanner is often referred to as a raw file, as opposed to a derivative file—one that has been processed, altered, edited, or changed in any way. A camera raw file is a specific kind of raw file that holds all the information captured by a digital camera's sensor, in a completely unprocessed form. But if you have instead set your camera to capture images and save them as TIFF files or JPEGs, those original files can be considered raw files as well.

Post-processing, or image editing, produces more files. Saving them becomes another step in your workflow and they take up more storage space. Derivative files are changed somehow from their original raw state. They may consist simply of your raw files with a few color and tone adjustments, resized to print, or may be complex, layered composite images. You may also save intermediate editing steps as additional derivative files, in case you want to return an image easily to a previous state.

Photo files can be stored on different devices. The easiest, fastest, and most accessible form of storage is to keep image files on your computer's internal hard drive. If you scan an image, the scanner sends the image directly to it. After you use a digital camera, you must transfer your photos from the memory card to the hard drive before editing them. Memory cards are not good for long-term storage, and you will probably

want to erase (or reformat) the card for reuse anyway, so it is best to download your files onto a hard drive promptly.

But your computer's internal hard drive may run out of room—especially if you keep making and storing photographs. External hard drives are available that can be plugged in to any computer to add to its storage capacity. Some, called portable drives are smaller and better protected against being bumped and jostled than a full-sized external drive. Drives designated as pocket drives are even smaller, very light, and draw their power directly from the computer. Even though they are well protected against the stresses of being carried, no hard drive should be dropped.

Digital files can be lost instantly. Hard drives are susceptible to stray dust, spikes of electricity, and magnetic fields, in addition to theft or physical damage. External media like disks or tapes are sensitive to storage conditions and can become unreadable (sometimes called corrupt) over time. Losing files can be your own doing; you can accidentally delete files or write over one unintentionally by saving something else with the same name.

Fortunately, with digital photographs you can have several originals. Keeping a set of identical copies of each picture file is essential to protect you against loss. You will want to have a backup strategy that you can both follow and afford (see more on page 215).

In addition to having backup copies of everything, you will also want to make sure that you can find something among all the copies. The next page describe ways to name and label your work so you can quickly search for and find anything.

External hard drives are easy to add whenever you need more storage.

Portable hard drives (far left) and pocket drives (near left) let you move your files easily to another computer or download your memory cards on location.

Optical disk storage is less likely to be damaged by magnetism, electrical storms, or water. Gold CDs and DVDs (shown here) have a longer storage life than other kinds.

External tape drives are good for backup. Tapes are an inexpensive way to store large quantities of data, but it takes longer for them to retrieve files than other devices.

CAPACITY: DIGITAL CAMERA MEMORY CARDS

Card capacity	Number of 15MB files that can be stored
256MB	16
512MB	32
1GB	64
2GB	128
4GB	256

CAPACITY: EXTERNAL STORAGE DEVICES

	Capacity	Number of 15MB files that can be stored
CD-ROM	700MB	45
DVD	4.7GB	300
DDS Tape	20GB	1300
Blu-Ray/HD DVD	50GB	3000
750GB hard drive	750GB	50,000

Computers are good at keeping track of things, but you have to help them. With film-based photography, there is only one original—a negative or slide. Photographers have all had to devise a personal system, not only to store and find an original piece of film, but also to keep track of any information relating to it. A digital image consists of data, so information about it—also data—is called metadata.

Metadata comes in several forms. Simple and readily available metadata includes the name of the file, its size, and its format: a 22MB JPEG file named RailStation.jpg, for example. This information is part of the file itself, so it is not lost if the file is moved or copied, and it is displayed by the computer in any list or directory of files. A date is also part of that kind of file metadata, although it is usually the date the file was added to the computer.

Digital cameras save capture information. Each file, whether it is a JPEG, a TIFF, or a proprietary camera raw format, has an internal data block, separate from the image's pixel data, that the camera uses to write and save the specifics of each frame. A camera can save the aperture and shutter speed, time and date, ISO setting, lens focal length, metering mode, camera brand and model, and even the GPS location for each exposure. This camera-related metadata is kept in a standard form called Exif (exchangeable image file format), and each different category of information (like shutter speed) is called a tag or a field.

Metadata can be added later. IPTC (International Press Telecommunications Council) fields are intended to hold metadata about the photographer, the subject, and the picture's use. Applications like image editors, browsers, and image database managers (see page 214) let you view information in these fields, add to it, or change it. IPTC data are displayed by one of these programs as one of several panels. The IPTC Contact panel, for example, has fields for the name and contact information of the file's creator.

IPTC metadata can be added to a group of images at once. You may want to, as soon as you download a shoot from one or more memory cards, tag each photograph with your e-mail address and copyright.

Metadata stays with the image. If you make a copy of the file, or make a derivative version, its metadata is transferred to the new file. This can be useful. For example, if you post one of your photographs on a Web site or send it to a stock agency, your copyright and contact information stays with it; anyone who downloads it is warned that the image can't be reused without permission and has a way to reach you to negotiate for use.

Keywords and ratings are metadata. Individual files can be tagged with descriptive words that make finding it easier. In a similar way, a rating (stars) or a label (colors) can be applied to a photograph to distinguish it from others that are similar. Once you have a few thousand photographs, you will be glad you spent the time to add this kind of metadata. Page 214 shows programs that let you search by keyword and rating.

VICTOR SCHRAGER
Manolo Blahnik Shoe, 2005

Manolo Blahnik has designed thousands of high-fashion shoes in London since his start in the early 1970s. This photograph was commissioned on the occasion of a retrospective show of his work. Keywords that might be assigned: Job, Manolo Blahnik, Shoe, Green, Neiman Marcus, Retrospective.

Photographer's applications computer software programs can help with many of your tasks. Image editing is the centerpiece of post-processing, getting the photograph you took to look exactly the way you want. And with Photoshop, for example, you can also read existing metadata and embed your own into a file (File>File Info, see also page 213). But Photoshop alone won't help you get organized or find anything.

Browsers like Bridge, a component of Photoshop that is usable separately, help you organize and locate images. It can download photos from a memory card, display thumbnails (small versions of the files) of an entire folder of images, apply metadata, keywords, and ratings to all or a selected group of them, and search your hard drive for a file or a set of files.

Workflow applications like Photoshop Lightroom and Aperture may do everything you need. Like Bridge, they will download raw files from a memory card into a location you specify, let you rename and tag them with keywords, and help you find specific files. In addition, you can make image adjustments, resize, and print the images. And they can help you find specific files in your storage folders.

Cataloging applications are specifically designed to help you find needles in your haystack. Sometimes called an image database or digital asset management program, a cataloging program like the one shown

top right can keep track of hundreds of thousands of images. Like a browser or workflow application, it can embed a selected group of images with keywords and other metadata. It can search for and display images based on multiple criteria. It can quickly assemble groups of selected pictures to present to a client on screen, to print, or to post on a Web site.

A cataloging application saves information about a file and its location in its own separate database file. So you can use it to find files that have been stored offline, which means that the storage medium or volume is not connected to the computer. This helps you find backup copies saved on, for example, the CD and DVD disks you keep in your safe-deposit box. Because its database is separate, you can add some metadata to an entry that is not embedded in the file; if you distribute the file, some keywords can remain private.

These applications all let you display your work as a slide show. You can select a group of photographs to be seen on the monitor one at a time, filling the screen. In some cases you can automate a presentation and choose the timing and the transitions (like a dissolve) between images. With Photoshop Lightroom and Aperture, you can also superimpose selected text and play your choice of music along with the slide show.

Extensis Portfolio (above, right) is a cataloging application, and Adobe Bridge (right) is a browser. Each application facilitates some of the essential organizing you'll need to do as your picture collection grows into the thousands.

Portfolio stores a thumbnail, metadata, and location for each image you add to its database. You can search for and find files even if they have been stored on the backup DVDs you keep at a friend's house.

Bridge lets you apply a one-through-five star system to rate your photographs and can filter a search so you only see the images that have earned ratings above a selected level.

The Find command in applications that can search metadata let you combine criteria to find a very specific group of images. The search illustrated here will find all the photographs in the folder called Pictures of mountains in the United States that you made since the beginning of 2007 and tagged with a rating of four or five stars. You could add more lines to narrow the search further. "Keywords do not contain Montana," for example, will exclude certain images from the group.

AN ARCHIVING WORKFLOW FOR RAW FILES

1. Download your files directly from the camera or through a card reader.

2. Rename the files. Use a clear, logical system that will still be useful after you have 50,000 photographs.

3. Add bulk metadata. Bulk metadata (for example, your name, contact information, and copyright) goes on all your photographs.

4. Convert the camera raw files to DNG if you choose (page 166). Some applications let you do it all—convert, rename, and append metadata—as you download.

5. Add individual keywords. With most applications you can display a large number of image thumbnails and apply a keyword to a selected group.

6. Apply ratings. Decide which image, of several similar ones, is the one worth returning to. Give a higher rating to the best of the shoot.

7. Save on a second hard drive. If you have a mirror RAID (see text above, right), this happens automatically. After saving a second copy of everything, you can reformat your camera's memory card to use again.

8. Back up on two optical disks. Store disks in a cool, dry, dark place for maximum life. Give each disk a unique name so you can file and find it easily, for example Photo Files 2007-045.

9. Add to your image cataloging database as soon as you write the files to optical disks so it can keep track of the copies in your offline storage system.

With digital photographs you can have more than one original. And since they take up little actual space, it makes sense to have several copies of everything. Prints, slides, and negatives have always been vulnerable to catastrophic loss or damage, as well as to degradation over time. Image files that are digital can be stored unchanged for the foreseeable future and—importantly—they can be duplicated exactly. You can dramatically reduce your chances of loss by keeping copies of all your images.

Have a backup strategy that you can stay with. Don't wait until you have lost some important images before you make and stick to a plan for archiving your work.

It is most convenient to have all your files online; this means that everything is on one or more hard drives that are powered up and connected to the computer whenever you work. But hard drives can fail; to be safe you should also have at least two additional copies of everything, and preferably three or more.

The best system, at a minimum, is to make a second copy of all your raw files on another hard drive as soon as they are renamed and tagged (and before you have erased them from the memory card) and, shortly thereafter, make two more copies on removable media like optical (CD or DVD) disks. The second copy on a hard drive lets you restore files quickly in case of a primary drive failure or other data loss; the copies on removable disks can be kept in two different locations to protect you in case of a disaster like fire or theft.

Keep your working files separate. You will also want to have an organizing and backup strategy for finished derivative files and for ones that are still in progress.

A RAID array can help. RAID is an acronym for redundant array of inexpensive (or independent) disks. You can use your computer's operating system to format, or initialize, two disk drives for RAID level 1, called mirroring. Once formatted this way, the two drives act like one—you see only one icon for the drive, and read from and write to it normally. But, invisibly, all data is written to both. This kind of RAID array is called fault-tolerant because it creates redundant data; if one drive fails, all its data is still, identically, on the other drive.

NAMING YOUR PHOTOGRAPHS

Always rename your photographs as you download them or soon afterward. Your camera gives each picture a file name as you take it; but it is likely to be something relatively meaningless to you, like DSC_0147.NEF. And—since most cameras start numbering over again with 0001 every time you use a new, erased, or reformatted memory card—eventually you will end up with a lot of different pictures with the same name.

Metadata holds the key, or at least the keywords. If you want to find that picture you took of Aunt Rita falling in the pool at Uncle Bart's birthday party three years ago, it's easy regardless of its file name. You were careful, of course, to keyword that file with the words Rita, Bart, Birthday, and Pool, and the camera automatically recorded the date into its Exif data. So, as long as you have at least one application that can search through your photographs using embedded metadata, you can find that photograph even if its file name is still DSC_0147.NEF and even if you have 50 pictures with that same name. However, the opportunity to give your picture a name gives you a chance to be more organized about saving it.

How should you name your files? There is a place in each file's IPTC metadata for a caption, so you can save a long title, like "Aunt Rita slips on birthday cake and falls in the pool at Uncle Bart's birthday party." The file name doesn't have to be the title because there is another place for it; in fact, the caption field is a place that is also searchable.

You can certainly use a title, or part of a title, as a name. But computers usually keep files in alphabetical order. If you name the files by subject they will be scattered; photos of Aunt Rita won't be anywhere near those of Uncle Bart.

It's probably more useful to use names that will keep them in chronological order, so they stay in the sequence you made them. If you rename our example 2004-07-15 Raw 016, it will be stored after the first 15 pictures you took on July 15, 2004. You can keep all the photographs from that month in a folder named 2004-07 and—kept inside another folder named 2004—it will appear just below the folder with all your photographs from June of the same year.

Chronological files make backups easier. Since you should be saving multiple copies of your files, chronological names make it easy to keep track of what has been backed up. You can attach a colored label to the last file name you backed up, then remove it after the next time you write a backup disk.

Prints and negatives are more challenging to store than digital image files. Since they are physical objects, they are affected by their environment. To prolong their life, you need to consider practices and materials usually referred to as archival.

Stability is good, change is bad when it comes to preserving your work. Photographic materials will keep longer the colder they are, and are best kept at about 40 percent relative humidity. But few people can keep their entire archive in a humidity-controlled meat locker. Thankfully, most of us will be able to significantly prolong the life of our photographs simply by keeping them from experiencing big changes in humidity and temperature.

Negatives present unique problems. Correctly processed black-and-white film contains only three things: silver, gelatin, and a plastic support. Polyester is universally used as a film base and is extremely stable and nonreactive. Unfortunately, silver is susceptible to airborne pollutants, especially sulfur compounds, and gelatin may be damaged by insects.

Color slides, color negatives, and wet-process color photographs have a much shorter life span than their black-and-white counterparts. Keep them cool, dark, and stable for the longest life.

Paper is affected by acidity. Any paper that is acidic by manufacture (as most wood-pulp papers are) or left in contact with anything acidic, will eventually deteriorate. Make sure the paper on which you print is acid-free, as well as any interleaving paper, mat board, and storage boxes you use. Prints are safest stored in sleeves or bags made of polyethylene, polyester, or polypropylene. These plastics are chemically inert, and protect against airborne pollutants as well as abrasion.

Some inkjet inks contain solvents that are slow to evaporate. Uncoated papers allow these vapors to be absorbed into the surface. But prints made on glossy and semigloss coated surfaces should be allowed to "outgas" or cure for a few days before storing in impermeable plastic or framing. Leaving a print pressed against absorbent paper for a day will do as well.

Negatives should be stored in protective sleeves. Polyethylene pages, like the ones shown, are fine for long-term storage and have the advantage of allowing the film to be seen without being handled. Conventional contact prints can be made by projecting light through the plastic. Similarly, reference-quality scans can be made without removing the film. Pages are available to fit common film sizes.

Store pages that hold film in a safe environment. Archival boxes made from acid-free cardboard are a good choice. A polyethylene outer bag sheds water and prevents changes of humidity inside. Storage boxes made of polypropylene are also available.

Prints should be kept in archival boxes. Elegant archival portfolio boxes like this clamshell design on the left make a beautiful presentation but may be too expensive for regular storage. Simple acid-free cardboard storage boxes, shown on the right, are as safe. Larger sizes are made from acid-free corrugated cardboard to be more rigid.

JOHN WILLIS Recycled Realities #10, 1999

Bales of paper waste awaiting the recycling mill *were Willis's subjects during weekly shooting excursions for more than four years while he worked collaboratively with photographer Tom Young. Images of people in the scrap, Willis says, "beg us to look within at our transitory existence."*

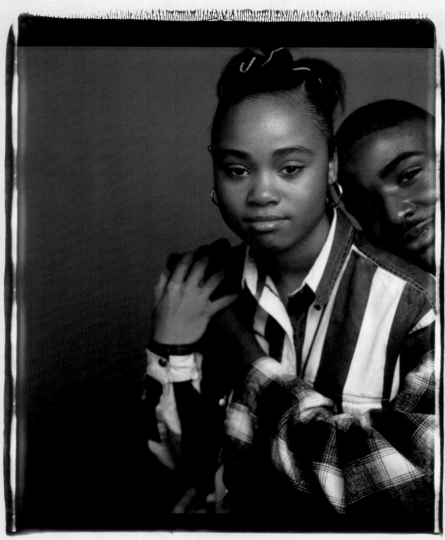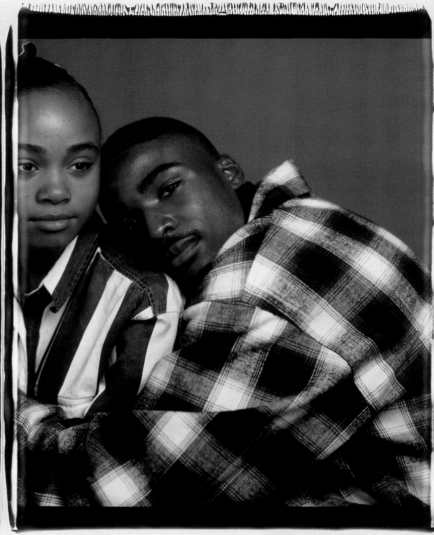

DAWOUD BEY Darshall and Mark, 1993

"A portrait, I have come to believe," says Dawoud Bey, *"is as much about the photographer as it is about the subject/person in front of the camera. . . .*
What I am looking for is also a moment of self-recognition; the moment in which I as the photographer recognize some aspect of myself in the person I am photographing."

Bey often produces very large prints, 40 x 50-inch prints made from 4 x 5 negatives, or here, using Polaroid's 20 x 24-inch camera, assembling multiple images for the portrait. "In making these large prints I intend to create a heightened sense of human presence along with a heightened quality of physical description."

print finishing and display

Your choice of mounting materials depends on the degree of permanence you want for a print. Archival-quality materials last the longest but are the most expensive. They are preferred by museums, collectors, and others concerned with long-term preservation. Most prints, however, can be happily mounted on less-expensive but good quality materials available in art supply stores.

The paper in any print (and the gelatin and silver in a traditionally-made photograph) can be seriously damaged by contact with cheap paper, masking tape, and other materials that deteriorate in a relatively short time and generate destructive byproducts in doing so. If you want a print to last for even a few years, avoid long-term contact with ordinary cardboard, brown wrapping paper, brown envelopes, manila folders, and glassine. (The archivally minded would say to avoid any contact of prints with such materials.) Also avoid attaching to the print pressure-sensitive tapes, such as masking tape or cellophane tape, brown paper tape, rubber cement, animal glues, and spray adhesives.

Spotting corrects small imperfections in a silver-based print. White specks on a print are the most frequent problem, caused by dust on the negative or printing paper. You may also find dark specks or hairline scratches. Most spotting is done after the print has been completely processed and dried. The exception is local reduction or bleaching, which is done on a wet print.

The best spotting adds dye or pigment to match the tone and color—and sometimes the texture—of the surrounding area well enough to blend in. The procedure is like that of a professional magician; you can only make things disappear if your audience doesn't notice your technique. Look at the print extra-close while you work on it; if your results look good to you then, you can be sure no one will notice from a normal viewing distance.

Retouching changes the subject. With silver-based materials, spotting usually refers to correcting flaws caused by the process, like unavoidable dust spots and scratches. Retouching changes some aspect of the subject, for example, removing facial blemishes in a portrait.

For digital images, both kinds of alteration are called retouching, and are applied during editing rather than after the print is made. See page 192 for more.

Practice is essential with all these techniques. Work on some scrap prints before you start on a good print. Do the minimum amount of spotting needed to make the blemish inconspicuous. Too much spotting can look worse than not enough.

SPOTTING

Remove white spots with dyes that you add to the print until the tone of the area being spotted matches the surrounding tone. Liquid photographic dyes, such as Spotone, sink into the emulsion and match the surface gloss of unspotted areas. They are usually available in sets of at least three colors—neutral, warm (brown-black), and cool (blue-black)—so that the tones of different papers can be matched.

You'll also need one or more very fine brushes—an artist's watercolor brush, size 000 or smaller, from an art supply store will be much better than a spotting brush from a camera store—facial tissue to wipe the brushes; a little water; a small, flat dish to mix the colors; and a scrap print or a few margin trimmings to test them.

Defects in digital images can be removed with software so prints appear spot-free, but spotting techniques shown here are also useful if your prints are scratched or damaged later. These instructions are for black-and-white prints. Spotting color prints uses a similar technique of carefully matching the surrounding color and tone with dyes or special pencils.

1. **Match the dye to the color of your print.** Pick up a drop of the neutral black on a brush and place it in the mixing dish. Spread a little on a margin trimming and compare the dye color to the color of the print to be spotted. If necessary, mix in some of the warmer or cooler dyes until the spotting color matches the print. If you print consistently with one paper, you can premix some dye that matches its color and save it in a separate bottle.

2. **Spot the darkest areas first.** Dip the brush into the dye, wipe it almost dry, and touch it gently to any spots in completely black areas of the print. Use a dotting or stippling motion with an almost-dry brush; too much liquid on the brush will make an unsightly blob.

3. **Now work in lighter areas.** Spread out the dye in the mixing dish and add a drop of water to part of it to dilute the dye for lighter areas. The dyes are permanent once they are applied to the print, so it is safer to spot with a light shade of dye—you can always add more. Spot from the center of a speck to the outside so you don't add color outside the speck.

ETCHING

Etching can remove a small or thin black mark that obviously doesn't belong where it is, such as a dark scratch in a sky area. Gently stroke the sharp tip of a new mat knife blade or a single-edge razor blade over the black spot or nick it lightly until it blends into its surroundings. Use short, light strokes to scrape off just a bit of silver at a time so that the surface of the print is not gouged. Etching generally does not work as well with RC papers as it does with fiber-base papers.

LOCAL REDUCTION

Local reduction or bleaching lightens larger areas. Farmer's Reducer (diluted 1:10) or Spot Off bleaches out larger areas than can be etched and also brightens highlights in a black-and-white print. Prints are reduced while they are wet. Squeegee or blot off excess water and apply the reducer with a brush (used for this purpose only), a cotton swab, or a toothpick wrapped in cotton.

If the print does not lighten enough within a minute or so, rinse, blot dry, and reapply fresh reducer. Refix the print for a few minutes before washing as usual. To prevent stains, do not use reducer in combination with toner.

MOUNTING SUPPLIES

Mount board or mat board is available in many colors, thicknesses, and surface finishes.

Color is usually neutral white, because it does not distract attention from the print. Off-white, gray, or black mount board are sometimes used.

Thickness or weight of the board is stated as its ply. Smaller prints can be mounted on 2-ply (single-weight) board. More expensive 4-ply (double-weight) or even 8-ply board is better for larger prints.

Surface finish ranges from glossy to highly textured. A matte, not overly textured, surface is unobtrusive.

Size. Boards are available precut or an art supply store can cut them for you, but it is less expensive to buy a large piece of board and cut it down yourself. A full sheet is usually 30 x 40 inches.

Quality. Archival-quality mount board, sometimes called museum board, is free of the potentially damaging acids usually present in paper. It lasts the longest, but is not always necessary. Less expensive conservation board is also acid-free and can be found in art supply stores.

Dry-mount tissue is a thin sheet of paper coated on both sides with a waxy adhesive that becomes sticky when heated. Placed between the print and the mount board, the tissue bonds the print firmly to the board. Several types are available that melt at varying temperatures. Some are removable, which lets you readjust the position of a print; others make a permanent bond.

Cold-mount tissue does not require a heated mounting press. Some adhere on contact, others do not adhere until pressure is applied, so that they can be repositioned if necessary.

Cover sheet protects the print or mount from surface damage. Use a light-weight piece of paper as a cover sheet between each print in a stack of mounted prints to prevent surface abrasion if one print slides across another. Use a heavy piece of paper or piece of mount board over the surface of the print when in the mounting press.

Release paper will not bond to hot dry-mount tissue. Use it between cover sheet and print in the mounting press.

Tape hinges a print or an overmat to a backing board. Gummed linen or Tyvek tape is best and should always be used for hinge mounting a print. Use linen tape also to hinge an overmat to a backing board; self-adhesive tapes can shorten the life of the print.

MOUNTING EQUIPMENT

Mounting press has a heating plate hinged to a bed plate. The press heats and applies pressure to melt the dry-mount tissue, bonding the print and mounting board together. It can also flatten unmounted fiber-base prints, which tend to curl in low humidity.

Tacking iron heat bonds a small area of the dry-mount tissue to the back of the print and the front of the mounting board to keep the print in position until it is put in the press.

Utility knife with sharp blade, held against a metal straightedge, trims mounting stock and other materials to size. A paper cutter can be used for lightweight materials, but make sure the blade is aligned squarely and cuts smoothly.

Mat cutter holds a knife blade that can be rotated to cut either a perpendicular edge or a beveled (angled) one. It can be easier to use than an ordinary knife, especially for cutting windows in overmats.

If you expect to do a lot of matting, consider a larger mat cutting system that incorporates a straightedge and cutter, like the one below. The mat cutters used in frame shops can be quite expensive, but there are smaller, less expensive versions for the home studio.

Two ways to mount a print are shown on the following two pages. Dry mounting bonds a print smoothly to a backing board. But even when using removable dry-mount tissue, a dry-mounted print is not easily removed. Dry mounting is best for work intended for display rather than sale, or for work printed on paper that doesn't lie flat.

Bleed mounting trims the edges of the mounting board along the edges of a dry-mounted print's image. Nothing is visible but the print itself, but its edges are left vulnerable to damage. More often, prints are dry mounted with a wide border around the edges.

An overmat provides additional protection for a dry-mounted print and is the best option for the attractive display of an unmounted print.

A cutting surface underneath mount boards or prints will let you cut them without damaging table or counter tops. Plastic self-healing cutting boards are made, or you can use a piece of cardboard or scrap mounting board.

Metal ruler measures the print and board. A heavyweight, unmarked straightedge acts as a guide for the utility knife or mat cutter and is safer than a thin metal measuring rule or T-square. A wooden or plastic ruler should not be used because the knife can cut into it.

Miscellaneous: pencil, soft eraser, razor blade. A T-square makes it easier to get square corners. For archival or other purposes where extra care is required, cotton gloves protect the print or mat during handling.

BLEED MOUNTING A bleed-mounted print has no border. After mounting, the print is trimmed to the edges.

1 Heat the press to 200° F or as instructed for the dry-mount tissue. The resin coating of RC prints can melt at temperatures higher than 210° F; use a dry-mount tissue suitable for them, one that bonds at temperatures lower than 210° F.

Make sure the materials are clean. Even a small bit of dirt trapped between print and board will cause a visible lump in the print.

Predry a fiber-base print and its mount board, with cover sheet on top, for about 30 sec in the press. Do not predry RC prints, just the mount board and cover sheet.

2 Tack the dry-mount tissue to the print. Heat the tacking iron to the same temperature indicated for the press. With the print face down on a clean surface and mounting tissue on top, tack the tissue to the print by touching the center of the print with the iron and sliding it an inch or so toward a side. Do not tack at the corners. Lift the tissue to make sure the print is firmly attached.

Trim off any mounting tissue that extends beyond the print, so the print doesn't unintentionally stick to the cover sheet.

NOTE: If you are mounting a digital print, do not heat it. Use a cold-mount tissue or hinge the print under an overmat.

3 Tack the dry-mount tissue and print to the board. Place the print and tissue face up on the mount board. Tack the tissue to the board with a short stroke of the tacking iron toward the corner. Repeat at the diagonal corner. Keep the tissue flat to prevent wrinkles.

4 Mount the print. Put the sandwich of board, tissue, and print (with cover sheet on top) into the press. A fiber-base print should bond in 30–40 sec. Let it cool, then test the adhesion by bending down a corner of the board slightly. If the print pops up, return it to the press for a longer time. Don't leave the print in the press excessively long; heat shortens the life of a photograph.

Keep an RC print in the press for the shortest time that will fuse the dry-mount tissue to the print and board.

5 Trim the mounted print. Put the print face up on a suitable cutting surface. Trim the edges of the mounted print with a utility knife or mat cutter, using a ruler or a metal straight edge as a guide. The blade must be sharp to make a clean cut. Several light slices often work better than only one cut. Press down firmly on the ruler so it does not slip—and be careful not to cut your fingers.

6 The finished print. Because the edges of a bleed-mounted print come right up to the edges of the mount board, be careful when handling the mounted print so you don't accidentally chip or otherwise damage the edges. You may wish to carefully darken the edges with a marking pen.

JO WHALEY Cerambycidae, Selected Writings, 2003

Whaley prefers overmatting her still-life prints with white rag board. A dried bug is combined with a book by Helen Keller found at the local shooting range.

1 Heat the press to 200° F or as instructed with the dry-mount tissue. The resin coating of RC photographic paper can melt at temperatures higher than 210° F; use a suitable dry-mount tissue, one that bonds at temperatures lower than 210° F.

Test a scrap print made the same way as the print you want to mount, to make sure it can withstand heat. Leave it in the press for one or two minutes, then look for any changes.

Make sure the materials are clean. Even a small bit of dirt trapped between print and board will cause a visible lump in the print.

Predry the mount board and cover sheet for about 30 sec in the press.

2 Tack the dry-mount tissue to the print. Heat the tacking iron to the same temperature indicated for the press. With the print face down on a clean surface and mounting tissue on top, tack the tissue to the print by touching the center of the print with the iron and sliding it an inch or so toward a side. Do not tack at the corners. Lift the tissue to make sure the print is firmly attached.

Trim off any mounting tissue that extends beyond the print, so the print doesn't unintentionally stick to the cover sheet.

NOTE: If you are mounting a digital print, do not heat it. Use a cold-mount tissue or hinge the print under an overmat.

3 Trim the print and dry-mount tissue. Place the print and dry-mount tissue face up on a suitable cutting surface. Use a utility knife or mat cutter, with a ruler or metal straight edge as a guide, to trim off the white print borders plus the tissue underneath. Cut straight down so that the edges of print and tissue are even. Watch your fingers.

4 Position the print on the mount board. It is convenient to mount prints on boards of a consistent size. Choose one of the conventional sizes that may be purchased precut: 8 x 10-inch prints are often mounted on 11 x 14-inch or 14 x 17-inch boards.

Position the print so the side margins are equal. Then adjust the print top to bottom. Often the print is positioned so that the bottom margin is slightly larger than the top.

5 Tack the dry-mount tissue and print to the board. Without disturbing the position of the print, slightly raise one corner of the print only. Tack the tissue to the board with a short stroke of the tacking iron toward the corner. Repeat at the diagonal corner. Keep the tissue flat against the board to prevent wrinkles.

6 Mount the print. Put the sandwich of board, tissue, and print (with cover sheet on top) into the press. A fiber-base print should bond in 30–40 sec. Let it cool, then test the adhesion by bending down a corner of the board slightly. If the print pops up, return it to the press for a longer time. Don't leave the print in the press excessively long; heat shortens the life of a photograph.

Keep a print in the press for the shortest time that will fuse the dry-mount tissue to the print and board.

7 The finished print.

An overmat provides a raised border around a print. It consists of a mat board rectangle with a hole cut in it, placed over a print that has been affixed to a backing board. The raised border helps protects the surface of the print from something sliding across it—such as another print. If the print is framed, it prevents the print surface from contact with the glass. Since the overmat is replaceable, a new one can be made if the original mat becomes soiled.

One of the great pleasures of photography is showing your prints to other people—but one of the great irritations is having someone leave a fingerprint on the mounting board of your best print. Prevent problems by handling your own and other people's pictures only by the edges.

TIP: Practice cutting the inner corners. It takes some skill to cut the inner edges of an overmat with precision. It becomes easier after a few tries, so spend some time practicing with scrap board to get the knack of cutting perfectly clean corners.

Overmat

Hinge

Photo corner

Backing board

CUTTING AN OVERMAT

1 Measure the image area. If you don't want the image cropped by the overmat, either measure just within the image area so that the white print border will not show or measure to leave equal borders all around the image. The image area for this picture is 5 3/4 inches high by 9 1/2 inches wide.

2 Plan the mount dimensions. Mounted horizontally on an 11 x 14-inch horizontal board, this print leaves a 2 1/4-inch border on the top and sides, a 3-inch border on the bottom. The overmat window will be cut to the size of the cropped image. You need two boards: one for the backing, one for the overmat.

3 Mark the cuts on the mat board. With a sharp pencil, mark the back of one board for the inner cut, using the dimensions of the image that you want visible. Measure with the ruler, but draw the lines against a firmly braced T-square aligned with the mat edge to ensure that the lines will be square.

4 Cut the overmat. Using a metal ruler or straightedge as a guide, cut each inside edge, stopping exactly at the corners. If necessary, finish the corners with a razor blade, maintaining the angle of the cut. Erase remaining pencil marks from the backing board so that they don't transfer to the print.

5 Attach the overmat to the backing board. Hinge the overmat to the backing board with a strip of gummed linen tape, shown below, left. Slip the print between the backing board and the overmat.

6 Position and attach the print. Align the print with the inner edges of the overmat. Lift the overmat carefully (far left, bottom) so you don't change the print's position. Attach the print to the backing board using one of the methods below.

ATTACHING AN OVERMATTED PRINT TO A BACKING BOARD

You can dry mount the print with a border, as shown on the previous page. Cornering and hinging, shown below, let you remove the print from its backing board, in case the board needs replacing.

Cornering. Photo corners, like the ones used to mount pictures in snapshot albums, are the best way to hold a print in place under a window. To be sure your corners are acid-free, make your own (see below) and attach them to the backing board with a strip of tape.

Hinging. Hinging holds the print in place with strips of tape attached to the upper back edge of the print and to the backing board. A folded hinge (below left) is hidden by the print. You can reinforce a folded hinge with a piece of tape. A pendant hinge is hidden if an overmat is used.

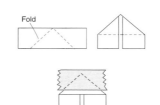
Fold

Print
Folded hinge
Backing board

Pendant hinge

JOHN GOSSAGE Stallschreiberstrasse, West Berlin, 1989

The Berlin Wall was a glaring symbol of post-World War II political tension.
It divided Germany's major city with a concrete-and-razor-wire barrier
between the "free world" west and the communist east. Gossage's photographs,
made between 1982 and the Wall's demolition in 1989, are purposefully dark,
threatening, and foreboding. His large prints are so dark that covering them
with ordinary glass all but turns them into mirrors. For a New York gallery
exhibition, Gossage framed them using nonreflective museum glass—the only
way the images could readily be seen.

Framing a print for the wall sets it apart as a special object. Whether you've made it for a family member's birthday or a gallery exhibit, matting and framing asserts that this photograph is to be viewed as a piece of art. Once you have made a print you are proud of, you will want to consider processes and materials for presentation that are attractive and also archival, a term for anything done for the sake of long-term preservation.

Matting and framing have several goals— to call attention to your photographs, to create an elegant environment for them, to isolate them from distracting elements, and to protect them from damage. There are almost as many display options as there are photographs, but a few generalities do apply. Keep in mind that framing is a specialty and many photographers leave it to a professional, but—on a modest scale— you can do it all yourself.

Mat your photograph before it is framed. A mat is a sheet or sheets of specially-made stiff paper board; the best is made from cotton rag rather than wood pulp. A thin sheet might be the thickness of three or four playing cards, heavy mat board (called 8-ply) is 1/8-inch thick. Most matted prints are a sandwich with the print held in place between a backing sheet and an overmat (see page opposite). Sometimes a print is affixed to the front of a single sheet (pages 222–223).

An overmatted print held in place with corners is most often your best presentation choice because the print can be safely removed at any time. If a mat becomes soiled or damaged, it can be replaced. Museums often overmat and frame a print one way for one exhibition then, later, mat and frame it a different way for another show. An overmat allows for the normal expansion and contraction of paper with changing temperature and humidity.

Framed photographs are usually glazed, covered with a sheet of clear glass or plastic. Small works can be glazed with plain glass, but clear plastic is lighter and less likely to break and damage the work if mishandled. A framed photograph can be displayed unglazed, but glazing protects it

from physical damage and also from harmful ultraviolet (UV) rays that accelerate fading.

Daylight and fluorescent light contain a high percentage of damaging UV. Plain glass absorbs about half of it, while plain acrylic absorbs about two-thirds. Coatings can extend that; conservation glass absorbs 97% of UV, while UV-filtering acrylic absorbs 99%.

Also available are reflection-control glass and acrylic, both with and without UV-absorbing coatings. Standard non-glare glass shouldn't be used for glazing because it can produce optical distortion.

Matting separates the print from the glazing. Direct contact with glazing will eventually damage a print's surface. Prints mounted to the front of a mat, with no overmat to ensure an airspace, should be in a shadow-box style frame, in which the frame separates the glazing from the backing, instead of pressing them together.

Frames can be wood or metal. If you use wood frames, make sure there is a vapor barrier (usually aluminum or plastic tape) between the mat package and the wood. Wood is acidic; direct contact will shorten the life of anything made of paper. Avoid pressure-sensitive tapes unless you know them to be acid-free.

Frame mouldings come in a wide variety of cross-sections, finishes, and colors. Aluminum section frames come in standard length pairs; for a 16 x 20-inch frame you need a pair of 16-inch pieces, a pair of 20-inch pieces, and a 16 x 20-inch sheet of glass or acrylic. Hardware to connect the pieces comes with the frame pairs; you can easily assemble it all with a screwdriver.

New presentation methods appear as technology changes. Lightweight rigid plastic and honeycombed aluminum sheets have been developed to hold large prints extremely flat. Special optically-clear laminations can adhere a print to the back of an acrylic sheet with no bubbles or flaws, bonding the two so the face of the acrylic sheet becomes the surface of the photograph. There are no rules; just make sure, whatever presentation you choose, that you think it's the best choice.

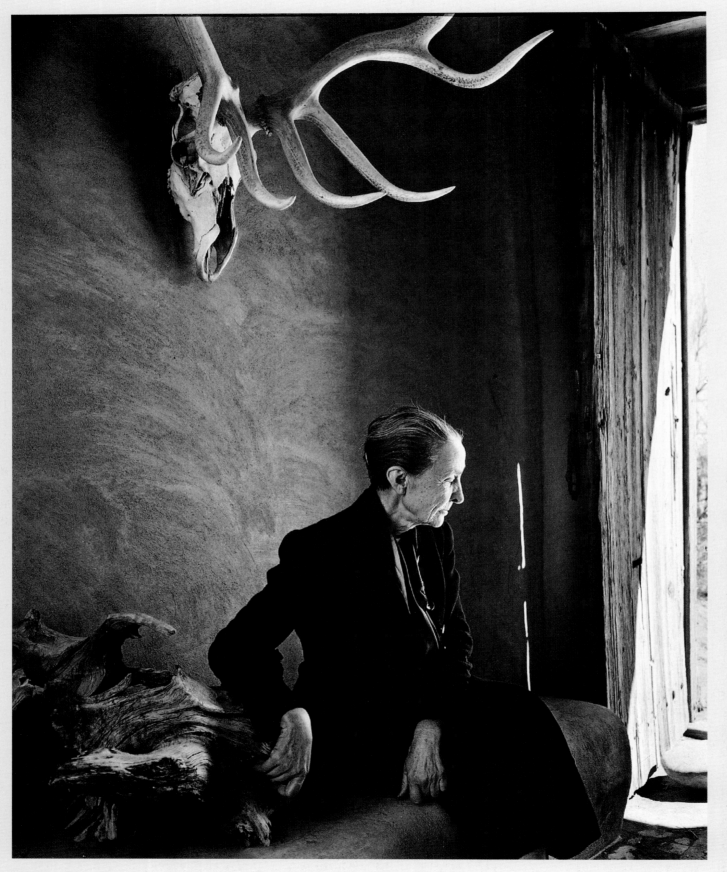

YOUSUF KARSH Georgia O'Keeffe, 1956

Yousuf Karsh's portraits include presidents, popes, and most of the century's greatest musicians, writers, and artists, including the painter Georgia O'Keeffe. This portrait is typical of Karsh's work, conveying very strongly the sitter's public image, that is, what we expect that particular person to look like. Karsh generally photographed people in their own environments but imposed on his portraits his distinctive style: carefully posed and lighted setups, rich dark tones, often with face and hands highlighted.

Notice the lighting on your subject. Soft, relatively diffused light is the easiest to handle because it is kind to faces and won't change much, even if you change your position. But stronger lighting, as on both pages here, can add interest and emphasis. Move around your subject, or move them around, to take a look at how the light on them changes.

lighting

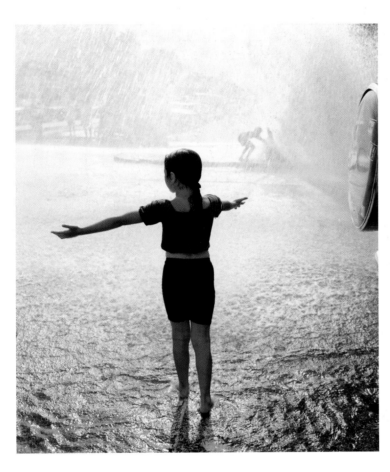

PAUL D'AMATO Isela, Chicago, 1993

Embrace the light, this photograph suggests. It is one D'Amato made during his 14-year personal project of photographing Chicago's Pilsen neighborhood and its mostly immigrant Mexican residents.

Changes in lighting will change your pictures, whether you make them digitally or on film. Outdoors, if clouds darken the sky, or you change position so that your subject is lit from behind, or if you move from a bright area to the shade, your pictures will change as a result. Light changes indoors, too. Your subject may move closer to a sunny window, or you may turn on overhead lights or decide to use flash lighting.

Light can affect the feeling of a photograph so that a subject appears, for example, brilliant and crisp, hazy and soft, harsh or smooth. If you make a point of observing the light on your subject, you will soon learn to predict how that light will affect your photographs, and you will find it easier to use existing light or to arrange the lighting yourself.

The direction of light is important because of shadows, specifically those that are visible from camera position. Light, except for the most diffuse sources, casts shadows that can emphasize texture and volume or can diminish them. The main source of light—the sun, a bright window in a dark room, a flash unit—illuminates the side of the subject nearest the light and casts shadows on the opposite side.

When looking at the lighting on a scene, you need to take into account not only the direction of the light (and the shadows it casts), but also the position of the camera (will those shadows be visible in the picture?). Snapshooters are sometimes advised to "stand with the light over your shoulder." This creates safe but often uninteresting front lighting in which the entire subject is evenly lit, with few shadows visible because they are all cast behind the subject. Compare front lighting with side or back lighting in which shadows are visible from camera position (photographs, this page and opposite). There is nothing necessarily wrong with front lighting; you may want it for some subjects. Nor does side or back lighting enhance every scene.

Before you shoot, take a moment to consider your alternatives. Will moving to another position show the scene in a more interesting light? Can you move the subject relative to the light, or maybe move the light to another position? Outdoors, you have little control over the direction of light, except for waiting for the sun to move across the sky or in some cases by moving the subject. If you set up lights indoors, you have many more options.

RICHARD COPLEY Grand Central, New York City, 1998

Back lighting comes toward the camera from behind the subject. Shadows are cast toward the camera and so are prominent, with the front of the subject in shadow. Back lighting can make translucent objects seem to glow and can create rim lighting, a bright outline around the subject, as on the heads and shoulders of the people in the photo above (see the last photo on page 236).

GARRY WINOGRAND New York City, 1968

Front lighting comes from behind the camera toward the subject. The front of the subject is evenly lit with minimal shadows visible. Surface details are seen clearly, but volume and textures are less pronounced than they would be in side lighting where shadows are more prominent. Flash used on camera is a common source of front lighting.

HENRY WESSEL San Francisco, 1977

Side lighting comes toward the side of the subject and camera. Shadows are prominent, cast at the side of the subject, which tends to emphasize texture and volume. Early morning and late afternoon are favorite times for photographers to work outdoors, because the low position of the sun in the sky produces side lighting and back lighting.

Degree of Diffusion: From Hard to Soft Light

Another important characteristic of lighting is its degree of diffusion, which can range from contrasty and hard-edged to soft and diffuse. When people refer to the "quality" of light, they usually mean its degree of diffusion.

Direct light creates hard-edged, dark shadows. Its rays are nearly parallel, striking the subject from one direction. The smaller the light (relative to the size of the subject) or the farther away, the sharper and darker the shadows will be. The sharpest shadows are created by a point source, a light small enough or far away enough that

its actual size is irrelevant.

A spotlight is one source of direct light. Its diameter is small, and some spotlights have a built-in lens to focus the light even more directly. If you think of a performer on stage in a single spotlight, you can imagine an extreme case of direct light: lit areas are very light, shadows are hard-edged and black unless there are reflective areas near the subject to bounce some light into them.

The sun on a clear day is another source of direct light. Although the sun is large in actual size, it is so far away that it occupies only a

small area of the sky and therefore casts sharp, dark shadows. When its rays are scattered in many directions by clouds or other atmospheric matter, it does not cast direct light. Then its light is directional-diffused or even—as on a day with an overcast sky—fully diffused.

Diffused light scatters onto the subject from many directions. It shows little or no directionality. Shadows, if they are present at all, are relatively light. Shadow edges are indistinct, and subjects seem surrounded by illumination.

LOTTE JACOBI Albert Einstein, Princeton, New Jersey, 1938

Directional-diffused light combines qualities of direct and diffused light. Shadows are visible, but not as prominent as in direct light. Working for Life *magazine, Jacobi photographed Einstein indoors with the main light coming from a large window to the right but with another window behind the photographer letting light into the shadows.*

IMOGEN CUNNINGHAM My Father after Ninety, 1937

Direct light has hard-edged shadows. It illuminates subjects such as those that are in the sun on a clear day. Even though Cunningham exposed carefully to keep the shadows from getting too dark, they are still sharp-edged. This photograph was in the book After Ninety, *which Cunningham began to edit when she herself was over ninety and still photographing.*

Sources of diffused light are broad compared to the size of the subject—a heavily overcast sky, for example, where the sun's rays are completely scattered and the entire sky becomes the source of light. Fully diffused light indoors would require a very large, diffused light source close to the subject plus reflectors or fill lights to further open the shadows. Tenting (page 255) is one way of fully diffusing light.

Directional-diffused light is partially direct with some diffused or scattered rays. It appears to come from a definite direction and creates distinct shadows, but with edges that are softer than those of direct light. The shadow edges change smoothly from light to dark, and the shadows should have visible detail.

Sources of directional-diffused light are relatively broad. Indoors, windows or doorways are sources when sunlight bounces in from outdoors rather than shining directly into the room. Floodlights used relatively close to the subject are also diffuse sources; their light is even softer if directed first at a reflector and bounced onto the subject (like the umbrella light on page 234) or if partially scattered by a diffusion screen placed in front of the light. Outdoors, the usually direct light from the sun is broadened on a slightly hazy day, when the sun's rays are partially scattered and the surrounding sky becomes a more important part of the light source. Bright sunlight can also produce directional-diffused light when it shines on a reflective surface such as concrete and then bounces onto a subject shaded from direct rays by a tree or nearby building.

DANNY LYON Sparky and Cowboy (Gary Rogues), 1965

Fully diffused light provides an even, soft illumination. Here, the light is coming from above, as can be seen from the soft shadows under their chins. But light is also bouncing in from both sides, further reducing contrast and flattening the overall appearance. An overcast day or a shaded area commonly has diffused light.

What kind of light will you find when you photograph in available light, the light that already exists in a scene? It may be any of the lighting situations shown here or on the preceding pages. Stop for a moment before you begin to photograph to see how the light affects the subject and to decide whether you want to change your position, your subject's position, or the light itself.

A clear, sunny day creates bright highlights and dark, hard-edged shadows (this page, top). On a sunny day, take a look at the direction the light is coming from. You might want to move the subject or move around it yourself so the light better reveals the subject's shape or texture as seen by the camera. If you are relatively close to your subject—for example, when making a portrait—you might want to lighten the shadows by adding fill light (page 238) or by taking the person out of the sun and into the shade where the light is not so contrasty. You can't control light outdoors, but you can at least observe it and work with it.

On an overcast day, at dusk, or in the shade, the light will be diffused and soft (this page, bottom). This is a revealing light that illuminates all parts of the scene. It can be a beautiful light for portraits, gently modeling the planes of the face.

The light changes as the time of day changes. The sun gets higher and then lower in the sky, affecting the direction in which shadows fall. If the day is sunny, many photographers prefer to work in the early morning or late afternoon, because when the sun is close to the horizon, it casts long shadows and rakes across the surface of objects, increasing the sense of texture and volume.

BILL GASKINS Ava, Atlanta, Georgia, 1997 ▲

Direct light outdoors can produce prominent shadows, so it is important to notice how such light is striking a subject.

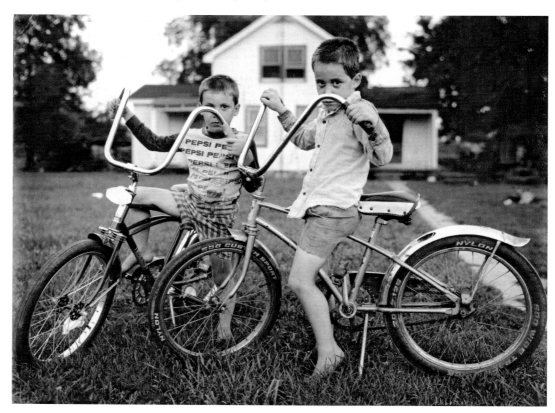

BILL BURKE Two Boys with Bicycles, Lewis County, Kentucky, 1975

Diffused light outdoors, such as from an overcast sky, is soft and revealing. Similar lighting called open shade exists, for example, in the shade of a building even on a sunny day. You can shoot from almost any position without the light on the subject, or its apparent contrast, changing.

Available light indoors can be contrasty or flat, depending on the source of light. Near a lamp or window, especially if there are not many in the room, the light is directional, with bright areas fading off quickly into shadow (this page, top). The contrast between light and dark is often so great that you can keep details in highlights or shadows, but not in both. If, however, there are many light fixtures, the light can be softly diffused, illuminating all parts of the scene (this page, bottom).

When shooting indoors, expose for the most important parts of the picture. The eye adapts easily to variations in light; you can glance at a light area, then quickly see detail in a nearby dark area. But there will often be a greater range of contrast indoors than film can record, so rather than making an overall meter reading, you need to select the part of the scene that you want to see clearly and meter for that.

Light indoors is often relatively dim. If you want to use the existing light and not add flash or other light to a scene, you may have to use a slow shutter speed and/or a wide aperture. Use a tripod at slow shutter speeds or brace your camera against a table or other object so that camera motion during the exposure does not blur the picture. Focus carefully, because there is very little depth of field if your lens is set to a wide aperture. A fast film, or high ISO setting on a digital camera—400 or higher—will help.

▲

MARGARET BOURKE-WHITE
Mahatma Gandhi, 1946

Shooting toward a bright window or lamp indoors creates contrasty light. The side facing the light source is much brighter than the side facing the camera.

POLLY BROWN Talk of the Town Barber Shop, Roxbury, Massachusetts, 1986

Diffused light indoors occurs when light comes from several different directions, such as from windows on more than one side of a room or from numerous light fixtures.

TYPES OF ARTIFICIAL LIGHT

Photofloods have a tungsten filament, like a household bulb, but produce more light than a conventional bulb of the same wattage. The bulbs put out light of 3200K color temperature for use with indoor color films. The bulbs have a relatively short life, and put out an increasingly reddish light as they age. Studio photographers call photofloods (and quartz-halogen lights, below) "hot lights" to distinguish them from electronic flash.

Quartz-halogen bulbs contain a gas that prolongs the life of the bulb. They (and their lamp housing fixtures) are often more expensive than photofloods, but they last much longer and maintain a more constant color temperature over their life. Quartz bulbs are color balanced for indoor color films.

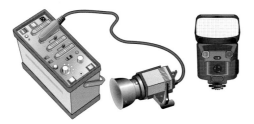

Flash equipment (see page 241) ranges from large studio units that power multiple heads to units small enough to clip onto or be built into a camera. Flash should be used with daylight-balanced color films.

Depending on its housing, any of the above can be a floodlight, which spreads its beam over a wide angle, or a spotlight, which has a lens in its housing that focuses the light into a concentrated beam. A spotlight often is adjustable so the light can be varied from very narrow to relatively wide.

REFLECTORS AND LIGHT-CONTROL DEVICES

Bowl-shaped reflectors are used with photo lamps to concentrate the light and point it toward the subject. Some bulbs have a metallic coating on the back of the bulb that eliminates the need for a separate reflector.

Snoot is a tube attached to the front of a lamp housing to narrow its beam. It is used to highlight specific areas.

Grid also attaches to the front of a lamp housing and uses an array of tiny tubes to narrow its beam. Grids are available in a variety of spread angles.

Umbrella reflector is used with a light to produce a wide, relatively diffused light. The light source is pointed away from the subject into the umbrella, which then bounces a broad beam of light onto the scene. Umbrella reflectors come in various surfaces such as silvered for maximum reflectivity, soft white for a more diffuse light, and gold to warm skin tones.

Reflector flat is a piece of cardboard or other material used to bounce light into shadow areas.

Flag is a small panel usually mounted on a stand and positioned so it shades some part of the subject or shields the camera lens from light that could cause flare, the same effect you get outdoors if the sun shines directly into the lens.

Gobo is a plate of metal or glass in front of the bulb that creates a pattern of projected light.

Barn doors are a pair (or two pairs) of black panels that mount on the front of a light source. They can be folded at various angles in front of the light and, like a flag, are used to keep part of the illumination away from the subject or from the lens.

DIFFUSERS AND FILTERS

Diffusion screen, often a translucent plastic, placed in front of a light will soften it and make shadows less distinct. The material must be heat resistant if used close to tungsten bulbs. The screen may clip onto a reflector or fit into a filter holder.

Tent is a translucent material that wraps around the subject instead of around the light source. Lights shine on the outside of the tent, producing a very diffused and even illumination. See the tent diagrammed on page 255.

Softbox completely encloses one or more lamps and produces a soft, even light.

Filter holder accepts filters or gels that change the color of the light, diffusion screens that soften it, or polarizing screens to remove glare or reflections.

SUPPORTS FOR LIGHTS AND OTHER DEVICES

Light stands hold a lamp, reflector, or other equipment in place. The basic model has three folding legs and a center section that can be raised or lowered.

Cross arm or boom attaches to a vertical stand to position a light at a distance from the stand. A counterweight at the opposite end of the arm keeps the stand from falling over.

Umbrella mount attaches to a light stand and has a bracket for an umbrella reflector, plus another for the light that shines into the umbrella.

Background paper or seamless is not lighting equipment but is a common accessory in a studio setup. It is a heavy paper that comes in long rolls, 4 feet or wider, in various colors to provide a solid-toned, nonreflective backdrop that can be extended down a wall and across the floor or a table so you can make photographs without a visible break or horizon line. If the paper becomes soiled or wrinkled, fresh paper is unrolled and the old paper cut off. The roll is supported on two upright poles with a cross piece that runs through the hollow inner core of the roll.

When Arnold Newman was asked to make a portrait of President Lyndon B. Johnson in the Oval Office at the White House, Newman covered the windows with cloths to block unwanted light, mounted two view cameras—a 4 x 5 and an 8 x 10—and arranged his lights and reflectors.

The lighting setup looks complicated, but its intention is simple—to illuminate the subject in a way that resembles ordinary daytime lighting. This type of lighting looks natural and realistic because it is the kind people see most often. It consists of one main source of light coming from above, usually from the sun but here from the large umbrella reflector. It also has fill light that lightens shadow areas. In nature, this is light from the entire dome of the sky or from other reflective surfaces; here it comes from the smaller lights.

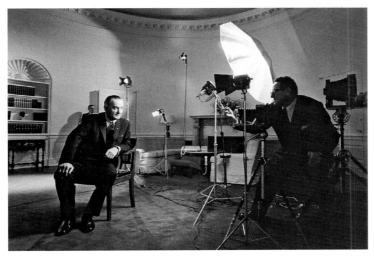

Y.R. OKAMOTO Arnold Newman Photographing President Lyndon B. Johnson, 1963

A softbox provides a very soft and diffused illumination. The light scatters over the subject from many directions providing almost shadowless lighting. Photographers often use a softbox or an umbrella reflector (shown above in the photograph of Arnold Newman at work) to produce the natural look of a broad, diffused window light.

A floodlight or direct flash produces directional lighting. Notice how dark and hard edged the shadows are compared to the photo above.

The same properties are present in artificial light as in available light. The direction of light and the amount of its diffusion can create a hard-edged light or a soft and diffused light. Because you set up and arrange artificial lights, you need to understand how to adjust and control them to produce the effect you want.

The bigger the light source relative to the subject, the softer the quality of the light. The sun, although large, produces hard-edged, dark shadows because it is so far away that it appears as a very small circle in the sky. Similarly, the farther back you move a light, the smaller it will be relative to the subject and the harder the shadows will appear. The closer you move the same light, the broader the light source will be, the more its rays will strike the subject from different angles, and the softer and more diffused its lighting will appear.

The more diffused the source, the softer the light. A spotlight focuses its light very sharply on a subject producing bright highlights and very dark, hard-edged shadows. A floodlight is a slightly wider source, but still one with relatively hard-edged shadows, especially when used at a distance. A softbox or umbrella reflector is much more diffused and soft—and usually also much wider.

Use the type of light and its distance to control the light on your subject. If you want sharp, dark shadows, use a directional source, such as a photoflood or direct flash, relatively far from the subject. If you want soft or no shadows, use a broad light source, such as a softbox or umbrella reflector, close to the subject.

Where do you start when making a photograph with artificial light? Using lights like photofloods or electronic flash that you bring to a scene and arrange yourself requires a bit more thought than making a photograph by available light where you begin with the light that is already there and observe what it is doing to the subject.

The most natural-looking light imitates the most common source of light—the sun, one main light source casting one dominant set of shadows. We are used to illumination that comes from above the horizon, and ranges from a combination of bright sun and skylight to overcast and haze.

The place to begin is by positioning the main light. This light, also called the key light, should create the only visible shadows, or at least the most important ones, if a natural effect is desired. Two or three equally bright lights producing multiple shadows create a feeling of

artificiality and confusion. The position of the main light affects the appearance of texture and volume (see pictures below). Flat frontal lighting (first photograph) decreases both texture and volume, while lighting that rakes across surface features (as seen from camera position) increases it. Natural light usually comes from a height above that of the subject, so this is the most common position for the main source of artificial light. Lighting from a very low angle can suggest mystery, drama, or even menace just because it seems unnatural. A cliché of horror movie lighting is that the monster is lighted from below.

Some types of lighting have been traditionally associated with certain subjects. Side lighting has long been considered appropriate for male portraits because it emphasizes rugged facial features. Butterfly lighting was once used for idealized portraits of Hollywood movie stars. The lighting is named

for the symmetrical shadow underneath the nose, similar to, though not as long as, the one in the top-lighting photograph, below, fourth from left. The main light is placed high and in front of the subject, which smoothes the shadows of skin texture, while producing sculptured facial contours (page 252, bottom).

Lighting can influence the emotional character of an image. The pictures below show how the mood of a photograph can be influenced merely by changing the position of one light. Each suggests different aspects— real or not—of the subject's personality.

Most photographs made with artificial light employ more than one light source. Almost always a fill light or reflector is used to lighten shadows. Sometimes, an accent light is used to produce bright highlights, and a background light is added to create tonal separation between the subject and background.

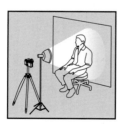 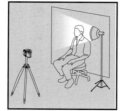 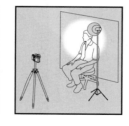 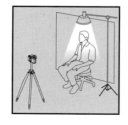 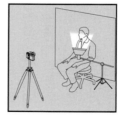 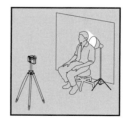

Front lighting.
With the light placed as near the lens axis as possible (here just to the right of the camera), only thin shadows are visible from camera position. This axis lighting seems to flatten out the volume of the subject and minimize textures.

Side lighting.
Sometimes referred to as "hatchet" lighting because it can split a subject in half. This type of lighting emphasizes facial features and reveals textures like that of skin. The light is at subject level, directly to the side.

High side lighting.
A main light at about 45° to one side and 45° above the subject has long been the classic angle for portrait lighting, one that seems natural and flattering. It models the face into a three-dimensional form.

Top lighting.
A light almost directly above the subject creates deep shadows in the eye sockets and under the nose and chin. This effect is often seen in pictures made outdoors at noon when the sun is overhead.

Under lighting.
Light from below produces odd-looking shadows because light in nature seldom comes from below. Firelight is one source. High-tech scenes, such as by a computer monitor, are modern settings for under lighting.

Back lighting.
A light pointing at the back of a subject outlines its shape with a rim of light like a halo. Position a back light carefully so it does not shine into the camera lens and create sharpness-reducing flare, and so the fixture itself is not visible.

TIMOTHY GREENFIELD-SANDERS
Portrait of Steve Buscemi

A large softbox placed to the left of the camera provided directional but even, soft light for this portrait. The softbox leaves shadows, such as the one cast by Buscemi's nose, falling away gradually rather than leaving a hard edge.

Fill light makes shadows less dark by adding light to them. When you look at a contrasty scene, your eye automatically adjusts for differences in brightness. As you glance from a bright to a shadowed area, the eye's pupil opens up to admit more light. But film or a camera's digital sensor cannot make such adjustments; it can record detail and texture in brightly lit areas or in deeply shadowed ones, but generally not in both at the same time. So if important shadow areas are much darker than lit areas—for example, the shaded side of a person's face in a portrait—consider whether adding fill light will improve your picture.

Fill light is most useful with color transparencies. As little as two stops difference between lit and shaded areas can make shadows very dark, even black, in a color slide. The film in the camera is the final product when shooting slides, so only limited corrections can be made later during printing or post-processing.

Fill light can also be useful with black-and-white materials. In a black-and-white portrait of a partly shaded subject, shadows that are two stops darker than the lit side of the face will be dark but still show full texture and detail. But when shadows get to be three or more stops darker than lit areas, fill light becomes useful. You can also control contrast by adjusting tones during image editing, but results are often better if you add fill light, rather than trying to lighten a too-dark shadow when printing.

Artificial lighting often requires fill light. Light from a single photoflood or flash often produces a very contrasty light in which the shaded side of the face will be very dark if the lit side is exposed and printed normally. Notice how dark the shaded areas are in the single-light portraits on page 236. You might want such contrasty lighting for certain photographs, but ordinarily fill light would be added to make the shadows lighter.

Some daylight scenes benefit from fill light. It is easier to get a pleasant expression on a person's face in a sunlit outdoor portrait if the subject is lit from the side or from behind and is not squinting directly into the sun. These positions, however, can make the shadowed side of the face too dark. In such cases, you can add fill light to decrease the contrast between the lit and shadowed side of the face. You can also use fill light outdoors for close-ups of flowers or other relatively small objects in which the shadows would otherwise be too dark.

A reflector is a simple, effective, and inexpensive way to add fill light. A reflector placed on the opposite side of the subject from the main light bounces the main light into shadow areas. A simple reflector, or flat, can be made from a piece of stiff cardboard, 16 x 20 inches or larger, with a soft matte white finish on one side. The other side can be covered with aluminum foil that has first been crumpled and then partially smoothed flat. The white side will give a soft, diffused, even light suitable for lightening shadows in portraits, still lifes, and other subjects. The foil side reflects a more brilliant, harder light.

A floodlight or flash can also be used for fill lighting. A light source used as a fill is generally placed close to the lens so that any secondary shadows will not be visible. The fill is usually not intended to eliminate the shadow altogether, so it is normally of less intensity than the main light. It can have lower output than the main light, be placed farther away from the subject, or have a translucent diffusing screen placed in front of it.

A black "reflector" is useful at times. It is a sort of antifill that absorbs light and prevents it from reaching the subject. If you want to darken a shadow, a black cloth or card placed on the opposite side of the subject from the main light will remove fill light by absorbing light from the main light.

FILL LIGHT RATIOS

The difference between the lit side of a subject and the shadow side can be stated as a ratio. The higher the ratio, the greater the contrast. Doubling the ratio is equivalent to a one-stop change between highlights and shadows.

1:1 ratio. The lit side is no lighter than the "shadow" side—in fact, there are no significant shadows. If an exposure for the lit side metered, for example, 1/125 sec at f/5.6, the exposure for the shadow side would meter the same.

2:1 ratio. The lit side is twice as light as the shadow side (a one-stop difference between meter readings), which will make shadows visible but very light. If the lit side metered 1/125 sec at f/5.6, the shadow side would meter one stop less at f/4.

4:1 ratio. The lit side is four times—two stops—lighter than the shadow side, which will render shadows darker, but still show texture and detail in them. If the lit side metered 1/125 sec at f/5.6, the shadow side would meter two stops less at f/2.8. Portraits are conventionally made at a 3:1 to 4:1 ratio, with the lit side of the face between one and one-half and two stops lighter than the shadowed side.

8:1 ratio. The lit side is eight times—three stops—lighter than shadows. At 8:1 (or higher), some detail is likely to be lost in highlights, shadows, or both. If the lit side metered 1/125 sec at f/5.6, the shadow side would meter three stops less at f/2.

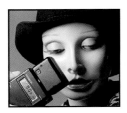

No fill light.
Side lighting from a single photoflood leaves one side of the face darkly shadowed. The lit side meters f/8 at 1/60 sec.

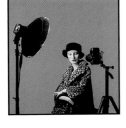

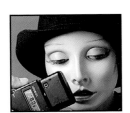

With fill light.
A white reflector to the right of the head bounces light back into the shadow areas on the cheek and chin to lighten the shadows. The lit side still meters f/8 at 1/60 sec.

No fill light.
The shadow side meters f/2.8 at 1/60 sec or 3 stops less than the lit side (f/8 to f/5.6 would be a one-stop difference, to f/4 two stops), an 8:1 ratio.

With fill light.
The shadow side meters between f/5.6 and f/4, a one-and-a-half-stop difference, or a 3:1 ratio.

To measure the difference between highlights and shadows, meter the lit side and note the combination of f-stop and shutter speed. Then compare that to the f-stop and shutter speed combination for the shadow side. Count the number of stops difference between the two exposures. If there is too much difference between the lit side and shadows, move the fill closer to the subject or move the main light farther away.

With a reflected-light meter (such as that used in the demonstration pictures to the left), you can meter directly from the subject or from a gray card held close to the subject. You need to get close enough to meter only the lit (or shadow) area, without getting so close that you cast—and meter—your own shadow.

With an incident-light meter, point the meter first toward the main light from subject position, then toward the fill.

LOIS GREENFIELD
Ross McCormack and Antony
Hamilton of the Australian
Dance Theater for GQ, 2004

*Flash stops motion—an
understatement for this
photograph. The burst
of light from a flash is
so brief—usually faster
than the fastest shutter
speed on a camera—
that it shows most
moving subjects sharply.*

*These two dancers
were cast members from
the dance performance
Held, that was based on
Greenfield's photog-
raphy. In the actual
performance, Greenfield
herself was on stage
shooting with a digital
camera, and the live-
action photographs were
projected as part of the
performance. More work
by Lois Greenfield is on
page 258–259.*

**Flash units provide a convenient means of
increasing the light, indoors or out.** An
electronic flash unit, sometimes called a
strobe, has a tube filled with xenon or other
inert gas that emits a brief burst of light
when subjected to a surge of electricity.
The unit may be powered by batteries built
into a camera, by batteries or an AC
connection built into the flash unit, or by a
separate power pack.

**Professional photographers find flash
particularly useful.** Photojournalists often
have to work fast in an unfamiliar setting to
record action while it is happening. Not
only does flash stop the motion of a
moving subject, but it prevents blur caused
by hand holding the camera. The light is
portable and predictable; flash delivers a
measured and repeatable quantity of light
anywhere the photographer takes it, unlike
available light, which may be too dim or
otherwise unsuitable. Studio photographers
like flash because it stops motion, it is
cooler than heat-producing tungsten lights,

plus it has easily adjustable output that is
very consistent in brightness and color.

**A camera-mounted flash unit is
convenient to carry and use.** The light from
the flash illuminates whatever is directly in
front of the lens. But flash-on-camera (or
any single light that is positioned very
close to the lens axis) creates a nearly
shadowless light. The result is a flatness—
reduced modeling and texture—that may
not be desirable for every subject. A flash
unit that you can use from an off-camera
position offers more lighting options.

**The burst of light from electronic flash is
very brief.** Even 1/1000 second, which is
relatively long for a flash duration, will
show most moving subjects sharply, a great
advantage in many situations (see photo-
graph, above). The disadvantage is that the
flash lasts for such a brief instant during the
exposure that you can't see how the light
affects the subject—for example, where the
shadows will fall. Larger units provide a
modeling light, a small halogen light built

into the flash unit and used as an aid in
positioning the flash.

**Make sure your flash is fully charged and
ready to fire each time you trigger it.** A
ready light on the flash (or in a camera with
through-the-lens flash metering) will tell you
when the flash is ready to fire.

**NOTE: Flash must be synchronized with
the camera's shutter.** A sync cord (or other
electronic connection such as a hot shoe)
links the flash and the camera so that the
flash fires when the shutter is fully open.
A camera with a leaf shutter (for example,
a view camera) can be used with flash at
any shutter speed when the shutter is set to
X sync. A camera with a focal-plane
shutter (such as a single-lens reflex camera)
may have to be used with flash at relatively
slow shutter speeds since the shutter
curtains on some models are fully open
only at 1/60 sec or slower. Many newer
models, however, sync with flash at 1/125
or 1/250 sec. At too high a shutter speed,
only part of the picture will be exposed.

TYPES OF FLASH UNITS

Built-in flash is now part of most cameras.

Hot-shoe flash has a mounting foot that slips into the hot-shoe bracket on top of a camera. The hot shoe provides an electrical connection that fires the flash when the camera shutter is released. Some units, like the one shown here, have a head that tilts so the flash can be used on the camera but still provide indirect bounce light.

Handle-mount flash puts out more light than a typical hot-shoe unit. Its handle serves as a grip and can hold batteries to power the unit.

Studio flash units are powerful devices that can fire one or more flash heads that are connected by cable to the power pack. On most units, both the flash and the modeling lights' brightnesses can be adjusted for individual flash heads.

Self-contained flash heads have a built-in power pack.

FLASH METERING

Automatic flash has a light-sensitive cell and electronic thyristor circuitry that determine the duration of the flash needed by measuring the light reflected back from the subject during the exposure. Some units can also be operated manually.

Dedicated (or designated) flash is always an automatic flash and is designed to be used with a particular camera. In automatic operation, the flash sets the camera's shutter to the correct speed for flash and activates a signal in the viewfinder when the flash is ready to fire. Do not use a flash unit dedicated for one camera on any other unless the manufacturer says they are compatible. The camera, flash, or both may be damaged.

Through-the-lens metering has a sensor inside the camera that reads the amount of light that actually reaches the film or digital sensor. Better systems can read both ambient light and light from the flash and can adjust the flash to provide fill lighting.

Flash meter measures the brief burst of light from flash so that the camera lens can be set to the correct f-stop.

FLASH ACCESSORIES

Sync cord connects a flash to a camera so that the flash fires when the camera's shutter is released. Not all cameras have a terminal that accepts this cord.

Flash slave unit fires an auxiliary flash when it detects a pulse of light from a primary flash that is triggered by the camera.

Modeling light, a small halogen light built into the flash head, helps in positioning the direction of the flash.

Light modifiers, such as a softbox diffuser or an umbrella reflector, can be used with flash, just as they can with continuous light sources, to make the light more diffused than direct light.

DESCRIBING FLASH POWER

A guide number is one way of describing a flash unit's power. Flash manufacturers label units with a guide number, a rating that indicates its power when used at a given ISO. The higher the guide number, the more powerful the flash. Watt-seconds is another description of a unit's output, usually used with larger units.

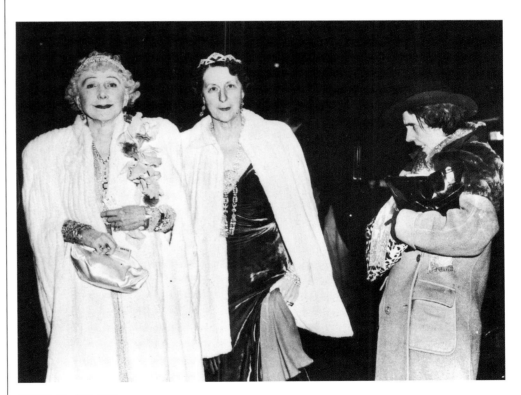

WEEGEE The Critic, 1943

Weegee (Arthur Fellig) specialized in street scenes in New York City—*here, a close encounter between denizens of two different worlds.*

Weegee almost always used direct flash on camera, a flat, two-dimensional lighting that revealed every detail in a merciless blast of light, a perfect illumi- *nation for his subject matter. The picture also shows that light rapidly gets dimmer as the distance from the light source to the subject increases, which is why the three people in the foreground are adequately exposed while the background is almost black (see page 243).*

Basic Flash Techniques

The easiest way to light a scene with flash is with direct flash on camera, a flash unit mounted on the camera and pointed directly at the subject (shown top, left). More likely than not, you will get an adequately exposed picture if you follow the instructions that come with the unit. The trouble is that this type of lighting is rather bland and somewhat unnatural; the subject looks two-dimensional with texture and volume flattened out by the shadowless, frontal lighting. The fault lies not with the flash but with its position close to the camera lens.

You can get more varied and interesting lighting with the flash in other positions. The goal is the same as with any other form of lighting: to make the lighting resemble natural illumination.

Since almost all natural lighting comes from above the subject, good results come from a flash held above the level of the subject or bounced in such a way that the light comes from above. Light that comes from one side is also effective and is usually more appealing than light that falls straight on the subject from the direction of the camera.

Natural lighting, whether indoors or outdoors, rarely strikes a subject exclusively from one direction. For example, shadows are filled in by light bounced off the ground or nearby surfaces. Outdoors, skylight fills shadows, too. You can do the same with flash, although the main light should still be dominant. Bouncing the main light onto the subject from another surface will diffuse some of the light and create softer shadows (bottom, right).

Aim the flash carefully so that the light doesn't create odd shadows or distracting reflections. The duration of a flash burst is too short to see the effect of different positions while shooting.

NOTE: Many portable flash units have a wide-angle-to-telephoto zoom feature. This does not actually change the output of the light but changes how widely the light spreads. With direct flash, use the settings appropriate to the lens you are using. When bouncing the flash, use the normal setting regardless of the focal length of the lens.

Direct flash on camera. This is the simplest method, one that lets you move around and shoot quickly. But the light tends to be flat, producing few of the shadows that model the subject to suggest volume and texture. Flash on camera also may produce red eye, a reddish reflection from the eye caused by light bouncing off the blood-rich retina.

Direct flash also produces visible shadows when the subject is positioned close to a light-colored background.

Direct flash off camera. Compared to on-camera flash, this produces more texture and volume. The flash is connected to the camera by a long sync cord and held at arm's length (or attached to a light stand) above and to the side. Point the center of the flash head carefully at the most important part of the subject. You can't see the results as you shoot, so it's easy to let your aim wander. This technique works best relatively close to the subject. As you move back you are more likely to mis-aim the flash.

Note how even when direct flash is positioned off camera, it will cast dark shadows on a light background.

Flash bounced from above. Bounce light is softer and more natural-looking than direct flash. The flash can be left on the camera if the flash has a head that swivels upward. In a room with a relatively low ceiling, the flash can be pointed upward and bounced off the ceiling (preferably neutral in color unless you are shooting in black and white). When aiming the flash, make sure the light bouncing off the surface actually hits the subject. A bounce-flash accessory simplifies bounce use; a card or mini-umbrella clips above the flash head and the light bounces off that.

Flash bounced from side. For soft lighting, with good modeling of features, the light can be bounced onto the subject from a reflector (such as the umbrella reflector, below) or light-colored wall (as neutral as possible for color photographs). **NOTE:** If you are using a flash on automatic exposure, its sensor must be pointed toward the subject, not toward the umbrella. Through-the-lens (TTL) automatic metering would work well in this situation. (See page 245.)

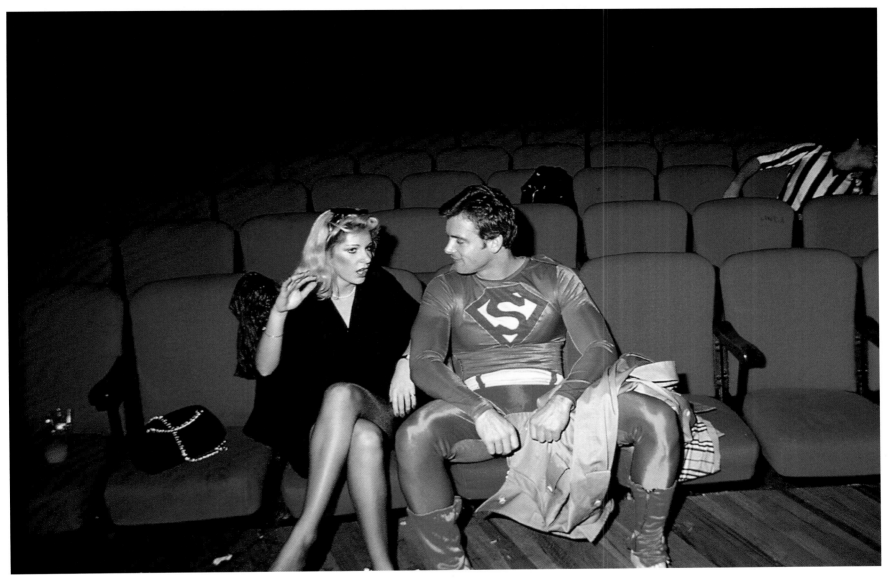

JEFF JACOBSON Halloween Party, New York City, 1982

This photograph provides a demonstration of what is called the inverse square law. Understanding it will help you use your flash more effectively.

As light travels farther from a light source, its rays spread out, cover a wider area, and lose brightness. Notice how the seats in the photograph above received less light the farther they were from the camera's flash. The level of light drops rapidly as the distance increases between the light source and the subject. At twice a given distance from a light source, an object receives only one-fourth the illumination.

Direct flash correctly exposes subjects at only one specific distance, as shown above with Superman and his friend. Here the photographer chose a lens aperture (f/8) to correctly expose Superman. If he had chosen a larger aperture (f/4), the man in the third row would have been better exposed, but Superman would have received too much light and been overexposed.

The inverse square law explains why the first row of seats is brightly lit while the ones behind grow darker and darker: Intensity of illumination is inversely proportional to the square of the distance from light to subject.

5 ft 10 ft

At 5 feet from the flash, the light fully illuminates the square. At 10 feet from the flash, the light spreads across 4 times the original area. Any given square at 10 feet receives only 1/4 the light received by the original square.

Manually controlled flash units emit a fixed amount of light. Exposure is controlled by the photographer adjusting the size of the lens aperture; the greater the distance from flash to subject, the weaker the illumination that reaches the subject and the larger the lens aperture needs to be. The correct lens f-stop can be determined either by using a flash meter or by calculating the f-stop based on the power of the flash and the distance to the subject.

Before using your manual flash unit for anything important, test it with a good flash meter or make some practice shots. Many flash units are not actually as powerful as their guide numbers or calculator dials suggest.

Studio photographers and other professionals often use a flash meter. It is similar to an ordinary handheld exposure meter but is designed to read the brief, intense burst of light from flash, which ordinary exposure meters cannot. A flash meter simplifies exposure calculations with multiple-light setups, with bounce flash, flash used as fill with natural light, or if cumulative firings are used to build an exposure.

USING A FLASH UNIT'S CALCULATOR DIAL

Your flash can help you calculate a manual flash exposure. (Each model looks different, but the underlying principles are the same.) The dial will tell you what lens f-stop to use for a given ISO speed and flash-to-subject distance.

1. Set the flash to manual.

2. Set your camera to a shutter speed that will synchronize with flash. The maximum sync speed may be marked on the camera in red or with a lightning bolt. On the dial shown at left, for example, all speeds at or below 1/125 sec will sync with flash. Check your camera's manual. (See pages 247–248 for more on using flash at different shutter speeds.)

3. Set the flash calculator dial to the film or sensor speed you are using (in the dial shown at right, ISO 100).

4. Find the distance from flash to subject (here, 15 feet). Estimate the distance or focus on the subject and read the distance on the lens's distance scale.

5. Set your lens to the f-stop that is opposite that distance on the flash unit's calculator dial (here, f/5.6).

- Lens f-stop
- Distance to subject
- ISO speed

MANUAL EXPOSURES FOR BOUNCE FLASH

Bounce flash travels an extra distance. The flash-to-subject distance is measured from the flash to the reflecting surface to the subject, not straight from flash to subject.

1-3. See steps 1–3, above.

4. Estimate the distance from the flash to the reflecting surface to the subject.

5. Find the aperture that is opposite that distance on the calculator dial. On the dial above, right, if the distance is 10 ft, the aperture would be f/8.

6. Open the lens a bit more to allow for light absorbed by the reflecting surface. If the light is bounced from a low white ceiling, a nearby white wall, or an umbrella reflector, select a lens aperture at least one and a half stops wider (between f/4 and f/5.6, in this example). Set your lens accordingly. Bracket your exposures to be safe.

 Avoid dark or high ceilings. Bounce flash won't work well in gyms or auditoriums, for example.

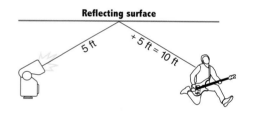

Reflecting surface

5 ft

+ 5 ft = 10 ft

USING A FLASH METER

A flash meter is the most accurate way to work with manual flash, including bounce flash.

1. Set the meter to the ISO speed you are using, 80 in this example. Set your camera's shutter speed to one that will synchronize with flash (see above).

2. This flash meter operates like an incident meter. It measures the light emitted by the flash that is falling on the subject. Position the flash meter just in front of the subject, and point it toward the camera.

3. Activate the meter, set its mode for "non-cord" use, then press the manual button on the flash to fire it. The readout on the meter will show the lens f-stop to use.

4. You can also use a sync cord to connect the camera to the flash. Disconnect the sync cord from the camera and connect it to the meter's PC socket. Set the "cord" mode. Fire the flash with the meter's trigger button. The meter's readout will indicate the correct lens f-stop. Set the f-stop on the lens and reconnect the cord to the camera.

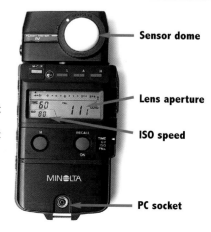

- Sensor dome
- Lens aperture
- ISO speed
- PC socket

AUTOMATIC EXPOSURE
Sensor on flash meters light reflected from the subject

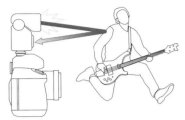

An automatic flash controls exposure with a sensor on the flash unit. It measures the light reflected from the subject during the exposure and cuts off the flash when the exposure is correct.

The flash will have a calculator dial or other readout giving a choice of distance ranges and matching lens f-stops. You can move closer to or farther from the subject, as long as your lens is set to a suggested f-stop and you are within the distance range for that f-stop.

Automatic models vary in design and operation, so check the manufacturer's instruction book for your model.

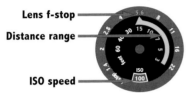

Lens f-stop

Distance range

ISO speed

1. Set the calculator dial to the film or sensor speed you are using (ISO 100 is shown here).

2. Select the distance range within which you will shoot. On the dial above, you can shoot anywhere between 3–15 feet from the subject.

3. Set the camera for manual operation, and the lens to the recommended f-stop for the selected distance range. Here, f/5.6.

The range of distances is often color coded. If your distance range is in yellow, for example, you may have to input yellow on a separate dial on the flash.

4. Set the camera's shutter to a speed that will synchronize with the flash. The usable speed or speeds may be marked on the camera in red or with a lightning bolt.

5. Trigger the unit's test button (see your manual). If an indicator light comes on, the scene will receive enough light for a correct exposure.

6. Compose the picture and push the shutter-release button.

Automatic flash units and automatic through-the-lens (TTL) flash/camera systems react to the amount of light reflected back from the subject during the exposure. After the flash is triggered, light striking the subject reflects back to a light-sensitive cell or sensor (called a thyristor) in the flash unit or camera. When the sensor receives enough light, it cuts off the flash.

These units let you move closer to or farther from your subject without changing the f-stop, as long as you stay within a certain distance range. (This distance range can be found on calculator dials on some flash models. If not, refer to your manual.)

Dedicated flash units are designed to be used with a particular camera. They usually offer features such as balancing the amount of flash to that of the existing light on the scene, for fill-flash use. A more sophisticated version utilizes multiple sensors to meter and compare the light on different parts of the scene, so that you are more likely to get a correct exposure even if, for example, the subject is not in the center of the frame.

When doesn't automatic or TTL flash work well? Unless you have a multiple-sensor unit, the subject may be underexposed and too dark if it does not fill enough of the center of the frame and is close to a much lighter background, such as a white wall. The subject may be overexposed and too light if it is against a much darker background, such as outdoors at night. Set the exposure manually for such scenes, or bracket your exposures by making an initial exposure, then others with less and more exposure.

Bounce flash presents a special situation. The flash is not pointed at the subject, but at a wall or other reflective surface. If the sensor is also pointed at the wall, an incorrect reading of the light will be made. Some automatic flash units solve this problem with a sensor that remains pointed at the subject even though the flash head is swiveled to the side or above. These units, as well as TTL systems, will calculate a bounce flash exposure correctly because the sensors read the same light received by the camera. Without such equipment, you must calculate the exposure manually.

AUTOMATIC TTL EXPOSURE
Sensor in camera meters light reflected from the subject

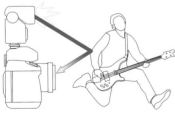

A camera that automatically controls flash exposure through the lens (TTL) measures the light reflected from the subject using a sensor (or sensors) in the camera and cuts off the flash when the exposure is correct.

These systems let you use any f-stop on a lens, instead of having to use a designated one. They can compare the light from the flash with the existing light on the scene and combine the two.

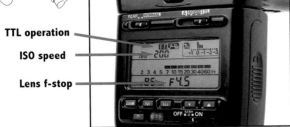

TTL operation

ISO speed

Lens f-stop

1. Set your flash to TTL operation. The camera will automatically set the ISO speed.

2. Set the camera's exposure mode (shutter or aperture priority or programmed automatic).

3. Select any f-stop on your lens.

4. Set the camera's shutter to a speed that will synchronize with flash. Some camera/flash systems will prevent you from using a shutter speed faster than sync speed. Depending on your camera/flash system and how you set the camera, you can make the flash the dominant light on the subject, balance the existing light evenly with the flash light, or let the existing light dominate with the flash providing fill light.

5. Trigger the unit's test button to confirm that the exposure is correct. If an indicator light does not come on, use a wider f-stop.

6. Compose the picture and push the shutter-release button.

Lighting with Flash

Fill Flash: To Lighten Shadows

Flash can be used as a fill light. A sunny day is a pleasant time to photograph, but direct sunlight does not provide the most flattering light for portraits. Facing someone directly into the sun will light the face overall but often causes the person to squint. Turning someone away from the light can put too much of the face in dark shadow.

Flash used as an addition to the basic exposure can open up dark shadows so they show detail (right, top). It is better not to overpower the sunlight with the flash, but to add just enough so that the shadows are still somewhat darker than the highlights—for portraits, about one or two stops.

Flash can increase the light on a fully shaded subject that is against a brighter background, in much the same way as it is used to lighten shadows on a partly shaded subject (right, bottom). Without flash, the photographer could have gotten a good exposure for the brighter part of the scene or for the shaded part, but not for both. Using flash reduced the difference in brightness between the two areas. The same technique works with backlit subjects indoors.

Color slide film and digital photographs particularly benefit from using flash for fill light. Transparencies are made directly from the film in the camera, so it is not easy to lighten shadows, especially when they are very deep. Even with color negative film or digital cameras that can capture detail in darker areas, shadow tones will often look better with a little fill light added during exposure than if you wait until you are adjusting the image for printing.

There are other uses for flash plus available light. Flash used outdoors during the day is usually simply a means to lighten shadows so they won't be overly dark. But you can also combine flash with existing light for more unusual results (see pages 248–249 and 257).

Sunlit subject, no fill. *Shadows can be very dark in a sunlit scene, so dark that you can't record details in both the shadows and brightly lit areas.*

Sunlit subject with flash fill. *For portraits or for close-ups, such as flowers in nature, fill light will lighten the shadows and preserve details.*

Exposed for shaded foreground, no flash. *Flash is useful to lighten a nearby, fully shaded subject that is against a much lighter background. Simply exposing the foreground correctly makes the background too light.*

Exposed for sunlit background, no flash. *Exposing the background correctly makes the darker foreground too dark.*

Exposed for sunlit background, flash lightens shaded foreground. *By adding flash fill you can get a good exposure for both the shaded foreground and lighter background.*

Shaded subject against bright background, no fill. Shadows can be very dark in a sunlit scene, so dark that film will not record details in both the shadows and brightly lit areas.

Shaded subject with flash fill 2 stops less than the background. The flash lightens the shaded subject somewhat.

Shaded subject with flash fill 1 stop less than the background. The lightened shadows provide an image closer to how the eye might perceive the scene.

Shaded subject with flash fill equal to the background. The subject and sky are now of equal brightness. Depending on the scene, this may make the subject seem a little too light.

FLASH PLUS AVAILABLE LIGHT

You can use flash outdoors during the day to lighten shaded areas (see illustrations, opposite). You can also use this technique indoors when you want to include an area much brighter than the existing light on the subject, such as a view outside a window.

You will need to balance the effect of the light from the flash (determined by your f-stop, the distance to the subject, and the flash output) with the effect of the existing light on the subject (determined by your f-stop and shutter speed). Some basic instructions follow, but see your flash manufacturer's instruction book for details about your unit.
TIP: Small flash units are not powerful enough to balance with bright sunlight except when used relatively close to the subject, at about 5 to 10 ft.

Automatic operation. If your camera meters light from flash through the lens (TTL), it can also measure the existing light and automatically provide the correct illumination from the flash (see page 245). Depending on the particular combination of flash and camera, you may be able to select the balance of light, for example, having the areas lit by the flash about as bright as those areas that are sunlit, or having the flash lighten the shadows slightly, but not have them as bright as the rest of the scene.

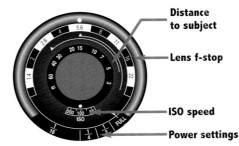

Distance to subject
Lens f-stop
ISO speed
Power settings

Manual operation. If your camera does not meter flash through the lens, make the camera/flash settings manually, as described here. You will need a camera and flash that can be set for manual operation, plus a flash that has a calculator dial something like the one shown here or a chart of recommended settings. These instructions assume your flash is located on or close to your camera.

First, find the settings for a flash exposure.
1. Set your camera and flash unit to manual operation.

2. Set the ISO speed on your camera and on your flash unit's calculator dial. For this example, ISO 100.

3. Focus on your subject. Read the distance to your subject from your lens's distance scale. Here, 5 ft.

4. On your flash calculator dial, find the number that is opposite the distance to your subject. Here it is 16 or f/16. This will give you the correct lens f-stop to use for a flash exposure.

Now, find the settings for an available-light exposure.
5. Meter the existing light on your subject using the camera's built-in meter or a hand-held meter. Find the correct shutter speed to use in combination with the f-stop determined in Step 4. Set your camera accordingly. (Does your camera synchronize with flash at this shutter speed? See NOTE below.)

6. The combination of f-stop and shutter speed set in Step 5 will make the shaded (flash-lit) areas about as light as the areas lit by existing light. Suppose you want the flash-filled shadows one stop darker than those lit by existing light. Here's how to do it.

How to balance flash and existing light.
7. **If your flash has adjustable power settings.**
Note the power setting that your flash unit's calculator dial indicates (such as full power, 1/2 power, 1/4 power). If you want the flash-filled shadows one stop darker than areas lit by existing light, set the flash to the next lower power setting (for example, from full power to 1/2 power).

If your flash does NOT have adjustable power settings. If you want to decrease the intensity of light from the flash so that flash-filled shadows are somewhat darker than areas lit by existing light, drape one or two layers of white handkerchief or facial tissue over the unit.

8. You can change the aperture to be one stop smaller and the shutter speed to be one stop slower. This keeps the exposure from the existing light exactly the same, but reduces the exposure from flash by one stop.

9. You can also step back from your subject to decrease the amount of light reaching the subject, although this will also change the framing of the scene. To create a one-stop difference between lit and shaded areas, multiply the original distance by 1.4. For example, if you had been 5 ft from the subject, step back to 7 ft.

NOTE: Whatever your settings, your shutter speed must be no faster than the flash sync speed for your camera. If your f-stop/shutter speed combination is f/16 at 1/250 sec, but your camera synchronizes with flash no faster than 1/125 sec, increase the light from your flash so you can use an equivalent exposure of f/22 (one stop smaller aperture) at 1/125 sec (one stop slower shutter speed).

You can increase the light from the flash either by increasing the power output or by moving the flash closer to your subject. To move close enough to increase the light from the flash by one stop, divide the distance to the subject by 1.4, then move the flash to the new distance.

Some newer dedicated flash units can be used for fill at shutter speeds higher than the sync speed, but only when used with a matching SLR.

Lighting with Flash continued
Controlling Background Brightness

You can use flash plus existing light to make the background lighter or darker. In the photographs at right, shot at dusk in relatively dim light, notice how the faster the shutter speed, the darker the background became. The motion of the jumping guitar player also changed; the slower the shutter speed, the lighter the background and the more the movement blurred. The output of the flash stayed the same, as did the lens aperture. Only the shutter speed was changed, which changed the length of time that existing light reached the film.

HOW TO CONTROL BACKGROUND BRIGHTNESS

Changing the shutter speed when using flash will let you vary the lightness of the background. A foreground subject will be consistently exposed until the shutter speed becomes very slow.

1. Set your camera and flash for manual operation.

2. Determine the correct flash exposure for your subject. Use your flash unit's calculator dial or a flash meter to find the lens f-stop to use (see page 244). Set your lens accordingly.

3. Now find the exposure for the scene without flash. Use a hand-held exposure meter or one built into your camera to meter the background. Using the f-stop from Step 2, find the shutter speed that, when used with the f-stop you have set, will correctly expose the lightest part of the background in which you want full detail. This combination matches the exposure of the subject (with flash) to that of the background (without flash). See the photograph center top, labeled "Start."

4. Make one or more exposures at that combination of f-stop and shutter speed. Then make some exposures at the same f-stop, but at different shutter speeds. You can shoot at a faster shutter speed (which will darken the background) as long as the speed still synchronizes with flash. A slower shutter speed will lighten the entire scene, perhaps too much, as in the photograph far right, bottom. **TIP:** Use a tripod. At slow shutter speeds, camera motion may blur the entire scene. A tripod will prevent this.

If you shoot in color indoors with this technique, the color of the existing light can affect the color balance in parts of the photograph at longer exposures. Light from a flash is relatively bluish, like daylight, while tungsten bulbs are reddish, fluorescent bulbs greenish. Parts of the scene closer to the flash will be cooler, or more bluish.

Outdoor photographs can exhibit a similar mismatch very early and very late in the day when the light is more reddish. See the photograph on the opposite page, bottom, in which the subject is in cool light from the flash that contrasts with the warm background.

EXISTING LIGHT DECREASED; FLASH STAYS THE SAME

1/60 sec at f/5.6
At a shutter speed faster than 1/30 sec, the background is somewhat darker.

1/125 sec at f/5.6
The flash is the dominant light, but the shutter speed lets in enough existing light to maintain some background detail.

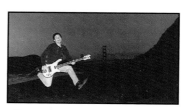

1/250 sec at f/5.6
The flash is the dominant light. The subject is correctly exposed, but the background is dark because there is not enough existing light to illuminate it at this exposure. This is the typical look of a flash exposure outdoors in dim light or indoors in a large room. The brief burst of light from the flash froze the subject in mid-air. This is the fastest shutter speed at which this particular camera syncs with flash.

1/500 sec. at f/5.6
The shutter speed is too fast to synchronize with flash. The shutter curtain was only about half open when the flash fired, so only half the picture was exposed.

START: FLASH EXPOSURE MATCHES EXISTING LIGHT

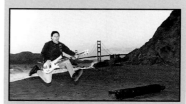

1/30 sec at f/5.6
In this series, this picture was the starting point: the combination of correct flash exposure plus a standard exposure for the scene overall. The existing light has built up enough exposure to make the fast-moving parts of the subject very slightly blurred.

EXISTING LIGHT INCREASED; FLASH STAYS THE SAME

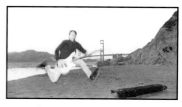

1/15 sec at f/5.6
The moving subject now produces two images, a sharp one frozen by the electronic flash, and a blurred one from the available light. The flash lights up for a brief moment, freezing the subject at that instant. However, the shutter remains open for a relatively long time, which lets the existing light show the subject's continuing motion. The ghost image from the existing light is noticeable only when the subject is moving, as it is here. When the subject is stationary, the flash and existing-light images will exactly overlap.

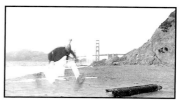

1/8 sec at f/5.6
As the slow shutter speed slows further, the available light begins to overpower both the background and the flash-lit subject. The subject is quite blurred, and the photograph is overexposed.

1/4 sec at f/5.6
The slow shutter speed now considerably overexposes the entire picture, overpowering the image produced by the flash.

RINEKE DIJKSTRA Coney Island, N.Y., USA, June 20, 1993 ▶

The photographer added a little fill flash to isolate her subject from the minimal background. Dijkstra often photographs people whose lives seem in transition. Here the subject is marked by a self-consciousness that parallels the uneasy passage between childhood and adulthood.

KIM HEACOX King Penguins at Dawn, South Georgia Island

For this kind of scene, make two exposure calculations—one for the light cast by the flash, the other for the sunrise. Determine the correct flash exposure for the nearest penguin; set the lens f-stop accordingly. Then make a reflected-light reading of the horizon to find the correct shutter speed to use in combination with the f-stop you have set.

The exposure for the nearest penguin matches that for the sky, so they are both normally exposed. Light from the flash did not expose the farther penguins as much, which made them darker.

You don't need a complicated lighting arrangement for portraits—or many other subjects. In fact, often the simpler the lighting, the better. Many photographers prefer to keep portrait setups as simple as possible so the subject is relaxed. Lights, tripods, and other paraphernalia can make some subjects overly conscious of the fact that they are being photographed, resulting in a stiff, awkward expression.

Outdoors, open shade or an overcast sky provides a soft, even light (photograph opposite, right). The people are not lit by direct sunlight, but by light reflected from the ground, from clouds, or from nearby surfaces such as a wall. Open shade or overcast light is relatively bluish, so if you are shooting color film, a 1A (skylight) or 81A (light yellow) filter on the camera lens will warm the color of the light by removing excess blue.

Indoors, window light is a convenient source of light during the day (photograph this page). Contrast between lit and shaded areas will be very high if direct sunlight falls on the subject, so generally it is best to have the subject lit only by indirect light bouncing into the room. Even so, a single window can be a contrasty source of light, causing those parts of the subject facing away from the window to appear dark.

A main light plus reflector fill is the simplest setup if you want to arrange the lighting yourself (photograph opposite, left). Bouncing the light into an umbrella reflector, rather than lighting the subject directly, softens the light, makes it easier to control, and may even eliminate the need for fill.

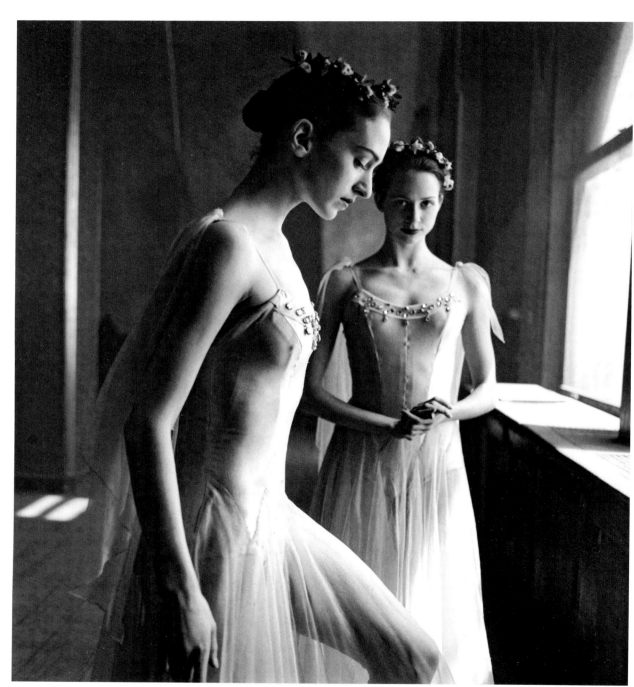

RODNEY SMITH Deanna and Eva #1, New York City, 1999

Window light can be quite contrasty, so keep an eye on the amount of contrast between lit and shaded areas. A reflector opposite the window can bounce fill light onto the side of the subject away from the window. Sometimes a nearby light-colored wall can do the same.

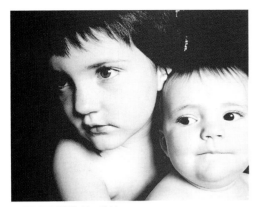

JANET DELANEY Two Children

A single main light—photoflood or flash—bounced into an umbrella reflector, with reflector on the other side, is a simple lighting setup indoors. The position commonly used for a portrait main light is about 45° to one side and 45° above the subject.

FAZAL SHEIKH Rachel and Ochol, Sudanese Refugee Camp, Lokichoggio, Kenya, 1992

In open shade outdoors, light bounces onto the subject from different directions. A wall, tree, or other object can block the direct rays of the sun. In this case, an overcast sky diffused the light, providing soft, even illumination.

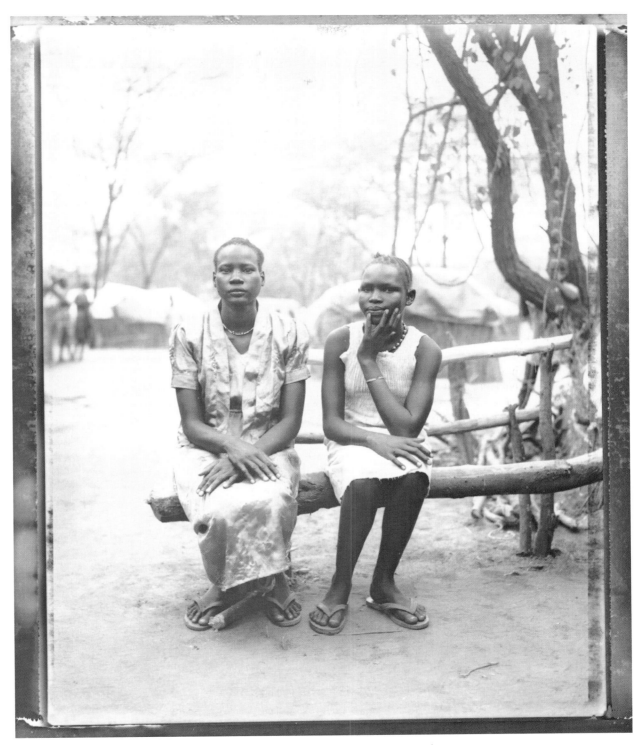

Multiple-Light Portrait Setups

Conventional portrait lighting is realistic but flattering. If you have ever gone to a commercial portrait studio to have your picture made, the photographer may have arranged the lights somewhat as in the diagrams shown to the right. These lighting setups model most faces in a pleasing manner and can be used to modify some features—for example, using broad lighting to widen a thin face.

A typical studio portrait setup uses a moderately long camera lens so that the subject can be placed at least 6 feet from the camera; this avoids the distortion that would be caused by having the camera too close to the subject. The subject's head is often positioned at a slight angle to the camera—turned just enough to hide one ear.

Your choice of main light affects the quality of the light. Direct light from photofloods is shown here, creating relatively hard-edged shadows. A diffused light (such as a soft box or umbrella reflector) used as the main light would create a more gradual transition between highlights and shadows.

Another common portrait lighting style is virtually shadowless. A typical setup is a highly diffused main light placed close to the camera, plus a fill light. Such lighting is soft, attractive, and easy to use. However, when you don't want such even, shadowless lighting, you can use lights to create a more dramatic effect.

Flash units, direct or diffused, can be used, although when you are learning lighting, the effects of different light positions are easier to judge with continuously burning sources such as a photoflood.

TYPES OF LIGHTING SETUPS

SHORT LIGHTING

Short lighting places the main light on the side of the face away from the camera. Short lighting is the most common lighting, used with average oval faces as well as with round faces to thin them down. The four photographs opposite (top) show the separate effect of each of the four lights in this setup.

BROAD LIGHTING

Broad lighting places the main light on the side of the face toward the camera. This tends to widen the features, so it is used mainly with thin or narrow faces. The main light is high so that the catchlight reflected in the eye is at 1 o'clock. The main light in this position may make the side of the head, often the ear, too bright. A barn door on the light or a flag (see page 234) will shade the ear.

BUTTERFLY LIGHTING

Butterfly lighting places the main light directly in front of the face. This type of lighting is sometimes called glamour lighting. The light is positioned high enough to create a symmetrical shadow under the nose but not so high that the upper lip or the eye sockets are excessively shadowed. Fashion photographers often use a variation called beauty lighting, where the main light is large—like an umbrella—and just above the camera.

SETTING UP THE LIGHTS FOR SHORT LIGHTING

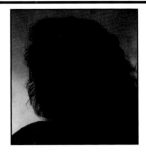

The main light in a short lighting setup is on the side of the face away from the camera. Here a 500-watt photoflood is placed at a 45° angle at a distance of about 4 feet. The main light is positioned high, with the catch-light, the reflection of the light source in the eyes, at 11 o'clock.

The fill light is close to the camera lens on the opposite side from the main light. Here it is a diffused 500-watt photoflood. Since it is farther away than the main light, it lightens but does not eliminate the shadows from the main light. Catchlights from the fill are usually retouched out of the final image.

The accent or back light is usually a spotlight placed high behind the subject, shining toward the camera but not into the lens. It rakes across the hair to emphasize texture and bring out sheen. Sometimes a second accent light is added to place an edge highlight on hair or clothing.

The background light helps separate the subject from the background. Here it is a small photoflood on a short stand placed behind the subject and to one side. It can be placed directly behind the subject if the fixture itself is not visible in the picture.

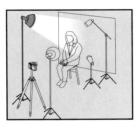

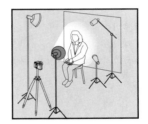

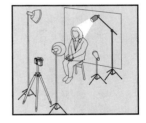

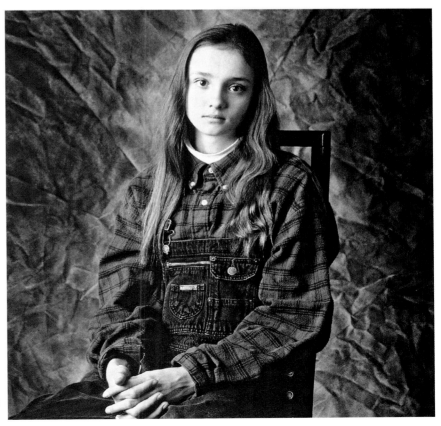

JAN OSWALD

Notice the effect of the background light in this portrait, putting a gentle halo around the girl.

Lighting Textured Objects

Lighting for a textured object depends on whether you want to emphasize the texture. In the photograph at right, top, the light is raking across the scene at a low angle to the surface, creating shadows that underline every bump and ripple. The same principle can be put to work with any textured object, such as rocks, textured fabrics, or facial wrinkles. Simply aim a source of direct light so it skims across the surface, choose a time of day when the sun is at a low angle in relation to the object, or arrange the object so light strikes it from the desired direction.

Shadows must be seen if the texture is to be prominent, which is why side or back lighting is used when a pronounced texture is desired—the shadows cast will be visible from camera position. Front lighting (also called axis lighting) minimizes textures. The light points at the subject from the same direction as the lens, so shadows are produced, but they won't be very visible from camera position (photograph, right, bottom). If you want to minimize textures in a portrait because your subject is self-conscious about facial wrinkles, place the main light close to the lens so the subject is lit from the front.

Side lighting emphasizes texture.
The light skims across the subject's surface at a low angle, producing shadows on the subject's surface that are visible from camera position.

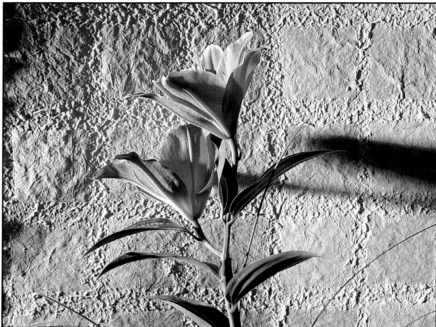

Front lighting minimizes texture.
The light comes from camera position, producing few of the visible shadows that delineate texture.

Tenting removes unwanted reflections from glossy surfaces by replacing them with larger reflections of the tent itself. The cornet (left) was so shiny that it reflected images of the camera and lights that the photographer needed to shoot it. To solve the problem, Fil Hunter isolated the horn inside a light tent (see drawing, above).

The horn and its background are evenly and diffusely lit by two lights shining through the thin material of the tent, which itself makes a pleasing and simple pattern of reflections in the horn's shiny surfaces. The camera, looking in through the opening in the tent from the shadows outside, stays out of the picture, as do other potentially distracting reflections.

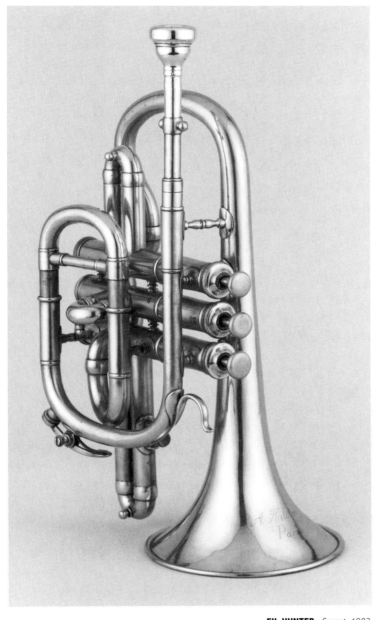

FIL HUNTER Cornet, 1982

Photographing objects with glossy surfaces can be like photographing a mirror. Highly polished materials such as metal, ceramic, or plastic can reflect every detail of their surroundings, a distracting trait when the surroundings include such irrelevant items as lights, photographer, and camera. Sometimes reflections work well in a photograph, making interesting patterns or giving information about the surface quality, but often it is necessary to eliminate at least some of them.

Reflections can be controlled in various ways. To some extent this can be done by moving your equipment or the object around until reflections are no longer distracting. You can also hang strips of paper or pieces of foil-covered cardboard just outside the picture area to place reflections where you want them. A special dulling spray available in art supply stores can reduce reflections, but use it sparingly to avoid giving the surface a flat, lifeless look.

A polarizing filter will help if the reflections are not on a metallic surface. Sometimes polarizing screens are used on the lights as well.

Tenting an object surrounds it partially or completely with plain surfaces like large sheets of translucent paper that are then lit to produce soft, diffused reflections (shown at left).

Using a camera that views through the lens is the best way to keep track of reflections. Even a slight change in the angle at which you view a shiny object can change the pattern of visible reflections.

Try lighting translucent or partially transparent objects from behind—glassware, ice, thin fabrics, leaves and flowers, for example. The light can seem to shine from within, giving the object a depth and luminosity that could not be achieved with flat frontal lighting. If you illuminate the background (as in the lighting setup below) instead of shining the light directly on the object, the lighting will be soft and diffused.

If you want a darker background, place the light below the object. Often glasses and bottles are placed over a hole cut in the supporting surface so a light from below illuminates only the object above it. Glassware is almost always lighted from behind or below since frontal illumination usually causes distracting reflections.

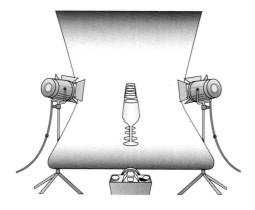

ERICH HARTMANN Crystal Glassware

Lighting translucent objects from behind adds visual interest. A row of crystal glasses (right) is softly lighted from the back by two large spotlights whose joined beams bounce off a sheet of seamless white paper, as shown above. The shadow that surrounds the bases of the glassware provides contrast with the brilliance of the reflected light and lends an air of cool elegance to the photograph.

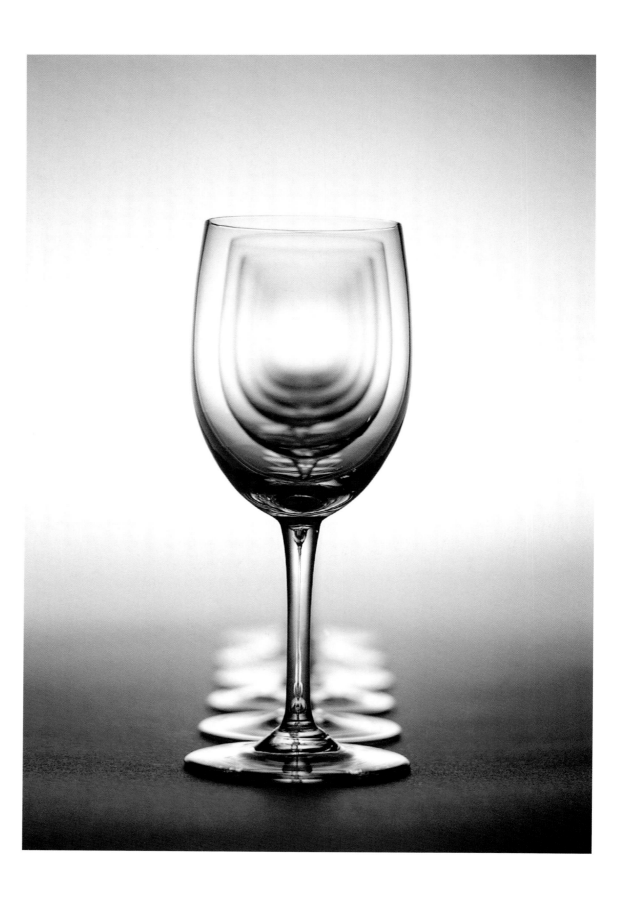

GREGORY HEISLER Low Riders, Santa Ana, California, 1979

Electronic flash and available light combined to make this glossy portrait of two people and their 1947 Fleetline Chevrolet. Gregory Heisler made the picture in dim light at dusk. While the car slowly backed up, Heisler set off two battery-powered flash units, then left the shutter open for 2 sec more. The image is sharp where the car and riders were lit by the flash; the image is streaked and blurred where available light provided the illumination, as on the front fender and in the reflections in the chrome strips.

Some flash units feature rear-curtain synchronization, which fires the flash just before the shutter closes instead of when it opens. Any blurred exposure from existing light will extend to the sharp flash exposure, giving the impression of motion.

photographer at WORK

Dance Photographer Lois Greenfield

"The root of my interest is movement," says dance photographer Lois Greenfield, "or rather how movement can be interpreted photographically. And dance provides a perfect opportunity for this. You might say that dance is my landscape." In Greenfield's landscape, dancers dispense with gravity as they walk on air, hang in space, and intersect the image frame and each other in improbable movement. No tricks are involved: no wires holding up the dancers, no unusual point of view making it look as if the dancers are in the air when they are not, no composite of dancers assembled from different shots.

Greenfield approaches her work differently from conventional dance photographers who often have the choreographer arrange a pose for them or who simply capture the peak moment of a movement. She says of her earlier work, "People would look at one of my pictures of Baryshnikov in a spectacular leap ten feet off the ground and say, 'What a great photograph!' But I knew that it wasn't; it was merely a great dance moment competently captured." Her dissatisfaction with merely recording dance choreography led her to explore other ways of working with dancers. She quotes a Duane Michals comment she heard at a lecture as part of her inspiration: "I want to create something that would not have existed without me."

She began collaborating with dancers David Parsons and Daniel Ezralow, encouraging them to see how their bodies moved, independent of the choreography they had been trained to perform. That left the dancers free to soar, leap, lunge, and fall, and Greenfield free to explore her personal vision. Each already had an active career, but when they got together, Greenfield says, something new happened. It felt, "as if we were toys which came to life when the toymaker went to sleep. At night the toys played!"

Recording motion sharply is vital to Greenfield's stop-action photography. She uses a Broncolor Grafit A2 electronic flash because she can adjust it to a very short flash duration for the crispest possible image. She began with a 35mm single-lens reflex camera, but switched to a medium-format single-lens reflex Hasselblad that she now uses with a digital back. That camera synchronizes with flash at a faster shutter speed than most 35mm cameras, so she is less likely to have problems with existing light registering on the image and causing blurred motion.

When she switched cameras, she discovered a bonus: the square format improved the composition by giving equal emphasis to all sides of the image; she prefers it to the standard horizontal frame that seems to replicate ordinary vision. Unlike a rectangular format, dancers could no longer fit next to each other in the same way within the frame, which inspired her to place them in unconventional arrangements.

Greenfield's dancers are sharply photographed, but not simply frozen in time. Questions about the past and future enter the pictures, too. "Because of the seeming impossibility of what my dancers are doing, you can't help asking yourself, 'Where are they coming from? Where are they going?' Or even, 'How are they going to land in one piece?'"

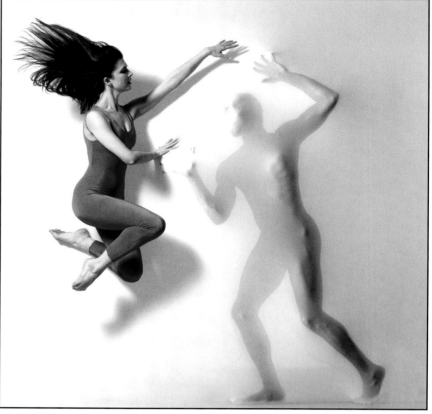

LOIS GREENFIELD Sierra Ring and Dartanion A. Reed, ASEID Dance Company, 2006

LOIS GREENFIELD
Self Portrait with Daniel Ezralow and David Parsons, 1985

Lois Greenfield thinks of the dancers she photographs as her collaborators, not just as performers who are demonstrating choreographed moments from a particular dance. One of Greenfield's collaborators, Daniel Ezralow (shown at left), described himself as "a piece of clay which he would throw up in the air to make a different shape each time." "I'm obviously slicing time into very thin fragments," Greenfield says, "Yet I'm really exploding time by allowing the viewer to contemplate the 1/2000 of a second that my strobes afford me."

Of her recent work, in which she often uses props, Greenfield says, "I add elements and props to add psychological drama and transform the identity of the dancer." She feels intrigued by metamorphosis, the changes "from human to animal, or animal to plant, from spirit into matter and matter giving way to spirit." In the photograph at right, she "wanted the image of the dancer to appear the way a viewer would see sand pouring through an hourglass."

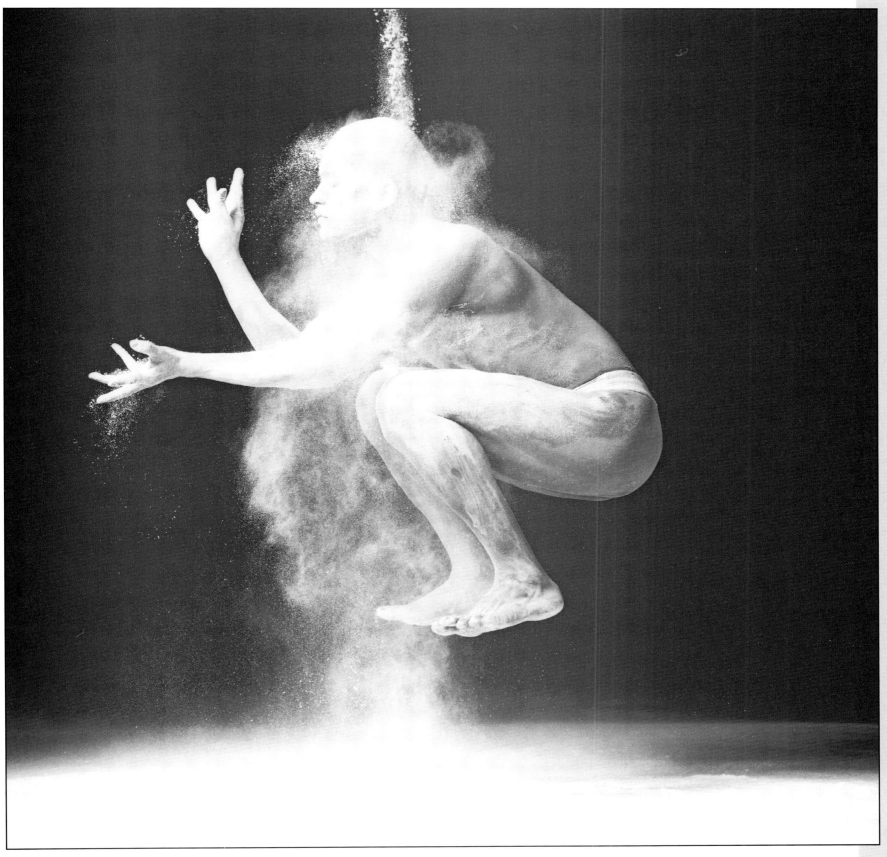

BERND AND HILLA BECHER Framework Houses, 2001

The Bechers photographed many examples of the same type of subject—water towers, blast furnaces, gas tanks, or framework houses—approaching each example in the same way. Camera, film, and development are the same for each photograph, and so is the framing, lighting, perspective, and distance. When seen as a group, a grid of prints (as above) on a wall or two hundred in a book, the effect of such precision is to draw the viewer into noticing the subtle differences between one structure and the next, and to begin to question—among objects built for the same use—the cause of those differences.

extending the image

This chapter shows some of the ways to expand your thinking about the way photographs can present an idea. You can manipulate a photograph and radically change the image formed in the camera (or make a print entirely without a camera) in order to make a print that is more interesting or exciting to you, to express a personal viewpoint that could not be conveyed by conventional methods, or just to see what an image will look like in a different form.

The main pitfall in manipulating an image or a group of images is doing it merely for the sake of change. You need to experiment with special techniques to see what they do and what their potential is with your own photographs. Once you have gained experience with various techniques, it's important first to have an idea about what you want to communicate, then use special techniques, if desired, to strengthen an image, solve a problem, or communicate a visual idea more clearly.

The size of an image, its scale, affects the response viewers will have to it, whether it is displayed on a computer's monitor, projected on a screen, or printed. The size of an image, sometimes referred to as its scale, has a lot to do with the response it will elicit in a viewer.

Any photographic image can be made in a variety of sizes, from the microscopic to the mammoth. Tiny computer chips have internal circuitry—visible only under a microscope—that is printed photographically, and giant pictures on roadside billboards are photographically produced. The options for investigating scale are broad and it is your choice. You may not want your photographs quite that small or that large, but you don't have to accept 8 x 10 or 8 1/2 x 11-inch prints without at least considering the possibilities.

Large images can be powerful. People naturally hold larger photographs at arm's length or step back from large pieces on the wall, unconsciously adjusting their viewing distance. When looking at a picture we naturally try to keep the viewing angle consistent regardless of scale. But even after finding a comfortable viewing distance there is still a feeling with large work that more is more.

Digital images can be printed as large as the printer allows. If you don't have immediate access to wide-format printing equipment, you can find a nearby service bureau or sign shop that will make prints for you up to about five feet wide. A web search will turn up shops that can print for you even larger—up to 16 feet wide—using inkjet printers called grand format.

Large images can be assembled from small ones. An image with a commanding presence on a wall can be made up of elements that you can print yourself with modest equipment. The very large piece shown above, right, was assembled from 42 color prints—each of a size that required no access to equipment beyond a conventional color darkroom. The image on page 265 (bottom) was constructed from 120 prints about the size of index cards. The individual photographs could have been made by any one-hour photo lab or department-store photo kiosk.

BOHNCHANG KOO Good-bye Paradise (Blue Series), 1993 (above left) and a detail of one panel (left)

Koo assembled many individual images into a gallery display that measured about 20 x 28 feet overall. He wanted to "express the world, like a midnight sky, of dead animals' spirits," Koo made photograms by contact printing through the pages of a book of animal drawings, using additional colored light to make the splashes of red, suggesting blood. The contact prints superimpose both sides of the printed page. He then rephotographed the small prints, making negatives he could enlarge on color photographic paper to the final size of 40 x 48 inches for each individual image.

Small photographs are intimate. Very large work announces its presence forcefully; it is imposing and grand. But small works are subtle. Beginning with the relatively small daguerreotype, (page 347) photography could lay claim to being the jewel of the graphic arts. Even after enlarging became commonplace, many photographers preferred to make and exhibit contact prints no larger than 5 x 7 inches.

Mount a small print to see. Presentation has a lot to do with the way you will feel about an image. A small snapshot from the one-hour lab will look right at home stuck to the refrigerator with a magnet. But the same photograph presented in a mat and frame demands to be taken seriously.

Small objects focus the attention. The good news is that the care you take in making and presenting a piece will be noticed; the bad news is that any defects will seem larger. Small work demands care and precision.

TODD WALKER Pages from *Eighteen by Shakespeare and Walker*, 1992

Walker made tiny books entirely by hand. He collected printing and bookbinding equipment antiquated by progress, and printed his images using 19th century photo processes that he revived. In this case the photographs were printed by collotype—ink transferred from gelatin-coated glass—after he separated the colors (into CMYK) on a computer with an early version of video editing software.

LEWIS BALTZ Ronde de Nuit, Installation View, Centre George Pompidou, Paris, 1992

Monumental scale is used to address monumental topics. Here, Baltz questions the impact of technology—and its representation—on our future.

Multiple Images
More Is Better

Assembling multiple images can magnify their effect. Photographs naturally gather into groups, becoming a series with a common subject, theme, style, or approach. Arranging photographs as a series is a common way to bring coherence to an exhibition or book.

A sequence is a series intended to be viewed in a particular order. A photographic sequence by Duane Michals appears on page 373. Michals' sequences can be described as cinematic, or narrative, because they tell a story. Minor White (page 85) in the 1960s put his poetic and spiritually-oriented photographs together in sequences that are visually coherent but non-narrative. Once you feel confident that you can consistently make a single, compelling photograph, try a sequence or series. These are good places to start, but they are not the only ways you can assemble your photographs to reinforce an idea.

A diptych is a two-part work of art. In ancient times, a diptych was a two-part tablet, hinged in the middle so it could fold, protecting the writing surfaces. Now it typically refers to a pair of photographs or paintings meant to be seen together (see a diptych by Bart Parker on page 378). Below is a triptych, a three-part photograph, intended to be read as a single image. Like a short sequence, it is important that all the parts are seen together, and the meaning of a diptych or triptych can not be adequately conveyed by seeing only part of the piece.

Time can create a sequence. A photograph is always linked to a particular moment; related moments can be collected to document change. Nicholas Nixon (page 10) has made a portrait of his wife and her three sisters annually since 1975. Karl Baden (opposite page, top) has been photographing himself daily, as identically as possible, since 1987. These photographers confront the passage of time and the aging process that we are powerless to affect.

Multiple images can be assembled to show a view unavailable to our eyes. You can bring together photographs taken in different places—and at different times—to create a new environment. The photocollage on the opposite page, bottom, is made of 120 different views made in sequence. Each reveals a slightly different perspective and the resulting image integrates them all into a surreal but still accurate view. Using stitching software, multiple images can be assembled seamlessly, too (see pages 204 and 205). How do you want to represent time and space?

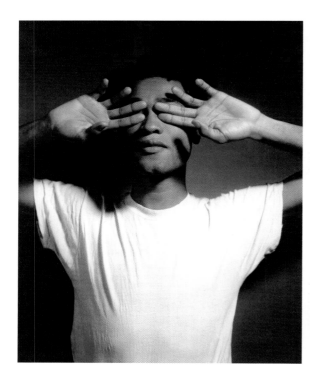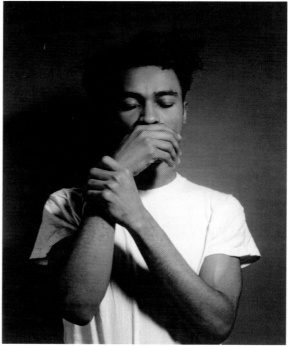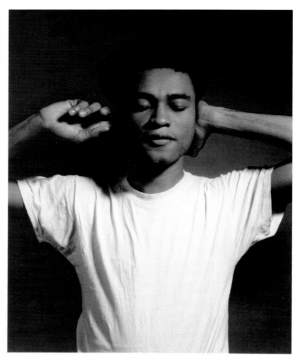

CARRIE MAE WEEMS See, Speak, Hear, 1996

Weems' work addresses issues concerning African-Americans, women, and other themes. "The focus of my work is to describe simply and directly those aspects of American culture in need of deeper illumination."

KARL BADEN Every Day

Baden photographs himself every day in the same way and has done so, he says, "obsessively" since February 1987. He has attempted to "standardize every aspect of the procedure so that only one variable remains: whatever change may occur in my face and flesh for the rest of my life." An installation view of the project is shown at right, below.

3.01.1987

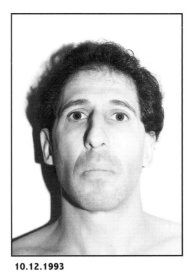

10.12.1993

2.23.2000

9.28.2006

MASUMI HAYASHI West 25th Street Station, RTA, 1993

Dozens of small prints, each taken separately, assemble to represent a personal 360° view. By taking the photographs in sequence, Hayashi presents her own view of both space and time.

You can photograph scenes that could never exist by creating directly from your imagination. There is an idea that all of us share that photography has a connection to the truth. Even the most sophisticated and skeptical observers perceive photographs differently than paintings. Even when we know we can't really believe a photograph, we want to. This natural reaction to photographs is a powerful tool in your hands.

There are no rules for personal expression. Journalists must abide by a set of general ethical principles and—usually—a specific set imposed by an individual publication. If you're not reporting the news, however, you can exert as much control as you'd like over what your photographs look like.

You are already comfortable with certain decisions when you capture an image, choosing subject matter, vantage point, timing, and lighting. You may ask someone to smile for the camera. It's only a short step to hiring, costuming, and posing a model, and creating an entire environment (photograph on opposite page).

The camera sees with one eye. You don't need to be concerned with anything outside its vision. Thomas Demand (photograph at right, top) locks his camera in place as he begins to build his elaborate structures, and refers to its vantage point often during the several months it takes to finish his construction. Like a movie set, nothing out of view needs to be finished.

Perspective can be manipulated. We normally get most of our depth perception from stereoscopic vision, each eye sees a slightly different image. But because a photograph is flat, we perceive depth by using other cues—for example, objects at a distance appear smaller. By creating objects smaller than we would normally see them you can use forced perspective to create a false sense of depth. In the photograph at right, Nagatani (who worked in special effects for several Hollywood movies) created forced perspective by making some of the fish very small.

Look at advertising photographs for ideas. Commercial clients have big budgets and can materialize almost anything.

THOMAS DEMAND Space Simulator, 2003

Demand creates intricate structures in his studio entirely from paper and cardboard that are photographed, then destroyed. Even the light fixtures above are paper. This is a simulation of a simulator; his large prints from 8 x 10 negatives show everything clearly, "the imperfection is the beauty of it." Thomas Demand, "Space Simulator, 2003". 300 x 429, C—Print/Diasec, © Thomas Demand/VG Bild Kunst, Bonn. Courtesy 303 Gallery, New York

PATRICK NAGATANI ANDRÉE TRACEY Great Yellow Father, 1988

Nagatani and Tracey fabricated and assembled every element of this photograph and carried it all into Polaroid's New York studio. This piece is two frames from Polaroid's supersized studio camera that makes instant 20 x 24-inch prints. Hand-made papier-mâché fish are hung from above with fishing line against a painted canvas backdrop. The figure in the lower right and the legs at left are the two artists.

SANDY SKOGLUND Radioactive Cats, 1980

Each cat is a sculpture in clay fabricated by the artist. *She wanted to "undermine the stereotype in our culture of the cute, domesticated pet. The cats are meant to dominate the scene as survivors in a post-nuclear situation because they've adapted by turning green." The piece portrays "the triumph of the animal world that we've manipulated for so long."*

Skoglund often spends months creating every detail of an installation before she photographs it. Neither the installation nor the photograph is the final product by itself. She sees both as intertwined.

The physical qualities of a photograph do not have to be limited to size and texture. Photographs can be affixed to a three dimensional object, like the piece at right. Or you can shape the photograph itself by printing on a surface like plastic that can be distorted or molded.

Adding to or changing the surface of your photograph will differentiate it from those photographs meant to be seen as a window through which you view the world. The photographs on the opposite page, top, have an altered surface that, in the original, present a tactile quality. The cyanotype on page 272 has gold stars affixed to its surface as if it were being rewarded by a proud schoolteacher.

Photographs can be incorporated into larger constructions. In the 1960s, artists expanded the definition of art past the self-contained single object. Installation art considers a location and environment to be an integral part of the work. Photographs are often central to an installation, for example the piece on the opposite page, bottom, and on page 270.

Conventionally presented photographs are objects, too. When you enclose your photograph in a mat and frame, their separate qualities blend together and we perceive a single three-dimensional object. The way several framed photographs are hung can also affect the way they are perceived; are they close together or far apart? Are they all in a line or at different heights?

You may choose to present your photographs as a portfolio to be opened, its contents spread out on a table and handled. Commercially-made portfolio cases and boxes come in a wide variety, or you can make your own. The presentation should suit your purpose as well as the contents; if you are showing tearsheets to a magazine editor, you are likely to want your materials to leave a different impression than when you show finished prints to a museum curator. See pages 342–343.

ROBERT HEINECKEN Figure Cube, 1965

Heinecken pioneered the extension of photography into sculpture and printmaking and, as a teacher, influenced a generation of artists to be free of a traditional—and restrictive—definition of photography's boundaries.

DANA MOORE Crown (far left) and Light (near left), 1995

Moore has altered these photographs with an eraser. *She mines the flea markets for late 19th-century portraits called cabinet cards or cartes de visite, and alters them with the simplest of tools. With her eraser she abrades the emulsion, revealing the paper below. Moore says she only alters photos "with both ends of a #2 pencil."*

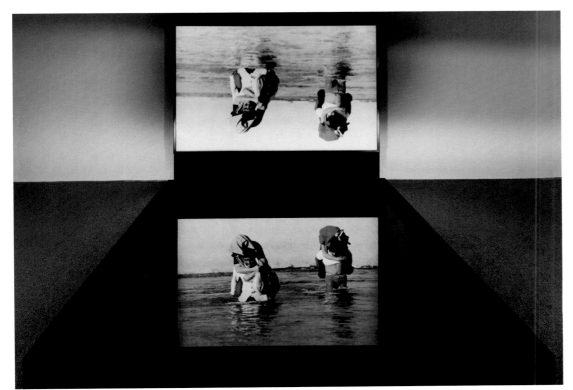

ALFREDO JAAR Coyote!, 1988

The physical qualities of Jaar's display amplify its meaning. *Coyote is the term used for those who, for a fee, smuggle illegal immigrants across the U.S. border from the south. This image of coyotes at work in the Rio Grande is displayed large—and upside down—as a back-lit transparency behind a pool of water. A viewer must look down at its reflection to confront the image properly, but the surface of the water is often disturbed by movement. The image, like the subject, is always shifting, troubled, and difficult to see clearly.*

Using Projections

We think of projection as a temporary display, usually accompanying a lecture or other oral presentation. But projected photographs can command a different kind of attention. Like a monitor display, slides and other projected images can have a greater dynamic range than a print. Simply projecting images on a screen makes them brighter, and usually much larger, than you could print them, and so have greater effect. Digital projectors are brighter than slide projectors, and focus more consistently, although only a very few can match the resolution of a 35mm slide.

Projection can be the primary means of display, as below. In it, the projected image merges with the building on which the projection falls. Projected images are often incorporated into gallery and museum installations, sometimes to wrap an image partway around three-dimensional objects.

KRZYSZTOF WODICZKO Projection on Allegheny County Memorial Hall, Pittsburgh, Pennsylvania, 1986

Skeletal hands playing the accordion are projected onto this public building. Wodiczko's projections all take a political turn. The accordion is an instrument popular with the European working-class population of Pittsburgh. The building is both a performance space and a soldiers' memorial. "Public Projection involves questioning both the function and the ownership of this property."

ED RUSCHA *Royal Road Test*, 1967

Ruscha produced his own artist's books inexpensively. *This one scientifically documents the results of Mason Williams, Ruscha's co-investigator, throwing a Royal typewriter out the window of a 1963 Buick traveling through the Nevada desert at 90mph. At the time, no publisher would risk publishing such eccentric—and unsaleable—material. Nevertheless, the book is entertaining and has become highly collectible.*

MIKE MANDEL *Seven Never Before Published Portraits of Edward Weston*, 1974

Mandel searched phone books across the country to find men named Edward Weston *and mailed them a questionnaire. He asked, among other things, if they could send a photograph that they "thought came out well," and if they had "any relationship to E. Weston, Photographer."*

The times have never been better for exploring ways to make your photographs into a book. Short-run digital printing, using a machine that merges the characteristics of a traditional offset press and an office copier, makes affordable—and easy—the printing of a single book.

One may be enough. Traditionally, photographers have considered books important because they can be reproduced identically in large numbers and distributed widely. But the first question you should ask yourself is, "How many do I really need?" Make the edition of your first book fit the existing demand. For most of us, that means counting our friends and relatives. You may be better off, at least for your first book, making only one, to test your ideas.

Artists (and students) favor the inexpensive. When there is no ready market for your products, controlling your budget is a key issue. Both examples on this page were produced—and paid for—by the artists themselves. To keep the cost down, each book has very few pages, a paper cover, and an inexpensive binding (the Mandel book is stapled).

Traditional offset presses can print quickly, but they take a long time to set up before and clean up after each press sheet. So the cost per page goes down rapidly as the number of copies goes up; it's usually not cost-effective to print offset fewer than 1000 of anything. If you don't have a ready audience for 1000 books, look online for short-run digital printing.

Making a book online is easy. iPhoto, supplied with each Mac computer, lets you upload photos to Apple's website and pay by credit card; a book arrives by mail a few days later. MyPublisher.com has similar features for those using Windows computers. Options include page size and number, and a choice of hard- or softcover. Other websites (try blurb.com) offer a variety of templates for laying out text and pictures. Some (try lulu.com) let you upload pages you have laid out yourself in a common format called PDF, and will make and sell copies for you (even assigning the ISBN number that is required to sell a book commercially).

Alternative processes offer many different choices when you want more than a straight black-and-white or color print. A cyanotype, for example, utilizes light-sensitive iron salts to form an image (see below). The following pages show some additional techniques.

Alternative printing processes like cyanotype, platinum, or palladium printing, first popular in the 19th century, require a negative the same size as the final print. There are several ways to make a negative of suitable size. You can copy your original negative onto large-format film. Or you can print digitally on transparent sheets made to be used with an inkjet printer. Digitally producing an enlarged negative lets you control its contrast and density, useful because the only way to adjust contrast in a cyanotype is to change the negative.

MAKING A CYANOTYPE

Materials needed. A negative the same size as the print to be made. A support for the light-sensitive coating: rag paper (such as artist's watercolor paper) or any natural-fiber cloth (such as cotton, wool, or silk).
Chemicals: potassium ferricyanide and ferric ammonium citrate (green scales). Optional: 3 percent hydrogen peroxide solution.
Scale for weighing the dry chemicals, graduated container, paint brush, stirring rod, contact printing frame or large piece of glass. A dimly lit room in which to coat the material and let it dry; cyanotype is not as light sensitive as ordinary printing paper, so darkroom safelights are not required.
Cyanotype chemicals stain; use newspapers to protect your working surfaces, plus gloves and an apron to protect your hands and clothing. Avoid skin contact.

Prepare the light-sensitive solution.
Mix solution A
 Ferric ammonium citrate (green scales) 1 oz (31 g)
 Distilled water 4 oz (116 ml)

Mix solution B
 Potassium ferricyanide .5 oz (15.5 g)
 Distilled water 4 oz (116 ml)

Mix together equal parts of solution A and solution B. Once mixed, the chemicals lose potency in about 12 hours, so mix only enough for one printing session.

Use a brush to apply an even coating of solution to the surface to be exposed. Coat enough to make some test strips, as well as final prints. Let dry in a dark area. A fan or hair dryer set on cool will speed the drying. Make sure the coated surface is completely dry; cloth takes longer to dry than paper, at least several hours. The dry surface will be bright yellow.

Place the emulsion (or printed) side of the negative against the coated side of the dry material. Assemble in a contact printing frame or under glass.

Expose. Exposure times will vary depending on the light source. A few minutes in direct sunlight, perhaps 15 minutes under a sunlamp or in a contact printer with UV bulbs—hence the need for test strips. The coated surface will be yellow before exposure, green as it is exposed, and finally blue-gray when fully exposed.

Wash and dry the print. Wash in running water for 5–10 min or until the water shows no trace of color. Dry.

Optional: Intensify the print. After washing, darken the blue by immersing the wet print in an intensifier of equal parts of 3 percent hydrogen peroxide and water. Immerse in enough solution to cover the print. Agitate for 30 sec. Wash for 5 min.

BETTY HAHN Starry Night III, 1975
Cyanotype with watercolors and applied stars

As a starting point for many variations that incorporated various printing processes, hand coloring, and other techniques, Betty Hahn used a publicity photograph of those mythic heroes, the Lone Ranger and Tonto. A cactus growing out of the Lone Ranger's head is a bonus.

ALISON CAREY Caprock Canyon, 2002

Carey fabricates land-scapes, photographs them on Polaroid Positive/Negative film, and then scans the 4 x 5-inch negatives. She prints them as negatives on transparent materials made for inkjet printing so the images can be printed in 19th-century processes. She most often makes a palladium print or, as this image, an ambrotype.

Platinum (and similar palladium) printing produces very beautiful and stable photographic images. Platinum paper has a light-sensitive coating that yields an image of platinum metal instead of silver. Its subtle gradations of tone give unsurpassed delicacy and depth to a print, and because platinum is chemically inert, the prints are extremely long lasting. Images produced around the turn of the century, when the platinum process was popular, still retain their richness and subtle detail. A book reproduction can only hint at the beauty of an original.

The main disadvantage of platinum prints is cost; platinum is much more expensive than silver. Like cyanotypes and other early processes, the paper is not available commercially and must be coated by hand. It is not very sensitive to light, so enlargements can't be made. Negatives have to be contact printed, which requires either using a large-format camera or making an enlarged negative. You can make enlarged negatives in a darkroom but larger sizes are more manageable and the subtle tones are easier to control by using a transparent medium in an inkjet printer.

If you want to try platinum printing, or one of several other 19th-century photographic processes, materials and instructions are available from Bostick & Sullivan, (505) 474-0890, www.bostick-sullivan.com.

KENRO IZU Still Life #151, 1991. Platinum/palladium print

Kenro Izu has been working in platinum since he saw a vintage Paul Strand platinum print. "At the time I didn't know it was platinum, but I was overwhelmed by the beauty of what black-and-white photography could be."

Izu coats his own paper (you can see the brush-strokes at the edges of the coated area in the print at left). He believes enlarged negatives lead to loss of quality, so he uses a view camera that holds 14 x 20-inch film specially cut to that size.

Gum bichromate printing led the revival of 19th-century printing processes in the 1970s. The materials are inexpensive, the process isn't complex or difficult, the results are permanent, you can print in any color and put as many images as you want on the same piece of paper—and it's fun.

MAKING A GUM PRINT

Materials needed. A negative the same size as the print to be made. A good paper (preferably 100% rag) for coating that can withstand prolonged immersion in water. The paper should be sized—a treatment to make the paper fibers less absorbent—so the highlights don't stain. Preshrink sheets in hot water, hang to dry.

Chemicals: gum arabic and ammonium dichromate (formerly known as ammonium bichromate). Potassium dichromate also works but is less light-sensitive.

Watercolor pigments in tubes. Get high-quality pigments, not student grade. Try an assortment; not all colors work equally well.

Scale for weighing the dry chemicals, graduated container, bristle or foam brush containing no metal, stirring rod, contact printing frame or large piece of glass. A dimly lit room in which to coat the material and let it dry; gum bichromate is not as light sensitive as ordinary printing paper, so darkroom safelights are not required.

Gloves and an apron to protect your hands and clothing.

Prepare the gum arabic solution.
Sometimes called gum acacia, gum arabic is sap from the acacia tree.

Gum arabic (granular or powdered)	70 g
Distilled water (room temperature)	200 ml

Gum dissolves very slowly in water but don't try to hurry it by using hot water. Wrap the gum in cheesecloth to filter out impurities and immerse it in the water for about a day. Gum arabic solution will spoil; keep it refrigerated.

Prepare the sensitizer.

Ammonium dichromate	55 g
Distilled water	100 ml

Sensitizing solution, stored in a brown glass bottle, should last indefinitely. Handle the liquid carefully; it can cause skin irritation.

Mix the coating solution. Use equal quantites of gum arabic and sensitizer, combined with pigment. Thoroughly mix the gum and pigment together first, then add the sensitizer just before coating and mix again. If you add too much pigment, it will flake off in development. Too little will make a more pale print, but you can recoat the paper and re-expose to build density. The amount of pigment the solution can hold depends on the color. Try starting with this:

Ammonium dichromate solution	20 ml
Distilled water (room temperature)	20 ml
Watercolor pigment	1.6 g

Coat the paper. Use paper a few inches larger than your negative, held to a table or board with pins or tape. Dip the brush in the coating solution; use long strokes to cover the area quckly, then smooth the coating with perpendicular strokes. Let dry.

Expose. Exposure times vary depending on the light source. Gum bichromate is more light-sensitive, requires less exposure, than cyanotype (page 272). Test first.

Develop in still water. Develop the print by floating it on top of still water in a tray at room temperature. First slide it under water to wet the surface, and remove it. Then hold it by opposite corners to curve the paper so you can place the center of the sheet on the water first, then lower the corners. This will prevent trapped bubbles that prevent development. Transfer it to a tray of fresh water (again face down on the surface) after about five minutes. Unexposed pigment will slowly fall to the bottom of the tray. Full development may take up to 30 min. Hang to dry.

SOOKANG KIM Inner Wear—Socks, 2004
Gum bichromate print

Building dark shadows takes multiple printings.
Kim prints, dries, recoats, and reprints as many as twelve times using the same negative. By varying colors (nine to make this print) and exposures, she can create delicate tones in the highlights with deep blacks and subtle color variations in the shadows.

AMY MELIOUS
Figs and Grapes, 1996. Image transfer

Image transfer and emulsion transfer involve peeling apart the layers of various Polaroid films and depositing them on another surface. The transfer process lets you go beyond a straightforward image to a more interpretive one. The inherent softness of these processes was enhanced here by the subtle and subdued colors of the bowl and fruit, as well as by the fine, textured surface of the watercolor paper that provided this image its final support.

POLAROID IMAGE TRANSFERS

Materials you'll need
Polaroid peel-apart film, such as Polacolor Type 669, 690, 59, 89, 559, or 809
Camera that accepts Polaroid film, an enlarger, or a slide printer
Watercolor paper or other transfer material
Tray for water, scissors, squeegee, roller
Smooth, clean surface to work on
Optional: hair dryer, amber 81B or light red CC20R filter

Preparation. You can photograph an image directly onto the film. However, if you want to make more than one transfer of the same image, try projecting an existing slide onto the film using a darkroom enlarger or a Polaroid Daylab slide printer. Some red dyes are lost during the transfer; to correct for this, you can use an amber or light red filter during the film exposure.

Soak watercolor paper for about 30 sec in a tray of warm water. Drain the paper, then squeegee off any excess water.

1. Make your exposure, wait 5–10 sec, peel apart the film. Discard the print. Quickly use the scissors to cut off the chemical pod opposite the tabs used to pull the film through the processor. (Don't touch the chemicals; they are caustic.)

2. Place the negative face down on the watercolor paper. Press the negative down. Use the roller to apply medium pressure to the back of the negative. Polaroid suggests rollling about four times in one direction only. If chemicals ooze out along the edges, you are applying too much pressure.

3. Let the image transfer for 1–2 minutes. Keep the negative warm to prevent dyes from lifting off when you peel off the negative. One way is to gently warm the back of the negative with a hair dryer set on low. Slowly peel off the negative. Then set aside the transferred image to finish drying naturally.

TIPS:
- Fine detail can be lost during the transfer, so select images where that won't be important.
- Let transfers dry completely before mounting or storing. If you frame a transfer, avoid having the image come in contact with the glass.
- After the transfer is dry, you can use colored pencils, inks, pastels, or watercolor to further alter it.

Polaroid's website, www.polaroid.com (click on Creative) features a section called *Creative Techniques: How to...* that shows in detail how to make image transfers as well as how to make emulsion lifts and how to manipulate SX-70 prints.

A photogram is a kind of contact print, made by placing objects, instead of just a negative, on a piece of light-sensitive material and exposing it to light. In the 1920s, about 80 years after the first camera photographs were made, photograms and other print manipulations such as solarization became popular with Man Ray and László Moholy-Nagy, who sought to explore the "pure" actions of light in space.

Any object that comes between the light source and the sensitized material can be used. You can try two-dimensional objects like cut paper or three-dimensional ones, opaque objects that block the light completely, transparent or translucent objects like a pitcher or a plastic bottle that bend the light rays, objects laid on glass and held at different levels above the paper, moving objects, smoke blown over the surface of the paper during the exposure—the possibilities are limitless. All these objects are light modulators—they change the light on its way to the paper. Light can be added to the paper as well as held back. For example, you might try a penlight flashed at the paper or suspended from a string and swung across the surface.

A photogram can be made on printing paper, film, or a digital scanner. If film or a scanner is used, the image can then be printed. Color photograms can be made by exposing color printing paper through different color filters or by using translucent, tinted objects to modulate the light. See page 169 for an example of a digital scanner used to make a photogram.

MAN RAY Rayograph, 1924

Man Ray arranged string, a toy gyroscope, and the end of a strip of movie film on a piece of photographic paper, then exposed the paper to light. The resulting image is open to interpretation. You can see it simply as an assemblage of forms and tones. Or if you see the large black background as a person's head in silhouette (like the silhouetted head in the movie film), then the strip of film might be a dream seen by the internal gyroscope of the brain.

ADAM FUSS Untitled, 1993

In a photogram, objects are arranged directly on light-sensitive material. *Adam Fuss has made photograms of flowers, water, animals, and other objects placed on wet-process color photographiuc paper. Fuss says, "We're so conditioned to the syntax of the camera that we don't realize that we are running on only half the visual alphabet. . . . It's what we see every day in the magazines, on billboards, and even on television. All those images are being produced basically the same way, through a lens and a camera. I'm saying that there are many, many other ways to produce photographic imagery, and I would imagine that a lot of them have yet to be explored."*

Cross processing of color film produces unpredictable, but often interesting color shifts. Ordinarily color negative films are developed in Kodak C-41 or similar chemicals. Color transparency films are developed in Kodak E-6 or similar chemicals. (One exception is Kodak Kodachrome film, which requires specialized processing.)

Instead of normal processing, you can process color negative film in E-6 chemistry, resulting in a positive transparency with lowered contrast and muted colors. You can process transparency film (except Kodachrome) in C-41 chemicals, producing a negative with increased contrast and highly saturated colors (see photograph, right).

Cross processing transparency film inherently increases contrast, so when shooting, lighting should not be too contrasty, or highlights may be too light and shadow areas too dark. On the other hand, you may be able to use this for effect. Increase the film exposure about a stop to help retain shadow detail and to enhance color saturation.

If you use a lab to process the film, be sure to provide clear instructions that you actually want slide film developed as if it were print film, or vice versa. Not all labs will do this, as cross processing can contaminate their chemicals. Try asking the lab operator to process your film in the last batch before the chemicals are due to be replaced.

Software can mimic the process, but interesting results can come from experimentation. Colors will be not altogether realistic, but that is the appeal of the process.

WALID GHANEM Iron & Steel, New York, 2000

To convey a feeling of cold and a sense of mystery for a new line of coats by designer Yohji Yamamoto, Ghanem processed transparency film as if it were negative film to heighten the contrast between the dark coat and walls and the model's fair skin. He processed the film in a lab, but printed the resulting negative himself in a darkroom to control the color of the model's skin tones.

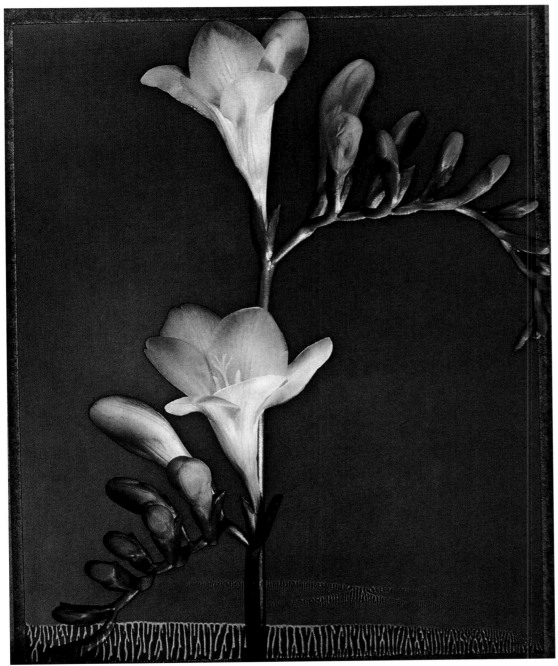

The Sabattier effect occurs when silver-based photographic materials are reexposed to light during development. This gives an image both negative and positive qualities and adds halolike Mackie lines between adjacent highlight and shadow areas (see illustration here and on page 367). The technique is commonly known as solarization, although, strictly speaking, solarization (which can look somewhat similar) takes place only when film is massively overexposed. The correct name for the phenomenon shown here is the Sabattier effect. Try Photoshop's Filter>Stylize>Solarize for a somewhat similar look.

The unusual appearance results from a combination of effects. When film or a conventional print is reexposed to light during development, there is little effect on the highlight areas of a negative (or the shadow areas of a print) because most of the exposed silver halide crystals there have already been reduced to black silver by the developer.

The thin or bright areas, however, contain many still-sensitive crystals that can respond to light and development. These areas therefore darken but usually remain somewhat lighter than the rest of the image.

Between the highlight and shadow areas, chemicals remaining from the first development retard further development; these border regions remain light, forming the Mackie lines.

TOM BARIL Freesia, 1996

The Sabattier effect gives unusual results with negatives. Tom Baril exposes 4 x 5 Polaroid T-55 Positive/Negative film, then peels the film pack apart as it is developing, exposing it to light. After development, he prints the image in a conventional darkroom on a warm-toned paper and finishes the processing in a bath of black tea to add a further tint to the paper. The result is a richly toned, detailed image that is both contemporary and reminiscent of nineteenth-century botanical illustrations. "In an age when the medium is becoming more and more high tech," Baril says, "I borrow from the past to create something which is both faithful to the tradition . . . and something that is uniquely mine."

Pinhole Photography

Would you like to make a picture that shows a unique view of the world? Use a one-of-a-kind camera? Have your pictures be more or less sharp from up close to infinity? Don't buy another expensive camera or lens—just reach for a handy box and construct a pinhole camera. All you need for pinhole photography is a light-tight container (the camera body), a pinhole aperture (instead of a lens) to let in light, and a light-sensitive material (film or paper). Or you can convert your digital camera to a pinhole lens.

PINHOLE EXPOSURES

EXPOSING WITH A DIGITAL PINHOLE
Replace your lens.
Make a pinhole body cap for your camera as described at right. Premade pinhole body caps are available to fit most popular D-SLRs; go to pinholeresource.com. Set the camera for manual exposure and take some experimental exposures to find the right shutter speed and ISO setting.

EXPOSING A PAPER NEGATIVE
Select a paper.
Graded paper in grade 1 or 2 gives the best results. You can use a double-weight paper if you want only a negative image. But, if you want to contact-print the negative to make a positive, use a single-weight paper so that it will be thin enough to print through.

Load paper into the camera under safelight or in complete darkness.
Close the camera and, if necessary, seal the closure with black tape. Make sure your "shutter" (a piece of black tape over the pinhole) is in place.

Start by working outdoors in midday sun. Paper has a slow "film speed," and the relatively dim light indoors can make the exposure impractically long.

Keep the camera stationary during the exposure. Everything from about 3 inches to infinity will be equally sharp (or equally unsharp, depending on how you look at it), so you can try including objects that are very close as well as far away.

Start with a trial exposure of 1 minute. Peel back the tape covering the pinhole, then replace the tape at the end of the exposure time. Develop the paper and evaluate the exposure. If the negative is too light, try double (or more) the exposure time. If too dark, cut the exposure time to half (or less).

EXPOSING A FILM NEGATIVE
Calculating an exposure with film. Film is much faster than paper, so ideally with film, you should meter the scene. To calculate the exposure, you'll need to determine your f-stop (which is determined by the size of your pinhole and camera) and then your shutter speed, depending on the brightness of the scene and the film speed.

To find your f-stop, divide the diameter of the aperture (the size of your pinhole) into the focal length of the camera (the distance from the pinhole to the film). Don't mix your measurement systems. Use either millimeters or use inches, not both.

Or, simply make a trial exposure. If you are using a film with a speed of ISO 100, try a 4 sec exposure with the camera diagrammed at right, top, constructed about 8 inches square.

DEALING WITH LIGHT LEAKS
If a large part of the negative turns black during development, your camera probably has a light leak. To check for leaks, place the loaded camera in the sun for a minute or two without opening the shutter and then develop the negative. If the negative has exposed areas, check for light leaks to fill or seal with tape, or repaint the inside of the camera with black paint.

CONSTRUCTING A PINHOLE CAMERA

You can use any existing box with a tight-fitting lid, like an oatmeal box or a squarish gift box with a deep lid. A shoe box can be used but because the lid is shallow, you'll have to tape the box shut every time you use it to make sure it is light tight. You can also construct a box from heavy mounting stock, as shown here. This box is versatile because you can move the two sections farther apart or closer together to adjust the angle of view (see diagrams at bottom). Paint the inside of the box flat black.

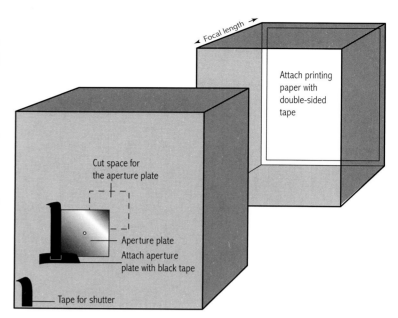

Focal length

Attach printing paper with double-sided tape

Cut space for the aperture plate

Aperture plate

Attach aperture plate with black tape

Tape for shutter

To drill the aperture, cut a 1-inch square piece from an aluminum beverage can, or use a piece of very thin brass. Pierce the metal with a needle. Try a size 8 U.S. sewing needle, which has a diameter of 0.57 mm. Keep the needle perpendicular to the metal and gently rotate it to pierce a small hole. To get a better grip on the needle, you can insert it in an X-Acto blade holder. Sand the back of the metal with fine sandpaper until the hole is smooth and round. Paint flat black the side that will face the film but be sure to clear paint out of your pinhole lens afterwards.

For a digital pinhole, make a pinhole in metal as shown here. Then drill or cut a larger hole for the plate in the center of a protective body cap that fits in place of your D-SLR's lens—most camera bodies are sold with one in place. Attach the pinhole with black tape, black caulk, or an opaque cement.

To increase the focal length, slide the front and back sections farther apart. You may need to use black tape to prevent light leaks.

Normal focal length
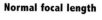
Angle of View

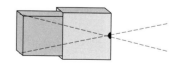
Long focal length

For a wider angle, shorten the focal length by building up the interior of the box, or curve the paper inside the box.

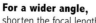
Short focal length

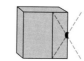
Short focal length

PINHOLE CAMERAS—HIGH TECH OR LOW?

One of the advantages of constructing your own camera is the possibility of design variations to create unique images. Instead of having a flat film plane parallel to the aperture, this camera was designed with an angled film plane to create distortion, readily visible in the photograph at right.

"This camera does have its problems though," says Jones, namely, the inverse square law. The light must travel an increasingly greater distance to reach the farthest part of the film plane, and in doing so gets dimmer. The far end of the film plane gets less exposure than the near end, so printing the positive requires considerable adjustment to balance the exposure overall.

NANCY SPENCER Child Monks, Qinghai Province, China, 2006

The photograph at right was taken with a digital camera (above) using a zone plate body cap. Zone plate is a variation of the pinhole that uses a series of concentric rings, alternating black and clear. Its advantage is that it transmits more light than a pinhole, allowing photographs like the one at right to be made indoors with a handheld camera. Even though they were monks, Spencer says, "Like children everywhere, they don't stand still for very long."

Pinhole photographs characteristically are equally, but softly, focused from immediately in front of the camera to the farthest distance. Some pinhole photographs emphasize the overall focus, like the one at left. The camera rested on the grass; the foreground, only inches away from the lens and the distant background are equally in focus. Other photographs, like the one below (actually made with a zone plate, a variation on pinhole photography), benefit from an overall softness that diffuses light sources like the window.

Both photographers represented on this page choose the pinhole for its ability to transform reality instead of just recording it. Jones loads paper rather than film in her handmade cameras; it is more economical and she likes the paper texture that prints through from a paper negative. Spencer appreciates the benefit, using her digital SLR, of being able to show her subjects their image on the camera's display immediately after the exposure.

◀

PEGGY ANN JONES Spyglass Well, 1985

The photograph was made with the home-made pinhole camera shown at far left. The image was recorded on traditional photo paper, developed and then contact printed in a darkroom. The black-and-white print was hand colored.

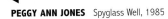

How to Make a Close-Up Photograph

A close-up subject must be focused closer than normal to the camera. If you want to make a large image of a small object, you can, at the simplest level, enlarge an ordinary exposure. However, this is not always satisfactory because image quality deteriorates in extreme enlargements. For better results use close-up techniques to get a large image to begin with.

This is done by using a macro lens (one designed for close-up work), by fitting a supplementary lens over the front of the regular lens, or by increasing the distance from lens to film with extension tubes or bellows inserted between the lens and the camera back (see opposite page). Some zoom lenses have a macro feature, but are not true macro lenses. You can focus closer than normal with these, but not as close as with a lens designed for close-up work.

Working close up is somewhat different from working at normal distances. After roughly focusing and composing the image, it is often easier to finish focusing by moving the entire camera or the subject farther away or closer rather than by refocusing the lens. During shooting, a tripod is almost a necessity because even a slight change in lens-to-subject distance changes the focus. A magnified image blurs with even a slight amount of camera movement, so a tripod also helps by keeping the camera steady. Photographers often use flash to avoid problems with camera movement when shooting close-ups.

Depth of field decreases as the subject is focused closer. Depth of field is shallow at close working distances, so focusing becomes critical. A 50mm lens at a distance of about 12 inches from the subject has a depth of field of 1/16 inch when the aperture is set at f/4. At f/11 the depth of field increases—but only to 1/2 inch.

A single-lens reflex or view camera is good for close-ups, because of its through-the-lens viewing. You can see exactly where the lens is focused and preview depth of field by stopping down the lens, an important ability with shallow depth of field. You can frame the image precisely and see just how the subject relates to the background. Most single-lens reflex cameras have through-the-lens metering, which makes close-up metering easier.

A rangefinder or twin-lens reflex camera is less convenient for close-ups, because you see the scene from a slightly different viewpoint than the taking lens does, and parallax, this difference in view, increases the closer you move to the subject.

A macro lens is your best choice for sharp close-ups. Most 50mm macro lenses without any accessories will focus as close as 4 inches and produce an image up to life size on the film or sensor (a 1:1 ratio). Image size can be increased even more by inserting extension tubes or bellows between the lens and the camera body.

A close-up lens attaches to the front of an ordinary camera lens. Close-up lenses come in different strengths or diopters; the higher the diopter number, the closer you can focus and the larger the image. Image size depends both on the strength of the diopter and the focal length of the camera lens; the longer the lens, the greater the image size with a given diopter.

HOW BIG IS A CLOSE-UP?

In normal photographic situations, the size of the image on film is less than one-tenth the size of the subject being photographed. Close-up images where the subject is closer than normal to the camera can range from about one-tenth to about 50 times life size. Beyond about 10 times life size, however, it is often more practical to take the photograph through a microscope. The term "photomacrograph" (or "macrophotograph") refers to close-ups that are life size or larger. Pictures through a microscope are photomicrographs.

The relative sizes of image and subject are expressed as a ratio, with the size of the image stated first: a 1:10 ratio means the image on the film (or on the chip in a digital camera) is one-tenth the size of the subject. Or the image size can be stated in terms of magnification: a 50x magnification means the image is 50 times the size of the subject. The magnification of an image smaller than life size (actually a reduction) is stated as a decimal: a .10x magnification produces an image one-tenth life size.

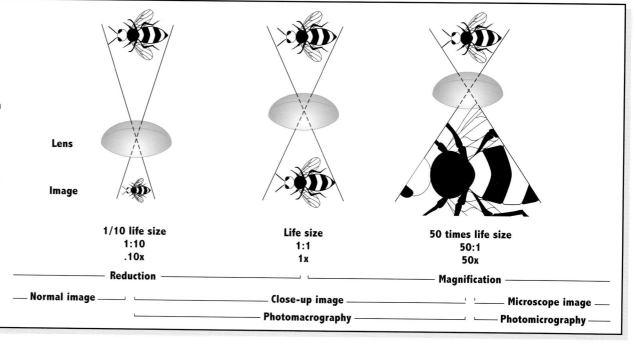

Lens

Image

1/10 life size
1:10
.10x

Life size
1:1
1x

50 times life size
50:1
50x

Reduction

Magnification

Normal image

Close-up image

Microscope image

Photomacrography

Photomicrography

Extension tubes (top) and bellows fit between the lens and the camera. They increase the distance from the lens to the film; the greater the distance, the closer you can bring the lens to the subject and the larger the resulting image will be. Quality is generally better than with close-up lenses.

50mm macro lens, medium distance
The closer a lens comes to a subject, the bigger the image will be. The magnifications produced by moving closer to a subject with a 55mm macro lens are shown at right. Here, the picture was taken from about 2 ft away.

50mm macro lens, 4 inches
Setting the lens to focus as close as possible and moving the lens about 4 inches from the bees caused the insects to appear life size.

50mm macro lens with extension tube, 2 inches
Adding an extension tube, which moved the lens to only 2 inches from the honeycomb, produced larger-than-life-size bees.

To get an accurate close-up exposure, you first need to get an accurate light reading. Then you need to adjust that reading when the lens is extended farther than normal from the film or when the exposure is longer than about a second.

The small size of a close-up subject can make metering difficult. The subject is usually so small that you might meter more background than subject and so get an inaccurate reading. Using a spot-meter is one solution; it can accurately read even very small objects. You could also make a substitution reading from a gray card, or use an incident-light meter to read the light falling on the subject.

Increase the exposure with bellows or extension tubes. Placing a bellows or extension tube between the lens and the camera body moves the lens farther from the film or sensor. The farther the lens extends, the dimmer the light reaching the image plane, and the more you must increase the exposure.

A camera that has a through-the-lens meter will read the light that actually reaches the film. If the object fills the viewing screen (or that part of the screen that shows the area being read), the meter will calculate a corrected exposure by itself.

Manually set exposures. Your bellows or extension tube may interrupt the automatic coupling between lens and camera. If so, or if you are using a handheld meter, adjust the exposure yourself. To do so, follow the recommendations given by the manufacturer of the tubes or bellows, or use the method shown at left.

Long exposures may need to be increased. With film, you need to compensate for reciprocity failure if your final shutter speed is 1 sec or longer.

Bracket—to be sure. Any exposure problem with close-ups is likely to be underexposure. So for safety, first determine what you think is the right exposure, then make additional shots at wider apertures or slower shutter speeds.

Use electronic flash. A flash will allow you to shoot at a small aperture and also eliminate the possibility of blur caused by camera movement at a slow shutter speed.

CALCULATING THE EXPOSURE INCREASE FOR CLOSE-UPS

If your camera does not automatically increase the exposure for close-ups, calculate the increase by measuring the long side of the scene that appears in the viewfinder. Then find the required exposure increase in the chart.

If the long side of the area visible in the viewfinder measures:								
in inches	11	5^1/8	3^1/4	2^1/4	2	1^3/4	1^3/8	1
open lens aperture this number of f-stops	1/3	2/3	1	1^1/3	1^1/2	1^2/3	2	2^1/2
or multiply exposure time by	1.3	1.6	2	2.5	2.8	3.2	4	5.7

Increase applies to a lens of any focal length used with a 35mm camera

Copying a flat object, such as an old family portrait, a painting, or book page, requires more than just casually snapping the picture. You will encounter many of the same technical concerns that you do with close-up photography (pages 282–283)—a great deal of enlargement if your original is small, the need for camera support, and so on. Plus, you need to align the camera squarely and provide very even and shadowless lighting. The techniques are not difficult but do demand some attention to detail.

Small flat objects may be best reproduced using a scanner but sometimes, even for such pieces, rephotographing with a camera may be a better idea. Trying to hold a book page flat on a scanner isn't always very effective and often puts damaging stress on the binding; with a copy stand (right, top) book pages can be copied while holding the book only halfway open. Once you have a copy stand set up, you can make a number of digital copies very rapidly.

If you use film, your choice depends on the copy (the term for the original material to be reproduced)—black and white or color. Black-and-white film has black, white, and gray tones that are appropriate for copying ordinary photographs, pencil drawings, and paintings. Fine-grain, low-ISO film is best for black-and-white reproduction of these objects.

Black-and-white line copy has no gray tones, only black and white ones (like the rhinoceros, opposite). Ink drawings, charts, and black-and-white reproductions in books are examples. The clean whites and crisp blacks of line copy can be emphasized with black-and-white film processed for higher-than-normal contrast. Underexpose the film by one stop, develop for 1 1/2 times the normal development time, then increase the contrast when you print to remove any traces of gray tones.

If you want a color reproduction, select film balanced for your light source. Use tungsten film for ordinary tungsten or halogen lights, daylight film for daylight, open shade, or flash. With both digital and film, include a standard gray card in at least your first frame to aid in achieving exact

color balance in your output later.

A camera with through-the-lens viewing is best because it lets you accurately position the copy and check for glare and reflections. A digital, 35mm, or medium-format single-lens reflex is fine for most work. Use a view camera, which produces a 4 x 5-inch or larger negative, when you want maximum detail. With an SLR, if the copy is small, you will need to use extension tubes, bellows, or a macro lens to enlarge the image enough to fill the film format. A view camera has its bellows built in. It is preferable not to use supplementary close-up lenses; they often display aberrations that are more noticeable in copy work than with ordinary close-ups.

A steady support for the camera is vital because even a slight amount of motion creates unsatisfactory softness in copy work. A tripod or copy stand provides stability. If you use a copy stand, an accessory right-angle viewer on the camera will help you view and focus. A cable release to trigger the shutter reduces camera motion at the moment of exposure.

The copy and the camera must be parallel to each other, otherwise your reproduction will be distorted. A copy stand (this page, top) holds the copy horizontally; once the camera is attached and leveled, it can be moved up and down the central column while the film plane of the camera remains parallel to the copy.

Oversize objects can be hung on a wall (this page, center). Mount the copy flat against the wall. Move the camera close to the wall and adjust the tripod height so the lens is lined up with the center of the copy, then move the camera straight back from the wall. A view camera often has lines on the ground-glass viewing screen that let you check the image's alignment. You can use the edges of an SLR camera's finder frame to check the alignment.

Measure everything. A tape measure will help you make sure each light is the same distance from the lens, wall, and floor. With your camera on a tripod and the copy on a wall (this page, center), set the lights, lens, and the center of the copy at the same distance from the floor.

TECHNIQUES FOR MAKING PHOTOGRAPHIC COPIES

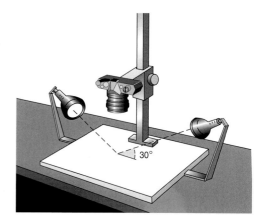

A copy stand is a convenient way to photograph a small object like a book or small print, which is placed flat on the baseboard. The camera mounts on the central column and can be moved up or down to adjust the framing of the image. Sometimes lights are attached to the sides to provide illumination at an angle to the baseboard.

Wall mounting can be used for a larger item, such as a painting. The object to be copied is hung on the wall. The camera is positioned on a tripod squarely in front of the object. Lights on each side are at a 30° angle to the wall. Lights at a shallow angle—less than 45° if possible—will reduce the chance of glare.

If the object being copied is behind glass, or has a very glossy surface, you may see a reflection of your camera in the glass. Eliminate the reflection by shielding the camera behind a black card or cloth, at least twice the dimensions of the copy, with a hole cut in it for the lens.

Your choice of film depends on the object being copied. Line copy, such as an engraving or woodcut (above), black-and-white book page, or ink drawing, has only black tones and white tones, no grays. High-contrast litho film, although hard to find, will produce the best reproduction. A continuous-tone original, such as an ordinary black-and-white photograph or a pencil drawing, has a range of gray tones, as well as black and white, and should be copied on fine-grain, general-purpose film.

The 16th-century woodcut above, by Albrecht Dürer (1471–1528), is a clear illustration of the need for accurate description that preceded the invention of photography. Dürer had never seen a living rhinoceros, and relied on someone else's sketch as the basis for his print. Nonetheless, this woodcut was often reproduced as factual in natural history books, up until the 19th century.

Your goal for lighting should be even, shadowless light over the entire surface of the copy. Although it is possible to use existing daylight if you have a bright area of diffused light to work in, it is usually more practical to set up lights. Position two identical lights, one on each side of the copy at about a 30° angle to it, aimed at the center of the copy.

Most photographers are more comfortable with continuous light sources, such as photofloods, than they are with flash because the effect of the lighting is easier to judge. But if you make more than the occasional copy, you will appreciate the exact repeatability of flash—both in brightness and color balance. If you use incandescent lights, make sure the bulbs are the same age because light output can weaken or change color as a bulb is used.

Check the evenness of the illumination by metering the four corners and the middle of the copy. With black-and-white or color negative film, there should be no more than 1/2 stop difference in any area, even less with digital capture or color slides. You can use an incident-light meter (held close to the copy and pointed toward the camera). Or you can use a reflected-light meter (pointed toward the copy). Take reflected-light readings from a gray card and not from the copy itself so that the tones of the copy do not affect the readings.

Reflections can be a problem if you need to place a piece of glass over your copy to hold it flat or if the copy itself is shiny. If you have set the lights far enough away from the camera and at a shallow enough angle to the copy, reflections will not be from the lights but probably come from other objects in the room.

Check for reflections of the camera itself, the tripod, or even your body. If you see them, hide the camera behind a piece of black card or cloth with a hole cut in it for the lens (opposite page, bottom). Shade your lights so they don't shine on the camera. Always look through the lens when checking for light or camera reflections. Even if you are right beside the camera, you may not see them otherwise.

A polarizing filter on the camera lens will help eliminate reflections that are due to heavily textured copy. In some cases, you may need to use polarizing screens on the lights plus a polarizing filter on the lens.

Meter the copy using an incident-light meter, or a reflected-light meter and a gray card. Select a medium aperture. Depth of field is very shallow if your focusing distance is close, and a medium aperture provides enough depth of field— if your copy is flat—to allow for slight focusing error. Also, you will get a sharper image at a medium aperture than at the lens's smallest one.

You may need to increase your basic exposure if you are using extension tubes or bellows that extend the lens farther than normal from the film or sensor. You also need to increase the exposure if you are using a polarizing filter (1 1/3 stops). If you are using film, another increase may be needed—for reciprocity failure. Add the extra exposure for a filter first, then calculate the reciprocity compensation. A reflected-light meter that is built into the camera and reads through the lens has the advantage of directly adjusting for everything but reciprocity failure (page 77). If your camera is automatic, be sure that it is set to its manual exposure mode. Metering from a gray card and not from the object being copied will produce the best results.

Bracketing your exposures will ensure your work pays off. You should be able to judge digital exposures immediately with a histogram. With film, once you have made the initial exposure, make a few more at varying exposures: one stop more and less with black-and-white film, 1/2 stop more and less with color. If possible, leave your camera and the copy set up and develop a test exposure (or view your capture on a full-sized monitor) so you can reshoot, if needed, with minimum effort.

CATHERINE WAGNER Wonderwall, Louisiana World Exposition, New Orleans, 1984

Wagner's 4 x 5 negative provides precise rendering of small details in this crowded scene, even in a very big print. She chooses a view camera for the high resolution of large-format film and also for the camera's ability to control convergence. From this high vantage point, any other camera would render the numerous vertical lines at angles to each other instead of parallel (see pages 300–301).

view camera

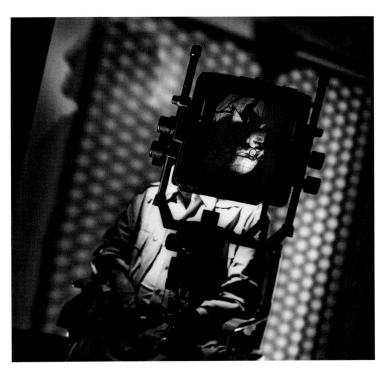

MICHAEL GRECCO Portrait of Arnold Newman, 1994

The face of portrait photographer Arnold Newman *appears upside down on the ground glass of a view camera. An upside-down image is what a photographer sees when focusing a view camera.*

A view camera's movements give you the ability to control the position, focus, and shape of your subject as it appears in your photograph.

Handling a view camera and developing sheet film are not difficult, but are somewhat different from techniques used with other cameras.

Why would a photographer use a bulky, heavy, slow-working view camera—a camera that has few or no automatic features, that has to be used with a tripod, that shows you an image upside down that is so dim that you need to put a dark cloth over the camera and your head to see it? The answer is that the view camera does some jobs so well that it is worth the trouble of using it.

A view camera's movements give you an extraordinary amount of control over the image. The camera's back (image plane or film plane) and front (lens plane) can be independently moved in any direction: up, down, or sideways, tilted forward or back, swiveled to either side. These movements can change the area of a scene that will be recorded, select the most sharply focused plane, or alter the shape of the subject itself.

The view camera's large format is also an advantage. The most common size for view cameras is 4 x 5 inches, for which digital adapter backs are made. Other film sizes are also used: 5 x 7, 8 x 10, and sometimes larger. While modern small-camera films (1 x 1 1/2 inches is the size of 35mm film) and digital cameras can make excellent enlargements, the greatest image clarity and detail and the least grain are produced from a large-size negative or capture area. Because digital capture backs for view cameras are not in common use—and as expensive as a new car—this chapter refers only to film. The operating principles, however, are the same.

A view camera's movements give it the ability to change and control an image. Unlike most cameras, which are permanently aligned so that lens and film stay exactly parallel, a view camera can be deliberately unaligned.

These movements and their effects, which are explained on the following pages, are easier to understand if you have a view camera at hand so you can demonstrate the effects for yourself.

To make full use of a view camera's movements, you must use it with a lens of adequate covering power, that is, a lens that produces a large image circle. As shown at right, a lens projects a circular image that decreases in sharpness and brightness at the edges. If a camera has a rigid body, the image circle needs to be just large enough to cover the size of the film being used. But a view camera lens must produce an image circle larger than the film size so that there is plenty of room within the image circle for various camera movements. If the movements are so great that the film intersects the edge of the image circle, the photograph will be vignetted—out of focus and dark in one or more corners. Covering power increases—the usable image circle gets slightly larger—as the lens is stopped down.

A lens with good covering power (producing a large image circle) is necessary for a view camera. Camera movements such as rise, fall, or shift move the position of the film within the image circle (as shown above). But for you to be able to use these movements, your lens needs to produce an image that is larger than the actual size of the film. Check the corners of the viewing screen before exposure to make sure the camera movements have not placed the film outside the image circle, vignetting the picture (dotted lines).

VIEW CAMERA MOVEMENTS

Side View	Top View	Side View	Top View

Rise and fall move the front or back of the camera in a flat plane, like opening or closing an ordinary window. Rise moves the front or back up; fall moves the front or back down.

Shift (like rise and fall) also moves the front or back of the camera in a flat plane, but from side to side in a motion like moving a sliding door.

Tilt tips the front or back of the camera forward or backward around a horizontal axis. Nodding your head yes is a tilt of your face.

Swing twists the front or back of the camera around a vertical axis to the left or right. Shaking your head no is a swing of your face.

This simplified view camera shows its basic relationship to all cameras: It is a box with a lens at one end and a sheet of film at the other. Unlike other cameras, however, the shape of the box can be changed.

Lens board, which holds the lens, can be moved independently up or down, forward or back, from side to side, or at an angle.

Bellows expand or contract so that the lens board and camera back can be moved together or farther apart.

Ground-glass viewing screen shows the image.

Film holder holds individual pieces of sheet film. This style holds two sheets of film. A dark slide protects the film from light except when an exposure is made. The top of the dark slide is color coded: white side out for unexposed film, black side out for exposed film or an empty holder.

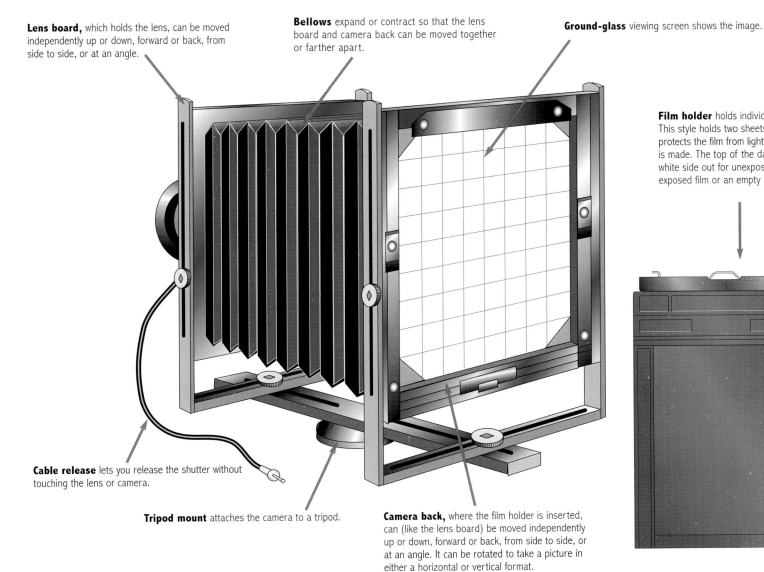

Cable release lets you release the shutter without touching the lens or camera.

Tripod mount attaches the camera to a tripod.

Camera back, where the film holder is inserted, can (like the lens board) be moved independently up or down, forward or back, from side to side, or at an angle. It can be rotated to take a picture in either a horizontal or vertical format.

Rise, an upward movement, and fall, a downward movement, change the placement of the image on the film by changing the position of film and lens relative to each other. Moving the back moves the film to include various parts of the image circle. Moving the front moves the image circle so that a different part of it falls on the film.

Rise or fall of the back does not affect the shape of the subject. The effect is not unlike cropping a photograph during printing—the amount of the object shown or its position within the frame may change but not the shape of the object itself.

Rise or fall of the front changes the point of view and to some extent the shape. In the pictures opposite, the change in shape is too slight to be seen in the cube, but the difference in point of view is visible in the change of relationship between the cube and the small post.

Why not just raise or lower the camera? That is a good solution, when you can do so, but rise and fall give you an extra edge of control when your tripod can't raise or lower any more. In addition, moving the camera, like front rise and fall, changes the visual relation of objects (see last two illustrations, opposite). Back rise and fall give you the option of moving the image within the frame without changing the position of objects relative to each other.

EZRA STOLLER Kitt Peak Solar Observatory, Pima County, Arizona, 1970

Architectural photographers use rise and fall to keep the lines of a building straight. In this scene, for example, if you wanted to see more at the top or bottom of the structure, you could just tilt the camera and tripod up or down, but that would make vertical lines in the image converge (see page 300). The solution is to keep the camera level, and use the camera's rise or fall movements, which make more visible at the top or bottom, but don't distort the shape of the building at the same time.

Ezra Stoller photographed buildings by Frank Lloyd Wright, Eero Saarinen, and many other architects. "Photography is space, light, texture, of course," Stoller once said, "but the really important element is time. That nanosecond when the image organizes itself on the ground glass."

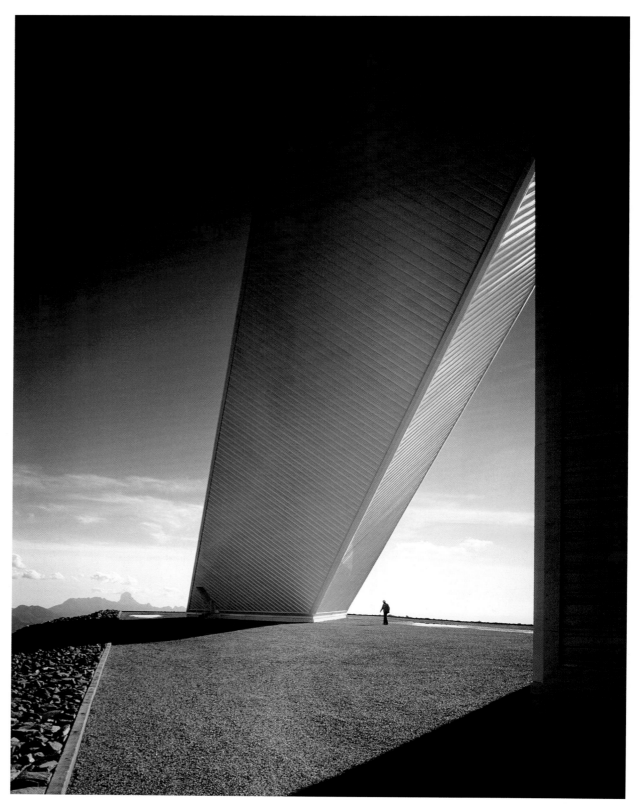

RISE AND FALL ARE UP OR DOWN MOVEMENTS

Rise or fall of the front or back changes the position of the image in the frame. Rise or fall of the front moves the lens and so affects the relative position of foreground and background objects.

Compare the photograph of the reference cube (below), which was made with no movements set into the camera, to the photographs that follow to see the changes in shape, sharpness, and position that take place as a result of camera movements.

▼

Controls zeroed. The object being photographed appears in the center of the ground-glass viewing screen. It is inverted (upside down and reversed left to right). The camera back and front are centered.

Back rise or front fall. The object has been moved to the bottom of the viewing screen (the top of the picture when viewed right side up). This is done by either raising the back or lowering the front (lens board).

Back fall or front rise. To move the object to the top of the viewing screen (the bottom of the actual picture), lower the back or raise the front.

Final prints are shown below. The image on the camera's viewing screen would be upside down, as in the diagrams above.

Reference cube—all controls zeroed (in neutral position). This photo was shot with all camera adjustments at zero, looking down from an angle of 45°. The cube was centered, with focus on the top front edge of the cube.

The image falls in the center of the picture frame. The cube's top front edge, being closest to the camera, is the largest. It is also the sharpest. The cube is symmetrical, with the two visible surfaces of the cube falling away in size and sharpness at an equal rate.

Back rise, raising the back of the camera, moves the cube higher on the film without changing its shape. If you compare this photograph with that of the reference cube, you'll see that this movement does not affect the position of the small post in front of the cube. The top of the post still lines up with the cube's front edge.

Back fall, lowering the back of the camera, lowers the position of the cube on the film. Like back rise, there is no change in the shape of the cube or its relation to the post. This is because the film, though raised or lowered, still gets the same image from the lens, which has not moved relative to the original alignment of cube and post.

Front rise, raising the lens, lowers the image of the cube on the film, just as back fall does. However, moving the lens causes a change that does not occur with back movement: it changes the relation between cube and post because the lens is now looking at them from a slightly different position. The farther apart that near and far objects are, the more this will be evident. Compare the apparent height of the post here with its height in the pictures at left; the post has dropped slightly below the edge of the cube.

Front fall, lowering the lens, raises the image on the film. Because the lens has moved, it also affects the relation of cube and post. Now the post appears to have moved slightly above the front edge of the cube.

Shift, a sideways movement, is the same as rise and fall except the movement takes place from side to side. If you were to lay the camera on its side and raise or lower the back, you would produce the same effect as back shift. One way in which rise and fall are the same as shift is that neither changes the angle between the planes of film, lens, and subject. Raise, lower, or shift the back of the camera, and the film is still squarely facing the lens; the only difference is that a different part of the film is now directly behind the lens.

Since shift is simply a sideways version of rise and fall, the results are similar. Back movement to the left moves the subject to the left; back movement to the right moves it to the right. Left or right lens movements have just the opposite results.

Spatial relationships change with front shift but not with back shift, because the lens now views objects from a different point. Lens shift has the same effect on the point of view as moving the entire camera to the left or right. Back shift simply moves the entire image within the frame. The examples at right illustrate these movements, with the reference cube included for comparison.

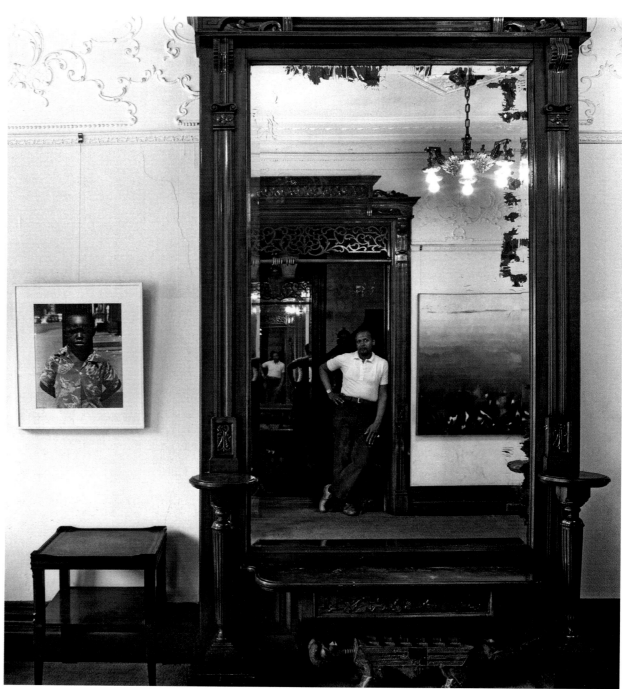

KURT EDWARD FISHBACK Roy DeCarava, 1982

Shift can be used to get your camera out of the picture. *Kurt Edward Fishback wanted the multiple reflections of photographer Roy DeCarava in his portrait, but he was also getting reflections of his own camera and tripod. He couldn't move any farther to the left, which would have removed from the image not only the equipment, but one of the reflections of DeCarava as well. Instead, he used the shift movement on his view camera, which helped get himself out of the picture while keeping all the reflections of DeCarava.*

SHIFT IS A SIDEWAYS MOVEMENT

Shift of the front or back changes the position of the image in the frame. Shift of the front moves the lens, and so affects the relative position of foreground and background objects.

Controls zeroed. The image is in the center of the viewing screen.

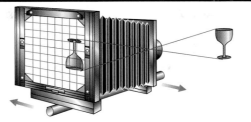

Back shift left or front shift right. The object has been moved to the right side of the viewing screen (left side of the actual photograph) by moving the camera back to the left or the front to the right.

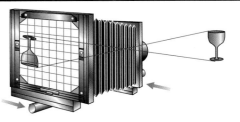

Back shift right or front shift left. To move the object to the other side of the picture, move the back to the right or the front to the left.

Final prints are shown below. The image on the camera's viewing screen would be upside down, as in the diagrams above.

Top view

Reference cube—all controls zeroed. Shift, like rise and fall, has little perceptible effect on the shape of an object. Compare the reference cube with the four cubes to the right of it. While the cubes move back and forth on the film, they continue to look very much the same.

Back shift left, moving the back to the left, moves the cube to the left on the film. A camera equipped with a back that can move the film from side to side, as well as up and down, can place an object wherever desired on a sheet of film.

Back shift right, moving the back to the right, moves the image to the right. Comparison of this picture with the previous one shows no change in the shape of either the cube or the post in front of it. Their spatial relationship has remained unchanged also, despite the movement of the image on the film.

Front shift left, moving the lens to the left, moves the image on the film to the right. It also changes the relationship of post to cube. Since the lens actually moves to the left, it views the two objects from a slightly different position. One object appears to have moved slightly with respect to the other. The farther apart near and far objects are, the more a change is seen. Compare the position of the post against the vertical lines on the cube in this picture and the next.

Front shift right, moving the lens to the right, moves the image to the left and changes the relationships in space between objects. To summarize: If you want to move the image on the film but otherwise change nothing, raise, lower, or shift the back. If you want to move the image and also change the spatial relationship of objects, raise, lower, or shift the lens.

Tilt, a forward or backward angled movement, can change both the shape and the focus of the image on the film. The preceding pages show that rise, fall, and shift have little or no effect on the shape of an object being photographed because they do not change the angular relationship of the planes of film, lens, and object. But what happens with tilt, an angling of either the camera front or camera back?

Any change of the angle between front and back relocates the plane of focus, changing the way the picture looks. But the overall appearance of the photograph also depends on whether you change that angle by tilting the front or back of the camera. Tilting the back of the camera changes the shape of the object and also changes the focus. Tilting the front of the camera only changes the focus without changing the shape of the object.

Tilting the back changes the shape. To understand why this happens, look again at the reference cube. The bottom of the film sheet is the same distance from the lens as the top of the film sheet. As a result, light rays coming from the lens to the top and the bottom of the film traveled the same distance, and the top back edge and the bottom front edge of the cube are the same size in the photograph. But change those distances by tilting the camera back, and the sizes change.

The rule is: The farther the image travels inside the camera, the larger it gets. Since images appear upside down on film, tilting the top of the camera back to the rear will make the bottom of an object appear bigger in the photograph; tilting the top of the camera back to the front will make the top of an object appear bigger.

Tilting the front changes the focus. A tilt of the camera front does not change distances inside the camera and thus does not affect image size or shape, but it does affect focus by altering the lens's relationship to the film plane. Set the shape first by adjusting the back, then locate the plane of focus by adjusting the front.

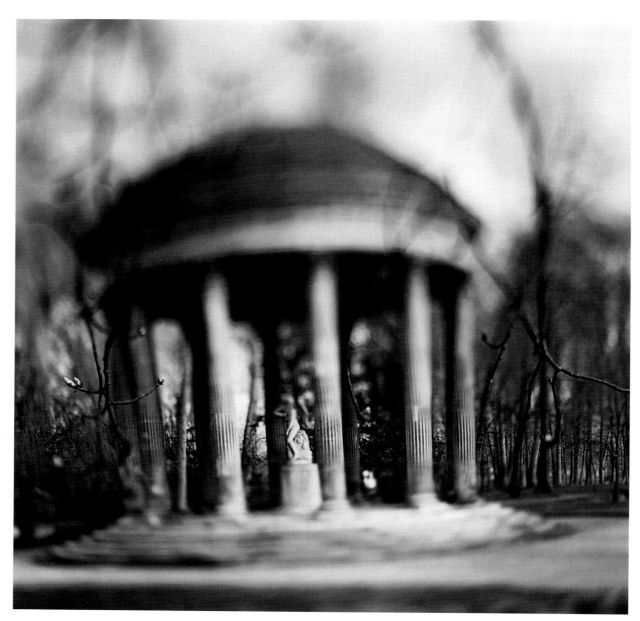

KEITH CARTER Temple of Love, Versailles, 1999

Keith Carter uses a medium-format camera with a lens that can tilt like a view camera's front. Tilting the lens relocates the plane of focus so that it is at an angle to the film plane; in this photograph, it is almost horizontal. The center of this scene remains sharp while the upper and lower parts blur. Carter presents the world in a way our eyes can never see it.

TILT IS AN ANGLED FORWARD OR BACKWARD MOVEMENT

Tilt of the back affects the shape of an object, which helps to control convergence (the apparent angling of parallel lines toward each other in a photograph). Tilt of the front or back relocates the plane of focus, which helps you make the most effective use of depth of field.

Controls zeroed. The images of two objects being photographed appear the same size on the viewing screen.

Back tilt toward the back. The image must travel farther from the lens to reach the top of the viewing screen than to reach the bottom. As light rays travel, they spread apart and increase the size of the image on the top of the screen (the bottom of the actual photograph) compared to the size of the image on the bottom of the screen.

Back tilt toward the front. The size of the image on the bottom of the viewing screen increases compared to the size of the image on the top of the screen.

Final prints are shown below. The image on the camera's viewing screen would be upside down, as in the diagrams above.

Reference cube—all controls zeroed. The 45° angle of view has produced an image that falls off in both size and sharpness at an equal rate on both the top and the front faces. As a result the two faces are exactly the same size and shape. Note also that the vertical lines on the front face, which are actually parallel on the cube, do not appear parallel in the photograph, but converge (come closer together) toward the bottom.

Back tilt, moving the camera back toward the back. The back of the camera is tilted so that the top of the film is farther away from the lens than in the reference shot. This movement enlarges the bottom of the cube, bringing its lines more nearly parallel. At the same time, this tilt has moved the bottom of the film closer to the lens than it was in the reference shot, shrinking the top back edge of the cube so that it converges more than before.

Back tilt, moving the camera back toward the front. If the back of the camera is tilted the other way, so that the top of the film is forward and the bottom is moved away from the lens, the top of the cube expands at the back and its sides become more parallel. The front bottom shrinks so its sides converge more. This movement results in some light loss on the part of the film moved farther from the lens. In this case the back edge of the top face is affected. In the picture at left the bottom edge of the front face is affected.

Front tilt, moving the camera front toward the back. When the lens is tilted, there is no change in the distance from lens to film; thus there is no change in the shape of the cube. However, there is a distinct change in focus. Here the lens has been tipped backward. This relocates the plane of focus to lay along the front face of the cube, pulling all of it into sharp focus. The top of the cube, however, is now more blurred than in the reference shot.

Front tilt, moving the camera front toward the front. If the lens is tilted forward, the top of the cube becomes sharp and the front more blurred. The focus control that lens tilt gives can be put to good use when combined with back tilt. Look again at the two back-tilt shots at the left; after tilting the back, the blurry side could have been made sharp by tilting the lens—although the other face would then be out of focus.

Swing, an angled left or right movement, can change the shape or focus of the image. Like tilt, it has different effects depending on whether the front (lens plane) or back (image plane) is moved.

Swinging the back of the camera changes the shape. Like tilting the back, it moves one part of the film closer to the lens while moving another part farther away. This produces changes of shape in the image, reducing the size of one side (the image on the side of the back moved closer to the lens) while enlarging the other.

Swinging the front of the camera changes the focus. It swivels the lens to the left or right. As with tilt, any change in the angle between front and back (by moving either one) relocates the plane of focus. The general effect is to move the sharply defined zone of focus that is normally parallel to the film into a new position where it can cut at an angle across an object. Look at the two cubes, opposite page, far right. A narrow diagonal path of sharp focus travels across the top of each cube and runs down one side of the front.

JOANN VERBURG News from Paris, 1994

Swinging the camera front to the left or right manipulates the plane of focus. In this photograph, an odd juxtaposition between the newspaper photo and the sculpture is enhanced by an angled plane of focus.

SWING IS AN ANGLED LEFT OR RIGHT MOVEMENT

Swing of the back affects the shape of an object, which helps to control convergence. Swing of the front relocates the plane of focus, which helps you make the most effective use of depth of field.

Top view

Controls zeroed. The images of two objects being photographed appear the same size on the viewing screen.

Left swing of the camera back. If one side of the camera back is swung away from the subject, part of the image will have to travel farther to reach the camera back and so will increase in size. Here the image on the left side of the viewing screen (the right side of the scene and of the photograph) has been increased in size by swinging the left side of the camera back away from the lens.

Right swing of the camera back. With the right side of the camera back swung away from the subject, the size of the image on the right side of the viewing screen (the left side of the scene and of the photograph) will increase in size.

Final prints are shown below. The image on the camera's viewing screen would be upside down, as in the diagrams above.

Top view

Reference cube—all controls zeroed. Comparing the reference cube to the pictures at right shows the effect on shape you can make by changing the angle of film to object. If you didn't understand the process by which such changes can be made, it would be hard to know that these swing shots—or the two back-tilt shots on page 295—are all of the same object, taken from the same spot with the same camera and lens.

Left swing, moving the left side of the camera back toward the back. This movement of the camera back swings the left side of the film away from the object and the right side closer to it, making the left side of the cube smaller and the right side larger. (Remember, the image is inverted on the ground glass.) This effect is the same as tilt, but sideways instead of backward or forward.

Right swing, moving the right side of the camera back toward the back. Here the right side of the film is swung away from the object and the left side closer to it. The results are the opposite of those in the previous picture. In both of them it can be seen that there is a falling off of sharpness on the "enlarged" edges of the cube. This is because swinging the back changed the angle between back and lens, relocating the plane of focus.

Left swing, moving the left side of the camera front toward the back. Since it is the lens that is being swung, and not the film, there is no change in the cube's shape. However, the position of the focal plane has been radically altered. In the reference shot it was parallel to the near edge of the cube, and that edge was sharp from one end to the other. Here the focus is a plane that skews through the cube, cutting diagonally across the top and down the left side of the cube's face.

Right swing, moving the right side of the camera front toward the back. Here is the same phenomenon as in the previous picture, except that the plane of sharp focus cuts the cube along its right side instead of its left. This selectivity of focus, particularly when tilt and swing of the lens are combined, can move the focal plane around very precisely to sharpen certain objects and throw others out of focus. For a good example of this, see page 299 bottom.

Using a View Camera to Control the Image

The practical applications of the view camera's ability to rise, fall, shift, tilt, and swing are virtually endless. You can control the plane of focus, which determines the parts of the scene that will be sharp. You can control the shape of an object by adjusting its horizontal or vertical perspective. You can control the placement of the scene within the image frame. The effects of these movements are summarized here and illustrated on the following pages.

CONTROLLING THE PLANE OF FOCUS AND DEPTH OF FIELD

Suppose you need to get a horizontal surface in focus from the front of a subject to the back.

Tilt the front of the camera forward to align the plane of focus more with the top plane of the subject. Stop down the lens if you want also to increase the depth of field.

CONTROLLING HORIZONTAL PERSPECTIVE WHEN SHOOTING AT A SIDE ANGLE TO THE SUBJECT

Top view

This technique is useful when the camera is pointing at a left-to-right angle to the subject, such as in architectural, product, or still-life photography.

The subject looks like this on the ground glass, with converging horizontal lines.

Top view

Change the perspective by swinging the camera back (a) parallel to the face of the subject. Align the plane of focus with the object's parallel face by swinging the camera front (b) parallel to the camera back. Refocus, if needed.

The perspective will be corrected so that horizontal lines will no longer converge.

CONTROLLING VERTICAL PERSPECTIVE WHEN SHOOTING FROM A LOW CAMERA ANGLE

This technique is useful when the camera is pointing upward, such as when photographing buildings from a low angle.

The subject looks like this on the ground glass, with converging vertical lines. (Remember that the image is upside down on the ground glass.)

a b

Change the perspective by tilting the camera back (a) parallel to the face of the subject. Change the focus by tilting the camera front (b) parallel to the camera back. Refocus, if needed.

The perspective will be altered so that vertical lines will no longer converge.

CONTROLLING VERTICAL PLACEMENT OF A SUBJECT IN THE IMAGE FRAME

If the subject looks like this on the ground glass.

Or like this.

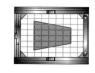

Move the subject image within the frame by using the front rise or fall or the back rise or fall.

The placement of the subject within the frame will be changed. This technique can also be used to reduce reflections of the camera by not photographing the subject head on.

CONTROLLING VERTICAL PERSPECTIVE WHEN SHOOTING FROM A HIGH CAMERA ANGLE

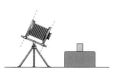

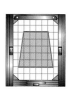

This technique is useful when the camera is pointing downward, which often happens in still life and product photography.

The subject looks (upside down) like this on the ground glass, with converging vertical lines.

a b

Change the perspective by tilting the camera back (a) parallel to the face of the subject. Change the focus by tilting the camera front (b) parallel to the camera back. Refocus, if needed.

The perspective will be altered so that vertical lines will no longer converge.

CONTROLLING HORIZONTAL PLACEMENT OF A SUBJECT IN THE IMAGE FRAME

If the subject looks like this on the ground glass.

Or like this.

Top view

Move the image within the frame by shifting the front or back.

The placement of the subject within the frame will be changed. The technique can also be used to reduce or remove reflections.

ADJUSTING THE PLANE OF FOCUS TO MAKE THE ENTIRE SCENE SHARP

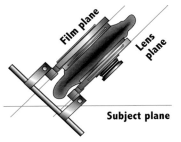

The book is partly out of focus because the lens plane and the film plane are not parallel to the subject plane. Instead of a regular accordion bellows, the diagrams show a bag bellows that can bring camera front and back closer together for use with a short focal-length lens.

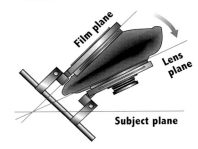

Tilting the front of the camera forward brings the entire page into sharp focus. The camera diagram illustrates the Scheimpflug principle, explained at right.

ADJUSTING THE PLANE OF FOCUS TO MAKE ONLY PART OF THE SCENE SHARP

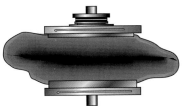

Top view

Here the photographer wanted just the spilled beans sharp, not those in the foreground and background jars.

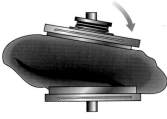

A swing of the camera front to the right moves the plane of focus to angle along the receding pile of beans. The photographer opened up the lens to its maximum of f/5.6, which throws the other jars out of focus and directs attention to the beans.

A view camera's movements let you control sharpness in an image, an advantage that becomes evident when photographing something that is not parallel to the film, like the rare book shown here. If you focus on the part of the book close to the camera, the top of the book, more distant, is blurred and vice versa. A compromise focus on the middle of the page might not give enough depth of field even if you stopped the lens all the way down.

With a view camera you can adjust the plane of focus. If you set your view camera like any other camera, with front and back parallel to each other, the plane of focus will always cut through the subject parallel to the film. With a view camera, you can make more of the book page sharp by adjusting the camera front to move the plane of focus until it coincides as exactly as possible with the surface of the book page. If the page is still not completely sharp, it is because the page is not completely flat; stop down the lens aperture to increase the depth of field.

Scheimpflug makes it predictable. If you want to know how to adjust a view camera so that a specific plane of the subject is in focus, the Scheimpflug principle tells you. This rule (named after its discoverer) says that if the camera's lens plane and film plane are not parallel, then the plane of focus will meet those two planes in a line. Fortunately, you don't have to calculate exactly where the three planes meet (you will be able to see on the ground glass when the image is sharp), but it does tell you which way to swing or tilt in order to relocate the plane of focus where you want it.

If you want only part of the picture to be sharp, this too is adjustable with a view camera. By swinging or tilting the camera front, the plane of focus can be angled across the picture, as in the photographs of the spilled beans, left, and the photographs on pages 294 and 296.

A view camera is often used in architectural photography for controlling perspective. It is almost impossible to photograph a building without convergence unless a view camera is used. You don't have to make parallel lines in the subject appear parallel in the photograph, but a view camera provides the means if you want to do so.

Photographing a building head on isn't always as simple as it seems. Suppose you wanted to photograph the building at right with just one side or face showing. If you leveled the camera and pointed it straight at the building, you would show only the bottom of the building (photograph, near right).

Tilting up the camera shows the entire building but introduces a potentially undesirable perspective (photograph, far right): the vertical lines seem to come together or converge. This happens because the top of the building is farther away and so appears smaller than the bottom of the building. When you look up at any building, your eyes also see the same converging lines, but the brain compensates for the convergence and it passes unnoticed. In a photograph, however, it is immediately noticeable.

The view camera's cure for convergence is shown in the photograph opposite, left. The camera's back is adjusted to remain parallel to the building (eliminating the distortion), while still showing the building from bottom to top.

Another problem arises if you want to photograph a building with two sides showing. In the photograph opposite, center, the vertical lines appear correct but the horizontal lines converge. They make the near top corner of the building seem to jut up unnaturally sharp and high in a so-called ship's-prow effect. Swinging the back more nearly parallel to one of the sides (usually the wider one) reduces the horizontal convergence and with it the ship's prow (opposite, right).

CONTROLLING CONVERGING LINES: THE KEYSTONE EFFECT

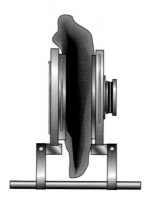

Standing at street level and shooting straight at a building produces too much street and too little building. Sometimes it is possible to move back far enough to show the entire building while keeping the camera level, but this adds even more foreground and usually something gets in the way.

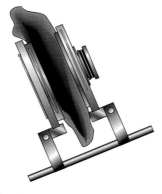

Tilting the whole camera up shows the entire building but distorts its shape. Since the top is farther from the camera than the bottom, it appears smaller; the vertical lines of the building seem to be coming closer together, or converging, near the top. This is named the keystone effect, after the wedge-shaped stone at the top of an arch. This convergence gives the illusion that the building is falling backward—an effect particularly noticeable when only one side of the building is visible.

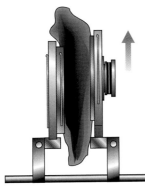

To straighten up the converging vertical lines, keep the camera back parallel to the face of the building. To keep the face of the building in focus, make sure the lens is parallel to the camera back. One way to do this is to level the camera and then use the rising front or falling back movements or both.

Another solution is to point the camera upward toward the top of the building, then use the tilting movements—first to tilt the back to a vertical position (which squares the shape of the building), then to tilt the lens so it is parallel to the camera back (which brings the face of the building into focus). The lens and film will end up in the same positions with both methods.

CONTROLLING CONVERGING LINES: THE SHIP'S-PROW EFFECT

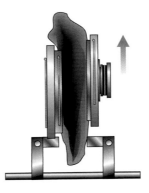

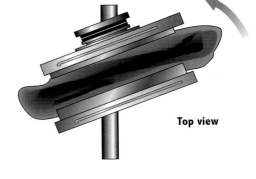

Top view

Photographing at an angle to a building can also create distortion. In this view showing two sides of a building, the camera has been adjusted as in the preceding picture. The vertical lines of the building do not converge, but the horizontal lines of the building's sides do, since they are still at an angle to the camera. This produces an exaggeratedly sharp angle, called the ship's-prow effect, at the top left front corner of the building.

To remove the ship's-prow effect, add two more movements. Swing the camera back so it is parallel to one side of the building. Here the back is parallel to the wider side. Also, swing the lens so it is parallel to the camera back, which keeps the entire side of the building in focus. It is important to check the corners of the image for vignetting when you use camera movements.

Equipment You'll Need

CAMERA EQUIPMENT

You may already have some of the following equipment.

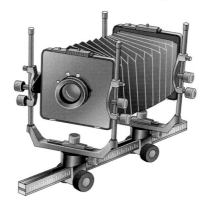

4 x 5 view camera is the most popular size. The term 4 x 5 ("four by five") describes the size of film the camera accepts—4 x 5 inches. Most camera bodies are made of metal. A few are made of wood, which is lighter to carry around, an advantage when working outdoors.

Lens is mounted in a lens board that slips into the camera's front standard (the frame that facilitates the lens movements). The lens should be suitable for large-format use, that is, produce an image circle large enough to allow for camera movements. For a 4 x 5 format, a normal focal length is 150mm, long focal length 210mm or longer, short focal length 105mm or shorter.

Sheet film holders for 4 x 5-inch film. Film is loaded before use into the reusable holder. Each holder accepts two sheets of film, one on each side. If you carry six holders, you will be able to make twelve exposures before you have to reload.

4 x 5 film of your choice. Like roll film, sheet film is made in black and white or color, in various film speeds, and for negatives or transparencies. Polaroid and Fuji make color and black-and-white self-developing films that are usable in special film holders.

Fuji and Kodak package some of their color and black-and-white sheet films in individual protective packets (called QuickLoad or Readyload) that can be handled in the light. For use, the packets slip into a matching film holder or one made for 4 x 5 self-developing film. After exposure you can take the packets directly to a lab for processing or you can open the packets and remove the film in your own darkroom.

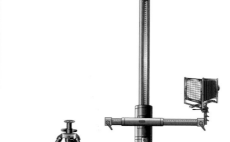

Tripod is essential. Use a tripod sturdy enough for your camera, not a tiny one designed for 35mm use. For studio use, a camera stand on wheels makes it easy to move the camera around.

Focusing cloth covers your head and the ground glass. The cloth blocks extraneous light so you can see the relatively faint ground-glass image better.

Focusing magnifier or loupe lets you fine-tune focus.

Handheld light meter is needed for exposure calculations. Automatic exposure is not a view camera feature.

Cable release lets you release the shutter without touching the camera. It's possible to release the shutter without a cable release, but if you do you are likely to introduce camera movement and consequent blur.

Carrying case usually holds everything but your tripod. A case is a must for field work and is even convenient in a studio.

Polaroid back lets you expose and process instant films.

Digital backs attach to a traditional camera to let you make digital images.

Bag (or wide-angle) bellows (shown on page 299) is useful when the lens board must be brought very close to the camera back, such as with a very short-focal-length lens. The standard accordion-type bellow becomes rigid when compressed, and allows no movements.

Bellows extensions and rail extensions let you move the lens board farther than normal from the camera back, for close-up work or to use a very long-focal-length lens.

Changing bag lets you reload your film holders when you are in the field or when a darkroom is not available.

EQUIPMENT & CHEMICALS FOR PROCESSING SHEET FILM

Sheet film hangers hold individual sheets of film for processing.

Processing tanks hold enough chemicals to process a number of sheets of film at a time.

Developing trays (such as you use for processing printing paper) can be used instead of hangers and tanks if you have only a few sheets of film to process.

Film processing chemicals are the same ones used in processing roll film.

Film washers hold film in hangers for a running water wash.

MAKING AN EXPOSURE, STEP-BY-STEP

Because a view camera is so adjustable, its use requires the photographer to make many decisions. A beginner can easily get an I-don't-know-what-to-do-next feeling. So here are some suggestions.

1 Set up the camera with the controls in zero position. Set the camera on a sturdy tripod, attach a cable release to the shutter mechanism, point the camera toward the scene, zero the movements, and level the camera (right, top). Open the shutter for viewing and open the lens aperture to its widest setting. Use a focusing cloth to see the image clearly (center).

2 Roughly frame and focus. Adjust the back for a horizontal or vertical format and use the tripod head to roughly frame the image on the ground glass. Roughly focus by adjusting the distance between the camera front and camera back. The closer you are to the subject, the more you will need to increase the distance between front and back.

3 Make more precise adjustments. To change the shape or perspective of the objects in the scene, tilt or swing the camera back. You may also want to move the position of the image on the film by adjusting the tripod or using the rise, fall, or shift movements. Check the focus again (bottom). If necessary, reposition the plane of focus by tilting or swinging the lens. You can preview the depth of field by stopping down the lens diaphragm to the aperture you intend to use to make an exposure.

4 Make final adjustments. When the image is the way you want it, tighten all the controls. Check the corners of the viewing screen for possible vignetting. You may need to decrease some of the camera movements (especially lens movements) to eliminate vignetting.

5 Make an exposure. Close the shutter, adjust the aperture and shutter speed, and cock the shutter. Insert a loaded film holder until it reaches the stop flange that positions it. Remove the holder's dark slide to uncover a sheet of film that faces the lens, make sure the camera is steady, and release the shutter. Replace the dark slide so the all-black side faces out. Your exposure is now complete. Remove the film holder.

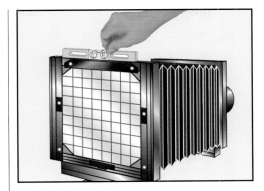

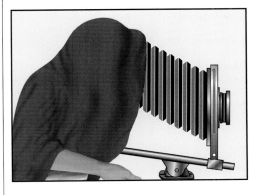

Leveling the camera. Zero the movements (sometimes called putting them in normal position) and level the camera before making any other adjustments. Zeroing is important because even a slight tilt or swing of the lens or back, for example, can distinctly change the focus. A spirit level, like a carpenter uses, levels the camera. Many cameras come with built-in spirit levels. Vertical leveling is important if you want the camera to be parallel to a vertical plane such as a building face. Horizontal leveling (left) is vital; without it the picture may seem off balance even if there are no horizontal lines in the scene.

Using a focusing cloth. The view camera's ground glass shows a relatively dim image, especially when you close down the lens to preview depth of field. A focusing cloth that covers the camera back and your head makes the image much more visible by keeping out stray light. You may not need the cloth if the subject is brightly lighted in an otherwise darkened room, but in most cases it is a necessity. Some photographers like a two-layer cloth—black on one side and white on the other—to reflect heat outdoors and to double as a fill-light reflector.

Checking the focus. A hand-held magnifier, or loupe, is useful for checking the focus on the ground glass. Check the depth of field by examining the focus with the lens stopped down. Examine the ground glass carefully for vignetting if camera movements (especially lens movements) are used. If the ground glass has cut corners, like the one shown here, you can check for vignetting by looking through one of the corners at the shape of the lens diaphragm. If there is no vignetting, the diaphragm will appear rounded—and not pointed—at its ends.

Loading and Processing Sheet Film

Load film in total darkness into sheet-film holders that accept two sheets of film, one on each side. Each sheet is protected by a light-tight dark slide that you remove after the holder is inserted in the camera for exposure. After exposure, but before you remove the holder from the camera, insert the holder's slide with the all-black side facing out. This is the only way to tell that the film below it has been exposed and to avoid an unintentional double exposure.

The film must be loaded with the emulsion side out; film loaded with the backing side out (facing toward the lens during exposure) will not produce a usable image. The emulsion side is determined by finding the code notches in one corner that identify the kind of film. When the film is in a horizontal position, the notches are in the lower right-hand (or upper left-hand) corner when the emulsion side of the film faces you.

Developing sheet film follows the same basic procedure as developing roll film, except for the way the film is held during development. Three tanks or trays are used—for developer, stop bath, and fixer. Add a fourth step, a water presoak before development, to tray development but not with tanks and hangers. The film is agitated and transferred from one solution to the next in total darkness. Fill tanks with enough solution to more than cover film in hangers. If you use trays, use at least one size larger than the film—5 x 7 trays for 4 x 5 film—and fill them deep enough for the number of sheets to be developed. One inch of liquid is probably a minimum.

Check the instructions carefully for the proper development time. The time will depend on whether you use intermittent agitation in a tank (usually stated as the time for "deep" tanks) or constant agitation in a tray.

LOADING SHEET FILM

Dusting holders. It is a good idea to dust the film holders each time before loading them. This is usually less trouble than trying to retouch the spots on your image caused by dust on the unexposed film. A soft, wide paintbrush (used only for this purpose) or a negative brush works well; canned air or a bulb syringe also helps. Dust both sides of the dark slide, under the film guides, and around the bottom flap. Tapping the top of the holder can help dislodge dust inside the slot where the dark slides are inserted.

Finding the notches. Sheet film has notches on one edge—a different set for each type of film—so you can identify it and determine the emulsion side. The notches are always located so the emulsion side is facing you when the film is in a horizontal position and the notches are in the lower right-hand corner. Load the film with the holder in your left hand and the film in your right with your index finger resting on the notches. (If you are left-handed you may want to load with the holder in your right hand and the film in your left.) Touch only the edges.

Checking film insertion. Open the bottom flap. Insert the film in the flap end of the holder underneath narrow guides. The guides for film are below the set of guides that the dark slide fits into. If you rest your fingers lightly on top of the guides you can feel even in the dark if the film is loading properly. Also make sure that the film is inserted all the way past the raised ridge at the flap end. When the film is in, hold the flap shut with one hand while you push the dark slide in with the other.

Unexposed/exposed film. The dark slide has two different sides—one all black, the other with a white (or, in older holders, bare metal) band at the top—so you can tell if the film in the holder is unexposed or exposed. When you load unexposed film, insert the slide with the white band facing out (top). After exposure, reinsert the slide with the black band facing out (bottom). The white band also has a series of raised dots or notches so you can identify it in the dark.

PROCESSING SHEET FILM

Loading hangers. Tank processing using film hangers is a convenient way to develop a number of sheets of film at one time. Load the hanger in the dark. First, spring open its top channel. Then slip the film down into the side channels until it fits into the bottom channel. Spring back the top channel, locking the film in place. Stack loaded hangers upright against the wall until all the film is ready for processing. Even better, use a clean, dry processing tank to collect the hangers as you load them. Handle them carefully.

Tank processing. Hold the stack of loaded hangers in both hands with your forefingers under the protruding ends. Don't squeeze too many hangers into the tank; allow at least 1/2 inch of space between hangers. To start development, lower the stack—carefully but not slowly—into the developer. Tap the hangers sharply against the top of the tank to dislodge any air bubbles from the film. Make sure the hangers are separated. Immediately begin to agitate the film.

Tank agitation. Agitation for tank development takes place for the first minute, and 15 sec for each successive minute of development time. Lift the entire stack of hangers completely out of the developer. Tip it almost 90° to one side to drain the developer from the film. Replace it in the developer. Immediately lift the stack again and tilt almost 90° to drain to the opposite side. Replace in solution. These two operations together should take about 15 sec. Remove and replace hangers smoothly. Too-rapid motion will cause noticeable overdevelopment at edges.

Tray processing. If you have just a few sheets of film to develop, you can process them in trays. Fan the sheets so that they can be grasped quickly one at a time. Hold the film in one hand. With the other hand take a sheet and completely immerse it, emulsion side up, in the developer. Repeat until all sheets are immersed. (A water presoak before development is useful to prevent the sheets from sticking to each other.) If you are chemically sensitive, you may find tank development easier; individual sheets of film are not always easy to handle while wearing protective gloves.

Tray agitation. All the film should be emulsion side up toward one corner of the tray. Slip out the bottom sheet of film and place it on top of the pile. Gently push it under the solution. Continue shuffling the pile of film a sheet at a time until the end of the development period. If you are developing only a single sheet of film, agitate by gently rocking the tray back and forth, then side to side. Be careful handling the film; the emulsion softens during development and scratches easily. As with roll film, complete the processing with stop bath, fixer, and a washing aid.

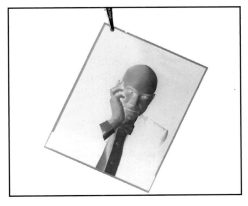

Washing and drying. Commercial film washers do the job best, but a few loose sheets of film at a time can be washed in a tray. Regulate the water flow carefully to avoid excessive swirling that could cause scratching. Film in hangers can be washed in a tank and then hung up to dry right in the hangers or sheets can be clipped to a line to dry as shown above. Separate the film enough so that the sheets do not accidentally stick together. A quick soak in a wetting agent such as Kodak Photo-Flo after washing will prevent water spots.

GEORGE TICE Petit's Mobil Station, Cherry Hill, New Jersey, 1974

Night photographs pose challenging extremes of contrast that the Zone
System can help you tame. Tice shoots with an 8 x 10 view camera; each sheet
of the large-format film can be developed separately according to the way he
wants to render the particular scene recorded on it.

the zone system

Have you ever looked at a scene and known just how you wanted the final print to appear? In the Zone System, this is called visualization. Sooner or later every photographer has this experience. Sometimes the image turns out just the way you expected, but as often as not for the beginning photographer, the negative you end up with makes it impossible to produce the print you had in mind. For example, the contrast range of a scene (the difference between its lightest and darkest parts) is often greater than the contrast range of normally processed photographic materials. The result is highlights so light and/or shadows so dark that details in them are lost.

The Zone System is a method for controlling the black-and-white photographic process. Conceived by Ansel Adams and Fred Archer, it organizes the many decisions that go into exposing, developing, and printing a negative. Briefly, it works this way: You make exposure readings of the luminances (the lightness or darkness) of important elements in a scene. You decide what print values (shades of gray) you want these elements to be in a final print. Then you expose and develop the film to produce a negative that can, in fact, produce such a print.

The Zone System lets you visualize how the tones in any scene will look in a print and to choose either a literal recording or a departure from reality. Even if you continue to use ordinary exposure and development techniques, understanding the Zone System will help you apply them more confidently. This chapter is a brief introduction to the Zone System. See the Bibliography for books that tell how to put it into full use.

The Zone System has four scales that describe how light or dark an area is. See the scales shown at right.

Subject values describe the amount of light reflected or emitted by various objects in a scene. Subject values can be measured by a reflected-light meter. A low or dark subject value produces a low meter reading; a high or light subject value produces a high meter reading. Each division of this scale is one stop away from the next (it produces either half or twice the negative exposure). Subject values are easiest to meter with a handheld meter (a spot meter is best), but with a little number juggling you can determine them with a meter built into a camera (see page 310 bottom).

Negative-density values describe the amount of silver in various parts of the negative after it has been developed. Clear or thin areas of a negative have little or no silver; dense areas have a great deal of silver. These values can be measured by a densitometer, a device that gauges the amount of light stopped or passed by different portions of the negative.

Print values describe the amount of silver in various parts of a print. The darkest areas of a print have the most silver, the lightest areas have the least. These values can be measured by a reflection densitometer if desired but are ordinarily simply evaluated by eye in terms of how light or dark they appear.

The Zone scale is crucial because it links the values on the other three scales. It provides descriptions of values to which subject values, negative-density values, and print values can be compared. If you famliarize yourself with the divisions of the zone scale (opposite page), you will be able to visualize the final print. The zones aid you in examining subject values, in deciding how you want them to appear as print values, and in then planning how to expose and develop a negative that will produce the desired print.

The zone scale has 11 tones, based on Ansel Adams's description in his book *The Negative*. There are more than 11 shades of gray in a print, of course—Zone VII, for example, represents all tones between Zones VI and VIII—but the 11 zones provide a convenient means of visualizing and identifying tones in the subject, the negative, and the print.

In Ansel Adams's original version of the Zone System, he divided the zone scale into ten segments (0–IX). When he retested newer film and paper, he revised the zone scale to eleven segments (0–X). The information here is based on the current version of the system.

Some commonly photographed surfaces are listed on the opposite page in the zones where they are often placed if a realistic representation is desired; average light-toned skin in sunlight, for example, appears realistically rendered in Zone VI.

Zone 0 (zero) is the deepest black print value that photographic printing paper can produce, resulting from a clear area (a low negative-density value) on the corresponding part of the negative, which in turn was caused by a dark area (a low subject value) in the corresponding part of the scene that was photographed.

Zone X is the lightest possible print value—the pure white of the paper base, a dense area of the negative (a high negative-density value), and a light-toned area in the scene (a high subject value).

Zone V corresponds to a middle gray, the tone of a standard-gray test card of 18 percent reflectance. A reflected-light exposure meter measures the lightness or darkness of all the objects in its field of view and then gives an exposure recommendation that would render the average of those tones in Zone V middle gray.

ZONE SYSTEM SCALES

The Zone System's four scales describe the lightness or darkness of a given area at the various stages in making a photograph. The divisions of the scales are labeled with roman numerals to avoid confusion with f-stops or other settings.

LOW METER READING **HIGH METER READING**

Subject values are measured when metering a scene and range from dark shadows to bright highlights. Each value meters one stop from its neighbor. Only 11 subject values are shown here, but more will be present in a very high-contrast scene, such as a brightly sunlit location that also contains deeply shadowed areas. The same location on a foggy or overcast day will contain fewer than 11 values.

LITTLE OR NO SILVER **DENSE SILVER**

Negative-density values are those present in the developed negative. Film can record a somewhat greater number of values than the 11 shown here.

MAXIMUM BLACK SILVER **WHITE PAPER BASE**

Print values are visible in the final print. Printing paper limits the usable range of contrast. Black-and-white printing paper can record about 11 steps from maximum black to paper-base white.

| 0 | I | II | III | IV | V | VI | VII | VIII | IX | X |

Zones tie the other scales together. They give you a means of planning how light or dark an area in a subject will be in the final print.

Zone X. Five (or more) stops more exposure than Zone V middle gray. Maximum white of the paper base. Whites without texture: glaring white surfaces, light sources.

Zone IX. Four stops more exposure than Zone V middle gray. Near white. Slight tonality, but no visible texture: snow in flat sunlight.

Zone VIII. Three stops more exposure than Zone V middle gray. Very light gray. High values with delicate texture: very bright cement, textured snow, highlights on light-toned skin, the lightest wood at right.

Zone VII. Two stops more exposure than Zone V middle gray. Light gray. High values with full texture and detail: very light surfaces with full sense of texture, sand or snow with acute side lighting.

Zone VI. One stop more exposure than Zone V middle gray. Medium-light gray. Lighted side of average light-toned skin in sunlight, light stone or weathered wood, shadows on snow in a scene that includes both shaded and sunlit snow.

Zone V. Middle gray. The tone that a reflected-light meter assumes it is reading and for which it gives exposure recommendations. 18 percent reflectance neutral-gray test card, clear north sky, dark skin.

Zone IV. One stop less exposure than Zone V middle gray. Medium-dark gray. Dark areas with full texture and detail: dark stone, average dark foliage, shadows in landscapes, shadows on skin in sunlit portrait.

Zone III. Two stops less exposure than Zone V middle gray. Dark gray. Darkest shadow areas with texture and detail: very dark soil, very dark fabrics with full texture, the dark boards at right.

Zone II. Three stops less exposure than Zone V middle gray. Gray-black. Darkest area in which some suggestion of texture will appear in the print.

Zone I. Four stops less exposure than Zone V middle gray. A near black with slight tonality but no visible texture.

Zone 0. Five (or more) stops less exposure than Zone V middle gray. Maximum black that photographic paper can produce. The opening to a dark interior space, the open windows at right.

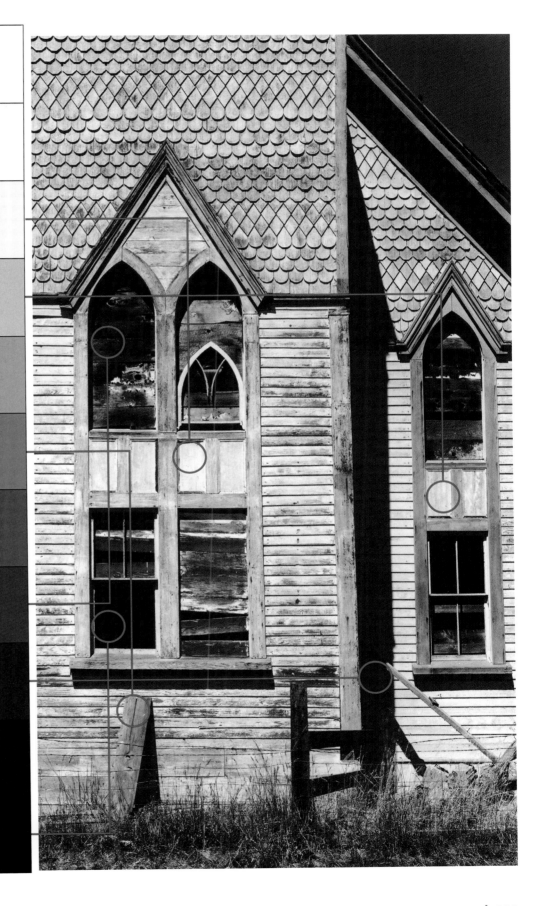

Know the limits of your materials. When you are standing in front of a subject and visualizing how it might look as a black-and-white print, you have to take into account that ordinary photographic materials given normal exposure, development, and printing cannot record with realistic texture and detail the entire range of luminances (subject tones) in many scenes. For example, a scene in bright sunlight can generally be rendered with texture and detail in either dark shadows or bright highlights but not both. Usually, you have to choose those areas in which you want the most detail in the print and then expose the negative accordingly.

With practice, you can accurately visualize the black-and-white tones in the final print by using the zone scale described on the preceding pages plus a reflected-light exposure meter, either handheld or built into a camera. (An incident-light meter cannot be used because it measures the light falling on the scene, and you will need to measure the luminances of individual areas.)

When you meter different areas, you can determine where each lies on the zone scale for any given exposure. Metering must be done carefully to get consistent results. Try to read areas of more or less uniform tone; the results from an area of mixed light and dark tones will be more difficult to predict. It is important to move in close enough to the subject to make readings of individual areas, but not so close that you cast a shadow on an area as you meter it. A spot meter is useful for reading small areas or those that are at a distance.

The meter does not know what area is being read or how you want it rendered in the print. It assumes it is reading a uniform middle-gray subject tone (such as a neutral-gray test card of 18% reflectance) and gives exposure recommendations accordingly. The meter measures the total

amount of light that strikes its light-sensitive cell from an area, then, taking into account the film speed, it calculates f-stop and shutter speed combinations that will produce sufficient negative density to reproduce the area as middle gray in a print.

If you choose one of the combinations of f-stop and shutter-speed that are recommended by the meter, you will have placed the metered area in Zone V. It will reproduce as middle gray in the print (print Value V). By altering the negative exposure you can place any one area in any zone you wish. One stop difference in exposure will produce one zone difference in tone. For example, one stop less than the recommended exposure places a metered area in Zone IV; one stop more places it in Zone VI.

Once one tone is placed in any zone, all other luminances in the scene fall in zones relative to the first one. Where tones fall depend on whether they are lighter or darker than the tone you placed, and by how much. Suppose a medium-bright area gives a meter reading of 7 (see meter, right, and photograph, opposite). Basing the exposure on this value (by setting 7 opposite the arrow on the meter's calculator dial) places this area in Zone V. Metering other areas shows that an important dark wood area reads two stops lower (5) and falls in Zone III, while a bright wood area reads three stops higher (10) and falls in Zone VIII.

A different exposure could have been chosen, causing all of the zones to shift equally lighter or darker (opposite, far right). For instance, by giving one stop more exposure you could have lightened the tones of the dark wood, placing them in Zone IV instead of III, but many of the bright values in the lightest wood would then fall in the undetailed white Zone IX. The Zone System allows you to visualize your options in advance.

COUNTING ZONES WITH A HAND-HELD REFLECTED-LIGHT METER

Some exposure meters make zone readings easy. With multiple positions visible on a dial, each measures a luminance (subject value) one stop—or one zone—from the next position. Suppose that metering a medium-toned area gives a reading of 7. Setting 7 opposite the arrow on the calculator dial places this area in Zone V. A lighter area meters 10, so it falls three zones lighter, in Zone VIII. A dark area meters at 5 and falls in Zone III. The first area metered will appear in the print as middle-gray print Value V, the bright wood as very light gray print Value VIII, and the dark wood as dark-gray print Value III (with standard negative development and printing). Zones can be counted in the same way if your meter shows EV (exposure value) numbers, which also are one stop apart.

The meter shown here has an angle of view of about 30–50°, about the angle of view of a normal-focal-length lens. A spot meter, which can read 5° or less, can make readings of very small areas or those that would otherwise be too far away to read, such as on the upper part of the house. Many handheld meters display only one aperture/shutter-speed combination at a time. If you have one, use the steps below.

USING EXPOSURE SETTINGS TO COUNT ZONES

What do you do if you can't read the difference in subject values (and so, the difference in zones) directly off the meter dial, as you can with the meter above? With a meter built into a camera or most digital meters, you can use the shutter speed and aperture combination displayed for a given reading. You will be able to find the various zones if you count the number of stops between exposure settings for different areas.

Suppose that metering the scene at right suggests exposures of f/5.6 at 1/60 sec for one area and f/16 at 1/60 sec for a lighter area. The area that metered f/16 is three stops (or zones) lighter than the area that metered f/5.6 (f/5.6 to f/8 is one stop; f/8 to f/11, two stops; f/11 to f/16, three stops). Placing the darker area in Zone V will cause the other to fall in Zone VIII, three zones higher.

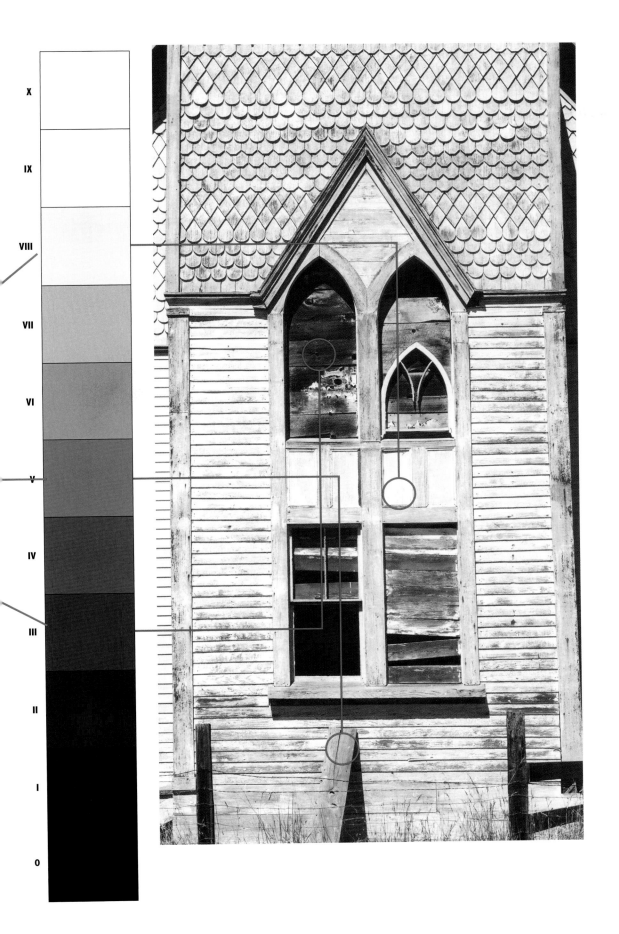

One stop difference in negative exposure creates one zone difference in all areas (if other factors remain the same). The negative exposure for the top print was one stop less than that given to the photograph at left. The negative exposure for the bottom print was one stop more than that for the photograph at left. All the values changed one zone with one stop difference in exposure.

How Development Controls Contrast

Exposure plus development affect the tones in a scene. You can place any one subject value in any zone you desire. You can also predict in which zones the other subject values will fall. But exposure is still only half the story in producing a negative. You may want to decrease contrast if the subject has too great a range of values. Or if the subject has only a narrow range of values, you may want to increase contrast so that the print doesn't look flat and dull.

Development can change the highlights and, as a result, control the overall contrast of the negative. The most common way to adjust contrast is to change the contrast grade of the paper—print a high-contrast negative on low-contrast paper and vice versa. But another way to change contrast is to change the development time of the negative.

Increasing development increases contrast, decreasing development decreases contrast. High values will shift considerably with changes in development time, but low values change little or not at all. Middle values change somewhat, although not as much as the upper ones.

This happens because the developer quickly reduces to silver the relatively few silver halide crystals that were struck by light in the slightly exposed shadow areas. Development of shadow areas is completed long before all the crystals in the greatly exposed highlight areas convert to silver.

The longer a negative is developed (up to a limit), the greater the silver density that develops in high values, while the shadow densities remain about the same. And the greater the difference between high-value and low-value densities, the greater the contrast.

There are advantages to adjusting the negative's contrast. A negative that prints with a minimum of dodging and burning on a normal-contrast paper is easier to print than, for example, a contrasty negative with dense highlights that require considerable burning. Even with an image that requires no burning or dodging, controlling contrast with development almost always results in a better-looking print than trying to make adjustments later with paper contrast.

Increased development *created more contrast by increasing the density of the high values in the negative. High values, such as the sidewalk, are lighter in this print than in the print (below) made from a normally developed negative.*

Normal development *was given to the negative.*

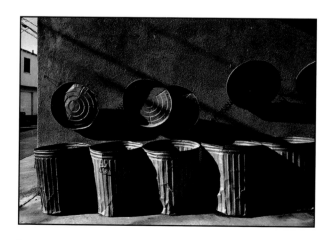

Decreased development *reduced the contrast by decreasing the density of high values, which now appear darker in the print.*

The length of time a negative is developed has an important effect on the contrast. The three versions of this scene received identical negative exposures and identical printing. Only the development time was changed. The highlights got lighter when development was increased and became darker when development was decreased.

Hence, the old photographic rule: Expose for the shadows, develop for the highlights. You can change the density of highlights (and the contrast) by changing the development, but low shadow values are set during exposure and remain about the same with any development.

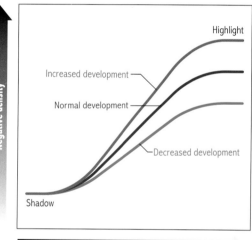

Expansions

Values as metered	Values after development	Values as metered

Contractions

Values as metered	Values after development	Values as metered

Changing the development time changes mostly the high values in a negative. Development control of high values can be quite precise. If an area is placed in Zone VIII during exposure, it will appear as a negative-density Value VIII if the film is given normal development. That same area could be developed to a Value VII with less development or to a Value IX with more development.

In Zone System terms, N stands for normal development. Values remain where they were placed or fell during an exposure. An area falling in Zone VII would appear as a negative-density Value VII and (given normal printing) as print Value VII.

An expansion (Normal-Plus development) is produced by increasing development time. As development time increases, subject values increase to higher values on the negative and contrast is increased. With N + 1 (normal-plus-one) development, a high value such as Zone VII would be increased one zone to Zone VIII. N + 2 indicates a greater expansion; a Zone VII value would be increased two zones to Zone IX.

A contraction (Normal-Minus development) is produced by decreasing development time. Subject values (and contrast) are reduced by decreasing the development time. With N–1 (normal-minus-one) development, a Zone IX value moves one zone down to Zone VIII. N–2 development is a greater contraction, down two zones.

Testing is the best way to determine your own development times. The tests, covered in detail in the books listed in the Bibliography, establish five standard elements for the individual photographer: actual film speed, normal development time, expanded development times, contracted development times, and standard printing time. Personal testing is recommended since cameras, meters, films, enlargers, papers, developers, and personal techniques all affect the results.

However, here are some rough guidelines for expanded and contracted development that you can use without testing and that will be helpful for approximate control of contrast.

- Use the manufacturer's stated film-speed rating to calculate the exposure.
- For normal development, use one of the manufacturer's suggested time and temperature combinations.
- For N + 1 expanded development, increase the development time 25%. If the recommended development time is 8 min for a given combination of film, developer, and temperature, then the high values can be shifted up one zone each by a 10 min development. For N + 2 expansion, increase the time 50%.
- For N–1 contracted development, which will shift the high values downward one zone each, develop for 80% of the normal time. For N–2 contraction, develop for 60% of the normal time.
- Compared to other films, Kodak T-Max films require less of a change in development time to produce a comparable change in negative density; change the time about half as much as you do with other films.

Changing the development time is easy with sheet film, since each exposure can be given individual development. With roll film, changing the contrast grade of the paper is often more practical.

The Zone System has four basic steps.

1. Visualize the final print. Decide how you want the print to look before you take the picture. For example, which dark or light areas do you want to show good detail.

2. Meter the most important area in the scene and place it in the zone where you want it rendered. Often this is the darkest area in which you want full texture (usually Zone III-1/2 or IV). Where you place a value determines your exposure.

3. Meter other areas (especially the lightest area in which you want full texture) to see in which zones they fall in relation to the area you have placed.

4. Make development choices. If you want the negative-density values to correspond to the relative luminances of various areas in the scene, develop the negative normally. Change the development time if you want to change the densities of the upper values while leaving the lower values about the same. Increasing the time increases the negative densities of the high values (which will make those areas lighter in the print) and also increases the contrast. Decreasing the development time decreases the negative densities of the high values (they will be darker in the print) and decreases the contrast.

You could also plan to print on a contrast grade of paper higher or lower than normal to control densities and contrast. A change of one printing paper contrast grade causes about a one-zone shift in the high values (when low values are matched in tone).

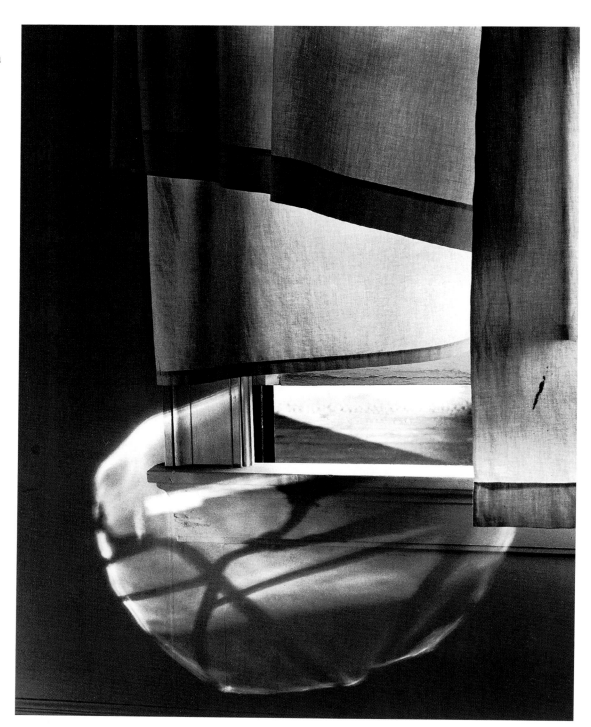

MINOR WHITE Windowsill Daydreaming, Rochester, New York, 1958

Minor White's name is often associated with the Zone System. He was an influential teacher who stressed the use of the system as a tool for the creative photographer. "A conversation with light," a phrase White used to describe the work of Alfred Stieglitz (page 365), might also characterize this image of sunlight caressing a windowsill. Reproduced with permission of the Minor White Archive, Princeton University Art Museum. Copyright © The Trustees of Princeton University

Using the Zone System with roll film. It is easy to change the development time with view camera photography, where sheets of film can be processed individually. But changing the development time can be valuable with roll film even though a whole roll of exposures is processed at one time. Sometimes a single image or situation is so important that it deserves special development; the other images on the roll will probably still be printable, possibly on a different grade of paper. Or better, you can shoot an entire roll under one set of conditions so it can be exposed and processed accordingly. Be cautious with increased development of roll film, though, as grain will increase too.

With roll film, you can also plan on changing printing paper contrast for some negatives on the roll. It is essential to give enough exposure to dark areas to produce printable densities in the negative while at the same time attempting to keep bright areas from becoming too dense to be printable. For example, if trial metering indicates about one stop too much contrast (that is, with shadows placed in Zone III, the high values in which you want full detail fall in Zone VIII or IX), contracted development for the entire roll will be useful. Most of the frames shot will print on a normal-contrast grade of paper; those shot under more contrasty conditions will print on a low-contrast grade; those shot in the shade (now low in contrast because of contracted development) will print on a high-contrast grade.

Using the Zone System with color film. With color materials, the Zone System provides a way to place a specific value and check where other values will fall. Changing development time to control contrast is not usually recommended for color materials because it produces unpredictable shifts in the color balance.

With color negatives, place the most important shadow value, just as you would with a black-and-white negative. Overly bright highlights can usually be darkened later during printing. If you want to experiment with using development to control contrast, try increasing the time in Kodak C-41 developer by about 20 percent; to decrease contrast try decreasing the time about 15 percent. Some color printing papers, such as Fujicolor Crystal Archive or Kodak Ektacolor, also permit some contrast control.

With color transparencies, correct exposure is vital because the film in the camera is the final viewing product. High values in a transparency lose texture and detail more easily than shadows do, so meter and place the most important light area rather than a dark area as you would with negative film. If you want a light area to retain texture, place it no higher than Zone VII. If you are not sure about the exposure, underexpose a bit rather than overexpose. Make sure skin tones are exposed correctly.

ALLEN HESS First Deck of the Steamer *President,* New Orleans, Louisiana, 1976

Hess used a roll-film camera with interchangeable backs. Carrying several rolls of film, each loaded in a different back, lets him put all the exposures that need a minus development—like this one—on the same roll of film.

photographer
at WORK

Using the Zone System—John Sexton

John Sexton was a photo student when he first encountered the Zone System. He attended an Ansel Adams lecture and then a workshop. Later, he became one of Adams's darkroom assistants, and now photographs and teaches photography workshops himself.

Sexton sees the Zone System as a communication process. The collaborators are the photographer and the materials. "But," he says, "most people don't listen to what the negative and the paper say to them visually. They don't really look at the results."

"The Zone System is simple," Sexton says, "once you understand that it's all about visualization," in other words, thinking ahead to how you want the print to look. There's nothing exotic about that, he says: "Everybody visualizes, from someone with a disc camera to someone with an 8 x 10 view camera. It's the only reason you press the shutter release. And most of us visualize something that is outside of the limitations of the material. If you start thinking, 'I may have to burn in the upper right corner,' you are visualizing. I used to hope a negative 'turned out.' I was really thinking about the print it might make."

"If people understand nothing else," he says, "they should understand that when you point a reflected-light meter at something, you are going to get middle gray. Exposure is the only way you can control shadow density, while exposure and development control the highlights." He recommends, "If in doubt, don't underexpose. If in doubt, don't overdevelop. Make a negative that gives you options. Your options are limited if you have thin shadows or bulletproof highlights. If you've got shadow detail and highlight detail, there's a lot you can do in the darkroom."

JOHN SEXTON Corn Lilies, Dusk, Yosemite National Park, California, 2002

Sexton photographed these corn lilies in a boggy meadow under the soft glow of evening twilight. He wanted more contrast than the scene provided, so he gave the film an N + 1 expanded development. To further increase the contrast, he then printed it on a grade 3 paper.

USING TORN PAPER TESTS FOR DODGING AND BURNING

When making a print, John Sexton almost always dodges to lighten some areas and/or burns to darken others. The question is: How much should a print be dodged or burned for best results? He begins by making a test strip to determine his basic exposure, then makes a straight print without dodging or burning.

Making a set of test patches. He examines the print and decides where he might want to dodge or burn. He tears a fresh sheet of printing paper into pieces to go over the areas he wants to see manipulated, fitting together a sort of jigsaw puzzle of the print. On the back of each piece of paper, he writes the planned amount of dodging or burning for that area. Once all the pieces are in place on the printing easel, he gives the exposure that produced a good straight print, dodging the appropriate areas as planned. He then burns the areas as planned.

Making a second set of patches. He sets aside the pieces of paper, then repeats the procedure with another set of torn pieces, doubling every manipulation. For example, if he had planned to dodge an area for 5 sec, he now dodges that same area for 10 sec. He gathers all the pieces of paper and develops them.

Evaluating the patches. After fixing, he turns on the white lights, puts his straight print on his print viewing area (shown right, bottom) and positions the torn pieces around the print. If he wants to see what the area dodged for 5 sec looks like, he positions that piece over the print. If it's not light enough, he'll try the piece dodged for 10 sec. And so on. Once he has assembled a print that begins to feel fairly close to the image he wants, he turns the torn pieces over to find the time for dodging or burning each area, creating a plan for the final print.

The benefit of this torn-paper procedure is that you can try various combinations of dodging and burning, without using sheet after sheet of paper. Lay a manipulated area over the straight print, look at it for a while, then quickly peel it off. You'll know right away which looks better, and much more accurately than if you had simply dodged or burned without testing.

ANNE LARSEN John Sexton in His Darkroom, 2003

JOHN SEXTON Coal Conveyor at Night, Alma, Wisconsin, 1987

Contracted development made this contrasty scene more printable. *The lighting on this coal conveyor at night was extremely contrasty. The lights on the coal conveyor provide the only illumination, and are themselves in the photograph. The 30-min exposure that was required made the scene even more contrasty due to reciprocity failure from a very long exposure (explained on page 77). In order to keep detail in both shadows and highlights, Sexton gave ample exposure and greatly reduced development to the negative.*

Sexton advises students to use the same tool that is the most important one in his darkroom: the trash can. "That's where most of my prints end up," he says. "Most of the prints I make are for my eyes only. As a photographer, I think you need to be constantly making mistakes: technical mistakes and aesthetic mistakes. As soon as you're no longer making either, you're probably done with that body of work. By risking mistakes, now I can get things on film that ten years ago I wouldn't have known how to handle."

EDWARD BURTYNSKY Nickel Tailings #32, Sudbury, Ontario, 1996

Seeing beauty in the poisonous is a way to draw attention to a problem.
Contamination from decommissioned and abandoned mines is measured, stud-
ied, discussed, and legislated, but the visual impact of a well-seen photograph
can bring attention quickly to an issue.

MARION POST WOLCOTT Planting Corn Along a River in Tennessee, 1940

This is among the earliest examples of color documentary photography.
Wolcott worked for the FSA (Farm Security Administration), which made a
well-known record—in black and white—of the American Depression of the
1930s. Less well known are the group's color photographs made within a few
years of the introduction of Kodachrome film.

How do you learn to make better pictures? Once you know the technical basics,
where do you go from there? Every time you make an exposure you make choices, either
deliberately or accidentally. Do you show the whole scene or just a detail? Do you make
everything sharp from foreground to background or have only part of the scene in focus? Do you use a
fast shutter speed to freeze motion sharply or a slow shutter speed to blur it?

**Your first step is to see your options, to see the potential photographs in front
of your camera.** Before you make an exposure, try to visualize the way the scene will look as a
print. Looking through the viewfinder helps. The scene is then at least reduced to a smaller size and
confined within the edges of the picture format, just as it will be in the print. As you look through the
viewfinder, imagine you are looking at a print, but one that you can still change. You can eliminate a dis-
tracting background by making it out of focus, by changing your position to a better angle, and so on.

Try to see how a picture communicates its visual content. Photography transforms a
three-dimensional event into a frozen instant reduced in size on a flat piece of paper, sometimes in black
and white instead of color. The event is abstracted, and even if you were there and can remember how it
"really" was, the image in front of you is the tangible remaining object. This concentration on the actual
image will help you visualize scenes as photographs when you are shooting.

One of your first choices is how much of a scene to show. Whether the subject is a person, a building, or a tree, beginners often are reluctant to show anything less than the whole thing. People often photograph a subject in its entirety—Grandpa is shown from head to toe even if that makes his head so small that you can't see his face clearly. In many cases, however, it was a particular aspect of the subject that got the photographer's attention in the first place, perhaps the expression on the face of the person, the peeling paint on the building, or a bent branch of the tree.

Get closer to your subject. "If your pictures aren't good enough, you aren't close enough," said Robert Capa, a war photographer known for the intensity and immediacy of his images (see his photograph on page 107). This simple piece of advice can help most beginning photographers improve their work. Getting closer eliminates distracting objects and simplifies the contents of a picture. It reduces the confusion of busy backgrounds, focuses attention on the main subject, and lets you see expressions on people's faces.

What is your photograph about? Instead of shooting right away, stop a moment to decide which part of a scene you really want to show. You might want to take one picture of the whole scene, then try a few details. Sometimes you won't want to move closer, as in photographing a prairie landscape where the spacious expanse of land and sky is important or in making an environmental portrait where the setting reveals something about the person.

Try to visualize what you want the photograph to look like. Then move around as you look through the viewfinder. Examine the edges of the image frame. Do they enclose or cut into the subject the way you want? In time, these decisions come more intuitively, but it is useful at first to work through them deliberately.

ARTHUR SIEGEL Right of Assembly, 1939

Siegel shot from a high vantage point to get in as much of this street demonstration as possible. He wanted to show each demonstrator to be an individual expressing a common belief, so he filled the frame with them and tried to get them all in sharp focus.

JEROME LIEBLING Cop's Hat, Union Square, New York, 1948

A detail of a scene can tell as much as and sometimes more than an overall shot. Liebling shot from below eye level, a humble vantage point, and intentionally used a very wide aperture to get very shallow depth of field. In the entire photograph, only the policeman's hat is in focus and the eye is drawn to it. A very small part of an image—like the badge here—can carry considerable symbolic weight.

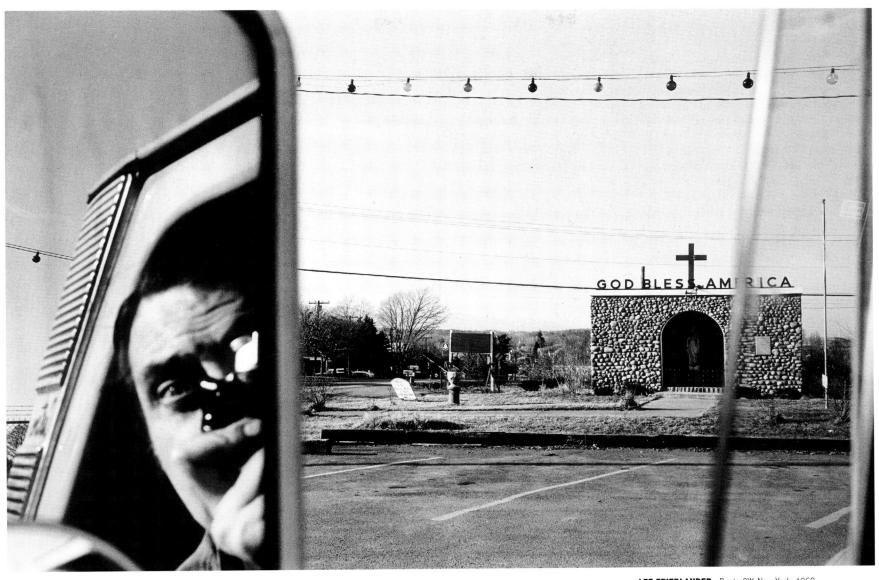

LEE FRIEDLANDER Route 9W, New York, 1969

Combining different elements in a scene can bring order out of chaos or sometimes a sense of dislocation to the ordinary. *Lee Friedlander wrote, "The camera is not merely a reflecting pool. . . . The mind-finger presses the release on the silly machine and it stops time and holds what its jaws can encompass and what the light will stain. That moment when the landscape speaks to the observer."*

The frame (the edges of a picture) isolates part of a larger scene. Photography is different from other visual arts in the way in which a picture is composed. A painter starts with a blank canvas and adds marks or shapes until it is complete. A photographer generally starts with a complete and seamless world and uses the frame of the viewfinder to select a portion of a scene so everything else is discarded. One process adds, the other subtracts.

Every time you make an exposure you make choices about framing—consciously or not. How do the edges of the picture influence the part of the scene that is shown? You can leave considerable space between the frame and a particular shape, bring the frame very close so it almost touches the shape, or use the frame to crop or cut into the shape. You can position an edge of an object or a line within an object so that it is parallel to one edge of the frame or position it at an angle to the frame. Such choices are

important because the viewer, who can't see the surroundings that were left out of the picture, will see how the frame meets the shapes in the print.

There is no need to be too analytical about this, but be attentive. Try looking at the edges of the viewfinder image as well as at the center of the picture and then move the frame around until the image you see through the viewfinder seems right to you. You can also cut a small rectangle in an 8 x 10-inch piece of black cardboard and look through the opening at a scene. Close one eye when you do, to see more like your lens. Such a frame is easier to move around and see through than a camera and can help you visualize your choices.

Judicious cropping can strengthen a picture but awkward cropping can be distracting. Ordinarily it is best not to cut off the foot of someone in motion or the hand of someone gesturing, but the deliberate use of such unconventional cropping can be

effective. Some pictures depend on the completion of a gesture or motion and make it difficult or impossible to crop into the subject successfully.

Portrait photographers recommend that you do not crop a person at a joint, such as a wrist or knee, because that part of the body will look unnaturally amputated or will seem to protrude into the picture without connection. It can also seem awkward if the top of a head or an elbow or a toe just touches the edge of the frame. Generally, it is better to crop in slightly or to leave a space.

Should your picture be horizontal or vertical? It is common for beginners to hold a camera horizontally, and only occasionally turn it to a vertical position. Unless you have a reason for doing otherwise, hold the camera horizontally for a horizontal subject, vertically for a vertical one. Otherwise, you are likely to create empty space that adds nothing to the picture.

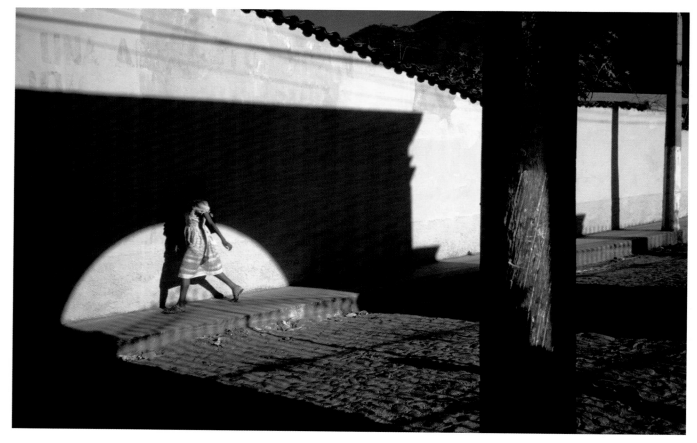

ALEX WEBB Ajijic, Mexico, 1983

How does the frame of a photograph (its edges) enclose a subject? How much space, if any, is needed around a subject? You may overlook framing when you are shooting, but it will be immediately evident in the final picture. Left, would you crop anything in this picture, or do you like it as it is?

PAUL SIMCOCK Businessmen, New York

The frame can define the visual subject of a photograph. *Here, it is the shadows, not the men themselves.*

The background is part of the picture—obvious, but easy to forget. Most photographs have a particular object or group of objects as a center of interest. When we look at a scene, we tend to focus our attention on whatever is of interest to us and ignore the rest, but the lens includes everything within its angle of view.

What do you do when your subject is in front of a less interesting or even distracting background? If background objects don't add anything to a picture except visual clutter, do what you can to eliminate them or at least to minimize their importance. Usually it is easiest to change your position so that you see the subject against a simpler background. Sometimes you can move the subject instead.

A busy background will call less attention to itself if it is blurred and indistinct rather than sharply focused. Set your lens to a wide aperture if you want to make the background out of focus while keeping the subject sharp. This works best if the background is relatively far away and you are focused on a subject that is relatively close to the camera. The viewfinder of a single-lens reflex camera shows you the scene at the lens's widest aperture; if you examine the scene through the viewfinder, you will get an idea of what the background will look like at that aperture. Some lenses have a preview button that stops down the lens so you can see how much of the scene will be sharp at any aperture.

Use the background when it contributes something. Even though many photographs could be improved by shooting closer to the subject, don't always zero in on a subject or you may cut out a setting that makes a picture come alive. An environmental portrait like the one on page 226 uses the background to tell you something about the subject. Backgrounds can give scale to a subject, or vice versa. And some backgrounds are what the picture is all about (this page, top).

GRAHAM NASH
Shadows, Milan, 1992

Painted shadows in the background join the person on the street. Nash says of the photo, "It's all complete, not posed. I'm just moving through my world and trying to be 360 degrees open to everything."

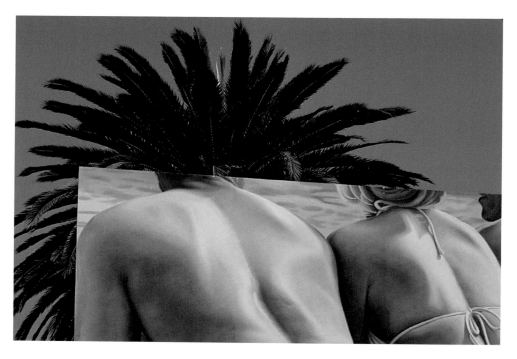

ROBERT LANDAU
Billboard, Los Angeles

Here, a palm tree crowns the occupant of a billboard.

SEAN KERNAN Man and Kitten, West Virginia Penitentiary

Sean Kernan was photographing in the yard of a prison when he saw an older convict playing with a kitten. Kernan made a few exposures where the man was standing (frames 3 and 4), then asked him to move near a steam vent that was blowing white into the winter air. Kernan says, "Now, after the fact, the steam seems like a crescent of purity cut into the midst of this devastation. I think the picture is of a moment when everything touched—the light, the lives, the violence, and the tenderness. I had about enough presence to remember to use the camera."

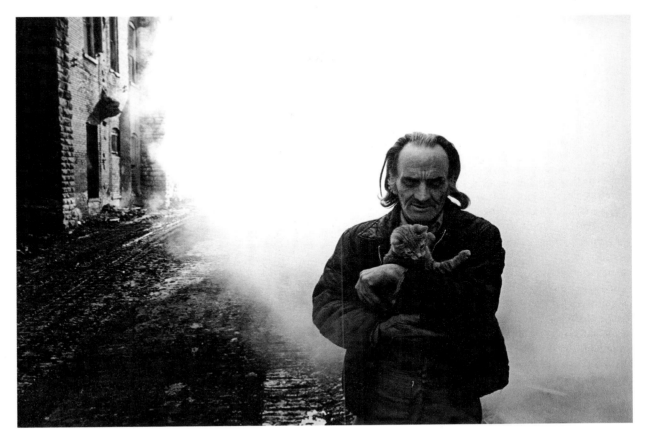

Basic Design
Spot/Line

What good is design? Most photographs are not constructed but are taken in an already existing environment from which the photographer, often working quickly, must select the best views. Nevertheless, it is still important for photographers to understand design concepts such as spot, line, shape, pattern, emphasis, and balance because certain elements of design are powerful in their ability to direct a viewer's attention.

Knowing, for example, that a single small object—a spot or a point—against a contrasting background attracts attention will help you predict where attention will go in a photograph. Even if you want to work fast and intuitively rather than with slow precision, basic knowledge about design will fine-tune and speed up your responses and will make you better able to evaluate your own and other people's work.

A single element of design seldom occurs in isolation. Although one can talk about the effect of a spot, for example, other design elements are almost always present, moderating each other's effect. Attention might be drawn by a spot and then attracted away by a pattern of lines elsewhere in the print. The simpler the subject, the more important any single element becomes, but one element rarely totally dominates any composition. The human element may attract the most attention of all; people will search out human presence in a photograph despite every obstacle of insistent design.

Any small shape, not necessarily a round one, can act as a spot or point. The word spotlight is a clue to the effect of a single spot against a neutral or contrasting background: it draws attention to itself and away from the surrounding area. This can be good if the spot itself is the subject or if in some way it adds interest to the subject. But a single spot can also be a distraction. For instance, a small bright object in a dark area can drag attention away from the subject; even a tiny, dark dust speck can attract attention if it is in a blank sky area.

The eye tends to connect two or more spots like a connect-the-numbers drawing. If there are only two spots, the eye continues to shift back and forth between them, sometimes a confusing effect if the eye has no place on which to settle attention. If there are three or more spots, suitably arranged, the brain will make shapes—a triangle, a square, and so on—out of them.

A line is a shape that is longer than it is wide. It may be actual or implied, as when the eye connects a series of spots or follows the direction of a person's gaze. Lines give direction by moving the eye across the picture. They create shapes when the eye completes a shape formed by a series of lines. In a photograph, lines are perceived in relation to the edges of the film format. This relationship is impossible to ignore, even when the lines are not near the edges of the print.

According to some theories, lines have psychological overtones: horizontal (calm, stability), vertical (stature, strength), diagonal (activity, motion), zigzag (rapid motion), curved (gracefulness, slowness). Horizontal objects, for example, tend to be stable, so we may come to associate horizontality with stability. In a similar way, yellows and reds conventionally have overtones of warmth by way of their associations with fire. However, such associations vary from person to person and are as much dependent on the subject as on any inherent quality in a line.

HIROMU KIRA The Thinker

A line can make a path that is easy for the eye to follow. Here, the movement is along the curved lines, stopping for a moment at the seated figure.

STEVE DZERIGIAN Rock Alignment, California Desert, 1996

This line of rocks is a sculpture that local residents and passersby change from time to time, sometimes a line, sometimes a spiral.

RUSSELL LEE Hidalgo County, Texas, 1939

The eye tends to connect two or more spots into a line or shape. *Above, the spots formed by the dark hardware against the light cabinets are an insistent element. Russell Lee often used direct flash on camera, especially in his work, as here, for the Farm Security Administration (see page 359). Lee liked direct flash because it rendered details sharply and was easy to use. It also produces minimal shadows and so tends to flatten out the objects in a scene into their graphic elements. The scene above has a harsh, clean brightness that is appealing in its austerity and to which the direct flash contributed.*

A shape is any defined area. In life, a shape can be two-dimensional, like a pattern on a wall, which has height and width; or three-dimensional, like a building, which has height, width, and depth. In a photograph, a shape is always two-dimensional, but tonal changes across an object can give the illusion of depth. Notice in the illustration at right how flat the large leaf, with its almost uniform gray tone, looks compared with the light and dark ridges of the smaller leaf. You can flatten out the shape of an object entirely by reducing it to one tone, as in a silhouette. The contour or edge shape of the object then becomes dominant, especially if the object is photographed against a contrasting background.

A single object standing alone draws attention to its shape, while two or more objects, such as the leaves at right, invite comparison of their shapes, including the shape of the space between them. The eye tends to complete a strong shape that has been cropped by the edge of the film format. Such cropping can draw attention repeatedly to the edge or even out of the picture area. Try cropping just into the left edge of the large leaf to see this effect.

Objects that are close together can be seen as a single shape. Objects of equal importance that are separated can cause the eye to shift back and forth between them, as between two spots. Bringing objects closer together can make them into a single unit; see for example, the women on the opposite page. Portrait studio photographers try to enhance the feeling of a family as a group by posing the members close together, often with some physical contact, such as placing one person's hand on another's shoulder.

Groupings can be visual as well as actual. Aligning objects one behind the other, intentionally or not, can make a visual grouping that may be easy to overlook when photographing a fast-moving scene, but which will be readily apparent in a photograph.

Multiple spots, lines, or shapes can create a pattern that adds interest and unites the elements in a scene, as do the small, dark squares in the photograph on the previous page. A viewer quickly notices variations in a pattern or the contrast between two patterns, in the same way that contrast between colors or between light and dark attracts the eye.

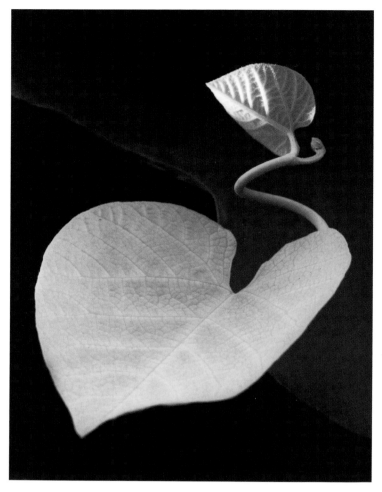

PAUL CAPONIGRO Two Leaves, 1963

What route does your eye follow when it looks at a photograph? One path in the photograph above might be up the right edge of the larger leaf, up the curved stem, around the smaller leaf to its bright tip, then down again to make the same journey. Take a small scrap of white paper and put it over the bottom tip of the larger leaf. Does your eye follow the same path as before, or does it jump back and forth between what are now two bright spots?

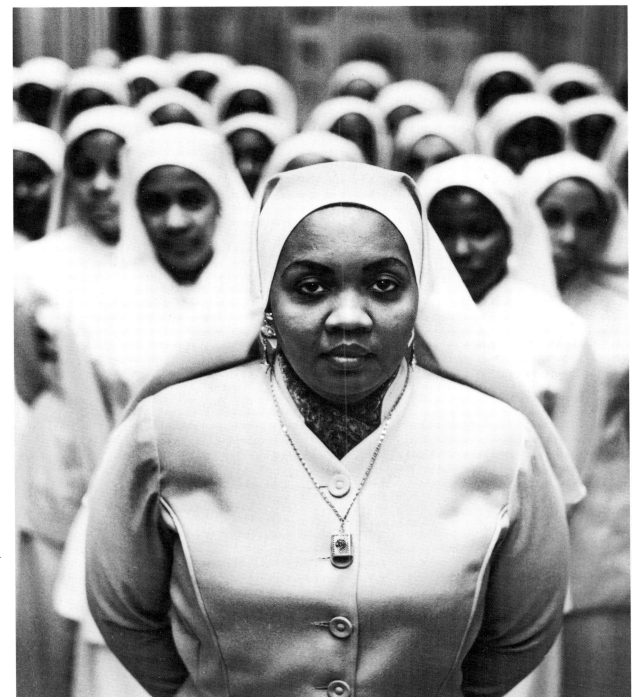

GORDON PARKS Ethel Shariff in Chicago, 1963

Repeated shapes can form a pattern. *A group of Black Muslim women form a solid band behind one of their leaders. Gordon Parks's camera position was closer to the woman in front than to the others, which made her appear larger. Being closer to her also reduced the depth of field so that when Parks focused on her, only she was sharp. The individual identities of the other women have been submerged by their being out of focus and by the repeated shapes of their head-dresses forming a pattern. The picture clearly identifies the leader and makes a visual statement about the solidarity of her followers.*

How do you emphasize some part of a photograph or play down another so that the viewer knows what is important and what isn't? If too many parts of a photograph demand equal attention, a viewer won't be sure what to look at first.

Contrast attracts attention. The eye is quick to notice differences such as sharp versus unsharp, light versus dark, large versus small. If you want to emphasize a subject, try to show it in a setting against which it stands out. Viewers tend to look at the sharpest part of a picture first, so you can call attention to a subject by focusing it sharply while leaving other objects out of focus (see page 320, bottom). A contrast of light and dark also adds emphasis; a small object can dominate a much larger background if it is of a contrasting tone or color.

Camera angle can emphasize a subject. If unnecessary clutter draws attention away from your subject, get closer. Shooting closer to an object will make it bigger while eliminating much of the surroundings. Sometimes shooting from a slightly higher or lower angle will remove distracting elements from the scene.

Use surrounding parts of the scene to reinforce emphasis. Objects that are of secondary interest, such as fences, roads, or edges, can form sight lines directed to the subject (right, top). The point at which two lines (real or implied) intersect attracts notice (see page 326), as does the direction in which people are looking. You may be able to find something in the foreground to frame the main subject and concentrate attention on it (see opposite page). A dark object may be easier than a light one to use as a frame because lighter areas tend to attract the eye first, but this is not always the case.

People know when a picture is in balance even if they can't explain why. A picture that is balanced does not call attention to that fact, but an unbalanced one can feel uncomfortably off center or top-heavy. Visually, dark is heavier than light, large is heavier than small, an object at the edge has more weight than at the center (like a weight on a seesaw), and a picture needs more apparent weight at the bottom to avoid a top-heavy feeling.

Except in the simplest cases, however, it is difficult to analyze exactly the weights and tensions that balance a picture, nor do you need to do so. A viewer intuitively weighs complexities of tone, size, position, and other elements, and you can do the same as you look through the viewfinder. Ask yourself if the viewfinder image feels balanced or if something isn't quite right that you would like to change. Move around a bit as you continue to look through the viewfinder. Even a slight change can make a big difference.

Some tension in a picture can be an asset. A centered, symmetrical arrangement, the same on one side as it is on the other, will certainly feel balanced and possibly satisfyingly stable, but it also may be boring. Perfect balance, total harmony, and exact symmetry make little demand on the viewer and consequently can fail to arouse interest. Try some off-center, asymmetrical arrangements; they risk feeling unbalanced but may succeed in adding impact (right, bottom).

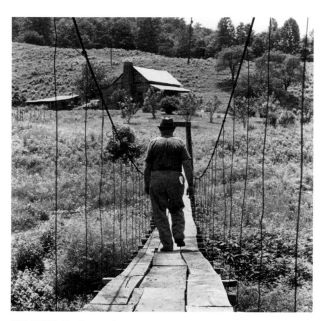

ROY CLARK Troublesome Creek, Kentucky, 1965

Lines formed by the sides and planks of the bridge focus attention on the man, as does his placement near the center of the picture. The quiet scene gets added interest from the man's dark form against the lighter boards of the bridge, his foot just raised in midstep, and the house in front of him as his visible destination.

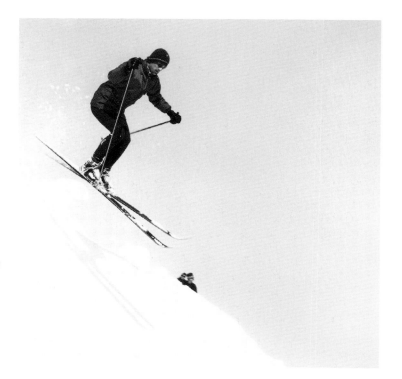

R.O. BRANDENBERGER Skier, Idaho, 1966

An off-center, asymmetrical composition can have a dynamic energy that is absent from a centered, symmetrical one. Take some sheets of white paper and lay them over the bottom and right side of the photo above so that the skier is centered in the frame. The picture is still interesting but lacks the headlong rush that it has when the long slope of the hill is ahead of the skier.

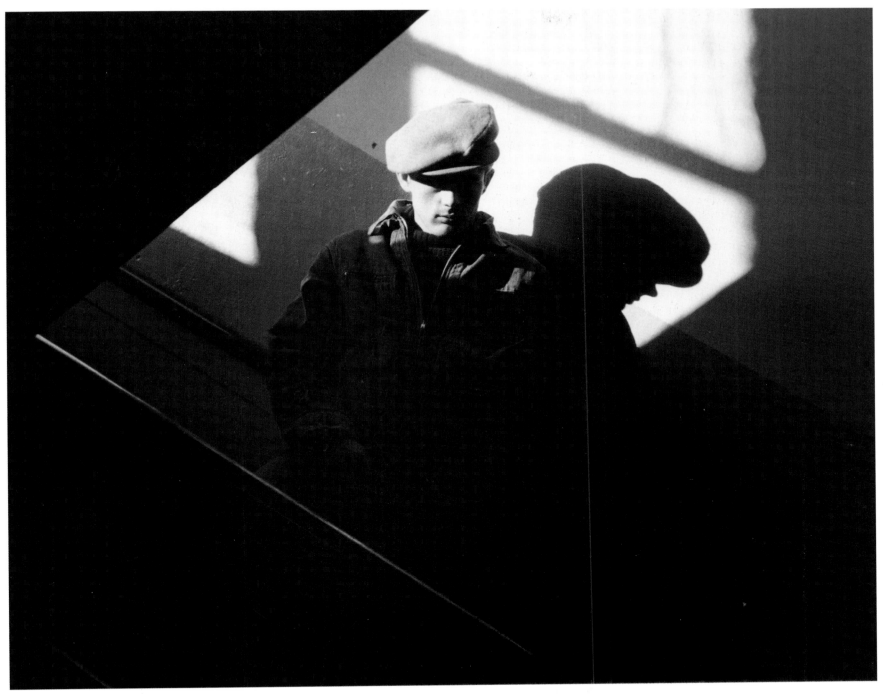

DENNIS STOCK James Dean in Light and Shadow, 1955

To emphasize your main subject, you can use a foreground object as a frame. A portrait of the actor James Dean, made in the year of his death, uses the dark shadows of a stairwell to frame him in a diamond-shaped patch of light. Dean's image was full of contradictions—tough and sensitve, boyish and manly, polite and wild—and the photograph echoes this in its split between light and dark, face only half visible, head shown both straight on and profiled in the shadow cast on the wall.

U.S. DEPARTMENT OF AGRICULTURE Family and Food, 1981

Pictures that convey data are often sharp overall. The United States Department of Agriculture photographed (left to right) Cynthia, John, Clint, and Valerie Schnekloth of Eldridge, Iowa, surrounded by the two-and-a-half tons of food an American family of four can consume in a year.

The sharpness of a photograph or of its various parts, is immediately noticeable. This is unlike ordinary life where, if your eyes are reasonably good, you seldom have to consider whether things are sharp or not.

People tend to look first at the sharpest part of a photograph. If a photograph is sharp overall, the viewer is more likely to see all parts of it as having equal value (this page, top). You can emphasize some part of a subject by making it sharper than the rest of the picture (see opposite).

Depth of field affects sharpness from near to far. If you focus on an object and set your lens to a wide aperture, you will decrease the depth of field (the acceptably sharp area) so that the background and foreground are more likely to be unsharp. Or you can use a small aperture to have the picture sharper overall.

Motion can be photographed either sharp or blurred. In life, moving objects appear sharp unless they are moving extremely fast, such as a hummingbird's wings. In a photograph, you can use a fast shutter speed to freeze the motion of a moving object.

Or you can use a slow shutter speed to deliberately blur the motion—just enough to indicate movement or so much that the subject's shape is altered (this page, bottom). Although the sharpest part is usually emphasized because the viewer tends to look there first, blurred motion can attract attention because it transmits information about how fast and in what manner the subject is moving.

A gain in motion sharpness can mean a loss in depth of field. If you change to a faster shutter speed to render motion sharply, you have to open to a larger aperture to keep the exposure the same. Since a larger aperture gives less depth of field, you may have to decide whether the motion sharpness is more important than the sharpness of depth of field. It may be impossible to have both.

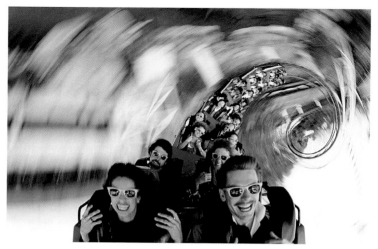

ROBERT LANDAU

Even a "still" photograph can give an impression of time and movement. In this photograph of thrill seekers on a roller coaster, Landau attached his camera to one of the cars and used a relatively slow shutter speed. With the camera moving at the same speed and in the same direction as the people, the stationary background appears to be swirling, capturing the sensation experienced by the riders.

PAUL SHAMBROOM B83 Nuclear Gravity Bombs in Weapons Storage Area, Barksdale Air Force Base, Louisiana, 1995

Contrast in a photograph can be part of the subject. *The ordinary human activity of tidying up seems jarring next to a row of the most powerful weapons in the U. S. arsenal. The slightly blurred human motion underscores the impassive weight of the sharply focused bombs.*

Most documentary photographers agree that with challenging subjects, getting through the door is the biggest obstacle. Shambroom had produced several series on hidden places of power—factories, corporate offices, police stations—that were good preparation for starting to photograph America's nuclear forces.

Contrast between light and dark draws a viewer's eye. A farmer's hands against a dark background, the outline of a leafless tree against a bright sky, a rim of light on someone's hair, a neon sign on a dark street—light not only illuminates a subject enough to record it on film but by itself can be the subject of a photograph.

Contrast sets off one part of a scene from another. Would you put a black ebony carving against a dark background or a light one? The dark background might make a picture that would be interesting for its somber tones. The light one would make a setting against which the carving would stand out prominently, just as a dark background contrasts with and sets off light tones (photograph, right). If you squint as you look at a scene, you can often get a better idea of what the tones will look like in a print and whether you should change your angle or move the subject to position it against a better background.

Contrast between two objects may be more apparent in color than in black and white. A red flower against green leaves is distinctly visible to the eye but may merge disappointingly into the foliage in a black-and-white print. The brightness of the flower is very similar to that of the leaves even though the colors are different. A lens filter can adjust the relative darkness of different colored objects.

Light along the edge of an object can make its shape stand out. If you chose to work with a dark background for an ebony statue, you could use edge lighting to make sure the statue didn't merge into the shadows behind it. Studio photographers often position a light so that it spills just over the edge of a subject from the back, making a bright outline that is effective against a darker background. Outdoors, the sun can create a similar effect if it illuminates the back or side of an object rather than the front.

Shadows or highlights can be shown as separate shapes. The contrast range of many scenes is too great for photographic materials to record realistically both dark shadows and bright highlights in one picture. This can be a problem, but it also gives you the option of using shadows or highlights as independent forms.

You can adjust contrast somewhat during film processing, conventional printing, and digital editing. Once film has been processed, the relative lightness or darkness of an area is fixed on the negative, but you can still change tones to some extent during conventional printing by such techniques as changing the contrast grade of the paper or printing filter, burning (adding exposure to darken part of a print), and dodging (holding back exposure to lighten an area). Contrast control with black-and-white prints is relatively easy; wet-process color prints allow less manipulation. Digital imaging provides even more control. Precisely selected areas can be manipulated, as well as the image overall.

FLOR GARDUÑO Basket of Light, Guatemala, 1989

A photograph may show shadows as darker than they seemed during shooting. Our eyes make adjustments for differences in light level, but photographs can emphasize details in only a fixed range of brightnesses. So a photograph may emphasize shapes of light and dark that in life do not seem so prominent.

BILL HEDRICH Oakton Community College, Des Plaines, Illinois, 1981

Contrast between light and dark attracts the eye. *The photographer chose a time of day and vantage point that emphasized the diagonal line of the stairs crossing with the building's own shadow. Notice how he placed two people at the crossing point and positioned the people at right so their shadows line up with the edge of the building. Bill Hedrich's architectural photographs are noted for being dramatic, but they are also truthful renditions of a building's features.*

Careful placement of a subject within the frame can strengthen an image. If you look at a scene through a camera's viewfinder as you move the camera around, you will probably see several choices for positioning the subject within the frame of the film format: dead center or off to one side, high or low, at one angle or another. Placement can draw attention to or away from a part of a scene. It can add stability or create momentum and tension. Some situations move too fast to allow any but the most intuitive shooting, but often you will have time to see what the effect will be with the subject in one part of the frame rather than another.

The most effective composition arises naturally from the subject itself. There are traditional formulas for positioning the center of interest (see box, right), but don't try to apply them rigidly. The goal of all the suggestions in this chapter is not to set down rules but to help you become more flexible as you develop your own style. The subject may also have something to say if you can hear it. Minor White, who was a teacher as well as a photographer, used to tell his students to let the subject generate its own composition.

The horizon line—the dividing line between land and sky—is a strong visual element. It can be easy, without much thought, to position the horizon line across the center of a landscape, dividing a scene into halves. Some photographers divide a landscape this way as a stylistic device, but unless handled skillfully, this can divide a picture into two areas of equal and competing interest that won't let the eye settle on either one. One suggestion for placement is to divide the image in thirds horizontally, then position the horizon in either the upper or lower third (photograph, this page). You can also try putting the horizon very near the top or the bottom of the frame.

Stop for a moment to consider what you want to emphasize. A horizon line toward the bottom of the frame emphasizes the sky. A horizon toward the top lets you see more of the land but still includes the strong contrast of sky. Omitting the horizon altogether leaves the eye free to concentrate on details of the land. Even without a horizon line, a photograph can feel misaligned

if the camera is tilted. Unless you want to tilt a picture for a purpose, always level the camera from side to side.

Motion should usually lead into, rather than immediately out of, the image area. Allow enough space in front of a moving subject so it does not seem uncomfortably crowded by the edge of the frame. The amount of space depends on the scene and your own intention. In a photograph, the direction in which a person (or even a statue) looks is an implied movement and requires space because a viewer tends to follow that direction to see what the person is looking at. Although it is usually best to allow adequate space, you can add interest to some scenes by framing a subject so that it looks or moves directly out of the picture area.

A subtler tension may be added by movement of a subject from right to left. For example, for people whose written language reads from left to right, a subject with strong left-to-right movement may seem slightly more natural or comfortable than a subject with strong right-to-left motion. You can see if you get this effect by looking at the photograph of the skier on page 330 and then looking at it in a mirror to reverse the subject's direction.

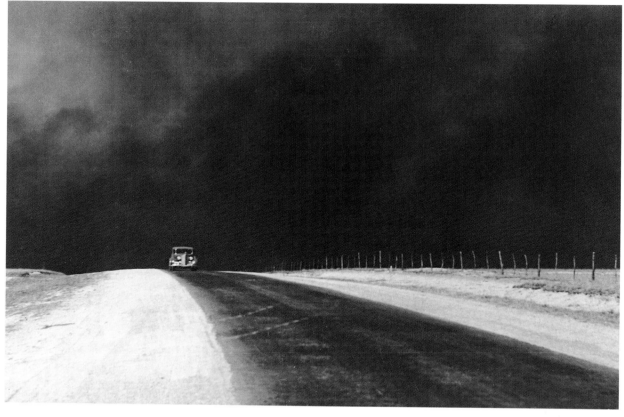

ARTHUR ROTHSTEIN
Dust Clouds over the Texas Panhandle, 1936

The horizon line is conventionally placed about one-third of the way up or down in the frame. This is less a rule than a reflection of the fact that, visually, asymmetry is more interesting than dividing the picture in half. Rothstein, like Marion Post Wolcott (pages 319 and 338), and Dorothea Lange (page 359), made many photographs for the Farm Security Administration to document the Depression of the 1930s.

COMPOSITIONAL FORMULAS

Rules of photographic composition were proposed in the nineteenth century based on techniques used by certain painters of the period. The rule of thirds, for example, was (and still is for some photographers) a popular compositional device. Draw imaginary lines dividing the picture area into thirds horizontally, then vertically. According to this formula, important subject areas should fall on the intersections of the lines or along the lines.

A person's face, for example, might be located on the upper left (theoretically the strongest) intersection, a horizon line on either the upper or lower horizontal line, and so on.

Try such formulas out for yourself. Experimenting with them will make you more aware of your options when you look at a scene, but don't expect a compositional cure-all for every picture. Look at photographs that work well, such as the one opposite or on page 43, to see if they fit a particular rule. If they don't, what makes them successful images?

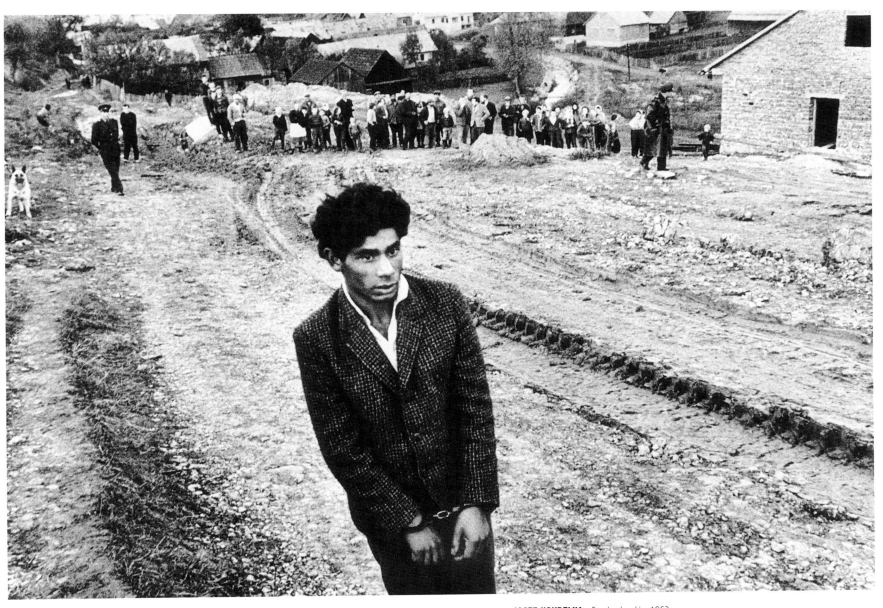

JOSEF KOUDELKA Czechoslovakia, 1963

The most extraordinary photographs merge composition with content on a level that rules do not explain. *Above, one of many photographs made by Josef Koudelka showing gypsies of Eastern Europe. The man, having been found guilty of murder, is on the way to the execution ground.*

John Szarkowski wrote about this photograph, "The handcuffs have compressed his silhouette to the shape of a simple wooden coffin. The track of a truck tire in the earth, like a rope from his neck, leads him forward. Within the tilted frame, his body falls backward, as in recognition of terror.

The relative distance of objects from the lens and from each other affects perspective, the illusion of three dimensions in a two-dimensional photograph. The brain judges depth in a scene mostly by comparing the size of objects in the foreground with those in the background; the bigger the apparent difference in the size of similar objects, the greater the distance between them seems to be. Move some object (or some part of it) very close to the lens, and it will look much bigger and therefore much closer than the rest of the scene. Parallel lines that appear to converge (to meet in the distance) are another strong indicator of depth (see photograph, page 85). The convergence is caused by the nearer part of the scene appearing bigger than the farther part.

Other factors affect perspective to a lesser degree. A sharply focused object may appear closer than out-of-focus ones. Side lighting enhances the impression of volume and depth, while front lighting or a silhouette reduces it. The lower half of a picture appears to be (and generally is) closer than the upper half. Overlapping objects also indicate which is closer. Warm colors (reds and oranges) often appear to come forward, while cool colors (blues and greens) appear to recede. In general, light-toned objects often appear to be closer than dark ones, with an important exception: atmospheric haze makes objects that are farther away lighter in tone than those that are closer, and a viewer recognizes this effect as an indication of distance in a landscape. Another factor is less consciously perceived by many people but still influences their impression of depth: objects appear to rise gradually relative to a viewer's position as they approach the horizon (see landscape, this page).

Photographs of landscapes often gain from an impression of depth. When depth is absent, for example in most people's vacation snapshots, they have to tell you how wonderful the scenery was because their pictures make even the Grand Canyon look flat and boring. To extend the impression of depth, especially in landscapes but also in any scene, try some or all of the following. Position some object in the foreground; if similar objects (or others of a known size) are farther away, the viewer will make the size comparisons that indicate depth. Position the horizon line in the upper part of the picture. Introduce lines (particularly converging ones), such as a road or a fence, that appear to lead from foreground to background.

Your point of view or vantage point can have a strong influence. An eye-level point of view is unobtrusive in a photograph, but shooting from higher or lower than eye level is more noticeable. Photographing an object by looking up at it can give it an imposing air as it looms above the viewer. Vertical lines, as in a building, appear to converge when the camera is tilted up, increasing the feeling of height. Looking straight down on a subject produces the opposite effect: objects are flattened out.

A moderate change in camera angle up or down can give a slight shift to the point of view, making a subject appear somewhat bigger or somewhat smaller without unduly attracting the viewer's attention. When you approach a scene, don't always shoot at eye level or in the first position from which you saw the subject. Look for interesting angles, the best background, or other elements that could add interest.

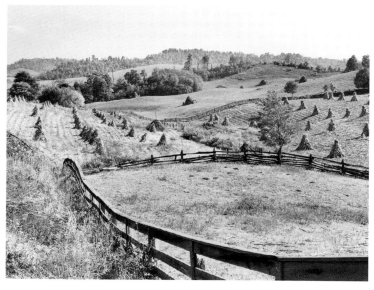

MARION POST WOLCOTT
Corn Fields, West Virginia, 1940

A standard recommendation for landscape photography is, "Put something in the foreground to give the scene depth." The reason that this device is used so often is that it does give a feeling of depth. Our perception of depth in a photograph is mostly due to size comparisons between near and far objects, and in the photograph above, it is easy to compare the size of the fence rails in the foreground with those at the end of the field.

It is your handling of whatever you put in the foreground that can rescue a well-used device of this sort from being a cliché. So many photographers have sighted along a fence or randomly included a branch of a tree across the top of a scene that it can be hard to see past the device itself. Here, the device gains interest because the line of the fence also draws the eye from the foreground deeper into the scene, and then down the rows of corn even farther away.

NEAL RANTOUL
Peddock's Island, Massachusetts, 2004

Shooting from below the subject can exaggerate its height. *The photographer also used a wide-angle lens to amplify that sensation.*

TOSHIO SHIBATA Grand Coulee Dam, Dougas County, Washington, 1996

Looking down on a subject can appear to flatten space and reduce a subject to its graphic elements. *Looking down along the front of this dam without any clues about its height flattens it almost into a roadway flowing to the horizon.*

Looking At—and Talking About—Photographs

Photographs are made in order to convey a certain vision or idea, perhaps the beauty of a transcendent landscape or the gritty look of a downtown street. Even snapshots are not made randomly: "I was in Paris" is a typical message from a snapshot. What vision or idea can be found in a particular photograph, and what graphic elements convey it to the viewer? You may never know exactly what the photographer intended, but you can identify the meaning that a photograph has for you. Following are some questions you can ask yourself when you look at a photograph. You don't need to ask every question every time, but they can give you a place to start. The box at right lists some terms that can help describe visual elements.

1. **What type of photograph is it?** Sometimes this is clear from the context: an advertising photograph in an ad, a news photograph on the front page. A caption or title can provide useful information, but look at the picture first so that the caption does not limit your response.

2. **What can you tell (or guess) about the photographer's intention?** For example, is an advertising photograph intended to convey specifics about the product? Or is it meant to say something about the beautiful (or macho or lovable) people who use this product, with the implication that if you use it you will look and feel just like they do?

3. **What emphasis has the photographer created and how has that been done?** For example, has selective focus been used so that the most important part of the scene is sharp, while less important parts are not?

4. **Do technical matters help or hinder the image?** For example, is the central element—perhaps someone's expression—lost in extraneous detail because the photographer was not close enough?

5. **Are graphic elements important, such as tone, line, or perspective?** What part of the photograph do you look at first? How does your eye move around the photograph? Does it skip from one person's face to another, follow a curved line, keep returning to one point?

6. **What else does the photograph reveal besides what is immediately evident?** If you spend some time looking at a photograph, you may find that you see things that you did not notice at first. A fashion photograph may give information about styles but say even more about the social roles that men and women play—or are encouraged to play—in our culture. A scientific photograph of a distant star cluster may have been made to itemize its stars but can also evoke the mystery of the universe.

7. **What emotional or physical impact does the photograph have?** Does it induce sorrow, amusement, peacefulness? Does it make your skin crawl, your muscles tense up, your eyes widen?

8. **How does this photograph relate to others made by the same photographer, in the same period, or of the same subject matter?** Is there any historical or social information that helps illuminate it? Is there a connection to art movements? Such knowledge can lead to a fuller appreciation of a work.

One caution when talking or writing about photographs: Eschew obfuscation. In other words, speak plainly. Don't try to trick out a simple thought in fancy dress, especially if you don't have much to say. See how you actually respond to a photograph and what you actually notice about it. A clear, simple observation is vastly better than a vague, rambling dissertation.

VISUAL ELEMENTS

Following are some of the terms that can be used to describe the visual or graphic elements of a photograph. See the page cited for an illustration (and often a discussion) of a particular element.

LIGHT
Frontlit: Light comes from camera position, few shadows (page 229 top)
Sidelit: Light comes from side, shadows cast to side (page 229 bottom)
Backlit: Light comes towards camera, front of subject shaded (page 228)
Direct light: Hard-edged, often dark, shadows (page 230 right)
Directional-diffused light: Distinct, but soft-edged shadows (page 230 left)
Diffused or revealing light: No, or almost no, shadows (page 231)
Silhouette: Subject very dark against light background (page 90 top)
Glowing light: Light comes or seems to come from subject (page 369)

TONE AND CONTRAST
High key: Mostly light tones (page 368 top)
Low key: Mostly dark tones (page 374)
Full scale: Many tones of black, gray, and white (page 129 bottom)
High contrast: Very dark and very light areas, with few middle grays (page 331)
Low contrast: Mostly middle grays (page 339 top)

TEXTURE
Emphasized: Usually due to light hitting the subject at an angle (page 254 top)
Minimized: Usually due to light coming from camera position (page 254 bottom)

FOCUS AND DEPTH OF FIELD
Sharp overall (page 332 top)
Soft focus (page 365 bottom)
Selective focus: One part sharp, others not (page 296)
Shallow depth of field: Short distance between nearest and farthest sharp areas (page 51)
Extensive depth of field: Considerable distance between nearest and farthest sharp areas (page 47)

VIEWPOINT
Eye-level (page 354)
Overhead, low level, or unusual point of view (page 339 bottom)
Frame: The way the edges of the photograph meet the shapes in it (pages 322–323)

SPACE AND PERSPECTIVE
Shallow space: Most objects seem close together in depth (page 49 top)
Deep space: Objects seem at different distances in space (page 146)
Positive space or figure: The most important form
Negative space or ground: That which surrounds the figure. Figure and ground are not always fixed and can reverse
Compressed perspective or telephoto effect: The scene seems to occupy an unusually shallow depth (page 61 left)
Expanded perspective or wide-angle distortion: Parts of the scene seem stretched or positioned unusually far apart (page 61 right)

LINE
Curved (page 326 top), **straight** (page 326 bottom)
Horizontal (page 387), **vertical** (page 326 bottom), **diagonal** (page 323)
Implied: such as by the direction someone is looking (page 341)

BALANCE
An internal, physical response. Does the image feel in balance or does it tilt or feel heavier in one part than another?

SEBASTIÃO SALGADO Gold Miners, Serra Pelada, Brazil, 1986

What does a photograph say to you? *Suppose you didn't know anything about this photograph. What does it reveal? What do you notice first when you look at the picture? What do the workers, especially at a distance, remind you of? What does that say about their activity? Does this photograph feel like it was made a long time ago? Does it remind you of past civilizations? Which ones?*

How does your knowledge, culture, and life experience affect your interpretation? Are you horrified to imagine yourself working day after day in this way? Are you inspired by the power of human spirit, strength, and perseverance? Is there a tension created by how the photograph might be interpreted?

How does the photographer's technique affect the image? How does the depth of field (everything sharp from near to far)

and scale of the objects (normal size in the foreground to tiny figures in the background) affect your perception? Does the photograph being in black and white rather than color have any effect?

How does the composition move your eye? Is there one part of the photograph that draws your attention? The man at the post is looking at an angle. Is there an implied diagonal line along the direction he is looking that also extends to the upper left side? What other shapes in the picture contribute to the implied line?

Does the man at the post symbolize or suggest anything to you? How might that affect the meaning of the photograph?

Sebastião Salgado has pursued personal projects such as photographing laborers throughout the world, *including those in sugar fields in Cuba, slaughterhouses in the*

American Midwest, and a steel plant in the Soviet Union. In the Amazon region of northern Brazil, he photographed workers excavating an open pit gold mine. Fifty thousand men swarm over the manmade hole the size of a football field. The mine is divided into small concessions 20 ft square, each worked by a team of 10 people, including diggers, carriers, and supervisors. As the men dig deeper into the muddy pit looking for good nuggets, unwanted soil is shoveled into sacks weighing as much as 130 lb, then carried up to the top of the crater.

In an introduction to Salgado's book An Uncertain Grace, *Eduardo Galeano wrote, "This is a stripped-down art. . . . The profoundest sadness of the universe is expressed without offering consolation, with no sugar coating. In Portuguese, salgado means 'salty.'"*

Suppose you decide to show your work to an editor, agency, potential client, gallery, or museum. What kind of work should you show? Editors, agents, and clients are looking for specific types of work, and you should tailor your portfolio to show them pictures they can use. Gallery and museum people, on the other hand, want to see your personal point of view. All of them give the same advice: Don't pad your portfolio. Putting mediocre pictures in with good ones produces a mediocre portfolio.

Jeffrey Hoone, Executive Director, Light Work and the Robert B. Menschel Gallery, Syracuse, New York. Hoone's choices are guided by the single goal of his organization—to provide direct support to artists working in photography and related new media. Light Work's Menschel gallery and their publication *The Contact Sheet* often feature artists from the residency program that has been sponsoring artists since 1976. Hoone says this program is "especially for emerging artists doing new and important work, and established artists working outside the mainstream. We have a broad view of what photography is all about and we try to present a diverse group of individuals."

The twelve to fifteen artists who are accepted into the residency program each year are chosen from applicants who send examples of work, artist's statement, a CV, and a description of what they would like to accomplish in a month at Light Work. Other than the proposal, the format for applicants is the same as for those seeking exhibition or publication. Hoone discourages applicants from sending prints or original work for logistical reasons, but they will review work in many other forms: among them slides, CDs, DVDs, video tape, and websites.

His best advice is to "be consistent. Show one body of work that demonstrates that you have really explored one idea or one method. Don't try to be versatile."

Kathy Ryan, Photo Editor, *New York Times Magazine*. Ryan wants to be the first to showcase talented new photographers. A mix of work by famous as well as new photographers keeps her magazine lively and adds an element of surprise for readers, she

says. And because she oversees several magazines that publish stories on a wide range of topics, she is looking for a variety of images to illustrate the written text.

Ryan views portfolios on a drop-off basis. Photographers leave their portfolios or photo stories and pick them up the next day. She makes color copies of images she likes and files them in categories such as "New York portrait photographers" or "international landscape photographers." She also files a few color copies from the pages of photo books she receives. When it's time to illustrate an article, she goes through her files to find inspiration. She does admit that when she sees a portfolio she particularly likes, she tries to assign that photographer to an appropriate story as soon as she can.

Ryan hates oversized portfolios with elaborately mounted or framed photos that come in huge, hard-to-open leather cases. "No mats, no mounts," she advises.

She prefers smaller portfolios that have the feel of a fine, hand-crafted book. She likes to see the images organized so that the portfolio reads almost like a photo book with a clear point of view, nice transitions between each section, and a rhythm to the presentation. She prefers to see many 5 x 7-inch prints rather than a few 11 x 14-inch ones. In fact, she would prefer a 40-image presentation to one with only 10 or 12 images. "I want to see how your mind works in different situations," she says. "I want to see where your passion is located."

While Ryan prefers to look at print portfolios, she says a good way to send work is an e-mail with a dozen or so images or a

link to your website. She wants to click though the pictures at her own rate and not be forced to watch a timed, music-enhanced slide show. She does look at mailed promotional pieces but rarely finds that one image is strong enough to lead to an assignment. Finally, Ryan advises new photographers that they can break into the world of magazine publishing by selling their work to small, avant-garde magazines like *ID* or *Interview*. These magazines often use portraiture, large-format, or stylish images.

Patrick Donehue, Vice President and Chief Photographer, Corbis Corporation. "We look for innovation, clarity, and purpose when we review the work of a prospective photographer. The images must tell a story in a new way that will appeal to the viewer." This is not an easy task, admits Donehue, "but really good photographers excel at it." He wants to see that the photographer understands his or her subject and cares deeply about it; this must

be conveyed in the pictures. "We look for images that are powerful, simple, and have soul embedded into their digital code," he says. "This is what makes great story telling possible."

It really doesn't matter to Donehue how images are presented to him. He reviews new work from CDs, on websites, and in printed portfolios that arrive in the mail. He is not interested in "fancy bells and whistles" but wants to be shown "how a photographer sees and how good they are at turning that vision into an image that will resonate with the viewer in a profound and meaningful manner."

Andrew Smith, Owner and Director, Andrew Smith Gallery, Santa Fe. Smith doesn't look at individual portfolios at his gallery, but will do so at public events where groups of portfolios are on display. Shows like the Houston FotoFest are excellent places to show work. "You're there one on one with a variety of people in the field," Smith says. "It's an opportunity to find out what's really going on."

Try to avoid the most common mistakes people make. For example, if you have two pictures that are pretty much the same, don't put both in your portfolio. "That's the sin of not editing."

Get familiar with the history of photography. It's a mistake to copy what has already been done, even if you are doing so inadvertently. If you are making landscapes, you need to know the work of people like Minor White, Paul Caponigro, and Elliot Porter. "Student work is often influenced by their teachers, so you need time to find your own voice. See what your teachers didn't teach you."

Elizabeth Kay, Curator, Andrew Smith Gallery, Santa Fe. Kay suggests that you keep showing your work even if several galleries have turned you down. "It's hard for anyone to go into a gallery to show work. Keep entering your work in shows, build up your résumé, assemble any articles about yourself in a press kit, put galleries on your mailing list and send them items like announcements about a show. It's important for them to see that you are active. There are as many personalities out there as there are galleries; it may take a while until you find the one that clicks with you. Persistence counts."

When you bring work to a gallery, Kay suggests showing only your strongest work. "It's better to bring in five great images than 35 of mixed quality. Gallery people have been looking at photographs for a long time. They can discern quality—or the lack of it—in a split second. If you're the slightest bit doubtful about an image, don't show it."

What should a photographer expect a gallery to do when they do offer a show? Each is unique. "You might have to pay for your own frames and shipping, plus half of any advertising. Negotiation may be possible, so don't be afraid to offer, for instance, a trade of some prints for ads. Typically, galleries today take 50 percent of sales."

Deborah Klochko, Director, Museum of Photographic Arts, San Diego. Showing your work to a museum (and many galleries) almost always involves a drop-off like that at the *New York Times Magazine.* You bring, mail, or e-mail your portfolio, and get it back in a week or two. The biggest issue, says Klochko, is time, which doesn't allow for a personal meeting with each photographer. The museum receives about forty portfolios a month; either she or the museum's curator looks at all of them.

She doesn't have time to meet with each photographer, nor does she feel it is her job to critique work. A simple thank-you letter is included when the portfolio is returned; some museums don't do that much. If either Klochko or the curator is interested, they will request more information.

Both look for a distinctive body of work, something they have not seen

before, and think the best work should expand a viewer's sense of a person, place, or time. Many photographers show work without having first employed much self-criticism; she feels that they should make sure they know something of the history of their medium as well as having the skill to create their own vision. She advises photographers not to get discouraged. "If your work doesn't fit here, it may fit somewhere else."

Joe Elbert, Assistant Managing Editor for Photography, *The Washington Post*. Elbert reviews portfolios of aspiring photographers who are looking for internships and, ultimately, for jobs. He evaluates images on four levels. Informative photos that make a record of an event represent the lowest common denominator of photos, Elbert says. Better but still not great, he says, are graphically appealing images. Elbert encourages photographers to seek emotionally appealing photos that cause a viewer to feel something, not just intellectualize about a subject. Ultimately, Elbert looks for intimate photographs. These, he admits, are the hardest to define, but include images that make the viewer feel close to the situation or in tune with the subject.

Ann Harvey, Art Director, Delta Airlines' *Sky Magazine*. Magazines like *Sky* are the ones you find on the airplane in the pocket of the seat in front of yours. Harvey looks for photographers with flexibility, enthusiasm, and the ability to take photographs that evoke the mood of a location. However, she doesn't even look at unsolicited portfolios and doesn't like getting cold calls. She says "the most important tool a photographer has right now is an excellent website that's easy to locate," and tries to look at links that she receives by e-mail. If she likes what she sees, she'll request a portfolio. "Presentation counts," she says. "Don't send a stack of tearsheets stuffed into a binder." Harvey also likes receiving occasional promotional postcards from photographers but says "it helps to have a rep," someone to sell your services to a client.

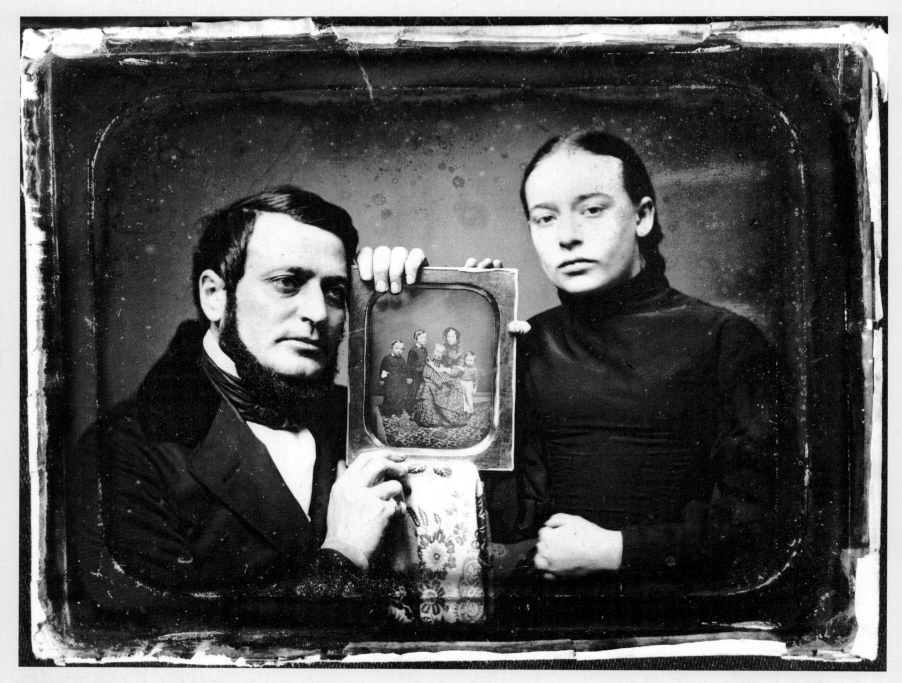

PHOTOGRAPHER UNKNOWN Daguerreotype of Couple Holding a Daguerreotype, c. 1850

*In the 19th century, photographs of people who were dead or unable to be present were often includ-
ed in family photographs.* It is tempting to try to interpret the relationships among the people shown
here. The man holds the daguerreotype carefully, his fingers loose and relaxed; he even touches his
head to the frame. The woman makes a minimum of contact with the photograph with her right hand
and clenches her left hand into a fist. She stares directly into the lens, the corners of her mouth pulled
down, unlike the man, who softly gazes into space as if recalling a dear memory. The photograph is
revealing, but still unexplained.

history of photography

Photography was one of many inventions of the 19th century—the electric light, the safety pin, dynamite, and the automobile are just a few—and of all of them, photography probably created the most astonishment and delight. Today most people take photographs for granted, but early viewers were awed and amazed by the objective records the camera made.

Photography took over what previously had been one of the main functions of art—the recording of factual visual information, such as the shape of an object, its size, and its relation to other objects. Instead of having a portrait painted, people had "Sun Drawn Miniatures" made. Instead of forming romantic notions of battles and faraway places from paintings, people began to see firsthand visual reports. And soon photography became an art in its own right.

This chapter explores some of the rich variety of materials and images in the history of photography. See the Bibliography for other sources.

The Invention of Photography

They said it couldn't be done. "The wish to capture evanescent reflections is not only impossible, as has been shown by thorough German investigation, but the mere desire alone . . . is blasphemy." Thus thundered a respected German publication, *Leipziger Stadtanzeiger,* in 1839 in response to the first public announcement of the invention of a successful photographic process. Such disbelief is surprising, since most of the basic optical and chemical principles that make photography possible had long been established.

The camera obscura was the forerunner of the modern camera. Since at least the time of Aristotle, it had been known that rays of light passing through a pinhole would form an image. The 10th-century Arabian scholar Alhazen described the effect in detail and told how to view an eclipse of the sun in a camera obscura (literally, "dark chamber"), a darkened room with a pinhole opening to the outside.

By the time of the Renaissance, a lens had been fitted into the hole to improve the image, and the room-sized device had been reduced to the size of a small box that could easily be carried about. The camera obscura became a drawing aid that enabled an artist to trace an image reflected onto a sheet of drawing paper.

What remained to be discovered was a way to fix the camera obscura image permanently. The darkening of certain silver compounds by exposure to light had been observed as early as the 17th century, but the unsolved and difficult problem was how to halt this reaction so that the image would not darken completely.

The first permanent picture was made by Joseph Nicéphore Niépce, a gentleman inventor living in central France. Niépce's experiments with lithography led him to the idea of attempting to take views directly from nature using the camera obscura. He first experimented with silver chloride, which he knew darkened on exposure to light, but then turned to bitumen of Judea, a kind of asphalt that hardened when exposed to light.

Niépce dissolved the bitumen in lavender oil, a solvent used in varnishes, then coated a sheet of pewter with the mixture. He placed the sheet in a camera obscura aimed through an open window at his courtyard and exposed it for eight hours. The light forming the image on the plate hardened the bitumen in bright areas and left it soft and soluble in dark areas. Niépce then washed the plate with lavender oil. This removed the still-soft bitumen that had not been struck by light, leaving a permanent image of the scene (right, top). Niépce named the process heliography (from the Greek *helios,* "sun," and *graphos,* "drawing").

News of Niépce's work reached another Frenchman, Louis Jacques Mandé Daguerre. Daguerre had been using the camera obscura for sketching and had also become interested in trying to preserve its images. He wrote Niépce suggesting an exchange of information, and by 1829 had become his partner.

The mid-19th century was ripe for an invention like photography. Interest in a new invention would spread simply by a growing interest in science, but photography was more. In Western countries a rising middle class with money to spend wanted pictures, especially family portraits, which until then only the rich had been able to afford. In addition, people were interested in faraway places; they traveled to them when they could and bought travel books and pictures when they could not.

Niépce did not live to see the impact that photography was to have. He died in 1833, several years before Daguerre perfected a process that he considered different enough from Niépce's to be announced to the world as the daguerreotype (right, bottom).

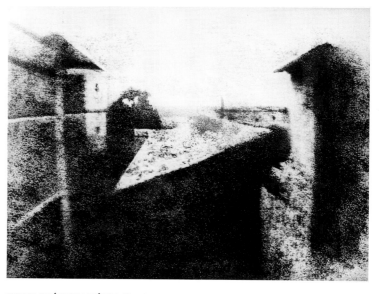

JOSEPH NICÉPHORE NIÉPCE View from His Window at Gras, c. 1826. Heliograph

Niépce produced the world's first photographic image—a view of the courtyard buildings on his estate in about 1826. It was made on a sheet of pewter covered with bitumen of Judea, a kind of asphalt that hardened when exposed to light. The unexposed, still soft bitumen was then dissolved, leaving a permanent image. The exposure time was so long (eight hours) that the sun moved across the sky and illuminated both sides of the courtyard.

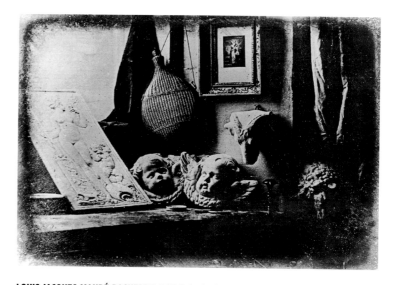

LOUIS JACQUES MANDÉ DAGUERRE Still Life in the Artist's Studio, 1837. Daguerreotype

The earliest known daguerreotype is by the inventor of the process, Louis Daguerre. The exposure was probably several minutes long—much less than the eight hours required by Niépce's heliograph, and the results were far superior—rich in detail and tonality. The enthusiastic reception of Daguerre's process extended to poetry: "Light is that silent artist / Which without the aid of man / Designs on silver bright /Daguerre's immortal plan."

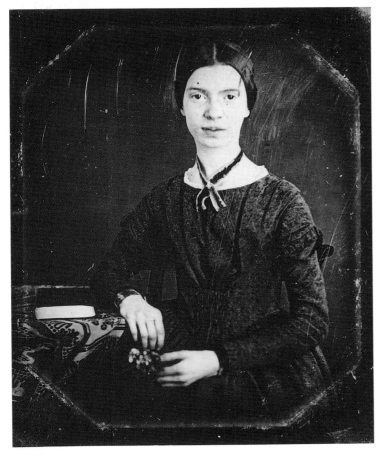

PHOTOGRAPHER UNKNOWN Emily Dickinson at Seventeen, c. 1847 Daguerreotype

The daguerreotype reached the height of its popularity in America. Millions of Americans, famous and obscure, had their portraits made. Although the exposure time was reduced to less than a minute, it was still long enough to demand a quiet dignity on the part of the subject.

This portrait, taken by an itinerant daguerreotypist, is the only known photograph of the 19th-century poet Emily Dickinson. Just like her poems, it seems direct on the surface but elusive on more intimate levels. Dickinson later described herself as "small, like the wren; and my hair is bold, like the chestnut burr; and my eyes, like the sherry in the glass that the guest leaves."

The response to the daguerreotype was sensational. After experimenting for many years, both with Niépce and alone, Daguerre was finally satisfied with his daguerreotype process, and it was announced before the French Academy of Sciences on January 7, 1839. A French newspaper rhapsodized: "What fineness in the strokes! What knowledge of chiaroscuro! What delicacy! What exquisite finish! . . . How admirably are the fore-shortenings given: this is Nature itself!" A British scientist was more specific: "The perfection and fidelity of the pictures are such that on examining them by microscopic power, details are discovered which are not perceivable to the naked eye in the original objects: a crack in plaster, a withered leaf lying on a projecting cornice, or an accumulation of dust in a hollow moulding of a distant building, are faithfully copied in these wonderful pictures." A daguerreotype viewed close up is still exciting to see. No printing process conveys the luminous tonal range and detail of an original.

Almost immediately after the process was announced, daguerreotype studios were opened to provide "Sun Drawn Miniatures" to a very willing public. By 1853 an estimated three million daguerreotypes per year were being produced in the United States alone—mostly portraits but also scenic views.

The daguerreotype was made on a highly polished surface of silver that was plated on a copper sheet. It was sensitized by being placed, silver side down, over a container of iodine crystals inside a box. Rising vapor from the iodine reacted with the silver, producing the light-sensitive compound silver iodide. During exposure in the camera, the plate recorded a latent image: a chemical change had taken place, but no evidence of it was visible. To develop the image the plate was placed, silver side down, in another box containing a dish of heated mercury at the bottom. Vapor from the mercury reacted with the exposed areas of the plate. Wherever light had struck the plate, mercury formed a frostlike amalgam, or alloy, with the silver. This amalgam made up the bright areas of the image. Where no light had struck, no amalgam was formed; the unchanged silver iodide was dissolved in sodium thiosulfate fixer, leaving the bare metal plate, which looked black, to form the dark areas of the picture.

The daguerreotype was very popular in its time, but it was a technological dead end. There were complaints about the difficulty of viewing, for the image could be seen clearly only from certain angles. The mercury vapor used in the process was highly poisonous and probably shortened the life of more than one daguerreotypist. But the most serious drawback was that each plate was unique; there was no way of producing copies except by rephotographing the original. The beautiful daguerreotype was rapidly—and easily—eclipsed by a negative-positive process that allowed any number of positive images to be made from a single negative.

Calotype: Pictures on Paper

Another photographic process was announced almost at once. On January 25, 1839, less than three weeks after the announcement of Daguerre's process to the French Academy, an English amateur scientist, William Henry Fox Talbot, appeared before the Royal Institution of Great Britain to announce that he too had invented a way to permanently fix the image of the camera obscura. Talbot was a disappointed man when he gave his hastily prepared report. He admitted later that Daguerre's prior announcement "frustrated the hope with which I had pursued, during nearly five years, this long and complicated series of experiments—the hope, namely, of being the first to announce to the world the existence of the New Art—which has since been named Photography."

Talbot made his images on paper. His first experiments had been with negative silhouettes made by placing objects on paper sensitized with silver chloride and exposing them to light. Then he experimented with images formed by a camera obscura, exposing the light-sensitive coating long enough for the image to become visible during the exposure.

In June 1840 Talbot announced a technique that became the basis of modern photography: the sensitized paper was exposed only long enough to produce a latent image, which then was chemically developed. Talbot reported that nothing could be seen on the paper after exposure, but "the picture existed there, although invisible; and by a chemical process . . . it was made to appear in all its perfection." To make the latent negative image visible, Talbot used silver iodide (the light-sensitive element of the daguerreotype) treated with gallo nitrate of silver. He called his invention a calotype (after the Greek *kalos,* "beautiful," and *typos,* "impression").

Talbot realized the value of photographs on paper rather than on metal: reproducibility. He placed the fully developed paper negative in contact with another sheet of sensitized paper and exposed both to light, a procedure now known as contact printing. The dark areas of the negative blocked the light from the other sheet of paper, while the clear areas allowed light through. The result was a positive image on paper resembling the natural tones of the original scene.

Because the print was made through the paper of a negative, the calotype lacked the sharp detail of the daguerreotype. Calotypes are beautiful in their own way, with the fibers in the paper producing a soft, slightly textured image that has been compared to a charcoal drawing. Although the calotype's reproducibility was a major advantage over the one-of-a-kind daguerreotype, both remained in use until the transparent negative appeared.

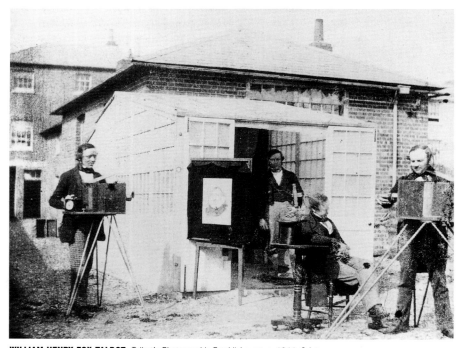

WILLIAM HENRY FOX TALBOT Talbot's Photographic Establishment, c. 1844. Calotype

The activities at Talbot's establishment near London are shown in this early calotype taken in two parts and pieced together. At left, an assistant copies a painting. In the center, possibly Talbot himself prepares a camera to take a portrait. At right, the man at the racks makes contact prints while another photographs a statue. At far right, the kneeling man holds a target for the maker of this photograph to focus on.

The prints for the first book to be illustrated with photographs, The Pencil of Nature, *had a "Notice to the Reader." Talbot gave his assurance that, "The plates of the present work are impressed by the agency of light alone, without any aid whatever from the artist's pencil. They are the sun pictures themselves, and not, as some persons have imagined, engravings in imitation."*

The collodion wet-plate process had the best feature of the daguerreotype—sharpness—and the best of the calotype—reproducibility. And it was more light sensitive than either of them, with exposures as short as five seconds. It combined so many advantages that despite its drawbacks virtually all photographers used it from its introduction in 1851 until the development of the gelatin dry plate.

For some time, workers had been looking for a substance that would bind the light-sensitive salts to a glass plate. Glass was better than paper or metal as a support for silver chloride because it was textureless, uniformly transparent, and chemically inert. A cousin of Niépce, Abel Niepce de Saint-Victor, found that egg white could be used, but since his albumen glass plates required very long exposures the search for a better substance continued. One suggested material was the newly invented collodion (nitrocellulose dissolved in ether and alcohol), which is sticky when wet, but soon dries into a tough, transparent skin. Frederick Scott Archer, an English sculptor who had been making calotypes of his sitters to use as studies, discovered that the collodion was an excellent basis for binding silver into an emulsion.

The disadvantage of collodion was that the plate had to be exposed and processed while it was still wet. Coating a plate required skill—nimble fingers, flexible wrists, and practiced timing. A mixture of collodion and potassium iodide was poured onto the middle of the plate. The photographer held the glass by the edges and tilted it back and forth and from side to side until the surface was evenly covered. The excess collodion was poured back into its container. Then the plate was sensitized by being dipped in a bath of silver nitrate. It was exposed for a latent image while still damp, developed in pyrogallic acid or iron sulfate, fixed, washed, and dried. All this had to be done right where the photograph was taken, which meant that to take a picture the photographer had to lug a complete darkroom along (below).

Collodion could be used to form either a negative or a positive image. Coated on glass, it produced a negative from which a positive could be printed onto albumen-coated paper. If the glass was backed with a dark material like black velvet, paper, or paint, the image was transformed into a positive, an ambrotype, a kind of imitation daguerreotype. Coated on dark enameled metal it also formed a positive image—the durable, cheap tintype popular in America for portraits to be placed in albums, on campaign buttons, and even on tombs.

One of the most popular uses was to make stereographic photographs. If two photographs are taken side by side and then viewed through a stereoscope (a device that presents only one photograph to each eye), the impression is of a three-dimensional image. Looking at stereos became a popular home entertainment during the 1850s (and lasted into the 20th century) like television today.

By the 1860s the world had millions of photographic images; 25 years earlier there had been none. Photographers were everywhere—taking portraits, going to war, exploring distant places and bringing home pictures to prove it.

The collodion wet-plate process had many advantages, but convenience was not among them. The glass plates on which the emulsion was spread had to be coated, exposed, and developed before the emulsion dried, which required transporting an entire darkroom to wherever the photograph was to be made.

A photographer described a typical load that an amateur might use: "I reached the railway station with a cab-load consisting of the following items: A 9" x 11" brass-bound camera weighing 21 lbs. A water-tight glass bath in a wooden case holding over 90 ozs. of solution [nitrate of silver] and weighing 12 lbs. A plate box with a dozen 9" x 11" plates weighing almost as many pounds. A box 24" x 18" x 12" into which were packed lenses, chemicals, and all the hundred-and-one articles necessary for a hard day's work, and weighing something like 28 lbs. [A tripod] over 5 ft in length. It weighed about 5 lbs. Lastly, there was the tent, that made a most convenient darkroom, about 40" x 40" and 6 1/2 ft high, with ample table accommodation; the whole packed into a leather case and weighed over 40 lbs . . . a load of about 120 lbs."

A Photographer in the Field, c. 1865

Gelatin Emulsion/Roll-Film Base: Photography for Everyone

Until the 1880s, few photographs were made by the general public. Almost everyone had been photographed at one time or another, certainly everyone had seen photographs, and probably many people had thought of taking pictures themselves. But the technical skill, the massive effort, and the expense and sheer quantity of equipment needed for the collodion wet-plate process restricted photography to the professionals and the most dedicated amateurs. Even they complained of the inconvenience of the process and made many attempts to improve it.

By the 1880s, the perfection of two techniques not only made possible a fast, dry plate but also eliminated the need for the clumsy, fragile glass plate itself. The first development was a new gelatin emulsion in which the light-sensitive silver salts could be suspended. It was based on gelatin—a jellylike substance processed from cattle bones and hides. It retained its speed when dry and could be applied on the other invention—film in rolls. Roll film revolutionized photography by making it simple enough for anyone to enjoy.

Much of the credit for popularizing photography goes to George Eastman, who began as a bank clerk in Rochester, New York, and built his Eastman Kodak Company into one of the country's foremost industrial enterprises. Almost from the day Eastman bought his first wet-plate camera in 1877, he searched for a simpler way to take pictures. "It seemed," he said, "that one ought to be able to carry less than a packhorse load."

Many people had experimented with roll film, but Eastman was the first to market it commercially, with his invention of the equipment to mass-produce film. The result was Eastman's American Film, a roll of paper coated with a thin gelatin emulsion. The emulsion had to be stripped from the opaque paper backing to provide a negative that light could shine through for making prints. Most photographers had trouble with this operation, as the negative often stretched when removed from the paper, so the film was usually sent back to the company for processing.

Roll film made possible a new kind of camera—inexpensive, light, and simple to operate—that made everyone a potential photographer. Eastman introduced the Kodak camera in 1888. It came loaded with enough film for 100 pictures. When the roll was used up, the owner returned the camera with the exposed film still in it to the Eastman company in Rochester. Soon the developed and printed photographs and the camera, reloaded with film, were sent back to the owner. The Kodak slogan was, "You push the button, we do the rest."

The Kodak camera became an international sensation almost overnight. With the invention by Hannibal Goodwin of a truly modern roll film (a transparent, flexible plastic, coated with a thin emulsion and sturdy enough to be used without a paper support), a new photographic era, of simple, light cameras and easy-to-handle roll film, had begun. The Eastman Kodak Company knew very early who would be the main users of its products, and it directed its advertising accordingly: "A collection of these pictures may be made to furnish a pictorial history of life as it is lived by the owner, that will grow more valuable every day that passes."

FREDRICK CHURCH George Eastman with a Kodak, 1890

George Eastman, who put the Kodak box camera on the market and thereby put photography into everybody's hands, stands aboard the S.S. Gallia in the act of using his invention. Roll film made the camera small enough to carry easily. Fast gelatin emulsions permitted 1/25-sec exposures so subjects did not have to strain to hold still.

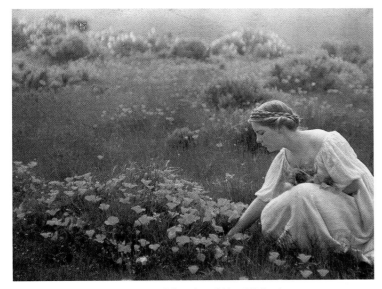

ARNOLD GENTHE Helen Cooke Wilson in a California Poppy Field, c. 1908. Autochrome

The Autochrome process was popular at the turn of the century with pictorialists who liked its graininess and subdued colors. The dots of color that composed the image blended at a normal viewing distance into a full range of colors, not unlike the effect that pointillist painters created with individual dots of paint.

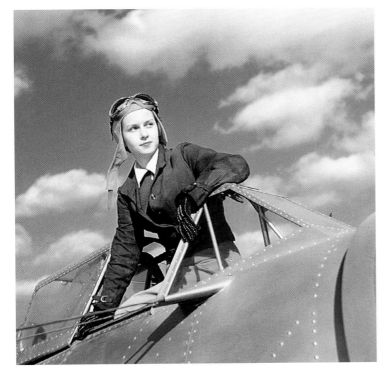

PHOTOGRAPHER UNKNOWN Untitled, circa 1936

Kodachrome transparency film, introduced in 1936, was created for the 35mm still photography market. It was the first accurate, inexpensive, easy-to-use, and reliable method for creating color photographs.

Daguerre himself knew that only one thing was needed to make his wonderful invention complete—color. "There is nothing else to be desired," he wrote, "but the presentation of these children of light to the astonished eye in the full splendour of their colors."

After several false starts, one of the first successes was demonstrated in 1861 by the British physicist James Clerk Maxwell. To illustrate a lecture on color vision, he devised a way to recreate the colors of a tartan ribbon. He had three negatives of the ribbon made, each through a different color filter—red, green, and blue. Positive black-and-white transparencies were made of the three negatives and projected through red, green, and blue filters like those on the camera. When the three images were superimposed, they produced an image of the ribbon in its original colors.

Maxwell had demonstrated additive color mixing, in which colors are produced by adding together varying amounts of light of the three primary colors, red, green, and blue. In 1869, an even more significant theory was made public. Louis Ducos du Hauron and Charles Cros, two Frenchmen working independently of each other, announced almost simultaneously their researches in subtractive color mixing. In subtractive mixing, the basis of present-day color photography, colors are created by combining cyan, magenta, and yellow dyes (the complements of red, green, and blue). The dyes subtract colors from the "white" light that contains all colors. There were many variations of Ducos du Hauron's basic subtractive process in which three separately dyed images were superimposed to form a full-color image. They include his own three-color carbon process, the carbro process, and in the 20th century, dye transfer printing.

The first commercially successful color was an additive process. In 1907, two French brothers, Antoine and Louis Lumière, marketed their Autochrome process. A glass plate was covered with tiny grains of potato starch dyed red-orange, green, and violet, in a layer only one starch grain thick. Then, a light-sensitive emulsion was added. Light struck the emulsion after passing through the colored grains. The emulsion behind each grain was exposed only by light from the scene that was the same color as that grain. The result after development was a full-color transparency (left, top).

Kodachrome, a subtractive process, made color photography practical. It was perfected by Leopold Mannes and Leopold Godowsky, two musicians and amateur photographic researchers who eventually joined forces with Eastman Kodak research scientists. Their collaboration led to the introduction in 1935 of Kodachrome, a single sheet of film coated with three layers of emulsion, each sensitive to one primary color (red, green, or blue). A single exposure produces a color image (left, bottom).

In the 1940s, Kodak introduced Ektachrome, which allowed photographers and small labs to proceess slides, and Kodacolor, the first color negative film.

Today it is difficult to imagine photography without color. The amateur market is huge, and the ubiquitous snapshot is always in color. Commercial and publishing markets use color extensively. Digital cameras always start by capturing a color image; anyone who wants black and white must discard the color information. Even photojournalism, documentary, and fine art photography, which have been in black and white for most of their history, are most often now in color.

People wanted portraits. Even when exposure times were long and having one's portrait taken meant sitting in bright sunlight for several minutes with eyes watering, trying not to blink or move, people flocked to portrait studios to have their likenesses drawn by "the sacred radiance of the Sun." Images of almost every famous person who had not died before 1839 have come down to us in portraits by photographers such as Nadar and Julia Margaret Cameron (right). Ordinary people were photographed as well—in Plumbe's National Daguerrian Gallery, where hand-tinted "Patent Premium Coloured Likenesses" were made, and in cut-rate shops where double-lens cameras took them "two at a pop." Small portraits called cartes-de-visite were immensely popular in the 1860s (opposite). For pioneers moving West in America, the pictures were a link to the family and friends they had left behind. Two books went West with the pioneers—a Bible and a photograph album.

Photographs had an almost mystical presence. After seeing some daguerreotype portraits, the poet Elizabeth Barrett wrote to a friend in 1843, "several of these wonderful portraits . . . like engravings—only exquisite and delicate beyond the work of graver—have I seen lately—longing to have such a memorial of every Being dear to me in the world. It is not merely the likeness which is precious in such cases—but the association and the sense of nearness involved in the thing . . . the fact of the very shadow of the person lying there fixed for ever! . . . I would rather have such a memorial of one I dearly loved, than the noblest artist's work ever produced. I do not say so in respect (or disrespect) to Art, but for Love's sake. Will you understand?— even if you will not agree?" The man on the opening page of this chapter would have understood.

JULIA MARGARET CAMERON Mrs. Duckworth, 1867

Cameron photographed her friends and peers, the well-known and the well-born, in Victorian England. This is Julia Jackson Duckworth, now best known for being the mother of author Virginia Woolf.

PHOTOGRAPHER UNKNOWN Woman in Costume

PHOTOGRAPHER UNKNOWN André Adolphe Disdéri

Cartes-de-visite were taken with a camera that exposed only one section of the photographic plate at a time. Thus the customer could strike several different poses for the price of one. At left is shown a print before it is cut into separate pictures. People collected cartes-de-visite in albums, inserting pictures of themselves, friends, relatives, and famous people like Queen Victoria.

One album cover advised: "Yes, this is my Album, but learn ere you look; / that all are expected to add to my book. / You are welcome to quiz it, the penalty is, / that you add your own Portrait for others to quiz."

André Adolphe Disdéri, who popularized these multiple portraits, is shown above on a carte-de-visite. Carte portraits became a fad when Napoleon III stopped on the way to war to pose for cartes-de-visite at Disdéri's studio.

Early travel photographs met a demand for pictures of faraway places. In the mid-19th century, the world seemed full of unexplored wonders. Steamships and railroads were making it possible for more people to travel, but distant lands still seemed exotic and mysterious and people were hungry for photographs of them. There had always been drawings portraying unfamiliar places, but they were an artist's personal vision. The camera seemed an extension of one's own vision; travel photographs were accepted as real and faithful images.

The Near East was of special interest. Not only was it exotic, but its association with biblical places and ancient cultures made it even more fascinating. Within a few months of the announcement of Daguerre's process in 1839, a photographic team was in Egypt. "We keep daguerreotyping away like lions," they reported, "and from Cairo hope to send home an interesting batch." Since there was no way of reproducing the daguerreotypes directly, they had to be traced and reproduced as copperplate engravings. With the invention of the calotype and later the collodion processes, actual pictures from the Near East were soon available.

The most spectacular scenery of the western United States was not much photographed until the late 1860s. Explorers and artists had been in the Rocky Mountain area long before this time, but the tales they told of the region and the sketches they made were often thought to be exaggerations. After the Civil War, when several government expeditions set out to explore and map the West, photographers accompanied them, not always to the delight of the other members of the expeditions. "The camera in its strong box was a heavy load to carry up the rocks," says a description of a Grand Canyon trip in 1871, "but it was nothing to the chemical and plate-holder box, which in turn was featherweight compared to the imitation hand organ which served for a darkroom." Civil War photographers Timothy H. O'Sullivan (below and opposite) and Alexander Gardner both went West with government expeditions. William Henry Jackson's photographs of Yellowstone helped convince Congress to set the area aside as a national park, as did the photographs of Yosemite made by Carleton Eugene Watkins.

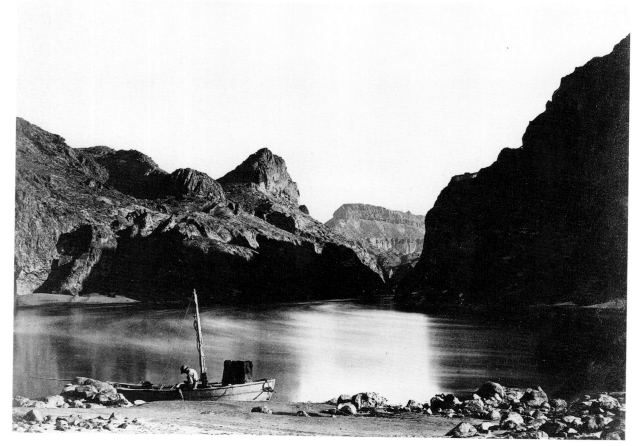

TIMOTHY H. O'SULLIVAN Black Canyon, Colorado River, 1871

Expeditions to photograph distant places were launched as soon as the invention of photography was announced. In addition to all the materials, chemicals, and knowledge needed to coat, expose, and process their photographs in remote places, expeditionary photographers also had to have considerable fortitude.

Timothy H. O'Sullivan, whose darkroom on a boat appears at left, described an area called the Humboldt Sink: "It was a pretty location to work in, and viewing there was as pleasant work as could be desired; the only drawback was an unlimited number of the most voracious and particularly poisonous mosquitoes that we met with during our entire trip. Add to this . . . frequent attacks of that most enervating of all fevers, known as the 'mountain ail,' and you will see why we did not work up more of that country."

Photographs made war scenes more immediate for those at home. Until photography's invention, wars seemed remote and rather exciting. People learned details of war from delayed news accounts or even later from returning soldiers or from paintings or poems. The disastrous British campaigns in the Crimean War of the 1850s were the first to be extensively photographed. The ill-fated Charge of the Light Brigade was only one of the catastrophes; official bungling, disease, starvation, and exposure took more British lives than did the enemy. However, Roger Fenton, the official photographer, generally depicted the war with scenic and idealized images.

Photographs from the American Civil War were the first to show the reality of war (below). Mathew B. Brady, a successful portrait photographer, conceived the idea of sending teams to photograph the war. No photographs were made during a battle; it was too hazardous. The collodion process required up to several seconds' exposure and the glass plates had to be processed on the spot, which made the photographer's darkroom-wagon a target for enemy gunners. Although Brady had hoped to sell his photographs, they often showed what people wanted only to forget. Brady took only a few, if any, photographs himself, and some of his men (Alexander Gardner and Timothy H. O'Sullivan among them) broke with him and set up their own operation. But it was Brady's idea and personal investment that launched an invaluable documentation of American history.

The first realistic view of war was shown by Civil War photographers such as Brady, Gardner, and O'Sullivan (right). Oliver Wendell Holmes had been on the battlefield at Antietam searching for his wounded son and later saw the photographs Brady made there: "Let him who wishes to know what war is look at this series of illustrations . . . It was so nearly like visiting the battlefield to look over these views, that all the emotions excited by the actual sight of the stained and sordid scene, strewed with rags and wrecks, came back to us, and we buried them in the recesses of our cabinet as we would have buried the mutilated remains of the dead they too vividly represented."

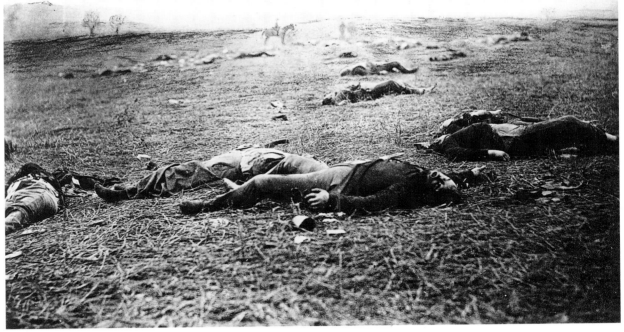

TIMOTHY H. O'SULLIVAN A Harvest of Death, Gettysburg, July 1863

Time and Motion in Early Photographs

The earliest photographs required very long exposures. Today, photographers using modern films consider a one-second exposure relatively long. But photographers using earlier processes had to work with much slower emulsions, and an exposure of several seconds was considered quite short.

People or objects that moved during the exposure were blurred or, if the exposure was long enough, disappeared completely. Busy streets sometimes looked deserted (near right) because most people had not stayed still long enough to register an image.

Stereographic photographs were the first to show action as it was taking place, with people in midstride or horses and carts in motion (half of a pair of stereo images is shown above, far right). This was possible because the short-focal-length lens of the stereo camera produced a bright, sharp image at wide apertures and thus could be used with very brief exposure times.

"How infinitely superior to those 'cities of the dead' with which we have hitherto been compelled to content ourselves," commented one viewer.

These "instantaneous" photographs revealed aspects of motion that the unaided eye was not able to see. Some of the arrested motions were so different from the conventional artistic representations that the photographs looked wrong. A galloping horse, for example, had often been drawn with all four feet off the ground—the front legs extended forward and hind legs extended back.

Eadweard Muybridge was a pioneer in motion studies. When his photographs of a galloping horse, published in 1878, showed that all four feet were off the ground only when they were bunched under the horse's belly, some people thought that Muybridge had altered the photographs. Using the new, fast gelatin emulsion and specially constructed multi-lens cameras, Muybridge compiled many studies of different animals and humans in action (right). In 1887, Muybridge compiled 781 studies of different animals and humans in action as the eleven-volume *Animal Locomotion.*

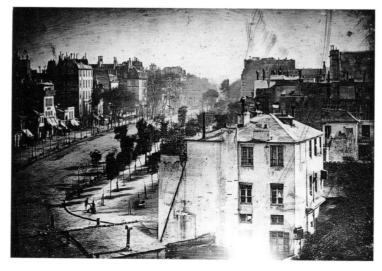

LOUIS JAQUES MANDÉ DAGUERRE Boulevard du Temple, Paris, 1839

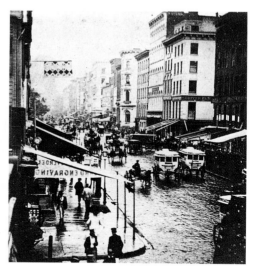

EDWARD ANTHONY Broadway, 1859

Two streets, both filled with people and traffic, have a different appearance. *The busy streets of a Parisian boulevard (above, left) appear depopulated because of the long exposure this daguerreotype required. Only a person getting a shoeshine near the corner of the sidewalk stood still long enough to be recorded; all the other people, horses, and carriages had blurred so much that no image of them appeared on the plate. Twenty years later, the relatively fast collodion process combined with the fast lens of a stereo camera to freeze the action on another busy street (above, right, one of a pair of stereo views).*

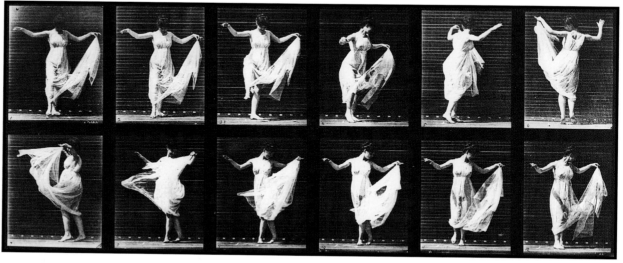

EADWEARD MUYBRIDGE Motion Study, c. 1885

The study of motion became technically possible as the sensitivity of photographic emulsions increased. *The pictures above were part of Eadweard Muybridge's project* Animal Locomotion, *which analyzed the movements of humans and many animals. Muybridge often used several cameras synchronized to work together so that each stage of a movement could be recorded simultaneously from different angles.*

EUGÈNE ATGET Café la Rotonde, Boulevard Montparnasse, Paris, date unknown

Eugène Atget artfully revealed the essence of Paris while seeming merely to document its external appearance. An uncluttered street in the early morning, with its graceful trees, broad sidewalks, and empty cafés speaks of the pervasive charm and architectural harmony of the city.

AUGUST SANDER Laborer, 1927 ▶

August Sander's photographs are documents of social types rather than portraits of individuals.
This photograph of a laborer with a load of bricks was one of hundreds Sander made of the types he saw in pre-World War II Germany. Holding his pose as if standing for a portrait painter, the subject displays his trade with stoic strength. There is no indication of time or even place. In fact, the background is deliberately absent; Sander eliminated it from the negative.

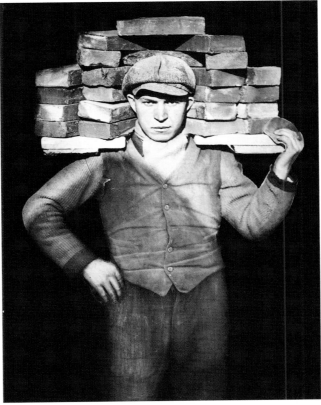

Photographs can be documents on many levels. Most snapshots record a particular scene to help the participants remember it later. A news photograph implies that this is what you would have seen if you had been there yourself. (Digital imaging may deal the death blow to this belief; see page 209.) On another level, a photograph can record reality and at the same time the photographer's comment on that reality. Lewis W. Hine said of his work: "I wanted to show the things that had to be corrected. I wanted to show the things that had to be appreciated." His statement describes the use of photography as a force for social change and a style that came to be known as documentary (see page 358).

Eugène Atget's work went beyond simple records, although he considered his photographs to be documents. A sign on his door read "Documents pour Artistes." Atget made thousands of photographs in the early 1900s of the streets, cafés (left, top), shops, monuments, parks, and people of the Paris he loved. His pictures won him little notice during his lifetime; he barely managed to eke out a living by selling them to artists, architects, and others who wanted visual records of the city. Many photographers can record the external appearance of a place, but Atget conveyed the atmosphere and mood of Paris as well.

August Sander chose to document a people—the citizens of pre-World War II Germany. His pictures were not meant to reveal personal character but to show the classes making up German society of that period. He photographed laborers (left), soldiers, merchants, provincial families, and other types, all formally posed. The portraits are so utterly factual and unsentimental as to be chilling at times; the individual disappears into class and social role.

Photography and Social Change

Photography soon went from documenting the world to documenting it for a cause. Jacob Riis, a Danish-born newspaper reporter of the late 19th century, was one of the first to use photography for social change. Riis had been writing about the grinding brutality of life in New York City's slums and began to take pictures (right, top) to show, as he said, what "no mere description could, the misery and vice that he had noticed in his ten years of experience . . . and suggest the direction in which good might be done."

Lewis W. Hine was a trained sociologist with a passionate social awareness, especially of the abuses of child labor (right, bottom). This evil was widespread in the early 20th century, and Hine documented it to provide evidence for reformers. With sarcastic fury he wrote of "'opportunities' for the child and the family to . . . relieve the over-burdened manufacturer, help him pay his rent, supply his equipment, take care of his rush and slack seasons, and help him to keep down his wage scale."

JACOB RIIS
Home of Italian Rag Picker, Jersey Street, 1894

Jacob Riis used his camera to expose the slum conditions of New York City. His photographs led to housing regulations that outlawed over-crowded quarters and windowless rooms.

To take photographs inside the tenements at night, Riis used magnesium powder ignited in a open pan to provide lighting in the dark rooms. The technique was the forerunner of the modern flash.

LEWIS W. HINE
Little Girl Spinner in Mollahan Cotton Mills, Newberry, South Carolina, 1908

Lewis Hine documented the abuses of child labor between 1908 and 1921, making 5,000 pictures for the National Child Labor Committee. One foreman casually dismissed accidents, such as children getting caught in the machinery. "Once in a while a finger is mashed or a foot, but it doesn't amount to anything."

DOROTHEA LANGE
Migrant Mother,
California, 1936

Dorothea Lange's work reveals her empathy for her subjects. She had a unique ability to photograph people at the moment that their expressions and gestures revealed their lives and feelings. Her photograph of a mother of seven who tried to support her children by picking peas, was one of those that came to symbolize the 1930s Depression.

The photographers of the Farm Security Administration recorded the Depression of the 1930s, when the nation's entire economic structure was in deep trouble and farm families were in particular need. Assistant Secretary of Agriculture Rexford G. Tugwell realized that the government's program of aid to farmers was expensive and controversial. To prove both the extent of the problem and the effectiveness of the cure, he appointed Roy Stryker to supervise photographic coverage of the program.

Stryker recruited a remarkable band of talent, including Dorothea Lange (left, top), Walker Evans, Russell Lee, Marion Post Wolcott, Arthur Rothstein (left, bottom), Gordon Parks, and Ben Shahn. The photographers of the Farm Security Administration produced a monumental collection of images showing the plight of "one third of a nation" during the Depression.

ARTHUR ROTHSTEIN
Dust Storm, Cimarron County,
Oklahoma, 1936

Arthur Rothstein was the first photographer Roy Stryker hired to document the plight of people during the Depression. During that period, drought turned parts of Oklahoma into a dust bowl. Here, the building and fence posts are almost buried in drifts of sand. Rothstein later wrote that while taking the picture, "I could hardly breathe because dust was everywhere."

Whatever the news event—from a prize-fight to a war—we expect to see pictures of it. Today we take photojournalism for granted, but news and pictures were not always partners. Drawings and cartoons appeared only occasionally in the drab 18th-century press. The 19th century saw the growth of illustrated newspapers such as the *Illustrated London News* and, in America, *Harper's Weekly,* and *Frank Leslie's Illustrated Newspaper.* Because the various tones of gray needed to reproduce a photograph could not be printed simultaneously with ordinary type, photographs had to be converted into drawings and then into woodcuts before they could appear as news pictures. The photograph merely furnished material for the artist.

The halftone process, perfected in the 1880s, permitted photographs and type to be printed together, and photographs became an expected addition to news stories. "These are no fancy sketches," the *Illustrated American* promised, "they are the actual life of the place reproduced upon paper."

The photo essay, a sequence of photographs plus brief textual material, came of age in the 1930s. It was pioneered by Stefan Lorant in European picture magazines and later in America by a score of publications such as *Life* and *Look.* Today, the heyday of the picture magazine has passed, due in part to competition from television. But photographs remain a major source of our information about the world and photo essays are making a comeback on the Internet.

ERICH SALOMON Visit of German Statesmen to Rome, 1931

Not until the 1920s did photographers get a small camera able to take pictures easily in dim light. Early cameras were relatively bulky, and the slowness of available films meant that using a camera indoors required a blinding burst of flashpowder. The first of the small cameras, the Ermanox, to be followed soon by the Leica, had a lens so fast— f/2—that unobtrusive, candid shooting finally became practical. Cameras began to infiltrate places where they hadn't been before, and the public began to see real people in the news.

Erich Salomon was one of the pioneers of such shooting, with a special talent for dressing in formal clothes and crashing diplomatic gatherings. His camera let him record those in power while they were preoccupied with other matters, such as at this 1931 meeting of German and Italian statesmen. In tribute to Salomon, the French foreign minister, Aristide Briand, is said to have remarked, "There are just three things necessary for a League of Nations conference: a few foreign secretaries, a table, and a Salomon."

The halftone process converts the continuous shades of gray in a photograph (right) into distinct units of black and white that can be printed with ink on paper (far right).

GUARDIA CIVIL

These stern men, enforcers of national law, are Franco's rural police. They patrol countryside, are feared by people in villages, which also have local police.

VILLAGE SCHOOL

Girls are taught in separate classes from the boys. Four rooms and four teachers handle all pupils, as many as 300 in winter, between the ages of 6 and 14.

← FAMILY DINNER

The Curiels eat thick bean and potato soup from common pot on dirt floor of their kitchen. The father, mother and four children all share the one bedroom.

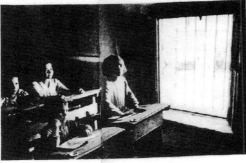

Spanish Village CONTINUED

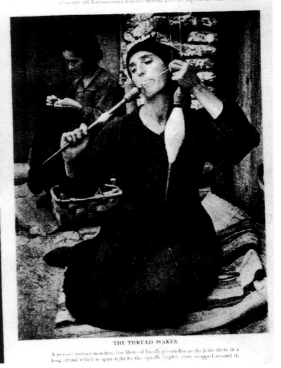

A CHRISTENING

While his godfather holds him over a font, the priest Don Manuel closes the lips of month-old Buenaventura Jimenez Moreno after his baptism at village church.

THE THREAD MAKER

A peasant woman moistens the fibers of locally grown flax as she joins them in a long strand which is spun tight by the spindle (right), then wrapped around it.

W. EUGENE SMITH From Spanish Village, 1951

The photo essay—pictures plus supporting text— was the mainstay of mass-circulation picture magazines such as **Life and Look.** *Above are two pages from "Spanish Village," photographed for* Life *by W. Eugene Smith, whose picture essays are unsurpassed in their power and photographic beauty.*

ALFRED EISENSTAEDT Ethiopian Soldier, 1935

War and social injustice are among the staples of news photography. The best of these photographs go beyond the simple recording of an event. They become symbols of the time in which they occurred.

In 1935, when the overwhelming force of a modern, mechanized Italian army invaded an ill-prepared Ethiopia, Alfred Eisenstaedt focused on the feet of a barefoot Ethiopian soldier.

MICHAEL S. WILLIAMSON
Homeless, Sacramento, California, 1982

Michael S. Williamson has made many photographs of the homeless. "I have to convince people that we are our brothers' keepers," he says, "that their problems are our problems." This group of homeless people used an abandoned power plant in Sacramento as a shelter for some time before police discovered and evicted them.

SUSAN MEISELAS
Awaiting Counterattack by the Guard, Matagalpa, Nicaragua, 1978

During the Sandinista revolt in Nicaragua, Susan Meiselas photographed these men at a barricade awaiting attack by government troops. She had to decide whether to stay and continue photographing or to leave to make the deadline for publication. "As a documentary photographer, I would have liked to stay, but I had to leave to get the pictures out. It was the first time that I realized what it means to be a photojournalist and deal with a deadline."

DANIEL HULSHIZER September 11, 2001

Despite the increasing dominance of video news, the still image has lost none of its power. Here, the Statue of Liberty holds her torch aloft against the background of the 9/11 disaster.

Was it just a photograph or was it art?

Almost from the moment of its birth, photography began staking out claims in areas that had long been reserved for painting. Portraits, still lifes, landscapes, nudes, and even allegories became photographic subject matter. Some artists bristled at the idea of photography as an art form. In 1862 a group of French artists formally protested that photography was a soulless, mechanical process, "never resulting in works which could. . . ever be compared with those works which are the fruits of intelligence and the study of art."

Photographers resented such assertions, but they in turn simply regarded photography as another kind of painting. The oldest known daguerreotype (page 346), taken by Daguerre himself in 1837, reveals this clearly. It is a still life self-consciously composed in the style of neoclassical painting.

Many photographers adapted styles of painting to the photographic print.

From the 1850s through the 1870s there was a rage for illustrative photographs similar to a storytelling style of painting popular at the time. Julia Margaret Cameron, in addition to producing elegant and powerful portraits (page 352), indulged in romantic costume scenes such as illustrations for Tennyson's *The Idylls of the King.* Oscar G. Rejlander pieced together 30 negatives to produce an allegorical pseudopainting entitled *The Two Ways of Life*—one way led to dissolution and despair, the other to good works and contentment.

At the time, the most famous and commercially the most successful of those intending to elevate photography to an art was Henry Peach Robinson. Robinson turned out many illustrative and allegorical composite photographs. These were carefully plotted in advance and combined several negatives to form the final print (right, top). Robinson became the leader of a so-called High Art movement in 19th-century photography, which advocated beauty and artistic effect no matter how it was obtained. In his *Pictorial Effect in Photography,* Robinson advised: "Any dodge, trick and conjuration of any kind is open to the photographer's use. . . . It is his imperative duty to avoid the mean, the bare and the ugly, and to aim to elevate his subject, to avoid awkward forms and to correct the unpicturesque."

By the 1880s a new movement championed naturalism as artistic photography.

Its leader, Peter Henry Emerson, was the first to campaign against the stand that "art" photographers had taken. He felt that true photographic art was possible only through exploiting the camera's ability to capture reality in a direct way (right, bottom). He scorned the pictorial school and its composite printing, costumed models, painted backdrops, and sentimental views of daily life.

Emerson laid down his own rules for what he called naturalistic photography: simplicity of equipment; no "faking" by means of lighting, posing, costumes, or props; free composition without reliance on classical rules; and no retouching ("the process by which a good, bad or indifferent photograph is converted into a bad drawing or painting"). He also promoted what he believed was a scientific focusing technique that imitated the way the eye perceives a scene: sharply focused on the main subject, but with the foreground and especially the background slightly out of focus.

Although Emerson later became convinced that photography was not an art at all but only "a handmaiden to science and art," his earlier ideas had already influenced a new generation of photographers who no longer felt the need to imitate painting but began to explore photography as an art in its own right.

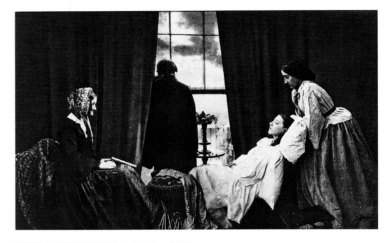

HENRY PEACH ROBINSON Fading Away, 1858

Henry Peach Robinson's High Art photography was inspired by romantic literature. He developed a composite photographic technique that allowed him to produce imaginary scenes. Fading Away (above) was staged by posing models separately and piecing together the images.

PETER HENRY EMERSON Gathering Water Lilies, 1885

Peter Henry Emerson rejected the methods of the High Art photographers. He insisted that photography should not imitate art but should strive for a naturalistic effect that was not artificially contrived. He illustrated his theories with his own photographs of peasants on the East Anglian marshes in England.

ALFRED STIEGLITZ The Steerage, 1907

Alfred Stieglitz championed pictorialist works that resembled paintings, but *his own photographs (except for a brief early period) did not include handwork or other alterations of the direct camera image. Above, the patterns he saw compelled him to make this photograph. "I saw a picture of shapes and underlying that the feeling I had about life."*

ROBERT DEMACHY
Une Balleteuse, 1900

Pictorialist photography at the turn of the century often resembled impressionist paintings, with light and atmosphere more important than sharp details.

Is photography an art? Photographers were still concerned with this question at the turn of the century. Art photographers, or pictorialists, wanted to separate their photographs from those taken for some other purpose—ordinary snapshots, for example. *The American Amateur Photographer* suggested: "If we had in America a dignified 'Photographic Salon,' with a competent jury, in which the only prizes should be the distinction of being admitted to the walls of the 'Salon,' we believe that our art would be greatly advanced. 'Art for art's sake' should be the inspiring word for every camera lover." The pictorial movement was international. Exhibitions where photographs were judged on their aesthetic merits were organized by the Vienna Camera Club, the Linked Ring Brotherhood in England, the Photo-Club de Paris, the American Photo-Secession, and others.

Many pictorialists believed that artistic merit increased if the photograph looked like some other kind of art—charcoal drawing, mezzotint, or anything other than photography. They patterned their work quite frankly on painting, especially the work of the French Impressionists, for whom mood and a sense of atmosphere and light were important. The pictorialists favored mist-covered landscapes and soft cityscapes; light was diffused, line was softened, and details were suppressed (left, bottom).

To achieve these effects, pictorialists often used printing techniques to which handwork was added—for example, gum-bichromate printing, where the image was transferred onto a thick, soft, often tinted coating that could easily be altered as the photographer wished. One critic was delighted: "The results no longer have anything in common with what used to be known as photography. For that reason, one could proudly say that these photographers have broken with the tradition of the artificial reproduction of nature. They have freed themselves from photography. They have sought the ideal in the works of artists. They have done away with photographic sharpness, the clear and disturbing representation of details, so that they can achieve simple, broad effects." Not everybody agreed. This did not fit at all into Peter Henry Emerson's ideas of naturalistic photography: "If pure photography is not good enough or 'high' enough . . . by all means let him become an artist and leave us alone and not try and foist 'fakes' upon us."

In America, Alfred Stieglitz was the leader and catalyst for photography as an art form and his influence is hard to overestimate. For more than 60 years he photographed (left, top), organized shows, and published influential and avant-garde work by photographers and other artists. In his galleries—the Little Galleries of the Photo-Secession (later known simply by its address, 291), the Intimate Gallery, and An American Place—he showed not only what he considered the best photographic works but also, for the first time in the United States, the works of Cézanne, Matisse, Picasso, and other modern artists. In his magazine *Camera Work*, he published photographic criticism and works whose only requirement was that they be worthy of the word art. Not only did he eventually force museum curators and art critics to grant photography a place beside the other arts, but by influence, example, and sheer force of personality he twice set the style for American photography: first toward the early pictorial impressionistic ideal and later toward sharply realistic, "straight" photography.

Some photographers interested in art in the early 20th century made images directly related to the photographic process, even while pictorialists were making photographs that looked very much like paintings. A movement was forming to return to the direct and unmanipulated photographs that characterized so much of 19th-century imagery. In 1917 Stieglitz devoted the last issue of *Camera Work* to Paul Strand, whose photographs he saw as representing a powerful new approach to photography as an art form. Strand believed that "objectivity is of the very essence of photography. . . . The fullest realization of this is accomplished without tricks of process or manipulation, through the use of straight photographic methods."

Stieglitz's own photographs were direct and unmanipulated. He felt that many of them were visual metaphors, accurate representations of objects in front of his camera and at the same time external counterparts or "equivalents" of his inner feelings. Since 1950, Minor White carried on and expanded Stieglitz's concept of the equivalent. For White, the goal of the serious photographer was "to get from the tangible to the intangible" so that a straight photograph of real objects functions as a metaphor for the photographer's or the viewer's state of mind.

Straight photography dominated photography as an art form from the 1930s to the 1970s, and is exemplified by Edward Weston. He used the simplest technique and a bare minimum of equipment: generally, an 8 x 10 view camera with lens stopped down to the smallest aperture for sharpness in all parts of the picture. He contact-printed negatives that were seldom cropped. "My way of working—I start with no preconceived idea—discovery excites me to focus—then rediscovery through the lens—final form of presentation seen on ground glass, the finished print previsioned complete in every detail of texture, movement, proportion, before exposure—the shutter's release automatically and finally fixes my conception, allowing no after manipulation—the ultimate end, the print, is but a duplication of all that I saw and felt through my camera." Many other photographers, such as Ansel Adams, Paul Caponigro, and Imogen Cunningham have used the straight approach.

▲
EDWARD WESTON Pepper No. 30, 1930

Edward Weston's direct photographs were both objective and personal. "Clouds, torsos, shells, peppers, trees, rocks, smokestacks are but interdependent, interrelated parts of a whole, which is life."

◄
PAUL STRAND The White Fence, Port Kent, New York, 1916

Paul Strand's straight approach to photography as an art form combined an objective view with personal meaning. "Look at the things around you, the immediate world around you. If you are alive it will mean something to you, and if you care enough about photography, and if you know how to use it, you will want to photograph that meaningness."

LÁSZLÓ MOHOLY-NAGY Jealousy, 1927

Photographers such as László Moholy-Nagy and Man Ray used many techniques in their explorations of real, unreal, and abstract imagery. The photomontage (above) combines pieces of several photographs. Moholy defined photomontage as *"a tumultuous collision of whimsical detail from which hidden meanings flash,"a definition that fits this ambiguous picture.*

In Man Ray's photograph (right), the dark lines along the woman's hand, as well as other altered tones, are due to solarization (Sabattier effect), exposing the image to light during development.

The beginning of the 20th century saw great changes in many areas, including science, technology, mathematics, politics, and also the arts. Movements like Fauvism, Expressionism, Cubism, Dada, and Surrealism were permanently changing the meaning of the word "art." The Futurist art movement proposed "to sweep from the field of art all motifs and subjects that have already been exploited . . . to destroy the cult of the past . . . to despise utterly every form of imitation . . . to extol every form of originality."

At the center of radical art, design, and thinking was the Bauhaus, a school in Berlin to which the Hungarian artist László Moholy-Nagy came in 1922. He attempted to find new ways of seeing the world and experimented with radical uses of photographic materials in an attempt to replace 19th-century pictorialist conventions with a "new vision" compatible with modern life. Moholy explored many ways of expanding photographic vision, through photograms, photomontage (left), the Sabattier effect (often called solarization), unusual angles, optical distortions, and multiple exposures. He felt that "properly used, they help to create a more complex and imaginary language of photography."

Another artist exploring new art forms was Man Ray, an American expatriate in Paris. He was drawn to Dada, a philosophy that commented on the absurdities of modern existence. "I like contradictions," he said. "We have never obtained the infinite variety and contradictions that exist in nature." Like Moholy, Man Ray used many techniques, including the Sabattier effect (below).

MAN RAY Solarization, 1929

A tremendous growth has taken place in the acceptance of photography as an art form, a change that started in the 1950s. Since then, photography has become a part of the college and art school curriculum, art museums have devoted considerable attention to photography, art galleries opened to sell only photographs, while photography entered other galleries that previously had sold only paintings or other traditional arts, and magazines such as *Artforum* and *Art in America* began to regularly publish photographs and essays about the medium.

American work of the 1950s was often described in terms of regional styles. Chicago was identified with the work of Aaron Siskind (below) and Harry Callahan (right). The West Coast was linked to the so-called straight photographers, such as Ansel Adams (page 198) and Minor White (pages 85 and 314). New York was thought of as the center for social documentation, such as by photographers in the politically active Photo League. Meanwhile, tied to no region, Robert Frank, a Swiss, was traveling across the United States photographing his own view of life in the 1950s (opposite).

An increasing number of colleges and art schools in the late 1960s offered photography courses, often in their art departments where a cross-fertilization of ideas took place between photographers and artists working in traditional art media. Some painters and other artists integrated photographs in their work or sometimes switched to photography altogether. Some photographers combined their images with painting, printmaking, or other media. Older photographic processes were revived, such as cyanotypes, gum bichromate, and platinum printing (pages 272–274).

Minor White said that in the 1950s photographers functioning as artists were so few that they used to clump together for warmth. The explosion of photography in academia helped push the medium in many directions (some are shown on the following pages), and the long battle over whether photography was an art, a battle that had been waged almost from the invention of the medium, was finally resolved. The winners were those who said it could be.

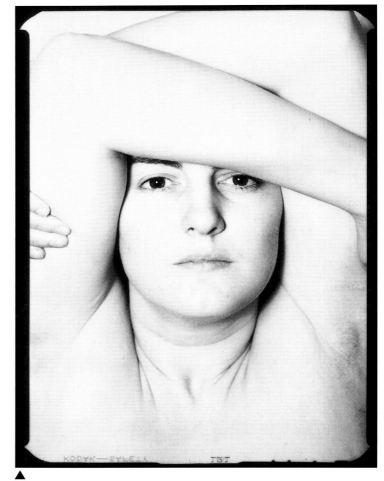

▲

HARRY CALLAHAN Eleanor, 1947

Harry Callahan's work was lyrical and personal. He returned again and again to three main themes, the emptiness of city scenes, the rich detail of landscapes, and portraits of his wife, Eleanor. He said, "It takes me a long time to change. I don't think you can just go out and figure out a bunch of visual ideas and photograph. The change happens in living and not through thinking."

◀

AARON SISKIND Chicago 30, 1949

Aaron Siskind's best-known work consists of surfaces abstracted from their normal context such as peeled and chipped paint or posters on walls (left). The subject of the photograph is the shapes, tonality, and other elements that appear in it, not the particular wall itself.

Siskind was active as a documentary photographer during the 1930s, but as he later recalled, "For some reason or other there was in me the desire to see the world clean and fresh and alive, as primitive things are clean and fresh and alive. The so-called documentary picture left me wanting something."

ROBERT FRANK Bar, New York City, 1955

Robert Frank's ironic view of America exerted a great influence on both the subject matter and style of photography as an art form. Like Frank's photographs, the works of Diane Arbus, Lee Friedlander, Garry Winogrand, and others were personal observations of some of the peculiar and occasionally grotesque aspects of American society. Above, a glimpse inside a New York bar is an unsettling comment on the emptiness of modern society. Jack Kerouac wrote in his introduction to Frank's book The Americans, "After seeing these pictures, you end up finally not knowing any more whether a jukebox is sadder than a coffin."

Photographers continued to explore a variety of subjects and issues. Some remained committed to form and beauty in the straight photography tradition of Edward Weston (page 366) or Ansel Adams (page 198), while others experimented with form to find a new vision. Shaped by repercussions of the Vietnam War and other conflicts, some photographers took the medium in political directions, following the leads of Robert Frank (page 369) or W. Eugene Smith (page 361). Photographers like Lee Friedlander (page 321), Diane Arbus, and Garry Winogrand (page 229) roamed the streets, recording the humor, pathos, and irony of daily life.

Photography found acceptance as a legitimate art form. During the late 1970s and early 1980s, emerging artists using photography like Cindy Sherman, Robert Mapplethorpe, and Barbara Kruger (page 379) were exhibited in art galleries, as opposed to photography galleries, and found they could prosper. Photographers like Irving Penn and Richard Avedon—better known for their commercial work—were given exhibitions of their editorial and personal work in major art museums, evoking controversy in some quarters. Technological advances in color photography, seldom embraced by art photographers in the past, helped it gain in popularity.

Museums hired photographic curators and charged them with building collections and exhibiting photography more regularly. New institutions like the International Center for Photography (1974) and the Center for Creative Photography (1975) were founded. By the early 1980s, photography had become a fixture in museums, academia, and the art world at large.

Photography attracted the attention of respected intellectuals from other fields as well. The theoretical writings of Walter Benjamin and Roland Barthes, long known in European circles, were exported to America and elsewhere. In *On Photography* (1977), Susan Sontag raised penetrating questions about the medium, its aesthetics, and its ties with the culture at large. Sontag validated photography as a subject worthy of serious analysis, which in turn fed its newfound acceptance as a legitimate art form and academic subject. By the early 1980s photography was not merely accepted, it was hot.

CINDY SHERMAN Untitled Film Still #13, 1978
Sherman rose to fame as an early postmodern art star with the Untitled Film Stills series, in which she played the role of an actor playing a role.

ROBERT CUMMING Academic Shading Exercise, 1975
The original title of this piece was "Academic shading exercise in which the negative proved closer to reality." Cummings' early photographic works, like this one, were labeled "photographic conceptualism" because they broke from the tradition of formal beauty in favor of stressing an idea.

RICHARD AVEDON Sandra Bennett, Twelve Year Old, Rocky Ford, Colorado, August 23, 1980

JERRY N. UELSMANN Threshold, 1999

Negatives are only the starting point for Jerry Uelsmann's work. He may print various combinations of different negatives, blocking out part of a scene, printing in part of another one, and generally merging realistic-looking objects that do not seem to belong together into a universe of dreamscapes.

Uelsmann used to do all of his work in a conventional darkroom, using multiple enlargers to combine his images. Now, he also uses digital imaging to create effects that would be difficult or impossible to do otherwise.

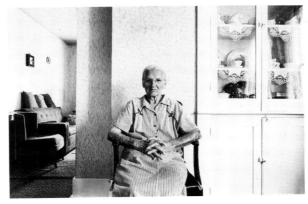

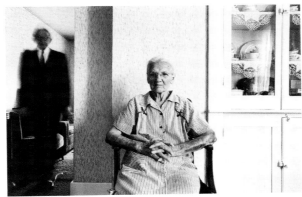

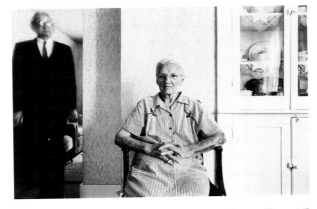

DUANE MICHALS Death Comes to the Old Lady, 1969

Serial imagery, sequences, and photo essays release the photographer from the confinement of a single picture. They can show variations of a single photograph or theme, show the same scene from different angles or at different times, bring together different images to make a particular statement, or, as here, tell a story.

Duane Michals tells stories that are seldom literal, but always relevant. "Photography to me is a matter of thinking rather than looking," he says, "it's revelation, not description." His photographs are often accompanied by titling or captions. Notice that you need the title of this story in order to understand it.

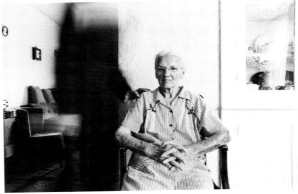

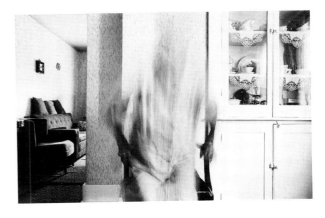

MASAHISA FUKASE Wakkanai, Japan, 1977

The graininess and darkness of high-speed film that has been pushed (see page 108) give Masahisa Fukase's photograph of ravens an ominous and brooding look. A flash unit added little light to the scene, but did create white reflections from the birds' eyes that add to the uneasy feeling of the photograph.

ROBERT PARKEHARRISON Flying Lesson, 1999

Robert ParkeHarrison constructs scenes of an elaborate personal struggle with the universe. "I want to make images that have open, narrative qualities," he says, "enough to suggest ideas about human limits. . . . Through my work I explore technology and a poetry of existence. These can be very heavy, overly didactic issues to convey in art, so I choose to portray them through a more theatrically absurd approach."

ANDREAS GURSKY Siemens, Karlsruhe, 1991

Andreas Gursky's large-scale and literal photographs of contemporary life dwarf the humans that have created that life for themselves. *The humans in this photograph of a modern manufacturing facility are visually no more important than the equipment and materials with which they work. That very equality creates a chill. "We are alone on this planet," Gursky says. "It is not a choice. Here we are. This is what everyone has to deal with."*

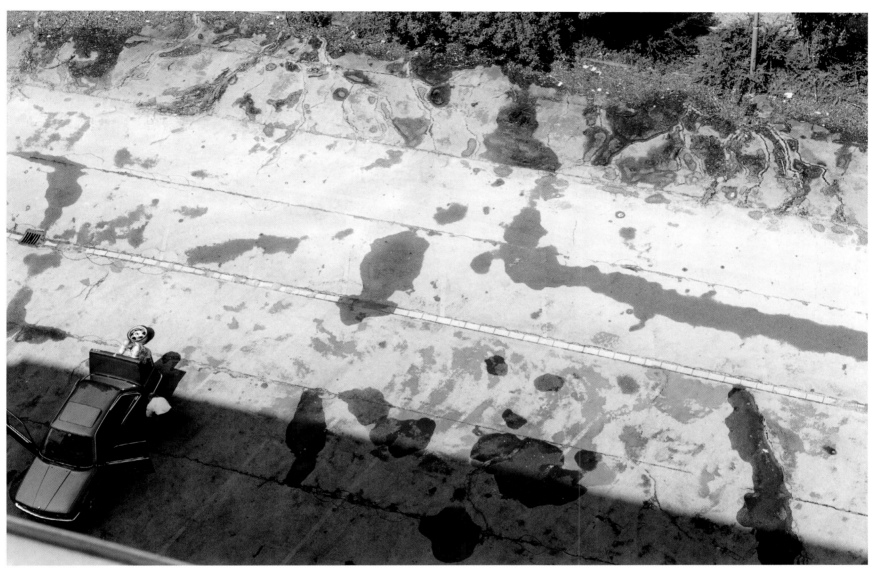

JOACHIM BROHM Areal 99 M2100, 2002

Joachim Brohm's photographs extend the documentary tradition. *Many photographers today have abandoned the idea that photographs can tell "the truth" about anything. Instead they try to record a personal story. Aware that the site of a large postwar industrial company on the outskirts of Munich was being refashioned, or "gentrified" according to contemporary city planning ideals, he began to photograph the area. For ten years he recorded the before, during, and after of the transformation, doing so as an artist with his own idiosyncratic vision. Collectively, assembled into the book,* Areal, *they present a clear response to the way cities reinvent themselves.*

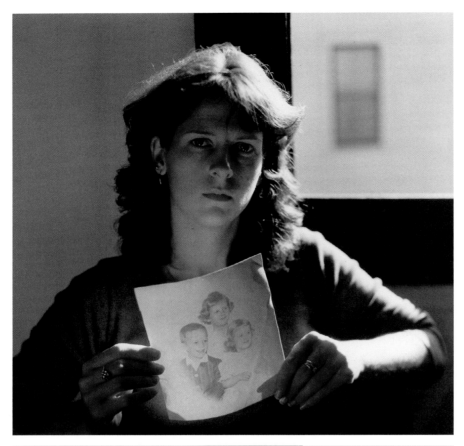

BART PARKER
Constance Holds Her Childhood Photograph, 1982

Parker's work often comments on aspects of the medium itself. *He is particularly interested in the nature of light, since it is central to every photographic process. He shows it here as it acts both by transmission and by reflection and reveals both image and person involved with the image. "These are things the optical translation does to what is seen. One dimension is discarded. One half of each viewpoint is discarded, as it is when you close one eye. The flow of time becomes a fixed sliver of the past."*

BARBARA KRUGER
Untitled (Are We Having Fun Yet?), 1987

Much of Barbara Kruger's work is a commentary about women's identity and the pressures on it. *She appropriates existing images, adds on contradictory or ambiguous comments, advertising slogans, or fragments of vaguely familiar popular wisdom, then displays the work in giant size (8 x 12 feet or more). She points in the direction she wants the viewer to go, but leaves the exact interpretation to the viewer. Does the gesture here suggest pain or alienation or fear? Does the text imply cynicism or delusion?*

Kruger's work is visually engaging as well as confrontational. "I want to make statements that are negative about the culture we're in," Kruger says, but she puts her statements in eye-catching form, "or else people will not look at them."

LARS TUNBJÖRK Linköping, 1992

A quirky juxtaposision of unrelated elements makes this photograph work.
Tunbjörk began as a globetrotting freelancer. Then, after shooting a successful
photo-essay in Britain, "I went home to Sweden and thought to myself, maybe I
should concentrate on what I know best—my own country."

ALEC SOTH Charles, Vasa, Minnesota, 2002

Soth leaves himself open to chance meetings. *Driving through an unfamiliar neighborhood, he noticed a large glass room built on the roof of a house. Soth introduced himself to the owner, who said the glass room was his "cockpit," a place where he and his daughter built model airplanes.*

NAN GOLDIN The Blue Bathroom, London, 1980

This self-portrait is from Goldin's series **The Ballad of Sexual Dependency,**
*that she calls a "diary I let people read." Photography became an essential part
of her life when, at eighteen, she "became social and started drinking and wanted
to remember the details of what happened."*

ABELARDO MORELL Camera Obscura Image of a Tree in Bathroom, Little Compton, Rhode Island, 1999

Morell turned this bathroom into a camera obscura, blocking all light except that coming from a small hole (about 3/8 inch) in the opaque window covering. His view camera inside the room captured the scene outside—projected upside-down on the room's interior—in a seven-hour exposure.

TEUN HOCKS Untitled, 2003

Dutch artist Hocks makes sketches first, then creates theatrical sets in which he plays the central role. *After the moment is captured, he makes enlargements—in this case a 4 x 5 foot black-and-white silver print—that he then paints with transparent oils.*

ARNO RAFAEL MINKKINEN Self-portrait, New City, New York, 1971

Minkkinen arranges his own body in front of the camera. He has said that early in his career "I discovered what I wanted to do with photography. I didn't want to look through the camera; I wanted to learn to think through it."

EMMET GOWIN Matera, Italy, 1980

Gowin's photographs are a model of clarity, but a full experience of his work comes only from seeing his original prints. The relationship between the rendering of a photographic print and its content is of great importance to him. He wants the viewer, on seeing a print, to "have an understanding of the place without ever having been a resident."

NAOYA HATAKEYAMA
River Series #2, 1993

Hatakeyama is captivated by Tokyo's underground world. In this photograph, he places his lens level with the artificial riverbank of one of the city's many concrete channels and separates the image into two contrasting views.

Troubleshooting
Finding the Problem/Finding the Solution

All photographers occasionally encounter problems with their pictures, sometimes due to equipment failure, sometimes to human failure. If your pictures don't look the way you expected, see below. You'll find illustrations of various problems—and what to do about them.

No picture at all

IMAGE AREA AND FILM EDGES ARE CLEAR IN NEGATIVE (DARK IN SLIDE). FILM FRAME NUMBERS AND MANUFACTURER'S NAME ARE VISIBLE.

The film was not exposed to light:
■ **Film did not wind through the camera.** If the entire roll of film is blank, an unexposed roll may have been processed by mistake. If you are sure you took pictures with the film in the camera, it probably did not catch on the film-advance sprockets and so did not advance from frame to frame. More about film loading and how to check for a proper load, page 5.
■ **Lens cap was left on.** Possible with a viewfinder/rangefinder camera, but not likely with a single-lens reflex or view camera, which views through the lens.
■ **Equipment failure.** Shutter failed to open, mirror in a reflex camera failed to move out of the way, or flash failed to fire. If problem recurs frequently, have equipment checked.

IMAGE AREA AND FILM EDGES ARE CLEAR IN NEGATIVE (DARK IN SLIDE). FILM FRAME NUMBERS AND MANUFACTURER'S NAME DO NOT SHOW.

■ **The film was put into fixer before it reached the developer.** Frame numbers and other data are exposed by the manufacturer along the film edges; they become visible only after development. If you use fixer first, this imprint, as well as the image, are removed from the film. If you developed the film yourself, review film processing, page 100–105. Label chemical containers so they don't get mixed up.

IMAGE AREA AND FILM EDGES ARE DARK IN NEGATIVE (LIGHT IN SLIDE). FILM FRAME NUMBERS AND MANUFACTURER'S NAME MAY BE OBSCURED.

Accidental exposure to light:
■ **Camera back was opened before film was rewound.** Close the back immediately if this happens. Rewind the film and process it, because not all the film may have been affected. More about film rewinding, page 8.
■ **Light reached the film after it was on the developing reel, but before it was put into a developing tank and covered.** Film must be loaded in total darkness, so be sure both room lights and safelights are off and there are no light leaks around doors or windows.

Camera/lens problems

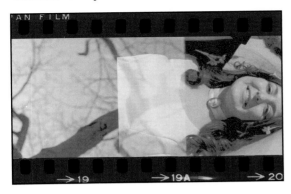

DOUBLE EXPOSURE
Image areas overlap.

■ **If images overlap on the entire roll, the film was put through the camera twice.** Rewind 35mm film entirely back into the cassette, including the film leader. If you leave the leader hanging out, you can mistake an exposed roll for an unexposed one and put it through the camera again.

■ **If images overlap on one or a few frames, the film did not advance properly between exposures.** Accidentally pushing the film rewind button would let you release the shutter without having advanced the film. Check the way you grip the camera. It is difficult to push the rewind button unintentionally, but it is possible to do so.

■ **If frames frequently overlap or if spaces between frames are of different widths, your film advance mechanism is probably failing.** The camera should be repaired.

FLARE OR FOGGING
Image area flared or foggy looking overall (darkened in negative, lightened in print or slide), with film edges unaffected.

■ **Direct light striking the lens surface.** Light that hits the front surface of the lens can bounce around inside the lens and cause an overall fogging of the image. Use a lens shade matched to your lens's focal length (see Vignetting, below) to block any light from shining directly on the lens.

■ **A light source included in the image.** This can also produce ghosting, multiple images in the shape of the lens diaphragm, and/or star points, streamers of light around the light source. The larger or brighter the light, the more ghosting you will get; distant or dim lights may not produce any. Difficult to cure because the cause is within the picture itself. Sometimes you can reduce the effect by changing your position.

■ **Dirt, dust, scratches, and fingerprints on lenses or lens filters.** These imperfections increase the likelihood of flare. Clean a lens or filter before using it if it is dirty.

LIGHT STREAKS
Streaks along edges and/or in image area (dark in negative, light in print or slide).

Accidental exposure to light, less damaging version of the previous problem. Other possible causes include:

■ **Light leaked into camera back.** A damaged camera back or loose locking mechanism can let stray light enter and streak the film. Inspect the camera back along opening edges and hinges, and make sure the back locks securely and stays in place.

■ **Light leaked into film cassette.** A bent film cassette or improperly secured end cap on a reuseable cassette can let in light and cause streaking. Inspect reusable cassettes carefully for damage before you refill them.

■ **Camera loaded, or film left, in overly bright light.** In very bright light, even an apparently undamaged camera or cassette can leak, causing streaks on the film. Load film in a shaded area or block direct light with your body. Keep undeveloped rolls of film away from light.

TORN SPROCKET HOLES, TORN FILM
Sprocket holes on edges of 35mm film are torn and/or film is torn through an image frame.

■ **Rewinding was forced without first engaging the rewind mechanism.** Some cameras rewind automatically at the end of a roll. Others require you to push a rewind button or lever. See manufacturer's instructions for how to rewind film with your camera.

■ **Film was forcibly advanced after the end of the roll was reached.** Don't try to squeeze just one more shot onto the end of a roll. You'll probably just tear it off the spool, making rewinding impossible. If this happens, retrieve the film by opening the camera back in a totally dark room or in a light-tight film changing bag.

VIGNETTING
Image obscured around the edges.

■ **Part of the image blocked by a lens shade or filter or both.** Use the correct size shade for your lens. Lens shades are made in sizes to match lens focal lengths. If the lens shade is too long for your lens, it can extend too far forward and partially block the image. Using more than one filter or a filter plus a lens shade can cause vignetting, especially with a short-focal-length lens. If necessary, take off the lens shade and use your hand to shade the lens. Just be sure your hand isn't visible.

■ **With a view camera, caused by a lens with inadequate coverage for the film format.** See page 288.

STATIC MARKS
Sparklike shapes dark in negative (light in print).

■ **Static electricity in the camera.** Winding film rapidly on a very cold, dry day can cause lightning-like marks. When humidity is very low, avoid snapping the film advance lever forward or otherwise advancing or rewinding film extremely rapidly.

■ **Static electricity in the darkroom.** Static marks in bead-like or other shapes can be caused by pulling undeveloped roll film rapidly away from its paper backing, pulling 35mm film through the cassette opening rather than taking the top off the cassette, ripping off rather than cutting off the tape that holds film on a spool, or passing film rapidly through your fingers. Handle film without rapid, friction-producing motions.

Specks, scratches, fingerprints on film, digital image, or print

DARK SCRATCH LINES IN PRINT

■ **Rough handling of film.** Scratching the film's emulsion side will scrape away the emulsion and make dark scratch lines visible in the print. Handle film with extreme care and avoid cinching roll film, sliding sheet film against a rough surface, or otherwise abrading the film. Check the film path in the camera for grit or unevenness. Do not drag film roughly in and out of negative preservers or an enlarger's negative carrier.

■ **Rough handling of print.** If scratches can be seen only on the print, not on the negative, the cause is abrasion of the print emulsion. Prevent this by handling paper with greater care. If you use print tongs, don't slide them across the print surface; even light pressure can mark the surface of the print. Grip paper with tongs in the print margin so tong marks can be trimmed off if necessary.

LIGHT SCRATCH LINES IN PRINT

■ **Rough handling of film.** Hairline scratches on the backing side of the negative will make light scratch lines visible in the print. More careful handling or storage of the negative will prevent future problems. Check the film pressure plate on the camera back for damage or raised areas that might be scratching the film as it advances or rewinds.

An already scratched negative can be improved somewhat by applying a light coating of oil. Edwal No-Scratch is an oily product that may at least partially improve the next print by temporarily filling in the scratch. A down-home remedy is to rub your finger on your nose or forehead to pick up a light coating of oil. Then gently smooth the oil over any fine scratches that are visible. Either method works only on scratches that print as white. The oil attracts dust, so clean the negative with film cleaner before storing.

DUST SPECKS ON NEGATIVE OR DIGITAL IMAGE
Black specks in positive (clear on negative).

■ **Dust on the film or sensor during exposure.** Bits of dust on the light-sensitive surface will keep light from reaching it during the exposure. Keep the inside of the camera dust free by blowing or dusting camera surfaces when you change lenses or reload film. With sheet film, dust film holders carefully and load film in a dust-free place. Black specks can be retouched in image editing; on silver prints etch or bleach to remove them (page 220).

■ **Stop bath too strong during film development.** The acid stop bath used between developer and fixer steps must be diluted to the proper strength or it can cause a chemical reaction that will lift off bits of the film emulsion making spots called pinholes. Check your film chemistry for proper dilution. Some photographers use a plain water rinse instead of a stop bath; the fixer won't last as long, but pinholes won't be a problem.

■ **Scratches on enlarger's glass condensers.** This could be the cause of dark, fuzzy-edged spots. Try a wider aperture, but the only real cure is to replace the condensers.

CRESCENT-SHAPED MARKS
Dark crescents in negative (light in print).

■ **Crimping or creasing the film while loading it onto the developing reel.** Handle film with care, especially if you have trouble loading it onto a developing reel and have to reel it on and off several times. Make sure developing reels are completely dry to prevent the film from sticking during loading. Spotting a print that shows marks will help (see page 220).

DUST SPECKS ON PRINT OR SCAN
White specks or small white spots on image.

■ **Dust is the culprit.** Dust on a negative, printing-frame glass, scanner glass, or glass negative carrier will keep light from passing through the negative and produce sharp white specks on the positive image. Fuzzy-edged spots may be due to dust on an enlarger's glass condensers. Dust all these surfaces carefully before printing, although it's almost impossible to keep them entirely free of dust. Dust loves wet negatives; hang just-washed film in a dust-free place to dry. White specks on a silver print can be darkened with dyes (see spotting, page 220). A digital image can be retouched during image editing but it is easier to keep things clean.

FINGERPRINTS
Fingerprints on film will appear oversize in an enlarged print; fingerprints caused by handling paper improperly will be lifesize.

■ **Touching film or paper emulsion with chemical-contaminated or greasy hands.** Rinse and dry hands after they have been in any chemical solution. Be particularly careful to clean fixer off hands. Hold film and paper by edges.

Fingerprints from grease might be removed by rewashing the film and treating it again with a wetting agent, or by cleaning the film with a cotton swab and film cleaner. Handling film with clean editing gloves is a sure way to prevent damage and is always done by curators and others concerned with film preservation.

Film development problems

EVERY FRAME ONLY PARTIALLY DEVELOPED
One edge of the entire roll of negatives lighter than the rest (darker in print).

■ **Not enough developer to cover the film.** Check the amount of developer needed to cover the reel (or reels, in a tank that holds more than one). Fill the tank with water, pour the water into a graduated container, and note the amount. Use this as your standard measure for the tank. Or simply fill the tank to overflowing when you add chemicals.

UNEVEN, STREAKY DEVELOPMENT OF NEGATIVE
Lighter streaks in negative (darker in print).

■ **Too little agitation in developer.** Without adequate agitation, exhausted chemicals can accumulate and slide across the surface of the film, retarding development and causing streaks in those areas. Prevent this by agitating regularly. See step 12, page 103, for how to agitate film.

OVERDEVELOPED AREAS AROUND SPROCKET HOLES
Repeated streaks coming from sprocket holes appear light on print (dark on film). Most visible in lighter areas, such as skies.

■ **Too much agitation in developer.** The goal of agitation is to move the developer evenly across the film's surface. Excessive agitation can force too much fresh developer through the film's sprocket holes, causing those areas to be more developed than the rest of the film. See step 12, page 103, for how to agitate film.

FILM SURFACE APPEARS CLOUDY
A milky white or tan look with most films. A pinkish cast with Kodak T-Max film.

■ **Probably due to inadequate fixing.** If film appears cloudy when you remove it from the fixer, immediately replace it in the fixer, agitating vigorously at 30-sec intervals. If the milky appearance isn't gone after 5 min, your fixer is exhausted. Cover the tank; refix with fresh fixer.
■ **Possibly old, light-struck, heat-damaged, or X-rayed film.** No cure for this. Use fresh film next time.

SCUM OR GRITTY RESIDUE ON FILM
■ **Inadequate washing or improper use of wetting agent.** Make sure wash water circulates well; dump wash water several times during the washing process, refilling the tank with fresh water. Dilute the wetting agent correctly; too strong a solution can leave a residue of its own on the film. Make sure film is completely dry before you work with it; damp film attracts dust and grit.
■ **Extremely hard water.** If you live in an area with very hard water, filtering your water at the tap can minimize problems with mineral particles depositing on the film. Mix wetting agent with distilled water to give a final clean rinse to the film.

FAINT, WATERY LOOKING MARKS ON FILM
Usually running along the length of the film.

■ **Uneven drying or water splashed on film during drying.** Treat film in a wetting solution, such as Kodak Photo-Flo, just before hanging it up to dry. Hang the film from one end with a clip holding down the other end so that the water can drip straight off the film and not puddle up. Don't let water from one roll of drying film drip onto another. Rewashing the damaged film or using film cleaner may remove the streaks. Spotting a print where streaks show can help, see page 220.

Film development problems, continued

RETICULATION
Image appears crinkled or cracked overall.

■ **Extreme variations in temperature of processing solutions.** Very large changes, such as processing film in very warm developer, then putting the film in very cold stop bath can cause the effect illustrated. Less extreme variations can cause increased grain. Keep all solutions, from developer to wash, at or within a few degrees of the same temperature.

BLANK PATCHES
Patches usually opaque in negative (light in print), occasionally clear in negative (dark in print).

■ **Two loops of film stuck together during film processing.** Winding two loops of film onto one loop of developing reel (not hard to do with a stainless-steel reel) or squeezing reeled film (possible with either a plastic or stainless-steel reel) can keep part of one film loop in contact with another. This keeps chemicals from reaching the film emulsion at the point of contact. Most often the area will be totally unprocessed and opaque (see illustration). It will be clear if the film separates during fixing.

Check that film is winding correctly by feeling how full the reel is. Listen as you reel the film; any crackling or other unusual sound indicates a problem. If winding doesn't proceed smoothly, unwind a few loops and start again.

AIR BELLS
Small, round dark spots in print (clear on negative). Air bells can also occur during print development, see Air Bells, page 393.

■ **Bubbles of air on the surface of the film during development.** The bubbles kept that part of the film from being developed. Vigorously tapping the film development tank at the start of the development period will dislodge any air bubbles from the film. See page 103, step 11.

Printing problems

IMAGE BACKWARDS IN PRINT

■ **Negative upside down in enlarger or printing frame.** Easy to identify. Easy to fix: flop the negative over and make another print.

VIGNETTED PRINT, NEGATIVE OK
White edges or corners on the print, or image appears within a circle.

■ **Light coming from the enlarger is obstructed.** Check the enlarger's condensers to make sure they are in the right position for the film size in use. Check that any filters or filter holders are not obstructing the enlarger's light.

MOTTLED, MEALY, UNEVEN LOOK TO THE PRINT

■ **Too little time or inadequate agitation in print developer.** Develop prints with constant agitation in fresh developer for no less than the minimum time recommended by the manufacturer. Don't pull a print out of the developer if it appears to be becoming too dark too soon. It's better to make another print with less exposure.
■ **Use of exhausted or too cold developer.** Use fresh developer within the temperature range recommended by manufacturer. If darkroom is too cold to maintain the temperature, flood the sink with enough warm water to surround the developing trays, but not float them away.

Printing problems, continued

AIR BELLS
Small, round light spots in print, negative OK. Round dark spots on the print with matching clear spots on the negative are caused by air bells during film development. See Air Bells, page 392.

■ **Bubbles of air on the surface of the print during development.** If a print is immersed face down in the developer, then not agitated enough, bubbles of air can stick to the print and prevent the developer from working. Slide prints into the developer face up and agitate continuously during the development period.

BLACK STREAKS APPEAR ACROSS PRINT EDGE AND/OR IN THE IMAGE

■ **Exposure of printing paper to white light.** Black streaks are the result of white light leaking into a damaged paper container or accidentally reaching the paper by, for example, having the paper container open while you turn on the room lights or open the enlarger lamp housing with the enlarger light on. Until your print is fixed, the only white light that should reach your paper is that from the enlarger during the exposure. Store your printing paper in its original wrapping, within its black bag and cardboard envelope or box.

LINES ACROSS A PRINT (DIGITAL PRINTS ONLY)

■ **Misaligned or clogged printheads** in an inkjet printer can cause lines or bands across a print. Use the printer's software utility to check for a problem. The same utility will run cleaning cycles to unblock a clogged print jet or print a test pattern to aid in realignment.

STAINS ON PRINTS (SILVER PRINTS ONLY)

■ **Can be caused at a variety of processing stages.** Too long a time in the developer, exhausted or too-warm developer, contamination of developer with fixer, exposure of paper to air during development by lifting it out of the developer too often, exhausted stop bath or fixer, delay in placing print into fixer, and inadequate fixing or washing are all possible culprits, as are handling with contaminated hands or tongs. Stain colors range from yellow and brown to purple. Review fixing and washing procedure (page 126–127) and information about contamination (page 97).

OVERALL GRAY CAST IN HIGHLIGHTS OR PAPER MARGINS

■ **Fogging of printing paper by stray light.** Check for light leaking into darkroom from outside, stray light from enlarger, too strong a safelight, too long or too close an exposure to a proper safelight. Fogging affects highlights first, so prints may be reduced in brilliance before fogging is seen in print margins. The light from slight fogging alone may be too weak to cause any visible response in the paper's emulsion, but when added to the slight exposure received by the highlights, it can be enough to make the print grayish. Compare highlights that should be pure white in the print with the white test patch described on page 129.
■ **Improper paper storage.** Fogging can occur if paper is stored near heat or in a package that is not light tight, or is outdated paper. Buy new paper and store properly.
■ **Too much time in developer.** Remove print at the end of the recommended developing time. If the print is too light, don't keep it in the developer for extra time. Make another print with more exposure.
■ **Room light on too soon after print in placed in fixer.** Give the fixer enough time to stop the action of the developer so the print isn't affected by exposure of the print to room light.

PRINTS FADE

■ **Improper processing** (Silver prints only).. Prints that look faded immediately after washing were bleached by a too-strong or too-warm fixer or by too long a time in the fixer. Later fading is caused by inadequate fixing or washing. Review the recommended fixing and washing procedure (page 126–127).
■ **Dye-based inks** (Digital prints only). Permanence is a problem for dyes in inkjet and dye-sublimation printers (as well as for traditional chromogenic color-print processes). The pigmented ink systems used in many inkjet printers designed for photographic use have a much longer expected lifespan.

Density (overall lightness/darkness) problems

Overexposed

Overdeveloped

Underexposed

Underdeveloped

NEGATIVE DENSE LOOKING, SLIDE TOO LIGHT

■ **Most likely, the film was overexposed.** Overexposed film will have considerable shadow detail and dense, blocked highlights. Don't meter your own shadow when you move in close to meter a scene; the meter will assume the scene is dark overall and will give more exposure.

If negatives are frequently too dense, your meter might be giving you too low a reading. See Negative Thin Looking (right) for suggestions on setting the film speed and checking your meter. Double the film speed to give the film one stop less exposure; for example, using ISO 400 film, but setting the speed to ISO 800.

■ **Film was overdeveloped.** Overdeveloped film will have normal shadow detail, with excessively dense, blocked highlights, and will be high in contrast. Develop film for no more than the recommended time and temperature.

NEGATIVE THIN LOOKING, SLIDE TOO DARK

■ **Most likely, the film was underexposed.** Underexposed film will have little detail in shadows. Tilt the camera down slightly when metering a scene that includes a bright sky so the meter doesn't assume the overall scene is very bright and give less exposure. Make sure your camera is set to the correct film speed. Some cameras set the film speed automatically; if you set it yourself, remember to check the speed setting. Film will be underexposed if you change from, for example, a fast ISO 400 film to slower ISO 100 film and forget to reset the film-speed setting.

If negatives are frequently too thin, your meter might be giving you too high a reading. Try comparing it to a meter that seems to be accurate. If the meter is reading too high, you can either get it repaired or, if your camera lets you do so, set the film speed lower than the film's actual rating. Halve the film speed to give the film an additional stop of exposure; for example, using ISO 400 film, but setting the speed to ISO 200. If the meter appears to be working correctly, review your metering techniques (pages 72–77).

■ **Film was underdeveloped.** Underdeveloped film will have normal detail in shadows, but little highlight density, and will be low in contrast. Develop film for the full time at the recommended temperature in fresh solutions at the correct dilution.

SNOW SCENE OR OTHER LIGHT SCENE TOO DARK
Negative thin, difficult to make a light-enough print. Slide too dark.

■ **Film underexposed.** The meter computed an exposure for a middle-gray tone, but the scene was actually lighter than middle gray, so it appears too dark. When photographing scenes that are very light overall, such as snow scenes or sunlit beach scenes, give 1 or 2 stops more exposure than the meter recommends. More about meters and middle gray on pages 70 and 76.

PRINT TOO LIGHT

■ **Most likely, print underexposed.** Make another print with more exposure.

■ **Print developed for much less than the recommended time.**

■ **Paper put in the easel with emulsion side down.**

PRINT TOO DARK

■ **Most likely, print overexposed.** Make another print with less exposure.

■ **Print developed for much more than the recommended time.** This might cause some darkening of the print, but is more likely to cause staining.

■ **Print looks darker after drying.** This is a normal result with fiber-base papers. A dry fiber-base print may appear 5–10 percent darker than when it was wet. Often, the dry down is not enough to cause problems, but for critical printing, you can reduce the exposure slightly to make a slightly lighter print that will compensate for the effect.

Contrast problems

PRINT TOO CONTRASTY
Print looks harsh. Difficult to get adequate texture and detail in highlights and/or shadows.

■ **Printing filter or paper contrast too high.** Make another print with a lower number printing filter or lower contrast grade of paper. Try dodging the shadows slightly, burning the highlights (see dodging and burning, pages 132–133).

If prints from many different scenes are too contrasty, you may be overdeveloping the film. Develop film for no more than the recommended time and temperature.

PRINT TOO FLAT
Print looks gray and dull, with no real blacks or brilliant whites.

■ **Printing filter or paper contrast too low.** Make another print with a higher number printing filter or higher contrast grade of paper.

If prints from many different scenes are too flat, you may be underdeveloping the film. Develop film for the full time at the recommended temperature in fresh solutions at the correct dilution.

SUBJECT VERY DARK AGAINST LIGHT BACKGROUND (OR VERY LIGHT AGAINST DARK BACKGROUND)

■ **Meter was influenced by the background.** If you make an overall reading when a subject is against a bright background such as a bright sky, your subject is likely to be underexposed and too dark. Occasionally you may have a related problem if your subject is small and light against a much larger, very dark background; the subject will be overexposed and too light. Move in close to meter just the subject, then set your shutter speed and aperture accordingly (see page 76). Some meters built into newer cameras avoid this problem; they have multiple sensors that meter and compare various parts of a scene, and automatically adjust the exposure.

Sharpness problems

NOTHING IN THE NEGATIVE IS SHARP. EASIER TO SEE IN AN ENLARGED PRINT, BUT MAY BE VISIBLE IN THE NEGATIVE.

■ **Most likely, camera motion.** Using a shutter speed that is too slow while you are hand holding a camera will blur the picture overall. As a rule of thumb, when hand holding the camera, use a shutter speed at least as fast as the focal length of your lens—1/100 sec with a 100mm lens, 1/250 sec with a 200mm lens, and so on. Use a tripod for slower shutter speeds. More about holding the camera steady on page 33.
■ **Extremely dirty lens.** This can reduce the crispness of the image overall, especially when combined with lens flare.
■ **Camera focus was completely wrong.** For example, when making a close-up, somehow the lens was focused on a far distance. Possible with an automatic-focus camera if you do not give the camera enough time to adjust the focus before you make an exposure.

MOVING SUBJECT NOT SHARP
Some other part of the scene is sharp, but moving subject is not.

■ **Shutter speed too slow.** More about shutter speeds and moving subjects on pages 20–21.

NOT ENOUGH OF SCENE IS SHARP

■ **Not enough depth of field.** Too wide an aperture will result in shallow depth of field, making the scene sharp where you focused the camera, but not in front of or behind that part of the scene. More about depth of field on pages 26–27 and 54–59.

Sharpness problems, continued

WRONG PART OF THE SCENE IS SHARP

■ **Camera wasn't focused on the main subject.** For example, the subject moved, but you didn't refocus the camera. Possible with an automatic-focus camera if you do not give the camera enough time to adjust the focus before you make an exposure.

ALL OR PART OF PRINT OUT OF FOCUS (NEGATIVE IS SHARP)

■ **If the entire print is out of focus, the enlarger vibrated during the exposure or was never focused properly.** Avoid jostling the enlarger or its base just before or during an exposure. A grain magnifier (shown on page 113) will help you focus the image sharply.

■ **If part of the print is out of focus, the negative may be buckling during the exposure.** Heat from the enlarger lamp can cause the negative to buckle and the image to go out of focus. A glass negative carrier will keep the negative flat. If you don't have one, avoid extremely long exposures or let the negative warm up by turning the enlarger on before you make the exposure, then refocus.

ONLY PART OF A COMPLETELY SHARP NEGATIVE CAN BE FOCUSED BY ENLARGER

■ **Enlarger out of alignment.** If the enlarger's negative carrier and lens are not parallel to its baseboard (and hence to the printing easel), you may not be able to focus the entire negative sharply on the easel. Ideally, realign the enlarger. If that isn't possible, use a small enlarger lens aperture; it may provide enough depth of field to make the entire image sharp. As a last resort, try propping up one end of the printing easel to bring it parallel to the negative carrier.

Color problems

GREENISH LOOK TO SCENE OVERALL

■ **Scene shot in fluorescent light.** Fluorescent lighting fixtures emit large amounts of greenish light and will give a greenish look to a scene. An FL fluorescent filter on the lens helps. See page 181.

■ **Scene shot in light filtered by green foliage.** Most likely to be a problem with skin tones. See Unexpected Color Cast, far right.

BLUISH OR REDDISH LOOK TO SCENE OVERALL

■ **Color film not matched to the type of lighting used.** Tungsten-balanced film shot in daylight or with flash will give a bluish look to a scene; use daylight-balanced film when shooting in daylight or with flash. Daylight-balanced film shot in tungsten light will give a reddish look to a scene; use tungsten-balanced indoor film when shooting in tungsten light. See page 149.

UNEXPECTED COLOR CAST

■ **Light reflected from a nearby colored object gives a color cast to the scene.** Photographing someone in the shade of a tree can add an unexpected greenish look to skin tones because the light was filtered through the green leaves. Similarly, light bouncing off a strongly colored wall can tint the scene the color of the wall. The effect is most noticeable on skin tones or neutral tones like white or gray.

Flash problems

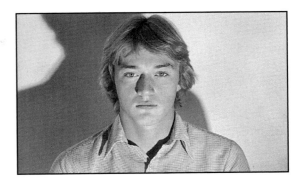

UNWANTED REFLECTIONS

■ **Light bouncing back from reflective surfaces.** Shooting straight at large windows, mirrors, metal surfaces, or shiny walls with the flash on or close to the camera can cause light to be reflected from the flash back into the lens. When photographing scenes that include reflective surfaces, move the camera and/or the flash to one side so that you shoot or illuminate the scene at an angle to the reflecting surface. Eyeglasses can create the same problem; have the person look at a slight angle to the camera or move the flash off-camera.

RED EYE
Red or amber appearance to a person's or an animal's eyes.

■ **Light reflecting from the blood-rich retina inside the eye.** Have the person look away from the camera or move the flash away from the camera. Some cameras have a red-eye reduction mode: the flash lights up briefly before the main exposure so that the subject's iris contracts, reducing the amount of visible red.

UNWANTED SHADOWS

■ **Flash positioned at an angle that caused shadows you didn't predict.** Sighting along a line from flash to subject will help predict how shadows will be cast. A small tungsten light positioned close to the flash will also help; large studio flash units have such modeling lights built in for just this purpose. Move the subject away from a wall so shadows fall on the ground and out of the film frame, instead of visibly on the wall.

MOVING SUBJECT PARTLY BLURRED

■ **Flash used in strong existing light.** Most likely to occur when existing light is bright and the camera's shutter speed is slow. The film records two images during the exposure—a sharp one from the very short flash exposure, and a blurred, ghost image created by strong existing light during the entire time the shutter was open. Make sure your shutter is set to the fastest speed usable with flash. Depending on the situation, you may also be able to dim the existing light, shoot when the subject isn't moving so much, or shoot at a faster shutter speed with the existing light alone. Consider deliberately combining the sharpness and blur, see page 257.

PART OF SCENE EXPOSED CORRECTLY, PART TOO LIGHT OR TOO DARK

■ **Parts of the original scene are at different distances from the flash.** Parts that are farther away are darker than those that are close because the farther that light travels from the flash, the dimmer it becomes. Try to group important parts of the subject at about the same distance from the flash.

ONE SIDE OF THE FILM FRAME IS DARK
Frame may be dark along an edge by the next frame (with a horizontally traveling shutter) or along an edge near the sprocket holes (with a vertically traveling shutter).

■ **Too fast a shutter speed with a camera that has a focal-plane shutter, such as a single-lens reflex camera.** The flash fired when the shutter was not fully open. If you set the shutter speed manually, check the manufacturer's instructions for how to set the camera for flash use. For most cameras, 1/60 sec is safe; faster speeds are usable with some cameras. The flash shutter speed may appear in a different color from the other shutter speeds, or may be marked with an X or lightning-bolt symbol. If the camera sets the shutter speed automatically with flash, and you have this problem, the camera needs repair.

Flash problems, continued

SUBJECT APPEARS TOO DARK OR TOO LIGHT
Manually setting the exposure for flash is more likely to
cause problems than automatic operation with a camera
that reads the illumination from the flash through the lens.
More about automatic versus manual flash operation on
pages 244–245.

■ **If the subject appears too dark, the scene was under-
exposed—too little light reached the subject.** If you
manually set the exposure for flash, an occasional frame that is
too dark probably results from setting the camera's lens aperture
incorrectly. In manual operation, increase the exposure about a
stop for scenes shot outdoors at night or in a large room like a
gymnasium; the relatively dark surroundings absorb light that
would otherwise bounce back to add to the exposure. If your flash
pictures are frequently too dark, try setting the flash unit's film-
speed dial to half the speed of the film you are using.

■ **If the subject appears too light, the scene was over-
exposed—too much light reached the subject.** Occasional
overexposure in manual operation is probably due to an error in
setting the camera's lens aperture. In manual operation, close down
the aperture about a stop when shooting in small, light-colored rooms
to compensate for excess light bouncing back from walls and ceiling. If
your flash pictures are usually overexposed, try setting the flash unit's
film-speed dial to twice the speed of the film you are using.

Digital problems

PIXELATION
Edges look stair-stepped. Details are indistinct.

■ **Image resolution is too low for the intended use.** 72
dpi is ideal for display on a monitor, but printing from an inkjet or
dye-sublimation printer requires from 200–300 dpi. If you scanned
the image, rescan it at a higher dpi setting.
 If the image came from a digital camera, try Photoshop
Image>Image Size to resample the image at a higher dpi. Next
time you photograph, use a higher resolution.

SOFT IMAGE
Details in the picture are not sharp.

■ **Possibly, poor focus or camera movement.** See
Sharpness problems, page 395–396.
■ **With a digital camera, quality level is too low.** At low
quality settings (also called basic or good), the camera compresses
the image file. When the image is reopened, details can be lost. The
visible results may be negligible when prints are very small, but will
be noticeable when they are enlarged.
 Anticipate the final size and reproduction method for your
images. Pictures to be used only on the Web can be shot at low
quality. Use the camera's highest quality setting if you might ever
want to make 8 x 10-inch prints.

DIGITAL NOISE
Odd, colored specks in dark areas

■ **Often occurs in shadow areas, in photos taken at
night, or in low light with a long exposure.** Try shooting at
a lower ISO. Instead of ISO 800 or 1600, try ISO 100 or ISO 200.
Try Photoshop Filter>Noise>Despeckle. This does reduce the
noise, although it softens the image somewhat. Some software
programs do a fairly good job of taking noise out of images. Try
the Photoshop plug-ins Quantum Mechanic Pro or Band Aide.
Check out www.camerabits.com for information.

BANDING
Unexpected bands in areas with no detail.

■ **With a digital camera, scene may have been shot at
too high an ISO.** Try shooting the scene with a lower ISO. You
may need to use a tripod and a slower shutter speed or add light
from a flash or additional room light. Sometimes the quality of the
available light may be preferable to adding light or using the flash
even if some banding occurs. In that case, use the higher ISO.

OVERSHARPENING
Details so crisp that they are contrasty and may show
digital noise.

■ **Oversharpening a digital image while working in an
image-editing program.** Return to the original file, if it has not
been sharpened. If you need to sharpen the image, do so less.
■ **Oversharpening while scanning.** Rescan the print, trans-
parency, or negative without sharpening it.

aberration An optical defect in a lens causing it to form an image that is not sharp or that is distorted. *See also* astigmatism, barrel distortion, chromatic aberration, coma, field curvature, pincushion distortion, spherical aberration.

acid A substance with a pH below 7. Since an acid neutralizes an alkali, a stop bath is usually an acidic solution that stops the action of the alkaline developer.

additive color A way to produce colors of light by mixing light of the three additive primary colors—red, green, and blue.

AE *See* automatic exposure.

AF *See* automatic focus.

agitate To move a solution over the surface of film or paper during development so that fresh liquid comes into contact with the surface.

albumen Egg white; used in early photographic emulsions as a coating for glass plates and, more commonly, for printing paper.

alkali A substance with a pH above 7. Developers are usually alkaline solutions.

ambient light *See* available light.

ambrotype A collodion wet-plate process in which the emulsion was coated on a glass plate. The negative image produced was visible as a positive image when the glass was backed with a dark material.

angle of view The area seen by a lens or viewfinder or read by a light meter.

aperture The size of the lens opening through which light passes.

aperture-priority A mode of automatic exposure in which the photographer selects the aperture and the camera sets the shutter speed that will produce the correct exposure.

application *See* software.

archival processing Processing designed to protect a print or negative as much as possible from premature deterioration caused by chemical reactions.

artificial light Light from an electric lamp, a flash bulb, or electronic flash. Often describes lights that the photographer has set up to illuminate a scene.

ASA A film speed rating similar to an ISO rating.

astigmatism A lens aberration or defect that is caused by the inability of a simple lens to focus oblique rays uniformly.

automatic exposure A mode of camera operation in which the camera adjusts the shutter speed, the aperture, or both to produce the correct exposure. Abbreviated AE.

automatic flash An electronic flash unit with a light-sensitive cell and electronic circuitry that measures the light reflected back from the subject and terminates the flash when the exposure is correct.

automatic focus A system by which the camera adjusts its lens to focus on a given area, for example, whatever is at the center of the image. *See* AF.

Av Abbreviation of aperture value. Used on some camera information displays as a shortened way to refer to aperture settings (f-stops).

available light The light that already exists where a photograph is to be made, as opposed to light brought in by the photographer. Often implies a relatively dim light. Also called ambient light or existing light.

axis lighting Light pointed at the subject from a position close to the camera's lens.

B *See* bulb.

back lighting Light that comes from behind the subject toward the camera.

backup An exact duplicate of a digital file or a group of files, made as protection against loss or damage.

banding Visible tonal bands produced by converting a continuously varying gradation into too few discrete gray levels.

barrel distortion A lens aberration or defect that causes straight lines to bow outward, away from the center of the image.

bellows A flexible, light-tight, and usually accordion-folded part of a view camera between the lens board in front and the viewing screen in back. Also used on a smaller camera for close-ups.

binary number A number consisting of one or more 1s and 0s.

bit The smallest unit of information usable by a computer, indicated by a 1 or a 0, describing one of two conditions: on or off.

bit depth The number of bits used to represent each pixel in an image, determining its color and tonal range.

bleed mount To mount a print so that there is no border between the edges of the print and the edges of the mounting surface.

blocked up Describes highlight areas that lack normal texture and detail. Due to excess contrast caused by, for example, overexposure or overdevelopment.

blooming Streaks or halos in a digital image around light sources or bright reflections. Caused by leaking of electrical charge between CCD elements due to overexposure.

blotters Sheets of absorbent paper made for photographic use. Wet prints can be dried by placing between blotters.

bounce light Light that does not travel directly from its source to the subject but is first reflected off another surface.

bracket To make several exposures, some greater and some less than the exposure that is calculated to be correct. Bracketing allows for error and permits selection of the best exposure after development.

brightness Strictly speaking, a subjective impression of the lightness of an object. The correct term for the measurable quantity of light reflected or produced by an object is luminance. *See also* luminance.

broad lighting Portrait lighting in which the main source of light illuminates the

side of the face turned toward the camera.

built-in meter A reflected-light exposure meter built into a camera so that light readings can be made directly from camera position.

bulb A shutter setting marked B at which the shutter remains open as long as the shutter release is held down.

burn (or burn in) 1. To darken a specific area of a print by giving it additional printing exposure. 2. To darken an area of a digital image during image editing.

butterfly lighting Portrait lighting in which the main source of light is placed high and directly in front of the face.

byte A unit of digital data containing eight bits. *See also* kilobyte, megabyte, gigabyte, terabyte.

cable release A long coiled wire with a plunger at one end and a socket at the other that attaches to a camera's shutter release. Pressing the plunger releases the shutter without touching (and possibly moving) the camera.

calibrate To adjust the output of a digital device, such as a computer monitor, to match a predefined standard.

calotype The first successful negative/positive photographic process; it produced an image on paper. Invented by Talbot; also called Talbotype.

camera A picture-taking device usually consisting of a light-tight box, a place for film or digital sensor, a shutter to admit a measured quantity of light, and a lens to focus the image.

camera obscura Latin for "dark chamber;" a darkened room with a small opening through which rays of light could enter and form an image of the scene outside. Eventually, a lens was added at the opening to improve the image, and the room was shrunk to a small, portable box.

carte-de-visite A small portrait, about the size of a visiting card, popular during the 1860's. People often collected them in albums.

cartridge *See* cassette.

cassette A light-tight metal or plastic container that permits a roll of 35mm film to be loaded into a camera in the light. Also called a cartridge.

catchlight A reflection of a light source in a subject's eye.

CCD Charge-coupled device. One of two types of light-sensing devices (the other is CMOS) placed in a grid to make the sensor in a digital camera. Also used as light-sensing devices in scanners.

CC filters *See* color compensating filters.

changing bag A light-tight bag into which a photographer can insert his or her hands to handle film when a darkroom is not available.

characteristic curve A diagram of the response to light of a photographic material, showing how increasing exposure affects silver density during development. Also called the D log E curve, since density is plotted against the logarithm of the exposure.

chromatic aberration A lens defect that bends light rays of different colors at different angles and therefore focuses them on different planes.

chrome A color transparency.

chromogenic film Film in which the final image is composed of dyes rather than silver.

circle of confusion The size of the largest circle, for a given image size and viewing distance, that can't be distinguished from a point or dot. Affects depth of field by determining which parts of an image will appear to be in focus and which will not.

close-up A larger-than-normal image that is formed on a negative by focusing the subject closer than normal to the lens with the use of supplementary lenses, extension tubes, or bellows.

close-up lens *See* supplementary lens.

CMOS Complementary metal oxide semiconductor. One of two types of light-sensing devices (the other is CCD) placed in a grid to make the sensor in a digital camera.

CMYK The four colors used in printing on a press or with most digital printers: cyan, magenta, yellow, and black. Digital images may be stored or edited as CMYK or RGB (red, green, blue) and converted between them See also RGB.

collodion A transparent, syrupy solution of pyroxylin (a nitrocellulose) dissolved in ether and alcohol; used as the basis for the emulsion in the wet-plate process.

color balance 1. A film's or a sensor's response to the colors of a scene. Color films are balanced for use with specific light sources. *See also* white balance. 2. The reproduction of colors in a color print, alterable during image editing or darkroom color printing.

color cast A trace of one color in all the colors in an image.

color compensating filters Gelatin filters that can be used to adjust the color balance during picture taking or in color printing. More expensive than acetate color printing filters, they can be used below the enlarger lens if the enlarger has no other place for filters. Abbreviated CC filters.

color management A means of coordinating the color output of various devices so that the colors you see in a digital image on your monitor, for example, will be the ones that appear when you print the image.

color printing filters Acetate filters used to adjust the color balance in color printing. They must be used with an enlarger that can hold filters between the enlarger lamp and the negative. Abbreviated CP filters.

color temperature A numerical description of the color of light measured in degrees Kelvin (K).

color temperature meter A device for estimating the color temperature of a light source. Usually used to determine the filtration needed to match the color balance of the light source with that of standard types of color film.

coma A lens aberration or defect that causes rays that pass obliquely through the lens to be focused at different points on the film plane.

complementary colors 1. Any two colors of light that when combined include all the wavelengths of light and thus produce white light (*see* additive color). 2. Any two dye colors that when combined absorb all wavelengths of light and thus produce black (*see* subtractive color). A colored filter absorbs light of its complementary color and passes light of its own color.

compression A means of reducing the file size for a digital image in order to reduce storage requirements or transmission speed across networks. "Lossy" techniques permanently eliminate information to obtain highly compressed, very small files. Lossless techniques compress images without losing any original information in the file.

condenser enlarger An enlarger that illuminates the negative with light that has been concentrated and directed by condenser lenses placed between the light source and the negative.

contact printing The process of placing a negative in contact with sensitized material, usually paper, and then passing light through the negative onto the material. The resulting image is the same size as the negative.

contamination Traces of chemicals that are present where they don't belong, causing loss of chemical activity, staining, or other problems.

continuous tone Describes an image with a smooth gradation of tones from black through gray to white.

contrast The difference in darkness or density between one tone and another.

contrast filter A colored filter used on a camera lens to lighten or darken selected colors in a black-and-white photograph. For example, a green filter used to darken red flowers against green leaves.

contrast grade The contrast that a printing paper produces. Systems of grading contrast are not uniform, but in general grades 0 and 1 have low or soft contrast; grades 2 and 3 have normal or medium contrast; grades 4, 5, and 6 have high or hard contrast.

contrasty Describes a scene, negative, or print with very great differences in brightness between light and dark areas. Opposite: flat.

convergence The phenomenon in which lines that are parallel in a subject, such as the vertical lines of a building, appear nonparallel in an image.

cool Bluish colors that by association with common objects (water, ice, and so on) give an impression of coolness.

correction filter A colored filter used on a camera lens to make black-and-white film produce the same relative brightnesses perceived by the human eye. For example, a yellow filter used to darken a blue sky so it does not appear excessively light.

coupled rangefinder *See* rangefinder.

covering power The area of the focal plane over which a lens projects an image that is acceptably sharp and uniformly illuminated.

CP filters *See* color printing filters.

crop To trim the edges of an image, often to improve the composition. Cropping can be done by moving the camera position while viewing a scene, by adjusting the enlarger or easel during printing, by using a cropping tool during image editing, or by trimming the finished print.

curvilinear distortion *See* barrel distortion; pincushion distortion.

cut film *See* sheet film.

daguerreotype The first practical photographic process, invented by Daguerre and described by him in 1839. The process produced a positive image formed by mercury vapor on a metal plate coated with silver iodide.

darkroom A room where photographs are developed and printed, sufficiently dark to handle light-sensitive materials without causing unwanted exposure.

dark slide *See* slide (2).

daylight film Color film that is balanced to produce accurate color renditions when the light source illuminating the photographed scene has a color temperature of about 5500K, such as in midday sunlight or with electronic flash or a blue flashbulb.

dedicated flash An electronic flash unit that when used with certain cameras will automatically set the correct shutter speed for use with flash and will trigger a light in the viewfinder when the flash is charged and ready to fire. Also called designated flash.

dense Describes a negative or an area of a negative in which a large amount of silver has been deposited. A dense negative transmits relatively little light. Opposite: thin.

densitometer An instrument that measures the darkness or density of a negative or print.

density The relative amount of silver present in various areas of film or silver paper after exposure or development, or of ink or dye present on a surface; therefore, the darkness of a print or the light-stopping ability of a negative or transparency.

depth of field The area between the nearest and farthest points from the camera that are acceptably sharp in an image.

depth of focus The small range of allowable focusing error that will still produce an acceptably sharp image when a lens is not focused exactly.

designated flash *See* dedicated flash.

developer A chemical solution that changes the invisible, latent image (on film or photographic paper) produced during exposure into a visible one.

development 1. The entire process by which exposed film or paper is treated with various chemicals to make an image that is visible and permanent. 2. Specifically, the step in which film or paper is immersed in developer.

diaphragm The mechanism controlling the brightness of light that passes through a lens. An iris diaphragm has overlapping metal leaves whose central opening can be adjusted to a larger or smaller size. *See also* aperture.

dichroic head An enlarger head that contains yellow, magenta, and cyan filters that can be moved in calibrated stages into or out of the light beam to change the color balance of the enlarging light.

diffuse Scattered, not all coming from the same direction. For example, sunlight on a cloudy day.

diffusion enlarger An enlarger that illuminates the negative by scattering light from many angles evenly over the surface of the negative.

digital imaging A method of image editing in which a picture is recorded as digital information that can be read and manipulated by a computer, and subsequently reformed as a visible image.

DIN A numerical rating used in Europe to describe the sensitivity of film to light. The DIN rating increases by 3 as the sensitivity of the film doubles.

diopter An optician's term to describe the power of a lens. In photography, it mainly indicates the magnifying power and focal length of a supplementary close-up lens.

distortion 1. A lens aberration that causes straight lines at the edge of an image to appear curved. 2. The changes in perspective that take place when a lens is used very close to (wide-angle distortion) or very far from (telephoto effect) a subject.

dodge 1. To lighten an area of a print by shading it during part of the printing exposure. 2. To lighten an area of a digital image during image editing.

dpi Dots per inch: a measure of the resolution of a digital printer or photomechanical halftone. The number of dots or points that can be printed or displayed by a device. Frequently (but inaccurately) used for resolution of an image or scanner, actually ppi or spi. *See also* ppi, spi, resolution.

dropout An image with black and white areas only and no intermediate gray tones.

dry down To become very slightly darker and less contrasty, as most black-and-white photographic printing papers do when they dry after processing.

dry mount To attach a print to another surface, usually cardboard, by placing a sheet of dry-mount tissue between the print and the mounting surface. This sandwich is placed in a heated press to melt an adhesive in the tissue. Pressure-sensitive tissue that does not require heat may also be used.

DX coding A checkered or bar code on some film cassettes. The checkered code can be automatically scanned by a suitably equipped camera for such information as film speed and number of frames.

dynamic range The difference between the lightest and darkest (or highest and lowest) values in a scene or image. *See also* contrast.

easel A holder to keep sensitized material, normally paper, flat and in position on the baseboard of an enlarger during projection printing. It usually has adjustable borders to frame the image to various sizes.

EI *See* exposure index.

electromagnetic spectrum The forms of radiant energy arranged by size of wavelength ranging from billionths of a millimeter (gamma rays) to several miles (radio waves). The visible spectrum is the part that the human eye sees as light: wavelengths of 400 to 700 nanometers (billionths of a meter), producing the sensation of the colors violet, blue, green, yellow, and red.

electronic flash A tube containing gas that produces a brief, brilliant flash of light when electrified. Unlike a flashbulb, an electronic flash unit is reusable. Also called a strobe.

emulsion A light-sensitive coating applied to photographic films or papers. It consists of silver halide crystals and other chemicals suspended in gelatin.

enlargement 1. An image, usually a print, that is larger than the negative. Made by projecting an enlarged image of the negative onto sensitized paper. 2. A digital print that is larger than the previous print.

enlarger An optical instrument ordinarily used to project an image of a negative onto sensitized paper. More accurately called a projection printer because it can project an image that is either larger or smaller than the negative.

etch To remove a small, dark imperfection in a print or negative by scraping away part of the emulsion.

EV *See* exposure value.

existing light *See* available light.

exposure 1. The act of letting light fall on a light-sensitive material. 2. The amount of light reaching the light-sensitive material; specifically, the intensity of light multiplied by the length of time it falls on the material.

exposure index A film-speed rating similar to an ISO rating. Abbreviated EI.

exposure meter An instrument that measures the amount of light falling on a subject (incident-light meter) or the amount of light emitted or reflected by a subject (reflected-light meter), allowing aperture and shutter-speed settings to be computed. Commonly called a light meter.

exposure value A system originally intended to simplify exposure calculations by assigning standardized number values to f-stop and shutter-speed combinations. More often, used simply as a shorthand way of describing the range of light levels within which equipment operates. For example, a manufacturer may describe a meter as operating from EV -1 to EV 20 (4 sec at f/1.4 to 1/2000 sec at f/22m with ISO 100 film).

extension tubes Metal rings that can be attached between a camera body and lens for close-up work. They extend the lens farther than normal from the film plane so that the lens can focus closer than normal to an object.

factor A number that tells how many times exposure must be increased to compensate for loss of light (for example, due to use of a filter).

Farmer's Reducer A solution of potassium ferricyanide and sodium thiosulfate that is used to decrease the amount of silver in a developed image.

fast Describes 1. a film, sensor, or paper that is very sensitive to light; 2. a lens that opens a very wide aperture; 3. a short shutter speed. Opposite: slow.

ferrotype To give a glossy photographic printing paper a very high sheen by drying the print with its emulsion pressed against a smooth metal plate, usually the hot metal drum or plate of a heat dryer.

fiber-base paper Formerly the standard type of photographic printing paper available; now an alternate to resin-coated papers.

field curvature A lens aberration or defect that causes the image to be formed along a curve instead of on a flat plane.

fill light A source of illumination that lightens shadows cast by the main light and thereby reduces the contrast in a photograph.

film A material used in a camera to record a photographic image. Generally it is a light-sensitive emulsion coated on a flexible acetate or plastic base.

film holder A light-tight container to hold the sheet film used in a view camera.

film plane *See* focal plane, image plane.

film speed The relative sensitivity to light of a film. There are several rating systems: ISO (the most common in the United States and Great Britain), DIN (common in Europe), and others. Film-speed ratings increase as the sensitivity of the film increases.

filter 1. A piece of colored glass, plastic, or other material that selectively absorbs some of the wavelengths of light passing through it. 2. To use such a filter to modify the wavelengths of light reaching a light-sensitive material.

filter factor *See* factor.

fisheye lens A lens with an extremely wide angle of view (as much as 180°) and considerable barrel distortion (straight lines at the edges of a scene appear to curve around the center of the image).

fixer A chemical solution (sodium thiosulfate or ammonium thiosulfate) that makes a photographic image insensitive to light. It dissolves unexposed silver halide crystals while leaving the developed silver image. Also called hypo.

flare Unwanted light that reflects and scatters inside a lens or camera. When it reaches the film, it causes a loss of contrast in the image.

flash 1. A light source, such as a flashbulb or electronic flash, that emits a very brief, bright burst of light. 2. To blacken

an area in a print by exposing it to white light, such as from a penlight flashlight.

flashbulb A bulb containing a mass of aluminum wire, oxygen, and an explosive primer. When the primer is electrically fired, it ignites the wire which emits a brief burst of brilliant light. A flashbulb is used once and then discarded.

flash meter An exposure meter that measures the brightness of flash lighting to determine the correct exposure for a particular setup.

flat 1. A scene, negative, or print with very little difference in brightness between light and dark areas. Opposite: contrasty. 2. *See* reflector.

floodlight An electric light designed to produce a broad, relatively diffused beam of light.

f-number A number that equals the focal length of a lens divided by the diameter of the aperture at a given setting. Theoretically, all lenses at the same f-number produce images of equal brightness. Also called f-stop or relative aperture.

focal length The distance from the lens to the focal plane when the lens is focused on infinity. The longer the focal length, the greater the magnification of the image.

focal plane The plane or surface on which a focused lens forms a sharp image. Also called the film plane.

focal-plane shutter A camera mechanism that admits light to expose film by moving a slit or opening in a roller blind just in front of the film (focal) plane.

focal point The point on a focused image where the rays of light intersect after reflecting from a single point on a subject.

focus 1. The position at which rays of light from a lens converge to form a sharp image. 2. To adjust the distance between lens and image to make the image as sharp as possible.

focusing cloth A dark cloth used in focusing a view camera. The cloth fits over the camera back and the photographer's head to keep out light, and to make the ground-glass image easier to see.

fog An overall density in the photographic image caused by unintentional exposure to light or unwanted chemical activity.

frame 1. The edges of an image. 2. A single image in a roll of film.

f-stop The common term for the aperture setting of a lens. *See also* f-number.

full-scale Describes a print having a wide range of tonal values from deep, rich black through many shades of gray or colors to brilliant white.

gamma A number that describes the rate at which tones or values change. A higher gamma is the same as higher contrast.

gamut The range of colors that can be seen or that a particular device can capture or reproduce. For example, the range of colors that your digital camera can record.

gelatin A substance produced from animal skins and bones, it is the basis for modern photographic emulsions. It holds light-sensitive silver halide crystals in suspension.

gigabyte (GB) 1,000,000,000 bytes. Used to describe the size of computer memory or storage.

glazing Covering a photograph, usually in a frame, with a clear sheet of glass or plastic.

glossy Describes a printing paper with a great deal of surface sheen. Opposite: matte.

graded-contrast paper A printing paper that produces a single level of contrast. To produce less or more contrast, a change has to be made to another grade of paper. See also variable-contrast paper.

graininess In an enlarged image, a speckled or mottled effect caused by oversized clumps of silver in the negative.

gray card A card that reflects a known percentage of the light falling on it. Often has a gray side reflecting 18 percent and a white side reflecting 90 percent of the light. Used to take accurate exposure-meter readings (meters base their exposures on a gray tone of 18 percent reflectance) or to provide a known gray tone in color work.

grayscale 1. A means of rendering a digital image in black, white and gray tones only. 2. A format or color space for describing such an image.

ground glass 1. A piece of glass roughened on one side so that an image focused on it can be seen on the other side. 2. The viewing screen in a reflex or view camera.

guide number A number used to calculate the f-setting (aperture) that correctly exposes a film of a given sensitivity (film speed) when the film is used with a specific flash unit at various distances from flash to subject. To find the f-setting, divide the guide number by the distance.

gum-bichromate process An early photographic process revived by contemporary photographers. The emulsion is a sensitized solution of gum arabic containing color pigments. The surface can be altered by hand during the printing process.

halftone An image that can be reproduced on the same printing press with ordinary type. The tones in the photograph are screened to a pattern of dots (close together in dark areas, farther apart in light areas) that give the illusion of continuous tone.

hanger A frame for holding sheet film during processing in a tank.

hard 1. Describes a scene, negative, or print of high contrast. Opposite: soft or low contrast. 2. Describes a printing paper emulsion of high contrast such as grades 5 and 6.

hardware The processor, monitor, printer, and other physical devices that make up a computer system. See software.

heliography An early photographic process, invented by Niépce, employing a polished pewter plate coated with bitumen of Judea, a substance that hardens on exposure to light.

highlight A very bright area in a scene, print, or transparency; a very dense, dark area in a negative. Also called a high value.

high value See highlight.

histogram A graph that shows the distribution in a digital image of tones (from white, through shades of gray, to black) or of colors.

hot shoe A bracket on the top of the camera that attaches a flash unit and provides an electrical connection to synchronize the camera shutter with the firing of the flash.

hyperfocal distance The distance to the nearest plane of the depth of field (the nearest object in focus) when the lens is focused on infinity. Also the distance to the plane of sharpest focus when infinity is at the farthest plane of the depth of field. Focusing on the hyperfocal distance extends the depth of field from half the hyperfocal distance to infinity.

hypo A common name for any fixer; taken from the abbreviation for sodium hyposulfite, the previous name for sodium thiosulfate (the active ingredient in most fixers).

hypo clearing agent or **hypo neutralizing agent** See washing aid.

illuminance The strength of light falling on a given area. Measurable by an incident-light (illuminance) meter.

illuminance meter See incident-light meter.

image plane A plane behind a lens that corresponds to a specific plane (object plane) in front of the lens. See film plane, focal plane.

incandescent light Light emitted when a substance is heated by electricity: for example, the tungsten filament in an ordinary light bulb.

incident-light meter An exposure meter that measures the amount of light incident to (falling on) a subject.

indoor film See tungsten film.

infinity The farthest position (marked ∞) on the distance scale of a lens. It includes all objects at the infinity distance (about 50 feet) from the lens or farther. When the infinity distance is within the depth of field, all objects at that distance or farther will be sharp.

infrared The band of invisible rays just beyond red, which people perceive to some extent as heat. Some photographic materials are sensitized to record infrared.

inkjet A digital printer that sprays microscopic droplets of ink onto a receptive surface (See media) to create the appearance of a continuous-tone photograph.

instant film A film such as Polaroid Time-Zero that contains the chemicals needed to develop an image automatically after exposure without the need for darkroom development.

intensification A process increasing the darkness of an already developed image. Used to improve negatives that have too little silver density to make a good print or to increase the density of an existing print. Opposite: reduction.

interchangeable lens A lens that can be removed from the camera and replaced with another lens, usually of a different focal length.

inverse square law A law of physics stating that the intensity of illumination is inversely proportional to the square of the distance between light and subject. This means that if the distance between light and subject is doubled, the light reaching the subject will be only one-quarter of the original illumination.

ISO A numerical rating that describes the sensitivity to light of film or of a digital camera's CCD. The ISO rating doubles as the sensitivity to light doubles.

Kelvin temperature See color temperature.

key light See main light.

kilobyte (KB) 1000 bytes. Used to describe the size of computer memory or storage.

latent image An image formed by the changes to the silver halide grains in photographic emulsion on exposure to light. The image is not visible until chemical development takes place.

latitude The amount of over- or underexposure possible without a significant loss in the quality of an image.

leaf shutter A camera mechanism that admits light to expose film by opening and shutting a circle of overlapping metal leaves.

lens A piece or several pieces of optical glass shaped to focus an image of a subject.

lens hood See lens shade.

lens shade A shield that fits around a lens to prevent unwanted light from hitting the front of the lens and causing flare. Also called a lens hood.

light meter See exposure meter.

light tight Absolutely dark. Protected by opaque material, overlapping panels, or some other system through which light cannot pass.

line print An image resembling a pen-and-ink drawing, with black lines on a white background (or white lines on a black background).

lith film A type of film made primarily for use in graphic arts and printing. It produces an image with very high contrast.

local reduction See reduction (3).

long lens A lens whose focal length is longer than the diagonal measurement of the film with which it is used. The angle of view with such a lens-film size combination is narrower at a given distance than the angle that the human eye sees.

lossless See compression.

lossy See compression.

low value A dark area in a scene, print, or transparency; a thin, low-density area in a negative.

luminance The light reflected or produced by a given area of a subject in a specific direction measurable by a reflected-light (luminance) meter.

luminance meter See reflected-light meter.

macro lens A lens designed for taking close-up pictures.

macrophotograph See photomacrograph.

main light The principal source of light in a photograph, particularly in a studio setup, casting the dominant shadows and defining the texture and volume of the subject. Also called key light.

manual exposure A nonautomatic mode of camera operation in which the photographer sets both the shutter speed and the aperture.

manual flash A nonautomatic mode of flash operation in which the photographer controls the exposure by adjusting the size of the camera aperture.

mat A cardboard rectangle with an opening cut in it that is placed over a print to frame it. Also called an overmat.

mat knife A short knife blade (usually replaceable) set in a large, easy-to-hold handle. Used for cutting cardboard mounts for prints.

matte Describes a printing paper with a relatively dull, nonreflective surface. Opposite: glossy.

media A loose term for the various papers, inks, and other materials used in a digital printer, or for various cards, tapes, disks, and other items used for storing digital data.

megabyte (MB) 1,000,000 bytes. Used to describe the size of computer memory or storage.

memory card An in-camera, removable storage device that saves images recorded by a digital camera until you are ready to transfer the images to a computer or other storage device.

middle gray A standard average gray tone of 18 percent reflectance. See also gray card.

midtone An area of medium brightness, neither a very dark shadow nor a very bright highlight. A medium gray tone in a print.

modeling light A small tungsten light built into some flash units. It helps the photographer judge the effect of various light positions because the duration of flash light is too brief to be judged directly.

mottle A mealy gray area of uneven development in a print or negative. Caused by too little agitation or too short a time in the developer.

narrow lighting See short lighting.

negative 1. Any image with tones that are the reverse of those in the subject. Opposite: positive. 2. The film in the camera during exposure that is subsequently developed to produce a negative image.

negative carrier A frame that holds a negative flat in an enlarger.

negative film Film that produces a negative image on exposure and development.

nonsilver process A printing process that does not depend on the sensitivity of a silver compound to form an image, for example, the cyanotype process, in which the light-sensitive surface consists of a mixture of iron salts.

normal lens A lens whose focus length is about the same as the diagonal measurement of the film with which it is used. The angle of view with this lens-film size combination is roughly the same at a given distance as the angle that the human eye sees clearly.

notching code Notches cut in the margin of sheet film so that the type of film and its emulsion side can be identified in the dark.

one-shot developer A developer used once and then discarded.

opaque Describes 1. any substance or surface that will not allow light to pass; 2. a paint used to block out portions of a negative so that they will not allow light to pass during printing.

open up To increase the size of a lens aperture. Opposite: stop down.

orthochromatic Photographic material that is sensitive to blue and green but not to red wavelengths of the visible spectrum. Abbreviated ortho.

overdevelop To give more than the normal amount of development.

overexpose To give more than normal exposure to film or paper.

overmat See mat.

oxidation Loss of chemical activity due to contact with oxygen in the air.

palette A data box that appears on a computer's monitor. Palettes displayed by image-editing software offer options for various editing tools, provide information, and so on.

pan 1. To follow the motion of a moving object with the camera. This will cause the object to look sharp and the background blurred. 2. See panchromatic.

panchromatic Film that is sensitive to all (or almost all) wavelengths of the visible spectrum. Abbreviated pan.

parallax The difference in point of view that occurs when the lens (or other device) through which the eye views a scene is separate from the lens that exposes the film.

PC connector See sync cord.

PC terminal The socket on a camera or flash unit into which a PC connector (sync cord) is inserted.

perspective The apparent size and depth of objects within an image.

photoflood An incandescent lamp that produces a very bright light but has a relatively short life.

photogram An image formed by placing material directly onto a sheet of sensitized film or printing paper and then exposing the sheet to light.

photomacrograph A close-up photograph that is life size or larger. Also called macrophotograph.

photomicrograph A photograph that is taken through a compound microscope.

photomontage A composite image made by assembling parts of several photographs.

pincushion distortion A lens aberration or defect that causes straight lines to bow inward toward the center of the image.

pinhole 1. A small clear spot on a negative usually caused by dust on the film during exposure or development or by a small air bubble that keeps developer from the film during development. 2. The tiny opening in a pinhole camera that produces an image.

pixel Short for picture element. Digital images are composed of many individual pixels, each having a specific color or tone that can be displayed, changed, or stored. When the pixels are small enough, the eye merges the individual pixels into continuous tones.

plane of critical focus The part of a scene that is most sharply focused.

plate In early photographic processes, the sheet of glass or metal on which emulsion was coated.

platinum print A print in which the final image is formed in platinum rather than silver. See also nonsilver process.

plug in An add-on software module for an application such as Adobe Photoshop that expands its capabilities. Some of Photoshop's plug-ins, for example, add special effects or borders, operate scanners, or increase control of selections and sharpening.

polarizing filter A filter that reduces reflections from nonmetallic surfaces such as glass or water by blocking light waves that are vibrating at selected angles to the filter.

positive Any image with tones corresponding to those of the subject. Opposite: negative.

posterization An image with its continuous gray tones or colors separated into a few distinct shades of gray or uniform colors.

ppi Pixels per inch, a measure of the resolution of a computer display, digital camera, or digital image. See also ppi, spi, and resolution.

presoak To soak film or paper in water prior to immersing it in a chemical (often developer).

press camera A camera that uses sheet film, like a view camera, but which is equipped with a viewfinder and a hand grip so it can be used without being mounted on a tripod. Once widely used by press photographers, it has been replaced by 35mm cameras.

primary colors Basic colors from which all other colors can be mixed. See also subtractive, additive.

print 1. A photographic image, usually a positive one on paper. 2. To produce such an image in a digital printer or from a negative or transparency by contact or projection printing in a darkroom.

printing frame A holder designed to keep sensitized material, usually paper, in full contact with a negative during contact printing.

profile The data for a digital device, such as a printer, that describes its gamut or range of colors. Used to match the gamut from one device to another. See also color management, gamut.

programmed automatic A mode of automatic exposure in which the camera sets both the shutter speed and the aperture that will produce the correct exposure.

projection printing The process of projecting an image of a negative onto sensitized material, usually paper. The image may be projected to any size, usually larger than the negative.

projector An optical instrument for forming the enlarged image of a transparency or a motion picture on a screen.

proof A test print made for the purpose of evaluating density, contrast, color balance, or subject composition.

push To expose film at a higher film-speed rating than normal, then to compensate in part for the resulting underexposure by giving greater development than normal. This permits shooting at a dimmer light level, a faster shutter speed, or a smaller aperture than would otherwise be possible.

RAM Random access memory. RAM chips are composed of integrated circuits acting as temporary data storage in a computer or other device to allow rapid data access and processing.

rangefinder 1. A device on a camera that measures the distance from camera to subject and shows when the subject is in focus. 2. A camera equipped with a rangefinder focusing device. Abbreviated RF.

raster streak A dark streak in photographs of television-screen or computer-monitor images, caused by using a too-fast shutter speed.

raw file 1. A digital camera photograph in exactly the form it was captured by the camera. 2. An unaltered original file, as from a scanner.

RC paper See resin-coated paper.

rear nodal point The point in a lens from which lens focal length (distance from lens to image plane) is measured. Undeviated rays of light cross the lens axis and each other at this point.

reciprocity law The theoretical effect on exposure of the relationship between length of exposure and intensity of light, stating that an increase in one will be balanced by a decrease in the other. For example, doubling the light intensity should be balanced exactly by halving the exposure time. In fact, the law does not hold true for very long or very short exposures. This reciprocity failure causes underexposure unless the exposure is increased. It also causes color shifts in color materials.

reducing agent The active ingredient in a developer. It changes exposed silver halide crystals into dark metallic silver. Also called the developing agent.

reduction 1. A print that is smaller than the size of the negative. 2. The part of development in which exposed

silver halide crystals forming an invisible latent image are converted to visible metallic silver. 3. A process that decreases the amount of dark silver in a developed image. Negatives are usually reduced to decrease density. Prints are reduced locally (only in certain parts) to brighten highlights. Opposite: intensification.

reel A metal or plastic reel with spiral grooves into which roll film is loaded for development.

reflected-light meter An exposure meter that measures the amount of light reflected or emitted by a subject. Sometimes called a luminance meter.

reflector 1. A reflective surface, such as a piece of white cardboard, that can be positioned to redirect light, especially into shadow areas. Also called a flat. 2. A reflective surface, often bowl-shaped, that is placed behind a lamp to direct more light from the lamp toward the subject.

reflex camera A camera with a built-in mirror that reflects the scene being photographed onto a ground-glass viewing screen. See also single-lens reflex, twin-lens reflex.

relative aperture See aperture, f-number.

replenisher A substance added to some types of developers after use to replace exhausted chemicals so that the developer can be used again.

resampling Increasing or decreasing the number of pixels in an image. The tonal values for a new pixel are found by averaging the values of the pixels merged into it or surrounding it.

resin-coated paper Printing paper with a water-resistant plastic coating that absorbs less moisture than uncoated paper, consequently reducing some processing times. Abbreviated RC.

resolution 1. The ability to differentiate fine detail, for example, some measure of the quality of a lens. 2. The fineness of detail or the amount of data available to represent detail in a given area. In a digital image file or on a computer monitor, resolution refers to the number of pixels in a linear inch (ppi); on a printer, to the number of dots printed in a linear inch (dpi); on a scanner, to the number of samples saved for a given area of the scanned image(spi). See also dpi, ppi, and spi.

reticulation A crinkling of the gelatin emulsion on film that can be caused by extreme temperature changes during processing.

reversal A process for making a positive image directly from film exposed in the camera; also for making a negative image directly from a negative or positive image from a positive transparency. In image-editing programs, reversing tones is called inverting.

reversal film Film that produces a positive image (a transparency).

RF See rangefinder.

RGB Red, green, and blue, the primary colors of light used in digital imaging that, when combined, can create a full-

color image on a computer monitor. Also refers to the way most digital color images are described in image-editing software. See also CMYK.

roll film Film that comes in a roll, protected from light by a length of paper wound around the film. Loosely applies to any film packaged in a roll rather than in flat sheets.

Sabattier effect A partial reversal of tones that occurs when film or paper is reexposed to light during development. Commonly called solarization.

safelight A light used in the darkroom during printing to provide general illumination without giving unwanted exposure.

scan The process of turning prints, transparencies, or negatives into digital images. A scanner and scanning software are required.

selective-contrast paper See variable-contrast paper.

sharp Describes an image or part of an image that shows crisp, precise texture and detail. Opposite: blurred or soft.

sheet film Film that is cut into individual flat pieces. Also called cut film.

short lens A lens whose focal length is shorter than the diagonal measurement of the film with which it is used. The angle of view with this lens-film combination is greater at a given distance than the angle seen by the human eye. Also called a wide-angle or wide-field lens.

short lighting A portrait lighting setup in which the main source of light illuminates the side of the face partially turned away from the camera. Also called narrow lighting.

shutter A mechanism that opens and closes to admit light into a camera for a measured length of time.

shutter-priority A mode of automatic exposure in which the photographer selects the shutter speed and the camera sets the aperture that will produce the correct exposure.

silhouette A scene or photograph in which the background is much more brightly lit than the subject.

silver halide The light-sensitive part of common photographic emulsions; the compounds silver chloride, silver bromide, silver fluoride, and silver iodide.

single-lens reflex A camera in which the image formed by the taking lens is reflected by a mirror onto a ground-glass screen for viewing. The mirror swings out of the way just before exposure to let the image reach the film. Abbreviated SLR.

slave An electronic flash unit that fires when it detects a burst of light from another flash unit.

slave eye A sensor that detects light to trigger a slave flash unit.

slide 1. A transparency (often a positive image in color) mounted between glass or in a frame of cardboard or other material so that it may be inserted into a projector. 2. A protective cover that is

removed from a sheet film holder when film in the holder is to be exposed. Also called dark slide.

slow Describes 1. a film or paper that is not very sensitive to light; 2. a lens whose widest aperture is relatively small; 3. a long shutter speed. Opposite: fast.

SLR See single-lens reflex.

sodium thiosulfate Active ingredient in some fixers. Most are ammonium thiosulfate.

soft 1. Describes an image that is blurred or out of focus. Opposite: sharp. 2. Describes a scene, negative, or print of low contrast. Opposite: hard or high contrast. 3. Describes a printing paper emulsion of low contrast, such as grade 0 or 1.

soft proof Previewing a digital image on a computer monitor to see how it will look when printed with a particular printer, ink, and paper.

software Programs used to direct a computer. Adobe Photoshop, for example, makes desired changes in a digital image or other digital file. See application.

solarization A reversal of image tones that occurs when film is massively overexposed. See also Sabattier effect.

speed 1. The relative sensitivity to light of film or paper. 2. The relative ability of a lens to admit more light by opening to a wider aperture.

spherical aberration A lens defect that causes rays that strike at the edges of the lens to be bent more than rays that strike at the center.

spi Samples per inch, a measure of the resolution of a scanner. See also dpi, ppi, and resolution.

spot To remove small imperfections in a print caused by dust specks, small scratches, or the like. Specifically, to paint a dye over small white blemishes.

spotlight An electric light that contains a small bright lamp, a reflector, and often a lens to concentrate the light. Designed to produce a narrow beam or bright light.

spot meter A reflected-light exposure meter with a very small angle of view, used to measure the brightness of a small portion of a subject.

stereograph A pair of photographs taken side by side and seen separately by each eye in viewing them through a stereoscope. The resulting image looks three-dimensional.

stitching Digitally combining several overlapping images of the same scene, usually seamlessly, to form a single larger image.

stock solution A concentrated chemical solution that is diluted before use.

stop 1. An aperture setting on a lens. 2. A change in exposure or illumination by a factor of two. One stop more exposure doubles the light reaching film or paper. One stop less halves the exposure. Either the aperture or the exposure time can be changed. 3. See stop down.

stop bath An acid solution used between the developer and the fixer to stop the action of the developer and to preserve the effectiveness of the fixer. Generally a dilute solution of acetic acid; plain water is sometimes used as a stop bath for film development.

stop down To decrease the size of a lens aperture. Opposite: open up.

strobe 1. Abbreviation of stroboscopic. Describes a light source that provides a series of brief pulses of light in rapid succession. 2. Used loosely to refer to any electronic flash.

subtractive color A way to produce colors by mixing dyes that contain varying proportions of the three subtractive primary colors—cyan, magenta, and yellow.

supplementary lens A lens that can be added to a camera lens for close-up work. It magnifies the image and permits focusing closer than normal to an object.

sync cord An electrical cord connecting a flash unit with a camera so that the two can be synchronized.

synchronize To cause a flash unit to fire at the same time the camera shutter is open.

synchro-sun A way to use flash as fill light in a photograph made in direct sunlight. The flash lightens shadows, decreasing the contrast in the scene.

T *See* time.

tacking iron A small, electrically heated tool used to melt the adhesive in dry-mount tissue, attaching it partially to the back of the print and to the mounting surface. This keeps the print in place during the mounting procedure.

taking lens The lens on a camera through which light passes to expose the film.

tank A container for developer or other processing chemicals into which film is placed for development.

telephoto effect A seeming change in perspective caused by using a long-focal-length lens very far from all parts of a scene. Objects appear closer together than they really are.

telephoto lens Loosely, any lens of very long focal length. Specifically, one constructed so that its effective focal length is longer than its actual size. *See also* long lens.

tenting A way to light a highly reflective object. The object is surrounded with large sheets of paper or translucent material lighted so that the object reflects them and not the lamps, camera, and other items in the studio.

terabyte (TB) 1,000,000,000,000 bytes. Used to describe the size of computer memory or storage.

thin Describes a negative or an area of a negative where relatively little silver has been deposited. A thin negative transmits a large amount of light. Opposite: dense.

time A shutter setting marked T at which the shutter remains open until reclosed by the photographer.

tintype An historic collodion wet-plate process in which the emulsion is coated onto a dark metal plate. It produces a direct positive image.

TLR *See* twin-lens reflex.

tone 1. To change the color of a print by immersing it in a chemical solution. 2. The lightness or darkness of a particular area. A highlight is a light tone, a shadow is a dark tone.

transparency An image on a transparent base, such as film or glass, that is viewed by transmitted light. *See* slide (1).

tripod A three-legged support for a camera. Usually the height is adjustable and the top or head is movable.

tungsten film Color film balanced to produce accurate color renditions when the light source that illuminates the scene has a color temperature of about 3200K, as do many tungsten lamps. Formerly called Type B film. *See also* Type A film.

tungsten light Light such as that from an ordinary light bulb containing a thin tungsten wire that becomes incandescent (emits light) when an electric current is passed along it. Also called incandescent light.

Tv Abbreviation of time value. Used on some camera information displays as a shortened way to refer to shutter-speed settings.

twin-lens reflex A camera in which two lenses are mounted above one another. The bottom (taking) lens forms an image on the exposed film. The top (viewing) lens forms an image that reflects upward onto a ground-glass viewing screen. *See* TLR.

Type A film Color film balanced to produce accurate color renditions when the light source that illuminates the scene has a color temperature of 3400K, as does a photoflood. None are currently made for still photography. *See also* tungsten film.

Type B film *See* tungsten film.

ultraviolet The part of the spectrum just beyond violet. Ultraviolet light is invisible to the human eye but strongly affects photographic materials.

underdevelop To give less development than normal.

underexpose To give less than normal exposure to film or paper.

value The relative lightness or darkness of an area. Low values are dark; high values are light.

variable-contrast paper A printing paper in which varying grades of print contrast can be obtained by changing the color of the enlarging light source, as by the use of filters. Also called selective-contrast paper. *See also* graded-contrast paper.

view camera A camera in which the taking lens forms an image directly on a ground-glass viewing screen. A film holder replaces the viewing screen before exposure. The front and back of the camera can be set at various positions and angles to change focus and perspective.

viewfinder 1. A small window on a camera through which the subject is seen and framed. 2. A camera that has a viewfinder, but not a rangefinder (which shows when the subject is focused).

viewing lens The lens on a camera through which the eye views the subject.

viewing screen In a reflex or view camera, the ground-glass surface on which the image is seen and focused.

vignette To underexpose the edges of an image. Sometimes done intentionally but more often caused accidentally by a lens that forms an image covering the film or paper only partially.

warm Reddish colors that by association with common objects (fire, sun, and so on) give an impression of warmth.

washing aid A chemical solution used between fixing and washing film or paper. It shortens the washing time by converting residues from the fixer into forms more easily dissolved by water. Also called hypo neutralizing (or clearing) agent.

wet-plate process An historic photographic process in which a glass or metal plate is coated with a collodion mixture, then sensitized with silver nitrate, exposed, and developed

while the collodion is still wet. It was popular from the 1850s until the introduction of the gelatin dry plate in the 1880s.

wetting agent A chemical solution used after washing film. By reducing the surface tension of the water remaining on the film, it speeds drying and prevents water spots.

white balance The setting on a digital camera that adjusts the camera for the color temperature of a particular light source, such as tungsten or daylight. With the correct setting, a white object will appear white, not tinged by the color of the light source.

white light A mixture of all wavelengths of the visible spectrum. The human eye sees the mixture as light that is colorless or white.

wide-angle distortion A change in perspective caused by using a wide-angle lens very close to a subject. Objects appear stretched out or farther apart than they really are.

wide-angle lens *See* short lens.

workflow A series of steps in sequence, like a checklist, to streamline a process like image editing or file archiving.

working solution A chemical solution diluted to the correct strength for use.

zone focus To preset the focus of a lens so that some future action will take place within the limits of the depth of field.

zone plate An image-forming device, similar to a pinhole, that is made of concentric rings, alternating opaque and clear.

zone system A way to plan negative exposure and development to achieve precise control of the darkness of various areas in a print.

zoom lens A lens adjustable to a range of focal lengths.

TECHNICAL INFORMATION

This book is a basic introductory text in photography, and you will find that other basic textbooks generally cover the same topics. However, you may wish to consult one or more additional beginners' texts because individual texts explain material in individual ways and may emphasize different points. The following books are of about the same level of difficulty.

Curtin, Dennis. *The Textbook of Digital Photography*. Boston, MA: Shortcourses.com, 2004.

Horenstein, Henry, and Russell Hart. *Photography*. Revised ed. Upper Saddle River, NJ: Prentice Hall, 2004.

Langford, Michael, Anna Fox and Richard Sawdon Smith. *Langford's Basic Photography*. 8th ed. Boston: Focal Press, 2007.

London, Barbara, and Jim Stone. *A Short Course in Photography*. 6th ed. Upper Saddle River, NJ: Prentice Hall, 2006.

Schaefer, John P. *Basic Techniques of Photography: The Ansel Adams Guide, Book 1*. Boston: Bulfinch, 1999.

ADVANCED OR SPECIALIZED

Adams, Ansel, with Robert Baker. *The Ansel Adams Photography Series. The Camera*, 1995; *The Negative*, 1995 (has Zone System details); *The Print*, 1995. Boston: Little, Brown and Company. Stresses full technical control of the photographic process as an aid to creative expression.

Anchell, Stephen G. *The Darkroom Cookbook*. Boston: Focal Press, 2000. A compendium of detailed information on more than 100 photographic formulas.

———. *Variable Contrast Printing Manual*. Boston: Focal Press, 1997.

DeCock, Liliane, ed. *Photo-Lab Index: Lifetime Edition*. Dobbs Ferry, NY: Morgan & Morgan, 1994. A storehouse of information about photographic products, including descriptions of materials and recommended procedures for their use.

DeMaio, Joe, Roberta Worth, and Dennis Curtin. *The New Darkroom Handbook*. 2nd ed. Boston: Focal Press, 1997.

Graves, Carson. *The Elements of Black-and-White Printing*. 2nd ed. Boston: Focal Press, 2001. Excellent for the intermediate-to-advanced printer.

———. *The Zone System for 35mm Photographers: A Basic Guide to Exposure Control*. Boston: Focal Press, 1996.

Hunter, Fil. *Light: Science and Magic. An Introduction to Photographic Lighting*. 2nd ed. Boston: Focal Press, 1997.

Johnson, Chris. *The Practical Zone System: A Simple Guide to Photographic Control*. 3rd ed. Boston, MA: Focal Press, 1999. A thorough, accessible zone system manual.

Kobré, Kenneth. *Photojournalism: The Professionals' Approach*. 5th ed. Boston: Focal Press, 2004. A comprehensive overview of equipment, techniques, and approaches used by photojournalists.

Meehan, Joseph. *Panoramic Photography*. Revised. New York: Amphoto, 1996. A well-illustrated guide to the techniques and aesthetics of panoramic photography.

Peres, Michael, ed. *The Focal Encyclopedia of Photography*. 4th ed. Boston: Focal Press, 2007.

Renner, Eric. *Pinhole Photography: Rediscovering a Historic Technique*. 3rd ed. Boston: Focal Press, 2004. Explains everything from creating pinhole cameras to manipulating pinhole images.

Stone, Jim. *A User's Guide to the View Camera*. 3rd ed. Upper Saddle River, NJ: Prentice Hall, 2004.

Stroebel, Leslie, et al. *Basic Photographic Materials and Processes*. 2nd ed. Boston: Focal Press, 2000. Detailed sections on sensitometry, optics, visual perception, and chemistry.

———. *View Camera Technique*. 7th ed. Boston: Focal Press, 1999.

Todd, Hollis N., and Richard D. Zakia. *Photographic Sensitometry: The Study of Tone Reproduction*. Dobbs Ferry, NY: Morgan & Morgan, 1969. Measuring, analyzing, and applying data on the effects of light on photographic materials.

White, Laurie. *Infrared Photography Handbook*. Buffalo, NY: Amherst Media, 1995.

Rice, Patrick. *Digital Infrared Photography*. Buffalo, NY: Amherst Media, 2004.

ALTERNATIVE PROCESSES

Arentz, Dick. *Platinum and Palladium Printing*. 2nd ed. Boston: Focal Press, 2004.

Barnier, John, ed. *Coming into Focus: A Step-by-Step Guide to Alternative Photographic Printing Processes*. San Francisco: Chronicle Books, 2000.

Blacklow, Laura. *New Dimensions in Photo Imaging: A Step-by-Step Manual*. 3rd ed. Boston: Focal Press, 2000. Detailed, easy-to-follow instructions for alternative processes including Polaroid transfers, Van Dyke, and gum bichromate.

Carr. Kathleen Thormod. *Polaroid Transfers: A Complete Visual Guide to Creating Image and Emulsion Transfers*. New York: Amphoto, 1997.

Crawford, William. *The Keepers of Light: A History and Working Guide to Early Photographic Processes*. Dobbs Ferry, NY: Morgan & Morgan, 1979.

Enfield, Jill. *Photo Imaging: A Complete Guide to Alternative Processes*. New York: Amphoto, 2002.

Hirsch, Robert and John Valentino. *Photographic Possibilities: The Expressive Use of Ideas, Materials and Processes*. Boston: Focal Press, 2001.

Reed, Martin, and Sarah Jones. *Silver Gelatin: A User's Guide to Liquid Photographic Emulsions*. New York: Amphoto, 1996. Instructions for coating and printing on anything from paper and glass to metal, stone, fabric, and ceramics.

Reilly, James. *Albumen & Salted Paper Book: The History and Practice of Photographic Printing 1840-1895*. Rochester, NY: Light Impressions, 1980.

Stone, Jim. *Darkroom Dynamics: A Guide to Creative Darkroom Techniques*. Boston: Focal Press, 1979. Instructions on expanding your imagery with multiple printing, toning, hand coloring, high contrast, and other techniques.

BUSINESS PRACTICES

American Society of Media Photographers. *ASMP Professional Business Practices in Photography*. 6th ed. New York: Allworth Press, 2001.

Crawford, Ted. *Business and Legal Forms for Photographers*. 3rd ed. New York: Allworth press, 2002.

DuBoff, Leonard D. *The Law (in Plain English) for Photographers*. Revised ed. New York: Allworth Press, 2002.

Heron, Michael, and David MacTavish. *Pricing Photography: The Complete Guide to Assignment & Stock Prices*. 3rd ed. New York: Allworth Press, 2002.

Kieffer, John. *The Photographer's Assistant: Learn the Inside Secrets of Professional Photography and Get Paid for It*. New York: Allworth Press, 2001.

Oberrecht, Kenn. *How to Open and Operate a Home-Based Photography Business*. 5th ed. Old Saybrook, CT: Globe Pequot Press, 2005.

Poehner, Donna, and Erica O'Connell. *2007 Photographer's Market: Where and How to Sell Your Photographs*. Cincinnati. Writer's Digest Books, 2006.

COLOR PHOTOGRAPHY

Hirsch, Robert. *Exploring Color Photography*. 4th ed. New York: McGraw-Hill Higher Education, 2004. Techniques, images, and history of color photography for the college level.

Horenstein, Henry. *Color Photography: A Working Manual*. Boston: Little, Brown and Company, 1995.

Wilhelm, Henry. *The Permanence and Care of Color Photographs: Traditional and Digital Color Prints, Color Negatives, Slides, and Motion Pictures*. Grinnell, IA: Preservation Publishing Co., 1993. The most comprehensive conservation guide to color materials available.

DIGITAL IMAGING

Adobe Creative Team. *Adobe Photoshop CS2 Classroom in a Book*. Berkeley: Adobe Press, 2005

Ang, Tom. *Digital Photographer's Handbook*. 3rd ed. New York: DK Publishing, 2006.

Blatner, David, and Bruce Fraser. *Real World Adobe Photoshop CS2*. Berkeley: Peachpit Press, 2005.

Bouton, Gary D. *Inside Photoshop CS*. Indianapolis: Sams Publishing, 2004. For intermediate to advanced Photoshop users.

Burkholder, Dan. *Making Digital Negatives for Contact Printing*. 2nd ed. San Antonio, TX: Bladed Iris Press, 1999.

Caponigro, John Paul. *Adobe Photoshop Master Class*. 2nd ed. Berkeley: Adobe Press, 2003.

Ciaglia, Joe. *Introduction to Digital Photography*. Upper Saddle River, NJ: Prentice Hall, 2002.

Davies, Adrian, and Phil Fennessy. *Digital Imaging for Photographers*. 4th ed. Boston: Focal Press, 2001.

Farace, Joe. *The Photographer's Internet Handbook*. Revised ed. New York: Allworth Press, 2001.

Fraser, Bruce, Chris Murphy, and Fred Bunting. *Real World Color Mangement*. 2nd ed. Berkeley: Peachpit Press, 2004.

Haynes, Barry, and Wendy Crumpler. *Photoshop CS Artistry: Mastering the Digital Image*. Indianapolis: New Riders Press, 2004.

Hollely, Douglas. *Digital Book Design and Publishing*. Rochester, NY: Cary Graphic Arts Press, 2001.

Krejcarek, Philip. *Digital Photography: A Hands-On Introduction*. San Francisco: Delmar Learning, 1997.

Krogh, Peter. *The DAM Book: Digital Asset Management for Photographers*. Cambridge: O'Reilly Media, 2005. How to organize, store, and find digital photographs.

Long, Ben. *Complete Digital Photography*. 3rd ed. Boston: Charles River Media, 2004.

Rodney, Andrew. *Color Management for Photographers: Hands on Techniques for Photoshop Users.*. Boston: Focal Press, 2005.

Weinman, Lynda. *Designing Web Graphics.4: How to Prepare Images and Media for the Web*. 4th ed. Indianapolis: New Riders Press, 2002.

HEALTH AND SAFETY

Rempel, Siegfried, and Wolfgang Rempel. *Health Hazards for Photographers*. New York: Lyons Press, 1992.

Shaw, Susan D., and Monona Rossol. *Overexposure: Health Hazards in Photography*. 2nd ed. New York: Allworth Press, 1991.

HISTORY AND CRITICISM

Aesthetics and Criticism

Adams, Robert. *Beauty in Photography: Essays in Defense of Traditional Values*. New York: Aperture, 1996. Reprint of 1981 edition.

Barrett, Terry. *Criticizing Photographs: An Introduction to Understanding Images*. 4th ed. New York: McGraw-Hill, 2005. A guide to the analysis and interpretation of images.

Barthes, Roland. *Camera Lucida*. New York: Hill and Wang, 1981.

Berger, John. *Ways of Seeing*. New York: Penguin Books, 1985.

Burgin, Victor. *Thinking Photography*. London: Macmillan, 1982.

Coleman, A. D. *Depth of Field: Essays on Photographs, Lens Culture, and Mass Media*. Albuquerque: University of New Mexico Press, 1998.

Edwards, Elizabeth, ed. *Anthropology and Photography 1860-1920*. New Haven, CT: Yale University Press, 1994. Reprint of 1992 edition.

Finn, David. *How to Look at Photographs: Reflections on the Art of Seeing*. New York: Harry N. Abrams, 1994.

Goldberg, Vicki. *Light Matters*. New York: Aperture, 2005.

———. *Photography in Print: Writings from 1816 to the Present*. Albuquerque: University of New Mexico Press, 1988. Reprint of 1981 edition.

Grundberg, Andy. *Crisis of the Real: Writings on Photography Since 1974*. 2nd ed. New York: Aperture, 1999. Readable, stimulating essays on contemporary issues in photography.

Heron, Liz, and Val Williams, eds. *Illuminations: Women's Writings on Photography from the 1850s to the Present*. Durham, NC: Duke University Press, 1996.

Jay, Bill. *Occam's Razor: An Outside-In View of Contemporary Photography*. Tucson: Nazraeli Press, 1992.

Kozloff, Max. *The Privileged Eye*. Albuquerque: University of New Mexico Press, 1987.

Lyons, Nathan, ed. *Photographers on Photography: A Critical Anthology*. Englewood Cliffs, NJ: Prentice Hall, 1996. Twenty-three well-known photographers (1880s to 1960s) discuss their own work and photography in general.

McLuhan, Marshall. *Understanding Media: The Extensions of Man*. Cambridge: MIT Press, 1994.

Mitchell, William J. *The Reconfigured Eye: Visual Truth in the Post-Photographic Era*. Cambridge: MIT Press, 1992. An analysis of digital imaging, including how it has affected what we see and the effects it may have.

Newhall, Beaumont, ed. *Photography: Essays and Images*. New York: Museum of Modern Art, 1980.

Ritchin, Fred. *In Our Own Image: Aperture Writers and Artists on Photography*. 2nd revised ed. New York: Aperture, 2006.

Scharf, Aaron. *Art and Photography*. Baltimore: Penguin Books, 1991. Reprint of 1974 edition. The interrelationship of photography and painting.

Sekula, Allan. *Photography Against the Grain*. Halifax: Press of the Nova Scotia College of Art and Design, 1984.

Solomon-Godeau, Abigail. *Photography at the Dock: Essays on Photographic History, Institutions, and Practices*. Minneapolis: University of Minnesota Press, 1991.

Sontag, Susan. *On Photography*. New York: Farrar, Straus and Giroux, 1977.

Wells, Liz. *Photography: A Critical Introduction*. 3rd ed. New York: Routledge, 2004

———, ed. *The Photography Reader*. New York: Routledge, 2002

History

Coe, Brian. *Cameras: From Daguerreotypes to Instant Pictures.* New York: Crown, 1978. A well-illustrated and complete history of the camera.

Coote, Jack. *The Illustrated History of Colour Photography.* Surbiton, Surrey: Fountain Press, 1994.

Foresta, Merry, et al. *Secrets of the Dark Chamber: The Art of the American Daguerreotype.* Washington, DC: Smithsonian Institution Press, 1995.

Frizot, Michel. *A New History of Photography.* Köln: Könemann, 1998. A comprehensive history.

Gernsheim, Helmut. *The Origins of Photography.* New York: Thames and Hudson,1982.

———. *The Rise of Photography 1850-1900. The Age of Collodion.* New York: Thames and Hudson, 1988. These two volumes are revised publications of Gernsheim's classic history of photography published in 1955.

Goldberg, Vicki, and Robert Silberman. *American Photography: A Century of Images.* San Francisco: Chronicle Books, 1999.

———. *The Power of Photography: How Photographs Changed Our Lives.* New York: Abbeville Press, 1991.

Green, Jonathan. *American Photography: A Critical History.* New York: Harry N. Abrams, 1984. A survey of American photography since 1945.

Hirsch, Robert. *Seizing the Light: A History of Photography.* New York: McGraw Hill, 2000.

Jammes, André, and Eugenia P. Janis. *The Art of French Calotype.* Princeton, NJ: Princeton University Press, 1983. A scholarly work on Second Empire photography, elegantly produced.

Marien, Mary Warner. *Photography: A Cultural History.* Upper Saddle River, NJ: Prentice Hall, 2003.

Moutoussamy-Ashe, Jeanne. *View Finders: Early Black Women Photographers.* New York: Dodd, Mead, 1986.

Mulligan, Therese and David Wooters. *A History of Photography from 1839 to the Present (The George Eastman House Collection).* Cologne: Taschen, 2006.

Newhall, Beaumont. *The History of Photography from 1839 to the Present.* Rev. ed. New York: Museum of Modern Art and Boston: Bulfinch, 1982.

Rosenblum, Naomi. *A History of Women Photographers.* New York: Abbeville Press, 1994.

———. *A World History of Photography.* 3rd ed. New York: Abbeville Press, 1997.

Rudisill, Richard. *Mirror Image: The Influence of the Daguerreotype on American Society.* Albuquerque: University of New Mexico Press, 1971. Fascinating social history of the cultural, commercial, and social effects of the daguerreotype on mid-19th century America.

Sandweiss, Martha A. *Photography in Nineteenth-Century America.* New York: Harry N. Abrams, 1991. An extensive exploration of the relationship between photography and culture.

Schaaf, Larry J. *Out of the Shadows: Herschel, Talbot and the Invention of Photography.* New Haven, CT: Yale University Press, 1992.

Szarkowski, John. *Photography Until Now.* New York: Museum of Modern Art, 1989. The history of photography organized according to the changing photographic technology.

Taft, Robert. *Photography and the American Scene.* New York: Dover Publications,1964. Reprint of 1938 edition. ACLS E-book online edition 2002.

Westerbeck, Colin. *Bystander: A History of Street Photography.* Boston: Bulfinch Press, 1994.

Willis, Deborah. *Reflections in Black. History of Black Photographers 1840 to the Present.* New York: W.W. Norton & Co., 2002. Reprint of 2000 edition.

Witkin, Lee, and Barbara London. *The Photograph Collector's Guide.* Boston: New York Graphic Society, 1979. Includes biographical entries with illustrations for over 200 photographers; lists of over 8000 other photographers, museums, and galleries; and other information.

Wood, John. *The Art of the Autochrome: The Birth of Color Photography.* Iowa City: University of Iowa Press, 1993.

VISUAL ANTHOLOGIES

Billeter, Erika. *Canto a la realidad: Fotografía latinoamericana 1860-1993.* Madrid: Casa de América, 1993. A definitive anthology of works by Latin American photographers.

Davis, Keith F. *An American Century of Photography. From Dry Plate to Digital: The Hallmark Photographic Collection.* New York: Harry N. Abrams, 1995.

Druckrey, Timothy, ed. *Iterations: The New Image.* Cambridge: MIT Press, 1994.

Easter, Eric D., et al., eds. *Songs of My People: African Americans: A Self-Portrait.* Boston: Little, Brown and Company, 1992. Photographs and text from an African-American perspective.

Eauclaire, Sally. *The New Color Photography.* New York: Abbeville, 1981.

Edey, Maitland. *Great Photographic Essays from Life.* Boston: New York Graphic Society, 1978. Twenty-two photographic essays including work by Abbott, Adams, Bourke-White, and others.

Enwezor, Okwui, et al., eds. *In/sight: African Photographers 1940 to the Present.* New York: Harry N. Abrams, 1996.

Ferrer, Elizabeth, ed. *Shadow Born of Earth: New Photography in Mexico.* New York: Universe Books, 1993.

Foresta, Merry, et al. *Between Home and Heaven. Contemporary American Landscape Photography.* Albuquerque: University of New Mexico Press, 1992.

Fralin, Frances. *The Indelible Image: Photographs of War: 1846 to the Present.* New York: Harry N. Abrams, 1985.

Green, Jonathan, ed. *Camera Work: A Critical Anthology.* Millerton, NY: Aperture, 1973.

Greenough, Sarah. *On the Art of Fixing a Shadow: 150 Years of Photography.* Boston: Bulfinch Press, 1989.

Grundberg, Andy, et al. *After Art: Rethinking 150 Years of Photography.* Seattle: University of Washington Press, 1995.

Grundberg, Andy, and Kathleen Gauss. *Photography and Art: Interactions Since 1946.* New York: Abbeville Press, 1987.

Hoy, Anne, ed. *Fabrications. Staged, Altered, and Appropriated Photographs.* New York: Abbeville Press, 1987.

Hurley, F. Jack. *Portrait of a Decade: Roy Stryker and the Development of Documentary Photography in the Thirties.* Baton Rouge: Louisiana State University Press, 1972.

Köhler, Michael, ed. *Constructed Realities: The Art of Staged Photography.* Zürich: Edition Stemmle, 1995. An anthology of staged photography including Sandy Skoglund, Cindy Sherman, and others.

Life Library of Photography. Rev. ed. New York: Time-Life Books, 1981-1983. Seventeen volumes plus yearbooks (1973-1981), all profusely illustrated. The books generally contain historical material and technical information.

Livingston, Jane, Rosalind E. Krauss, and Dawn Ades. *L'Amour Fou: Photography and Surrealism.* New York: Abbeville Press, 1985.

Naef, Weston J., and James N. Wood. *Era of Exploration: The Rise of Landscape Photography in the American West, 1860-1885.* New York: Metropolitan Museum of Art, 1975. Extensive treatment of the subject with emphasis on Watkins, O'Sullivan, Muybridge, Russell, and Jackson.

Noriega, Chon, et al., eds. *From the West: Chicano Narrative Photography.* San Francisco: Mexican Museum, 1996.

Roalf, Peggy, ed., *Strong Hearts: Native American Visions and Voices.* New York: Aperture, 1995.

Szarkowski, John, ed. *Mirrors and Windows: American Photography Since 1960.* New York: Museum of Modern Art, 1978.

———. *Looking at Photographs: 100 Pictures from the Collection of the Museum of Modern Art.* New York: Museum of Modern Art, 1976.

Weaver, Mike, ed. *The Art of Photography 1839-1989.* New Haven, CT: Yale University Press, 1989.

Weiermair, Peter, ed. *Prospect: Photography in Contemporary Art.* Zurich, Edition Stemmle, 1996. Surveys work of numerous artists from the post-photographic period.

INDIVIDUAL PHOTOGRAPHERS

The photographers listed below have images in this book.

Ansel Adams
Adams, Ansel, and John Szarkowski. *Ansel Adams at 100.* Boston: Bulfinch, 2003.

Nubar Alexanian
———. *Where Music Comes From.* Stockport, U.K.: Dewi Lewis, 1996.

Eve Arnold
———. *In Retrospect.* New York: Alfred A. Knopf, 1995.

Eugène Atget
———. *The Work of Atget.* New York: Museum of Modern Art and Boston: New York Graphic Society. Vol. 1: *Old France,* 1981. Vol. 2: *The Art of Old Paris,* 1982. Vol. 3: *The Ancien Régime,* 1983. Vol. 4: *Modern Times.* 1984.

Richard Avedon
———. *In the American West..* New York: Harry N. Abrams, 2005.

Karl Baden
———. *Contact Sheet 106: Karl Baden, Self-Portraits, 1974-2000.* Syracuse, NY: Light Work, 2000.

Lewis Baltz
———. *The Prototype Works.* Santa Monica: RAM Publications, 2000.

Micha Bar-Am
———. *Israel: A Photobiography: The First Fifty Years.* New York: Simon & Schuster, 1998.

Tom Baril
———. *Botanica.* Santa Fe: Arena Editions, 2000.

Bernd and Hilla Becher
———. *Industrial Landscapes.* Cambridge: MIT Press, 2002.

Dawoud Bey
———. *Dawoud Bey: Portraits 1975-1995.* Minneapolis: Walker Art Center, 1995.

Margaret Bourke-White
———. *Margaret Bourke-White: Photographer.* Boston: Bulfinch, 1998.

Manuel Alvarez Bravo
———. *Manuel Alvarez Bravo.* Paris: Hazan Editions, 2000.

Joachim Brohm
———. *Areal.* Göttingen, Germany: Steidl, 2003.

Bill Burke
———. *Autrefois, Maison Privee.* New York: powerHouse Books, 2003.

Harry Callahan
Salvesen, Britt and John Szarkowski. *Harry Callahan: The Photographer at Work.* New Haven: Yale University Press, 2006.

Julia Margaret Cameron
———. *Julia Margaret Cameron.* London: Phaidon, 2006.

Robert Capa
———. *Robert Capa: The Definitive Collection.* London: Phaidon, 2001.

Paul Caponigro
———. *Masterworks from Forty Years.* Carmel, CA: Photography West Graphics, 1993.

Keith Carter
———. *Keith Carter Photographs: Twenty-Five Years.* Austin: University of Texas Press, 1997.

Henri Cartier-Bresson
———. *Henri Cartier-Bresson: A Retrospective.* London: Thames and Hudson, 2003.

Linda Connor
———. *Luminance.* Carmel, CA: Center for Photographic Art, 1994.

Robert Cumming
———. *Robert Cumming: Photographic Works 1969-1980.* Limoges: F. R. A. C. Limousin, 1995.

Imogen Cunningham
———. *Ideas Without End: A Life in Photographs.* San Francisco: Chronicle Books, 1993.

L.J.M. Daguerre
Gernsheim, Helmut, and Alison Gernsheim. L.J.M. Daguerre: *The History of the Diorama and the Daguerreotype.* New York: Dover, 1969.

Louise Dahl-Wolfe
———. *A Photographer's Scrapbook.* New York: St. Martin's Press, 1984.

Robert Demachy
———. *Demachy: Photographe.* Paris: Contrejour, 1990.

Thomas Demand
———. *Thomas Demand.* New York: MOMA, 2005.

Rineke Dijkstra
———. *Portraits.* Munich: Schirmer/Mosel, 2005.

Peter Henry Emerson
Taylor, John. *The Old Order and the New: P. H. Emerson and Photography. 1885-1895.* Munich: Prestel, 2006.

Bibliography continued

Elliott Erwitt
———. *Personal Best.* New York: te Neues, 2006.

Walker Evans
———. *Walker Evans.* Princeton, NJ: Princeton University Press, 2000.

Andreas Feininger
———. *That's Photography.* Ostfildern: Hatje Cantz, 2004.

Kurt Edward Fishback
———. *Art in Residence: West Coast Artists in Their Space.* Oregon: Blue Heron Publishers, 2000.

Martine Franck
———. *One Day to the Next.* New York: Aperture, 1999.

Robert Frank
———. *The Americans.* 3rd ed. Zürich: Scalo, 1998.

Lee Friedlander
———. *Lee Friedlander.* New York: MOMA, 2005.

Masahisa Fukase
———. *The Solitude of Ravens.* San Francisco: Bedford Arts, Publishers, 1991.

Adam Fuss
———. *My Ghost.* Santa Fe: Twin Palms Publishers, 2001.

Flor Garduño
———. *Witnesses of Time.* New York: Thames and Hudson, 1992.

Bill Gaskins
———. *Good and Bad Hair.* Piscataway, NJ: Rutgers University Press,1992.

Arnold Genthe
———. *As I Remember.* New York: Reynal & Hitchcock, 1936.

Ralph Gibson
———. *Light Years.* Zürich: Edition Stemmle, 2006.

Nan Goldin
———. *Devil's Playground.* London: Phaidon Press, 2003.

John Gossage
———. *Berlin in the Time of the Wall.* Bethesda: Loosestrife Editions, 2004.

Emmet Gowin
———. *Changing the Earth.* New Haven: Yale University Press, 2002.

Lauren Greenfield
———. *Thin.* San Francisco: Chronicle Books, 2006.

Lois Greenfield
———. *Breaking Bounds.* San Francisco: Chronicle Books, 1992.

Timothy Greenfield-Sanders
———. *Face to Face: Selected Portraits 1977-2005.* Milan: Skira Editore, 2006.

Andreas Gursky
———*Andreas Gursky.* New York: Museum of Modern Art, 2001.

Betty Hahn
———. *Photography or Maybe Not.* Albuquerque: University of New Mexico Press, 1995.

Erich Hartmann
———. *In the Camps.* New York: W.W. Norton, 1995.

Naoya Hatakeyama
———. *Zeche Westfahlen I/II Ahlen.* Portland: Nazraeli Press, 2006.

Bill Hedrich
———. *Hedrich-Blessing: Architectural Photography, 1930-1981.* Rochester, NY: George Eastman House, 1981.

Lewis Hine
———. *Passionate Journey: Photographs 1905-1937.* Zürich: Edition Stemmle, 1997.

Teun Hocks
———. *Teun Hocks.* New York: Aperture, 2006.

Kenro Izu
———. *Passage to Angkor.* New York: Friends Without a Border, 2006.

Lotte Jacobi
———. *Lotte Jacobi: Photographs.* Boston: David R. Godine, 2003.

Jeff Jacobson
———. *Melting Point.* Portland: Nazraeli Press, 2006.

Lou Jones
———. *Final Exposure: Portraits from Death Row.* Philadelphia: American Friends Service Committee, 2002.

Kenneth Josephson
———. *Kenneth Josephson: A Retrospective.* Chicago: Art Institute of Chicago Museum, 1999.

Yousuf Karsh
———. *A Biography in Images.* New York: MFA Publications, 2003.

André Kertész
———. *André Kertész: His Life and Work.* Boston: Bulfinch Press, 1994.

Mark Klett and Byron Wolfe
———. *Yosemite in Time: Ice Ages, Tree Clocks, Ghost Rivers.* San Antonio: Trinity University Press, 2005.

Bohnchang Koo
———. *Portraits of Time.* Seoul: HOMI Publishing House, 2004.

Julieanne Kost
———. *Window Seat: The Art of Digital Photography and Creative Thinking.* Cambridge: O'Reilly Media, 2006.

Josef Koudelka
———. *Koudelka.* New York: Aperture, 2007.

Barbara Kruger
———. *Money Talks.* New York: Skarstedt Fine Art, 2005.

Dorothea Lange
———. *Dorothea Lange.* London: Phaidon, 2006.

Jacques-Henri Lartigue
———. *Lartigue: Album of a Century.* New York: Harry N. Abrams, 2003.

Annie Leibovitz
———. *A Photographer's Life: 1990-2005.* New York: Random House, 2006..

Helen Levitt
———. *Here and There.* New York: powerHouse, 2003.

Jerome Liebling
———. *The People, Yes.* New York: Aperture, 1988.

Loretta Lux
———. *Loretta Lux.* New York: Aperture, 2005.

Danny Lyon
———. *Forty Years.* Paris: Gallery Kamel Mennour, 2003.

Peter Magubane
———. *Women of South Africa: Their Fight for Freedom.* Boston: Little, Brown and Company, 1993.

Man Ray
———. *Photofile: Man Ray.* London: Thames and Hudson, 2006.

Susan Meiselas
———. *Carnival Strippers.* Gottingen: Steidl, 2003. Reprint of 1976 edition.

Ray K. Metzker
———. *Landscapes.* New York: Aperture, 2000.

Pedro Meyer
———. *The Real and the True: The Digital Photography of Pedro Meyer.* Berkeley: New Riders, 2005.

Duane Michals
Marco Livingstone. *The Essential Duane Michals.* Boston: Bullfinch Press, 1997.

Arno Minkkinen
———. *Saga: The Journey of Arno Rafael Minkkinen.* San Francisco: Chronicle Books, 2005.

László Moholy-Nagy
———. *Color in Transparency: Photographic Experiments in Color, 1934-1946.* Gottingen: Steidl/Bauhaus Archiv, 2006.

Abelardo Morell
———. *Abelardo Morell.* London: Phaidon Press, 2005.

David Muench
———. *Sacred Lands of Indian America.* New York: Harry N. Abrams, 2001.

Eadweard Muybridge
———. *Muybridge's Complete Human and Animal Locomotion.* 3 vols., reprint. New York: Dover, 1979.

James Nachtwey
———. *Inferno.* New York: Phaidon Press, 2000.

Patrick Nagatani
———. *Nuclear Enchantment.* Albuquerque: University of New Mexico Press, 1991.

Graham Nash
———. *Eye to Eye.* Gottingen: Steidl, 2004.

Arnold Newman
———. *Arnold Newman.* Munich: Taschen, 2006.

Joseph Nicéphore Niépce
———. *Lettres et Documents.* Paris: Centre National de la Photographie, 1983.

Nicholas Nixon
———. *Home: Photographs by Nicholas Nixon.* Revere, PA: Lodima Press, 2005.

Timothy O'Sullivan
———. *American Frontiers: The Photographs of Timothy H. O'Sullivan, 1867-1874.* New York: Aperture, 1981.

Robert ParkeHarrison
———. *The Architect's Brother.* Santa Fe: Twin Palms, 2000.

Bart Parker
———. *A Close Brush With Reality: Photographs and Writings, 1972-1981.* Rochester, NY: Visual Studies Workshop Press, 1981.

Olivia Parker
———. *Weighing the Planets.* Boston: New York Graphic Society, 1987.

Gordon Parks
———. *Bare Witness.* Milan: Skira, 2007.

Martin Parr
———. *Martin Parr.* London: Phaidon, 2002.

John Pfahl
———. *A Distanced Land: The Photographs of John Pfahl.* The Albuquerque: University of New Mexico Press, 1990.

Marc PoKempner
Schorlau, Wolfgang. *Down at Theresa's... Chicago Blues: The Photographs of Marc PoKempner.* Munich: Prestel Verlag, 2000.

Neal Rantoul
———. *American Series.* Boston: Pond Press, 2006.

Jacob Riis
———. *Jacob A. Riis: Photographer and Citizen.* New York: Aperture, 1993.

Miguel Rio Branco
———. *An Aperture Monograph.* New York: Aperture, 1998

Henry Peach Robinson
———. *Henry Peach Robinson: Master of Photographic Art: 1830-1901.* New York: Basil Blackwell, 1988.

Stuart Rome
———. *Forest.* Portland: Nazraeli Press, 2005.

Ed Ruscha
———. *Ed Ruscha: Photographer.* Gottingen: Steidl, 2006.

Sebastião Salgado
———. *Sahel: The End of the Road.* Berkeley: University of California Press, 2004.

Erich Salomon
———. *Photographies.* Strasbourg: Musees de Strasbourg, 2004.

August Sander
———. *People of the 20th Century.* New York: Harry N. Abrams, 2002.

Victor Schrager
———. *Bird Hand Book.* New York: Graphis, 2001.

John Sexton
———. *Places of Power: The Aesthetics of Technology.* Carmel Valley, CA: Ventana Editions, 2000.

Paul Shambroom
———. *Meetings.* London: Chris Boot, 2004.

Fazal Sheikh
———. *Moksha.* Gottingen: Steidl, 2005.

Cindy Sherman
———. *Cindy Sherman.* Paris: Flammarion, 2006.

Toshio Shibata
———. *Dam.* Portland: Nazraeli Press, 2004.

Aaron Siskind
———. *Aaron Siskind 100.* New York: powerHouse Books, 2003.

Sandy Skoglund
———. *Sandy Skoglund: Reality Under Siege.* New York: Harry N. Abrams, 1998.

Luther Smith
———. *The Trinity River: Photographs by Luther Smith.* Fort Worth: Texas Christian University Press, 1997.

W. Eugene Smith
———. *W. Eugene Smith: Photographs 1934-1975.* New York: Harry N. Abrams, 1998.

Alec Soth
———. *Sleeping by the Mississippi.* Gottingen: Steidl, 2004.

Jem Southam
———. *The Painter's Pool.* Portland: Nazraeli Press, 2006.

Alfred Stieglitz
———. *Alfred Stieglitz: The Key Set.* New York: Harry N. Abrams, 2002.

Dennis Stock
———. *James Dean: Fifty Years Ago.* New York: Harry N. Abrams, 2005.

Ezra Stoller
———. *Modern Architecture.* New York: Harry N. Abrams, 1999.

Jim Stone
———. *One Picture Book #29: Why My Photographs are Good.* Portland: Nazraeli, 2005.

Paul Strand
———. *Sixty Years of Photographs.* Carmel Valley, CA: Farrar, Straus & Giroux, 2000. Reprint of 1976 edition.

Thomas Struth
———. *Thomas Struth 1977–2002.* Dallas: Dallas Museum of Art, 2002.

Larry Sultan
———. *The Valley.* Zürich: Scalo, 2004.

William Henry Fox Talbot
Schaaf, Larry. *The Photographic Art of William Henry Fox Talbot.* Princeton, NJ: Princeton University Press, 2000.

George Tice
———. *Urban Landscapes.* New York: W. W. Norton & Company, 2002.

Philip Trager
———. *Philip Trager.* Gottingen: Steidl, 2006.

Pete Turner
———. *African Journey.* New York: Graphis Press, 2001.

David Turnley
Turnley, David et, al. *In Times of War and Peace.* New York: Abbeville Press, 1997.

Jerry N. Uelsmann
———. *Approaching The Shadow.* Portland: Nazraeli Press, 2000.

Peter Vanderwarker
———. *The Big Dig: Reshaping an American City.* Boston: Little, Brown & Co., 2001.

Massimo Vitali
———. *Massimo Vitali: Landscape and Figures.* Gottingen: Steidl, 2003.

Catherine Wagner
———. *Cross Sections.* Santa Fe: Twin Palms, 2001.

Todd Walker
———. *Todd Walker: Photographs.* Carmel: Friends of Photography, 1985.

Alex Webb
———. *Crossings: Photographs from the U. S.-Mexico Border.* New York: Monacelli Press, 2003.

Weegee (Arthur Fellig)
———. *Weegee.* London: Phaidon, 2004.

Carrie Mae Weems
———. *Carrie Mae Weems: Recent Work.* New York: George Braziller, 2003.

William Wegman
———. *Funney-Strange.* New Haven: Yale University Press, 2006.

Terri Weifenbach
———. *Lana.* Portland: Nazraeli Press, 2002.

Henry Wessel
———. *Five Books: California and the West, Odd Photos, Las Vegas, Real Estate Photographs, Night Walk.* Gottingen: Steidl, 2005.

Edward Weston
———. *Edward Weston.* Munich: Taschen, 2004.

Minor White
———. *Minor White: The Eye That Shapes.* Princeton, NJ: The Art Museum, Princeton University, 1989.

Michael S. Williamson
———. *Journey to Nowhere: The Saga of the New Underclass.* Garden City, NY: Dial Press, 1985.

Garry Winogrand
———. *Winogrand: Figments from the Real World.* New York: MOMA, 2003.

Marion Post Wolcott
———. *Looking for the Light.* New York: Alfred A. Knopf, 1992.

PERIODICALS

American Photo, Hachette Filipacchi Magazines, 1633 Broadway, 45th Floor, New York, NY 10019. Photography in all its forms; fame and fortune given an edge over fine art, with an emphasis on contemporary American work.

Aperture, 20 East 23rd Street, New York, NY 10010. A superbly printed quarterly dealing with photography as an art form. aperture.org

Artforum, 65 Bleecker Street, New York, NY 10012. This magazine, *Art in America*, and *ARTnews* have occasional articles about photography as an art form in addition to reviews of photographic shows. artforum.com

Art in America, 575 Broadway, 5th Floor, New York, NY 10012. Included in the subscription is their annual guide to galleries, museums, and artists; a useful art-world reference. artinamericamagazine.com

ARTnews, 48 West 38th Street, New York, NY 10018. artnewsonline.com

Black & White, PO Box 1529, Ross, CA 94957. bandwmag.com

Blind Spot, 210 Eleventh Ave., New York, NY 10001. blindspot.com

Camera Arts, P.O. Box 3941, Corrales, NM 87190. cameraarts.com

Computer Graphics World, COP Communications, Inc., 620 West Elk Ave., Glendale, CA 91204. Features current developments in digital imaging and computer graphics, primarily for commercial applications. cgw.com

Digital Photographer, 290 Maple Ct., Suite 232, Ventura, CA 93003. digiphotomag.com

LensWork, 909 3rd Street, Anacortes, WA 98221. High-quality reproductions, articles, and interviews. Non-technical. lenswork.com

PDN (Photo District News), 1515 Broadway, New York, NY 10036. Emphasis on commercial and professional photography, including electronic media. pdnonline.com

Photographer's Forum, 511 Olive Street, Santa Barbara, CA 93101. Geared toward students and others seeking photographic careers; includes school profiles. serbin.com/Photo_Forum

Photo Techniques, Preston Publications, 6600 W. Touhy Ave., Niles, IL 60714. Technical information on photographic materials, equipment, and processes. phototechmag.com

Pinhole Journal, Star Route 15, Box 1355, San Lorenzo, NM 88041. A quarterly publication on pinhole photography. pinholeresource.com

Popular Photography and Imaging, Hachette Filipacchi Magazines, 1633 Broadway, New York, NY 10019. popphoto.com

Professional Photographer, 229 Peachtree St NE, Suite 2200, International Tower, Atlanta, GA 30303. For commercial and industrial photographers with emphasis on electronic imaging. ppmag.com

Shutterbug, Patch Publishing, 1419 Chaffee Drive, Suite #1, Titusville, FL 32780. Features articles and technical data, but mainly new and used equipment for sale. shutterbug.net

Studio Photography, 3 Huntington Quadrangle, Suite 301N, Malville, NY 11747. imaginginfo.com

View Camera Magazine, P.O. Box 2328, Corrales, NM 87048. viewcamera.com

Many institutions and nonprofit groups involved with photography publish periodicals for their membership. Many cater to a specialized or regional interest, and they often serve as a springboard to national visibility for younger photographers.

Afterimage, 31 Prince Street, Rochester, NY 14607. From the Visual Studies Workshop. Includes scholarly articles on photography, film, and video; listings of shows, events, publications, and opportunities nationwide. vsw.org/afterimage

Archive, The Center for Creative Photography, University of Arizona, 843 East University Boulevard, Tucson, AZ 85719. Scholarly and occasional. creativephotography.org/store/archive.html

ASMP Bulletin, American Society of Media Photographers, 150 North Second Street, Philadelphia, PA 19106. A guide for the working professional published for ASMP members. asmp.org

Camerawork: A Journal of Photographic Arts. San Francisco Camerawork. 657 Mission Street, San Francisco, CA 94105. sfcamerawork.org

Contact Sheet, Light Work, 316 Waverly Avenue, Syracuse, NY 13244. Five issues annually, four monographs and one collection, all beautifully printed, that feature artists sponsored by this arts organization. lightwork.org

Exposure, Society for Photographic Education, 126 Peobody Hall, Miami University, Oxford, OH 45056. A periodical from an organization concerned with the teaching of photography, especially as a fine art. spenational.org

News Photographer, National Press Photographers Association, 3200 Croasdaile Dr., Suite 306, Durham, NC 27705. For working and student photojournalists. nppa.org

Photography Quarterly, The Center for Photography at Woodstock, 59 Tinker Street, Woodstock, NY 12498. cpw.org

SPOT, Houston Center for Photography, 1441 West Alabama, Houston, TX 77006. Magazine of contemporary images, discussion, and opinion, featuring the works of regional and national photographers, writers, and critics. hcponline.org

Credits

Cover images (left to right): View camera: Ken Kay; "Too Much Sugar": © Chip Simons; Landscape Bavaria: Grant Faint/Getty Images; Women Swimming: Lou Jones Photography.

viii: cutaway view camera photo by Ken Kay; computer screen courtesy of Getty Images, Inc—Liaison

Chapter 1 2: U. S. Navy Photo; 3: Lauren Greenfield/VII; 4: (all) © Ken Kobré; 5: (all) © Ken Kobré; 6: (t) © Ken Kobré; (cl) Barbara London; (cc, cr) U.S. Dept. of Agriculture; 7: (b) © Ken Kobré; 8: (tl, cr, bl, br) © Ken Kobré; (tr, tc, cc) Sibylla Herbrich; 9: (tc, tr, cc, cr) Sibylla Herbrich; (cl, tl) Scott Goldsmith Photography; ((bc) U.S. Dept. of Agriculture; 10: (t) Larry Sultan; (b) © Nicholas Nixon; 11: (t) Dr. Peter Magubane; (b) Massimo Vitali; 12: (t) Louise Dahl-Wolfe; Staley-Wise Gallery; (b) Stuart Rome; 13: (t) Terri Weifenbach; (b) Jem Southam

Chapter 2 14: Andreas Feininger/TimePix; 16: (tl, tr) Courtesy of Pentax; (c) Courtesy Nikon, USA, (b) "CANON", the Canon logo, and EOS are trademarks of Canon, Inc. All rights reserved. Used by permission; 17: (tl, tr, cl, cr, bl, br) Sibylla Herbrich; (t) Barbara London; 18: © Ken Kobré; 19: Chad Person; 20: Sibylla Herbrich; 21: Clifford Oto; 22: (t) Lazslo Moholy-Nagy/Courtesy Hattula Moholy-Nagy and the Moholy-Nagy Foundation, ARS New York; (b) Simon Bruty/Sports Illustrated; 23: Olivier Follmi/Hachette Photos; 24: Nubar Alexanian; 25: © Ken Kobré; 26: Duane Michals; 27: Duane Michals; 28: George Krause; 29: George Krause; 30: Jim Stone; 31 (tl, tr) Sibylla Herbrich; (bl, br) Jim Stone (tl, tr) Sibylla Herbrich; (b) Glen Fishback; (tc, tr, bc, br) Sibylla Herbrich; (tl, cl, bl) © Ken Kobré; 34: (t) James Nachtwey/VII; (b) (c) David Turnley/CORBIS. All Rights Reserved; 35: James Nachtwey/VII

Chapter 3 36: Julie Anand; 38: Peggy Ann Jones; 41: Joe Ciaglia; 42: Peter Vanderwarker Photographs; 43: Henri Cartier-Bresson/Magnum Photos, Inc; 44: (both) Jack Sal & Michael Belinsky; 45: Lou Jones Photography; 46: Karl Baden; 47: Muench Photography, Inc.; 48: Ian Van Coller; 49: (t) Martin Parr/Magnum Photos; (b) Chip Simons Photography; 50: (l, c) © Ken Kobré; (r, b) (c)Ken Kobre & U S Department of Agriculture; 51: Elliot Erwitt/Magnum Photos, Inc.; 52: Sibyla Herbrich; 53: James Glover; 54: Martine Franck/Magnum Photos, Inc.; 55: Micha Bar-Am; 57: Sibylla Herbrich; 58: Helen Levitt/Fraenkel Gallery; 59: John Pfahl; 60: David Arkey; 61: (t) Andreas Feininger/TimePix; (r) William G. Larson; 62: (c) Ken Kobre; 63: (c) Ken Kobre; 64: (t) Mary Ellen Mark; (b) "Portrait of Mary Ellen Mark" by Nancy Strogoff; 65: Mary Ellen Mark

Chapter 4 66: Kenneth Josephson; 67: © Ken Kobré; 68: © Ken Kobré; 70: Peggy Ann Jones; 71: © Ken Kobré; 72: Linda Connor; 73: © Ken Kobré; 74: © Ken Kobré; (tl, tc, tr, cl, cc, cr) © Ken Kobré; (bl, bc, br) Flint Born; 76: Sibylla Herbrich; (bl, br) © Ken Kobré; 77: (c) Marc PoKempner 1991; 78: "CANON", the Canon logo, and EOS are trademarks of Canon, Inc. All rights reserved. Used by permission; 79: John Moore for Scott Foresman-Addison Wesley; 80: (t) Eve Arnold/Magnum Photos, Inc.; (b) Daniel F. Kaufmann; 81: Daniel F. Kaufmann; 82: David Taylor; 83: (t, series) "The Thinker". Warren Difranco Hsu/International Art Guild Gallery, CA; (c, series) Andrew Lee Crooks; (b, br) David Taylor; 84: Luther Smith; 85: Minor White/Copyright (c) by the Trustees of Princeton University. All Rights Reserved. Reproduction courtesy of the Minor White Archive, Princeton University Museum; 86: (l) Joyce Neimanas, untitled #3, 1980; (r) Courtesy Polaroid; 87 (tl, tr) Jim Stone; (cl, cr) © Ken Kobré; (b) Martin Stupich; 89: Sibylla Herbrich; 90: (t) Ernst Haas/Getty Images, Inc.; (b) William Allan Allard/National Geographic Image Collection; 91: Manuel Alvarez Baravo, "Portrait of the Eternal/Retrato de lo Eterno". Courtesy of J Paul Getty Museum; 92: (t) Clint Clemens Photography; (b) Jason Evans; 93: Clint Clemens Photography

Chapter 5 94: Gretchen Schoeninger (American, b 1913), "Negative Exposure". 1937. Gelatin Silver Print. 24.3 x 16.8 cm. Photograph (c) 2005, The Art Institute of Chicago. All Rights Reserved; 96: © Ken Kobré; 98: © Ken Kobré; 99: Walker Evans/Courtesy of the Library of Congress; 101: © Ken Kobré; 102: © Ken Kobré; 103: © Ken Kobré; 104: © Ken Kobré; 105: © Ken Kobré; 106: (tl, tc, tr) Courtesy of (c) Eastman Kodak Company; (c) Jim Stone; (bl, bc, br) Robert Walch; 107: Robert Capa; 108: Ralph Gibson; 109: Jim Stone

Chapter 6 110: Ray K. Metzker; 112: Gerry Russell; 113: © Ken Kobré; 114: Elaine O'Neil, Festival, Lidul Park, Guanxian, China (c)1987; 116: Frank Herrera; 117: John Moore for Scott Foresman-Addison Wesley; 118: © Ken Kobré; 119: (tl, tc, tr, br) © Ken Kobré; (bl) Scot Tucker; 120: © Ken Kobré; 121: © Ken Kobré; 122: (tl, tr, bl) © Ken Kobré; (br) Scot Tucker; 123: (tl, tr) © Ken Kobré; (b) Scot Tucker; 125: © Ken Kobré; 126: © Ken Kobré; 127: © Ken Kobré; 128: Jim Stone; 129: Jim Stone; 130: Warren DiFranco Hsu; 131: (t) Ted Rice; (b) Warren DiFranco Hsu; 132: John Upton; 133: Gerry Russell; 134: (tl, tr) © Arnold Newman/Liaison Agency; (b) Rick Steadry; 136: Frederic Ohringer; 137: Olivia Parker

Chapter 7 (c)2003 Joel Meyerowitz. Courtesy of Ariel Meyerowitz Gallery, New York; 141: © Ken Kobré; 142: Maria Robledo; 143: Jim Scherer, foodpictures .com; 144: (t) Robert Richfield; (c) Georg Gerster/Photo Researchers, Inc.; (b) Peter Turner; 145: John Upton; 146: David Muench/Muench Photography, Inc.; 147: (t) Miguel Rio Branco/Magnum Photos; (b) © Ken Kobré; 149: (tl, tc, tr) © Ken Kobré; (cl, cc, cr) Sibylla Herbrich; (bl, br) Julie Stupsker; 150: Peter Marlow/Magnum Photos; 152: (t) Donald Dietz; (b) Ian van Coller; 153: Donald Dietz; 154: Donald Dietz; 156: Donal Dietz; 157: Barbara London; 158: James Baker; 159: Donald Dietz; 160: Walter Iooss, Jr.; 161: Walter Iooss, Jr.

Chapter 8 162: Colin Blakely; 163: Jim Stone; 164: Robert Richfield; 165: Jim Stone; 167: Paul Berger; 169: (t) Stan Strembicki; (b) Dennis DeHart, "Nutpod and Petunut", 2001; 170: (l) Monaco OPIX (TR), courtesy Monaco Systems, Inc.; (r) 3D color plots created using CHROMiX ColorThink. www.chromix.com/colorthink; 171: Kenda North; 172: (t, bl) Jim Stone; (bc) Ray K. Metzker; (br) Marc PoKempner; 173: Keith Johnson; 174: Hulleah J. Tsinhnahjinnie, "Idelia," 2003. Courtesy of the artist; 175: Gary Hallman, "Icarus Too", 2003; 176: Pedro Meyer; 177: Pedro Meyer

Chapter 9 178: Chris Collins; 180: Loretta Lux, Courtesy Yossi Milo Gallery; 181: Stan Strembicki; 182: Jim Stone; 183: Jim Stone; 184: Jim Stone; 185: William W. Dunmire; 186: Lawrence McFarland; 187: Lawrence McFarland; 188: Jim Stone; 189: Ian van Coller; 190: Duncan Smith; 191: Jim Stone; 192: (t) Elisa Tree and The Solomon Family Archive; (b) Jim Stone; 193: Francine Zazlow; 194: © Jamey Stillings Photography, Inc.; 195 (t) © Jamey Stillings Photography, Inc.; (b) Julieanne Kost, "Prison", 2003; 197: Mark Klett

Chapter 10 198: © Ansel Adams Publishing Rights Trust / CORBIS. All Rights Reserved; 200: (tl) HP printer; (tr) Peggy Ann Jones; (b) Epson printer; 201: © Annie Leibovitz/Contact Press Images; 202: Dornith Doherty; 203: Terry Abrams; 204-205: Mark Klett and Byron Wolfe; 205: (t) Jeff Chen-Hsing Liao; 206: (t) Ron Harris; (b) Paul Roark; 207: Philip Trager; 208: (l) Courtesy Pete Turner; (r) Courtesy International Center of Photography; 209: (l) Canon; (c,r) Michael Kienitz

Chapter 11 210: Stan Strembicki; 212 (t) Other World Computing; (tc) Seagate; (bc) Delkin; (b) Sony; 213: Victor Schrager; 214: Jim Stone; 216: Jim Stone; 217: John Willis

Chapter 12 218: Dawoud Bey; 220: Rick Steadry; 221: Jim Stone, © Ken Kobré; 222: Jim Stone, © Ken Kobré; (br) Jo Whaley; 223: Jim Stone, © Ken Kobré; 224: Jim Stone, © Ken Kobré; 225: John Gossage

Chapter 13 226: Yousuf Karsh/Woodfin Camp & Associates; 227: Paul D'Amato; 228: © Richard Copley; 229: (t) © 1984 Estate of Garry Winogrand. Collection Center for Creative Photography, The University of Arizona; (b) Henry Wessel; 230: (l) © Lotte Jacobi Collection, University of New Hampshire; (r) © Imogen Cunningham Trust; 231: © Danny Lyon/Magnum Photos; 232: (t) Bill Gaskins; (b) Bill Burke; 233: (t) Margaret Bourke-White/Getty Images; (b) Polly Brown; 235: (t) Y. R. Okamoto/Courtesy Lyndon Baines Johnson Library; (b) Red Rice; 236: Jack Sal/Michael Belenky; 237: Timothy Greenfield-Sanders; 238: © Ken Kobré; 239: © Ken Kobré; 240: © Lois Greenfield 1983; 241: Weegee/ICP/Liaison Agency; 242: © Ken Kobré; 243: © Jeff Jacobson; 246: (t) Jack Sal/Michael Belenky; (b) © Ken Kobré; 247: Justin F. Kimball; 248: Jason Doly; 249: (t) Rineke Dijkstra; (b) Kim Heacox/Getty; 250: Rodney Smith; 251: (l) Janet Delaney/Image Bank/Getty Images; (r) Fazal Sheikh; 252: David Arky; 253: (t) David Arky; (b) Jan Oswald/Image Bank/ Getty Images; 254: © Ken Kobré; 255: Fil Hunter; 256: Erich Hartmann/Magnum Photos; 257: Gregory Heisler; 258: (t) © Lois Greenfield 2006; (b) © Lois Greenfield 1985; 259: © Lois Greenfield 1995

Chapter 14 260: Bernd and Hilla Becher Courtesy Sonnabend 262: Bohnchang Koo; 263: (t) Courtesy of the estate of Todd Walker; (b) Lewis Baltz; 264: Carrie Mae Weems; 265: (t, c) Karl Baden Courtesy Howard Yezerski Gallery; (b) Courtesy of the estate of Masumi Hayashi; 266: (t) Thomas Demand; (b) Patrick Nagatani/André Tracey; 267: Radioactive Cats ©1980 Sandy Skoglund; 268: Robert Heinecken/Joy; 269: (t) Dana Moore; (b) ©1988 Alfredo Jaar, Collection Fonds National d'Art Contemporain (FNAC), Courtesy Galerie Lelong, New York; 270: ©Krzysztof Wodiczko Courtesy Galerie Lelong, New York; 271: (t) Ed Rusha/Leo Castelli Gallery; (b) Mike Mandel; 272: Betty Hahn; 273: (t) Alison Carey; (b) Kenro Izu; 274: Sookang Kim; 275: (t) Amy Melious; (b) Courtesy of Polaroid; 276: Man Ray, "Rayograph". 1924. (c)2005 Man Ray Trust/Artists Rights Society (ARS), NY/ADAGP, Paris; 277: © Adam Fuss/Courtesy Fraenkel Gallery, San Francisco; 278: Walid Ghanem; 279: Tom Baril/Image Bank; 280: (tl) Peggy Ann Jones; (tr) Peggy Ann Jones; (bl) Nancy Spencer; (br) Nancy Spencer; 283: Sybilla Herbrich

Chapter 15 286: © Canadien Centre d'Architecture and Catherine Wagner; 287: Michael Grecco Photography, Inc.; 288: Arthur Taussig; 290: Ezra Stoller ©Esto; 291: Ken Kay; 292: Kurt Edward Fishback; 293: Ken Kay; 294: Keith Carter; 295: Ken Kay; 296: ©Verburg 1994; 297: Ken Kay; 299: (tl, tr) Donald Dietz; (bl, br) Ken Kay; 300: Philip Trager; 301: Philip Trager; 304: © Ken Kobré; 305: © Ken Kobre

Chapter 16 306: George Tice; 309: John Upton; 311: John Upton; 312: Rick Steadry; 314: Minor White/Courtesy of the Minor White Archive, Princeton University. © 1982 by the Trustees of Princeton University. All Rights Reserved; 315: Allan Hess; 316: (t) © 2002 John Sexton. All Rights Reserved. (b) © 2003 Anne Larsen. All rights reserved; 317: © 2002 John Sexton. All Rights Reserved

Chapter 17 318: Edward Burtynsky/Image Courtesy: Charles Cowles Gallery, New York and Robert Koch Gallery, San Francisco; 319: Marion Post Walcott; 320: (t) Arthur Siegel, "Right of Assembly" Courtesy Irene Siegel; (b) Jerome Liebling Photography; 321: Lee Friedlander/Fraenkel Gallery; 322: Alex Webb, Magnum Photos; 323: Paul Fusco/Image Bank/Getty Images; 324: (t) Graham Nash; (b) Robert Landau; 325: Sean Kiernan; 326: (t) Hiromu Kira/Courtesy of the Marjorie & Leonard Vernon Collection; (b) Steve Dzerigian; 327: Russell Lee/Courtesy of the Library of Congress; 328: Paul Caponigro; 329: Gordon Parks; 330: (t) Roy Clark/U.S. Dept. of Agriculture; (b) R.O. Brandeberger/U.S. Dept. of Agriculture; 331: Dennis Stock; 332: U.S. Dept. of Agriculture; (b) Robert Landau; 333: © Paul Shambroom. All rights reserved; 334: Flor Garduno; 335: Bill Hedrich/Hedrich-Blessing; 336: Arthur Rothstein; 337: Josef Koudelka/Magnum Photos, Inc.; 338: Marion Post Walcott/Courtesy of the Library of Congress; 339: (t) Neal Rantoul; (b) © Toshio Shibata/Courtesy Laurence Miller Gallery, New York; 341: Sebastiao Salgado/Contact; 342: (t) Clinton Cargill; (b) Patrick Donehue; 343: (t) Barney McCulloch; (b) Photo by Aaron Serafino, MOPA

Chapter 18 Photographer Unknown, "Daguerreotype of Couple Holding a Daguerreotype". C. 1850. Gift of Virginia Cuthbert Elliott Digital Image © The Museum of Modern Art/Licensed by SCALA / Art Resource, NY; 346: (t) JOseph Nicephore Niepce/Gernsheim Collection, Harry Ransom Humanities Research Center, The University of Texas at Austin; (b) Louis Jaques Mande Daguerre/Collections of Societe Francaise de Photographie; 347: Amherst College Library; 348: William Henry Fox Talbot/Courtesy Lee Boltin Picture Library; 349: Gernsheim Collection/Photography Collection, Harry Ransom Humanities Research Center, The University of Texas at Austin; 350: Frederick Church/International Museum of Photography at George Eastman House; 351: (t) Arnold Genthe/Courtesy of Library of Congress; (b) Unknown/International Museum of Photography at George Eastman House; 352: Julia Margaret Cameron/Gernsheim Collection, Harry Ransom Humanities Research Center, The University of Texas at Austin; 353: Bibliotheque Nationale de France/Eddy van der Veen; 354: Timothy H. O'Sullivan/Courtesy of the Library of Congress; 355: Timothy H. O'Sullivan/Courtesy of the Library of Congress; 356: (tl) Louis Jaques Mande Daguerre/Bayerisches National Museum, Munchen; (tr) Edward Anthony/International Museum of Photography at George Eastman House; (b) Eadweard Muybridge; 357: (t) Eugene Atget, "Cafe la Rotonde, Boulevard Montparnasse, Paris". date unknown. Digital Image © The Museum of Modern

Index

LIGHT METER

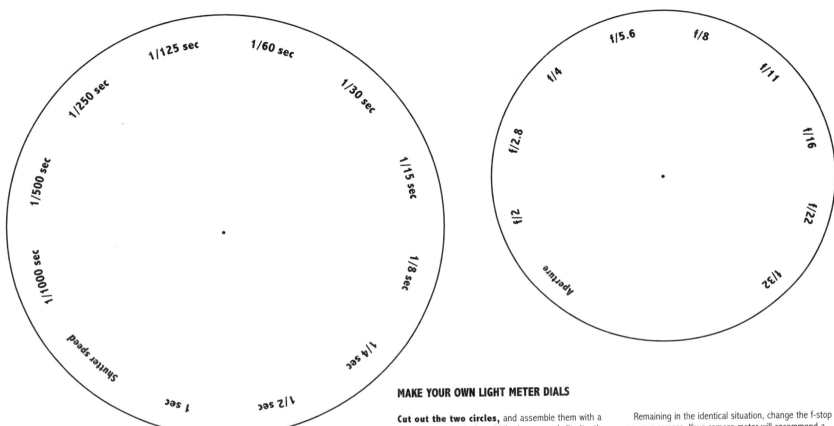

MAKE YOUR OWN LIGHT METER DIALS

Cut out the two circles, and assemble them with a pin or paper clip in the middle. In an evenly lit situation in which the lighting will not change, take an exposure reading with your in-camera meter. Using the paper meter, line up the f-stop and the shutter speed your camera meter indicates. Once this combination is set, you can easily see the other combinations available to you.

Remaining in the identical situation, change the f-stop on your camera. Your camera meter will recommend a new shutter speed. Look at your paper meter again and you will see that the new camera combination coincides with one of the combinations on the paper meter.

Shoot several rolls of film using the paper meter along with your in-camera meter. You will soon master the relationships between f-stops and shutter speeds. For more about equivalent exposures, see pages 28–29, and 68.